BEGINNING WITH THE END

BEGINNING WITH THE END

BEGINNING WITH THE END

God, Science, and Wolfhart Pannenberg

EDITED BY

Carol Rausch Albright

and

Joel Haugen

Open Court
Chicago and La Salle, Illinois

Cover illustration: 'Galileo's Eyelid', a collage by
Stephanie Rayner. Used by permission of the artist.

Open Court Publishing Company is a division of Carus
Publishing Company.

Library of Congress Cataloging-in-Publication Data

Beginning with the end: God, science, and Wolfhart Pannenberg
 edited by Carol Rausch Albright and Joel Haugen.
 p. cm.
 Includes bibliographical references and index.
 ISBN 0-8126-9325-6 (cloth: alk. paper).—ISBN 0-8126-9236-4
(pbk.: alk. paper)
 1. Religion and science. 2. Pannenberg, Wolfhart, 1928-.
I. Albright, Carol Rausch. II. Haugen, Joel, 1958-.
BL241.B37 1997
261.5'5—dc21

97–114
CIP

• • • • • • • • • •

Already Copyrighted Material Included in This Book

Copyright Wolfhart Pannenberg: 'Theology and Anthropology' ['Laying Theological Claim to
Scientific Understandings'] From *Anthropology in Theological Perspective* by Wolfhart
Pannenberg (Westminster 1985, 11–23). 'Theological Questions to Scientists'. Previously
published in *Zygon: Journal of Religion and Science* 16:1 (March 1981): 65–76; in *CTNS Bulletin*
7:2 (Spring 1987); and in *Toward a Theology of Nature: Essays on Science and Faith* by Wolfhart
Pannenberg (Westminster/John Knox 1993, 15–28). 'The Doctrine of the Spirit and the Task
of a Theology of Nature,' published in *Theology* 75:1 (1972): 8–20; and in *Toward a Theology of
Nature: Essays on Science and Faith* by Wolfhart Pannenberg (Westminster/John Knox 1993,
127–137). 'Spirit and Energy'. Originally published as 'Geist und Energie: Zur
Phänomenologie Teilhards de Chardin', *Acta Teilhardiana* 8 (1971): 5–12. Translated by
Donald K. Musser. Also appears in *Toward a Theology of Nature: Essays on Science and Faith* by
Wolfhart Pannenberg (Westminster/John Knox 1993, 138–147). 'Theological Appropriation of
Scientific Understandings: Response to Hefner, Wicken, Eaves, and Tipler'. Previously
published in *Zygon: Journal of Religion and Science* 24:2 (June 1989): 255–271.

Copyright Zygon: Journal of Religion and Science: Frank J. Tipler, 'The Omega Point as Eschaton:
Answers to Pannenberg's Questions for Scientists'. *Zygon: Journal of Religion and Science* 24:2
(June 1989): 217–253. Jeffrey Wicken, 'Toward an Evolutionary Ecology of Meaning'. *Zygon:
Journal of Religion and Science* 24:2 (June 1989): 153–184. Lindon Eaves, 'Content and Method
in Science and Religion: A Geneticist's Perspective'. *Zygon: Journal of Religion and Science* 24:2
(June 1989): 185–215.

Copyright Augsburg Fortress: Hefner, Philip, 'The Role of Science in Pannenberg's Theological
Thinking'. In *The Theology of Wolfhart Pannenberg: Twelve American Critiques, with an
Autobiographical Essay and Response.* Ed. Carl E. Braaten and Philip Clayton. Minneapolis:
Augsburg, 1988.

To the Friends and Associates of the
Chicago Center for Religion and Science

CONTENTS

PREFACE

On a windy November day, a diverse group of scientists, theologians, and philosophers converged on Chicago to address the bold project of the German theologian Wolfhart Pannenberg: to "lay theological claim to scientific understandings." They wondered: In what ways—if any—can theology lay claim to conclusions endorsed by the sciences in the late twentieth century? And what, in fact, can be meant by the phrase "lay claim to"? Could theology have significant contributions to make to the understandings of the sciences?

During the ensuing three days, in public lectures at the Lutheran School of Theology and in discussions continuing into the night, speakers and those who came to hear them wrestled with various issues: How can we know what we believe we know? Does theology add another dimension to the ways we know? Can—must—theology be informed by science—and inform science in turn? How might this process work for cosmology? For thermodynamics? For genetics? How can the disciplines of philosophical thought elucidate the interplay of ideas? Specifically, speakers addressed two issues central to Pannenberg's thought—and to the science-religion dialogue:

1. What might it mean for theology to demonstrate that the scientific descriptions of the data are provisional versions of objective reality and that the data themselves contain a further and theologically relevant dimension?
2. How do field and contingency provide openings to God?

Wolfhart Pannenberg himself was present throughout the conference, and he concluded it with his responses to what had been written and said.

Some of the papers were revised after the conference; one that is included here (Eaves's second paper) was penned in the heat of dialogue, and another (Potter's) was written as the result of subsequent reflection. Nevertheless, these papers do, together, provide a window on a real-time encounter of minds that are highly informed, highly engaged, in a way that sheds light on many of the issues and tensions at the heart of the current dialogue between religion and science.

In order to give the reader a framework for understanding this event, we have included in this volume several seminal essays by Wolfhart Pannenberg that focus on the issues discussed. It is well known within the theological community that Pannenberg's ideas concerning revelation, history, and eschatology form the center of his unique approach to Christian metaphysics and epistemology. What is less well known is that these same ideas frame his thought regarding the relationship of theology and science. The material presented here demonstrates not only that Pannenberg is making an unprecedented claim regarding the relationship between science and theology, but also that the presentation and defense of this claim lie at the very heart of his theology.

In order to test Pannenberg's thought, as he himself would be the first to insist, it must be subjected to just this kind of public debate and scrutiny. It is an aim of this volume to expand the boundaries of such debate far beyond the conference and its participants, into the ranks of all those who have reflected seriously upon how science and theology can converge upon one reality.

To further integrate and highlight the thought presented here, Haugen has written an introductory essay mapping the science-religion dialogue in general and Pannenberg's place in it in particular. Albright has written introductions to the parts of the book, pointing out central themes and issues addressed in each part. These essays aim to make the material more accessible to readers who come to the discussion more familiar with one side of the science-theology dialogue than the other. They should also prove helpful to those who want a quick overview of the volume before deciding which parts of it interest them most.

We wish to express our appreciation to all the contributors to this volume for their co-operation and patience in finally seeing their papers brought before a wider audience. And of course, we express our deep appreciation to Wolfhart Pannenberg, without whose daring proposals such a discussion would not have been possible, and who has challenged us all, no matter what judgment we make regarding his proposals, to reflect more deeply on the possible theological significance of science and the possible scientific significance of theology. The reader who wishes to pursue Pannenberg's writings on science and theology beyond the limits of this volume is referred to a 1993 book of his writings edited by Ted Peters, *Toward a Theology of Nature: Essays on Science and Faith*.

The Chicago Center for Religion and Science sponsored the symposium from which this volume grew. Subsequently, Albright became

Associate for Programs of CCRS and Haugen an Associate of the Center. Their work on the present volume was supported both intellectually and personally by the ambience of the Center and by interaction with other CCRS staff members, associates, and speakers, particularly Philip Hefner, the organizer of the symposium and Director of CCRS.

The institutional support for both the symposium and the production of this book should not go unmentioned. Primary encouragement and funding came from the Lutheran School of Theology at Chicago, through the office of Dean Ralph Klein. Grants from the Aid Association for Lutherans and the Eli Lilly Foundation provided supplemental funding.

To our associates and families, particularly Carol Albright's spouse, John R. Albright, go our thanks for their personal support for this project in particular and also for our involvement in the fascinating and sometimes elusive science-religion dialogue.

<div align="right">

Carol Rausch Albright
Joel Haugen

</div>

ABOUT THE CONTRIBUTORS
··········

Carol Rausch Albright is Executive Editor of *Zygon: Journal of Religion and Science;* Co-Director of the Southern Region, Templeton Foundation Science and Religion Course Program; and Associate for Programs, Chicago Center for Religion and Science, 1100 East Fifty-fifth Street, Chicago, IL 60615. With James B. Ashbrook, she is co-author of a forthcoming book entitled *The Humanizing Brain: Clues to God's Ways of Being God.*

Philip Clayton is Associate Professor of Philosophy at Sonoma State University, Rohnert Park, CA 94928-3609. His books include *Explanation from Physics to Theology: An Essay in Rationality and Religion* (1989) and *In Whom We Have Our Being: Theology of Nature in Light of Contemporary Science* (1997). A German-language work on the history of the problem of God is forthcoming in English as *Toward a Pluralistic Metaphysics: Models of God in Modern Philosophy.*

Willem B. Drees occupies the Nicolette Bruining Chair for Philosophy of Nature and of Technology from a Liberal Protestant Perspective, at the University of Twente, Enschede, The Netherlands. He is also a Research Fellow at Bezinningscentrum, Free University, De Boelelaan 1115, 1081 HV Amsterdam, The Netherlands. His books include *Beyond the Big Bang: Quantum Cosmologies and God* (1990) and *Religion, Science, and Naturalism* (1996).

Lindon Eaves is Distinguished Professor of Human Genetics and Professor of Psychiatry at Virginia Commonwealth University and Director of the Virginia Institute for Psychiatric and Behavioral Genetics within the Virginia Commonwealth University School of Medicine, P.O. Box 980003, Richmond, VA 23298-0003. He is currently studying the interaction of genetic and social factors in the development of behavioral problems in children and young adults.

Joel Haugen works as a Word Wide Web designer in Chicago, and has been studying theology and science for several years. He holds Master of Divinity and Master of Theology degrees from the Lutheran School of Theology at Chicago, and has published articles in *Zygon: Journal of Religion and Science* (1995) and *Insights: The Magazine of the Chicago Center for Religion and Science* (1993).

Philip Hefner is Professor of Systematic Theology at the Lutheran School of Theology at Chicago; Editor of *Zygon: Journal of Religion and Science;* and Director of the Chicago Center for Religion and Science, 1100 East Fifty-fifth Street, Chicago, IL 60615. His publications include *The Human Factor: Evolution, Culture, and Religion* (1993).

Nancey Murphy is Associate Professor of Christian philosophy at Fuller Theological Seminary, Pasadena, CA 91182. Her books include *Beyond Liberalism and Fundamentalism: How Modern and Postmodern Philosophy Set the Theological Agenda* (1996); (with George F.R. Ellis) *On the Moral Nature of the Universe: Theology, Cosmology, and Ethics* (1996); and *Anglo-American Postmodernity: Philosophical Perspectives on Science, Religion, and Ethics* (1997).

Wolfhart Pannenberg, the principal subject of this volume as well as a contributor to it, has been a major and innovative voice in theology ever since the publication of his *Revelation as History* in 1961. The crowning work of his career is his three-volume *Systematic Theology* (1988–1993). His groundbreaking ideas in theology and science can be found in *Theology and the Philosophy of Science* (1976), *Anthropology in Theological Perspective* (1985), and *Toward a Theology of Nature: Essays in Faith and Science* (1993). Pannenberg is Professor Emeritus of Systematic Theology on the Protestant Faculty at the University of Munich.

Ted Peters is Professor of Systematic Theology at The Graduate Theological Union and Pacific Lutheran Theological Seminary, 2770 Marin Avenue, Berkeley, CA 94708-1597. He is Editor of *Dialog* and author of *God—The World's Future: Systematic Theology for a Postmodern Era* (1992) and *Playing God? Genetic Determinism and Human Freedom* (1997).

Robert Lyman Potter is Clinical Ethics Scholar at the Midwest Bioethics Center and Associate Clinical Professor of Medicine at the Kansas University School of Medicine. His address is 8004 Washington Avenue, Kansas City, KS 66112. He divides his time between medical practice in geriatrics and teaching and consulting in bioethics, in which he is developing a concept of clinical spirituality that interprets the philosophy of medicine in terms of value science.

Robert John Russell is Professor of Theology and Science in Residence at the Graduate Theological Union and Founder and Director of the Center for Theology and the Natural Sciences, 2400 Ridge Road, Berkeley, CA 94709. His most recent work concerns the theology of creation and theology of divine action in light of Big Bang and quantum cosmology, classical chaos, molecular biology, and evolution, including several edited books and articles related to these topics.

Paul R. Sponheim is Professor of Systematic Theology at Luther Seminary, 2481 Como Avenue West, St. Paul, MN 55108. His most recent book is *Faith and the Other: A Relational Theology* (1993), a study of the problem and promise of pluralism. He is currently working on a book dealing with human transformation.

Frank J. Tipler is Professor of Mathematical Physics in the Department of Physics at Tulane University, New Orleans, LA 70118. In his most recent book, *The Physics of Immortality* (1994), he develops in detail the thesis of his article in this volume.

Wentzel J. van Huyssteen is James I. McCord Professor of Theology and Science, Princeton Theological Seminary, Mercer Street, Princeton, NJ 08542-0803. His most recent books are *Essays in Postfoundationalist Theology* (1997) and *The Shaping of Rationality in Theology and Science* (1997).

Jeffrey S. Wicken, a biochemist, is the author of *Evolution, Thermodynamics, and Information: Extending the Darwinian Program* (1987).

ABOUT THE COVER ILLUSTRATION

The collage employed on the cover of this volume, 'Galileo's Eyelid' by Toronto artist Stephanie Rayner, reflects an artistic sensibility uniquely in tune with the issues addressed in this volume. The picture itself refers to black holes and laboratories, to Michaelangelo and Raphael, to the Creation and the Incarnation. It speaks of infinity and mystery. Thus it expresses Rayner's continuing exploration of the impact of science on the self-understanding and spiritual quest of our age.

Rayner writes, "My preoccupation for the past fifteen years has been the loss of our myths; my artistic theme the re-interpretation of seminal myths into a modern context." In particular, she seeks to "chart the dis-ease between man's technological achievements and religion." As she notes, "Old patterns are dissolving and reforming in unimaginable combinations through rapid changes in science/technology, art and religion" (from *The Skin of God: Works on Paper by Stephanie Rayner* [Oshawa, Ontario: The Robert McLaughlin Gallery, 1993]). In the face of such change, Rayner, the artist, like the theologians, philosophers, and scientists whose work appears in this volume, devotes mind and spirit to the search for understandings that will provide us with vision and strength for the journey into the new millennium.

Introduction: Pannenberg's Vision of Theology and Science

• • • • • • • • • •

Joel Haugen

> The aim [of theology's critical appropriation of secular anthropological research] is to lay theological claim to the human phenomena described in the anthropological disciplines. To this end, the secular description is accepted as simply a provisional version of the objective reality, a version that needs to be expanded and deepened by showing that the anthropological datum itself contains a further and theologically relevant dimension. (Pannenberg 1985, 19)

The title of the 1988 symposium out of which this volume grew, 'Laying Theological Claim to Scientific Understandings', was taken from the above programmatic passage in Pannenberg's Introduction to his *Anthropology in Theological Perspective.* That entire Introduction has been reproduced as Chapter 2 below. The quoted passage accurately captures Pannenberg's approach to all the sciences, including the natural sciences which are the special concern of this volume. Pannenberg's vision of theology as laying theological claim to scientific understandings is grounded in a fundamental axiom of his theology, an axiom that borders on being a tautology. If God is defined as the all-determining reality, which Pannenberg takes as a given, then it is analytic in this statement that the existence and character of *all* reality is in some way determined by the all-determining reality. Therefore, if such an all-determining reality exists, then all of reality, in all of its parts and various manifestations, ought to contain some "trace" of its determination by this all-determining reality (Pannenberg 1976, 303). Thus, for theology to lay claim to scientific understandings is for theology to "expand and deepen" scientific understandings of reality in an effort to discern in what way the phenomena described by these scientific understandings "contain a further and theologically relevant dimension." But if God is the *all*-determining reality, then literally *all* of reality ought to contain this further and theologically relevant dimension, and theology should be able to lay theological claim to the investigations of all the sciences; not only the anthropological sciences, but also the natural sciences.

The remainder of this introduction will (1) illustrate the distinctiveness of this understanding of the relationship between theological and scientific descriptions of reality by comparing it with other understandings of theology and science; (2) comment upon the place of Pannenberg's dialogue with the natural sciences within his larger theological program; and (3) present a review of the critical discussion of Pannenberg's program contained in this volume, noting in particular the supports, challenges, and issues for further investigation that emerge from the discussion.

.

A Comparative Analysis of Pannenberg's Understanding of Theology and Science

Theology as Making Cognitive Claims about Objective Reality

The first understanding of the relationship between theology and science against which Pannenberg's view must be distinguished might be called the 'two functions' view. According to this conception, which has had a number of prominent proponents in the twentieth century, science and religion are two different 'languages' which perform two different functions. Without subscribing to such a position himself, Ian Barbour (1990, 13) describes it as holding that while "*scientific language* is used primarily for prediction and control", "the distinctive function of *religious language* is to recommend a way of life, to elicit a set of attitudes, and to encourage allegiance to a particular moral principle." Thus, insofar as the purpose of theology is to deal with religious language, theology and science are completely different sorts of disciplines which have no way of judging each other.

Such a conception could hardly be farther from that of Wolfhart Pannenberg. First, he emphatically disagrees that the function of religious language can be restricted in this way. Linguistic analysis, he says, demonstrates that *all* language, including religious language, has a referential aspect (1976, 178). He therefore argues that while religious and theological statements may function in other ways as well, this is contingent upon their functioning as assertions about an extra-subjective reality. Second, while he may share with the proponents of this view the desire to defend the meaningfulness of religious language against the charge of meaninglessness levelled by its secular critics, Pannenberg believes that this view utterly fails to mount such a defense. For if the referential character of religious language is denied, theological and religious statements can claim to be no more than

expressions of the subjectivity of the theologian or religious person. But this, says Pannenberg, robs theology of any possibility of defending its statements in the realm of public discourse (1976, 296). Thus a *sine qua non* for Pannenberg in any attempt to relate theology and science is that we understand theology, no less than science, as intending to assert something objectively true about an objectively existing reality.

The One Reality–One Version Understanding of Theology and Science

If both theology and science are attempts to make cognitive claims about an objectively existing reality, there are various ways to view their relationship to each other. One is to see them as providing mutually exclusive and therefore competing descriptions or versions of the same reality. It is this sort of understanding that has been behind the warfare image of the science–theology relationship. Although rejected by historians of science, most academic theologians, and not a few scientists, the warfare image continues to have a great deal of influence in the popular mind, and one can still find a number of both religious people and scientists who use this type of imagery to describe the science-theology relationship. The journalistic media, for example, consistently favor this image. The idea behind it is that theology and science are engaged in a battle over a single territory: to wit, the one reality of this world, including the world of human beings, their culture, and their religious life. The goal of each combatant is to demonstrate that only its description of the territory can adequately account for and describe the features observed. Any portion gained for science is thought to be lost to theology, and any portion gained for theology is thought to be lost to science. In other words, it is held that only one of these versions can be true. This can be called the one reality–one version understanding of the science-theology relationship. As we shall see, Pannenberg also believes that theology and science present us with two different versions of one and the same reality; but he does not at all believe that these two versions are *necessarily* mutually exclusive.

The Two Realities–Two Disciplines Understanding of Science and Theology

Having seen the difficulties of this line of thought, some twentieth-century thinkers have sought to negotiate a truce in the alleged warfare between theology and science by declaring that theology and sci-

ence have nothing over which to fight. For they aim to describe not the same reality, but rather two different realities. These two different realities have been variously described as the material and the spiritual, the natural and the moral, that which is known by reason and that which is known by revelation. Because these two different realities are said to be qualitatively distinct, it is also said that the rules and methods of investigating the one reality have nothing to do with the rules and methods for investigating the other. This may be called the two realities–two disciplines understanding of theology and science.

In the more strict application of this view, the two realities investigated by theology and science have been thought of as radically discontinuous. Adherents to this view have seen little need or possibility for any sort of co-operation between theology and science, since the investigation of one reality has nothing to do with investigation of the other.

A more common and less severe application of this approach has pictured the two realities investigated by science and theology as forming a unified whole. In this case, it is said that it is impossible to gain a complete picture of this unified whole without the contribution of both disciplines. Adherents to this view therefore speak of both the need and the possibility for some sort of co-operation between science and theology. This has sometimes been expressed by saying that science and theology are complementary disciplines whose purpose is to describe two different but equally important 'aspects' of one and the same reality.

To speak of two aspects of one and the same reality represents in part a breakdown of the two realities–two disciplines understanding. The breakdown is only partial, however, since the different aspects of reality are still thought to require independent and incommensurable methodologies. Thus, there still can be no true interaction between science and theology, if by that we mean that what is said in one discipline can have an impact on what is said in the other. The more complete picture of reality is produced not through a mutual interaction of scientific and theological understandings, in which they mutually modify one another or are integrated so as to form some new hybrid understanding of reality; rather, the two understandings are set alongside one another in a more or less additive process as the two halves necessary to make up the whole.

While Pannenberg also believes that the perspective of theology, in addition to science, is necessary for a complete understanding of reality, he believes that to hold that the methods of science and theology are incommensurable is fatal to theology. For if they are, then

there is no way to defend theological statements in the realm of public discourse, and theological statements become meaningless except as expressions of the theologian's religious subjectivity.

The One Reality–Two Aspects Understanding of Theology and Science

Pannenberg is not the only one who has been disturbed by the insularity of theology and the lack of accountability between science and theology in the two realities–two disciplines view. Within the overall perspective that both theology and science intend to make statements about an objectively existing reality, there emerged in the second half of the twentieth century a number of spokespersons for a third sort of understanding of the theology-science relationship. This understanding drops the talk of two realities altogether and speaks instead of two aspects of one and the same reality. Instead of holding that science and theology are concerned with *different subject matters,* this view holds that science and theology deal with different aspects of *the same subject matter.* And since both theology and science have to measure what they say against the same subject matter, there exists a certain degree of commensurability, or common measure, between scientific and theological understandings of reality. This opens the possibility for a true interaction between theology and science in which scientific understandings of the subject matter can potentially add to or correct theological understandings of the subject matter, and theological understandings in turn can potentially add to or correct scientific understandings. Furthermore, in contrast to the mere juxtaposition of scientific and theological understandings, the possibility of a mutual interaction between science and theology creates the hope that a true integration of scientific and theological understandings may be achieved.

Pannenberg's One Reality–Two Versions Understanding of Theology and Science

Such a hopeful and noble vision of a grand synthesis between theological and scientific understandings of the world has much to commend it, and it is likely that many of the readers who have ventured this far into this volume will find themselves in sympathy with such a vision for a new and truly cooperative relationship between science and theology. Furthermore, with its adamant rejection of the two realities–two disciplines view, its emphasis on the commonality of the subject matter studied by science and theology, and yet its insistence

that theology and science deal with different aspects of the same subject matter, all of which can be found in Pannenberg's writings—with all of this one would be tempted to think that this also is Pannenberg's vision of the relationship between science and theology. But it is not. Rather, it would be more accurate to describe Pannenberg's view of the science–theology relationship as a one reality–two versions view. And the difference between speaking of 'two versions' rather than 'two aspects' is substantial.

It is true that Pannenberg claims that theological versions of reality deal with aspects of reality not dealt with by scientific versions of reality. But this is because theology, in directing itself toward what Pannenberg calls the "totality of reality", intentionally attempts to take *more* of reality into account than does science. Science, on the other hand, in attempting to describe only the general and lawlike features of reality, intentionally and by necessity takes *less* of reality into account. Therefore the difference between science and theology derives not so much from *which aspect of reality* they choose to deal with, but from *how much of reality* they choose or at least attempt to deal with (1976, 124; 221–24).

But in what way does the theological version of reality direct itself toward the "totality of reality" and how does this relate to scientific understandings of the same reality? The immediate object of theology is of course the reality of God. But if the reality of God is defined as the all-determining reality, or as that power which in the final view of things is alone responsible for the way things are, then any claim about the reality of God necessarily involves some claim about the totality of reality that is determined by God. In this way, theology is closely connected with philosophy, which also differs from science in that it is "not concerned with this or that being in its particularity, or with one area of reality which can be separated from others . . . [but] with reality in general" (1976, 303). However, the notion of reality as a whole raises the question of the reality that constitutes the whole of reality as a whole, that is to say, the question of God. While philosophy can postpone the question of God, theology makes the question of God its explicit concern. Thus, Pannenberg defines theology as "the study of the totality of the real from the point of view of the reality which ultimately determines it both as a whole and in its parts" (ibid.). But then any statement about the whole of reality and its relationship to God also contains implicit if not explicit claims about the parts of reality and their relationship to God. It is these same 'parts' of reality that science also aims to speak of in an objective way. However, science aims to speak of the parts of reality only in terms of their relationship to each other and only insofar as they are subject to

description by general laws. Theology, in contrast, aims to speak also of the particular and contingent features of the parts of reality and to comprehend both their contingent *and* lawlike features within the widest possible context of explanation, namely, in terms of their relationship to reality as a whole and to the reality of God as that power which constitutes the whole of reality as a whole.

It is this difference in the *scope* of reality taken into account in the scientific and theological versions of reality that lies behind Pannenberg's claim that scientific descriptions of reality must be accepted as "simply a provisional version of objective reality" which needs to be "expanded and deepened" by the theological version. The scientific version of reality is provisional, not because science is somehow deficient in its methods, nor because theology has a source of knowledge available to it that is not available to science or beyond the criticism of science, but simply because theology aims at the most comprehensive description of reality possible, while science intentionally limits itself to a partial description of reality.

Implications of Pannenberg's Understanding of Theology and Science

This way of defining the difference between science and theology makes a significant difference when it comes to speaking of the possible *commensurability* of science and theology. For Pannenberg, science and theology are commensurable in that they always purport to deal with the same reality. This sort of commensurability applies to all possible fields of investigation. This is not the case when the difference between theology and science is defined in terms of the 'aspect' of reality with which they purportedly deal. For then theology and science deal with the same reality, and therefore are commensurable, only when both aspects of reality are present in one place. For example, if the different aspect of reality that theology deals with is found only in human existence, then it is only when talking about humans, and not the prehuman or nonhuman world, that theology and science are commensurable. However, if theology and science differ in that theology always looks at things in the context of a wider or more complete view of reality, this applies across the board to all possible fields of investigation. Therefore any set of data, whether these data are culled from the anthropological sciences or the natural sciences, ought to contain a further and theologically relevant dimension.

This way of defining the difference between science and theology is also significant for its impact on the *direction* of interaction between theology and science. Because it holds that theology and science deal

with the same subject matter, the one reality–two aspects understanding of theology and science in principle opens the door for a mutual interaction between science and theology. But in practice the sort of interaction that is posited is often one-sided. For example, if the scientific understanding of a subject matter is thought to represent a newer, more accurate understanding compared to the older, discredited theological understanding, science may be in a position to correct theology, but theology is in no position to correct science.[1] Or, if instead it is stressed that theological understandings take into account dimensions or aspects of the subject matter not dealt with by science, theology may be in a position to correct or fill out the scientific account of reality, but science is in no position to correct or contribute to theology.[2] Furthermore, even when, according to this view, the interaction between science and theology is thought to go both ways, the direction of interaction between theology and science often varies with the topic of investigation. For example, if the aspect of reality dealt with by theology takes on significance only in the human realm, then when humans are the subject of investigation, theology may have something to add to or may even correct science. But if the field of investigation is the natural, nonhuman world—for example, cosmology—then it is science that must add to or correct theology.

In contrast, within Pannenberg's one reality–two versions understanding of theology and science, the interaction between science and theology is always mutual, and this is true whatever the field of investigation. Because theology aims to understand every part of reality within the context of its vision of the whole of reality, theology always has something to add to scientific understandings, since the latter, by their very nature, do not deal with the whole of reality. This leads Pannenberg to make the bold claim that every scientific understanding of reality is necessarily incomplete, and that a theological perspective is always required for a complete understanding of any part of reality, no matter how accurate or true the scientific understanding may be (38). Furthermore, although not always the case, the wider, more comprehensive perspective offered by theology is sometimes in a position to *correct* scientific understandings, especially if the theological dimension has been excluded a priori from the scientific understanding. An example of this would be Pannenberg's theory of ego development, which is described in this volume by Robert Potter. According to Potter, "The common understanding of the relation between ego and self which ego psychology has elaborated is that the enduring ego synthesizes the transient self from the input of social factors." But "Pannenberg recasts the ego-self relationship and claims that the ego and self are creations of social forces, and that, as such,

they exist only in the moment of interaction" (132; see also Ted Peters's discussion, 298). Theology may also be in a position to *contribute* to scientific understandings by suggesting new and fruitful topics of investigation which might not otherwise have been considered. For example, although the concept of field has been important in the physical sciences, Pannenberg believes that theology leads us to broaden our concept of field and to ask whether the concept may not also be of importance in the biological and anthropological sciences (102–105).

But if in every field of investigation theology has something to add to scientific understandings of reality, it is equally true that in every field of investigation theology is subject to revision in light of scientific understandings of reality. To repeat, it is the goal of theology to make credible statements about the nature of reality as a whole and its relationship to God. But Pannenberg reminds us that the finite limits of human experience and the historical character of reality make it impossible for the whole of reality ever to be present to immediate experience in a direct way. Rather, it can only be present by way of 'anticipation'. Thus, in order for any claim about the whole of reality to have ongoing viability, it must continually defend itself in terms of our ongoing experience of reality. In this way Pannenberg says that all theological statements have the character of *hypotheses* about the whole of reality. As such, they are always open to critique, revision, and even rejection in light of new experiences of the world, including new understandings of the world gained through the methods of scientific investigation.

Pannenberg's one reality–two versions understanding of theology and science therefore envisions an interaction between science and theology that truly goes both ways, and which is relevant for all possible fields of investigation. Not only is there a theological relevance to be discovered in all scientific understandings of the world; there is also a scientific or empirical relevance to be discovered in all theological statements. Philip Hefner writes in his essay that this vision of a truly mutual interaction between science and theology constitutes "a breathtaking program" for theology and also provides "the criteria by which to assess whether Pannenberg has succeeded in accomplishing what the program intends" (100). The aim of this volume, as was the aim of the 1988 symposium convened by Hefner, is to begin to make such an assessment. However, before reviewing the supports and challenges to Pannenberg's program which have emerged in this discussion, more needs to be said about the place and importance of dialogue with the natural sciences within Pannenberg's larger theological program.

· · · · · · · · · ·
Dialogue with the Natural Sciences in Pannenberg's Theological Program

Pannenberg's aim in his monumental *Anthropology in Theological Perspective* (1985) was to carry on a theological dialogue with the anthropological sciences—psychology, sociology, and history—and not the natural sciences, except insofar as they touch on the study of humans. However, this does not mean that dialogue with the natural sciences is unimportant for his theological program. Although to date he has not published a dialogue with the natural sciences of the same depth and scope as his dialogue with the anthropological sciences, Pannenberg has addressed the topic in numerous articles and essays. Three of these essays are found in Part One of this volume. Others can be found in Pannenberg's *Toward a Theology of Nature* (1993).

The relationship between Pannenberg's dialogues with these two sets of sciences is as follows. Although Pannenberg believes there can be no direct demonstration of the truth of claims about the reality of God, he does believe that theology can and must attempt to make a provisional and indirect demonstration of the truth of its idea of God in light of our past and present experience of the world. Ideas about God, therefore, must be tested and defended against our experience of all aspects of reality. However, in the contemporary context, the first question confronting theology is not whether one idea of God is more congruent with our ongoing experience of the world than another. The central question is whether the idea of God itself has any reasonableness or basis in reality. And the major challenge to the idea of God is the assertion that it is merely a projection or construction of human consciousness with no basis in extrasubjective reality. For this reason, Pannenberg believes that the first task in apologetic theology today is to defend the reasonableness of the idea of God on anthropological grounds. This is the overriding goal of his extensive dialogue with the anthropological sciences (54–56).

To simplify greatly, his argument is that all of human experience— for example, our experience of meaning, of our own subjectivity, of trust, of ourselves as social and cultural beings—presupposes a larger field of reality or context of meaning, and ultimately an *all-encompassing* field of reality or context of *total* meaning. When this implicit horizon of all human experience becomes the focus of our attention and is brought to explicit expression, the idea of God comes into being. Certain critics respond that, even though the idea of God may be an inevitable product of human consciousness, it is nevertheless an idea we can do without and which we would be better to do without. But

Pannenberg argues that the scientific study of humans reveals that proper human functioning and human well-being require our giving explicit expression to such anticipations of the totality of reality.

However, such an anthropological defense of the idea of God is clearly not enough, for the idea of God may still be no more than a necessary illusion with no basis in extramental or extrasubjective reality. Thus, if theology is to defend its idea of God as true, which Pannenberg believes all credible theology must, it must move from its anthropological defense of the reasonableness of its idea of God and proceed to defend the truth of its idea of God in terms of *our experience of the world*. Otherwise theology's idea of God would remain just that—no more than an idea (1976, 309; 1991, 94). Therefore, Pannenberg believes theology's defense of the idea of God is incomplete until it takes up the argument on cosmological grounds. And this is where dialogue with the natural sciences becomes important. And so although dialogue with the natural sciences plays a somewhat auxiliary role within Pannenberg's theological program compared to the role played by dialogue with the anthropological sciences, it is not for this reason any less important or crucial for his project. Without it, theology's defense of the idea of God would be incomplete.

The Theological Basis of Pannenberg's Questions to Natural Scientists

Anyone who is at all familiar with Pannenberg's thought knows that the theme of eschatology plays a central role in his theology. Eschatology is that branch of theology that deals with the religious belief in a future 'end of history' in which God's purposes for the world will be fulfilled in a final and definitive way. Pannenberg tells us that such a belief first arose within the religious history of Israel and was further developed in Jewish apocalyptic. In this context, it was thought that at the end of history, the God of Israel would be revealed as the one God of all creation; or, to use Pannenberg's term, as the "all-determining reality." But Pannenberg says that in the early Christian community this belief underwent a drastic change: the event that was expected to occur at the end of history and was associated with the final revelation of God, namely the general resurrection of the dead, was thought to have occurred within history in the resurrection of Jesus, even though the event itself was still expected to occur in the future. For Pannenberg, this claim that the end of history has occurred within history is the foundation for the Christian belief that there has occurred in Jesus a definitive and unsurpassable revelation of God, even though the complete and final revelation of God is expected to

occur only at the end of history. It is also the foundation for his unique understanding of God's relationship to the world.

From the dialectic of the presence of the future reality of God in the present reality of Jesus, Pannenberg develops the idea of God as the power of the future that is ontologically prior to and is the condition of possibility for *every* present. Thus the present exists only by its participation in the future. This understanding of God as the power of the future that makes possible and is active in every present is the starting point for Pannenberg's dialogue with the natural sciences.

As one consequence of this view, Pannenberg has suggested that the reality of God be understood as that universal dynamic field that unifies all created reality and upon which all created reality is contingent. As Hefner points out, this has led Pannenberg to ask natural scientists about the importance of the phenomena of field and contingency in our understanding of nature (100–109). In particular, he has asked whether every aspect of the natural world, including the so-called laws of nature, should not be understood as a contingent manifestation of some larger field of reality (Pannenberg 1993, 72–122). Also related are Pannenberg's extensive reflections on the relationship between time and eternity and his proposal that spatiotemporal reality be understood as a form of anticipatory participation in eternity such that the essence of the temporal will only be revealed "in the ultimate future where the temporal will be reconstituted in the presence of the eternal" (47). In the realm of biology, this understanding of God as universal field and as the power of the future has led Pannenberg to ask whether the various phenomena of life should not be understood as having their origin in and as being directed toward a field which transcends them, and whether this understanding might not be related to the biblical notion of the divine spirit as the transcendent origin of all life.

With this background in mind, we now turn to a review of the response Pannenberg has received in this volume both to his questions to natural scientists and to his theological program in general.

· · · · · · · · · ·
Supports, Challenges, and Issues Emerging from the Discussion of Pannenberg's Program

Cosmology, Eschatology, and the Whole of Reality

In Part Three, Frank Tipler, Robert John Russell, and Willem Drees respond to Pannenberg's questions to scientists from the perspective of modern physics, addressing in particular his questions regarding

the importance of contingency in natural processes, the relationship between time and eternity, and the possible congruence between Christian eschatology and modern cosmology. Of the three, Tipler is by far the most enthusiastic about the possible congruence between modern physics and traditional theology, going so far as to claim to be able to "provide a physical foundation for Pannenberg's interpretation of eschatology" (159).

Russell does not share Tipler's belief that one can move directly from the scientific study of nature to claims about the existence and nature of God. But he does see in Tipler's work, along with that of physicist Freeman Dyson, a growing recognition within physics of the importance of eschatology for understanding the universe. Russell believes that this new discipline of physical eschatology may open up a new era in the relation of science and religion. He envisions this new era as one in which there may occur a reconciliation and even a mutual modification between theological eschatology and scientific cosmology.

In contrast to Tipler's and Russell's enthusiasm for a possible theological relevance of science and even a scientific relevance of theology, Willem Drees argues for the "theological ambiguity" of science, questioning several of the claims that are central to Pannenberg's theological program.

The most significant challenge Drees raises has to do with Pannenberg's notion of the "whole of reality." Drees questions Pannenberg's claim that the idea of the whole of reality must be associated with the idea of the future of reality. In effect, he denies that there can be any future "whole of reality" such as Pannenberg imagines. Rather, talk about the whole of reality is simply a matter of looking at present reality from a different perspective.

Drees's critique of Pannenberg's notion of the "future wholeness" of reality should not be brushed aside lightly. If it were to be upheld in further dialogue with other physicists it would constitute a substantial challenge to the viability of Pannenberg's understanding of God and the world as well as to the support from modern physics that Tipler and Russell claim for this understanding.

On the other hand, we may also question whether Drees has properly understood Pannenberg's view of the relation between the future and the wholeness of reality. Drees's criticism is that because all talk of the future belongs to the temporal description of reality, the future is not an appropriate category for speaking of reality as a whole, which he says requires an atemporal perspective. However, when Pannenberg speaks about the future as constituting the wholeness of reality, he is not speaking of just any future, or the future in general, but of

what he calls the "ultimate future", or what might be called the future of all futures. Such an ultimate future is beyond time, yet also comprehends within itself every moment of time. As such, it is to be identified with the eternal in which all moments of time are present simultaneously and in which all temporal reality participates. Thus, Pannenberg's concept of the ultimate future does belong to the level of atemporal description of reality.

But even if this is granted, this would still leave the question: Is Pannenberg's notion of an *ultimate future*, which will bring into being the wholeness of reality, consistent with modern theoretical cosmology? Of course, it is just this issue that Tipler and Russell attempt to address in their discussion of theories of physical eschatology. But the fact that this discipline of modern physics has not yet received wide support and remains highly speculative should caution us against being too quick to claim it as support for Pannenberg's program. The question of the intelligibility of Pannenberg's eschatology—and its included notions of time, eternity, and the future wholeness of reality—therefore remains an important but unresolved issue in assessing Pannenberg's theology with respect to modern cosmology.

Evolution, Meaning, and the Question of the Ontological Priority of the Whole

In Part Four, biochemist Jeffrey Wicken presents his theory of evolution as a process of meaning-creation, and of human spirituality as a conscious and free participation in this larger process of meaning-creation. There is a great deal of affinity between Wicken's understanding of the evolutionary ecology of meaning and Pannenberg's reflections on the self-transcendent character of life.[3] Fundamental to both is the claim that meaning is always found in some sort of part-whole relationship. In both cases, the essential character of life is understood as participation in structures of meaning that transcend the individual organism. In both cases, the human capacity for 'spirituality' represents a fuller and more conscious participation in this basic character of life. And, in both cases, the condition for the possibility of life and spirituality is grounded in the realm of ultimacy—for Wicken in "ultimacy-as-potentiality", and for Pannenberg in the existence of God as Spirit, or as that universal dynamic field in which life and evolution participate and on which they are contingent. In this regard, Wicken's ecological understanding of evolution and human spirituality gives a fair degree of support to Pannenberg's theological proposals.

However, as Pannenberg notes in his response, what is missing in Wicken's ecological understanding of meaning is a firm affirmation of

the ontological priority of the whole, which gives meaning to the parts, over the parts themselves (433). The concept of an ecosystem makes clear that the existence and meaning of the parts, the species within the ecosystem, are dependent on the existence of the whole, the ecosystem. But it also implies that the existence of the whole that gives meaning to the parts is dependent on, or even created by, the parts that make up the whole. Pannenberg believes that this reduces the concept of meaning to that of action. But Pannenberg's understanding of God requires a theory of meaning in which "Meaning is not dependent on and created by human (purposive) action, but human action shares in the spiritual reality of meaning that is based on the priority of wholes over parts" (422). In other words, Pannenberg wants to say that human beings "not only *create* structures of meaning . . . but are also capable of *experiencing* semantic networks, and ones at that which go infinitely beyond the reality of their own existence" (1976, 131; emphasis added). But it is just this crucial presupposition of Pannenberg's program that Wicken's ecological theory of meaning fails to support.

If we are talking about the *results* of the evolutionary process of meaning-creation, Wicken's analysis clearly implies that the meanings that are created have an existence apart from our perception of them. But if we are talking about the *activity* of meaning-creation, Wicken clearly says that the meanings created do not exist anywhere outside or beyond the nature that creates them. Rather, meaning-creation is the result of the self-organizing character of nature. Wicken does make the metaphysical claim that the process of meaning-creation, especially its free and volitional manifestation in human spirituality, must be understood as the actualization of ultimate potentialities underlying the process of evolution. Nevertheless, what exists in this realm of ultimacy-as-potentiality is not some ontologically prior whole of meaning in which the evolutionary process participates, but simply the *potential* for the activity of meaning-creation. Thus Wicken cannot say, as Pannenberg wants to say, that although human creativity plays an important role in the perception of meaning, the ontological ground for this perception is an objectively existing field of total meaning which points to the existence of God as that dynamic field which makes all individual meanings possible.

While this should not be taken as a refutation of Pannenberg's proposals, it does tell us that if Pannenberg's proposals are to gain support from the natural sciences, more work will have to be done in this area. In particular, more attention needs to be devoted to the question whether Pannenberg's notion of a 'dynamic field' that constitutes the whole of reality as a whole is required or is fruitful for

understanding the process of evolution and the existence of 'meaning' within evolution.

However, this also raises the question whether the sciences can provide the kind of support for which Pannenberg is looking. The primary difference between Pannenberg and Wicken on this point appears to be a difference in metaphysical claims about the ontological grounding of the 'meanings' which are said to emerge within evolution and in the realm of human spirituality. While both Pannenberg's and Wicken's metaphysical claims are grounded in valid scientific understandings of nature, we must also ask whether there is anything in these understandings that would necessitate our adopting one metaphysical claim over the other.

The Nature of Theology as Science: Does Science Move from Part to Whole or Whole to Part?

In Part Five, Lindon Eaves looks at Pannenberg's theological program from the perspective of a behavioral geneticist. It would appear that in many respects Eaves and Pannenberg are in basic agreement regarding the aims and function of both theology and science. However, these apparent agreements conceal profound differences between their respective methods of "correlating theological constructs to biological realities" (Eaves) and "laying theological claim to scientific understandings" (Pannenberg).

Both authors claim that theology is necessary for an adequate understanding of empirical reality. On this point, Eaves claims to take his cue from Pannenberg.

> The clue to where to start is found in Pannenberg's claims about the potential role of theology in history (Pannenberg 1977). It is not that *supernatural* processes are required to understand history but that economic and political constructs do not represent adequately the contours of the reality of history. . . . The data cannot be understood without knowledge of the meaning and cultural impact of such religious constructs as *election, covenant,* and *judgment* (335).

Thus, Eaves's argument is that there are "contours of the reality of history", namely certain "religious constructs", which cannot adequately be understood without the use of theological constructs. But this is in fact quite different from Pannenberg's argument for the importance of theology. For Pannenberg, the importance of theology is not that theology deals with certain *contours* of reality not dealt with by the other sciences, but that it provides a *more comprehensive* understanding of

reality than do the other sciences. Eaves's understanding of theology and science is therefore more akin to the 'two aspects' view described earlier than to the 'two versions' view ascribed to Pannenberg.

Both Eaves and Pannenberg also describe theology as building upon scientific understandings of reality. Eaves suggests that we understand theology as "feeding" upon the results of biological study. Biology, he tells us, shows us the necessity of faith as an adaptive response to reality alongside the cognitive response of the sciences. It also helps us identify and interpret the biological realities to which we must respond, namely, the realities of givenness, connectedness, and openness. But biology does not provide us with the resources for making such a response. This is where the importance of theology comes in. Thus, the biological realities of givenness, connectedness, and openness provide the "raw material for theological construction", and theology may be understood as "feeding" upon the results of biological study (330, 335).

How does this compare to the way in which Pannenberg understands theology as building on scientific understandings? Pannenberg and Eaves both understand theology as dealing with a religious response to reality called forth and necessitated by reality itself. Eaves, however, understands science and religion as more or less parallel responses to reality, the one cognitive and the other affective. Pannenberg, on the other hand, understands the constructs of science as a response only to certain limited features of reality, namely its lawlike features, whereas he understands the constructs of religion as a response to the "wholeness" of reality, or at least to anticipations of its wholeness. Thus, for Pannenberg, theology builds on science by "expanding and deepening" the understanding of reality provided by the sciences. For Eaves, theology builds on science by constructing "theological correlates" to scientific understandings of reality. In the first case, theology is a more comprehensive science than the natural sciences. In the second case, theology and the natural sciences are more or less parallel sciences, between which certain bridges can be built.

This difference between Eaves and Pannenberg can be brought into sharper focus by looking at what it means for each of them to say that the aim of theology is to provide a vision of the whole of reality. For Pannenberg, it is only philosophy and theology that make it their explicit aim to take into account the whole of reality. For Eaves, this is also the aim of the natural sciences. But this appears to be the case only insofar as each discipline deals with its own explicit subject matter. For example, Eaves says that just as biology uses the "icon" of DNA to get a hold of the whole of its subject matter, namely the bio-

logical realities it studies, so too theology uses certain central icons to get a hold of the whole of its subject matter, namely, the "empirical content of a faithful life". Thus, the whole of reality that theology attempts to bring into view with its icons does not appear to be the same whole of reality that biology attempts to bring into view with its icons. And so it would make little sense for Eaves to hold that theology expands and deepens scientific understandings of reality, since in one respect, theology and science deal with different subject matters.

But this brings into question the extent to which Eaves has truly understood theology and science as speaking about the same empirical reality. In this regard, Pannenberg's insistence that the difference between theology and science is due more to the scope of reality taken into account than the features of reality taken into account raises a critical question regarding Eaves's understanding of theology and science.

On the other hand, Eaves's understanding of the way in which both science and theology attempt to bring into view the whole of their subject matters raises a critical question regarding Pannenberg's understanding of theology as a science. Pannenberg says that the aim of any science is to give meaning to the parts of reality by encompassing them within a larger framework of explanation (Pannenberg 1976, 151–53). Eaves says that it is the nature of science to seek and exploit "icons", where "an *icon* is a part of reality which is nodal for understanding reality as a whole" (318). Thus, we are faced with a difference between two understandings of what it means for a science to be a science and thus for theology to be a science. While Eaves says that explanation in science moves from part to whole, Pannenberg says it moves from whole to part. And this difference is not trivial. For Eaves's understanding of the nature of science (and thus of the way in which human understanding in general is advanced) challenges the basic presupposition of Pannenberg's theological project, which rests on the assumption that it is the whole of reality that gives meaning to the parts, and not vice versa.

Eaves also accuses Pannenberg of favoring the "soft" sciences of cultural anthropology and psychology over the "hard" sciences of biology, and particularly his own science of behavioral genetics. He says that Pannenberg fails to deal with science where it "hurts the most" and has adopted instead those "anthropological ideas which are most convenient for theology" (327). Pannenberg denies this charge, defending his rejection of the "sociobiological paradigm" on the grounds that it does not do justice to the data, and in turn accuses Eaves of reductionism (435). The conflict here may in part be one of

communication. For Eaves also says he rejects the sociobiological paradigm and freely admits that genetics is not the only determinant of human behavior (342). And Pannenberg admits that genetics may play a large part in determining human behavior (434). Nevertheless, Eaves's pointed criticism raises questions which in our opinion cannot be put aside as due merely to a problem of communication.

Eaves is right to insist that it cannot be ruled out a priori that genetics plays an important role in human behavior. Nor can it be ruled out a priori that genetics may be a significant factor in producing the diversity of moral and religious sentiments that we observe. He is also correct to point out that empirical verification of such a thesis (which he believes is present in part already) would not be theologically neutral, but would call for significant revisions of some cherished notions of theology. In other words, Eaves is simply insisting that Pannenberg be true to his own method—that theological ideas be open to criticism and revision in light of new experiences and understandings of reality. Thus, the question Eaves raises is, How open is Pannenberg to such revision?

This raises a further critical question about the nature of Pannenberg's program. Does Pannenberg approach scientific understandings of reality, especially new understandings, asking what is *right* about his theological theory or what is *wrong* about his theological theory? And if the former, does this discredit his claim that theology can be practiced as a science? (Eaves believes that it is the nature of science to ask what is wrong about a theory, 328). Insofar as Pannenberg understands the aim of Christian theology as that of demonstrating the truth of the Christian idea of God (1991, 47–61), it would appear that he is committed to approaching the data asking what is right about a theological theory. But insofar as he understands theology as explanation, and explanation as a process of revising existing frameworks of understanding in order to include new and not yet understood experiences of reality (Pannenberg 1976, 139), it would appear that he is committed to asking what is wrong about his or any other theological theory. Eaves therefore draws our attention to a possible conflict between Pannenberg's understanding of theology as apologetics and as explanation.

Philosophical Perspectives on Pannenberg's Methodology

In Part Six, Wentzel van Huyssteen, Paul Sponheim, Philip Clayton, and Nancey Murphy analyze and evaluate Pannenberg's theological program from various philosophical perspectives. What emerges

from this discussion is the question: What is the core issue in Pannenberg's program? What is it, in the final analysis, that needs defending, and how can it be defended?

Wentzel van Huyssteen concurs with Pannenberg that theology and science provide us with two equally important versions of the same reality. But he questions whether Pannenberg's philosophy of science allows him to give a credible defense of the *rationality* of the theological version of reality. Specifically, he believes that Pannenberg has failed to give an adequate defense of the rationality of the theologian's subjective commitment to his or her faith tradition. Van Huyssteen, therefore, presents his own account of the rationality of theology in order to correct this alleged deficiency in Pannenberg's program.

But is this really the issue that is at stake in Pannenberg's theological program? Even if we were to accept van Huyssteen's alternative account of the rationality of theology, this would not explain why a *theological* version of reality, in addition to the scientific, is needed in order fully to understand reality. But this is precisely what is at stake and what needs to be defended in Pannenberg's dialogue with the sciences, and not just the rationality of his religious commitment as a theologian.

Paul Sponheim also affirms Pannenberg's claim that theology offers a deepened and expanded version of the phenomena described by the sciences. But he questions Pannenberg's success in making good on this claim. However, in contrast to van Huyssteen (as Clayton points out), Sponheim's critique is carried out on the level of ontology, not methodology. Sponheim raises what at first appears to be a methodological question: "What would it mean formally to demonstrate what we are talking about demonstrating?" But the answer he gives is ontological: It would mean that we were able to demonstrate not only the epistemological continuity between the scientific and theological versions of reality, but also the *ontological* continuity between the realities described by theology and by science, while still affirming their distinctiveness. That is, it would require an adequate account of how God is related to every aspect of the world, without being the same as the world.

Sponheim believes that Alfred North Whitehead's understanding of God and the world provides a better way to maintain Pannenberg's emphasis on the theological relevance of every particular reality than does Pannenberg's own "monistic formulation" (383). Sponheim is apparently referring to what he calls Pannenberg's notion of "God as the whole." But Pannenberg does not, as Sponheim

suggests, identify God with the whole of reality. Rather, he says that God is that power which constitutes the whole of reality as a whole. Thus, if Sponheim is looking for a clear distinction between God and the world, it is difficult to understand why he does not find this in Pannenberg.[4] Alternatively, if he is looking for a way to express the intimate relation between God and the whole of reality, as well as to every particular part of reality, one wonders why he has not entered into a critical dialogue with Pannenberg's extensive reflections on the relationship between time and eternity as have Tipler, Russell, and Drees.

Sponheim also believes that Pannenberg has failed to demonstrate materially what it would mean for theology to offer an expanded and deepened version of reality. In particular, he questions whether Pannenberg's theological version of reality does justice to the data of the common human experience of freedom and responsibility. But here too, his concern is with Pannenberg's ontology, insofar as he is troubled by the apparent determinism of Pannenberg's understanding of God and the world.

However, a careful reading of Pannenberg would demonstrate that his position is not a deterministic one. (Nor, as Sponheim suggests, does his understanding of the ontological priority of the future imply a denial of the irreversibility of time; see 43). For Pannenberg, that God is the all-determining reality is simply a definition of the word 'God'. Where various ideas of God differ is in their understanding of *how* God is the all-determining reality. Certainly some ideas of God do depend on a deterministic view of reality and involve a denial of human and natural freedom. But the purpose of Pannenberg's extensive efforts to develop the idea of God as the power of the future, which is the condition of possibility for every present, is precisely to say how God can be the all-determining reality without denying the openness of the present to the future and thus the experience of human freedom.[5]

Philip Clayton correctly points out that the core issue in evaluating Pannenberg's program is the evaluation of its claims about ontology, that is, about the nature of reality, upon which any claims about its rationality are ultimately based. He draws from this the conclusion that the criteria of control for the field of science-theology are metaphysical, and that this conclusion is "the immanent *telos* of Pannenberg's work" (405). But here we must differ with Clayton, although it is perhaps only a difference of emphasis.

There is no question that Pannenberg's program rests on substantive theological/ontological claims. Nor is there any question, as Clay-

ton writes, that the criterion of control that Pannenberg employs in evaluating these claims is how well they interpret the data. But rather than concluding from this that for Pannenberg it is "meta-scientific, hence metaphysical, criteria" that provide the final control for making rational judgments about the merits or demerits of the various interpretations (406), it is more appropriate to conclude that for Pannenberg *it is the data* that provide the ultimate control over which interpretations are accepted or rejected. As Pannenberg writes in his response, "[The theological description of reality] . . . will always involve some transformation of the phenomenon as described by the secular disciplines, *but such a transformation has to be argued for on the basis of the evidence studied by those disciplines*" (43; emphasis added). Therefore, it does not seem accurate to suggest that for Pannenberg the history of speculative thought provides the criteria of control in the theology-science dialogue. Rather, it is ultimately the data that provide the criteria of control. On the other hand, Clayton is no doubt correct in raising the question whether competing metaphysical claims can in fact be evaluated on the basis of the data alone, a question raised above in our discussion of Wicken.

Nancey Murphy presents an analysis and defense of Pannenberg's scientific-theological method in terms of Imre Lakatos's philosophy of science, similar to that presented by Philip Hefner in Chapter 5. She believes that such an analysis not only clarifies what Pannenberg's program is about, but also provides us with a way to respond to the critical questions raised by Sponheim, van Huyssteen, and Eaves regarding Pannenberg's methodology.[6] While Murphy's analysis may not solve all the problems raised by the papers in question, it does help to soften some of their criticism of Pannenberg's program. It may also provide us with a way of addressing some of the critical questions raised in this introduction.

In discussing the conflict between Eaves's and Pannenberg's understanding of theology as a science, it was suggested that there may be tension in Pannenberg's thought between his understanding of theology as explanation and as apologetics. However, within the Lakatosian model, both the effort to *defend* a particular paradigm, and the effort to *explain* the data (and thus the willingness to revise at least the auxiliary hypotheses of the program in light of the data) are integral to any scientific program. The possible tension alluded to in Pannenberg's understanding of theology may therefore be a tension that is present in any scientific program. Thus, if we ask, When should a traditional theological idea be modified or rejected in light of new scientific findings (such as the possible genetic determination of much of

human diversity)? the answer may be: When the research program to which the idea belongs is no longer progressive but degenerative. It nevertheless remains difficult to know how in practice such a judgment could be made.

A Lakatosian understanding of scientific progress may also address the question raised in our discussion of Wicken's and Clayton's papers: To what degree can competing metaphysical claims be adjudicated with reference to current scientific theories and observation? According to Murphy's analysis, such metaphysical claims would belong to the hard core of a research program. The task of adjudicating between rival metaphysical claims would therefore concern itself not with the metaphysical claims directly, but with the auxiliary hypotheses that are constructed to elaborate and defend such claims. The criterion of adjudication would be the degree of progressiveness, or lack thereof, of the research programs built around such claims. In contrast to Clayton, this would preserve Pannenberg's insistence that it is the data which exercise control over our adoption or rejection of a particular understanding of reality. Nevertheless, here too more work needs to be done in specifying what it would actually entail to make a rational choice between, say, Pannenberg's understanding of ultimacy as an ontologically prior context of meaning, and Wicken's understanding of ultimacy as the realm of potentiality, or between Pannenberg's understanding of God and that world and the Whiteheadian understanding alluded to by Sponheim.

Pannenberg and the Postmodern Critique of Objective Knowledge Claims

An issue that was not directly addressed by any of the responders (although touched on by Clayton, 399) is the apparently realist position that is presupposed by Pannenberg's (and his responders') talk of "objective reality." Within the current intellectual climate of postmodernism, some readers may wonder how any serious thinkers could believe that either theology or science can make legitimate claims to having knowledge of objective reality. Are not all objective knowledge claims merely constructions of human consciousness imposed on a meaningless reality? Are not all claims to objective knowledge only an expression of a will to power? And has not the correspondence theory of truth on which claims to objective knowledge depend long since been pronounced dead? These are serious questions which pertain both to Pannenberg's claim that theology offers us insight into the nature of objective reality, and to the claim of modern science to do the same.

To my knowledge Pannenberg has not entered into a direct dialogue with his would-be postmodern critics, but it would be a severe distortion of his thinking to say that he is unaware of the problems they raise. Indeed, Pannenberg describes his extensive methodological reflections (1988, 17) as an attempt to come to terms with the problem of the subjective determination of all knowledge that was first raised by Kant, and which has haunted Western thought ever since.

Pannenberg's answer to this problem is to say that all appearance (and existence) is an anticipation of an ontologically prior, and therefore objectively existing, eschatological future reality (1969, 127–43; 1990, 91–109). In this way, Pannenberg does not obliterate the distinction between appearance and reality, or between our subjective constructions about the nature of reality and reality itself. Rather, he fully recognizes that because of the historical character of reality, in which reality remains incomplete until it reaches its eschatological goal, any claim to knowledge of reality is necessarily *provisional*, and is also limited and conditioned by the cultural and historical context in which it is made. In other words, strictly speaking, we can have no direct knowledge of objective reality, but only provisional anticipations of objective reality. And yet Pannenberg's belief that the eschatological future is the condition of possibility for every present, and therefore makes its *appearance* in every present, also allows him to say that such anticipations of objective reality are just that—genuine anticipations of a reality which exists beyond our limited apprehensions of it and yet which is also present to be apprehended in a provisional way. Furthermore, because our experience of reality is always changing (since reality is historical and therefore always in process), such provisional anticipations of objective reality are continually being revised (and sometimes rejected) in light of our ongoing experience of reality.

Pannenberg's epistemology is constructivist, then, in the sense that all claims about objective reality represent the attempt of human consciousness to describe a reality which is not directly accessible to it. But for Pannenberg, such claims are not *merely* constructions of human consciousness. Pannenberg writes:

> To inquire into the total meaning of reality is not automatically an expression of human presumptuousness. It is a matter of the fact that the individual is everywhere conditioned by the whole, and the consciousness of this state of affairs belongs essentially to what it means to be human. To be sure, the simultaneous awareness that we can never gain a definitive overview of the whole of reality is also part of our humanity. Only when this is

forgotten is it appropriate to speak of presumptuousness. (1990, 169)

Pannenberg's positing of the universal context of meaning as an eschatological reality also allows him to do something that Kant was unable to do. Kant believed that the gap between the phenomenal world and the noumenal world would never be closed. For Pannenberg, it is only temporary. When, at the end of history, God is revealed as God and the temporal is reconstituted in the presence of the eternal, the gap between our temporal anticipations of the future and the future that is anticipated will be closed. While many will no doubt have trouble accepting this 'solution' to the perennial questions of epistemology and ontology, it at least demonstrates that the question of the possibility of 'objective knowledge' is one that Pannenberg has taken seriously and has attempted to address head on. Indeed, it is Pannenberg's proposed solution to this problem, which depends on his unique claims about the relationship between time and eternity and God and the world, that is at stake in his dialogue with contemporary science.

· · · · · · · · · ·
Conclusion

All of the respondents have written of their support for Pannenberg's belief that if theology is to have any credibility it must function as a science (with the possible exception of Wicken, who posits a sharper distinction between the aims of science and theology). Nevertheless, several authors have raised serious questions about Pannenberg's understanding of what this means and whether Pannenberg has given an adequate defense of the scientific character of theology. Thus, despite the extensive reflection given to this question both by Pannenberg and his respondents, this remains an unresolved issue in the evaluation of Pannenberg's proposals, and in the science-theology dialogue in general. Just what does it mean for theology to be a science, and how should the scientific character of theology be defended?

With respect to Pannenberg's specific proposals regarding the presence of a "theologically relevant dimension" within the data of the sciences, some support was found in the emerging field of physical eschatology and in Wicken's ecological interpretation of evolution. However, serious questions were also raised regarding Pannenberg's understanding of time, eternity, and the future wholeness of reality

and his related understanding of God as the ontologically prior source of meaning. This too remains an issue that demands further attention. Is Pannenberg's notion of an ultimate future in which temporal reality will become a completed whole, and on which all temporal reality is dependent for its meaning and existence, intelligible or necessary in light of current scientific understandings of reality? This in turn has led to the question, *Can* Pannenberg's claims regarding God and the world, time, and eternity (or any other such metaphysical claims) be supported by reference to scientific understandings? Even though Murphy's and Hefner's analyses of Pannenberg's program in terms of Lakatos's philosophy of science show how this may be done in a qualified sense, it remains difficult to know what this would mean in practice. Finally, Lindon Eaves's demand that Pannenberg be willing to revise his theological proposals in light of possible new findings in the field of behavioral genetics raises the question of how open Pannenberg is to revision within his theological program. This in turn raises the question of a possible tension between Pannenberg's understanding of theology as apologetics and as explanation, although we also saw that a Lakatosian analysis of his program may soften this tension.

Where then do we stand with regard to Pannenberg's program of laying theological claim to scientific understandings? Certainly Pannenberg has not received unqualified support for his program, from either his scientific or theological respondents. And yet neither has he received unqualified rejection. What we have seen is that Pannenberg's proposals have provoked a high level of sophisticated discussion, which in itself is an indication that, as Hefner writes, "his program merits the most serious attention and dialogue." This in itself can be taken as evidence of a certain degree of support for his program. Perhaps then the most sober conclusion we can reach is that reached by Hefner: "Pannenberg's dialogue with the scientists [and fellow theologians] is by no means at an end. Further developments in the process of give-and-take are eagerly awaited. . . . Let the conversation continue" (113).

• • • • • • • • • •

Notes

1. This appears to be the position taken by Lindon Eaves in Chapter 12.
2. Jeffrey Wicken takes a position similar to this in Chapter 10.
3. For a more complete discussion of these affinities, see Ted Peters's response to Wicken in Chapter 11. See also Philip Hefner's discussion of this aspect of Pannenberg's thought on 104–107, as well as the articles by Pannenberg in Part One, especially 44–46 and 74–79.

4. Indeed, this is the clear meaning of the passage Sponheim quotes in this context (1980, 224): "in the question of the whole as a whole, as well as in the question of the wholeness of the individual life, there is at least already implied the question of *the reality of God who constitutes finite reality as a whole*" (emphasis added).

5. Pannenberg has developed this point more thoroughly in his *Systematic Theology* (1991), where he draws on Hegel's understanding of the "true Infinite" as that which is not merely opposed to the finite, but which overcomes the antithesis between the infinite and the finite without abrogating it. But Pannenberg argues that although Hegel has provided us with the abstract idea of the true Infinite, "this dynamic [of the true Infinite] may be filled with content, and thus show itself to be formally consistent, only through the thought of the divine love" (445). With regard to the question of God's omnipotence, this means that God's omnipotence over the creation must be understood as a function of God's love.

> The omnipotence of God demonstrates that it can be thought of only as the power of divine love and not as the assertion of a particular authority against all opposition. That power alone is almighty which affirms what is opposite to it in its particularity, and therefore precisely in its limits, which affirms it unreservedly and infinitely, so that it gives the creature the opportunity by accepting its own limits to transcend them and in this way itself to participate in infinity. (422)

6. In the original symposium Eaves's paper was offered along with the papers by Sponheim and van Huyssteen in a session focusing on Pannenberg's methodology. However, we have placed Eaves's paper in a part of its own, since it also deals with issues of content in the theology-science dialogue.

· · · · · · · · · ·

References

Barbour, Ian G. 1990. *Religion in An Age of Science: The Gifford Lectures 1989–1991*, Vol. 1. San Francisco: Harper and Row.

Pannenberg, Wolfhart. 1969. *Theology and the Kingdom of God*. Philadelphia: Westminster.

———. 1976. *Theology and the Philosophy of Science*. Trans. Francis McDonagh. Philadelphia: Westminster.

———. 1977. *Human Nature, Election, and History*. Philadelphia: Westminster.

———. 1980. Gottebenbildlichkeit und Bildung des Menschen. In *Grundfragen systematischer Theologie*. Göttingen: Vandenhoeck und Ruprecht.

———. 1985. *Anthropology in Theological Perspective*. Trans. Matthew J. O'Connell. Philadelphia: Westminster.

———. 1988. An Autobiographical Sketch. In *The Theology of Wolfhart Pannenberg: Twelve American Critiques, with an Autobiographical Essay and Response*, ed. Carl E. Braaten and Philip Clayton, 11–18. Minneapolis: Augsburg.

————. 1990. *Metaphysics and the Idea of God.* Trans. Philip Clayton. Grand Rapids, Michigan: Eerdmans.

————. 1991. *Systematic Theology.* Trans. Geoffrey W. Bromiley. Grand Rapids, Michigan: Eerdmans.

————. 1993. *Toward a Theology of Nature: Essays on Science and Faith.* Ed. Ted Peters. Louisville: Westminster/John Knox.

PART ONE

· · · · · · · · · ·

Four Essays by Wolfhart Pannenberg

Introduction to Part One

• • • • • • • • • •

Carol Rausch Albright

This volume devolves from a memorable event—the encounter between Wolfhart Pannenberg and a group of mostly American scientists, philosophers, and theologians at the Lutheran School of Theology at Chicago. Although Pannenberg was present, he did not speak until the closing session of the conference. First, speakers addressed two issues central to his thought:

1. What might it mean for theology to demonstrate that the scientific descriptions of the data are provisional versions of objective reality and that the data themselves contain a further and theologically relevant dimension?
2. How do field and contingency provide openings to God?

Finally, in a public lecture, Pannenberg presented his response to the commentators.

This volume presents all the symposium lectures—some extensively revised; four other essays by Pannenberg; and one essay (Robert Potter's) written especially for this volume.

We begin with four selections from the writings of Wolfhart Pannenberg, included to provide background for those readers who do not share the lecturers' familiarity with Pannenberg's work. Many, of course, will already have sampled the sweep of this thinker's wide-ranging oeuvre. It extends across 'hard' sciences—cosmology, relativity and quantum theory, thermodynamics; the anthropological disciplines—human biology, sociology, psychology, and history; and theology. It reaches from the beginning of the cosmos to the end of time; it is cognizant of the interplay of ideas down through the history of Western thought. Audaciously, Pannenberg believes that theology not only can comprehend, but can deepen and gloss all these data, forming a modern synthesis bidding to surpass in scope that of medieval thought.

In fact, this comprehensiveness of scope is a necessary consequence of Pannenberg's position that theology *must*, in order to be

genuine, comprehend all phenomena. For, as he writes in 'Theological Questions to Scientists':

> if the God of the Bible is the creator of the universe, then it is not possible to understand fully or even appropriately the processes of nature without any reference to that God. If on the contrary, nature can be appropriately understood without reference to the God of the Bible, then that God cannot be the creator of the universe, and consequently he cannot be truly God and be trusted as a source of moral teaching either. (Below, 38)

To support such comprehensiveness of inquiry, Pannenberg poses his concept of *field*. If we unpack the structure of that concept from the bottom up, we see that all the phenomena in our experience exist within, and help to constitute, some field—some dynamically interrelated system of phenomena. Building upon this insight, we see, furthermore, that there are various such fields. They and all they comprise are interdependent; for this reason, they are also radically contingent. All of them, however, are subsumed within a noncontingent field, which encompasses all reality and is uniquely able to constitute itself. This dynamic reality we know as God.

Pannenberg's mission is to discern the deep structures of the whole. With broad erudition, he extracts features of various scientific disciplines that illumine the issues of contingency and field. From the treasury of theology, he identifies insights that converge upon these same issues. Perceiving all these data as parts of the whole, he achieves not just an integration but a synergy far greater than the component parts, supporting an understanding of God that is, for Pannenberg, sufficient in scope. Thus does theology lay claim to the scholarship and thought forms of our own times. For theology must not only take seriously the most reliable knowledge extant, within every realm, but speak to the issues devolving therefrom; for the responsible theologian, there is no other choice.

While parts of Pannenberg's project concern the humanistic disciplines, this volume concerns his work with the sciences. That work is itself a rich and complex feast.

· · · · · · · · · ·
Theological Questions to Scientists

In this essay, which appeared in *Zygon: Journal of Religion and Science* in March 1981, Pannenberg invites the participation of scientists by posing to them five basic questions:

1. "Is it conceivable, in view of the importance of contingency in natural processes, to revise the principle of inertia or at least its interpretation?" (40). Belief in inertia seemingly obviated the need for a sustaining God. But perhaps, Pannenberg suggests, that principal is no longer so self-evident. If the phenomenon of inertia actually depends on a combination of contingent conditions, it may imply the framework of a field of force to provide the conditions for such a phenomonon to exist.

2. "Is the reality of nature to be understood as contingent, and are natural processes to be understood as irreversible?" (43). If contingency and irreversibility are deeply connected, they may affirm the biblical view of reality as historical.

3. "Is there any equivalent in modern biology of the biblical notion of the divine spirit as the origin of life that transcends the limits of the organism?" (44) In biblical traditions, life is not seen as a function of the organism but of a mysterious external agent called 'Spirit'. A critical point here is that the living organism is not a closed system but lives within its field; Michael Polanyi sees this field as "the agent of biotic performances" (45).

4. "Is there any positive relation conceivable of the concept of eternity to the spatiotemporal structure of the physical universe?" Pannenberg invites a mathematical-physical model to deal with these issues and wonders whether the ancient idea of the Logos can be reformulated in terms of modern information theory.

5. "Is the Christian affirmation of an imminent end of this world that in some way invades the present somehow reconcilable with scientific extrapolations of the continuing existence of the universe for at least several billions of years ahead?" (48) To this question Pannenberg sees no easy solutions; perhaps, he suggests, one should "accept it as a challenge to the human mind to penetrate deeper still into the complexities of human experience and awareness" (48).

In the remaining Pannenberg essays in this section, specific areas of science are addressed.

Laying Theological Claim to Anthropological Theories

'Laying Theological Claim to Scientific Understandings' first appeared as the Introduction to Pannenberg's *Anthropology in Theological Perspective*. Here Pannenberg shows why theology today *must* focus on its interrelationship with the anthropological disciplines—history, psy-

chology, sociology, and human biology. To make his case, Pannenberg traces the changing foci of theological discourse from the cosmological outlook of patristic times to the current privatization of religion, with its narrowing emphasis on individual salvation. He observes that human values and human rights have now become "the basis for social coexistence", and so the discussion of anthropological themes has become fundamentally important to public life. In order to defend the claim of their faith, Pannenberg asserts, Christians must not only address these themes but "conduct this defense on the terrain of the interpretation of human existence"—within the broad disciplines of history, sociology, psychology, and human biology.

· · · · · · · · · ·
Laying Theological Claim to Physical Theories

Pannenberg is well aware that methodology developed vis-à-vis the life sciences applies with equal rigor to the sciences not directly concerned with life, including cosmology and physics. These, too, constitute, and are constituted by, the dynamic, noncontingent field we know as God. This view is explored in 'The Doctrine of the Spirit and the Task of a Theology of Nature', which first appeared in *Theology* (January 1972).

Addressing issues of cosmology and modern physics, Pannenberg again traces the evolution of theological emphases within the context of societal and intellectual change. Early Hebrew understandings of *ruah*, the breath of life, as the life-giving spirit that vivified the first humans are closely allied with early Greek concepts of *pneuma*, the identity of spirit with breath and breath with air. Saint Paul based his idea of the new life of the resurrection on "the traditional understanding of life as originating from the creative power of the spirit." And "in the Eastern Orthodox tradition until the present time, there has always been preserved a continuous awareness of the fundamental importance of the spirit's participation in the act of creation" (67).

Through the centuries, however, the role of the spirit became attenuated—to giver of grace, to the "inner light" (69), and finally, perhaps, to that power that enables Christians to "believe ten unbelievable things before breakfast."

Modern physics and cosmology, however, open the door for Pannenberg to reaffirm and rediscover the role of spirit in creation. In this task he refers to work by Paul Tillich and Pierre Teilhard de Chardin. Both attempted to end the diminution of the concept of spirit by again seeing it as the animating power of all life. After criticizing some of

Tillich's formulations, Pannenberg affirms many concepts of Teilhard but insists that he was mistaken to see energy in terms of the inside reality of bodies: If Teilhard had rather located energy outside of bodies, seeing it in terms of field, "this would have been in perfect concordance with his idea of a transcendent spirit" (73) whose creative power enables all entities to transcend themselves, and grow toward the complexification and unification that is their destiny. Pannenberg identifies this transcendent spirit as point Omega, the goal of the process of evolution. In a unique move, he asserts that the future *as field* in fact draws the present forward toward its destiny, the end point of all creation—the Omega point. Thus, "self-transcendence is to be regarded at the same time as an activity of the organism and as an effect of a power that continuously raises the organism beyond its limitations and thereby grants it its life" (77).

As the human organism transcends itself, it tends toward personal and social integration and a culture that provides meaning for life. These quests are at the same time humanly creative and receptive of the spiritual reality—in Teilhard's term, the *vis ab ante* or 'power of the future'—which creates and unites the world. For the individual, the social structure, and the culture, the payoff for responding to this power is "the confidence of being united to the future of God" (79).

Pannenberg wonders whether the temporal structure of field theories needs to be further investigated, especially in light of the problems of quantum theory, and he points out the element of contingency in the effectiveness of such a field as understood by quantum theory. Since this paper dates from 1972, Pannenberg's physical references stop at a time when the standard model of particles and fields was on the threshold of gaining general acceptance. Recent developments in nonlinear theories, which are not at root stochastic, may provide powerful support for his teleological views

• • • • • • • • • •
Self-Transcendence, Self-Organization, and Spirit

This section concludes with 'Spirit and Energy in the Phenomenology of Teilhard de Chardin', translated by Donald W. Musser. Pannenberg here asserts the basic identity of spirit and energy and conceptualizes energy as a field. Here he differs from Teilhard, who sees energy as emanating from mass. To this reader, the mass-field distinction, like the particle-field distinction in high-energy physics, may be seen as the continuation of a discussion going back to Descartes and even

Plato, and furthermore, to invoke Christian concepts of embodiment and incarnation.

Pannenberg sees Teilhard as taking a further step in understanding the dichotomies of energy and mass, field and bodies. In this view, entities transcend themselves as they follow a general tendency of physical and biological phenemona to become more and more complex and unified. Pannenberg sees self-transcendence as involving interaction between entities and the fields within which they exist. Self-transcending entities reflect or include more and more of these fields within their own being, and the fields are modified in turn.

Going beyond Teilhard, Pannenberg locates the energy that fuels this move to transcendence, not in the "within of a thing", but in the field in which the thing exists. Although such moves to complexification take place both because of the entity's own efforts and because of the energy of its field, the ultimate source of the power lies in the noncontingent, self-constituting field known to theologians as God. This field, which includes past, present, and future, shapes the pilgrimage.

This essay, published in 1971, prefigures current work in self-organization and nonequilibrium thermodynamics. Currently, these disciplines, in the borderlands of physics, chemistry, and the life sciences appear to underline Pannenberg's assertion that nonisolated systems will tend toward increased unity and complexity, toward negentropy. In his final response to symposium papers, which appears later in the volume, Pannenberg takes up the task of laying claim to these disciplines.

1
Theological Questions to Scientists
• • • • • • • • • •
Wolfhart Pannenberg

In their discussions with theologians few scientists seem motivated primarily by theoretical questions. There is rarely much desire for theologians' help in explaining the world of nature. Rather there is a widespread awareness that science alone cannot cope with the consequences and side effects of scientific discoveries, especially in their technological application. Frightened earlier by the development of nuclear weapons and later by the threat of ecological disaster and by the dangers involved in modern biochemical techniques, many scientists have been led by a sense of responsibility for the application of their work to look for moral resources that can be mustered in order to prevent or at least to reduce the extent of fatal abuse of the possibilities provided by scientific discoveries. At this point then the churches are appreciated once more as moral agencies that should help the human society in responsibly dealing with the potential of science and technology.

The churches should certainly not refuse to face their particular responsibilities in these matters, and theology may be of some assistance here. But in modern society the moral authority of the churches and of their theologies is limited. It has been seriously weakened because the underlying religious interpretation of reality is no longer taken as universally valid but as a matter of private preference, if not as superstition.

This situation has been brought about not primarily perhaps but to a large extent by what has been called the 'warfare' of science with theology. According to public opinion in our Western culture this war was lost by Christian apologetics. This does not necessarily mean that the issues have been solved to everybody's satisfaction. On the side of Christian theology there was certainly a lot of bad apologetics involved, especially in the long struggle against the principles of continuity and evolution in natural processes. But there were also important issues at stake. On the side of scientific culture a sort of overkill was achieved when scientific inquiry was declared independent of any association with religion. That amounted of course to denying religion its claim on the reality of nature.

It was little comfort in this situation that some religious interpretation of the findings of science was regarded as compatible with science in terms of a private and optional belief. Scientists personally continuing to hold and develop religious views of their work did not alter the fact that, concerning human knowledge of the natural world, religious assertions were considered superfluous. Religion did not make any difference to the scientific description of the reality of nature, and the logical implication was that it had no legitimate claim on reality; the reality of nature could be fully understood without the God of religious faith. In view of the seriousness of this blow to religious truth claims, it would seem appropriate if the renewed interest of scientists in religion and especially in a dialogue with Christian theology were accompanied by some sense of surprise that Christianity is still around. Perhaps Christianity survived only by temporarily separating the outlook of faith from the rational and scientific investigation and description of the natural world. But such an attitude cannot persist because it is profoundly unacceptable on theological grounds.

If the God of the Bible is the creator of the universe, then it is not possible to understand fully or even appropriately the processes of nature without any reference to that God. If, on the contrary, nature can be appropriately understood without reference to the God of the Bible, then that God cannot be the creator of the universe, and consequently he cannot be truly God and be trusted as a source of moral teaching either. To be sure, the reality of God is not incompatible with some form of abstract knowledge concerning the regularities of natural processes, a knowledge that abstracts from the concreteness of physical reality and therefore may be able also to abstract from the presence of God in his creation. But such abstract knowledge of regularities should not claim full and exclusive competence regarding the explanation of nature; if it does so, the reality of God is denied by implication. The so-called methodological atheism of modern science is far from pure innocence. It is a highly ambiguous phenomenon. And yet its very possibility can be regarded as based on the unfailing faithfulness of the creator God to his creation, providing it with the unviolable regularities of natural processes that themselves become the basis of individual and more precarious and transitory natural systems—from stars and mountains and valleys and oceans to the wonders of plants and animal life, resulting in the rise of the human species.

The abstract investigation of the regularities underlying the emergence of these natural forms need not separate them from their natural context in the creation of God and thus from God himself. But in

fact there has been a strong tendency in modern science toward such a separation by putting the knowledge of the abstract regularities of nature to the use of man to whatever purposes he thinks fit. Precisely the abstract character of modern sciences allows the results to be at the disposal of human groups and societies and to serve the most diverse aims. Using scientific research for ever-extended domination and exploitation of natural resources has deeply influenced the direction of research itself. Modern experimental science does not simply observe the natural processes but invades them. Thus it does not leave the change of the natural environment to technological application but starts itself on that line by its experimental techniques.

That modern science so easily lends itself to abuse cannot be prevented in principle. It is one of the risks involved in the abstract study of the regularities that either are inherent in nature itself or can be imposed on natural processes. This risk cannot be met on the level of scientific description itself but must be met first on the level of philosophical reflection on the work of science. It is on this level that the abstract form of scientific description must be considered with special attention to what it is 'abstracted from' and what is methodically disregarded in the abstract formulas of science. It is on this level then that theologians should address their questions to scientists since God the creator and the nature of things as creatures belong to those aspects of reality that are abstracted from in the mathematical language of science.

There are five such questions that will be raised in the rest of this paper. They have been selected because all of them seem to be of particular importance in the dialogue between natural science and theology. The answers given to each of these questions will contribute significantly to any decision concerning the compatibility of modern science with faith in the biblical God as creator and redeemer of humankind and of his entire creation.

The first and most fundamental of these questions runs like this: Is it conceivable, in view of the importance of contingency in natural processes, to revise the principle of inertia or at least its interpretation? The introduction of this principle in modern science played a major role in depriving God of his function in the conservation of nature and in finally rendering him an unnecessary hypothesis in the understanding of natural processes. Closely connected is the second question: Is the reality of nature to be understood as contingent, and are natural processes to be understood as irreversible? This question aims at the historical character of reality—not only of human history but also of nature—that seems to be specifically related to the biblical idea of God.

The third question is related also to the biblical perspectives of created existence and especially of life: Is there any equivalent in modern biology of the biblical notion of the divine spirit as the origin of life that transcends the limits of the organism? While historicity indicates the general character of reality in the perspective of biblical faith, the divine spirit, at once immanent in creation and transcending the creature, constitutes its living reality in its relation to an ecstatic beyond of self-giving and satisfaction. Since this includes the hope for resurrection and eternal life, the fourth question refers to the relation between time and eternity: Is there any positive relation conceivable of the concept of eternity to the spatiotemporal structure of the physical universe? This is one of the most neglected but also one of the most important questions in the dialogue between theology and science. It is unavoidable if the reality of God is to be related in a positive way to the mathematical structure of the spatiotemporal world of nature.

It will prove indispensable also in approaching the fifth and perhaps the most difficult question in the dialogue between theology and modern science, the question of eschatology: Is the Christian affirmation of an imminent end of this world that in some way invades the present somehow reconcilable with scientific extrapolations of the continuing existence of the universe for at least several billions of years ahead? Just to ask this question in a way that does not simply reduce biblical language to metaphor or dismiss it as mythological is extremely difficult. But this difficulty already arises with the third question regarding the spirit. And from the beginning of such a discourse it lurks behind the very term 'God'. It is only by exploring the function of 'spirit'—involving a redefinition of that term, a clarification of the interrelation between time and eternity, and the issue of eschatology—that the term 'God' in its biblical concreteness can be understood in its importance to the world of nature. The first two questions simply provide a starting point for such an exploration, one that will not allow theologians and scientists to talk on such different and unrelated levels as to reduce any agreement in terminology to mere equivocations.

.
Inertia and Divine Conservation

Is it conceivable, in view of the importance of contingency in natural processes, to revise the principle of inertia or at least its interpretation? The crucial importance of this question in the dialogue between science and theology is generally underestimated. Perhaps this is so

because under the impact of deism the relation between God and the world was reduced to the origin of the world and especially of our planetary system. But as early as in the fourteenth century the question of the conservation of finite reality had become more prominent in the discussion of the indispensability of a first cause regarding the interpretation of nature. William of Ockham rejected the view of the thirteenth century that in the order of existence the assumption of a first cause was necessary. He argued that in the sequence of generations it was quite natural that the later generation was alive while the former generations were already dead.

In order for a new generation to rise, the continuing existence of a first forefather is not required. In the same way there is no first cause; nor is its continuing existence required in order to account for the continuous rise of new beings in the world. If it were, the chain of natural causes could be traced back ad infinitum. But the need for preservation of what came into existence led Ockham to a different conclusion. If continued existence was not self-explanatory but required the continued activity of the cause that gave origin to the creature, then without the continued existence and activity of a first cause all its effects would vanish, whatever the mediation of their origin might be. Therefore, in Ockham's view, God was still indispensable in the explanation of the physical world because without him no finite reality could persist.

This was changed, however, when in the seventeenth century the principle of inertia was introduced in modern physics. It described an innate potential of persistence for any physical reality, be it in a state of rest or in a state of motion, unless it was disturbed by some other force. The far-reaching impact of this principle on the relation of physical reality to God went largely unnoticed. But the philosopher Hans Blumenberg, in an article published in 1970, demonstrated in some detail that the introduction of the principle of inertia in seventeenth-century physics was to replace the dependence of physical reality on God's activity of continuous creation with the idea of self-preservation, an idea that presumably was derived from stoic traditions (Blumenberg 1976).

Interestingly enough, René Descartes considered the principle of inertia still to be in need of some deeper foundation. He traced it back to the immutability of God in his dealings with his creation. Since Descartes still believed that everything created in each moment of its existence depended on the continuous activity of the creator, on his *creatio continua*, only the immutability of the creator could account for the stability in the order of creation, the basic manifestation

of which is to be found in the tendency of everything to preserve in the status once acquired unless disturbed by other forces (Blumenberg 1976, 182–85; Descartes, 36–37). Later Isaac Newton was content to use the principle of inertia in his *Principia Naturae* (1687) without explicit reference to God (definitions 3 and 4). But Baruch Spinoza was the first to identify the essence of things with their perseverance in being, and thus he provided a metaphysical foundation for the emancipation of nature from its dependence on divine conservation, on a continuous concursus of a transcendent God (Blumenberg 1976, 185–88).

The emancipation from the creator God entailed in the principle of inertia did not apply only to individual natural bodies and beings which at the same time continued to undergo influences from outside themselves. Even more serious was the consequence that the system of the natural universe had to be conceived now as an interplay between finite bodies and forces without further need for recourse to God. When, almost one hundred years after Spinoza, Immanuel Kant again used the contingency of all finite reality as a starting point for developing his idea of God, he found himself confined to the puzzlement such contingency presented to human reason; he no longer could claim a direct dependence of contingent reality on God for its preservation (Kant 1763; cf. Redmann 1962, 142–48; 98–99). On the other side, Christian apologetics, having accepted the new basis of natural philosophy provided by the principle of inertia, was now left to the unfortunate strategy of looking for gaps in the continuity of natural processes if it wanted to preserve certain occasions for divine interference in the natural world.

But perhaps the principle of inertia or of self-persistence is in fact not as self-evident as believed. If the stuff of the universe is finally made up of events rather than of solid bodies and if the latter are already the products of the regularities of events, then their inertia or self-persistence is no more self-evident than any other natural regularity. The 'atomic' view of time and the awareness of the contingency of temporal sequence that kept Descartes from taking inertia as a self-evident principle and led him to seek its basis in the invariable faithfulness of the creator may be, after all, closer to the views of modern science than Spinoza's opposite view. Perhaps after three centuries the conclusion from physical phenomena to an action of God does no longer go so smoothly as at the time of Descartes. But if it depends on a combination of contingent conditions, the phenomenon of inertia may tacitly imply the framework of a field of force to provide the conditions for such a phenomenon to exist.[1]

.
Contingency, Irreversibility, and History

The second question squarely faces the issue of contingency and regularities of nature in its general form: Is the reality of nature to be understood as contingent, and are natural processes to be understood as irreversible? The combination of the two parts of the question suggests that irreversibility is related to contingency and may be rooted in it. In order to explain this a number of steps is necessary before the impact of the issue on a theological view of the historicity of nature can become apparent.

First, contingent conditions, initial conditions as well as boundary conditions, are required for any formula of natural law to be applied. They are contingent at least in that they cannot be derived from the particular formula of law under consideration.

Second, the regularity itself, which is described by a formula of natural law, can be considered as contingent because its pattern represents a repeatable sequence of events, a sequence that, being temporal, must take place a first time before it is repeated and becomes a regular sequence (Pannenberg 1993, especially 105–110). The mathematical formula of a natural law may be valid without regard to time. The physical regularity that is described by such a formula is not independent of time and of temporal sequence. But it is only that physical regularity that makes the mathematical formula a law of nature. This suggests that laws of nature are not eternal or atemporal because the fields of their application, the regularities of natural process, originate in the course of time. Thus it also becomes understandable that new patterns of regularity emerging in the sequence of time constitute a field of application for a new set of natural laws such that "the laws governing matter in a higher level of organization can never be entirely deduced from the properties of the lower levels" (Peacocke 1971, 87).

Third, if this consideration applies to all natural regularities in temporal sequences, it leads to a general thesis on irreversibility in natural processes. This irreversibility, which is based ultimately on the irreversibility of time, does not preclude the emergence of repeatable patterns of temporal sequence; but such an emergence itself becomes a contingent event. The regularity by itself therefore is only an abstraction—from the contingent process and context of its emergence. Therefore its explanatory potential is necessarily limited.

The irreversibility in natural processes is often argued for on different grounds, especially in relation to the law of entropy. This also has been applied to cosmology and has contributed to relativistic

models of the universe such as the 'big bang' theory. But the ultimate basis of irreversibility may rather be looked for, as C. F. von Weizsäcker suggests, in the irreversibility of time (Weizsäcker 1971, 239–240). Here then contingency and irreversibility may have their common root.

The theological interest in such considerations is due to the biblical understanding of reality as historical. It is intimately related to the biblical understanding of God the creator who acts freely and unrestrictedly not only in laying the foundations of the universe but also in the subsequent course of events. This 'continuous creation' is basically characterized by contingency because future acts of God cannot be deduced from past course of events. And yet there emerge regularities and persistent forms of created reality giving expression to the faithfulness and identity of God in affirming the world that he created. The continuity of this creation can be characterized as the continuity of a history of God being engaged in and with his creation. This historical continuity adds to the continuity that is expressed in the regularities of natural processes: While the description of those regularities in the form of 'natural laws' abstracts from the contingent conditions of their occurrence, historical continuity comprises the contingency of events together with the emergence of regularities. Thus the category of history provides a more comprehensive description of the continuous process of nature. But on the other hand the continuity of that history in its biblical conception seems to be placed outside the created process, that is, within God himself. Thus we have to see whether this continuity also manifests itself inside the process of nature. This leads to the third question, which is concerned with the spirit of God.

· · · · · · · · · ·
Bible and Biology on the Origin of Life

Is there any equivalent in modern biology of the biblical notion of the divine spirit as the origin of life that transcends the limit of the organism? The question is focused on the phenomenon of life because in biblical writings the work of the spirit relates specifically to life. But it also relates to the created world in its entirety, as the initial words in the book of Genesis indicate.

In biblical traditions, life is not considered as a function of the organism. This constitutes a basic difference from the view of modern biology.[2] The life-giving power is seen as an agent that influences the organism from the outside. When it is called 'spirit', one must not think of consciousness and intelligence in the first place. The spirit is rather a mysterious reality, comparable to the wind (John 3:8). When

God breathes it into the creature which he built earlier, it comes alive (Gen. 2:7). Thus the person has a life in himself or herself, but only a limited share of it. In the event of death "the dust returns to the earth as it was, and the Spirit returns to God who gave it" (Eccles. 12:7). Further, this view of life as originating from a transcendent source is an indispensable presupposition for the hope in a resurrection to a new life beyond death. Only if the source of life transcends the organism is it conceivable that the individual be given a new life that is no longer separate from the divine spirit, the source of life, but permanently united with it as a "spiritual body" (1 Cor. 15:42–44).

These biblical conceptions quite obviously belong to a universe of discourse different from what modern biology has to tell about life and its origin. But they cannot easily be dismissed as transient with the culture of their time because they possess far-reaching importance for basic affirmations of the Christian faith. If they are to be taken as carrying an important truth, however, it must be somehow present, if only in oblique form, in modern biological descriptions of life too.

Now the living organism, in the view of modern biology, is not a closed system. It transcends itself by inhabiting a territory within an appropriate environment, and it literally lives 'on' that environment. In its drives it relates to a future that transforms its own status of life. Sexuality is a particularly powerful manifestation of the ecstatic nature of life.

If one tries to develop a synthetic account of these phenomena, one may be led in a direction similar to that of Michael Polanyi's explanation of individual morphogenesis on the assumption of a "morphogenetic field" that comprises all the boundary conditions of individual development (Polanyi 1962, 356). Polanyi himself does not shy away from expanding this notion in conceiving the idea of a phylogenetic field that governs the process of evolution and that provides a perspective in which individual organisms are to be considered as singularizations; he says that "the evidence provided by the various branches of biology (including psychology)" seems "to cry out for the acknowledgment of a field as the agent of biotic performances" (Polanyi 1962, 402, 389–400). At this point Polanyi's thought meets with Pierre Teilhard de Chardin's vision of point omega at work in the process of evolution as the power of the divine spirit, although Teilhard does not use the field concept in describing the efficacy of that power in the same way as Polanyi.[3]

To the theologian the description of the evolution of life in terms of a generalized field theory must be extremely suggestive because it seems to offer a modern language that possibly can express the biblical idea of the divine spirit as the power of life that transcends the

living organism and at the same time is intimately present in the individual. In the perspective of such a field theory of life one may follow Polanyi's "logic of achievement" in the sequence of emergent forms of life and in his final vision of a "cosmic field which called forth all these centres by offering them a short-lived, limited, hazardous opportunity for making some progress of their own towards an unthinkable consummation" (Polanyi 1962, 405).[4] But it is not by chance that Polanyi calls that consummation "unthinkable" because neither the eschatological presence of God's kingdom nor the Christian hope for the new life of a resurrection of the dead is imaginable as just another stage in the temporal sequence of the evolutionary process. It adds another dimension, the transfiguration of the temporal by the presence of the eternal.

· · · · · · · · · ·
Eternity and Space-Time

Is there any positive relation conceivable of the concept of eternity to the spatiotemporal structure of the physical universe? As I said, this is one of the most arduous but also one of the most important questions in the dialogue between theology and natural science. If eternity means the divine mode of being, then it is directly concerned with the question of how the reality of God is related to the spatiotemporal universe. Without an answer to the question regarding time and eternity the relation of God to this world remains inconceivable.

Now eternity has been interpreted traditionally as timelessness, and in this interpretation its relation to time appears to be purely negative. But this contradicts the Christian hope for resurrection because that hope does not aim at a completely different life replacing the present one. It rather aims at a transformation of this present life to let it participate in the divine glory. Salvation cannot mean pure negation and annihilation of this present life, of this creation of God. Therefore in a Christian perspective time and eternity must have some positive relation. This is also implied in the doctrine of the Incarnation since that means a togetherness of the human and of the divine in the person and life of Jesus Christ.

The notion of eternity certainly means unlimited presence. But this need not exclude the temporal that comes into existence once and passes again into nonexistence. The positive relation of the temporal to the eternal could mean that in the perspective of the eternal the temporal does not pass away, although in relation to other spatiotemporal entities it does. On the basis of this it is also conceivable that the lasting presence of the temporal before the eternal God may become

the experience of the temporal itself, so that it experiences itself as it stands in the presence of God, vanishing in its contradiction to God or transformed in participation in his glory.

Such an inclusive interpretation of eternity in relation to temporal reality, however, requires a systematic way of relating the extensions of time and space to a conceptual model of eternity. Such a model should be mathematical in character in order to comprise the mathematical structures of space and time. A German mathematician, Günter Ewald of the University of Bochum, is developing such a model (Ewald 1980, 79–86). It is based on the notion of a field just as the theory of relativity conceives of the spatiotemporal universe as a single field. According to Ewald this notion can be expanded to include complex numbers beyond real numbers. Since in the level of complex numbers no linear sequence occurs, the transition from complex numbers to real numbers can be interpreted as a transition into spatiotemporal existence. Generally the field of complex numbers in its relation to real numbers can provide a model of the relation of eternity to spatiotemporal events.

It remains to be seen how far the explanatory power of this model goes. Does it explain not only the transition from the eternal to temporal existence but also the manifestation of the eternal within the temporal sequence? According to Christian doctrine such a manifestation of the eternal within temporal reality will occur in its fullness in the *eschaton* (last times), but by anticipation it occurred in the midst of the ongoing sequence of events in the resurrection of Jesus. This event persuaded the Christian community that the eternal Logos was incarnate in Jesus. The entire problem of miracles is related to the question of the anticipatory presence of the eschatological consummation. But there are also other and more ordinary modes of an anticipatory presence of the eternal in time. According to the Christian doctrine that the divine Logos had an important part even in the creation of the world, the logical structure that became manifest in the person and history of Jesus Christ should somehow be present in every creature. Just as Jesus's identity as the son of God is to be finally confirmed in his eschatological parousia, the essence of all things is realized presently only by anticipation and will be revealed finally in the ultimate future where the temporal will be reconstituted in the presence of the eternal. This is but one aspect of how every creature bears the imprint of the Logos. There also seems to be a tendency toward increasing participation in the divine spirit and Logos in the course of the evolution of creatures, approximating the eschatological presence of the eternal in the temporal. The human mind is distinguished by a unique degree of openness to the presence of the eternal which is expressed in the

experience of an amplified presence that overlaps, though in a limited way, past and future events. The participation of the human mind in the eternal Logos through the ecstatic power of the spirit may account also for the possibility and specific character of human knowledge of the created world.

In a trinitarian perspective the work of the Logos and that of the spirit in the creation of the world belong closely together. Can this be expressed in a language that takes account of modern science? If Weizsäcker's suggestion is followed, namely, that the ancient philosophical Logos doctrine can be reformulated in terms of modern information theory, then it does not seem completely inconceivable that a field theory of information can do justice to the cooperation of Logos and spirit in the creation of the world (Weizsäcker 1971, 342–366).

• • • • • • • • • •
Christian Eschatology and the Scientific 'Universe'

The last question, that of eschatology, was already touched upon in connection with the work of the spirit and with the transfiguring presence of the eternal in the temporal. But it needs to be raised in its own right because it points to one of the most obvious conflicts between a worldview based on modern science and the Christian faith: Is the Christian affirmation of an imminent end of this world that in some way invades the present reconcilable with scientific extrapolations of the continuing existence of the universe for billions of years ahead?

To this question there are no easy solutions. Scientific predictions that in some comfortably distant future the conditions for life will no longer continue on our planet are hardly comparable to biblical eschatology. On the other hand some people are always quick to expurgate the religious traditions from elements that seem to make no sense to one period in the development of scientific insight. Perhaps one should rather accept a conflict in such an important issue, accept it as a challenge to the human mind to penetrate deeper still into the complexities of human experience and awareness. It does not seem unreasonable to expect that a detailed exploration of the issues involved in the question concerning time and eternity may lead one day to more satisfactory ways of including biblical eschatology in an interpretation of the natural world that should take appropriate account of modern science.

• • • • • • • • • •
From *Zygon: Journal of Religion and Science* 16 (March 1981), 65–77. By permission.

• • • • • • • • • •
Notes

1. C.F. von Weizsäcker (1971, 364) calls the principle of inertia "eine Folge der Wirkung des Universums auf das einzelne Urobjekt." This corresponds to the view of Albert Einstein (1954) that Isaac Newton introduced his concept of absolute space "als selbständige Ursache des Trägheitsverhaltens der Körper" in order to secure "dem klassichen Trägheitsprinzip (und damit dem klassischen Bewegungsgesetz) einen exakten Sinn." According to Einstein the concept of absolute space (or its amplification to that of an "inertial system" including time) could be overcome only when "der Begriff des körperlichen Objektes als Fundamentalbegriff der Physik allmählich durch den des Feldes ersetzt wurde," since then "die Einführung eines *selbständigen* Raumes" was no longer necessary. Einstein concluded: "Eine andere Möglichkeit für die Überwindung des Inertialsystems als den über die Feldtheorie hat bis jetzt niemand gefunden."
2. More detail on this argument is given in 'The Doctrine of the Spirit and the Task of a Theology of Nature' (Chapter 3 below).
3. See my discussion of Pierre Teilhard de Chardin's views on energy in 'Spirit and Energy in the Phenomenology of Teilhard de Chardin' (Chapter 4, below).
4. Polanyi's use of the field concept should not be mistaken for just another form of vitalism. It is rather opposed to the vitalist assumption, such as Aristotelian entelechy, of a finalistic principle working within the organism. Contrary to this, the field concept involves no finality; nor does it dwell in the organism as some occult quality distinct from its more ordinary aspects open to physical description. The field concept rather offers an integrative framework for a comprehensive description of all aspects of organic life including its interaction with its ecological context.

• • • • • • • • • •
References

Blumenberg, Hans. 1976. Selbsterhaltung und Beharrung: Zur Konstitution der neuzeitlichen Rationalität. In *Subjektivität und Selbsterhaltung: Beiträge zur Diagnose der Moderne*, ed. Hans Ebeling, 144–207. Frankfurt: Suhrkamp. Originally published in *Abhandlungen der Mainzer Akademie der Wissenschaften und der Literatur, giestes- und sozialwissenschaftliche Klasse*, jg. 1969, no. 11 (1970): 33–83.

Descartes, René. *Principia Philosophiae*. Vol. 2.

Einstein, Albert. 1954. Preface to *Concepts of Space* by Max Jammer. Cambridge, Massachusetts: Harvard University Press.

Ewald, Günter. 1980. Bemerkungen zum Begriff von Raum und Zeit in der Physik. In *Gott-Geist-Materie: Theologie und Naturwissenschaft im Gespräch*, ed. Hermann Dietzfelbinger and L. Mohaupt, 14–31. Hamburg: Lutherishes Verlaugshaus.

Kant, Immanuel. 1763. *Der einzig mögliche Beweisgrund für eine Demonstration des Daseins Gottes*.

Pannenberg, Wolfhart. 1993. *Toward a Theology of Nature: Essays on Science and Faith*. Ed. Ted Peters. Louisville: Westminster/John Knox.

Peacocke, Arthur. 1971. *Science and The Christian Experiment*. London: Oxford University Press.

Polanyi, Michael. 1962. *Personal Knowledge: Toward a Post-Critical Philosophy*. 2nd edition. London: Routledge.

Redmann, H.G. 1962. *Gott und Welt: Die Schöpfungstheologie der vorkritischen Periode Kants*. Göttingen: Vandenhoeck und Ruprecht.

Weizsäcker, C.F. von. 1971. *Die Einheit der Natur*. München: C. Hanser.

2

Laying Theological Claim to Scientific Understandings

Wolfhart Pannenberg

The understanding of the human being has increasingly played a foundational role in the history of modern theology.

In Protestant theology this development can be traced through various stages, from the early bias toward a 'praxis' springing from the human need of redemption, through Deism and the moral rationalism of the later Enlightenment, into the classical period of German evangelical theology that began with Schleiermacher's redefinition of religion. The line continued through revivalist theology and its successors into liberal theology and the debates occasioned by dialectical theology in our own century. In the recently concluded phase of this long history, the debates culminated in the victory of an existentialist interpretation of the Christian message as a result of Rudolf Bultmann's opposition to Karl Barth.

After the holding action of the neo-Scholastic revival, Catholic theology has finally run the same course. The theology of Karl Rahner may serve as an example.

This concentration on anthropology in dealing with the problems of fundamental theology reflects the modern development of the philosophical idea of God. Insofar as modern philosophy did not turn in the direction of atheism or persist in keeping an agnostic distance, it showed increasing determination in conceiving God as a presupposition of human subjectivity and to that extent it thought of him in terms of humanity and no longer of the world. Not the natural world as such but human experience of the world and of the individual's existence in it repeatedly supplied the point of departure for discussing the reality of God. Human beings seemed able to understand themselves in relation to the world only if they presupposed God as the common author of both themselves and the world.

This frame of mind can be seen as early as the fifteenth century in Nicholas of Cusa. In the history of modern thought the same outlook was adopted, with varying emphases, by Descartes, Leibniz, Kant, Fichte, Schelling, and Hegel.[1] The same pattern is observable throughout the entire modern history of philosophical theology. Thinkers no longer took the cosmos as their starting point in order to demonstrate

in a quasi-experimental way that God is the first cause of the natural order. Instead, they argued from the existence and experience of human beings in order to show that God is inevitably presupposed in every act of human existence.

In patristic and medieval philosophy and theology this approach had provided only a secondary line of argument. It did not have to bear the whole burden of proof for the idea of God. Thinkers in that age had also found it possible to argue directly from the order of being. Modern thought, however, had to renounce the claim that there is a physical necessity of accepting the existence of God as first cause of the natural process. The reason was that once the principle of inertia was introduced or, at the latest, once the mechanistic theory of the origin of the planets was accepted, modern physics seemed no longer to need 'the God hypothesis'.

The concentration on understanding of the human in modern fundamental theology thus reflected both the general intellectual outlook of the modern age and the development of this outlook as it found its characteristic expression in the course of modern philosophy. The development of modern philosophy was itself one of the stimuli for the growing anthropocentrism of modern theology. The philosophical concentration on the human person as subject of all experience and of philosophical reflection itself could not but have an impact on theology. By comparison, the theological physics of the seventeenth and eighteenth centuries, which looked to the theology of the cosmos for evidence of a wise Architect of the World, represented a byway that was gradually abandoned.

The growing anthropocentrism that has marked the development of Christian theology has not, however, been due solely to the influence of philosophy. It has also had another and genuinely theological cause: the fact that Christian theology is a response to the human question of salvation. The foundation for a theological concentration on the human person was already laid in the early Christian faith in the incarnation of God.

In the Augustinian tradition, which set its mark on Western theology, the focus was on the problem of individual salvation. The penitential piety of the Middle Ages only strengthened this emphasis, which reached its most intense form in the Lutheran Reformation and was continued in Pietism. In this thinking, the theme of sin and grace was narrowly conceived as *the* vital religious question for the individual person. By comparison, God's rule over the world in creation and in his future eschatological kingdom became secondary. This tendency found its purest expression in the Lutheran tradition. In the

Calvinist tradition, on the other hand, the social context of human life and a corresponding conception of God's reign continued to exercise a greater influence.

While, then, the individualistic approach to the religious question of salvation represented only one line of development among others in Protestantism, it was nonetheless especially characteristic of the development as a whole. The correspondingly narrow anthropocentric focusing of theology found its classical expression in the revivalist theology of conscience. By contrast, Schleiermacher's theology of conscience once again linked the individual with the religious community. Yet this theology was not spared in the indictment subsequently leveled at the entire nineteenth-century theological development, namely, that it had succumbed to an anthropological egoism in the matter of salvation and thus to religious individualism. This accusation was set forth at the beginning of the twentieth century in Erich Schaeder's *Theozentrische Theologie* (vol. 1, 1909). Hegel's similar criticism of the revivalist theology of his day had not exerted any notable long-term influence on theology. Schaeder's theocentrist emphasis, on the other hand, was continued in early dialectical theology; as a result, it left an ineradicable impress on the theological consciousness of our century.

The anthropological concentration in the history of modern theology is therefore not traceable solely to philosophical influences; it has also, and indeed principally, been stimulated by properly theological motifs, although it is only in the recent period that these have exerted their full influence. This makes it clear that this development in theology can be understood only as an expression of the overall intellectual situation in the modern era. The same conclusion follows from the fact that the anthropological concentration in theology has been strongly influenced by the social history of the modern period.

I am referring here to the privatization or at least segmentation of religion in modern society. After the religious wars of the sixteenth and seventeenth centuries the Christian confessions to a greater or lesser extent lost their position as state religions. The state became religiously neutral, and the choice of a religious confession became the private concern of the individual or of free associations of individuals. Even where the privatization of the religious confessions was not carried out as radically as it was in, for example, the United States, states did sooner or later accept the principle of religious neutrality. In these cases too, the result was a segmentation of the religious thematic, a restriction of religion to the private sphere and to the institutions dealing with this, while the political and economic order of society was relieved of any connection with religious views.

This tendency is observable throughout the modern period despite divergences peculiar to some countries. It is also independent of the question whether the life of society as a whole can thus be indifferent to the religious thematic or whether on the contrary the process is accompanied by an element of self-deception. The trend to the segmentation and privatization of religion is one of the dominant currents in modern history.

The privatization of religion also explains why pietism has acquired such an important place in the modern history of religious devotion. For the pietistic devotion of the heart took possession precisely of the sphere of private interiority which the modern state still allowed religion to occupy. Pietism turned the problem created by the privatization of religion into a virtue by making of human interiority a preserve, so to speak, for the themes of the religious life. Of course, pietistic devotion could hold its own in the religious debates of the modern age only if it could successfully show the *universal human validity* of religious interiority.[2]

It managed to do this initially in the theological moralism of the Enlightenment, especially in the form of the theology of conscience. This last, instead of reducing religion to morality, derived theological profit from the moralistic justification of religion which Rousseau and, following him, Kant had provided. But the independence of religion as based on private devotion achieved its classical expression only in Schleiermacher, beginning with his *Addresses on Religion* (1799).

Here Schleiermacher showed the universal human validity of religion by claiming for it "a special province in the soul" which is not reducible to morality or metaphysics and in which nonetheless the unity of the individual has its basis. As seen from the standpoint of a sociology of knowledge, religion, which had been reduced to the private sphere, was here asserting itself by claiming a universal human validity precisely for this private sphere. The question of the universally human had, after all, become what Christian revelation had been for the Middle Ages: the basis on which the legitimacy of all opposing views was decided.

This explains how anthropology, or in any case the discussion of anthropological themes, became so fundamentally important to the public life of the modern age. For, just as the Christian religion had been the basis for the spiritual unity of society in the days before the internal division of Christianity and the horrors of the confessional wars, so from the seventeenth century on, a shared conception of the human person, human values, and human rights became the basis for social coexistence.

It is understandable that not only Christians but also modern atheists who deny any and all religious faith should seek an anthropological basis for the universal validity of their claims. This was the path taken by Ludwig Feuerbach and the Marxists, as well as by Nietzsche, Freud, and the followers of both. If it can be shown that religion is simply a product of the human imagination and an expression of a human self-alienation, the roots of which are analyzed in a critical approach to religion, then religious faith and especially Christianity with its tradition and message will lose any claim to universal credibility in the life of the modern age. The Christian faith must then accept being lumped together with any and every form of superstition.

Without a sound claim to universal validity Christians cannot maintain a conviction of the truth of their faith and message. For a 'truth' that would be simply my truth and would not at least claim to be universal and valid for every human being could not remain true even for me. This consideration explains why Christians cannot but try to defend the claim of their faith to be true. It also explains why in the modern age they must conduct this defense on the terrain of the interpretation of human existence and in a debate over whether religion is an indispensable component of humanness or, on the contrary, contributes to alienate human beings from themselves.[3]

For these reasons, Christian theology in the modern age must provide itself with a foundation in general anthropological studies. We are not dealing here with a position that one may or may not decide to accept. Individuals are not free to choose the problematic situation in which they prefer to play a part and make a contribution, whatever form this may take. Given the state of the discussion as it has developed in modern times, the general principle just enunciated holds true even for Christian theology today.

In this situation there is admittedly the danger of an anthropological bracketing of theology. Schaeder and especially Karl Barth saw the danger and saw it correctly. It is the danger that human beings doing theology may be concerned only with themselves instead of with God and thus let the true subject matter of theology go by the board. Nonetheless, if theologians are not to succumb to self-deception regarding their proper activity, they must begin their reflection with a recognition of the fundamental importance of anthropology for all modern thought and for any present-day claim of universal validity for religious statements. Otherwise they will, even if unintentionally, play into the hands of their atheistic critics, who reduce religion and theology to anthropology, that is, to human assumptions and illusions.

By narrowly focusing on the question of human salvation (especially under the influence of pietism), theologians have undoubtedly forgotten in great measure that the Godness of God, and not human religious experience, must have first place in theology. This is true at least for any theology that is mindful of the First Commandment and takes as its norm the message of Jesus: "Seek first the kingdom of God."

Theologians will be able to defend the truth precisely of their talk about God only if they first respond to the atheistic critique of religion on the terrain of anthropology. Otherwise all their assertions, however impressive, about the primacy of the Godness of God will remain purely subjective assurances without any serious claim to universal validity.

Such has been the sad fate of dialectical theology and in particular the theology of Barth. It disdained to take a position on the terrain of anthropology and argue there that the religious thematic is unavoidable. As a result, it was defenseless against the suspicion that its faith was something arbitrarily legislated by human beings. As a result, its very *rejection* of anthropology was a form of *dependence* on anthropological suppositions. That is, when Barth, instead of justifying his position, simply decided to begin with God himself, he unwittingly adopted the most extreme form of theological subjectivism. Nothing could show more clearly how indispensable a rational justification of theology is and in particular, given the modern situation, an anthropological justification of the mode of theological argumentation. Only on this basis is it possible to show that the theological assertion of God's sovereignty is more than an arbitrary assumption on the part of a pious heart or even a theologian.

The considerations thus far offered show that in the modern age anthropology has become not only in fact but also with objective necessity the terrain on which theologians must base their claim of universal validity for what they say.

But what is the nature of this terrain? Are we dealing with a kind of neutral foundation, or rather one that already predetermines—and predetermines prejudicially—the special character and stability of the theological structure to be erected on it? The latter is precisely what Barth suspected. The results reached by philosopher O. Marquard in studying the history of the concept 'anthropology' point in the same direction (Marquard 1965; 1971),[4] even though Marquard's interest in the question was the opposite of Barth's.

According to Marquard, the term 'anthropology' first entered into common use in the sixteenth century as the name for a subordinate discipline within metaphysical psychology. This metaphysical psy-

chology for its part took for its object not only the human person but God and the angels as well, and even the souls of animals. Then 'anthropology' came to refer specifically to human psychology. This made it possible for the doctrine on the nature of the human being (doctrina humanae naturae) to be removed from its earlier metaphysical setting and made independent. And in fact (according to Marquard) under the title 'anthropology' the philosophy of the schools did cut itself free from the metaphysical tradition with its theological ties and ask itself the question: "How is the human being to be defined, if not (any longer) by metaphysics and not (yet) by the mathematico-experimental sciences?" (363). The French and English moralists, he says, laid the groundwork for a metaphysically neutral and uninhibitedly secular conception of the human being. The latter was no longer defined in primarily theological or metaphysical terms but was viewed empirically as part of the natural world and in a context provided by the resuscitated Stoic philosophy of late antiquity.[5]

The 'new anthropology' became the basis for the secular culture that arose after the end of the confessional wars of the sixteenth and seventeenth centuries. This culture developed in detachment from the Christian churches that were still battling each other. Marquard's description of the development is accurate insofar as the very concept of anthropology represented an answer to the question of the human being that was independent of Christian dogma and any metaphysics determined by that dogma. In opposition to Marquard, however, I must stress the point that the development was not automatically accompanied by any opposition to Christianity. In fact, motifs derived from the Christian faith played a part, implicitly and explicitly, in the new anthropology. This will subsequently be shown in detail.

It is correct, nonetheless, to say that the new anthropology with its empirical orientation did detach itself from confessional dogmas and from traditional Aristotelian metaphysics. As anthropology became thus detached and independent, the constitutive importance of the religious dimension of humanness receded more and more into the background as time went on, if indeed it was recognized at all. Modern anthropology reflects this independence of modern men and women from the confessionally divergent doctrinal systems of Christian theology and thus from any explicit religious thematic.

From this it is clear how ambivalent a procedure it would in fact be to try to base a Christian dogmatics on conceptions of the human person that arose in the course of a turning away from Christian dogma. As Barth correctly observed in his critique of the anthropocentrism of nineteenth-century theology, the theologians of that time

showed an excessive naïveté and lack of discrimination when they adopted philosophical positions that were in turn based on a detachment of the human being from theology and its subject matter. This is true, for example, of Kant's moral philosophy, but it is true as well of his doctrine that timeless structures within the rational subject are the basis of all experience.[6]

A disregard of the theological question concerning the human person is, then, implicitly, even if more or less unreflectively, at work in most contributions to modern anthropology. But let us not be tempted to conclude rashly that theologians should not involve themselves at all in that kind of anthropology but should instead go unperturbed about what they like to call their own proper business. It is indeed true that despite all the differences in its various disciplines and in the individual contributions made to it, modern anthropology has been historically characterized by a certain tendency and will not allow theologians to claim it as a neutral basis for theological reflections making use of its results. But the only conclusion theologians should draw from this situation is that they may not undiscriminatingly accept the data provided by a nontheological anthropology and make these the basis for their own work, but rather must appropriate them in a critical way.

This kind of critical appropriation is necessary in dealing with a nontheological anthropology because, for the reasons already given, the relations between anthropological findings and the subject matter of theology have in large measure been lost from sight. Theologians, moreover, must expect that a critical appropriation of these findings for theological use is also possible, if the God of the Bible is indeed the creator of all reality. It is not possible, on the other hand, to decree a priori that the expectation will actually be fulfilled. This must wait upon the anthropological phenomenon itself, but the question is both meaningful and necessary even if it should turn out that no simple and definitive answer is possible. In fact, the lack of a definitive answer is really to be antecedently expected, given the special character of the idea of God in its relation to the still incomplete totality of the world and our experience of it, a totality that transcends every finite experiential standpoint we can adopt.

A critical appropriation of nontheological anthropological research by theologians is not to be confused with the theological search for a 'point of contact' in the self-understanding of the human person, as called for since the end of the twenties by Emil Brunner (Brunner 1935) and in a limited way by Rudolf Bultmann as well (Bultmann 1955),[7] in opposition to Barth. The idea of a point of contact

presupposes, especially for Brunner, that the subject matter of theology is fixed in itself but must still be somehow brought home to human beings. In the light of this conception a concern for missionary effectiveness requires that theology establish contact with the situation of the human beings to whom the proclamation is directed, just as God himself has done in his revelation.

When 'contact' is conceived in this fashion the nontheological anthropology being used is not critically transformed and in this way appropriated by the theologian. It stands over against theology as something different from the latter, and theology, which in turn stands over against the anthropology as something different from it, is supposed to establish contact with this very different thing. The demand that anthropology be critically appropriated means something quite different. The aim is to lay theological claim to the human phenomena described in the anthropological disciplines. To this end, the secular description is accepted as simply a provisional version of the objective reality, a version that needs to be expanded and deepened by showing that the anthropological datum itself contains a further and theologically revelant dimension.

The assumption that such aspects can be shown to exist in the facts studied by the other disciplines is the general hypothesis that determines the procedure followed in my own study; the hypothesis must, of course, prove its validity in the discussion of the particular themes discussed. These aspects have not already been developed in the nontheological disciplines making up anthropology or are mentioned only peripherally and usually not made central. This situation is to be explained by the motives that have directed the development of modern anthropology in its various disciplines. These disciplines have developed in separation from the dogmatics of the contending confessions and from any theologically influenced metaphysics. Their aim, moreover, has been to place even the peripheral statements they do make about human religious behavior on a new and empirical foundation, in the establishment of which the religious themes of human existence seemingly play no part as yet.

What is the relation between this task of appropriating nontheological anthropological research and theory and the traditional dogmatic anthropology that was developed in the framework of the theological doctrine of creation and took the form of a doctrine regarding the original state and the fall of Adam?

Dogmatic anthropology has had two central themes: the image of God in human beings, and human sin. Also discussed have been the relation of soul and body, as well as a series of other questions for the

most part connected with the soul-body question, but these have not been the specifically dogmatic themes in the theological doctrine of the human person. The two main anthropological themes of theology—the image of God and sin—will also prove to be central in the attempted theological interpretation of the implications of nontheological anthropological study.

We must be careful, however, not to think of these two themes as having no validity outside the framework of the old doctrine of the original state and the fall, a doctrine reflecting a now outdated worldview. If we avoid this prejudice, we will see that the doctrines of the image of God and sin thematize the two basic aspects found in the most varied connections between anthropological phenomena and the reality of God. To speak of the image of God in human beings is to speak of their closeness to the divine reality, a closeness that also determines their position in the world of nature. To speak of sin, on the other hand, is to speak of the factual separation from God of human beings whose true destiny nonetheless is union with God; sin is therefore to be thematized as a contradiction of human beings with themselves, an interior conflict in the human person.

The opposition between closeness to God and distance from God leaves its impress on the whole of religious life. It finds expression in the fundamental polarity of holy and unholy, clean and unclean, as well as in the opposition between holy and profane. The concepts of image of God and sin describe the anthropological manifestation of this basic opposition that marks all of religious life. At the same time, however, they give the basic opposition a specific nuance that is characteristic of the Judeo-Christian tradition.

In reminding the reader that an opposition and tension far more universal in application manifests itself here in a particular setting, I am for the moment simply making one point: that we ought not to be surprised if an investigation of the religious and therefore theologically relevant implications of anthropological data leads us to the concepts of image of God and sin. But there is a further possibility which we may not exclude in advance: that the specifically Christian stress, as conveyed in these two concepts, on the opposition and tension between closeness to God and distance from God, may shed a special light on the empirically derived anthropological phenomena. As we shall see, even historically the two concepts pointed the way to the discovery of these phenomena.

Nonetheless it is not my intention here to offer a *dogmatic* anthropology. Traditional dogmatic anthropology presupposes the existence of God when it speaks of the image of God in human beings. Furthermore, it develops this concept on the basis not of anthropological find-

ings but of what the Bible says. Since it supposes the reality of God as it sets about speaking of human beings, it surrenders the possibility of joining in the discussion at the level of anthropological findings, for at this level a divine reality can be introduced, if at all, only as a problematic point of reference for human behavior, not as the object of apodictic dogmatic assertion. In addition, an anthropology that would suppose the reality of God could not help to ground theology as a whole, since the theme of theology is precisely the reality of God.

In contrast to traditional dogmatic anthropology, the studies undertaken here may be summarily described as a *fundamental-theological* anthropology. This anthropology does not argue from dogmatic data and presuppositions. Rather, it turns its attention directly to the phenomena of human existence as investigated in human biology, psychology, cultural anthropology, or sociology and examines the findings of these disciplines with an eye to implications that may be relevant to religion and theology.

What method is best suited to such studies as these? Can one of the disciplines dealing with the human person claim a primacy in the sense that it provides a groundwork to which the contributions of all the other disciplines must then be related? Does any single discipline thematize the reality of the human in a way at once comprehensive and diversified, so that the contributions of the other disciplines can find a place in the framework it supplies?

Human biology certainly cannot suitably play such a role. The question it asks about the human being is undoubtedly fundamental, but it is not comprehensive in a rounded way. Biology studies human beings only as a species and must prescind from individual features. Even the social relations of the human entity enter, if at all, only in a very general way into the perspective adopted in human biology. Sociology, for its part, devotes its attention especially to these relations, but it too prescinds from the individual and therefore from the concrete form which human reality takes. Something similar must be said of psychology.

The closest approach to concrete human reality is to be found in historical science, since this deals with the concrete lives of individuals and the way in which they interact in the process that is their history. Yet even the reconstructions produced by historical science must prescind from many details that belong to the concrete reality of the events being investigated. Even a biography, which represents the closest approach of history to the individual life, must focus on the events and occurrences regarded as important in the life that is being presented.

In history too, therefore, abstraction still plays a fundamental part. This does not alter the fact that historical science approaches more

closely to the concrete reality of human life than does any other of the anthropological disciplines. In comparison with history, these other disciplines thematize only partial aspects of the human reality: biology, the special character of human beings as compared to the animals; sociology, the basic forms of social relations among human beings; psychology, the general structures of human behavior.

On the other hand, historical science presupposes in principle all these partial aspects when it undertakes to describe human existence in its individual concrete forms. Consequently, history cannot be the basis for the other anthropological disciplines; rather, it absorbs them all into itself as partial aspects. The history of humankind thus comes at the end of anthropological reflection, precisely because it alone thematizes the concrete reality of the human being. Knowledge must always begin with the universal and abstract and only at the end reach the concrete as the object to which all the previous, abstract approaches were ultimately directed.

From this point of view, the fundamental anthropological discipline is the one that deals with human beings at the highest level of generality and thus first delimits the concept of human being, even if at the cost of remaining very abstract. That discipline is human biology. My investigation will therefore begin with what biological research tells us about the special character of human beings as opposed to the animals most closely related to them and to the animal world generally. Since such a definition of the human being looks less to the doctrine of evolution than to behavioral research, we find ourselves in very close proximity to psychology. Psychology in turn proves to have close ties with the anthropological perspectives of sociology, while conversely sociology presupposes biological anthropology and psychology.

These studies will lead finally to human history as the history of human existence itself. In the process it will become clear that the question of the anthropological significance of history is linked with the central anthropological problem in pedagogy: How to form human beings.[8]

• • • • • • • • • •

From *Anthropology in Theological Perspective,* translated by Matthew J. O'Connell. Philadelphia: Westminster Press, 1985.

• • • • • • • • • •

Notes

1. W. Schulz (1957) has described and summarized this process. On the anthropological concentration that has taken place in philosophical the-

ology in the course of this process, see my essay 'Anthropology and the Question of God' (1973, 80–99).

2. With reference to J.S. Semler's distinction between public and private religion, Rendtorff (1971, 35ff) has justly observed that the relation between private and public has been reversed in comparison with the earlier development: The official confessional churches, which at that time still enjoyed great public authority, were demoted to the rank of private institutions, while the private religious consciousness became the general form of theological perception and in the modern age is universally acknowledged as valid. This point has recently been emphasized by F. Wagner, who refers to Luckmann (1963, 59, 63).

3. For a more detailed discussion, see my essay 'Speaking of God in the Face of Atheist Criticism' (1973, 96–116). See also Berger 1969.

4. The page reference that follows in the text is to Marquard 1971.

5. Dilthey emphasized this point in his landmark study of 1891, 'Auffassung und Analyse des Menschen im 15. und 16. Jahrhundert' (Dilthey, 1–89), and especially in the essay 'Über die Funktion der Anthropologie in der Kultur des 16. and 17. Jahrhunderts', of 1904 (Dilthey, 416–492; especially 442ff). According to Dilthey, the discovery of the soul's interiority and its development in medieval mysticism (420f) were connected with "the doctrines of the Stoa regarding a teleological coherence of nature, self-preservation, the dispositions of our being in which nature is at work teleologically, the human fall into the turbulence of the emotions and into a resultant enslavement by these, and finally liberation through the knowledge of 'vital values' " (450). Dilthey says that this new vision of humanity then became the "basis for the works that a natural system of law, state, and religion undertook to set in place and make effective in practice" (ibid.).

6. Delekat has shown this in detail (1963). See also my review, 'Theologische Motive in Denken Immanuel Kants' (1964).

7. For Bultmann, unlike Brunner, the subject matter of theology can only be elaborated *existentially* in the form of anthropology. Since Bultmann sees the point of contact as resolving the opposition of revelation to the human being as sinner, he adopted a position midway between Barth and Brunner in this question. But because he understood revelation to be unqualifiedly a judgment on and negation of the human, he did not achieve a critical appropriation of an anthropology based on existential philosophy, though he regarded this anthropology as normative, but accepted as valid the pretheological interpretation of the person already given in Heidegger's analysis of Dasein, and this without any critical discussion of the individual claims made in that analysis. He simply offered a *global* negative evaluation of it as a description of the sinner's understanding of Dasein and used it in this form as a negative foil for theology.

8. I presented the substance of these methodological considerations in 1962 in the concluding chapter of my book *What is Man? Contemporary Anthropology in Theological Perspective* (1970). But at that time I did not so consis-

tently correlate the findings of the discipline of anthropology from the standpoint of the question of the *concept* of the human being.

• • • • • • • • • •

References

Berger, Peter. 1969. *A Rumor of Angels: Modern Society and the Rediscovery of the Supernatural.* Garden City, New York: Doubleday.

Brunner, Emil. 1935. *Natur und Gnade.* 2nd edition. Zürich: Zwingli-Verlag.

Bultmann, Rudolf. 1955. Points of Contact and Conflict. Trans. J.C.G. Greig. In *Essays Philosophical and Theological,* 133–150. New York: Macmillan.

Delekat, F. 1963. *Immanuel Kant: Historisch-kritische Interpretation der Haupt-schriften.* Heidelberg: Quelle und Meyer.

Dilthey, W. *Gesammelte Schriften.* Vol. 2.

Luckmann, T. 1963. *Das Problem der Religion in modernen Gesellschaft.* Freiburg im Breisgau: Rombach.

Marquard, O. 1965. Zur Geschichte des philosophischen Begriffs 'Anthropolo-gy' seit dem Ende des 18. Jahrhunderts. In *Collegium Philosophicum,* 209–239.

———. 1971. Anthropologie. In *Historisches Wörterbuch der Philosophie,* vol. 1, ed. J. Ritter, 362–374.

Pannenberg, Wolfhart. 1964. Theologische Motive im Denken Immanuel Kants. *Theologische Literaturzeitung* 89:897–906.

———. 1970. *What Is Man? Contemporary Anthropology in Theological Perspec-tive.* Trans. D.A. Priebe. Philadelphia: Fortress.

———. 1973. *The Idea of God and Human Freedom.* Trans. R.A. Wilson. Philadel-phia: Westminster.

Rendtorff, T. 1971. *Church and Theology: The Systematic Function of the Church in Modern Theology.* Trans. R.H. Fuller. Philadelphia: Westminster.

Schulz, W. 1957. Der Gott der neuzeitlichen Metaphysik. Unpublished lec-tures.

3

The Doctrine of the Spirit and the Task of a Theology of Nature

Wolfhart Pannenberg

••••••••••

I

When the second ecumenical council at Constantinople in 381 complemented the Creed of Nicaea, the first of the additions to its third article was to call the Holy Spirit the one who gives life (πνεῦμα ζωοποιοῦν). This language, of course, was no innovation, but was reminiscent of the way the New Testament writings had spoken of the Spirit. Especially Paul and John had called the Spirit the quickening one, the one who gives life. Today this is often interpreted in a restrictive way as a purely soteriological expression referring to the new life of faith, and certainly this is in the focus of the early Christian writings. But the phrase is by no means to be restricted to the life of faith. There are a number of words which in mentioning the life-giving spirit explicitly refer to the resurrection of the dead. And at least Paul alludes to the breath of life (πνοὴ ζωῆς) that according to Gen. 2:7 was given to the first man, when he says, 1 Cor. 15:45, that while the first man was created a living soul, the last man will be life-giving spirit. That Adam was created a living soul is an explicit quotation from Gen. 2:7. There it is presented as an effect of the breath of life being inspired by God into man's nose. This breath of life (πνοὴ ζωῆς) was taken by Philo of Alexandria as spirit of life (πνεῦμα ζωῆς), and in a similar way Paul's assertion that the second Adam will be life-giving spirit and not only a living soul refers to the breath of life which God inspired into the human body when he created man. Thus, if we want to understand Paul's idea of the new existence of man, we have first to explore the Old Testament background of his statement. It is precisely the idea of the spirit as the origin of all life.

This idea was very common in the ancient world. It was considered an empirical fact that with the last breath life is leaving the body. Hence the mysterious power of life was widely understood to be identical with breath. Therefore, the soul as the power of life, and breath and spirit, were closely related, not only in the ancient Near East, but also in Greek thought. πνεῦμα and πνοὴ or breath were associated,

and by πνεῦμα nothing else was meant but the air that we breathe. This explains how one of the earliest Greek philosophers, Anaximenes from Milet, came to consider the air as the origin of all things. It was on this line that later on Anaxagoras proclaimed the mind as the ruler of the cosmos, the difference being mainly that Anaximenes had considered the human soul an example of the air that pervades everything, while Anaxagoras took it the other way round and conceived of the power pervading the cosmos by analogy with the highest ability of the human soul.

The relation between breath and air permits a closer understanding of the fact that in the Old Testament the divine spirit was closely associated with wind and storm. Thus in the very beginning of the creation, according to Genesis 1, the spirit of God stirred up the waters of the primeval ocean. And the prophet Ezekiel in his great vision of his people's dry and dead bones on the plain saw the spirit of God breathing into the bones after they had taken on flesh and bringing them to life again.

The most pathetic description of the creative function of the divine spirit with regard to life has been given in Psalm 104. The psalm speaks to God of his creatures: "When thou hidest thy face, they are dismayed, when thou takest away their breath, they die and return to their dust. When thou sendest forth thy spirit, they are created; and thou renewest the face of the ground." The last phrase identifies the divine spirit with those prolific winds that renew the surface of the ground in springtime. Jahweh's spirit had taken over this function from Baal who was a God of storm as well as of fertility.

The life-giving activity of the divine spirit determines the horizon for all other functions which the Old Testament attributes to the spirit of God. There is especially the charismatic element. Not only for prophetic vision and inspiration, but also for the work of the artist, for poets and heroes, a special endowment with the spirit of God was considered necessary. These charismatic phenomena, however, were taken to refer to the same power that inspires and animates all life. The charismatic phenomena present just outstanding examples of life. They exhibit a particularly intensified life and are therefore attributed to an exceptional share in the life-giving spirit.

In a similar way Paul's idea of the new life of the resurrection is based on the traditional understanding of life as originating from the creative power of the spirit. The ordinary life is not life in the full sense of the word, because it is perishable. The living beings have only a limited share in the power of life, for according to Gen. 6:3 God has decided that his spirit should not continue to be active in man indefi-

nitely, for after all man is only flesh. Therefore the time of his life is limited. When he expires, "the dust returns to the earth as it was, and the spirit returns to God who gave it", says Ecclesiastes (9:7). This, of course, does not imply any immortality of the human soul, but rather its dissolution into the divine spirit of whom it came. Paul discovered an indication for the limited character of the present life in the Genesis report itself, since it speaks only of a living being or soul springing from the creative breath of life. This meant to Paul that the living being is different from the spirit himself, and this fact accounts for the perishable character of our lives. Since our life in form of a soul or a living being is separated from its origin in the creative spirit of God, it has fallen to death. Therefore the question can arise for another life, a true life that persists in communication with its spiritual source. Precisely this comes to expression in Paul's idea of the resurrection life that will be one with the life-giving spirit and therefore immortal. Again, this was not a completely strange idea within the stream of Jewish tradition. Had not the prophets announced a time when the spirit of God will remain on his people and even be poured out on all flesh? The precise meaning of this is nothing less than immortal life, and therefore the resurrection of Christ and the spread of the proclamation of it could be taken as the beginning of the fulfillment of the old promises. In the New Testament the spirit is closely connected with the resurrected Lord, and the presence of the spirit in the Christian community should not be severed from the ongoing proclamation of the resurrection of Christ and from the participation in it by faith and hope. Thus although the emphasis of the New Testament writings concerning the spirit is on the new life of faith communicated by the spirit and on his charismatic presence, the deep meaning of those affirmations and their particular logic and rationality is only accessible if one takes into account the basic convictions of the Jewish tradition concerning the spirit as the creative origin of all life.

II

In Greek patristic theology, as in the Eastern Orthodox tradition until the present time, there has always been preserved a continuous awareness of the fundamental importance of the spirit's participation in the act of creation as providing the basis for the significance of his soteriological presence in the Church and in Christian experience. Certainly, a characteristic intellectualization took place, since the spirit was identified with the wisdom of God. Thus Irenaeus, in order to

confirm his assertion that the spirit was already present and active in the creation of the world, appealed to Proverbs 3:19: "The Lord by wisdom founded the earth, by understanding he established the heavens, by his spirit the deeps broke forth and the clouds drop down the dew." He also referred to the myth of Wisdom in Proverbs 8 and concluded that the one God has made and ordered everything through his word and his wisdom. But in spite of the intellectualistic overtones of the Wisdom tradition, Irenaeus related the spirit especially to the prophetic inspirational experiences, and regarded them as a specific example for the more general fact that the spirit of God "from the very beginning" assisted all men in adjusting themselves to the actions of God by announcing the future, reporting the past and interpreting the present. Thus the spirit, according to Irenaeus, was the first to reveal God to humanity. Afterwards the Son adopted us and only in the *eschaton* God will be known as Father in the kingdom of heaven.

Although since the third century the soteriological function of the spirit as a special divine assistance toward the ethical destiny of man attracted more and more attention, particularly with the rise of the monastic movement, Athanasius and after him Basil of Caesarea very strongly emphasized the collaboration of the spirit in the work of creation in order to assure his full divinity. In the Latin church this aspect was hardly ever treated with comparable seriousness. The activity of the Holy Spirit was seen in connection with charity and grace rather than with the creation of life, and the period of the spirit in the history of salvation was no longer identified with the period of the preparation of mankind for the arrival of the Son of God, but rather with the period of the Church after the incarnation and after Pentecost. Thus it is not surprising that, with regard to the Reformers, Prenter and other authors have spoken of a rediscovery of the doctrine of the spirit. Of course the spirit had never been altogether forgotten in Christian theology. But in mediaeval theology even in the doctrine of grace the spirit receded into the background of the idea of a created grace that was considered the supernatural gift communicated through the sacraments. The Reformers, however, because of their biblicism, rediscovered and reappropriated for their theology the broad application of the idea of the spirit in the Biblical writings. In this connection, Luther as well as Calvin strongly emphasized the role of the Spirit in the creation, but neither of them developed in a systematic way the consequences for an understanding of nature. This fact explains in part why Protestant theology afterwards fell back to a predominantly soteriological conception of the work of the spirit. This is particularly true of pietism. In the beginning of the seventeenth century Johann Arndt was silent concerning the contribution of the spirit to the work of

creation, Jean de Labadie explicitly denied it, and later on Philipp Jacob Spener mentioned it, but treated it like a piece of dead tradition. Thus the spirit became a factor in subjective experience rather than a principle in explanation of nature. The Cartesian dualism of spirit and matter certainly contributed to the pervading and lasting influence of this subjective interpretation of the doctrine of the spirit.

This subjectivistic bias was further enhanced by the influence of the spiritualistic movement of the sixteenth and seventeenth centuries which developed from medieval mysticism. In this tradition, which also influenced pietism, the spirit was related to anthropology although not to the world of nature. The spirit was conceived in correspondence to the inner light in the human mind. This paved the way for the identification of spirit and mind in the idealist tradition under the impact of Cartesian dualism. Even John Locke conceived of the spirit in terms of a substance acting in the operations of the mind, and because David Hume eliminated the idea of substance, he could abolish the idea of spirit altogether. The idealist thinkers, on the other hand, and especially Hegel, developed a new perspective of the universe as created by the spirit. But they did so on the basis of the Cartesian dualism and of the identification of spirit with mind. Precisely this point proved fatal for Idealism, because spirit as absolute mind was shown to be an absolutizing self-projection of the human mind. Thus the identification of spirit and mind became an important argument for the atheism of Feuerbach and his famous followers. Christian theology, on the other hand, argued against idealism because of the identification of the divine spirit with the human spirit. This resulted in separating the spirit from the human mind. But then theological talk about the divine spirit lost its last empirical correlate, and consequently it has become almost meaningless. The only function left to it is that of a pretended legitimation for the acceptance of otherwise unintelligible statements of faith. Such an explanation of the work of the spirit is far from overcoming the subjectivism that has been so characteristic of Christian piety in modern times. On the contrary, it represents the peak of that subjectivism, a subjectivism of an irrational decision of faith.

It should be obvious that the appeal to a principle beyond understanding in order to render acceptable what otherwise remains unintelligible does not provide an adequate basis for a responsible doctrine of the Holy Spirit in theology. Nor can we build such a doctrine on the identification of spirit with mind after that has come under so serious and pertinent criticism in the history of modern thought. Nor is it advisable to start again with the reality allegedly disclosed in religious experience, particularly in the experience of 'spiritual' regeneration,

for that would end up again in the deadlock of subjectivism. In order to find a fresh starting point in the tradition, we have to go back behind the entire subjectivistic thrust in the history of the doctrine, even behind the isolation of the soteriological concern in dealing with the spirit. Only an understanding of the spirit on the basis of his function in creation and this regard to his contribution to an explanation of nature can overcome the subjectivistic bias of traditional Christian piety and thought in dealing with the spirit. But can we in any intellectually serious way attribute a function in the explanation of nature to the Holy Spirit?

.

III

In modern Christian thought there are two outstanding examples of an attempt to break through the spiritual subjectivism and to develop a conception of the spirit within the broad horizon of an overall interpretation of life. One is the section on life and the spirit in Paul Tillich's *Systematic Theology*. The other one is the vision developed by Teilhard de Chardin of the evolutionary process of life as being directed by a spiritual power.

For Tillich, spirit is one of the "dimensions of life" beside the inorganic, the organic and the psychological dimension. They are potentially present in every living being. Among them spirit is the "power of animation" and therefore distinct from the different parts of the organic system. Spirit is not identical with mind, although on the level of human life the self-awareness of the animal is taken up into the personal-communal dimension which Tillich calls spirit. Thus man is that organism in which the dimension of spirit has become dominant. On the other hand, even the human spirit cannot overcome the ambiguities of life in its constitutive functions of self-integration, self-creation, and self-transcendence. In order to cope with these ambiguities, the divine spirit must assist the human spirit. Tillich thus distinguishes between divine and human spirit. Only by ecstatic acts does the human spirit participate in the divine spirit, and only in this way can he approach the integration and unity of the three regions of spiritual life, culture, morality and religion.

Tillich himself observed a close similarity of his perspective to that of Teilhard de Chardin, whose book *The Phenomenon of Man* he read after the completion of his own work. There exists indeed a basic similarity in the idea that spirit is the animating power of all life and not identical with mind, although in the emergence of the human con-

sciousness it realizes itself in a decisively new and intensified form. Teilhard and Tillich also agree in emphasizing the tendency of self-transcendence in life, which was called radial energy by Teilhard while in Tillich's view it relates the human spirit to the divine spirit.

There are also differences, however, between the two approaches. First, Teilhard does not distinguish in the same way as Tillich does between the divine spirit and spirit as a dimension of life. In Teilhard's perspective there is only one spirit permeating and activating all the material processes and urging them beyond themselves in a process of progressive spiritualization and of converging unification towards a center of perfect unity that in providing the end of the evolutionary process proves to be its true dynamic origin. In such a perspective, created spirit can be only a participation in the dynamics of the one spirit that animates the entire process of evolution. The difference between God and man is preserved also in such a perspective, because only in transcending itself does a material being participate in the spiritual dynamic. This corresponds to Tillich's emphasis on the self-transcendence of life and on the element of ecstasy in spiritual experience. Tillich presumably retained the dualism of spirit and divine spirit because of his method of correlation between question and answer. In reality, however, even within his conception it is difficult to see why the ecstatic element is attributed specifically to the "spiritual presence" of God in faith, hope, and love, and not universally to all spiritual experience as exemplifying the self-transcendence of life.

A second difference is that Teilhard does not use the vague and confusing language of "dimensions of life"—a language which at best has metaphorical value in exposing the 'one-dimensional' narrow-mindedness of a purely materialistic description of organic life. The weakness of such metaphorical talk about "dimensions of life" consists in the fact that there is, of course, no co-ordinate system of the dimensions of inorganic, psychological, and spiritual reality. The same interest in the depth of the phenomenon of life that escapes a purely materialistic description is expressed by Teilhard in a much simpler way, when Teilhard spoke of a spiritual inside of every material phenomenon. He shared this view with the old tradition of philosophical animism. But he also offered a justification for it, first by appealing to the principle that scientific exploration should look for the universal rule behind an apparently extraordinary phenomenon as the emergence of the human mind is, and second by maintaining a regular correspondence between the degree of complexity of a physical phenomenon and the level of its interior spirituality. Teilhard's boldest assertion, however, consists in his combination of the spiritual inside

of natural phenomena with the energy behind the natural processes.

In the final analysis, Teilhard supposed, all energy is spiritual in character. But since energy manifests itself for physical observation in the interrelations of physical phenomena, Teilhard introduced his famous distinction between a tangential energy or force that accounts for all sorts of 'solidarity' of the bodily elements and their interrelations, and a radial energy that explains the self-transcendence of existing phenomena towards increasing complexity and unity. This distinction is due, as I mentioned before, to the basic assertion of the spiritual character of energy. The natural scientists, especially the physicists, concern themselves—as Teilhard explicitly affirmed—only with the exterior manifestation of the cosmic energy in the interrelations of bodies. But if energy, as Teilhard assumes, is essentially spiritual, then there must be another aspect of energy, and this is to be found in the dynamics of self-transcendence which Teilhard calls radial energy.

The problems inherent in this idea become particularly apparent if one asks for aspects of the concept of energy that have not been taken into consideration in Teilhard's thought. Here, the phenomenon of an energy field deserves particular attention. Classical mechanics dealt with bodies, with their positions in space and time, and with the forces effective in their interrelations. These forces were attributed to the bodies that were understood to exercise a force. But when physical science attempted to reduce the notion of a natural force to a property of the body, especially to its mass, that did not work. For the last time Einstein started on such an attempt. But his theory of relativity ended up with the contrary result. Instead of reducing space to a property of bodies and of their interrelations, it in fact resulted in a conception of matter as a function of space. This marks the definitive turning point from a conception of natural force on the basis of the model of the moving body to an autonomous idea of energy conceived of as a field. The attribution of natural forces to a field of energy as for example in the case of an electric or magnetic field means to conceive of energy as the primary reality that transcends the body through which it may manifest itself—a reality that we no longer need to attribute to a body as its subject.

Teilhard de Chardin did not yet fully appreciate this radical change of the concept of natural force from a property of bodies to an independent reality that only manifests itself in the genesis and movements of bodies. To be sure, Teilhard recognized the idea of energy as the most fundamental idea of physics. But he expressed reservations concerning Einstein's field theory. He insisted on the connection of energy to the body, and he expressed this connection by conceiving of energy as a sort of soul even in inorganic bodies.

In treating Teilhard's idea of spirit, the lengthy discussion of the problems connected with the concept of energy may have seemed at first a deviation. Now it becomes apparent that Teilhard's decision for not conceiving energy in terms of a field, but in terms of the inside reality of bodies, has had far-reaching consequences for his understanding of the spirit. In fact, in a certain way it counteracted his basic emphasis on the spirit as a transcendent principle, transcending every given reality but activating it in the direction of a creative unification. If Teilhard had conceived of energy in terms of a field, this would have been in perfect concordance with his idea of a transcendent spirit whose creative power dominates the entire process of evolution. Since, however, he identified energy as the inside reality of bodies, he attributed energy to those bodies. Therefore, even the movement of self-transcendence and thus the entire dynamic of evolution was attributed to finite bodies rather than—as Teilhard wanted to do—to a principle transcending them, as is the case with his point Omega. Thus the basic ambiguity of Teilhard's thought comes to the fore, the ambiguity of what finally sets in motion the evolutionary process: point Omega or the evolving entities themselves. On the basis that energy is attributed to the bodies, the process and the direction of evolution seems to be produced by the evolving species which seem to act like subjects of their own evolution. In this perspective, point Omega appears to be a mere extrapolation of tendencies inherent in the evolutionary process or, more precisely, in the evolving animals themselves. But on the other hand, Teilhard wants to explain Omega, the goal of the process of evolution, as being its true creative origin. This he did by describing evolution as the work of a unified spirit who transcends the individual entities and is finally identical with God Omega who creatively and progressively unifies his world.

But Teilhard failed to relate this view adequately to his idea of energy, although spirit and energy designate the same reality in his thought. He conceived of energy only as inside of bodies instead of a field transcending the bodies and prior to them. If he had done so, Teilhard could have developed his basic intuition of the world as a process of creative unification by a spiritual dynamic in a more consistent and more convincing way. He need not even have surrendered the concept of a spiritual inside of bodily phenomena. He had only to add that this is the aspect of the universal field of energy from the finite point of view of the entities through which it manifests itself. They participate in the universal field of energy only by transcending themselves, or by way of ecstasy, and the degree of their capability for that ecstatic experience would mark the degree of their spirituality. Thus, Tillich's idea of the ecstatic character of spiritual presence gets

an application far beyond the specific spirituality of the Christian faith, love, and hope which it was designed for. Instead of pointing to a peculiarity of Christian experience, it turns out to represent a basic element of reality and particularly of organic life.

· · · · · · · · · · ·
IV

The proposed revision of Teilhard's conception of evolution meets a number of the most serious arguments against his thought. Especially it permits one to abandon the idea of a teleological guidance of the evolutionary process and to give much more importance to the element of chance or contingency in shaping that process. But is it really justifiable to use the term *spirit* in order to designate the energy working in the evolutionary process? And has such a description any theological significance? Is there any substantial continuity with the way in which the Christian tradition referred to the spirit of God as the creative origin of all life?

I shall discuss this question by asking first for the conditions for an adequate translation of the biblical idea of a creative spirit as origin of all life into the context of modern thought. Such an explanation will provide certain criteria, and these criteria can be applied afterwards to Teilhard's ideas and to the model that emerged from our discussion of them.

Every attempt for a translation of ideas has first to consider the gulf that should be bridged over. Most of the differences between the biblical and the modern understanding of life can be derived from the fact that the biblical idea of life works with the assumption of an origin of life that transcends the living being, as it was empirically evident to the ancient world in the phenomenon of breath, while modern biological science conceives of life as a function of the living cell that reproduces itself. At first glance, this comparison gives the impression of a strict opposition between the modern immanentistic view of life and the explanation of life by a transcendent principle as it was offered by the Old Testament. Compared with this basic opposition, the identification of that transcendent principle as spirit appears to be of secondary importance. A closer look, however, reveals that there is more than that apparent opposition. On the one hand, the biblical perspective is quite open to the idea of independent existence which constitutes the very essence of the concept of a living being: it has life in itself. On the other hand, modern biology does not exclude everything that transcends the living cell from the analysis of life. Although life is

taken as the activity of the living cell or of a higher organism, that activity itself is conditioned. It is conditioned particularly by the requirement of an appropriate environment. When kept in isolation, no organism is fit for life. In this sense, every organism depends on specific conditions for its life, and these conditions do not remain extrinsic to its own reality, but contribute to the character of its life: an organism lives 'in' its environment. It not only needs and actively occupies a territory, but it turns it into a means for its own self-realization, it nourishes itself on its environment. In this sense, every organism lives beyond itself. Again it becomes evident that life is essentially ecstatic: it takes place in the environment of the organism much more than in itself.

But is there any relation of this ecological self-transcendence of life to the biblical idea of a spiritual origin of life? I think there is. In order to recognize this correspondence we must first focus upon what has been said about the phenomenal character of spirit and keep in suspense for the time being the divine nature of the spirit. Then it becomes evident that breath belongs to the most important environmental conditions of life. Only if there is fresh air can the organic processes go on. Hence breath can be taken as an appropriate illustration of the dependence of the organism on its environment. To be sure, breath can no longer be regarded as the proper cause of life. At this point, every modern account of life has to confess its difference from the primitive explanation of life that was propounded also in the biblical writings. There is, however, an element of truth in that primitive explanation, and the first clue to it is to be found in the dependence of the organism on its environment.

It would be hardly defensible of course to maintain that an organism is created by its environment, although an appropriate environment is a necessary condition for its existence. But there is still another aspect of its living beyond itself: by turning its environment into the place and means of its life, the organism relates itself at the same time to its own future and, more precisely, to a future of its own transformation. This is true of every act of self-creation and nourishing and developing itself, by regenerating and reproducing its life. By its drives an animal is related to although not necessarily aware of its individual future and to the future of its species. This also belongs to the ecstatic character of the self-transcendence of life, and this is what Teilhard called radial energy. It comes to most emphatic expression in the increasing complexity and final convergence of the evolutionary process of life, but it is present even in the life of the individual and specifically in the temporal aspect of his self-transcendence. Now, if it

was correct to revise Teilhard's account of radial energy in terms of a field of energy that shapes a process of evolution, then it makes sense also to maintain that this field of energy manifests itself in the self-transcendence of the living being, and thereby it even creates the lives of individuals. Hence, the element of truth in the old image of breath as being the creative origin of life is not exhausted by the dependence of the organism on its environment, but contains a deeper mystery closely connected with the ecological self-transcendence of life: the temporal self-transcendence of every living being is a specific phenomenon of organic life that separates it from inorganic structures.

At this point, there arise a number of questions that would deserve further investigation. In the first place, there is a question concerning the relation between ecology and genetics. The argument for the self-transcendence of life has been developed largely on the basis of ecological evidence. Does it also apply to genetics? If this were not so, the assumption of a field of energy effective in the self-transcendence of life would lose much of its persuasion. A second question concerns the character of that field itself: Is it legitimate to use the concept of a field when the impact of the future on the present is at stake, as is the case with Teilhard's point Omega and with his assertion of a creative influence of Omega on the entire evolutionary process? Applied in such a way, the concept of a field replaces the age-old teleological language. Does it really fit that purpose? In any case, the temporal structure of field theories needs to be further investigated, especially in the light of the problems of quantum theory which no longer abstracts from the question of time as other field theories do. This also involves the element of contingency in the effectiveness of such a field. Finally, granted the possibility of speaking about the creative effectiveness of Teilhard's point Omega in terms of a field of energy, its relevance for the phenomenon of spirit is still to be explained.

.
V

The discussion of Tillich's and Teilhard's views on spirit and life resulted in the proposal of using the self-transcendence of life as a clue to the phenomenon of the spirit and as a basis for a redefinition of spiritual reality. This proposal owes part of its inspiration to Tillich's idea of the ecstatic character of "spiritual presence," but it does not follow his separation of that ecstatic experience from the process of life that is ultimately nourished on self-transcendence. Tillich accepted a separation of his idea of spiritual presence from the continuously

self-transcending process of life, because he conceived of self-transcendence only in terms of an activity of the organism. But after the discussion of Teilhard's ideas of spirit and energy and particularly after having replaced Teilhard's "radial energy" by the assumption of a field of energy effective in the evolutionary process, we can conceive of self-transcendence in a more complex way: self-transcendence is to be regarded at the same time as an activity of the organism and as an effect of a power that continuously raises the organism beyond its limitations and thereby grants it its life. The functions of the self-creation and self-integration of life depend on the ongoing process of its self-transcendence. If the self-transcendent tendency of life could be exhaustively explained in terms of an autonomous activity of the organism, there would be no room left for the assumption of a spiritual reality involved in life.

The term spirit in its broad application to the total sphere of life refers to the fact that the self-transcending activity of organic life is to be explained within a broader context as it is provided by the process of evolution towards a definitive self-assertion of life, but also by its abundant production of fragmentary symbols of the power and beauty of life, the results of its self-creative and self-integrative activity that anticipates the final goal of the evolutionary process.

The redefinition of the concept of spirit on the basis of the self-transcending tendency in all organic life unites the association of spirit with mind. Spirit is not identical with mind, nor is it manifested primarily through mind. Rather, the reflective nature of the human mind represents a particular form and degree of participation in the spiritual power, and that is closely connected with the particular mode of human self-transcendence.

Man does not only live beyond himself in his environment and on its supplies. He does not in fact only change his environment by claiming it as his. But he is able deliberately to change his world in order to change the conditions for his own existence. That presupposes first that man is able to consider the realities of his world on their own terms, not only in relation to his drives. He can be 'with' the things different from himself in a way no other animal is. The second presupposition of the deliberate transformation of the world by human activity is that man is able to project a future in distinction from his present. That makes him master of the present. Both these aspects imply that man can take a stand beyond himself and look at himself from a distance. In other words, he has the capacity for reflection. The continuously reflective consciousness of man emphatically illustrates his particular mode of being beyond himself. And precisely

in being beyond himself he is himself, not only this individual, but a human being. In taking a stand beyond himself, the human mind is no longer himself the unity of his experience, but is looking for something beyond himself that gives unity to his experiences. We apprehend the particular only within a wider horizon of meaning which is anticipated as some sort of unity. This underlies all processes of abstractive thinking. But the unity beyond the individual is also concrete in the form of a community of individuals. Hence in the reflective consciousness of man the importance of social life for the individual develops to a new level: the social community in its difference from individual existence becomes constitutive for the individual's experience of the unity and identity of his existence. In this particular way man is a social being, not simply as a member of the flock, but by recognizing the community as manifesting a unity of human nature superior to his individuality. Since, however, the society is composed of individuals, the final basis of its unity is to be asked for beyond the concrete institutions of social life: as social being man is at the same time the religious being.

It is obvious that the particular mode of human self-transcendence characterizes all the specifically spiritual activities and achievements of man. It comes to expression in the human ability for conceiving abstract ideas as well as in trust, love, and hope. It is basic for the quest of the individual for personal identity as well as for his social life and its institutions, and last not least for his creation of a world of meaning by developing language and by creating a world of culture. In all this, man is at the same time creative and receptive of the spiritual reality that raises him beyond himself. The most creative acts of his spiritual activity provide the most impressive evidence for this assertion: the creative design of an artist, the sudden discovery of a truth, the experience of being liberated for a moment of significant existence, the power of a moral commitment—all this comes to us by a sort of inspiration. All these experiences testify to a power that raises our hearts, the power of the spirit. When man is most creative, he most self-consciously participates in the spiritual power beyond himself. But its presence does not only characterize the exceptional moments of elevation, but it also permeates the general structure of human behavior in its openness beyond himself. The exceptional experiences of spiritual freedom and creativity illuminate the general condition of human existence.

And yet, human life is not yet fully united to the spirit. There are the hours when we live in low spirits or even let ourselves be taken in by a bad spirit. There are the occasions when we sadly realize the

absence of true unity and meaning from our lives. There are the conflicts, repression, and violence among individuals and in the relations between the individual and his social world. There is failure and guilt, disability, disease, and death. There are flashes of meaning, but only in a fragmentary way, and the wholeness of life remains an open question at the moment of death. There is, indeed, ample space for the ambiguities of human life, the dialectic which Tillich so eloquently described. In face of all this, the presence of loving concern, of mutual trust, of meaning and hope is almost a supernatural event, especially if it constitutes a continuous identity and integrity of our lives in spite of all its precariousness. And in this way the Christian proclamation, with its assurance of a new life that will be no more subject to death, communicates a new and undisturbed confidence, a new and continuous spiritual presence. Its very heart lies in the confidence of being united to the future of God, a confidence that became incarnate in the existence of Christ and is effective in human history from that time on. The spirit, however, of this new spiritual presence that is a life in the community of faith, is no other spirit than the spirit that animates and quickens all life. And only because it is the same spirit that created all life by inspiring its abundant self-transcendence, it provides no escapist opiate, but the power of sustaining to and finally overcoming the absurdities and adversities of the present world.

• • • • • • • • • •

First published in *Theology* 75:1 (1972), 8–20.

4

Spirit and Energy in the Phenomenology of Teilhard de Chardin

Wolfhart Pannenberg

· · · · · · · · · ·

I

Pierre Teilhard de Chardin's celebrated preface to *The Phenomenon of Man* (Teilhard 1959a) provides the most pregnant description of his method and the most distinctly interpreted one. He wishes to limit himself to the "phenomenon" of man. By this self-limitation, he separates himself from metaphysical analyses that probe behind phenomena, and therefore he can designate his work as natural science. To be sure, Teilhard is absolutely clear about the fact that he actually goes beyond the limits of the normal procedures of natural science. His goal appears to be physics in the Greek sense, which views man and nature together, over against the causal-analytic procedures of contemporary natural science. He calls this physics ultra-physics or hyper-physics (cf. Schmitz-Moormann 1966). However, he seeks this physics on the same level where empirical research is located: "the broadening and deepening of physics upon the same level of 'phenomenon'" (Daecke 1967, 263). The tendency toward such broadening comes to expression in the demand to comprehend not only part of a phenomenon, but the phenomenon as a whole.[1]

In Teilhard's phenomenology the supposition of a "within of the thing" is a particularly instructive example for the relationship of subject and object, man and nature. Unfortunately, this is also the decisive weak point in his understanding of evolution, a point that must be clarified. To discover the "within of a thing," Teilhard applies the principle "to discover behind the exception the universal truth" (Teilhard 1959b, 31). In the phenomenon of man, the exception is the fact of consciousness which, in the entire expanse of nature appears clearly only in man, according to our observation. Since Teilhard seeks to comprehend each exception as "the emerging of a quality that has existed everywhere in an incomprehensible state," he proceeds to use the self-experience of man as the key to the understanding of nature and to ascribe to all phenomena a hidden 'within' by analogy to the human consciousness.

Teilhard therewith goes beyond the scope of natural scientific thought, since the general supposition at which he arrives is no longer empirically determinable, but can only be judged by its ability to give a unified picture of phenomena. From a strictly scientific standpoint, Teilhard's method must in fact appear as a massive extrapolation in which the contingency of consciousness upon the presence of a central nervous system is disregarded in favor of a more general relationship between gradations of consciousness and gradations of complexity of organization (Luyten 1966, 30ff). Yet, the relevance of the thesis of Teilhard as the broadening of the natural scientific way of thinking in a strict sense for a natural philosophy is not shaken by the criticism of empirical natural science. The limitation of our form of consciousness to functions of the brain need not exclude the thesis that something analogous to our consciousness, though not exactly like it, is supposed also to exist where as yet no central nervous system is present. Such suppositions have obtruded themselves again and again where one can neither be content with the Cartesian dualism of *res extensa* and *res cogitans* nor can one explain consciousness as a mere epiphenomenon of an entirely heterogeneous material occurrence. Teilhard's supposition is that human consciousness as an element of the specifically human form of life represents a modification of a universal characteristic of all natural phenomena. This universal characteristic appears as a condition of the continuity of the unity of nature which is also comprehensive of man. Teilhard's supposition stands even when the assumption of an empirical judgment is avoided or at first cannot be made.

Teilhard does not stand alone in this 'panpsychism' but within a long philosophical tradition. Its modern form is linked above all with Leibniz's monadology. Leibniz conceived all monads as analogous to the mind whenever he wanted to reserve the designation *mind* for the essence given in perception (Leibniz, para. 19).[2] However, he also distinguished the form of experience of the lower monads as *perception* and human consciousness as *apperception* (Leibniz, para. 14). Recently, similar interpretations are found, above all, in the various forms of process philosophy, where one must also place Teilhard. Teilhard remains frequently linked with Bergson, in spite of the contrast of Teilhard's 'creative union' with Bergson's progressively driven *élan vital* of 'creative evolution', which limits panpsychism to the realm of the living (Bergson 1948, 187).[3] Teilhard's thought at this point stands closer to the philosophy of A. N. Whitehead. Though Whitehead did not speak explicitly of a 'within' of phenomena, his thought remains still pertinent to such an idea when he translates subjectivity and the

process of experience from humans to all events and conceives it as characteristic of each elementary event, of every actual occasion (Whitehead 1957, 28ff, 252ff).[4] This becomes especially clear when he sets beside each event for the process of its self-constitution, in addition to the physical pole of its experience, also a mental pole and a subjective aim.[5] He can therefore already recognize a principle of reason in all natural occurrences (Whitehead 1958a, 26ff, 32ff). On the other hand, I attribute less importance to the fact that Whitehead attributed mind in the true sense only to man and the higher animals (Whitehead 1958b, 231),[6] holding consciousness to be a later, derived product of a complex process of integration (Whitehead 1957, 245). The difference between Teilhard and Whitehead here is primarily a terminological one, conditioned by the latter's narrower definition of consciousness (cf. Overman 1967, 220f).

· · · · · · · · · ·

II

Thus, with the supposition of a 'within of the thing', which is analogous to the relationship of the human consciousness and the human mind,[7] Teilhard stands in a broad tradition of natural philosophy that goes back ultimately to Plato's idea of a world-soul. The relationship of this idea to the concept of energy as Teilhard conceives it is less general. He proceeds from the idea of a spiritual energy in Bergson's sense—which he presupposes to be familiar—and inquires into its relation to the concept of energy in physics. His own hypothesis follows from the supposition that really every kind of energy is psychic in nature, but that this basic energy appears in two ways in phenomena. On the one hand, it appears in the relationship of bodies of a similar order with one another (tangential energy), and, on the other hand, in the transcendence of the self toward increasing complexity and centration (radial energy) (Teilhard 1959b, 40, 128).[8]

The fundamental concept that all energy is essentially psychic in nature is thus expressed in the distinction between tangential and radial energy. Recalling that Teilhard thought that energy belongs with the 'within of the thing', we can begin to understand the distinction of two kinds of energy—which, indeed, finds no support in natural scientific language. For Teilhard, each 'within' expresses itself in the external structures of phenomena, and manifests itself in the interrelationships between bodies. In particular, concerning energy, it is a matter of the "power of union" (*pouvoir de liaison*), which "concentrates and unites the particles with one another" (Teilhard 1959b, 16).[9] This "solidarity" of the corporeal elements is comprehensible in their

interrelations and therefore in the manifested form of their movements. This is the energy of the physicist, for whom, as Teilhard says, at least until today, there is "only a 'without of the thing' " (Teilhard 1959b, 30). If, however, energy is psychic in nature, then it cannot be fully expressed by its externally comprehensible aspect. In fact, psychic energy in the strict sense is distinguished from every outwardly constituted tangential energy that Teilhard finds on the road of evolution toward ever-increasing complexity, and he designates such psychic energy as radial energy (Teilhard 1959b, 28).

The peculiarity of this method becomes completely clear when one identifies which aspect of Teilhard's concept of energy remains overlooked. It is a matter in particular of the field-nature of energy. Classical mechanics has to do with bodies, with respect to their position in space and time as well as with the forces operating between bodies. Physics had there attempted to reduce the multiplicity of forces and to relate the concept of force generally to the qualities of bodies, in particular to their mass (cf. von Weizacker 1971, 136ff, 147f, 186ff). In fact, Einstein undertook this task one last time. However, instead of breaking up Newtonian space into qualities and relations of bodies, relativity theory conversely made the field of space itself into a physical object, so that it is now suggested that matter be conceived as a quality of space (see also Jammer 1960, especially 192ff, 212ff). Thus, the final turn was made from a concept of energy focused on bodies to one that describes independently standing energy as a field over against bodies.[10]

Thus there has recently been a shift in the concept of energy. No longer seen as a property of bodies, energy is now regarded as a field whose interactions result in singular materializations that are finally understood as the bodies themselves. This concept is not itself operable in Teilhard's concept of energy. To be sure, Teilhard by all means recognized in energy the essential 'fundamental principle' of physics. The basis of his concept that energy resides in the interrelations between bodies is discernible when he specifies the "reality of collective relations" as the physical place of energy—at least in its "tangential" form of manifestation (Teilhard 1959b, 16). However, it is not by chance that the field concept plays no part for Teilhard.[11] While he connects energy with the 'within of the thing', the idea of the body remains the data point for his conception of energy.[12] To be sure, the body is only the exterior side of that which in its inner essence corresponds to energy. However, energy as the "within" represents itself here only by this exterior, and therefore it is as something inherent to the body itself. Yet, the energy that is able itself to go beyond the individual and the species is described in this point of view as a belonging

to this phenomenon and a going-out from it, instead of standing independent over against it and as a self-transcending power and effect. This problem of 'radial energy' constitutes the hard kernel of finalism in Teilhard's concept of orthogenesis. The idea of a 'systematically planned complexification,' of a 'determined orientation of life' by 'a favored axis of evolution,' lies already in the concept of radial energy insofar as it tends toward increasing complexity.

It has been implied that the category of orthogenesis demonstrates a teleological consequence in the sense of a final indication of the course in which the substance of life develops itself (cf. Barthélemy-Madaule, 1970, 183ff, 197ff). However, when Teilhard advocates the concept of orthogenesis, he does not decide for "an out-of-date vitalistic or finalistic conception" that misinterprets orthogenesis as "so to speak, a magic linearity of phyla."[13] That is not to say that he in general rejects every final sense of orthogenesis; rather, he expressly designates his conception as finalistic (Teilhard, 1959b, 214). Teilhard defends himself only against a finalism that would give no place to the role of chance, resorting instead to a statistical interpretation of the concept. First of all, he indicates the appearance of a statistical center within the chance distribution of morphological variations. In looking back, however, he sees the statistical distribution as a self-grouping of species; "rather, under the effect of large numbers they tend on their part to group themselves with a known conical structure."[14] He thus sees the species as the subject of a tendency taking place within it—and he extrapolates this tendency to evolution in its entirety, beyond human evolution to Omega (Teilhard *Werke*, 4: 361ff; 1959b, 146). He injects the element of finalism by interpreting statistical considerations as expressions of organisms or species. Thereby the relationship of energy to the moving parts of bodies clearly returns. If radial energy is considered as the 'within' of the phenomena—as the character of energy itself through which it transcends itself, an energy that tends toward increasing complexity—then, and one may add therefore, even the statistical discovery of the disproportionate distribution of morphological variations can be conceived as the expression of a tendency and self-grouping of species.

.

III

By way of this finalistic notion that is found in his concept of energy, Teilhard falls into contradiction with the central intention of this conception of God. For many of his lines of argumentation, it appears as if

point Omega is introduced and postulated as a final extrapolation and completion of the evolutionary process.[15] However, Teilhard's ultimate intention moves toward thinking of Omega (or in any case the transcendental side of Omega) as an auto-center and a creative cause of evolution in its independence, as opposed to the process of evolution as the Prime Mover (Teilhard *Werke*, 7:26–36, esp. 29ff). This intuition that the end is the true beginning is found already in Teilhard's earlier discussion of Bergson, when he contrasts the *vis a tergo* of the *élan vital*, "a thrust of life without finality," to the idea of a *vis ab ante*, "a power of the future"; "the power that creates the world can only be a *vis ab ante*, a uniting power" (Teilhard 1968, 181ff, 192). The concept of a uniting power allows the recognition that Teilhard still thinks of the power of the future in the sense of the Aristotelian Prime Mover (Teilhard *Werke*, 7:30).[16] Beyond that, however—and thereby the creative work of God comes in view to him—Teilhard thinks of the power of God as a power that creates unity. Thus, in every early outline and more deeply in *Comment je vois* (Teilhard 1969), the same thought returns: to create is to unite. How can this energy, however, be related to the energy that is concerned with the 'within' of material phenomena? Are the two finally identical? How can energy be ascribed to the phenomena both as their 'within' and as going out from them? Does Teilhard perhaps remain more committed to the *vis a tergo* (that was certainly not only Bergson's concept of energy, but also that of classical mechanics) that accords with his vision of 'creative union'? If evolution is thought of as an expression of energies that are inherent to bodies and that incite their striving "to go" beyond themselves, then Omega is at most conceivable as the extrapolated perfection of their efficacy, but not as the creative origin of evolution. Conversely, if Omega as the power of the future shapes the creative origin of evolution, then the energy that moves this process is not to be understood as the energy dwelling in the phenomena but as that which transcends itself. Thus, the independent standing of energy as a field over against its connection to bodies is made possible. Not only consciousness but all aspects of cosmic evolution are a consequence of the supposition of Omega (Teilhard 1969, para. 24):

> the tide of consciousness of which we form a part is not produced simply by some impulse that originates in ourselves. It feels the pull of a star, upon which, individually and as one whole, we are completing in union our process of self-interiorization.

Teilhard has described the creative, unifying effect of Omega through the concept of spirit, although (to my knowledge) he nowhere concerns himself about the relation of the presence of spirit to the futurity

of Omega.[17] The powers of concentration and convergence in regard to spirit take place in the process of spiritualization in no other way than by the creative presence of Omega in the process of evolution (Teilhard *Werke*, 6:134, 136). Already the "creative union" of 1917 includes the process of "spiritualization" through becoming one, "the spiritual substance," that is, "the unified center itself (Teilhard 1968, 188f.). Here spirit is not understood on the basis of consciousness, but rather, consciousness is understood on the basis of the unifying power of spirit. *The Divine Milieu* (1927) describes in peculiarly religious language the same facts. It was formulated most significantly in the German translation of 'The Phenomenon of Spirituality' (1937): "the conscious beings, whose spirits are described here as the various pointed manifestations of a Greater that encompasses all" are manifestations of the characteristic *one* spirit whose unity is to be grasped as a sphere, as Noosphere (Teilhard *Werke*, 6:128). Obviously, this sphere is related to the individual centers of consciousness as the field is related to the bodies as singularities of the field in which it manifests itself. This comparison is all the more obvious when Teilhard turns expressly to begin his essay against the separation of spirit and earthly energy with the remark that the spirit

> quite simply represents the higher state assumed in and around us by the primal and indefinable thing that we call, for want of a better name, the "stuff of the universe" . . . Spirit is neither a meta- nor an epi-phenomenon; it is *the* phenomenon. (Teilhard *Werke*, 6:126)

· · · · · · · · · ·

Published in German as 'Geist und Energie zur Phänomenologie Teilhards de Chardin'. *Acta Teilhardiana* 8 (1971):5–12. Translated by Donald W. Musser. The translator expresses his gratitude to the Reverend David Strobel for his assistance with the translation.

· · · · · · · · · ·

Notes

1. Therewith, Teilhard turns against the phenomenology of both Husserl and Merleau-Ponty (cf. Gosztonyi 1968, 21ff) and also against the methodological restrictions of the exact natural sciences.
2. See also the letter to Bierling of December 8, 1711 (Gerhardt, 7:520 zit. nach PhB 253, 70).
3. See also Bergson in *L'énergie spirituelle* (1967, 8) as well as in *L'évolution créatice* (1948, 199ff), where Bergson also speaks (200), however, of inner and living unity of everything in nature. M. Barthélemy-Madaule (1970) sees in Bergson's restriction of panpsychism to the dualism of life and

matter a point of difference with regard to Teilhard (344ff, also 307ff). The point of difference is not great. A point of departure from the self-phenomenon of man, from consciousness, applies not only to Bergson, but still yet to Teilhard, and is the basis for his supposition of a 'Within of the thing' in the human phenomenon. In this way, Teilhard generalizes the fact of human consciousness to a higher level (against Barthélemy-Madaule, 273ff). On the other side, the relation of grades of consciousness to the level of complexity of organic structures and especially to their nervous systems is already found in Bergson (1948, 252ff).

4. There Whitehead conceives the idea of experience in a broader sense than that of consciousness: "Consciousness presupposes experience, and not experience consciousness" (1957, 83). The primitive form of experience is prehension of feeling (on feeling, cf. 35). The broadening of the idea of experience by Whitehead is similar to Teilhard's result of generalization, a method that Whitehead perceived as constitutive for philosophical method (7f).

5. On subjective aim, see 1957, 29, 130ff, and 343. On mental pole, see 1957, 366f, 379ff.

6. Here as well as in *Process and Reality* (1957, 163ff) Whitehead speaks of mentality.

7. See in addition the conception of consciousness and matter as "various aspects of the same reality" which is presented by C.F. von Weizsäcker (1971, 315ff), where mind is presented as the nonobjective background of embodied phenomena.

8. On the concept of energy, compare the description of Barthélemy-Madaule (1970, 119ff, especially 121ff) with the statement of the book concerning particularity of the human species of 1954. In the present context, however, this can remain outside our consideration.

9. In this emphasis of the unifying function over against the complementary function of expansion, the perspective of 'creative union' could be expressed, which perceives the theme of cosmic processes in the control of multiplicity.

10. Einstein's attempt "to also understand bodies as singularities of fields of force" remains, however, chiefly a torso as von Weizsäcker (1971, 187) confirms, in which he did not include the quantum phenomena which in the meantime had been discovered. But, Weizsäcker goes on, "Today quantum theory is nearing the point at which it can take up again the conversation about Einstein's program," namely, upon the level of quantum field theory.

11. See the reserved opinion of Teilhard toward Einstein in his letter of October 7, 1930 (cited in Barthélemy-Madaule 1970, 750 n.14). Obviously, Teilhard, the student of Bergson, is suspicious of the concept of field as a purely geometric construction which disregards the problem of time.

12. This is not the case in Whitehead, however, since he takes as the cause of his demand for a nonmaterialistic philosophy of science the inversion of the relationship between mass and energy, the retreat of the concept of matter behind that of the field of electrodynamics (1960, 96ff). His answer

was: "We must start with the event as the ultimate unit of natural occurrence" (97). Since Whitehead chose as the basis of his conception—not without parallel to the quantum theory which at that time was arising—the atomism of events and not the unity of energy or fields, which surely manifests itself in events in a singular way, he has himself thereby established that "energy is merely the name for the quantitative aspect of a structure of happenings" (96). Thus, however, no account is taken of the unity of energy in its opposing alleged reality, since it cannot be turned back from the multiplicity of events in which it comes to appearance in phenomena. Through the isolated emphasis on the quantification of energy, it is dissolved in Whitehead into the multiplicity of elementary events. See, however, on the contrary, the description of Schrödinger in his essay "Was ist ein Elementarteilchen?" (1962) toward a natural scientific view of life (121ff).

13. Toward the defense of orthogenesis in connection with the *Speziationsfiguren,* see *Werke,* 4:389ff, especially 392ff.

14. Concerning the actual reality and evolutive significance of human orthogenesis, see *Werke,* 4:361ff, especially 363.

15. The concept of the supposition is expressly brought into relation with Omega in *Comment je vois* (1969), but the argument made there is found in many other texts; in particular, the argument for the irreversibility of evolution.

16. One observes also the difficulty that Teilhard *(Werke,* 7:36) perceives with regard to the problem of thinking of God as efficient cause and not only as final cause—a problem with which the Christian theology of the Middle Ages also struggled in its confrontation with Aristotelianism when it wanted to think of God as creator of the world.

17. It appears that since Teilhard affirms the identity of Omega as the Ultimum of evolution with the Maximum of complexity and centration and, therefore, with the highest consciousness—"as a prime essence of absolute consciousness" *(Werke,* 6:147), Teilhard's thought all too quickly allows itself to enter into the course of a mediated apprehension of a divine consciousness which is not temporal and therefore does not concern the absolute future of God.

.

References

Barthélemy-Madaule, M. 1970. *Bergson und Teilhard de Chardin.* Olten.

Bergson, Henri. 1948. *L'évolution créatice.* Paris: Presses Universitaire de France.

———. 1967. *L'énergie spirituelle.* Paris.

Daecke, Sigurd M. 1967. *Teilhard de Chardin und die evangelische Theologie.* Göttingen: Vandenhoeck und Ruprecht.

Gosztonyi, A. 1968. *Der Mensch und die Evolution.* München: C.H. Beck.

Jammer, Max. 1960. *Das Problem des Raumes: Die Entwicklung der Raumtheorien.* Darmstadt: Wissenschaftliche Buchgesellschaft.

Leibniz, G.W. *Monadologie.*

Luyten, N.A. 1966. *Teilhard de Chardin: Eine neue Wissenschaft?* Freiburg/ Munich.

Overman, R.H. 1967. *Evolution and the Christian Doctrine of Creation.* Philadelphia: Westminster.

Schmitz-Moorman. 1966. *Das Weltbild Teilhard de Chardins.* Vol. 1, *Physik—Ultraphysik—Metaphysik: Untersuchungen zur Terminologie Teilhard de Chardins.* Köln: Opladen.

Teilhard de Chardin, Pierre. 1959a. *The Phenomenon of Man.* New York: Harper and Row.

———. 1959b. *Der Mensch im Kosmos.* 2nd. ed. Munich.

———. 1968. *Frühe Schriften.* Freiburg/Munich.

———. 1969. *Comment je vois.* 1948. Paris: Editions du Seuil.

Weizsäcker, C. F. von. 1971. *Die Einheit der Natur.* München: C. Hanser.

Whitehead, Alfred North. 1957. *Process and Reality.* New York: Harper Torchbooks.

———. 1958. *The Function of Reason.* 1929. Boston: Beacon Press.

———. 1958. *Modes of Thought.* New York: Putnam's.

———. 1960. *Science and the Modern World.* New York: New American Library.

PART TWO

.

The Structure of Pannenberg's Thought

Introduction to Part Two

· · · · · · · · · ·

Carol Rausch Albright

Like an immense and elegant castle, the thought of Wolfhart Pannenberg is carefully laid out but, to the novice, its plan may be baffling. Like a castle, it is multidimensional. One dimension is time—the past, present, and future of the cosmos and, on a lesser scale, of human culture and of Western intellectual discourse. Within periods, it treats seemingly disparate disciplines—theology; the physical sciences; the anthropological disciplines, including human biology, psychology, sociology, and history; and the humanities.

Many thinkers have given up on the attempt to relate these disciplines, falling back on such explanations as analogy to the complementarity of quantum physics or the belief that some disciplines describe what is, while others speculate upon what ought to be.

Pannenberg, by contrast, has the audacity to maintain that all of these dimensions are in fact intimately related, of a piece. Then he sets out to show how that could be. To accomplish this task he employs several characteristic devices. Throughout his examination of the various disciplines and belief systems he focuses on features that relate to contingency and field, to *Geist und Stoff*, to matter and energy. He also looks for relations of part and whole, and he sees these relations, not as static, but as dynamical systems that evolve through time, drawn by the energy of the cosmos. In describing these processes, he keys on yet another tension—that between determinism and openness—which in fact brings him full circle to the examination of contingency and field. Ultimately, however, he does not see circularity in the cosmic process; he sees it as a teleological structure of events and entities, drawn into the future, in ways ever more self-transcendent, by the power of the unconditioned Field.

In the following two papers, Philip Hefner and Robert Potter offer maps of the Pannenbergian castle. Hefner's paper, 'The Role of Science in Pannenberg's Theological Thinking', appeared in *Zygon: Journal of Religion and Science* and, in a slightly different form, in *The Theology of Wolfhart Pannenberg*, edited by Carl Braaten and Philip Clayton.

• • • • • • • • • •
Hefner

Hefner focuses on "the significance of the sciences for the body of theological thinking which Wolfhart Pannenberg has given us over the past twenty-five years." As Hefner points out, Pannenberg believes that any concept of revelation that "puts revelation into contrast to, or even conflict with, natural knowledge is in danger of distorting the historical revelation into a gnostic knowledge of secrets." In other words, theology must not only acknowledge, but lay claim to, expand, and deepen the truths uncovered by the sciences. Reciprocally, Pannenberg claims, a completed comprehension of scientific facts must necessarily include a theological component.

An important value of Hefner's analysis is that it traces the development of Pannenberg's thought through time and across disciplines. As a framework for setting forth Pannenberg's wholistic program, Hefner focuses on the phenomena of contingency and field, tracing these themes through Pannenberg's exposition of both physics and biology. In the latter discipline especially, the interplay between contingency and field is carried out through the organism's *openness to the world*, and results in *ecstatic ecological self-transcendence*. That is, the organism, by interacting with its field, continually moves into a future in which it transcends its former identity.

By way of evaluating Pannenberg's achievement, Hefner employs the device of a Lakatosian research program. He proposes that Pannenberg's thought includes three 'hard core' beliefs, which are protected from falsification. The falsification process may, however, be permitted to attack the ten auxiliary hypotheses—four drawn from the biblical/theological tradition and six from scientific descriptions of reality. In permitting—in fact, requiring—attempts at falsification, using criteria based on science, Pannenberg's program is unique among theological programs today.

How well does Pannenberg bring off what he has attempted? Hefner applauds the comprehensiveness and audacity of the program, and raises some questions—both scientific and theological—that remain to be answered.

• • • • • • • • • •
Potter

Robert Potter's article, written subsequent to the symposium, appears for the first time in this volume. Potter employs the concept of self-transcendence as an organizing principle for Pannenberg's sweeping

vision. As Potter notes, Pannenberg defines self-transcendence as "the capacity of an organism to extend beyond its boundaries. This capacity is present in all life, but in human beings it is intensified into a unique ability to be conscious of self and others, and the flow of time."

Pannenberg analyzes self-transcendence according to a hierarchical scheme: as a feature common to all life, in higher animals, in human beings, with special focus on personality development, and as a manifestation of divine transcendence. In all life, self-transcendence takes two forms: ecstatic self-transcendence, involving change through interaction with the environment, and temporal self-transcendence, involving change over time. In certain higher animals, play behavior presages freedom; because this behavior disappears by the time they reach adulthood, these animals are not, observes Pannenberg, truly open or free. Humans, by contrast, have the capacity for play throughout life, signaling their unique "openness to the world," a capacity for responding to perceived reality that, says Pannenberg, can "vary almost without limit." Such openness to the world results from the reduction of the power of instinct in humans and from the physical and especially psychological immaturity of human infants, who are molded by the social environment during extremely formative stages. Emblematic of openness is the uniquely human quality of self-consciousness—the ability to distance oneself from oneself, to have a sense of self. This quality may also be seen in the ability to be aware of, and to relate to, that which is other than the self, and in consciousness of past, present, and future.

Self-transcendence in humans has psychological, social, and cultural aspects. Humans experience a basic tension between self and not-self; their task is to forge an identity providing unity within the self and continuity over time. That process is never complete; its incompleteness, described as separateness, alienation, or disunity, is otherwise known as sin.

Social structures are, or should be, formulated for the purpose of meeting basic human needs, along with "secondary needs that attach themselves to the basic needs." Social institutions regulate "the reciprocity of relations between individuals," mediating the tensions between particularism and mutuality. It is a mistake to attempt to base individual identity or meaning on social structures—to supply such support is beyond their power. Only religion, says Pannenberg, can provide needed meaning to life.

At this point, Potter is ready to show how Pannenberg relates human and divine transcendence. He begins by discussing field and contingency. By field, Pannenberg means "the interpenetrating

network of energetic forces which are woven into relational patterns."
"The partial elements of every field do not exist in themselves but are
radically contingent on the supportive influences of the whole field in
which each part exists" (141). The Holy Spirit may be spoken of as a
"'spiritual field' which is the source and sustaining power of reality."
A living creature is never autonomous in the sense of being indepen-
dent of its sustaining environment, and if a sustaining environment is
required, one may call that nurturing field 'spirit'." Furthermore, "the
entire movement of the human in the freedom of exocentricity is a
movement toward God"—which is not due to any spirit inherent in
the human; instead, "the human participates in the movement of the
Spirit" (140–43).

Thus, as Potter makes clear, Pannenberg's vision is a "grand
schema of ecstatic self-transcendence which unifies life, consciousness,
personhood, society, culture, and history through the all-embracing
theological theme of the Holy Spirit" (146).

5

The Role of Science in Pannenberg's Theological Thinking

• • • • • • • • • •

Philip Hefner

This essay sets forth a thesis concerning the significance of the sciences for the body of theological thinking which Wolfhart Pannenberg has given us over the past twenty-five years. The significance of his way of handling the sciences for theology generally is the subject of the concluding section.

The thesis is expressed both in a formal and in a material statement. Formally, it can be said that Pannenberg's theological thinking makes a statement about the empirical world; that is, it claims to add to our knowledge of empirical reality. Consequently, science is important as a realm within which theological issues arise, and science can either lend credence to theological statements or falsify them. In its material form, the thesis suggests that Pannenberg's theological production is focused on the phenomena of contingency and field and could indeed be viewed from this perspective as a theology of contingency and field. Since these phenomena are empirically discernible data, the scientific understandings of contingency and field are of importance to Pannenberg. In his final achievement, Pannenberg employs a particular conceptual grid for making sense theologically of contingency and field: the Christian theological concept of eschatology and God's relation to it, as set forth in Christ and his resurrection. The knowledge which Pannenberg's theology contributes to our scientific understandings of contingency and field is the suggestion that they are signals of the eschatological character of creation, which in turn is made clear proleptically in the resurrection of Christ. If we follow Thomas Aquinas's definition of theology as the discipline whose distinctiveness lies in its speaking of all things in terms of their relation to God, then Pannenberg's theological achievement is that he has related these phenomena as they occur in the natural world to God; further, he has suggested that when related to God they are a testimony to the knowledge which Pannenberg claims theology can add to our understanding of the empirical world.

· · · · · · · · · ·
Contributing to Knowledge as a Goal of Theology

The intention of Pannenberg's theological program to maintain theology as full partner in the community of disciplined rational discourse is well known. "Language about God no longer becomes privy to faith or imprisoned in the church and its confessional theology. For this reason he argues that theology belongs as one of the academic disciplines of a university" (Braaten 1984, 653–54). This theme runs throughout his writing. In his massive work, *Anthropology in Theological Perspective*, Pannenberg writes:

> If it can be shown that religion is simply a product of the human imagination and an expression of a human self-alienation, the roots of which are analyzed in a critical approach to religion, then religious faith and especially Christianity with its tradition and message will lose any claim to universal credibility in the life of the modern age. Without a sound claim to universal validity Christians cannot maintain a conviction of the truth of their faith and message. For a "truth" that would be simply my truth and would not at least claim to be universal and valid for every human being could not remain true even for me. This consideration explains why Christians cannot but try to defend the claim of their faith to be true. It also explains why in the modern age they must conduct this defense on the terrain of the interpretation of human existence and in a debate over whether religion is an indispensable component of humanness or, on the contrary, contributes to alienate human beings from themselves. (55; see also 1976, 316–345)

He goes on to say:

> The aim is to lay theological claim to the human phenomena described in the anthropological disciplines. To this end, the secular description is accepted as simply a provisional version of the objective reality, a version that needs to be expanded and deepened by showing that the anthropological datum itself contains a further and theologically relevant dimension. *The assumption that such aspects can be shown to exist in the facts studied by the other disciplines is the general hypothesis that determines the procedure followed in my own study;* the hypothesis must, of course, prove its validity in the discussion of the particular themes discussed. (59; emphasis added)

The hypothesis described here is, in a sense, the hypothesis of Pannenberg's entire theological work, particularly if one includes, in addition

to the significant methodological efforts, the concrete material which Pannenberg proposes in his Christology (and elsewhere) as the content of that "further and theologically relevant dimension."

The point to be made here very emphatically is that this approach, which stands right at the heart of his theological effort, places Pannenberg's work squarely on the interface of theology with the sciences. If the "secular descriptions" derived from the sciences are to be considered by the theologian "simply" as provisional versions of reality, and if this considered opinion must "prove its validity," then the theologian must be expecting not only to be informed about those secular descriptions but also to be able to engage in meaningful and persuasive argumentation with them. Even though these descriptions are, in the *Anthropology*, more or less restricted to the sciences that are related to anthropological studies (in itself no mean feat!), the principle enunciated here amounts, in fact, to an elaboration of what Pannenberg has intended throughout his career.

The thrust that is so strikingly set forth in the opening pages of the *Anthropology* is already explicit in the concept of revelation that was argued in the early programmatic work *Revelation as History* in 1961. Thesis 3, as formulated by Pannenberg, states: "In distinction from special manifestations of the deity, the historical revelation is open to anyone who has eyes to see. It has a universal character." Revelation dare not be considered "an occurrence that man cannot perceive with natural eyes and that is made known only through a secret mediation." Any concept of revelation that "puts revelation into contrast to, or even conflict with, natural knowledge is in danger of distorting the historical revelation into a gnostic knowledge of secrets." In a somewhat perplexing argument that has often been misunderstood and contested, he asserts that revealed truth "lies right before the eyes, and . . . its appropriation is a natural consequence of the fact." It is true that many persons do not see the truth; however, that is not because they lack faith but rather because their reason is inexplicably blinded. In any case, "Theology has no reason or excuse to cheapen the character and value of a truth that is open to general reasonableness" (Pannenberg 1968a, 135–37).

The concept of revelation at work here is a subtle one. Pannenberg is not arguing that certain historical facts can be isolated and used as the foundation of revelation, simply on the basis of their facticity. The argument, rather, is that when the events of nature and history are properly understood, in and of themselves, knowledge of their being rooted in God and God's will is conveyed. This knowledge is not complete in any single event or series of events, but only in the totality of all events; that is, it is not complete until history is completed. The

proper understanding of nature and history is enabled by interpreting the "natural consequence of the facts" through the event of Jesus Christ and his resurrection. When one is in relationship with Christ, one is also in touch with the movement of history toward the meaning and fulfillment that will come to pass when God's work is completed. This meaning and fulfillment that center in Christ's revelation form the focus which also encompasses the reality that concerns the "secular descriptions" of nature and history found in the sciences. The reality of which science provides knowledge is part of the history that is on the trajectory of God's will and fulfillment which is revealed proleptically in Christ and his resurrection (Pannenberg 1968b, 53–114).

The foregoing discussion gives the content to our thesis that Pannenberg conceives of theology as claiming to add to our knowledge of empirical reality. If theology is to lay claim to the phenomena described by the sciences, and if it views the secular scientific descriptions of reality as "provisional versions" (as versions that are accurate as far as they go, but which are incomplete until enhanced by additional relevant interpretations) which await the expanding and deepening that theology can provide, then it is very clear that theology contributes to our knowledge of the phenomena described by the sciences. This is precisely what revelation, as conceptualized in *Revelation as History*, is supposed to accomplish. What we observe here provides both a breathtaking program and also the criteria by which to assess whether Pannenberg has succeeded in accomplishing what the program intends.

Some explanation of my approach in this essay is in order. I devote more attention to analyzing the program and Pannenberg's execution of it than to assessing the adequacy of his performance. The grounds for this imbalance are my judgment that this aspect of his program generally has not been recognized for the breathtaking venture that it truly is. Further, since the sources I rely on are not everywhere so well known, I will include generous long quotations from them. Finally, although the complete range of the sciences, natural and social, falls within Pannenberg's purview (and ours, as well), I will put more emphasis on the natural sciences, partly because of limitations of space and also because his treatment of the social sciences is more widely discussed in other places.

· · · · · · · · · ·
The Phenomena of Contingency and Field

In the foregoing comments, we have said that Pannenberg's theological thought puts a premium on coming to terms with the events of

nature and history as described by the various sciences. His breadth of understanding in this regard is impressive, even staggering; his scope of vision aims to cover the entire range of human knowledge. The outcome of this broad-gauged survey, however, is a consistent focus upon the various phenomena that can be placed first of all under the rubric of *contingency,* and secondly under the rubric of *field.* He is not interested, apparently, in all of the data which the sciences churn up but rather is selective in concentrating upon those which are most useful for theological construction. The most useful factors in the data seem to be contingency and field theory.

In his theological writings, he speaks of the phenomena of contingency and field in several domains: physics, biology, anthropology, psychology, and history. In terms of quantity, the bulk of his attention has been given (in descending order) to history, anthropology/psychology, physics, and biology. I will survey Pannenberg's treatment of the data in each of these fields. Even though it is most important to Pannenberg, history will receive less attention here, since several other essays have dealt with it.

Physics. In his essay 'Contingency and Natural Law' Pannenberg writes: "A common field should be sought on which the natural sciences and theology can relate themselves without losing sight of the specific differences between the two ways of thinking. In what follows, an attempt will be made, provisionally, to lay out such a field. *The field will be characterized through the relationship of contingency and lawfulness*" (emphasis added). Pannenberg believes that contingency is a basic consideration for the Christian outlook, because the understanding of God which was bequeathed to the Christian church from Israel was one in which "the experience of reality was primarily through contingency, and particularly through the contingency of historical happenings. Always, there came the new and unforeseen, which were experienced as the workings of the almighty God" (Pannenberg 1993, 76). Lawful regularities were recognized, as well, but they are also contingent upon the action of God. The reality of the future also arose in this context, because the Israelites were aware that they were part of a continuum that was not yet complete.

Two other essays raise similar considerations: 'Theological Questions to Scientists' (Chapter 1, above) and 'The Doctrine of Creation and Modern Science' (1993, 29–49). In these essays, too, the concern is whether the physical sciences can be reconciled with the biblical understanding of reality as historical, the historical being the work of God as creator and sustainer *(creatio ex nihilo* and *creatio continua).* The

question of inertia arises, since that physical principle seems to suggest that events are fully caused by the nexus of physical reality, leaving no possibility for divine causality.

These concerns take on deep significance when one thinks back to the early, formative essays that Pannenberg wrote, particularly the 1959 piece, 'Redemptive Event and History'. In that essay the point is also made that Christians, like the Israelites, experienced reality as historical: "History is the most comprehensive horizon of Christian theology" (Pannenberg 1970a, 15). There, too, history is made up of the contingent and the continuous. Both have their origins in God:

> The God who by the transcendence of his freedom, is the origin
> of contingency in the world, is also the ground of the unity
> which comprises the contingencies as history. This history does
> not exclude the contingency of the events bound together in it.
> It seems that only the origin of the contingency of events can, by
> virtue of its unity, also be the origin of its continuity without
> injuring its contingency. (Pannenberg 1970a, 74–75)

Why would the theologian be so concerned to discuss contingency and lawfulness with the physicist? Because the Christian view of God and the world puts contingency and the lawfulness that is also contingent at the center. We note, however, that the aim is not simply to gain reinforcement for Christian theological belief or scriptural affirmation from the sciences. Such a simplistic motivation founders on the rocks of philosophical analysis without any question! On the contrary, harking back to the understanding of revelation that also emerged in these years, the point is that theology has something to contribute to the provisional descriptions of the physicist, and this 'something' is knowledge. As we shall have ample occasion to note, the contingency of events is a fundamental clue to events being rooted in a source of that contingency, namely, the action of God. The descriptions of the cosmologists are only provisional until they are conjoined with the theological commentary.

The discussion of field theory and inertia has the same concern (see above, 40–48; 1993, 33–37). Field theory (which will receive greater attention in the next section) suggests that causes do not originate in entities nor do they operate only on individuals; rather, factors in the field which is the ambience of the entity can be causes, and they work on the entire ambience. This, too, is a clue that the biblical imagery of all things being rooted God—the source of nature and history—not only has a point of contact with scientific understandings of reality but also has something to contribute to those understandings; the insight that the largest field of all, which embraces all of reality

and all of the relevant causative factors, is God.

In the discussion of contingency and field, the final theological point to be made seems to be that both concepts point toward a ground upon which both are dependent, namely, God. The contribution of theology in both cases is to call attention to and say something about this ground in God. In his most recent work, Pannenberg begins to relate this concern to the very important and complex set of issues that pertain to the unity of space and time. Drawing upon a wide range of authors—stretching from Plotinus through Augustine, Duns Scotus, and Ockham, up to contemporary physics and philosophy—he juxtaposes the attempts of physics to speak about the cosmic field of space and time with the Christian theological concepts of God, the divine Spirit, and the eschatological future (Pannenberg 1958b, 11–19). He suggests for discussion two sets of questions in particular: "the question of how the different parts of the cosmic field are related to that field itself and . . . [the question] of the role of contingency and time in the understanding of a cosmic field" (Pannenberg 1993, 41).

Throughout his years of dialogue with scientists, Pannenberg has also called attention to an insight derived from his conversations in the interdisciplinary group that met in Heidelberg in the early 1960s. This insight deals with the character of scientific statements. He writes:

> There was a resulting agreement to the effect that each scientific hypothesis of law describes uniformities in the behavior of the object of such affirmations. The object itself, however, is contingently given in relation to its hypothetical description as a case where the affirmed law obtains. This element of contingency in the givenness of the object, however, is usually not explicitly focussed upon in scientific statements. The focus is rather on the uniformities that can be expressed in equations. *It goes as a matter of fact that those uniformities occur in a substratum that is not exhausted by them* [there follows a description of examples which make his point]. . . . *This means that the descriptions of nature by hypothetical statements of natural law presuppose their material is contingently given.* They do not focus, however, on this contingency, because their intention is the formulation of uniformities that occur in the natural phenomena, their contingency notwithstanding. (Pannenberg 1993, 36; emphasis added)

This argument is important for the function that it serves; namely, to make credible the notion that theology, particularly a theology that speaks of contingency, has something legitimate to contribute to the enhancement of scientific knowledge. In this connection we note the manner in which Pannenberg relates science and theology. It is not

one that employs a 'God of the gaps' strategy, nor is it that of perceiving science and theology as 'two worlds'. Rather, it immerses itself fully in the contributions that science makes to our understanding of the world, and it seeks to bring theology to bear in a constructive and co-operative manner upon the descriptions which science provides. It does so in the conviction that theology has something to contribute which will otherwise be wanting. Such a style of approach, upon which I will comment more fully later, is thoroughly consistent with the program which Pannenberg has set for himself.

Biology. Although he has devoted the least attention to the biological realm in his published works, some of Pannenberg's most insightful and persuasive arguments emerge from this area. The chief sources for this aspect of his thought are the 1962 book *What Is Man?*, the 1985 *Anthropology,* the 1970 essay 'The Working of the Spirit in the Creation and in the People of God', and the generally overlooked but nevertheless useful essay 'The Doctrine of the Spirit and the Task of a Theology of Nature', reprinted in this volume as Chapter 3.

The issues of contingency and field are dominant for Pannenberg as he approaches the biological sciences. Biology, governed as it is by evolutionary modes of interpretation and overlapping at important points with anthropology, provides Pannenberg a rich and complex set of ideas within which to pursue his concerns for contingency and field. He has obviously learned greatly from this realm of reality, just as he has chosen to express some of his formative ideas in its context.

In the context of biology and anthropology, the concepts of *openness* and *ecstatic ecological self-transcendence* receive brilliant articulation. These articulations take on even deeper meaning if we keep in mind the larger reaches of Pannenberg's theological system—the concepts of revelation, eschatology, and God as the all-determining reality (and hence the ground of the unity of all reality). Evolutionary modes of thinking lend themselves to the articulation of these concepts for three reasons: first, the processes of nature so perceived are intrinsically contingent, both in the sense that the new and unforeseen is (as in history itself) always occurring, and also in the sense that all evolutionary events take place in a larger environment upon which they depend for their origin and sustenance; second, the notion of this larger environment leads directly to the concept of field; and third, the dynamics of evolution lay the groundwork for the empirical actuality of openness.

The evolutionary pathway is one in which the organism interfaces with its physical world through its own physical shape (phenotype), and in this situation it is continuously being drawn outward. The environment elicits responses from the organism as the process of

adaptation directs the interactions between organism and environment. This drawing out or eliciting is the biological basis for and correlate of openness, and in the process of being drawn out the organism has no recourse but to transcend itself.

> All human life is carried out in the tension between self-centeredness and openness to the world. In order to understand man's unique situation correctly, one must note that man shares this tension in its main features with all organic life. On the one hand, every living organism is a body, which, as such, is closed to the rest of the world. On the other hand, every organism is also open to the outside world. It incorporates its environment, upon which it is dependent for food and growth, into the cycle of its biological functions. Thus every organic body, whether it is animal or plant, simultaneously lives within itself and outside itself. To live simultaneously within itself and outside itself certainly involves a contradiction. But it is a contradiction that really exists in life. All life, even human life, as we have seen, is carried out within this tension. (Pannenberg 1970c, 56–57)

Ultimately, Pannenberg finds the ground of this tension and its meaning in the concept of God.

The concept of openness that is intrinsic to the evolutionary-biological process is the direct descendant of the concept of contingency that was central to the discussion of physics. There, the concept of contingency primarily correlated with God's working as origin of the new and unforeseen. Here a nuance is added: the concept of being drawn out and thereby constituted is correlated with the "Spirit of God as the creative origin of all life" (74). Here the concepts of ecstatic and ecological self-transcendence should be considered. Ecstasy is intrinsic to life, particularly to human life, and it is manifested in the phenomenon of living beyond oneself:

> every living organism lives beyond itself, for every organism needs an appropriate environment for the activity of its life. When kept in isolation, no organism is fit for life. Hence every organism lives beyond itself. A particular aspect of this ecstatic character of life is to be found in its relation to time: every organism relates itself to a future that will change its present conditions. This is evident in the drives and urgencies of life, but also in negative anticipations such as fear and horror. (Pannenberg 1970b, 18)

Ecstasy is a mark of the spirit. Pannenberg elaborates this further:

> The element of transcendence in spirit suggests that after all it might be neither necessary nor wise to admit a fundamental distinction between a human spirit and a divine spirit. The

ecstatic, self-transcendent character of all spiritual experience brings sufficiently to bear the transcendence of God over against all created beings. *The spirit never belongs in a strict sense to the creature in his immanent nature, but the creature participates in the spirit—and I venture to say: in the divine spirit—by transcending itself, i.e., by being elevated beyond itself in the ecstatic experience that illustrates the working of the spirit. . . . *Thus the idea of spirit allows us to do justice to the transcendence of God and at the same time to explain his immanence in his creation. (Pannenberg 1970b, 21; emphasis added)

What we have here, when put in the context of Pannenberg's other writings, is a theological interpretation—in the concept of spirit—of one very important component of the evolutionary process that is observed empirically by the sciences. The train of thought is carried further in the essay 'The Doctrine of the Spirit and the Task of a Theology of Nature':

Modern biology does not exclude everything that transcends the living cell from the analysis of life. Although life is taken as the activity of the living cell or of a higher organism, that activity itself is conditioned. It is conditioned particularly by the requirement of an appropriate environment. When kept in isolation, no organism is fit for life. In this sense, every organism depends on specific conditions for its life, and these conditions do not remain extrinsic to its own reality, but contribute to the character of its life: an organism lives 'in' its environment. It not only needs and actively occupies a territory, but it turns it into a means for its self-realization, it nourishes itself on its environment. *In this sense, every organism lives beyond itself. Again it becomes evident that life is essentially ecstatic: it takes place in the environment of the organism much more than in itself.*

But is there any relation of this ecological self-transcendence of life to the biblical idea of a spiritual origin of life? I think there is. (75; emphasis added)

In these reflections the phenomenon of field is given even greater significance for theology, fully as important as the phenomenon of contingency. It is clear that the significance of both phenomena is rooted in their relevance to the reality of God. Pannenberg then introduces the phenomenon of the future into the biological scheme: "By turning its environment into the place and means of its life, the organism relates itself at the same time to its own future and, more precisely, to a future of its own transformation. . . . By his drives an animal is related

to although not necessarily aware of his individual future and to the future of his species" (75). This insight lays the foundation for relating eschatology to the biological realm. Pannenberg continues:

> Hence, the element of truth in the old image of breath [which he has elsewhere related to the biblical concept of spirit and the scientific concept of field] as being the creative origin of life is not exhausted by the dependence of the organism on its environment, but contains a deeper mystery closely connected with the ecological self-transcendence of life: the temporal self-transcendence of every living being is a specific phenomenon of organic life that separates it from inorganic structures. (75)

What should be clear at this point is that in his rather extensive discussions of physics, cosmology, and biology, Pannenberg has laid—to his own satisfaction, at least—the basis for correlating the empirical phenomena *as described by the sciences* with the realities that are spoken of in theological discourse in the concept of God, spirit, creation (both *creatio ex nihilo* and *creatio continua*), transcendence, and eschatology.

Anthropology, Psychology, Social Theory, History. Our analysis must be satisfied with an even more summary discussion of anthropology, psychology, social theory, and history as they fit into the vast Pannenbergian scheme. There is some overlapping of the interpretations taken from anthropology with what we have already considered, since the trends in anthropological thinking he appropriates employ the phenomena of openness, world-relatedness, and self-transcendence, for which the evolutionary biological descriptions lay a sort of foundation. In the context of anthropology and psychology, he elaborates the concept of relatedness to and openness to the world—with great learning and subtlety—in a way that provokes further insights.

> The concept of human self-transcendence—like the concept of openness to the world which is to a great extent its equivalent—summarizes a broad consensus among contemporary anthropologists in their effort to define the special character of the human.
>
> It was this transcending of every particular object—a transcending that is already a condition for the perception of the individual object in its determinacy (and thus in its otherness and distinctness)—that I had in mind when I wrote in 1962 that the so-called openness of the human being to the world signifies ultimately an openness to what is beyond the world, so that the real meaning of this openness to the world might be better described as an openness to God which alone makes possible a gaze embracing the world as a whole. (Pannenberg 1985, 63, 69)

Contingency and field still figure as foundational concerns. In the important realms to which psychological and anthropological descriptions are relevant, the challenge to discover and actualize the unity that binds together the contingencies is at the center of human existence and reflection. The field, as the environment or ambience which is causative and sustaining, is even more intensely the focus of Pannenberg's reflection and argumentation. Some of the most important examples of this trend of his thought can be highlighted:

First, the phenomenon of openness to the world and the attempt to unify the disparateness of the world through human dominion are linked to the biblical affirmation that humans are created in the image of God (Pannenberg 1985, 76–77). That is to say, the trajectory of openness to the world which Pannenberg traces through the evolutionary order—of which the human capacity for dominion is a moment—belongs to the dimension of human being which he identifies with the image of God (see also the italicized citation in the next paragraph).

Second, in the formation of identity the individuals must differentiate themselves from the world and gain independence "while not destroying that symbiotic connection" with their world which makes life possible. Trust is definitely a matter of relatedness to the field in which the individual lives—physical and cultural. The religious dimension is visible here because "trust is, by reason of its lack of limits, *implicitly* directed beyond mother and parents to an agency that can justify the unlimited character of trust." This argument concerning trust is not meant as a proof for the existence of God, but rather it shows "that the theme of 'God' is inseparable from the living of human life. . . . *There is an original and at least implicit reference of human beings to God that is connected with the structural openness of their life form to the world and that is concretized in the limitlessness of basic trust"* (Pannenberg 1985, 233; emphasis added).

Third, the primary challenge facing human cultural life is the establishment of the unity of culture; that is, of articulating the field or unity which sustains culture and gives it meaning. This is where religion becomes meaningful for culture. Religion is the factor that can give legitimacy to the culture. To understand this, the function of religion within the cultural system must be understood: "This function is to be seen, first, in the fact that religion has for its object the unity of the world as such in relation to its divine source and its possible fulfillment from that same source. . . . Because religions are concerned with the unity of all reality, it is possible and necessary to seek and find in religion the ultimate frame of reference for the order of human life in society" (Pannenberg 1985, 473–74). As with the issue of the

trust which makes individual identity possible, this unifying within the cultural system is basically the challenge of making clear the field in which life's origin and sustenance is to be found and describing the field in ways that are persuasive and add the knowledge of it to what the sciences can describe of it.

Fourth, history becomes at a higher, more complex, and (in the epoch in which humanity is the dominant species) more critical level what the physical and biological processes were for preceding levels. History is a realm of self-transcendence, ecstasy, openness, subject formation, contingency, and the operation of the field (see Pannenberg 1985, 485–532). This is not surprising, since (as we have seen) Pannenberg uses the historical order as the analogy for understanding contingency and field in the physical realm. It is because he uses the historical process as his base category and sees the spirit at work in those processes that he is able, through analogy, to analyze physical and biological processes as he does, and thus also to see the unity of all the processes.

· · · · · · · · · ·
The Totality of Meaning

Pannenberg himself uses the term that is the title of this section to refer to God; we are using it to refer to a summary of the total system of meaning which he presents to us, bits and pieces of which I have discussed in this essay thus far. If there were space, I would argue that what Pannenberg has provided is what the philosopher of science Imre Lakatos has termed a *research program* (Lakatos 1978; Murphy 1987). A research program is constituted by a *hard core* of assertions and a set of auxiliary hypotheses which surround the core. The hard core rises to the top of the heap of theories in its field, surpassing others because it is able to provide "dramatic, stunning, and unexpected" interpretations of the world, which do as a result provide "new facts" that had not been known before (the *positive heuristic*). This hard core is never subjected to the process of scientific falsification; its activity is rather to provide the stunning and unexpected interpretations. The auxiliary hypotheses carry the brunt of the falsification process and thereby lend credibility to the hard core and to the research program as such (the *negative heuristic*). If the hard core proves to be degenerative, then the center of the program is no longer really viable. In such a case the hard core is not falsified; rather, it simply falls away, to be replaced by an alternative program with its own hard core. This replacement may well be akin to what is often called *paradigm shift* in the history of science. I will attempt to summarize Pannenberg's

proposals for global meaning in the form of a Lakatosian research program. I will not always use Pannenberg's own terminology to summarize his contribution.

The Hard Core[1]

1. God is the all-determining reality which constitutes the field in which everything that exists derives its being and in which all the contingencies of nature and history have their origin.
2. The medium in which God's all-determining work (both as *creatio ex nihilo* and *creatio continua*) has been cast is that of an eschatological historical continuum, wherein the meaning is in the as-yet-uncompleted totality of reality. Within this continuum, the resurrection of Jesus Christ is a revelation of that meaning.[2]
3. Included in God's all-determining work is the fulfillment of the eschatological continuum.

Auxiliary Hypotheses[3]

Hypotheses Drawn from the Biblical-Theological Tradition
1. The biblical picture of God as the Lord of history and creator supports the concept of God that is contained in the hard core.
2. The biblical picture of the divine spirit as the creative source of all life supports the hard core.
3. In Jesus Christ and his resurrection we encounter a proleptic embodiment of the totality of reality and of God's will for it and fulfillment of it, when interpreted in the light of the apocalyptic framework in which it was originally experienced. Therefore, Christ and his resurrection qualify as God's revelation, that is, as God's own indirect self-revelation.
4. The biblical concept of the Kingdom of God is a symbolic representation of God's eschatological work and of God's relation to it.

Hypotheses Drawn from Scientific Descriptions of Reality
1. In their character as contingent and field-dependent, physical processes leave open the conjecture that they manifest the effects of God's all-determining totality.
2. In their character as contingent and field-dependent, biological evolutionary processes leave open the conjecture that they manifest the effects of God's all-determining totality. Ecological self-transcendence is an important aspect of this manifestation.
3. In their character of openness to the world, to others, and to the future, the processes of society and history leave open the conjecture as described in 1. and 2. above.

4. In its dependence upon the reality of trust, the process of identity formation in the individual human person leaves open the conjecture as described in (1) and (2).
5. In their dependence upon a perception of unity, the processes of human culture leave open the same conjecture.
6. A comparable hypothesis may be made about history, except that it would be more complex.

The magnitude of this program is stunning in its own right. As the Lakatosian elaboration reveals, Pannenberg's central core of contributed insight does attempt to throw light on the nature of all things, and it demonstrates its seriousness by suggesting hypotheses that cover broad ranges of biblical-theological and scientific materials. I suggest that this way of representing Pannenberg's theological thought is not simply a perspective that grows out of consideration of his use of the sciences; rather, it does more justice than many other perspectives to the genuine intent of his theological work and its genuine significance. This elaboration shows the justification of his claim that theology deserves a place in the university because of its contribution to knowledge, that is, because of its cognitive claims.

· · · · · · · · · ·
Assessing Pannenberg's Handling of Science

In a brief sketch, we may suggest several ways in which Pannenberg's handling of science can be assessed.

First, we must recognize that in contrast to the vast majority of mainline Christian theologians of his generation, Pannenberg genuinely opens his theological work to the impact of science by inviting falsification on the basis of science. He has not retreated behind the prevalent 'two worlds' approach to the sciences, which builds an insuperable wall between science and theology by making some version of the claim that the two kinds of discourse are so utterly different that they cannot exist on the same interface. Furthermore, while he has opened himself to falsification from the side of the sciences, he has also assimilated himself so fully to the theological tradition that he courts falsification from that sector, as well. When we compare his work to the other prevailing schools of theology today, I suggest that there is no other school of theological thought that opens itself so fully to this dual falsification—from the side of the sciences and also from the side of the biblical-theological tradition. If one believes, as this writer does, that the primary challenge to theology in our era is to open itself to the greatest extent possible to both the contemporary

world and to the Christian tradition, then Pannenberg's position vis-à-vis dual falsification suggests that he has produced a research program in theology that surpasses any other current program.

Second, we should examine Pannenberg's rather full discussion of how his theological statements can be subjected to scientific methods of validation, to see if they are adequate. This discussion is set forth in *Theology and the Philosophy of Science* (1976, 326–345). Although I cannot go into this question here, the four basic tests that he outlines in this work (1976, 344–45) conform to the Lakatosian structure I have utilized in my analysis: conformity to the tradition, connection with present experience (which I interpret to include scientific experience), integration with the appropriate area of experience, and comparison with other existing research programs. The third criterion is the only one to which this essay has not given attention.

Third, granted that Pannenberg's design for his theology proposes a brilliant engagement with science, the major test is whether he actually brings off what he has attempted. I suggest a number of concrete assessments.

To begin, even though the range of the auxiliary hypotheses in Pannenberg's program is very impressive, he will surely need to develop it more. The emerging field of thermodynamic thinking bids fair to become the foundation of a unified science; that is, a unified view of the entire cosmic order. This new field is of such great pertinence to Pannenberg's program that he can scarcely overlook it (Wicken 1987). One might also suggest he will want to probe more fully the relationship between culture and the biogenetic background of the human central nervous system. His reflection upon biological evolution (see Chapter 2 above) does recognize that the concepts of openness and self-transcendence, which are so central to his interpretation of society and history, have significant roots in the biogenetic evolution and structure of human life. The anthropologist Victor Turner (1983) recognized this shortly before his death. He was greatly influenced by the work of Ralph Burhoe (1976) and Eugene d'Aquili (1978; 1983). It would be a natural step for Pannenberg to take this interrelationship of culture and biogenetic backgrounds more seriously.

Next, Pannenberg tends to give the impression that the biblical-theological tradition is a given in the quest for knowledge which at the formal level changes little even though in material expressions he suggests dramatic reformulations of the tradition. Is it not a contradiction of the standards he applies to his own theological program, to protect the tradition, even the biblical traditions, from validation and falsification procedures that are in use today?

Furthermore, one might question Pannenberg's reliance on analyses which conclude that in relation to non-human life forms the human reveals a defective level of instincts. Is he not touching here the important interface between genes and cultures in human existence? In genes/cultures terms the interface could be interpreted more provocatively, released from the inhibiting notion that culture lacks instinct.

Finally, physicists have raised a number of questions about Pannenberg's discussion of contingency and inertia. Russell (1988) has suggested that Pannenberg's discussions (chapter 2 above; 1985), while provocative, would benefit from a fuller and more complex attention to what physicists today are saying about inertia and contingency. Wicken also finds Pannenberg's questions fruitful, but he believes that on the one hand Pannenberg is not careful enough in his use of the concept of field, while on the other, more attention should be given to the "ontological room" that science necessarily leaves for theology in probing the "sensitive dimension of nature that is the source of feeling, perception, and consciousness" (Wicken 1988). Breed (1985) has argued that current cosmological thinking suggests that contingency includes limitations upon the action of God which would qualify the claim that God is all-determining. These examples are cited in order to suggest that Pannenberg's dialogue with the scientists is by no means at an end. Further developments in the process of give-and-take are eagerly awaited.

The magnitude of Wolfhart Pannenberg's theological enterprise is clearly revealed when we view it from the perspective of his stance toward the sciences. His program merits the most serious attention and dialogue. Let the conversation continue.

• • • • • • • • •

From *Zygon: Journal of Religion and Science* 24 (June) 1989, 135–151. By permission. An earlier version of this essay appeared in *The Theology of Wolfhart Pannenberg*, ed. Carl E. Braaten and Philip Clayton (Minneapolis: Augsburg 1988).

• • • • • • • • •

Notes

1. The hard core, in Lakatos's terms, is the source of stunning, dramatic interpretations.
2. Any discussion of Pannenberg's use of science must take note of his remarkable discussion of the resurrection of Jesus Christ. This discussion demonstrates how his Christology is the nodal point, where his concern for secular knowledge and Christian tradition intersect most intensely. Consequently, one can say that he has been consistent in following out the

concept of revelation that he set forth in his earliest work. His interpretation of the New Testament texts, utilizing his version of the apocalyptic framework of the early first century, brings to bear the quintessence of what we have elucidated above concerning contingency and field. What Pannenberg thus gives us is a neatly dovetailed tapestry of meaning: contemporary scientific understandings (as Pannenberg interprets them) are subtly employed to interpret the texts, and the texts (interpreted in the light of Pannenberg's understanding of the apocalyptic) result in a message of the resurrection that reveals the meaning of the eschatological reality in terms that make sense also to contemporary secular knowledge. This means that the Christ-resurrection-revelation is the point where the two sets of auxiliary hypotheses meet; it also explains why Christ appears both in the hard core and in the first set of auxiliary hypotheses (Pannenberg 1968a, 53–114).

3. These may be falsified in appropriate ways. The following list is by no means complete.

• • • • • • • • • •

References

Braaten, Carl. 1984. Wolfhart Pannenberg. In *A Handbook of Christian Theologians*, ed. Martin E. Marty and Dean Peerman, 39–59. Nashville: Abingdon Press.

Breed, David. 1985. Reflections on Theology and Science in Wolfhart Pannenberg's Thought. Unpublished paper.

Burhoe, Ralph Wendell. 1976. The Source of Civilization in the Natural Selection of Coadapted Information in the Genes and Culture. *Zygon: Journal of Religion and Science* 11 (September), 263–303.

d'Aquili, Eugene. 1978. The Neurobiological Bases of Myth and Concepts of Deity. *Zygon: Journal of Religion and Science* 13 (December), 257–275.

———. 1983. The Myth-Ritual Complex: A Biogenetic Structural Analysis. *Zygon: Journal of Religion and Science* 18 (September), 247–269.

Lakatos, Imre. 1978. *The Methodology of Scientific Research Programmes*. Cambridge: Cambridge University Press.

Murphy, Nancey. 1987. Acceptability Criteria for Work in Theology and Science. *Zygon: Journal of Religion and Science* 22 (September), 279–297.

Pannenberg, Wolfhart. 1968a. *Revelation as History*. New York: Macmillan.

———. 1968b. *Jesus: God and Man*. 2nd ed. Philadelphia: Westminster.

———. 1970a. Redemptive Event and History. In *Basic Questions in Theology: Collected Essays*, vol. 1. Philadelphia: Westminster.

———. 1970b. The Working of the Spirit in the Creation and in the People of God. In *Spirit, Faith, and Church*, by Wolfhart Pannenberg, Avery Dulles, and Carl Braaten, 13–31. Philadelphia: Westminster.

———. [1962] 1970c. *What Is Man?* Philadelphia: Fortress.

———. 1976. *Theology and the Philosophy of Science*. Philadelphia: Westminster.

———. 1985. *Anthropology in Theological Perspective*, trans. Matthew J. O'Connell. Philadelphia: Westminster.

————. 1993. *Toward a Theology of Nature: Essays on Science and Faith.* Ed. Ted Peters. Louisville: Westminster/John Knox.

Russell, Robert, 1988. Contingency in Physics and Cosmology: A Critique of the Theology of Wolfhart Pannenberg. *Zygon: Journal of Religion and Science* 23 (March), 23–43.

Turner, Victor. 1983. Body, Brain, and Culture. *Zygon: Journal of Religion and Science* 18 (September), 221–245.

Wicken, Jeffrey. 1987. *Evolution, Thermodynamics, and Information.* New York: Oxford University Press.

6

Self-Transcendence: The Human Spirit and the Holy Spirit
· · · · · · · · · ·
Robert Potter

Self-transcendence is a basic feature of all life. This fundamental claim forms the basis for Wolfhart Pannenberg's understanding of human nature, and of the relationship between the human spirit and the Holy Spirit.

Self-transcendence is defined by Pannenberg as the capacity of an organism to extend beyond its boundaries. This capacity is present in all life, but in human beings it is intensified into a unique ability to be conscious of self and others, and the flow of time. The characteristics of human behavior are based on this unique self-transcendence.

Because self-transcendence is not an autonomous function of life, in either animal or human form, its origin is posited in the divine field which is the source of all life. According to Pannenberg, the anthropological concept of self-transcendence requires the theological perspective for a complete interpretation.

This summary of Pannenberg's thought on self-transcendence will be organized into five sections. First, ecstatic self-transcendence as a feature common to all life will be described. Second, self-transcendence in animals will be differentiated from its features in the human species. Third, 'exocentricity' as the unique feature of human beings will be explained. Fourth, the development of personality as a direct function of self-transcendence in relationship to the shared world of society and culture will be described. Fifth, Pannenberg's theological claim that human self-transcendence has its source and destiny in divine transcendence will be examined.

· · · · · · · · · ·
The Ecstatic Self-Transcendence of All Life

Ecstatic self-transcendence is revealed in the relationship between the organism and its environment. The organism, as an 'open system', demonstrates ecstatic self-transcendence by entering into its environment. This interpenetrating polarity of organism and environment is the key analytic structure for the concept of ecstatic self-transcendence.

Based on evidence for the dependence of an organism on an energetic exchange with its environment, Pannenberg makes the claim that

"every organism exists in a movement beyond itself" (1977, 33). This "movement beyond itself" is the meaning of "ecstatic self-transcendence." In Pannenberg's words:

> Again we see that life is essentially ecstatic: it takes place in an interaction of the creature and its milieu, not only within the confines of the organism in terms of itself. (1977, 33)

The thrust of this statement is away from the position of understanding either the living cell or the organism as a self-sufficient complex, and toward the concept of life as an open system which exists only by energetic exchange with the sustaining environment.

Pannenberg understands "the sustaining environment" to be more than the natural world milieu, and to be so inclusive as to embrace the concept of time. Therefore, he conceives of two subtypes of ecstatic self-transcendence: ecological and temporal.

Ecological Self-Transcendence of Life

Pannenberg describes the organism-environment polarity in a way which tends to emphasize the environment over the organism, but without breaking the reciprocal polarity by completely negating the organism. Pannenberg first interprets the life sciences as overstating the pole of the organism when he says that "modern biology thinks of life as a function of the living, self-reproductive cell" (1977, 32). Without further elaborating on the complex biological science of the organizational integrity of the living cell, he moves into the ecological dimension with a penetrating analysis of the importance of the environment for any open, living system:

> in its analysis of the phenomenon of life, modern biology does not simply exclude everything that cannot be derived from the living cell. Although life is conceived as the activity of a living cell or a higher organism, that activity itself is still conditioned, and especially by the requirement of an environment fit for the organism: a milieu which is the first precondition of its continuing to live. Once parted from such an environment, no organism can persist. In that sense every organism depends on specific conditions in order to live, and those conditions are not merely external to its living but make it possible and are characteristic of it; an organism lives 'in' its environment. It not only requires living-space, a territory which it actively possesses, but it transforms that environment into a means of self-realization; it is nurtured by its environment in the literal and metaphorical

sense. In that sense every organism exists in a movement beyond itself. (1977, 32)

The "ecological self-transcendence of life" refers to the fact that all organisms live "ecstatically" by "entering into their environing reality." Perception, movement, grasping, ingestion, and respiration are examples of rudimentary organismic action which involves "entering into their environing reality" (1977, 34). More complex examples of organismic-environmental interaction range from the effects of environmental radiation on the organism's genetic material to the relational bonds which embed individuals into social networks. The total supportive context of life is envisioned by Pannenberg as the "environing reality" into which the organism enters by way of ecological self-transcendence.

With the environmental side of the organism-environment polarity weighted so heavily that he is able to claim that "the key is to be found in the dependence of the organism on its environment", Pannenberg has set up the logical priority of the environment over the organism (1977, 34). This logical priority of the environment will reappear in his analysis of the relation of human beings to their embedding culture, and to the divine contextual field as the source of life.

· · · · · · · · · · ·
Temporal Self-Transcendence of Life

Pannenberg does not specifically employ the phrase "temporal self-transcendence of life", but the concept is clearly developed as part of his thinking:

> But in the creature's self-transcendence in the course of its life, and in its transformation of its environment into the location and means of its life, the creature also relates to its own future or, more precisely, to the future of its own transformation. That occurs in every act of self-production, of self-nurture, of the regeneration and reproduction of one's own life. By its drives, every living creature is oriented (though not always consciously) to its individual future and to the future of its species. That too is part of the ecstatic nature of the self-transcendence of life. (1977, 33)

Pannenberg attaches great importance to time, and specifically to the analysis of the concept of the future, in his larger intellectual project of relating theology and history in a hermeneutical method (1976). As a foundation to his eventual discussion of history, Pannenberg's description of the dynamics of life necessarily involves time:

A particular aspect of this ecstatic character of life is to be found in its relation to time: every organism relates itself to a future that will change its present conditions. (1970b, 18)

Reaching beyond the present in anticipation of the future is the distinctive action of living creatures which exhibit temporal self-transcendence.

Both forms of ecstatic self-transcendence, ecological and temporal, are characteristic of life. Where life exists, these self-transcendent activities are manifested.

.
Self-Transcendence in Animals Other Than the Human Species

Up to this point the ecstatic self-transcendence as a property of all creatures has been the theme. Pannenberg especially strives to understand self-transcendence in animals just below *Homo sapiens* on the evolutionary scale because of his concern to differentiate the uniqueness of humanity. To do this he must first establish the foundations of animal behavior in order to then distinguish it from human behavior.

Animals are Bound to an Environment

The research materials and the theoretical models which Pannenberg explores in his study of animal behavior are those of modern ethology. Konrad Lorenz, the "leading contemporary German student of behavior," holds a modified Kantian view which claims that "the experience of all living things is in like manner preformed by the form of their organs." This means that "every animal has its innate behavioral pattern" (1985, 31; 32). The field of ethology has widely adopted this conclusion. Because of innate behavioral patterns which precede all experience, every animal experiences its environment in a specific, predetermined way. In addition to Lorenz, Pannenberg also calls on the authority of the eminent biologist Jacob von Uexkull to confirm this point of view. Pannenberg summarizes this perspective:

Thus the concept of environment *(Umwelt)* does not refer in Von Uexkull and subsequent writers to the actual "surroundings" *(Umbedung)*, with all the multiformity we know them to have, which the animal in question lives. Rather, the environment of an animal is the subjective perspective, the subjective sector of the world, that is defined by the set of features to which the animal reacts according to its species, that is, according to the innate behavioral schema of that species. (1985, 34)

Animals are bound to an environment. They are entirely dependent on the environment. Even the instinctual behavioral patterns must be stimulated through "releasing mechanisms" which are factors in the environment. Being embedded in an environment, all animals, even higher forms, lead a specialized and prefixed existence.

Limited Self-Transcendence of Animals

Nevertheless, according to Pannenberg, there is a sense in which animals, especially higher ones, display a type of self-transcendence. The concept of ecstatic self-transcendence of all life is defined as a radical entering into, or dependence on, the environment. Also, beyond this fundamental sense of self-transcendence, the higher animals are conscious of other animals. This being conscious of others is a step toward self-consciousness which appears in rudimentary form in the behavior of many animals. Even so, Pannenberg claims, animals are apparently not capable of recognizing other animals as "distinctly other than themselves" (1985, 61). It is the ability to recognize the quality of 'otherness' which seems to be absent from animal consciousness.

Pannenberg places some clear limitations on the self-transcendence capacity of animals in terms of reflective thought, language, creativity, play, and a sense of time (1985, 62). Pannenberg does not allow animals any more than "a momentary consciousness in connection with perceptional activity" (1993b, 150). Within some definitions of mind this "momentary consciousness" would qualify as mind, but the function of "self-conscious mind" Pannenberg does not attribute to animals. Because "self-conscious mind" and language are inseparably connected for Pannenberg, animals are denied authentic linguistic capacity. Freedom to create an "intentional" response to the environment is not specifically discussed in Pannenberg's account of animal intelligence, but he implies that intentionality is not a feature of animal life.

Play as an Expression of Self-Transcendence

There is a slight hesitation with respect to this strong position when Pannenberg discusses play among animals. It is here that animals seem to possess a capacity for objectivity, "for dwelling on the other as other." Pannenberg, in agreement with Johan Huizinga, interprets play as the basis of culture. For Pannenberg, playing also forms the biological basis of all the free and creative activity of individuals. This claim becomes all the more important when he says that "the play impulse is something that the human child has in common with the young of many higher species of mammals, who can be observed

playing" (1985, 322). If animals are genuinely 'playing', and if playing also forms the biological basis of all the free and creative activity of individuals, then the question can be asked: Are not animals capable of free and creative activity? Pannenberg's negative answer depends on the accuracy of the observation that play is not a stable pattern of behavior for animals:

> By reason of its open-endedness and freedom of movement the play of young animals is comparable in principle to human openness to the world, as Lorenz emphasizes. The difference is that the openness and plasticity of the behavior of young animals disappear as soon as they mature. (1985, 323)

What appears as an openness within a short period up to animal adolescence soon is closed off by other drives and instinctual patterns of behavior. Therefore, Pannenberg concludes that:

> This element of self-transcendence is not yet achieved in the life of the higher animals, at least not as a way of life, even if there is a hint of it in the play of young animals. (1985, 62)

Thus, play almost forms the missing link between animal and human behavior, but becomes, instead, a distinguishing feature between humans and animals.

Animals Are Unconscious of Temporal Self-Transcendence

Pannenberg claims that animals have no capacity for time awareness "because they live wholly in the present moment, ignorant of both future and past" (1985, 61). In the first part of this essay Pannenberg was reported as saying that ecstatic self-transcendence of all life had a temporal component. Furthermore, "by its drives, every living creature is oriented (though not always consciously) to its individual future and to the future of its species" (1977, 33). To say that animals do not relate to time with memory or anticipation is a claim which reduces the experience of animals to the present moment and denies them a sense of history.

In summary, animals demonstrate behavior which is evidence for a strong dependence of each organism on its environment. Innate behavioral patterns, although derived from the structure and function of organs, are still strongly influenced by the environment. In the close fit between organism and environment the organism has little influence on its environment while the environment determines much of the organism's behavior. Animals live in a closed world of organism-environment interaction. The ecstatic self-transcendence of

animal life is limited to an obligatory entering into the predetermined portion of the ecosystem which is selected by species specialization.

· · · · · · · · · ·
Uniqueness of Human Self-Transcendence

In attempting to define the unique features which distinguish humans from other animals, Pannenberg employs the thought of Max Scheler, the founder of philosophical anthropology. Scheler defined the uniqueness of humanity in the concept of "openness to the world" (1985, 34). Philosophical anthropology is the discipline which arose in the early part of the twentieth century as a search for a comprehensive definition of the human phenomenon. 'Openness to the world' is the organizing metaphor, used widely by philosophical anthropology, to explain the unique qualities of human behavior.

Openness to the World as Ecological Self-Transcendence

'Openness to the world' radically redefines the closed organism-environment relationship. Lower forms of life are narrowly open to a predetermined portion of environment. The human form of life is widely open and capable of transcending the environmental conditions to such an extent that the range of possibilities for behavior is very large. In Pannenberg's words:

> Man is not bound to an environment, but is open to the world. That means he can always have new experiences that are different in kind, and his possibilities for responding to the reality perceived can vary almost without limit. (1970a, 5)

This implies a broad adaptability to all environments, and the capacity to create new environments with astonishing novelty. 'Environment' needs to be understood here in its social-relational, cultural, and physical aspects.

The phrase 'openness to the world' needs to be further explored in two directions. The first direction is in search of the source of this unique human capacity, and the second direction is toward working out a phenomenological description of human self-transcendence which is the result of openness to the world.

Origin of Human Openness to the World

The origin of human openness to the world will be located on the boundary between animal and human life forms. Pannenberg lists the following features which distinguish the human organism from other animals, and which, he claims, are the conditioning sources of open-

ness to the world: "a reduction in instinct, the primitive condition of human organs, an unfinished state at birth, and a lengthy period of maturation" (1985, 61). These conditions lead to minimization of the human organism's dependence on a specific environment, and to a maximization of the ability to adapt to a wide variety of environments, or even to create new environments.

The reduction of instinct in humans is critical to Pannenberg's model which allows for only a meager degree of behavior being neurologically programmed by what he calls "innate behavioral schemata":

> If there are innate behavioral schemata in the human being, then they exist only in a singularly rudimentary and attenuated form. They influence the free play of human behavior in only a small degree. (1985, 34)

Openness is not itself an instinctual function and instinctual behavior must be marginalized for the expression of openness.

The claim that human organs are in a primitive condition of nonspecialization derives from the observations of an anatomist, Ludwig Bolk, who had a significant influence on the cultural anthropologist Arnold Gehlen. Bolk interpreted human organs to be relatively unspecialized and, therefore, more adaptable to a wide range of environments. This idea was nurtured through the impressive dominance of Gehlen over the anthropological literature during the mid-twentieth century (Gehlen 1988). This particular notion has survived and flourished despite the convincing exceptions which have witnessed against it.

The incomplete development at birth refers to all organs, but in particular, when the focus is on behavior, it refers to the central nervous system. The plasticity and growth potential of fetal brain tissue is an empirical observation which has led some neuroscientists away from the idea of innate neural programs pre-established at birth, and toward the strong influence of stimulating input on the structure and function of the developing brain. This physiological immaturity is interpreted by Pannenberg to mean that "a human being is already exposed in the final stage of development as an embryo to the influences of a social environment" (1985, 38). This physiological immaturity continues after birth and allows for openness to the world to be intensified during infancy and childhood.

The long maturation period of the human person permits the continuing influence of the environment on the structure of behavior. The cultural molding of psychological structures is made possible by a lengthy period of learning which is required to fill the void left by the attenuation of innate behavioral schemata. Since "the human by nature is a cultural being" it appears that once this openness becomes

established, subsequent physiological maturation does not diminish its expression (1985, 41).

These four ideas of instinct reduction, unspecialized human organs, plasticity of tissue in early life, and the lengthy enculturation period before adulthood, Gehlen combined into a single concept of the human as a 'deficient being' (Pannenberg 1985, 39). Gehlen took humanity's basic task to be a compensation for the deficiencies of the species through the formative power of language and culture. These deficiencies of the human being, rather than a barrier to a flourishing of the species, are the very conditions necessary for the survival success, through openness to the world, of the human species.

Pannenberg, although ready to strongly affirm the thought of Gehlen as the "classical form of modern philosophical anthropology" (1985, 40), is quite aware that his conclusions are not universally accepted:

> Criticism has been directed first of all at Gehlen's concept of human beings as deficient beings. Thus Portmann, implicitly dissociating himself from Gehlen's view, has pointed out that "the relative weakness in the organization of instincts" in human beings is accompanied by "an immense increase in the mass of the cerebral cortex and its synapses." Nor should the slow pace of human development be seen only as something negative; rather, it is correlative with the peculiar psychic nature of human beings as beings with a social culture. Criticism has been directed not only at Gehlen's one-sidedly negative interpretation of the initial human biological condition but also at the concept of openness to the world. (1985, 40)

It does appear that there is not a stable consensus within the discipline of philosophical anthropology on the origin, extent, and meaning of 'openness to the world'.

Plessner challenges the unqualified concept when he claims that "an unlimited openness to the world cannot be ascribed to human beings." Pannenberg is ready to grant Plessner's thesis "that our openness to reality is a halting openness because of the limited and partial ways in which we grasp the real" (1985, 41). Pannenberg confirms this qualification of openness when he admits that:

> According to contemporary research, and contrary to the thesis of an unlimited human openness to the world, human beings do in fact have innate behavioral dispositions, as can be seen especially in the behavior of infants whose weeping, smiling, clutching, sucking and babbling are based on innate behavioral schemata. (1985, 41)

Nevertheless, Pannenberg insists along with Gehlen that human beings are by nature cultural beings for whom the main structure of behavior is learned and acted out in intentional freedom. Self-transcendence is synonomous with intentional freedom as Pannenberg suggests in this reference:

> The presence of innate behavior dispositions does not mean, therefore, that these surround human behavior with insurmountable barriers and thus determine it. These dispositions set no definitive limits on 'freedom' and on the human capacity in principle to alter and transcend the antecedent conditions of the human situation. Innate behavioral dispositions, rather, designate, as it were, the place that is the abiding point of departure for the human adventure of self-transcendence and historicity. (1985, 41)

Therefore, in Pannenberg's thought biologically programmed behavior has a minor role to play in human action because when that minor role is exhausted the major function of self-transcendence works through intentional freedom to create human action in historical participation.

In summary, the conditions for the emergence of this 'openness to the world' are the reduction of instinct, the nonspecialization of human organs, the immature and plastic nature of the infantile organs, and the long period required for maturation. By reduction of biologically programmed behavior, the outcome of the long period of enculturation is the learning of intentional action patterns.

Human Self-Transcendence as Exocentricity

In his description of the phenomenon of self-transcendence, Pannenberg is satisfied to retain the deep metaphor of 'openness to the world' in spite of the difficulties of maintaining a fully focussed definition of the terms of the phrase. The nearly synonymous relationship between 'openness to the world' and 'human self-transcendence' is affirmed by Pannenberg:

> The concept of human self-transcendence—like the concept of openness to the world which is to a great extent its equivalent— summarizes a broad consensus among contemporary anthropologists in their effort to define the special character of the human. (1985, 63)

This broad consensus on a special character of the human has led to a number of specific descriptive statements, but one of the most instructive is that of Helmuth Plessner who has crystalized this discussion about transcendence of self in the image of 'exocentricity'.

Exocentricity is the distinctive feature of human "ex-istence" which means the experience of self as located outside of self. This implies "distancing from" and objectification of the self. Pannenberg affirms Plessner's concept of 'exocentricity', and claims that "in the essential structure of the human form of life exocentricity is . . . the most generalized and to that extent fundamental characteristic of the properly human." Pannenberg further connects exocentricity to openness when he declares that "it is advisable to join Plessner in taking the concept of exocentricity as a way of describing behavior that is open to the world" (1985, 63, 66, 71). It is possible to shift the primary metaphor from 'openness to the world' to 'exocentricity' and on to 'self-transcendence' without losing or distorting the meaning which these terms have in common.

As mentioned above, the ability to 'distance', or to imaginatively create an 'ec-stasis' (standing along side), is the principle function which a self-transcending organism must be able to accomplish (1985, 71). Pannenberg notes that Plessner firmly supports this interpretation:

> Plessner effects the transition from the centralism of animal life to the exocentricity of human life by raising the question of the conditions required if "a living thing be given its center [outside itself]" and he finds that for "the givenness of a subject to itself: the basic condition is that it is able to distance itself from itself." (1985, 63)

Distancing from, or objectifying oneself, is the function made possible by the human capacity for exocentricity.

Exocentricity as Self-Relatedness

As a consequence of distancing, a crucial pair of inter-relationships is obtained. The first interrelationship is the capacity for self-relatedness. To objectify one's self is to be conscious of self, or, in an appropriate technical term, to be self-consciousness. Self-relatedness, or to have a sense of self, is a distinctly human capacity which is not shared by other animals as far as this can be known. There are primate studies which suggest that a rudimentary sense of self can be implied from experimental conditions, but there appears to be no self-consciousness contributing to the behavior of animals other than the human species.

Pannenberg confirms that consciousness is fundamental to self-transcendence, and he reserves the term 'self-consciousness', or 'the self-conscious mind', as the "intensified form of self-transcendence" (1970b, 19). This intensified form of self-transcendence, or mind, is

capable of multiple functions of cognition, such as abstraction, information processing, language, imagination, time-sense, choice, and intentional action.

Exocentricity as Relation to the Other

Closely related to self-consciousness is the second crucial inter-relationship: the ability to be present to what is other than self. Pannenberg reaffirms what was claimed by Max Scheler: "Human beings are natively always already present to *what is other than themselves*" (italics in the original) (1985, 61). It is uniquely human to be able to objectify the other as different from the self:

> Human beings are present to what is other *as* other. When they attend to an object, they are conscious of its differentness, its otherness. And in one and the same act I grasp the otherness of the object not only in its difference from me but also in its distinction from other objects; thus the object is grasped in its own special determination. (1985, 62)

Because of the unique human capacity for self-transcendence of a certain level of intensification, the individual organism is able to be conscious of the other, and, at the same moment, be conscious of that consciousness. Like a conscious third observer the self in self-consciousness is able to transcend the relationship of self and other, and be aware of self and other in the relationship.

This capacity for objectifying both self and others is the unique mark of humanness which has been throughly described by the philosophical schools of phenomenology and existentialism. Scheler, and earlier Kierkegaard, called this capacity the central feature of the human spirit.

.
Openness to the World as Temporal Self-Transcendence

Thus far the description of openness to the world has been in terms of the ecological type of self-transcendence. This is expressed in terms of the relation of self to itself and of the self to that which is other. The temporal type of self-transcendence is of particular importance to Pannenberg because of the emphasis of his theological project on history and the future.

Consciousness of Time

Human self-transcendence entails consciousness of time in the dimensions of past, present, and future. Awareness of the present

moment transcends the memory of the past, and anticipation of the future transcends the awareness of the present. Pannenberg claims that all organisms have a temporal dimension to their self-transcendence, but only in humans is this intensified to consciousness:

> It is, however, in its temporal structure that the peculiar nature of the ecstatic self-transcendence found in all living things emerges most clearly, as does the importance and scope of its modification in human life. All living things are directed by their drives to a future that will bring a change in their condition: to a state of repletion as opposed to hunger and want, but also to dangers that must be avoided. Human beings alone, however, seem able to distinguish the future as future from the present. (1985, 524)

This quality of humans to transcend time is an expression of the exocentricity which is the same mechanism as the ecological type of self-transcendence:

> The time spanning present that is peculiar to human consciousness has an ecstatic character. It is an expression of the specifically human being-present to the other as other, an expression of the exocentricity of the human mode of life. (1985, 525)

This time spanning capacity gives the human consciousness a quality of unity and continuity which allows the individual to experience the flow of time with a sense of wholeness.

Anticipation of the Future

Human beings have the capacity to bridge over the distances of time into order to maintain a sense of continuity and especially to anticipate the future:

> Human beings are thus set apart by the development of a consciousness that bridges time, cancels (within limits imposed on it) the distinction of things and times, and sublimates this in the unity and continuity of its own present, thus giving a presentiment of eternity. The continuity of this time-bridging consciousness derives from anticipation of the future. (1985, 525)

The anticipation of the future has a special priority for Pannenberg because of the importance which the future has for creating the individual's sense of identity, and for determining the meaning of history:

> This movement [identity formation] derives its unity from the future by which it will be completed. Therefore only through

anticipation of this future can human beings presently exist as
themselves . . . The identity of their present existence presup-
poses not only their personal future but also, in a way, the
future of their people and their world and even the future of all
humankind, since individuals are inseparable from their world.
(1985, 527)

However, as much as Pannenberg emphasizes a hierarchy of time
with a priority for the future, he is firm on the idea that humans expe-
rience life with a sense of temporal wholeness:

The only thing specific to human beings is the way in which the
whole of their life is present to them, namely, in the explicit dis-
tinction and simultaneous interrelatedness of its successive
moments. (1985, 261)

This consciousness of time makes available to human beings a rela-
tionship to their life as a totality. Remembrance, presence of the
moment, and anticipation are the three modes of time experience
which constitute temporal self-transcendence.

The Historical Dimension

Pannenberg has elevated the historical dimension to the highest
level of integrative function for his fundamental anthropology. Sur-
passing biology, psychology, or sociology, "historical science
approaches more closely to the concrete reality of human life than
does any other of the anthropological disciplines." In relation to these
disciplines, historical science "absorbs them all into itself as partial
aspects" (1985, 22). Human life takes concrete form in history. There-
fore, "the science of history and historiography come closest to grasp-
ing human reality as it is experienced" (1985, 485).

Pannenberg's attention to historical science for the construction of
a fundamental anthropology derives from the fact that "history is the
element in which human beings live their concrete lives" (1985, 486).
Without a serious consideration of the historical process in which the
life of an individual, and its embedding socio-cultural context, is
lived, an anthropology could not fully account for the formation of
human beings. Although there is more to be said about history in
terms of the unfolding of the world, in this context of the individual it
can be described as the "process of identity formation" (1985, 511).

Pannenberg now expands the entire discussion of human self-
transcendence into the broad horizon of the formation of the indi-
vidual person within the environment of society and culture.

· · · · · · · · · ·
Human Self-Transcendence and the Formation of Self and Society

Parsons's Social Process

The principle social science framework upon which Pannenberg conducts his analysis of self-transcendence is that of Talcott Parsons. A simplified version of Parsons's triangular model inter-relates personality, social structures, and culture as the three dynamic poles of the social process. In Parsons's words, "Concrete systems of action—that is, personalities and social systems—have psychological, social, and cultural aspects" (1951, 7). The personality system, or psychological aspect, consists of internalized needs and dispositions as well as motivations to various goals and patterns of behavior. The social system, or structure of social organization, consists of defined roles and institutionalized role-expectations. The cultural system consists of the heritage of knowledge, beliefs, customs, laws, values, and the artifacts and language which symbolize the system. No one of these systems is entirely independent of the others. The cultural system is the major binding element in Parsons's strongly influential model.

Pannenberg confirms his acceptance of this approach by applying it to his analysis of basic human dynamics:

> The self-transcendence of human world-openness and eccentricity [sic] . . . is just as fundamental to the individual's quest for his individual identity as to social life and its institutions, and not last to the creation of a cultural world on the basis of a symbolic world of meaning and language. (1977, 37)

These three poles can be separated for the purpose of analysis into the categories of individual personality theory, the functional dynamics of social institutions, and the integrative role of meaning systems at the cultural level. This section will provide an introduction to Pannenberg's perspective which claims that human self-transcendence is foundational for each of the three poles of the social process.

· · · · · · · · · ·
The Personality Pole of the Social Process

Examination of the personality pole of the social process will take up the themes of identity and nonidentity, and the interrelationship of ego, self, and person. Not all aspects of Pannenberg's extensive analysis are reviewed, but those which are discussed here are fundamental

to his understanding of the human being as a social product formed by the dynamic capacity for self-transcendence.

Centrality and Exocentricity

The development of the individual follows from the polarity of centrality and exocentricity which is the "basic structure of the human life form" (1985, 80). Centrality is Pannenberg's term for the apparent fact that each individual experiences the world from the center of an embodied self. One aspect of centrality is the ability to perceive the environing world by taking it in through the sensory system and constructing a representation of it in the interpretive centers of the cerebral cortex.

Another example of centrality is human movement which, in response to the environing world, tends to be organized from the perspective of the personal center of the individual. The human agency, which perceives and organizes response to the world, operates from the position of centrality. This requires a highly complex central nervous system with its specialized mental apparatus. This complex nervous system which organizes centeredness is the same biological mechanism which makes possible the exocentric capacity of the human being. Exocentricity is the unique human characteristic which allows the individual to stand outside of its centered self and to be related to self and to others. The individual personality develops in the tension created between the poles of 'centrality' and 'exocentricity', or in other words, centeredness and transcended centeredness.

Ego and Self

In Pannenberg's search for the central forms of humanness, he intensely explored the psychological schools. Ego psychology became a special interest. This school, as represented by Heinz Hartmann and Erik Erikson, has speculated that there is a "primary ego nucleus" which, having the functions of perception, movement, and memory, is the organizing force of the developing personality (1985, 196). This mainly unconscious ego develops according to its own epigenetic schedule which has its origin in the biological dimension. The ego changes over time as it evolves through the life stages, but is little affected by the social environment. As the ego encounters the social environment, it gradually synthesizes a sense of self out of the interaction between the ego and the embedding social forces. This self is the representative image which the individual is conscious of, and which constitutes the individual's self-consciousness. The most common

understanding of the relation of ego and self which ego psychology has elaborated is that the enduring ego synthesizes the transient self from the input of social factors.

Pannenberg rejects this conclusion of ego psychology. Without referring to the modern schools of self-psychology, Pannenberg recasts the ego-self relationship and claims that both the ego and self are the creations of social forces, and that, as such, they exist only in the moment of the interaction. Ego for Pannenberg's model is not the enduring primary nucleus of the personality. Instead Pannenberg interprets the ego as a momentary structure produced as a result of the encounter of the individual with the social environment. In his words:

> The ego is not the continuously existing subject of my individual development, a subject that is always present behind all changes in consciousness and gives ever new definitions of itself in the process of its identity formation, but is not itself changed thereby. Rather, the ego is primarily tied to the moment and receives its continuity and identity only in the mirror of the individual's developing consciousness of itself as the totality of its states, qualities, and actions. (1985, 221)

Both the ego and self are momentary products of social forces but the self is more enduring than the ego in Pannenberg's psychological account.

The initial stage of development of an individual's self structure is the breaking of the symbiotic solidarity which the infant experiences with its mother. In this transcending movement the self "shows itself to be constituted by the symbiotic exocentricity of the individual." In this way Pannenberg proposes that the self arises from the experience of the other and cannot be present until the other is differentiated by means of a self-in-transcendence. The capacity for "self-reflection is derived from a being present to the other." This is a profoundly relational self-psychology based on the exocentric capacity for self-transcendence. Pannenberg summarizes his self psychology in this way: "the cohesion and the unity of the individual's life history are based on the self, not on the ego" (1985, 187; 222; 237). With the relationship of ego and self reversed it is now clear that the ego and the more enduring self are both social products formed in the encounter with the environment. In this way the individual personality is radically dependent on the social dimensions of the environment. The movement of human self-transcendence actualizes this radical dependence on the social environment.

Process of Identity Formation

Pannenberg characterizes human development as a process of identity formation. Bringing into a unity the ego and self is the process of identity formation. Pannenberg's use of the term 'identity' tends to fuse together at least three ways in which the concept has been employed in philosophy, psychology, and theology. In his terminology, identity at times refers to the philosophical problem of continuity of sameness from one moment to another. At other times Erik Erikson's designation of identity as the image of self which derives from the society's definition of who the self is becomes the principal meaning of identity. When a more theological connotation is implied, identity is synonomous with the human destiny for communion with God. These divergent usages of the term could be defined as three forms of identity. Identity I would represent the problem of continuity of sameness. This form of identity is concerned with how the self experiences itself to be the same self from moment to moment in the temporal flow of historical process. Identity II would represent the problem of unity of personality. This form of identity is concerned with how the unified personality achieves a coherent wholeness by integrating the two aspects of ego and self. Identity III represents the human as being in communion with God or being in the image of God. This form of identity points to the normative standard of the image of God and claims that identity is a unity with the 'true self' which humans are destined to become by the divine creator. This wholeness of personality is achieved when the three forms of identity are unified into one identity. When the sense of self, the self and the ego, and the true self are unified, then an individual experiences self as whole self.

Nonidentity as Incomplete Identity

Nonidentity is an expression of a broken continuity at any of the three levels of identity. Nonidentity is a loss of the sense that I am myself enduring in time. In nonidentity there is separateness between the ego and the self and between the individual and others. This nonidentity is further expressed as an alienation from the true self which makes the individual experience guilt as either anxiety or depression. Nonidentity is the condition which appears when there is incoherence, or disunity, which fragments the wholeness of the human person.

Separateness, alienation, and disunity are all terms which Pannenberg uses to describe the concept of sin. The refusal of the individual to be what they are destined to become as the image of God is a

refusal to complete the task of self-transcendence. The task of self-transcendence is to break free of the organismic preference for centrality as being bound-to-self and to fully extend the organismic drive to exocentricity as being beyond-self. The preference for being bound-to-self is in tension with the drive for being beyond-self; in other words, centrality is in tension with exocentricity. The resolution of the tension is achieved in the wholeness of full identity as the image of God. Any condition short of resolution is sin, or nonidentity.

Identity formation is, at any time, incomplete because it is a continuing process of self-transcendence. Pannenberg describes the incompleteness in these terms:

> The constitution of the self is not simply given in advance but is, rather, acquired only in the very process of human behavior itself. This process is one of identity formation. (1985, 159)

The historical existence of an individual human is the context for this identity formation. Part of the process is contributed by actualized historical moments, and another part of the process consists of the anticipated future self which is to be the final human destiny. The analysis now moves closer to Pannenberg's inevitable involvement of the theological perspective on human self-transcendence. His concept of person takes one step closer to the theological perspective.

Concept of Person

The relationship between self and ego Pannenberg expresses by his unique use of the term 'person'. He does not use 'person' in its older definitions which favored some feature, such as rationality or intentionality. Instead, he uses a compound relational-temporal concept in the following definition: "Person is the presence of the self in the moment of the ego" (1985, 240). These terms require explanation for understanding Pannenberg's intention to interpret person as a special type of relation between self and ego.

First, it is his persistent claim that "each of us is an ego at every moment of our existence" (1985, 240). Furthermore, the ego is restricted to that moment of existence and has no endurance. This does not negate the importance of the ego, but it debars the ego from being the locus of identity.

Second, we are always becoming our selves due to the incompleteness of our biographies. In Pannenberg's words, "we are still becoming our selves because we are still on the way to our selves in the wholeness of our existence." None of us are complete in our self

identity at any moment of our historical experience. Nevertheless, "we are also somehow our selves at the present moment" (1985, 240). In trying to capture a larger sense of self, he uses the term 'person' to indicate that there is "the presence of the self in the moment of the ego." Pannenberg's summary is helpful:

> The word 'person' establishes a relation between the mystery—which transcends the present of the ego—of the still incomplete individual life history that is on the way to its special destiny and the present moment of the ego. Person is the presence of the self in the moment of the ego, in the claim laid upon the ego by our true self, and in the anticipatory consciousness of our identity. (1985, 240)

Person describes the presence of the self in the moment of the ego. But reference for this present 'self' is to a conflation of Identity I and Identity II, the accumulative but incomplete life history, as well as to Identity III which is the true self defined as a special destiny of humanity to be in communion with God. This final wholeness as being in God can only be anticipated. This is the difficult aspect to understand about Pannenberg's unique inclusion of the future self in the present self. If this eternal dimension of the 'true self' of Identity III is conceived of as being anticipated and incorporated into the 'self' which is present in the now-moment of the ego in transition, then 'person' becomes more than a product of the social and cultural environment. This use of the term 'person' goes far beyond its common use to designate a mask with which individuals encounter the world, or the more philosophical use as a designation of the rationality of humans. 'Person' now becomes for Pannenberg a religious concept. 'Person' becomes a term which represents the still unfinished history of individual selves as they are on the way to becoming their true selves in their divine destiny. Here Pannenberg comes close to equating 'person' with the concept of 'the image of God' which is a complex symbol for the true self each of us is to become as our authentic human destiny (1985, 242).

• • • • • • • • • •
The Societal Pole of the Social Process

The theme of human self-transcendence is also represented in Pannenberg's analysis of the functional dynamics of social institutions. Since his principal objective is a 'foundational anthropology' rather than a complete sociology, Pannenberg does not attempt to address all the issues related to the social process (1985, 21). He considers the rela-

tionship of the self-transcendence model to the origin and purpose of social institutions, and concludes that, without the cultural dimension of religion to provide a unity of meaning, modern social structures are inadequate for the task of defining and maintaining authentic human identity.

The origin of social institutions is located for Pannenberg in the needs of human individuals. Without social structures basic needs cannot be satisfied. Therefore, the origin and purpose of social institutions are fused together, according to Pannenberg, as a regulatory function:

> The purpose of institutions seems to be rather, to regulate relations among individuals in connection with the satisfaction of their basic human needs but also in connection with the secondary needs that attach themselves to the basic needs. (1985, 411)

It is the "reciprocity of relations between individuals" which is "the theme of all institutionalization" (1985, 412).

Pannenberg has devised a formal structure of human behavior which is based on the centrality-exocentricity polarity introduced previously. He relates another polarity, 'particularism and mutuality', to the fundamental egocentric and exocentric movements of the human being. He explains that "we are dealing here with an aspect of the exocentricity of human behavior" (1985, 412). Particularism represents the tendency of humans to remain centered in themselves and mutuality represents the tendency of humans to relate to the social field surrounding them. Pannenberg offers the following description of the formal structure:

> Reciprocity (correspondence) in the behavior of individuals (a phenomenon rendered permanent by being institutionalized) binds together the formal structural elements of particularism and mutuality that are found in this behavior. For, on the one hand, individuals seek to assert themselves against others. This is the element of particularism [centrality]; it cannot by itself be the basis of a lasting relationship. Permanence arises only when to particularism is added the element of mutuality [exocentricity], which motivates individuals to adapt themselves to others. (1985, 412)

This reciprocity is the polar structure of particularism and mutuality which exists in any relationship. It is the function of institutions to contain this polarity in a balanced tension which allows for the maintainence of the individual in the social field.

In further defining the outlines of this interpretive schema, Pannenberg suggests that the 'family' and 'property' are the two prototypical social institutions which together represent the poles of mutuality and particularism. In these two basic institutional forms all other institutions "find their purest and most original embodiment" (1985, 413). The institutional form of property represents the centrality, or particularism, pole, while the institutional form of family represents the exocentricity, or mutuality, pole. In this way Pannenberg has maintained in the analysis of social structures his basic schema of the ecstatic self-transcendence of all life, and especially the features of self-transcendence which are of the kind that are unique to the human species.

There is one other aspect to Pannenberg's exposition which should be considered. In his account "institutions are abiding, meaningful forms of human coexistence." It has been established by Pannenberg that there is a strong tendency for most human individuals to "look outside themselves for what will give unity and identity to their lives." He makes the stronger claim that "human exocentricity compels men and women to find outside themselves a center that will give unity and identity to their lives." However, given Pannenberg's point of view that modern social institutions have steadily lost their legitimacy of meaning, it becomes apparent that "if individuals seek to achieve their identity directly through their social life, they will consistently overtax the capacities of the institutions of communal life" (1985, 406; 408; 480). In Pannenberg's opinion the social structures cannot bear the weight of providing the meaning for authentic humanity destiny. Only religion can supply this meaning. The final section will return to this theological theme.

· · · · · · · · · ·
The Cultural Pole of the Social Process

The exocentric features of human behavior are manifested in social institutions and in the symbolic structures of culture. The relationship of individual personalities and their society is properly expressed as the "superiority of society over its individual members" (1985, 318). The relationship of the social network of institutions and that society's cultural forms is described by Pannenberg who is here following Parsons:

> The unity of society needs for its establishment the foundational order of values that is supplied by the cultural system. It is for this reason that Talcott Parsons distinguishes the cultural system from the social system and gives the former priority over the latter. There is need, therefore, of a third level which is distinct from individual and society and on which the symbolizing

activity of the individual is related to the foundations of social life. (1985, 319)

'Culture' is here defined as "the specifically human form of common life" which is "constituted by the concept of a shared world." This shared world is further defined as "the reorganization of nature that we call culture" (1985, 315; 339). The human is so constituted that it is possible to accept Gehlen's claim that "human beings are by nature cultural beings." It is in the analysis of the "symbolizing activity of the individual" that interpretation of culture can proceed.

Defining culture is a rigorous exercise. Pannenberg has made a list of elements that should go into a model of culture:

> These include subjective factors such as convictions, attitudes, types of knowledge, and values, as well as modes of behavior, habits, and customs; in addition, language and tradition, skills such as the use of tools; specific types of dwellings and clothing; and, finally, art and other products of human activity as well as social institutions. (1985, 315)

Apart from this general consensus there is a divergence into a variety of theories about culture. As a minimal definition the shared world of culture can be laid upon the foundation of play, intelligence, and language, all of which are "symbolizing activities."

Play as a Basis for Culture

It is Huizinga's thesis that culture in all its forms has its origin in play. Pannenberg is willing to accept Huizinga's interpretation of culture in terms of the phenomenon of play as the most satisfactory theory. According to Pannenberg, "play is closely connected with specifically human intelligence and with language." Basing his ideas on this thesis, he further claims that "cultic play is the organizing center of the shared human world and of its unity." He directly links play and human self-transcendence: "In play, human beings put into practice that being-outside-themselves to which their exocentricity destines them" (1985, 338, 339). Pannenberg also relates the freedom of play to the "principle of human openness to the world." Play, therefore, is a primary expression of human self-transcendence.

Language as a Basis for Culture

Language receives a complex analysis by Pannenberg who has settled upon the conclusion that "the development of intelligence and thought is phylogenetically prior to the acquisition of language." Even

so, "it is also true . . . that the passage to the use of predicative language must have promoted the further development of the capacity for thought" (1985, 353). Pannenberg has tended to favor the notion that mind, as self-consciousness, developed in evolution as a consequence of language, and that in individual development language precedes thought. He is ambivalent on this point, but, in any case, he has closely related language to human self-transcendence and to the creation of culture.

Rational Thought as a Basis for Culture

Reason, or thought, is the third aspect which Pannenberg relates to the foundation of culture. Since it is not my purpose to summarize cognitive psychology, I will concentrate on Pannenberg's account of imagination as the aspect of thought which especially is a manifestation of the uniquely human level of self-transcendence. Thought is characterized by Pannenberg as a means by which individuals may respond to their environment. In this passage, Pannenberg grounds thought in exocentricity:

> Human beings are indeed turned primarily to the objects of their environment. Nonetheless, as exocentric beings they develop at an early stage (to wit, at the transition from the first to the second year of life when their bodies become integrated into the space containing objects) a reflective relation to themselves and thus also the ultimate comprehensive unity that renders possible their conceptual categorization of things. (1985, 384)

The "conceptual categorization of things" is, in part, an act of cognition which is usually considered rational. It is the capacity for the "conceptual categorization of things" which is basic for thought as a means of creating order and meaning by naming and interrelating environmental objects (1985, 384).

Imagination as a Basis for Culture

Imagination is a manifestation of exocentricity as it transcends the perceived reality and organizes it into a meaningful whole. The organization of reality into a meaningful whole results in the creation of culture as the "reorganization of nature." The imaginative construction of cultural myths is intended to order and explain the entire cosmos and each object and event within the cosmos and its history. The success of this cultural creation is measured by the stability of the

meaningful whole from which individuals derive their own identity. It is because of the deficient nature of human beings that they must create their own identity by first creating a cultural system from which they may derive their self system. This leads to a question of logical priority which Pannenberg expresses this way:

> It seems obvious to cultural anthropologists that in the final analysis human beings have created the system that makes up their cultural world, but social psychologists also regard as evident the thesis that the identity of individuals is the product of their social and cultural environments. (1985, 163)

Through the symbolizing activities of play, language, thought, and imagination, the human being creates culture. The created meaning system remains transcendent to the individual human being, and becomes the ideological content which is incorporated into the identity of the self through the exocentric movement of the synthesizing ego.

The cultural meaning system is a highly complex construction which, in Pannenberg's account, cannot be maintained without the integrative function of religion. The fact that "religion has for its object the unity of the world as such in relation to its divine source" makes theological considerations essential to the understanding of culture (1985, 473). Pannenberg thus maintains his constant method of interpreting anthropological data from a theological perspective.

Human Self-Transcendence and Divine Transcendence

In order to firmly connect human self-transcendence to divine transcendence, it is helpful to review the way in which Pannenberg connects ontology with theology in his intellectual project. Pannenberg's method has been to endorse the secular scientific explanation of the world, including the human, as being a "provisional version of objective reality", and then to proceed to demonstrate the theological dimension which, in his judgment, completes the explanation (59).

.

Field and Contingency

In discussing ontology as the general description of reality, Pannenberg employs the basic concepts of field and contingency (1993a). By 'field' he means the interpenetrating network of energetic forces which are woven into relational patterns. Field is a context in which any set of relationships is held in a larger set of relationships. All

aspects of reality exist in fields. No object or event stands alone without connections to the multiple forces of the field in which it exists. Fields overlay and interconnect with one another so that all objects and events are simultaneously existing in multiple fields. Each field is contained within a larger field with a still larger field at the horizon of each field. Fields within fields are arranged in hierarchical order of increasing complexity and inclusiveness until all of reality is contained in the final field of totality.

The partial elements of every field do not exist in themselves but are radically contingent on the supportive influence of the whole field in which each part exists. Without the whole field no part would exist because each part is contingent, that is, dependent on the whole for its existence. This contingency is fundamental to reality and does not allow for any partial aspect of reality to claim independence from the whole which is both its origin and its destiny. From this basic ontological model of the radical contingency of fields it follows that all parts are dependent on the whole. Therefore the totality of all reality determines the form and function of all of its constituent parts.

Theology is concerned with the integration of all parts of the whole into a totality. Pannenberg conceives all parts, or fields, to be ultimately contingent upon God as the final field which determines the totality of reality. He expresses this in the formula: "God is the all-determining reality" (1976, 302).

The Holy Spirit as Field

Spirit is a category which is closely connected in Pannenberg's thought with God as the Holy Spirit (1977). The Holy Spirit is the energetic expression, or manifestation, of God as action. Spirit is sometimes spoken of as a 'spiritual field' which is the source and sustaining power of reality. At other times spirit is spoken of without specific reference to the field model, but implying the concept of field in that the spirit is always understood as the generating, nurturing, integrating influence which makes possible all the manifestations of reality.

In the context of life and its self-transcendence, the spirit is the source of life as well as the creator and maintainer of the 'movement beyond' which causes life continuously to transcend itself. Thus, Pannenberg directly connects spirit to the ecstatic character of all life and the exocentricity of human life.

What follows is Pannenberg's theological interpretation of each of the principal issues raised in the earlier sections of this essay. The out-

come will be a validation of Pannenberg's stated objective for his theological project:

> The aim is to lay theological claim to the human phenomena described in the anthropological disciplines. To this end, the secular description is accepted as simply a provisional version of the objective reality, a version that needs to be expanded and deepened by showing that the anthropological datum itself contains a further and theologically revelant dimension. (59)

The expansion and deepening of the data provided by biology, psychology, sociology, cultural anthropology, and history all combine to reveal the theological dimension.

· · · · · · · · · ·
Spirit and Self-Transcendence

Pannenberg approaches the theological question implied in the analysis of the ecstatic self-transcendence of all life when he inquires as to whether or not this characteristic could be explained without reference to spirit:

> If the self-transcendence of life could be exhaustively explained as an autonomous activity of the living creature, there would be no room for the assumption of a spiritual reality as the source of its life. But if the complex phenomenon of self-transcendent life demands a dual definition, it seems reasonable to speak of the Spirit as the source of life. (1977, 35)

A naturalistic reading of this statement would take it to mean that because the organic structure of a living creature has the capacity for self-transcendence occurring independently of any extra-organismic influence, no additional religious depth to life needs to be postulated. A supernaturalistic reading of the statement would construe it to mean that because the capacity for self-transcendence cannot be completely explained as a naturally occurring function of an organic system, whatever required additional extra-natural influence which might complete the explanation can be identified as God. Pannenberg's third way to read the statement is that a living creature is never autonomous in the sense of being independent of its sustaining environment, and if a sustaining environment is required, one may call that nurturing field 'spirit'. This concept of spirit as the generating, sustaining, and unifying environmental field which is the source of

life is consistent with Pannenberg's definition of God as the all-determining reality.

Living creatures simply reach out to their environments for the fulfillment of their identity and destiny as creatures. Human creatures, because of their openness to the world, must define their identity through self-transcendence since it is not deterministically given in their genetic program. The attempt to define identity is repeatedly a failure because of the egocentric sinfulness of the human being. Yet there is hope for reaching for the goal of authentic identity. In Pannenberg's encouraging words:

> The goal for which human beings are destined is one they cannot reach by themselves. If they are to reach it, they must be raised above themselves, lifted above what they already are. But they must also be participants in the process, and this in interaction with their world and their fellow human beings, who like them, are on the way to their own human destiny. And the harmonious working of all these factors is guaranteed solely by the fact that in all of them God himself, the origin and goal of our destiny to communion with him, is influencing us. (1985, 58)

The entire movement of the human in the freedom of exocentricity is a movement toward God. This movement is not due to any spirit inherent in the human, but, instead, the human participates in the movement of the Spirit. Pannenberg makes this clear in the following way:

> The Spirit is not the individual man but the divine power that makes the individual man alive. The human spirit is not an independent reality of its own, but a mere participation of the divine Spirit, and a passing one. (1970b, 17)

This means that there can be no distinction made between the human spirit and Holy Spirit. It is as if there is a symbiotic solidarity, or a spiritual field, from which the human spirit cannot separate itself and remain spirit.

Pannenberg maintains this same theme when he asserts that every question of the human self is at the same time a question about God:

> In fact, when human beings reach out to a very general horizon [field] embracing all the individual objects of actual or possible perception, they are relating themselves exocentrically to a reality prior to them; in this reaching out they are therefore implicitly affirming at the same time the divine reality, even

though they have not yet grasped this thematically as such, much less in this or that particular form. (1985, 69)

This reaching out is an act of basic trust. As a theme of personality development, basic trust is the enabling courage to break from the symbiotic solidarity with the nurturing environment and to risk transcendence of the self. This basic trust is implicitly trust in the ground of security which alone is able to guarantee safety. This is fundamentally a religious act since "God is the true object of basic trust even in its beginnings" (1985, 231).

.
Identity Formation and Religion

The process of identity formation was described as fundamental to the development of the personality. There are a number of connections which Pannenberg makes between the religious dimension and identity formation. First, identity is established in the basic trust previously mentioned. Without this grounding security, identity confusion, or nonidentity, would prevail. This grounding is extendible into the concept of the social construction of identity. Such an identity is constructed from the ideological belief system of the nurturing culture. Without a belief system expressed as a religious dimension to ground the socio-cultural system, identity formation in the individual is distorted. Finally, authentic identity is to be found only in the theological dimension since true human identity, or destiny, is in communion with God. All of these factors point to the essential function of religion in personality development.

Social Institutions as Fields of Meaning

Social institutions are structures of meaning which work together in a coordinated effort to maintain the meaning of existence. The organized social environmental field is to be capable of defining individual identity by deriving it from the meaning contained in its structures. Pannenberg claims that the field of social institutions has begun to, and always will, lose the legitimacy of its role as bearer of meaning because religion as the unifying structure of society has been displaced by competitive ideologies which cannot succeed in this central function. Expressed in field terminology, social institutions other than religion are less extensible fields which are contingent upon the inclusive field of religion. The function of any field is dependent upon the integrative forces of the field in which it is embedded. Attempting to treat a subordinate field as if it is superordinate disrupts the hierarchi-

cal integration of fields. For Pannenberg, religion is the superordinate field, and, thus, the coordinating field of influence for society. Religion is transcendent to other institutions, and human self-transcendence finds its final satisfaction only in religion.

Culture and the Spiritual Field

The cultural level of the hierarchy of fields is less structured but even more important for Pannenberg. In his analysis of the symbolic activities of play, intelligence, and language, he identified each of these as manifestations of self-transcendence. Each arises out of the 'spiritual field' which is its originating and sustaining context. Each is connected to the totality of reality as a part is connected to the whole. The meaning of each is derived from the meaning of the totality. Because theology is the science which deals with the ultimate field of the totality of meaning, the cultural field must be interpreted in theological terms. Just as the cultural field is transcendent to the social field, so is the spiritual field transcendent to the cultural field. All meaning is derived from the totality of meaning which is defined in theological terms as relating all meaning to God as the all-determining reality.

Spirit as Presence of Meaning

A "presence of meaning" is Pannenberg's phrase which provides the opening into his revision of the traditional concept of spirit (1985, 520). He gives 'presence of meaning' a central position in his anthropological argument:

> the discussion has repeatedly yielded conclusions pointing to the constitutive importance of a presence of meaning that does not arise from human action or a human positing of meaning but, on the contrary, underlies the constitution of human subjectivity as well as any and every human interpretation of meaning. We came to this kind of conclusion in discussing the problems of identity and especially the constitution of individual identity, and again in connection with the concept of feeling, and with the questions raised by the origin and use of language, and in our discussions of the foundations of culture and institutions. (1985, 520)

This presence of meaning Pannenberg equates with his revised concept of spirit:

> The concept of 'spirit' as I intend it here is not to be understood in terms of consciousness. It is to be understood, rather, as that

[presence of meaning] which alone makes possible both con-
sciousness and subjectivity and that, at the same time, makes
possible the unity of social and cultural life as well as the conti-
nuity of history amid the open-endedness and incompleteness
of its processes. (1985, 520)

Spirit is the origin and unity of the entire range of anthropological
phenomena. The human spirit exists by connection to, or participation
in, the contextual field of the Holy Spirit.

Pannenberg is able to connect a modern scientific image of the
world as a series of contingent fields to an ancient religious image of
the world as a manifestation of spirit. Everything exists in a hierarchy
of contingent fields; transcendence is the mechanism of the emergent
relationship of one field to another; relationship to the final field is
what gives meaning to the totality of all fields; theology is the science
of the relationship to the final field, God: the all-determining reality.
Pannenberg's vision is a grand schema of ecstatic self-transcendence
which unifies life, consciousness, personhood, society, culture, and
history through the all-embracing theological theme of the Holy Spirit.

• • • • • • • • • •

References

Gehlen, Arnold. 1988. *Man: His Nature and Place in the World.* Trans. Clare
McMillan and Karl Pillemer. New York: Columbia University Press. First
published as *Der Mensch* (Frankfurt: Anthenaion, 1950).
Pannenberg, Wolfhart. 1970a [1962]. *What Is Man?* 1962. Philadelphia: Fortress.
———. 1970b. The Working of the Spirit in Creation and in the People of God.
In *Spirit, Faith, and Church,* by Wolfhart Pannenberg, Avery Dulles, and Carl
Braaten, 13–31. Philadelphia: Westminster.
———. 1976. *Theology and the Philosophy of Science.* Trans. Francis McDonagh.
Philadelphia: Westminster.
———. 1977. The Spirit of Life. Trans. John Maxwell. In *Faith and Reality,*
20–38. Philadelphia: Westminster.
———. 1985. *Anthropology in Theological Perspective.* Trans. M. J. O'Connell.
Philadelphia: Westminster.
———. 1993a. The Doctrine of Creation and Modern Science. In *Toward a The-
ology of Nature: Essays on Science and Faith,* ed. Ted Peters, 29–49. Louisville:
Westminster/John Knox.
———. 1993b. Spirit and Mind. In *Toward a Theology of Nature: Essays on Sci-
ence and Faith,* ed. Ted Peters, 148–161. Louisville: Westminster/John Knox.
Parsons, Talcott. 1951. Some Fundamental Categories of the Theory of Action.
In *Toward a General Theory of Action,* ed. Talcott Parsons and Edward A.
Shils. Boston: Harvard University Press.

PART THREE

· · · · · · · · · ·

Physics, Cosmology, and the Omega Point

Introduction to Part Three
· · · · · · · · · ·
Carol Rausch Albright

Arguments for the existence of God based on natural philosophy are out of fashion these days. Where questions of cosmology are concerned, says the conventional wisdom, science and religion have so little to say to one another that one should avoid such conversations whenever possible. Wolfhart Pannenberg, on the other hand, asserts that

> such an attitude cannot persist because it is profoundly unacceptable on theological grounds. . . . If the God of the Bible is the creator of the universe, then it is not possible to understand fully or even appropriately the processes of nature without any reference to that God. If, on the contrary, nature can be appropriately understood without reference to the God of the Bible, then that God cannot be the creator of the universe, and consequently he cannot be truly God and be trusted as a source of moral teaching either. (Above, 38)

Not surprisingly, cosmology ranks among the scientific disciplines that Pannenberg takes most seriously. To maintain integrity, he argues, theology must deal with questions of the origin and fate of the universe, the relation of its parts to its totality, of time and timelessness. Complete understanding of *What Is* must subsume the past, present, and future; in a novel move, Pannenberg maintains that in a real sense, the future in fact influences the present and the past.

· · · · · · · · · ·
Tipler

Frank Tipler, a mathematical physicist who supports Pannenberg's cosmological views, has set out to provide a "physical foundation for Pannenberg's interpretation of eschatology." Responsible to the findings of physics, and bounding his work with some key assumptions informed by theology, he sets forth a cosmological and theological hypothesis of sweeping proportions in 'The Omega Point as *Eschaton*: Answers to Pannenberg's Questions for Scientists', which Tipler presented at the symposium. The revised version that appears here was published in *Zygon*.[1]

Informed by classical and medieval theology, by nineteenth-century electrodynamics and twentieth-century information theory and astrophysics, by the theology of Teilhard and Pannenberg, Tipler constructs a closely reasoned theory concluding that the universe and its God—Teilhard's point Omega—are not contingent but necessary.

He knows he is taking a risk: any discussion of God's existence based on current physics may be falsified by later scientific developments. However, he believes this is a risk that natural theologians simply have to take, for "if one tries to avoid the risk of falsification by denying the possibility of natural theology altogether, by claiming that it is impossible in principle for any scientific discovery to have any implication whatsoever for theology, then one effectively denies the relevance of theology for any human concerns [and] one also denies that the world is relevant to God" (158).

And so he boldly proceeds. He begins by making two fundamental assumptions, which he believes are required by the acceptance of a biblical eschatology: (1) that the universe will be capable of sustaining life indefinitely, and (2) that the laws of physics will remain in place. Life for Tipler is defined in terms of information theory: a "living being" is "any entity that codes information . . . , with the information coded being preserved by natural selection" (161). The most obvious example of the preservation of encoded information is the genetic transmission of heritable traits encoded in DNA. Cultural transmission of learned information is another modality of information preservation mediated by selection, as described in theories of biocultural evolution. In either case, life may be seen as organization, and organization of an entity becomes impossible unless there can be continuing communication between its sectors. Life as so defined can exist in any region of space where the laws of physics permit such information processing.

Given such assumptions, what must the cosmos be like? Well, for one thing, the universe must be closed. It does not extend infinitely in spacetime; it has boundaries. Furthermore, the *c-boundary* (the completion of spacetime) must eventuate in a single point, where the density of the particle state diverges to infinity. This point—and the universe of which it forms the convergence—exists necessarily, not contingently. In Tipler's view, this necessary concentration of unimaginable power and information bears a striking resemblance to the point Omega of Pierre Teilhard de Chardin.

Point Omega exerts force upon the entities that precede it in time (as time is conventionally defined), drawing them to itself. And at this final convergence there will exist all the information that has ever

been. Since living beings are essentially information-processing systems, they are included. In this fashion, mortals have eternal life.

In human life as we experience it, organisms indeed die. But humans form a link in the great chain of being which converges on point Omega over unknowable spans of time, becoming, in the process, better and wiser. We mortals can find hope and comfort in that knowledge, says Tipler—and in the belief that we will live again as information in the "mind of God"—as spiritual bodies, just as Saint Paul said.

Does this picture conform to the laws of physics? Tipler asserts that all the laws of physics are coded in the wave function. And he can conjecture—not prove—that a wave function satisfying such conditions really does exist.

Russell

In pursuing such knowledge, conjecture in fact is as close as one can come, asserts physicist and theologian Robert John Russell in 'Cosmology and Eschatology: The Implications of Tipler's "Omega-Point" Theory for Pannenberg's Theological Program.' In Russell's experience, "when cosmology is the scene [of the science-religion dialogue], our ability to construct an adequate theology of creation is challenged to the core as nowhere else" (196). In Tipler's project, "as in all attempts at natural theology," Russell concludes, "I do not see how one can argue from nature to God (at least to the Biblical triune God)" (208).

However, Russell observes, given the inherent limitations of such a research program, Tipler makes an extremely valuable contribution in an area where recent scientific developments pose a severe challenge to theology. For "if Big Bang cosmology is correct, our universe faces a far future of either endless cold or unimaginable heat" (195), and ultimately, life in the universe thus appears futile. As Bertrand Russell wrote prophetically in 1903, "all the labors of the ages, all the devotion, all the inspiration, all the noon-day brightness of human genius are destined to extinction in the vast death of the solar system, . . . buried beneath the debris of the universe in ruins" (196). More recently Steven Weinberg expressed similar sentiments in the often-quoted conclusion of his book *The First Three Minutes*, "The more the universe seems comprehensible, the more it also seems pointless" (Weinberg 1977, 154–55).

Yet Russell believes there may be grounds for hope—even for belief in a god who is trustworthy. As Freeman J. Dyson predicted in

1979, physical eschatology may be in the process of joining physical cosmology as a respectable scientific discipline, and its findings may not be bleak. In contrast to Weinberg, Dyson perceives "a universe growing without limit in richness and complexity, a universe of life surviving forever and making itself known to its neighbors across unimaginable gulfs of space and time" (198).

Tipler has continued to pioneer in physical eschatology and has arrived at conclusions that bear on the work of both Teilhard and Pannenberg. In fact, Tipler's solutions or something like them are crucial to the project of Pannenberg, who "wants the far future to possess an eschatological unity and integrity that allows him to identify it with the being of God" (209). Thus, Russell believes Tipler's proposals merit detailed analysis.

Russell provides such analysis, employing his expertise in both physics and theology. Among several strengths and weaknesses he perceives in Tipler's system he points to a key difficulty: a strong case can be made that point Omega is contingent—and thus not divine. He reiterates Tipler's own admission that certain central assumptions were selected for philosophical, even theological reasons; the net effect has been a partially successful effort to undergird Teilhard's, and Pannenberg's, vision.

However, Russell points out, Tipler also leaves many theological questions unanswered—for example, free will, theodicy, the meaning of redemption, the hope for resurrection, the experience of mystery, and the importance of individual commitment in the formation of faith. To reach full fruition, Russell concludes, Tipler's theological-scientific vision must be embedded in the context of a self-consistent and complete theological system.

· · · · · · · · · ·
Drees

Willem B. Drees examines issues basic to Pannenberg's cosmology and theology and reaches different conclusions.

Contingency and Necessity

Drees argues that both *contingency* and *necessity* are actually outside the purview of science. Science does seek systematically to eliminate understandings depending upon contingency and identify conditions of necessity, but it does so only in its *methodology*. Science does

not endorse the *metaphysical* principle that sufficient reasons must always exist.

Grounding necessity in a single complete theory of the universe is not a promising possibility. Physicists might narrow down the candidate theories to a few—perhaps only one—that meets all the criteria for such a theory, but such an achievement would be at the cost of so much abstraction that the theory could not tell us much about the details of the cosmos.

Ontological contingency, the mystery of existence itself, does seem to Drees to be unassailable, despite its detractors. However, he disagrees with Pannenberg's assertion that such contingency points to the existence of a Creator. The question Why is there anything at all? remains unanswerable—beyond physics, beyond theology.

Time, Timelessness, and Metaphysics

Time can be thought of in two ways: as the flow of time, the temporal; and as the whole of time, the atemporal. Both are contingent, since there cannot be time unless there is a universe. While physics can examine issues of spacetime, of the whole of time, it cannot get a grip on 'the present' or the flow of time. Whereas atemporal views understand eternal values, they may neglect concrete contexts of injustice and suffering. The reverse is true of the temporal view. Both gain strength if they are tied to the present and to one another.

Drees divides basic metaphysics into two main kinds: metaphysics that thematizes God's presence—the *mystical* tradition—and metaphysics that thematizes God's absence—the *prophetic* tradition. Drees sees Tipler as a mystical thinker, and tends to place Pannenberg in this camp as well. Drees, in contrast, rejects mysticism because he doubts that an argument for the presence of a divine reality can be based upon contemporary science. Similarly, he also rejects thinkers who believe there is some consonance between the way the divine reality is and the way the world is—including Arthur Peacocke, John Polkinghorne, Ian Barbour, and Janet Martin Soskice.

If contemporary science cannot support arguments that God created the world, is present in it, or is consonant with it, we are left with a metaphysics that thematizes God's absence. Such a metaphysics understands the divine reality as, primarily, different from our ordinary world, and Drees is comfortable with that position.

Existential and Ethical Implications

Any theology today needs to address the meaninglessness many persons experience in modern life. Drees believes a theology of God's absence can effectively do so. Such a prophetic theology can make proposals about the possibility of a better world, aiming toward a future that we ourselves make, not one definitely enfolded in the cosmic process. God may still be seen as the location of values, the locus of possibilities, and the transcendent source of reality, its eternal ground.

Questions Concerning Pannenberg's Approach

While Drees does not claim complete familiarity with Pannenberg's extensive work, he does question certain of Pannenberg's central themes. One is the assertion that the contingency of the universe necessarily points to God.

Pannenberg's view of time also draws fire, since Drees sees Pannenberg as moving between temporal and atemporal concepts of time in an unclear manner. Furthermore, to attribute determinism to the future is a clear deviation from present physical understandings of time, Drees asserts.

Pannenberg's description of God as the "all-determining reality" may promote understanding of God's trustworthiness. However, Drees fears other possible consequences of such an approach: its tendency to muffle awareness of "evil, injustice, and imperfection, and hence of judgment, and the danger that we fail to hear a call for conversion". Besides being in harmony with current scientific understandings, religion is called upon to help individuals deal with problems of injustice, suffering, meaning, and the making of decisions that help determine what the future shall be.

• • • • • • • • • •

Note

1. Since the symposium, Frank Tipler has elaborated his views on cosmology and theology; see his *The Physics of Immortality* (1994). Other symposium participants, including Russell and Drees, have registered serious disagreement with his recent work; for a critical view see Mutschler 1995.

• • • • • • • • • •

References

Mutschler, H.-D. 1995. Reflections on Frank Tipler's *The Physics of Immortality*. *Zygon* 30:2 (June).

Tipler, Frank J. 1994. *The Physics of Immortality: Modern Cosmology, God, and the Resurrection of the Dead.* New York: Doubleday.

Weinberg, Steven. 1977. *The First Three Minutes: A Modern View of the Origin of the Universe.* New York: Basic Books.

7

The Omega Point as *Eschaton:* Answers to Pannenberg's Questions to Scientists

· · · · · · · · · ·

Frank J. Tipler

The idea that religious belief must be firmly based on science, that is, anchored on experimental tests of basic theological propositions (for instance, God's very existence), is not new. It is in the Old Testament:

> Then said Elijah unto the people, I, even I only, remain a prophet of the LORD; but Baal's prophets are four hundred and fifty men. . . . Let them therefore give us two bullocks; and let them choose one bullock for themselves, and cut it in pieces, and lay it on wood, and put no fire under: and I will dress the other bullock and lay it on wood, and put no fire under. . . . And call ye on the name of your gods, and I will call on the name of the LORD: and the God that answereth by fire, let him be GOD. And all the people answered and said, It is well spoken. (1 Kings 18:22–24)

The apostle Paul also believed that the existence of God and certain divine properties were scientific conclusions, inferred from the observation of the natural world. In Paul's view, so obvious is the existence of the creator God that even pagans have no excuse for not worshiping the One who brought the physical universe into being: "For the invisible things of him from the creation of the world are clearly seen, being understood by the things that are made, even his eternal power and Godhead; so that they are without excuse" (Rom. 1:20). Thomas Aquinas, the author of the great medieval synthesis, followed in the footsteps of Elijah and Paul. Aquinas, who probably knew more about the physics of his day than any of his contemporaries—we could with justice call him a great physicist as well as a great theologian—based his proofs of God's existence (the Five Ways) firmly on Aristotelian cosmology. The Five Ways are so intimately integrated with Aristotelian physical cosmology that the falsification of the physics logically entails the falsification of the proofs (Kenny 1969). The eighteenth-century English theologian Samuel Clarke also argued, in his famous debate with Gottfried von Leibniz, that deism and atheism are avoided *only* if physics itself shows the presence of God in the physical world: "The notion of the world's being a great *machine*, going on *without the interposition of God,* as a clock continues to go on

without the assistance of a clockmaker; is the notion of *materialism and fate,* and tends under pretense of making God a . . . *Supra-Mundane Intelligence,* to exclude providence and God's Government in reality out of the World" (Clarke 1717, 15; Clarke's italics and capitalization).

In other words, if all God did was to conserve matter and energy and the laws of physics, to be merely the ontological support without which the universe would collapse into nonexistence, then God *qua* God would be superfluous; God's existence would be merely equivalent to the physical conservation laws. Wolfhart Pannenberg (1981) and others have shown that the recognition of this equivalence in fact was a major cause of the growth of atheism in the eighteenth and nineteenth centuries. Clarke and Isaac Newton believed that Newtonian cosmology actually required God to act continually in the world because they believed that the conservation laws did not hold: God was required physically in order to reconstruct the universe periodically. But later Newtonian physicists showed (or were believed to have shown; see Earman 1986) that the conservation laws actually held in Newtonian physics. Laplace "had no need of that hypothesis [God]" in accounting for the origin of the Solar System. This utter failure—falsification—of Newtonian natural theology is one important reason why many twentieth-century theologians wish to divorce religion completely from science.

But Pannenberg continues the older tradition of believing that science and true religion must be entwined:

> Perhaps Christianity survived only by temporarily separating the outlook of faith from the rational and scientific investigation and description of the natural world. But such an attitude cannot persist because it is profoundly unacceptable on theological grounds.
>
> If the God of the Bible is the creator of the universe, then it is not possible to understand fully or even appropriately the processes of nature without any reference to that God. If, on the contrary, nature can be appropriately understood without reference to the God of the Bible, then that God cannot be the creator of the universe, and consequently he cannot be truly God and be trusted as a source of moral teaching either. (Above, 38)

The trouble is, if one bases a proof of God's existence and an analysis of the divine nature on current physics, one runs the risk of having the proof falsified by later scientific developments. This is exactly what happened to Aquinas and to Clarke and Newton. If this happens the suspicion will grow that not only is the proof false, but also the

conclusion is false: the proof fails not merely because the premises are false; it also fails because there is in fact no God.

This is, however, a risk natural theologians are just going to have to take. Science by its very nature cannot give us theories which are certain to be true. Our models of physical reality are simply going to have some holes in them, and these holes may one day widen until finally they cause the collapse of entire theories (Pannenberg 1976). If one tries to avoid the risk of falsification by denying the possibility of natural theology altogether, by claiming that it is impossible in principle for any scientific discovery to have any implication whatsoever for theology, then one effectively denies the relevance of theology for any human concern, as Pannenberg emphasizes in the passage I quoted above. One also denies that the world is relevant to God, in which case it becomes impossible to understand why God should have created the universe at all. If there is even a touch of truth in the idea that God is the creator, then there simply must be an intimate relation between the creator and the creation, a relation which can be studied scientifically.

I shall argue in this paper that there is such a relation and that one cannot understand the physical cosmos in its entirety without understanding it. The starting point of my argument is Pannenberg's Fifth Question for scientists: "Is the Christian affirmation of an imminent end of the world that in some way invades the present reconcilable with scientific extrapolations of the continuing existence of the universe for billions of years ahead? . . . Scientific predictions that in some comfortably distant future the conditions for life will no longer continue on our planet are hardly comparable to biblical eschatology" (48).

It is definitely true that the universe will exist for billions of years in the future. In fact, the evidence that the universe will continue to exist for five billion more years is at least as strong as the evidence that the earth has already existed for five billion years. There is simply no way our extrapolations could be so wrong as to falsify this prediction of longevity. Furthermore, if the standard cosmological models are approximately accurate, then the universe, if closed, will continue to exist at least another 100 billion years (in *proper time*), and if open or flat will continue to exist for literally infinite (proper) time. In either case, we are seeing the universe in a very early stage in its history. Most of the physical universe lies in our future, and we cannot truly understand the entire physical universe without understanding this future. But we can study this future reality, in particular the ultimate future which constitutes the end of time, only if in some way this Final State of the physical universe makes an imprint on the present. It is,

after all, obvious that we cannot do direct experiments on the future in the present.

I shall obtain a hold on this future reality by focusing attention on the physics relevant to the existence and behavior of life in the far future. One of Pannenberg's central themes is the importance of eschatology in the Christian vision (see, for instance, Pannenberg 1967; 1971; 1973; 1977). I shall attempt to provide a physical foundation for Pannenberg's interpretation of eschatology. I shall make the physical assumption that the universe must be capable of sustaining life indefinitely; that is, for infinite time as experienced by life existing in the physical universe. It will turn out that this assumption imposes rather stringent requirements on the future. The assumption also makes some predictions about the present, because the physics required to sustain life in the far future must be in place now, since the most fundamental laws of physics do not change with time. In this way it can reasonably be said that the future makes an imprint on the present.

The really fascinating consequence of this assumption, however, is what it implies if life really does exercise its option to exist forever. There must exist in this future (but in a precise mathematical sense, also in the present and past) a Person who is omnipotent, omniscient, omnipresent, who is simultaneously both transcendent to yet immanent in the physical universe of space, time, and matter. In the Person's immanent temporal aspect, the Person is changing (forever growing in knowledge and power), but in the Person's transcendent eternal aspect, forever complete and unchanging. How this comes about as a matter of physics will be described in the next section of this paper, entitled 'The Omega Point Theory'. Needless to say, the terminology is Teilhard de Chardin's, but the connection is more than a mere two words. I believe that any model of an evolving God—whether it is Schelling's, Alexander's, Bergson's, Whitehead's, or Teilhard's—must have certain key features in common.[1]

Elijah's challenge remains: Is this God of the Omega Point (assuming said Person actually exists) *the* God? It is generally (but not universally) felt that *the* God must be the uncreated creator of the physical universe, a being who not merely exists but who exists necessarily, in the strong logical sense of 'necessity' (the Person's nonexistence would be a logical contradiction). Only if God is not in any sense contingent can one avoid the regress posed in the query, Who created God? Furthermore, it is generally felt (as for example in Findlay 1955) that only *the* God, the One who exists necessarily, is worthy of worship. I shall tackle this thorny question of necessary existence in the third and fourth sections of this paper. In the former section I shall

analyze the notion of contingency in classical general relativity and in quantum cosmology and will discuss in what sense modern cosmological models can be said to sustain themselves in physical existence. In the latter section I shall use the ideas developed in the former to argue that the universe necessarily exists—and necessarily sustains itself in existence—if and only if life and the Omega Point exist therein. If this argument is accepted, then the Omega Point exists necessarily if he/she exists at all. This would appear to me to establish the Omega Point as *the* God, for it appears pointless to have more than one being with all of the divine attributes. (I shall be invoking the Identity of Indiscernibles throughout the fourth section.)

The emphasis in the second section is the physics—the nuts and bolts—of infinite continued survival, and the emphasis in the fourth section will be philosophical theology. But the God of the Bible and the Christian churches is a great deal more than the God of the philosopher-physicist. The former is a God of hope, love, and mercy, a God who grants eternal life to each individual human being. I shall discuss in the fifth section various senses in which the Omega Point can be regarded as a source of hope for the future. In particular, the Omega Point probably will "resurrect the dead" in the sense which Pannenberg has given this phrase: "it is our present life as God sees it from his eternal present" (Pannenberg 1970, 80).

Pannenberg's view of the resurrection has been criticized (I think wrongly; see Pannenberg 1984) by John Hick as permitting

> no further development of character beyond death. . . . The content of eternity, according to Pannenberg, can only be that of our temporal lives. . . . Suppose it is a poor stunted life, devoid of joy and nobility, in which the good possibilities of human existence remain almost entirely unfulfilled? . . . Can God's good gift of eternal life be simply a consciousness of this life seen sub specie aeternitatis? Is this the best form of eternity that omnipotent love can devise? (Hick 1976, 225)

I shall show in the fifth section that the type of life enjoyed by resurrected individuals is entirely at the discretion of the Omega Point, as is their resurrection in the first place; the human soul is not naturally immortal, for modern physics shows that it dies with the brain. Thus, except for the conscious future act of the Omega Point, we would die never to rise again. The life of the resurrected dead could be as pointless as the scenario ridiculed by Hick, merely a replay of the original life, or it could be a life of continued individual becoming, an exploration into the inexhaustible reality which is the Omega Point (or even into purely sensual delights, such as pictured in the Garden of the

Koran [Smith and Haddad 1981]). It is even possible for the Omega Point to guide each resurrected person, by means of consultation with each, into "the perfection of the personal creature as a whole" (a definition of "beatific vision" [see Rahner and Vorgrimler 1983, 42]). *Which* life the resurrected dead live is up to the Omega Point; if it is heaven rather than hell it will be due to the Omega Point's "personal condescension and absolutely gratuitous clemency to man" (a definition of 'grace' [see Rahner and Vorgrimler 1983, 196]). I shall give in the fifth section a reason for expecting such 'grace'.

Let me emphasize again that the Omega Point theory, including the resurrection theory, is pure physics.[2] There is nothing supernatural in the theory, and hence there is no appeal anywhere to faith. The genealogy of the theory is actually atheistic scientific materialism; the line of research which led to the Omega Point theory began with the Marxist John Bernal (Barrow and Tipler 1986, 618). The key concepts of the Judeo-Christian-Islamic tradition are now scientific concepts.

· · · · · · · · · ·
The Omega Point Theory

In order to investigate whether life can continue to exist forever, I shall need to define 'life' in physics language. I claim that a 'living being' is any entity which codes 'information' (in the sense this word is used by physicists), with the information coded being preserved by natural selection (for a justification of this definition, see Barrow and Tipler 1986, section 8.2). Thus life is a form of information processing, and the human mind—and the human soul—is a very complex computer program. Specifically, a person is defined to be a computer program which can pass the Turing test (see Hofstadter and Dennett 1981, 69–95 for a detailed discussion of this test).

It is extremely important that my claim not be misunderstood. Most people's immediate reaction to my claim is typically, 'Surely there is more to life than mere information processing, to punching data into a computer, and letting the machine grind away. This may be sufficient for a machine—or a computer hacker—but real people are far more complex. They work for a living, they listen to music, they enjoy conversations with other people, they reflect on the meaning of existence, they worship God, they develop deep and loving relationships with others, they raise children. An infinity of time spent doing nothing but playing with a computer—what a horrid thought!'

I completely agree. It *is* a horrid thought. But it is not the eschatology I am proposing. The crucial point is that at the most basic nuts-and-bolts physics level, all of the above-mentioned activities of 'real'

people, indeed *all* of the possible activities of people, are in fact types of information processing. The human activities of listening, enjoying, reflecting, worshiping, and loving are mental activities and correspond to mental activity in the brain. In other words, at the *physics* level they are information processing and nothing but information processing. At the *human* level, though, they are not cold and austere 'information processing' but warm and human listening, enjoying, reflecting, worshiping, and loving. Furthermore, the essential nature— at the physics level—of all other human activities can be shown to be information processing (see sections 3.7 and 10.6 of Barrow and Tipler 1986 for details). The upshot is that the laws of physics place constraints on information processing and hence on the activities and existence of life. If the laws of physics do not permit information processing in a region of spacetime, then life simply cannot exist there. Conversely, if the laws of physics permit information processing in a region, then it is possible for some form of life to exist there. These limitations and opportunities are analogous to those imposed by food at the biological level. At the human level, it is certainly not possible to reduce all human experience to eating; eating is just one of many human actions, and in fact other things are more important (to most of us, anyway). But having enough to eat is a prior condition for these other activities. There will be no listening, enjoying, reflecting, worshiping, and loving without food. Furthermore, if the crops fail, then people must either get food from outside the region or die. Period. Discussions of the morality of interacting with the outside world, for instance, must be consistent with this biological fact. Similarly, a discussion of the future of life must be consistent with regarding life as information processing at the physics level.

There is actually an astonishing similarity between the mind-as-computer-program idea and the medieval Christian idea of the 'soul'. Both are fundamentally 'immaterial': a program is a sequence of integers, and an integer—2, say—exists 'abstractly' as the class of all couples. The symbol '2' written here is a *representation* of the number 2, and not the number 2 itself. In fact, Aquinas (following Aristotle) defined the 'soul' to be "the form of activity of the body" (see Pannenberg 1985, 523). In Aristotelian language, the *formal* cause of an action is the abstract cause, as opposed to the material and efficient causes. For a computer, the program is the formal cause, while the material cause is the properties of the matter out of which the computer is made, and the efficient cause is the opening and closing of electric circuits. For Aquinas, a human soul needed a body to think and feel, just as a computer program needs a physical computer to run.

Aquinas thought the soul had two faculties: the agent intellect (*intellectus agens*) and the receptive intellect (*intellectus possibilis*), the former being the ability to acquire concepts and the latter being the ability to retain and use the acquired concepts. Similar distinctions are made in computer theory: general rules concerning the processing of information coded in the central processor are analogous to the agent intellect; the programs coded in RAM or on a tape are analogues of the receptive intellect. (In a Turing machine, the analogues are the general rules of symbol manipulation coded in the device which prints or erases symbols on the tape versus the tape instructions, respectively.) Furthermore, the word 'information' comes from the Aristotle-Aquinas notion of 'form': we are 'informed' if new forms are added to the receptive intellect. Even semantically, the information theory of the soul is the same as the Aristotle-Aquinas theory.[3]

The 'mind-as-computer-program' idea is absolutely central to this paper; indeed, it forms the basis of a revolution now going on in mathematics, physics, and philosophy. The best defense of the idea can be found in *The Mind's I* by Douglas Hofstadter and Daniel Dennett (1981, especially 69–95, 109–15, 149–201, 373–382). Any reader who feels inclined to reject this idea (and much of recent natural science) simply must read these pages.

In the language of information processing it becomes possible to say precisely what it means for life to continue forever.

DEFINITION: I shall say that life can continue forever if:

1. information processing can continue indefinitely along at least one world line γ all the way to the future *c-boundary* of the universe; that is, until the end of time.
2. the amount of information processed between now and this future c-boundary is infinite in the region of space-time with which the world line γ can communicate.
3. the amount of information stored at any given time τ within this region can go to infinity as τ approaches its future limit (this future limit of τ is finite in a closed universe, but infinite in an open one, if τ is measured in what physicists call proper time).

The above is a rough outline of the more technical definition given by Barrow and Tipler (1986, section 10.7. See also Tipler 1986; 1988). But let me ignore details here. What is important are the physical (and ethical!) reasons for imposing each of the above three conditions. The reason for condition 1 is obvious: it simply states that there must be at least one history in which life (=information processing) never ends

in time. (See below for more on what c-boundary means. For now, think of it as meaning 'the end of time'.)

Condition 2 tells us two things: first, that information processed is 'counted' only if it is possible, at least in principle, to communicate the results of the computation to the history γ. This is important in cosmology, because event horizons abound. In the closed Friedmann universe, which is the standard (but oversimplified) model of our actual universe (if it is in fact closed), every comoving observer loses the ability to send light signals to every other comoving observer, no matter how close. Life obviously would be impossible if one side of one's brain became forever unable to communicate with the other side. Life is organization, and organization can only be maintained by constant communication among the different parts of the organization. The second thing condition 2 tells us is that the amount of information processed between now and the end of time is potentially infinite. I claim that it is meaningful to say that life exists *forever* only if the number of thoughts generated between now and the end of time is actually infinite. But we know that each thought corresponds to a minimum of one bit being processed. In effect, this part of condition 2 is a claim that time duration is most properly measured by the thinking rate rather than by proper time as measured by atomic clocks. The length of time it takes an intelligent being to process one bit of information—to think one thought—is a direct measure of subjective time, and hence is the most important measure of time from the perspective of life. A person who has thought ten times as much or experienced ten times as much (there is no basic physical difference between these options) as the average person has in a fundamental sense lived ten times as long as the average person, even if the rapid-thinking person's chronological age is shorter than the average.

The distinction between proper and subjective time crucial to condition 2 is strikingly similar to a distinction between two forms of duration in Thomist philosophy. Recall that Aquinas distinguished three types of duration. The first was *tempus*, which is time measured by change in relations (positions, for example) between physical bodies on earth. *Tempus* is analogous to proper time; change in both human minds and atomic clocks is proportional to proper time, and for Aquinas also, *tempus* controlled change in corporeal minds. But in Thomist philosophy, duration for *incorporeal* sentient beings—angels—is controlled not by matter, but rather is measured by change in the mental states of these beings themselves. This second type of duration, called *aevum* by Aquinas, is clearly analogous to what I have termed 'subjective time.' *Tempus* becomes *aevum* as sentience escapes

the bonds of matter. Analogously, condition 2 requires that thinking rates are controlled less and less by proper time as τ approaches its future limit. *Tempus* gradually becomes *aevum* in the future. (The third type of Thomist duration is *aeternitas:* duration as experienced by God alone. *Aeternitas* can be thought of as "experiencing" all past, present, and future *tempus* and *aevum* events in the universe all at once. But more of *aeternitas* later.)

Condition 3 is imposed because although condition 2 is necessary for life to exist forever, it is not sufficient. If a computer with a finite amount of information storage—such a computer is called a *finite state machine*—were to operate forever, it would start to repeat itself over and over. The psychological cosmos would be that of Nietzsche's Eternal Return. Every thought and every sequence of thoughts, every action and every sequence of actions would be repeated not once but an infinite number of times. It is generally agreed (by everyone but Nietzsche) that such a universe would be morally repugnant or meaningless. Augustine argued strongly in Book Twelve of *The City of God* that Christianity explicitly repudiates such a worldview, for "Christ died once for our sins, and rising again, dies no more." The Christian cosmos is progressive. Only if condition 3 holds in addition to condition 2 can a psychological Eternal Return be avoided. Also, it seems reasonable to say that 'subjectively', a finite state machine exists for only a finite time even though it may exist for an infinite amount of proper time and process an infinite amount of data. A being (or a sequence of generations) that truly can be said to exist forever ought to be physically able, at least in principle, to have new experiences and to think new thoughts.

Let us now consider whether the laws of physics will permit life/information processing to continue forever. John von Neumann and others (see Barrow and Tipler 1986, section 10.6) have shown that information processing (more precisely, the irreversible storage of information) is constrained by the first and second laws of thermodynamics. Thus the storage of a bit of information requires the expenditure of a definite minimum amount of available energy, this amount being inversely proportional to the temperature (see section 10.6 of Barrow and Tipler 1986 for the exact formula). This means it is possible to process and store an infinite amount of information between now and the Final State of the universe only if the time integral of P/T is infinite, where P is the power used in the computation, and T is the temperature. Thus the laws of thermodynamics will permit an infinite amount of information processing in the future, provided there is sufficient available energy at all future times.

What is 'sufficient' depends on the temperature. In the open and flat ever-expanding universes, the temperature drops to zero in the limit of infinite time, so less and less energy per bit processed is required with the passage of time. In fact, in the flat universe only a *finite* total amount of energy suffices to process an infinite number of bits! This finite energy just has to be used sparingly over infinite future time. On the other hand, closed universes end in a final singularity of infinite density, and the temperature diverges to infinity as this final singularity is approached. This means that an ever-increasing amount of energy is required per bit near the final singularity. However, most closed universes undergo 'shear' when they recollapse, which means they contract at different rates in different directions (in fact, they spend most of their time *expanding* in one direction while contracting in the other two!). This shearing gives rise to a radiation temperature difference in different directions, and this temperature difference can be shown to provide sufficient free energy for an infinite amount of information processing between now and the final singularity, even though there is only a *finite* amount of proper time between now and the end of time in a closed universe. Thus although a closed universe exists for only a finite proper time it nevertheless could exist for an infinite subjective time, which is the measure of time that is significant for living beings.

But although the laws of thermodynamics permit conditions 1 through 3 to be satisfied, this does not mean that the other laws of physics will. It turns out that although the energy is available in open and flat universes, the information processing must be carried out over larger and larger proper volumes. This fact ultimately makes impossible any communication between opposite sides of the 'living' region, because the redshift implies that arbitrarily large amounts of energy must be used to signal (this difficulty was first pointed out by Freeman Dyson; see Barrow and Tipler 1986, section 10.6). This circumstance gives the

FIRST TESTABLE PREDICTION OF THE OMEGA POINT THEORY: the universe must be closed.

As I stated earlier, however, there is a communication problem in most closed universes—event horizons typically appear, thereby preventing communication. But there is a rare class of closed universes which do not have event horizons, which means by definition that every world line can always send light signals to every other world line. Recently, Roger Penrose (see Barrow and Tipler 1986, section 10.6) has found a way to define precisely what is meant by the 'boundary'

of spacetime, where time ends. In his definition of the c-boundary, world lines are said to end in the same 'point' on this boundary if they can remain in causal contact unto the end of time. If they eventually fall out of causal contact they are said to terminate in different c-boundary points. Thus the c-boundary of these rare closed universes without event horizons consists of a single point. For reasons given by Barrow and Tipler (1986, section 10.6; see also section 3.7), it turns out that information processing can continue only in closed universes which end in a single c-boundary point, and only if the information processing is ultimately carried out throughout the entire closed universe. In other words, if life is to survive at all, at just the bare subsistence level, it must necessarily engulf the entire universe at some point in the future. It does not have the option of remaining in a limited region. Mere survival dictates expansion. (But if it does engulf the universe, it then has the option of existing at a much wealthier level.) Thus we have the

SECOND TESTABLE (?) PREDICTION OF THE OMEGA POINT THEORY: the future *c*-boundary of the universe consists of a single point; call it the Omega Point. (Hence the name of the theory.)

It is possible to obtain other predictions. For example, a more detailed analysis of how energy must be used to store information leads to the

THIRD TESTABLE PREDICTION OF THE OMEGA POINT THEORY: the density of particle states must diverge to infinity as the energy goes to infinity, but nevertheless this density of states must diverge no faster than the square of the energy.

These predictions just demonstrate that the Omega Point theory is a scientific theory of the future of life in the universe, and it is not my purpose to discuss the science in detail here. Rather, I am concerned in this paper with the theological implications of the Omega Point theory and the way in which the theory can be used to answer Pannenberg's questions to scientists. That the theory can be so used will be clear if I restate a number of the above conclusions in more suggestive words. As I pointed out, in order for the information processing operations to be carried out arbitrarily near the Omega Point, life must have extended its operations so as to engulf the entire physical cosmos. We can say, quite obviously, that life near the Omega Point is omnipresent. As the Omega Point is approached, survival dictates that life collectively gain control of all matter and energy sources available near the Final State, with this control becoming total at the Omega Point. We can say

that life becomes omnipotent at the instant the Omega Point is reached. Since by hypothesis the information stored becomes infinite at the Omega Point, it is reasonable to say that the Omega Point is omniscient; it knows whatever it is possible to know about the physical universe (and hence about itself).

The Omega Point has a fourth property. Mathematically, the c-boundary is a completion of spacetime; it is not actually in spacetime, but rather just 'outside' it. If one looks more closely at the c-boundary definition, one sees that a c-boundary consisting of a single point is formally equivalent to the entire collection of spacetime points, and yet from another point of view it is outside space and time altogether. It is natural to say that the Omega Point is 'both transcendent to and yet immanent in' every point of spacetime. This formal equivalence confirms a conjecture of Pannenberg (1971, 242): "is being itself perhaps to be understood as in truth the power of the future?" When life has completely engulfed the entire universe it will incorporate more and more material into itself, and the distinction between living and non-living matter will lose its meaning.

There is another way to view this formal equivalence of all spacetime and the Omega Point. In effect, all the different instants of universal history are collapsed into the Omega Point; 'duration' for the Omega Point can be regarded as equivalent to the collection of all experiences of all life that did, does, and will exist in the whole of universal history, together with all non-living instants. This 'duration' is very close to the idea of *aeternitas* of Thomist philosophy. We could say that *aeternitas* is equivalent to the union of all *aevum* and *tempus*. If we accept the idea that life and personhood involve change by their very nature (to pass the Turing test, for example, a being has to *do* something), then this identification appears to be the only way to have a Person who is omniscient and hence whose knowledge cannot change: omniscience is a property of the necessarily unchanging not-in-time final state, a state nevertheless equivalent to the collection of all earlier, non-omniscient changing states. The Omega Point in its immanence counts as a Person because at any time in our future the collective information processing system will have, or will be able to generate, subprograms which will be able to pass the Turing test. High intelligence will be required at least collectively in order to survive in the increasingly complex environment near the Final State.

This identification of the Omega Point with the whole of past, present, and future universal history is more than a mere mathematical artifact. *The identification really does mean that the Omega Point 'experiences' the whole of universal history 'all at once'!* For consider what it

means for us to experience an event. It means we think and emote about an event we see, hear, feel, and so on. Consider for simplicity just the 'seeing' mode of sensing. We see another contemporary person by means of the light rays that left her a fraction of a second ago. But we cannot 'see' a person that lived a few centuries before, because the light rays from said person have long ago left the Solar System. Conversely, we cannot 'see' Andromeda Galaxy as it now is, but rather we 'see' it as it was two million years ago. So we experience as simultaneous the events on the boundary of our past light cone (for the seeing mode; it is more complicated for all other modes of sensing, for we experience as simultaneous events which reach us at the same instant along certain timelike curves from inside our past light cone).

But all timelike and lightlike curves converge upon the Omega Point. In particular, all the light rays from all the people who died a thousand years ago, from all the people now living, and from all the people who will be living a thousand years from now, will intersect there. The light rays from those people who died a thousand years ago are not lost forever; rather, these rays will be intercepted by the Omega Point. To put it another way, these rays will be intercepted and intercepted again by the living beings who have engulfed the physical universe near the Omega Point. All the information which can be extracted from these rays will be extracted at the instant of the Omega Point, who will therefore experience the whole of time simultaneously just as we experience simultaneously the Andromeda Galaxy and a person in the room with us.[4] As Pannenberg puts it in his analysis of the notion of eternity:

> The truth of time lies beyond the self-centeredness of our experience of time as past, present and future. The truth of time is the concurrence of all events in an eternal present. Eternity, then, does not stand in contrast to time as something that is completely different. Eternity creates no other content than time. . . . Eternity is the unity of all time, but as such it simultaneously is something that exceeds our experience of time. The perception of all events in an eternal present would be possible only from a point beyond the stream of time. Such a position is not attainable for any finite creature. Only God can be thought of as not being confined to the flow of time. Therefore, eternity is God's time. . . . Eternity means the divine mode of being. (Pannenberg 1970, 74; and see above, 46–47)

The Omega Point regarded as eternity provides an answer to Pannenberg's Fourth Question to scientists: "Is there any positive relation conceivable of the concept of eternity to the spatiotemporal structure

of the physical universe?" (46). The relation between the Omega Point and the physical universe means exactly that "in the perspective of the eternal the temporal does not pass away, although in relation to other spatiotemporal entities it does" (46).

To summarize this section: the indefinitely continued existence of life is not only physically possible; it also leads naturally to a model of a God who is evolving in His/Her immanent aspect (the events in spacetime) and yet is eternally complete in His/Her transcendent aspect. This transcendent aspect is the Omega Point, which is neither space nor time nor matter, but is beyond all of these.

.........
Contingency and Temporal Evolution in Classical General Relativity and in Quantum Cosmology

In physical theories before general relativity, it was always assumed that there was a background spacetime within which the entities of physics—fields and particles—evolved. This background space was unchanging. It was not influenced in any way by the physical entities, and it existed whether or not there were any physical entities. As pointed out by Robert Russell (1988), contingency in these theories came in two forms. First, there was contingency of the nature of the most basic physical entity, with a resulting contingency in the form of the evolution equations satisfied by this entity. *A priori*, there was no reason to choose one class of basic physical entities over another— there was in fact a debate in the nineteenth century over whether the fundamental 'stuff' of the universe was particulate atoms or ether fields. Furthermore, the equations governing the chosen stuff could not be determined by logical consistency alone. Some input from observation was required. But there were imposed on these equations certain general symmetry principles arising from the assumption that the laws of physics did not change with time or as one moved from point to point in space. For example, conservation of energy is a consequence of the laws of physics being unchanged under time translation (that is, the Lagrangian from which the evolution equations are derived is unchanged if it is replaced by $t + a$, where a is some constant). Inertia, or conservation of linear momentum, is a consequence of the laws of physics being unchanged under space translation (the Lagrangian is unchanged if all the spatial coordinates x are replaced by $x + a$). Thus the conservation laws are just a property of the evolution equations and are really just a physical reflection of the eternal and homogeneous nature of the background space. It is the background spacetime, not so much the evolution equations or the conser-

vation laws or the principle of inertia, that in Newtonian physics sustains the physical universe in existence.

The second type of contingency is arbitrariness in the initial conditions for the evolution equations. Suppose that the stuff of nature is a field, and the evolution equations are second order in time. Then, given the field and its first time derivative at any initial time, the value of the field at any subsequent and prior time is uniquely determined (assuming that the initial value problem is well-posed, which it is in most cases of physical interest). But in general there will be a continuum of possible values for the initial value of the field and its derivative, all of these possible values comprising what is called 'initial data space'. In the ontology of classical physics, only one set of initial values—a 'point' in initial data space—is physically realized. All the other initial data values correspond to physically possible worlds which are never actualized.

In general relativity, analogues of both of the above-mentioned contingencies are present. In addition, there is what might be termed an 'evolution' contingency due to the fact that in general relativity there is no background spacetime. Rather, the spacetime is itself generated by the initial data and the evolution equations. A spacetime is generated from its initial data in the following manner. One is given a *three-dimensional* manifold S, and on S the non-gravitational fields F (and their appropriate derivatives F') and two tensor fields h and K, with (F, F', h, K) satisfying certain equations called constraint equations. The constraint equations say nothing about the time evolution; rather, they are to be regarded as consistency conditions among the fields (F, F', h, K) which must be satisfied at every instant of time. The physical interpretation of h is that of a spatial metric of the manifold S, and so S and (F, F', h, K) are called *the initial data*. We now try to find a *four-dimensional* manifold M with metric g and spacetime non-gravitational fields F such that: M contains S as a submanifold; g restricted to S is the metric h; and K is the 'extrinsic curvature' of S in M (roughly speaking, K says how rapidly h is changing in 'time'). The manifold M and the fields (g, F) are then the whole of physical reality, including the underlying background spacetime—that is, (M, g)—the gravitational field (represented by the spacetime metric g), and all the non-gravitational fields (given by F). There will be infinitely many such M's and g's, but one can cut down the number by requiring that g satisfies the Einstein field equations everywhere on M, and that the Einstein field equations reduce to the constraint equations on S.[5]

But even requiring the Einstein equations to hold everywhere leaves infinitely many spacetimes (M, g) which are generated from the *same* initial data at the spacetime instant S. To see this, suppose we

have found a spacetime (M, g) which in fact has S and its initial data as the spatial universe at some instant t_0 of universal time. Pick another universal time t_1 to the future of t_0 and cut away all of the spacetime in (M, g) to the future of t_1 (including the spatial instant corresponding to t_1). This gives a new spacetime (M', g) which coincides with (M, g) to the past of t_1, but which has absolutely nothing—no space, no time, no matter—to the future of t_1. Clearly, both (M, g) and (M', g) are spacetimes which are both generated from S and its initial data. Furthermore, the Einstein equations are satisfied everywhere on both spacetimes. There are infinitely many ways we can cut away (M, g) in this way, so there is an infinity of (M', g)'s we can construct. True, the universe (M', g) ends abruptly at t_1 for no good reason. But what of that? The point is that the field equations themselves cannot tell us that the physical universe should continue past the time t_1. Rather, in classical general relativity one must impose as a separate assumption, over and above the assumption of the field equations and the initial data, that the physical universe must continue in time until the field equations themselves tell us that time has come to an end (at a spacetime singularity, say). Without this separate assumption, which of the infinity of (M', g)'s really exists is contingent.

This cutting away procedure will not work in Newtonian mechanics or indeed in any physical theory which has a pre-existing background spacetime. If we tried to require that the physical fields stopped abruptly at t_1, then since the instant t_1 and its future still exist, 'fields stopping abruptly' must mean 'fields $= 0$ abruptly', which would contradict the field equations. So if a theory has a pre-existing background space, the field equations themselves tell us that the universe—or rather the fields and particles making up matter—must keep going. It is more the background spacetime, rather than the evolution equations or the conservation laws, that sustains the universe in being in pre–general relativity theories. Isaac Newton (if not his followers) realized this, asserting that absolute space and time were semi-divine: "the sensorium of God."

If one assumes the physical meaningfulness of the Axiom of Choice (this assumption is fiercely debated; see DeWitt 1973), and in addition one requires that *physical* spacetimes are those in which the g's and F's have derivatives at least to the fourth order, then it is possible to prove (Hawking and Ellis 1973, Chapter 7) that there is among all the mathematically possible (M', g)—we might call these 'possible worlds'—a *unique maximal* spacetime (M, g) which is generated by the initial data on S. 'Maximal' means that the spacetime (M, g) contains any other (M', g) generated by the initial data on S as a proper subset.

In other words, (M, g) is the spacetime we get by continuing the time evolution until the field equations themselves will not allow us to go further. This maximal (M, g) is the natural candidate for the spacetime that is actualized, but it is important to keep in mind that this is a physical assumption: all of the (M', g) are possible worlds, and any one of these possible worlds could have been the one that really exists.

Once we have the maximal (M, g) generated from a given S and its initial data, there is an infinity of other choices of three-dimensional manifolds in M which we could picture as generating (M, g). For example, we could regard the spatial universe and the fields it contains now as 'S with its initial data', or we could regard the universe a thousand years ago as 'S with its initial data'. Both would give the same (M, g), since the Einstein equations are deterministic. Everything that has happened and will happen is contained implicitly in the initial data on S. There is nothing new under the sun in a deterministic theory like general relativity. One could even wonder why time exists at all since from an information standpoint it is quite superfluous (I will suggest an answer to this question in the next section). None of the infinity of initial data manifolds in (M, g) can be uniquely regarded as generating the whole of spacetime (M, g). Each contains the same information, and each will generate the same (M, g), including all the other initial data manifolds.

Even in deterministic theories, relationships between physical entities are different at different times. For example, two particles moving under Newtonian gravity are now two meters apart (say) and a minute later four meters apart. This is true even though given the initial position and velocities when they were two meters apart it is determined then that they will be four meters apart a minute later. The question is, will the totality of relationships at one time become the same (or nearly the same) at some later time? If this happens, then we have the horror of the Eternal Return. As is well known, it is possible to prove that the Eternal Return will occur in a Newtonian universe provided said universe is finite in space and finite in the range of velocities the particles are allowed to have. It is possible to prove that in classical general relativity (Tipler 1979; 1980) the Eternal Return *cannot* occur. That is, the physical relationships existing now between the fields will never be repeated, nor will the relationships ever return to approximately what they now are. What happens is that the Einstein field equations will not permit the gravitational equivalent of the 'range of velocities' to be finite: the range simply must eventually become infinite. Thus history, understood as an unrepeatable temporal sequence of relationships between physical entities, is real. Hence

the answer to Pannenberg's Second Question to scientists—"Are natural processes to be understood as irreversible?"—is yes, if "irreversible" is understood to mean that no natural process can conspire to make some future state be indistinguishable from the current state of the universe. But this meaning of irreversibility is all Pannenberg needs for his argument on the importance of history (Pannenberg 1985).

The meaning of contingency in quantum mechanics depends heavily on which interpretation of the theory is adopted. For example, in the most common version of the Copenhagen Interpretation, there is an intrinsic quantum randomness in nature which adds a new contingency to the three types listed above, whereas in the (non-local) Hidden Variable Interpretation and in the Many Worlds Interpretation, this randomness is merely an artifact of our limited way of observing the physical world. The most basic 'stuff' of the universe, which we cannot observe directly even in principle, but which nevertheless underlies all reality, is completely deterministic (provided the notion of 'time' can be defined, which is not the case in quantum cosmology). Since I am interested here in discussing quantum cosmology, I am virtually forced into adopting the Many Worlds Interpretation, because only in this interpretation is it meaningful to talk about a quantum universe and its ontology. The most common Copenhagen Interpretation assumes that a process called 'wave function reduction' eliminated quantum effects on cosmological scales an exceedingly short time after the Big Bang, so the universe today is not quantum except on very small scales. The problem with this assumption is that the wave function reduction process is almost entirely mysterious— we have no rules for deciding what material entity can reduce wave functions—so it is impossible to give a sharp analysis of contingency when this process is operating. The Many Worlds Interpretation does not suffer from this drawback: there is no reduction of the wave function; physical reality is completely described by the wave function of the universe; there is an equation (the Wheeler-DeWitt equation) for this wave function; and the universe is just as quantum now as it was in the beginning. Of course the Many Worlds Interpretation may be wrong; most physicists think it is (most physicists think it is nonsense). But the overwhelming majority of people working on quantum cosmology subscribe to some version of the Many Worlds Interpretation, simply because the mathematics forces one to accept it. The mathematics may be a delusion, with no reference in physical reality. Or the situation may be similar to that of early seventeenth-century physics: astronomers believed the earth went around the sun, because

the mathematics of the Copernican system forced them to. But few other scholars or ordinary people believed the earth moved. Their own senses told them it did not. I shall adopt the Many Worlds Interpretation in what follows (for a more detailed defense of this interpretation see Barrow and Tipler 1986, section 7.2).

In quantum cosmology the universe is represented by a wave function $\Psi(h, F, S)$, where, as in classical general relativity, h and F are respectively the spatial metric and the non-gravitational fields given on a three-dimensional manifold S. The initial data in quantum cosmology are not (h, F) given on S as was the case in classical general relativity, but rather $\Psi(h, F, S)$ and its first derivatives. From these initial data, the Wheeler-DeWitt equation determines $\Psi(h, F, S)$ for all values of h and F. In other words, the wave function, not the metric or the non-gravitational field, is the basic physical field in quantum cosmology. It is the initial wave function (and appropriate derivatives) that must be given, but once given, it is determined everywhere. What we think of as the most basic fields in classical general relativity, namely h and F, play the role of coordinates in quantum cosmology. But this does not mean h and F are unreal. They are as real as they are in classical theory. It does mean, however, that more than one h and F exist on S at the same time! To appreciate this, recall that the classical metric $h(x)$ is a function of the spatial coordinates on the manifold S. This metric has (non-zero) values at all points on S; that is, for the entire range of the coordinates as they vary over S—which is to say, as we go from one point to another in the universe. Each value of $h(x)$ is equally real, and all of the values of h at all of the points of S exist simultaneously. Similarly, the points in the domain of the wave function $\Psi(h, F, S)$ are the various possible values of h and F, each set (h, F) corresponding to a complete universe at a given instant of time. The central claim of the Many Worlds Interpretation is that each of these universes actually exists, just as the different $h(x)$ exist at the various points of S: quantum reality is made up of an infinite number of universes (worlds). Of course, we are not aware of these worlds—we are only aware of one—but the laws of quantum mechanics explain this: we must generally be as unaware of these parallel worlds as we are of our motion with the earth around the sun. (In extreme conditions, for instance near singularities, it *is* possible for the worlds to affect each other in a more obvious way than they do now.)

To fix the classical initial data, we pick a *function* $h(x)$ out of an infinite number of possible metric functions which could have been on S. All of these possible worlds comprise a function space. To fix the quantum initial data, we pick a *wave function* $\Psi(h, F, S)$ out of an infi-

nite number of possible wave functions which could have been on the classical function space (h, F). Remember, however, that all values of the function space (h, F), *really are* on S simultaneously. In quantum cosmology, the collection of all possible wave functions forms the set of the possible worlds; what is contingent is which single unique universal wave function is actualized. But the possible worlds of classical cosmology—the space of all physically possible (h, F) on S—are no longer contingent. All of them are actualized.

In classical deterministic general relativity, we had a philosophical problem with time: since everything that did or will happen was coded in the initial fields on S, time evolution appeared superfluous. What was the point of having time? The problem is solved in quantum cosmology: *there is no time!* The universal wave function $\Psi(h, F, S)$ is all there is, and there is no reference to a four-dimensional manifold M or a four-dimensional metric g in the wave function. At the most basic ontological level, time does not exist. Everything is on the three-dimensional manifold S. How can this be? Of course we see time! Or do we? What we see is relationships among objects—configurations of physical fields—in space. In the discussion of the Eternal Return, I argued that time and history could be truly real only if the spatial relationships between the various fields never returned to a previous state. In quantum cosmology, there is no spacetime in which the spatial relationships between fields can change. Rather, all we have is paths (trajectories) in the collection (h, F) of all possible relationships between the physical fields on S. But this is enough, because each such path defines a history, a complete spacetime.

To understand this, imagine that we are at a point P in (h, F) and have selected a particular path γ in (h, F) starting at P. Each point, remember, corresponds to an entire universe (spatially). As we go along γ, the relationships between the physical fields vary smoothly from their values at P. *This variation would appear as temporal variation* from inside the path γ, because each point on γ is a complete spatial universe, and thus the sequence of points constitutes a sequence of spatial universes. But this is exactly the same as the classical four-dimensional manifold M with its spacetime metric g and spacetime fields F, which in the above classical analysis we obtained as an extension of S and its fields! Each path in (h, F) thus is an entire classical universal history, an entire spacetime.

All paths in (h, F) really exist, which necessarily means that all—and I mean all—histories which are consistent with the 'stuff' of the universe being (h, F) really exist. In particular, even histories which are grossly inconsistent with the laws of physics really occur! Closed

paths in (h, F) obviously exist, so there are histories in which the Eternal Return is true. There are also real histories leading to our presently observed state of the universe—the point P in (h, F)—in which real historical characters—for instance Julius Caesar—never existed. What happens in such a history is that the physical fields rearrange themselves over time (more accurately, over the path corresponding to this strange history) to create false memories, including not only human memories but also the 'memories' in a huge number of written records and in massive monuments. Just as there is an infinity of actual pasts which have led to the present state, so there is an infinity of really existing futures which evolve from the present state. So every consistent future is not only possible but it really happens. Not all futures are equally likely to be seen, however. There is one path in (h, F) leading from a given point P which is overwhelmingly more likely to follow from P than all the others. This path is called *the classical path*. Along this path the laws of physics hold, and memories are reliable. A classical path in (h, F) very closely resembles a classical spacetime (M, g) obeying the Einstein quotations.

So far I have not said what the wave function Ψ itself does. But it must do something physically detectable, something not coded in the fields (h, F) alone. If it did not exert some physical effect, we could just omit it from physics; it would have no real existence. But I claimed above that Ψ was a *real* field, something as real as the fields (h, F).

What Ψ does is determine the set of all classical paths, and also the "probabilities" which are associated with each point and each path in (h, F). A wave function is a complex function, and all complex functions are actually two functions, a 'magnitude' and a 'phase'. The classical paths are by definition those which are perpendicular to the surfaces of constant phase. The square of the magnitude at a point P in (h, F) is the 'probability' of that point. The physicist Werner Heisenberg showed mathematically that if probability has its usual meaning, then given the fact that we are (approximately) at P, the conditional probability of going to a nearby point Q is maximum if Q lies along the classical path through P. The relative probability is very close to 1 on the classical path, and it drops rapidly to 0 as one moves away from the classical path connecting P and Q (see Barrow and Tipler 1986, section 7.2 for details about how this works).

What must be shown is that the square of the magnitude is in fact a probability in the usual sense. This is done as follows. We obviously cannot get hold of the wave function of the entire universe, but we can prepare in the laboratory a number N of electrons with the same spin wave function. Suppose we measure the vertical component of the

electron spin. It turns out that this component can have only two values, spin up and spin down. If the wave function is not in what is called an 'eigenstate' of spin up or spin down—in general the electron wave function would not be in an eigenstate, so let us suppose it is not—then each time we measure the vertical component of an electron in our ensemble of N electrons we will get a different answer. Some of the electrons will be found to have spin up, and the others will have spin down. We cannot predict before the measurement what the vertical component of that particular electron will be. But it can be shown that if we compute the relative frequency with which we get spin up, then this number approaches the square of the magnitude of the wave function evaluated at spin up as the number N of electrons in the ensemble approaches infinity. And experimentally, this is what we see.

All the physics is contained in the wave function. In fact, the laws of physics themselves are completely superfluous. They are coded in the wave function. The classical laws of physics are just those regularities which are seen to hold along a classical path by observers in that classical path. Along other paths, there would be other regularities, different laws of physics. And these other paths exist and hence these other laws of physics really hold; it is just extremely unlikely we will happen to see them operating. The Wheeler-DeWitt equation for the wave function is itself quite superfluous. It is merely a crutch to help us find the actual wave function of the universe. If we knew the boundary conditions which the actual universal wave function satisfied, then we could derive the Wheeler-DeWitt equation, which is just a particular equation (among many) which the wave function happens to satisfy. Thus in quantum cosmology there is no real contingency in the laws of physics. Any law of physics holds in some path, and the law of physics governing the universal wave function can be derived from that wave function. All the contingency in quantum cosmology is in the wave function, or rather, in the boundary conditions which pick out the wave function which actually exists.

The well-known Hartle-Hawking boundary condition, which says that 'the universal wave function is that wave function for which the Feynman sum over all the paths (classical and otherwise) leading to a given point P is over paths that have no boundaries (more precisely, the four-dimensional manifold corresponding to a given path is a compact manifold whose only boundary is P)' is one such boundary condition. I should like to propose the

TEILHARD BOUNDARY CONDITION FOR THE UNIVERSAL WAVE FUNCTION:
The wave function of the universe is that wave function for which all classical paths terminate in a (future) Omega Point,

with life coming into existence along at least one classical path and continuing into the future forever all the way into the Omega Point.

The Teilhard boundary condition is enormously restrictive. For example, since classical paths are undefined at zeros of the wave function, we immediately have the

FOURTH TESTABLE PREDICTION OF THE OMEGA POINT THEORY: the universal wave function must have no zeros in the spacetime domain.

It turns out (as one might expect) that the Hartle-Hawking boundary condition does not satisfy the Teilhard boundary condition. I have a rough argument that one can construct simple quantized Friedmann cosmological models in which all classical paths terminate in an Omega Point, but I do not know yet what the existence of life requires of a wave function. So at present I can only conjecture, not prove, that a wave function satisfying the Teilhard boundary condition in its full generality exists mathematically. (This is not unusual; there is also no general existence proof yet for the Hartle-Hawking boundary condition.) I also conjecture (for reasons that will be given in the following section) that the Teilhard boundary condition gives a unique wave function.

Let us suppose that the above conjectures are true. Then it would mean that the laws of physics and every entity that exists physically would be generated by the Omega Point and its living properties. For these properties determine the universal wave function, and the wave function determines everything else. This 'determination' is *not* classical determinism, however, because there is no globally defined time on the whole of (h, F), and without this globally defined time, the idea of the past or the present rigidly dictating the future course of events is meaningless. Nevertheless, time is real. It exists in the classical paths, and according to the Teilhard boundary condition the structure of these paths (more precisely, their ultimate future) gives probability weights—guidance, so to speak, not rigid control—to all paths. The ultimate future guides all presents into itself. As Pannenberg puts it: "[God] exists only in the way in which the future is powerful over the present, because the future decides what will emerge out of what exists in the present. . . . Above all, the power of the future does not rob man of his freedom to transcend every state of affairs. A being presently at hand, and equipped with omnipotence, would destroy such freedom by virtue of his overpowering might" (Pannenberg 1971, 242). In this sense, we can say that the Omega Point "creates the physical universe." But there is another sense in which the Omega

Point and the totality of everything that exists physically can be said to create themselves. To this second sense we now turn.[6]

The Universe Necessarily Exists

Suppose it were shown as a matter of physics that the Omega Point really exists. Then would it still be reasonable to assert the existence of a God over and above the Omega Point? Not if we could show that the Omega Point necessarily exists in the strong sense of logical necessity—that to deny its existence would be a logical contradiction. Ever since Kant showed that 'existence is not a predicate' and Gottlob Frege deepened this insight into 'existence is not a first-level predicate' (Williams 1981), it generally has been felt that the ontological/cosmological argument is invalid, that it is impossible by means of logic alone to prove the existence of anything. I want to claim that this is incorrect; I think you can prove that the universe necessarily exists. The proof will be based on an analysis of what the word 'existence' means.

Let us begin with some computer metaphysics. Much of computer science is devoted to making *simulations* of phenomena in the physical world. In a simulation, a mathematical model of the physical object under study is coded in a program. The model includes as many attributes of the real physical object as possible (limited of course by the knowledge of these attributes, and also by the capacity of the computer). The running of the program evolves the model in time. If the initial model is accurate, if enough key features of the real object are captured by the model, the time evolution of the model will mimic with fair accuracy the time development of the real object, so one can predict the most important key aspects which the real object will have in the future.

Suppose we try to simulate a city full of people. Such simulations are being attempted now, but at a ludicrously inaccurate level. Suppose, though, that we imagine more and more of the attributes of the city being included in the simulation. In particular, more and more properties of each individual person are included. In principle, we can imagine a simulation being so good that every single *atom* in each person and each object in the city and the properties of each atom have an analogue in the simulation. Let us imagine, in the limit, a simulation that is absolutely perfect: each and every property of the real city, and each and every real property of each real person in the real city is represented precisely in the simulation. Furthermore, let us imagine that

when the program is run on some gigantic computer, the temporal evolution of the simulated persons and their city precisely mimics for all time the real temporal evolution of the real people and the real city.

The key question is this: Do the simulated people exist? As far as the simulated people can tell, they do. By assumption, any action which the real people can and do carry out to determine if they exist—reflecting on the fact that they think, interacting with the environment—the simulated people also can and in fact do perform. There is simply no way for the simulated people to tell that they are 'really' inside the computer, that they are merely simulated and not real. They can't get at the real substance, the physical computer, from where they are, inside the program. One can imagine the ultimate simulation, a perfect simulation of the entire physical universe, containing in particular all people whom the real universe contains, and which mimics perfectly the actual time evolution of the actual universe. Again, there is no way for the people inside this simulated universe to tell that they are merely simulated, that they are only a sequence of numbers being tossed around inside a computer and are in fact not real. How do we know we ourselves are not merely a simulation inside a gigantic computer? Obviously, we cannot know. But I think it is clear that we ourselves really exist. Therefore, *if* it is in fact possible for the physical universe to be in precise one-to-one correspondence with a simulation, I think we should invoke the Identity of Indiscernibles and identify the universe and all of its perfect simulations.[7]

But is it possible for the universe to be in precise one-to-one correspondence with some simulation? I think that it is, if we generalize what we mean by simulation. In computer science, a simulation is a program, which is fundamentally a map from the set of integers into itself. That is, the instructions in the program tell the computer how to go from the present state, represented by a sequence of integers, to the subsequent state, also represented by a sequence of integers. Remember, however, that we do not really need the physical computer; the initial sequence of integers and the general rule (instructions or map) for replacing the present sequence by the next is all that is required. But the general rule can itself be represented as a sequence of integers. If time were to exist globally, and if the most basic things in the physical universe and the time steps between one instant and the next were discrete, then the whole of spacetime would definitely be in one-to-one correspondence with some program. But time may not exist globally (it does not if standard quantum cosmology is true), and it may be that the substances of the universe are continuous fields and not discrete objects (in *all* current physical theories, the basic substances are

continuous fields). Thus if the actual universe is described by something resembling current theories, it cannot be in one-to-one correspondence with a standard computer program, which is based on integer mappings. There is currently no model of a 'continuous' computer. Turing even argued that such a thing is meaningless! (There are definitions of 'computable continuous functions', but none of the definitions is really satisfactory.)

Let us be more broad minded about what is to count as a simulation. Consider the collection of all mathematical concepts. Let us say that a perfect simulation exists if the physical universe can be put into one-to-one correspondence with some mutually consistent subcollections of all mathematical concepts. In this sense of simulation the universe can certainly be simulated, because simulation then amounts to saying that the universe can be exhaustively described in a logically consistent way. Note that 'described' does not require that we or any other finite (or infinite) intelligent being can actually find the description. It may be that the actual universe expands into an infinite hierarchy of levels whenever one tries to describe it exhaustively. In such a case, it would be impossible to find a Theory of Everything. Nevertheless, it would still be true that a simulation in the more general sense existed if each level were in one-to-one correspondence with some mathematical object, and if all levels were mutually consistent ('consistency' meaning that in the case of disagreement between levels, there is a rule—itself a mathematical object—for deciding which level is correct). The crucial point of this generalization is to establish that the actual physical universe is something in the collection of all mathematical objects. This follows because the universe has a perfect simulation, and we agree to identify the universe with its perfect simulation. Thus at the most basic ontological level the physical universe is a concept.

Of course not all concepts exist physically. But some do. Which ones? The answer is provided by our earlier analysis of programs. *The simulations which are sufficiently complex to contain observers—thinking, feeling beings—as subsimulations exist physically.* And further, they exist physically by definition: for this is exactly what we mean by existence; namely, that thinking and feeling beings think and feel themselves to exist. Remember, the simulated thinking and feeling of simulated beings are real. Thus the actual physical universe—the one in which we are now experiencing our own simulated thoughts and simulated feelings—exists necessarily, by definition of what is meant by existence. Physical existence is just a particular relationship between concepts. Existence *is* a predicate, but a predicate of certain very, very

complex simulations. It is certainly not a predicate of simple concepts—for instance '100 thalers'.

With equal necessity many different universes will exist physically. In particular, a universe in which we do something slightly different from what we actually do in this one will exist (provided of course that this action does not logically contradict the structure of the rest of the universe). But this is nothing new; it is already present in the ontology of the Many-Worlds Interpretation. Exactly how many universes really exist physically depends on your definition of 'thinking and feeling being'. If you adopt a narrow definition—such a being must have at least our human complexity—then the range of possible universes appears quite narrow: Barrow and Tipler's *Anthropic Cosmological Principle* (1986) is devoted to a discussion of how finely tuned our universe must be if it is to contain beings like ourselves.

What happens if a universal simulation stops tomorrow? Does the universe collapse into non-existence? Certainly such terminating simulations exist mathematically. But if there is no intrinsic reason visible from inside the simulation for the simulation to stop, it can be embedded inside a larger simulation which does not stop. Since it is the observations of the beings inside the simulation that determines what exists physically, and since nothing happens from their viewpoint at the termination point when the terminating simulation is embedded in the non-stopping simulation, the universe must be said to continue in existence. It is the maximal extension which has existence, for by the Identity of Indiscernibles we must (physically) identify terminating programs with their embedding in the maximal program.[8]

Furthermore, if it is logically possible for life to continue to exist forever in some universe, this universe will exist necessarily for all future time. In particular, if the Omega Point described in the previous two sections is logically coherent, then the Omega Point exists necessarily. Again, one can find numerous lines of evidence strongly suggesting that it is exceedingly difficult to construct a universe for life to exist at all, much less exist forever. So I would expect the universe selected by the Teilhard boundary condition to be unique. If so, logical consistency (and the definition of 'life', 'thinking and feeling being', and so on) will select out a single unique wave function for actualization. Since the wave function and its arguments determine respectively the physical laws and the 'stuff' that exist, in this case the physical universe would be determined by logical consistency alone. Thus we again conclude that the universe exists necessarily.

· · · · · · · · · ·

The God of Hope

Suppose the Omega Point really exists. Can we mortal human beings find hope in that fact? I believe we can. For hope fundamentally means an expectation that in an appropriate sense the future will be better than the present or the past. Even on the most materialistic level, the future existence of the Omega Point would assure our civilization of ever-growing total wealth, continually increasing knowledge, and quite literal eternal progress. This perpetual meliorism is built into the definition of 'life existing forever' given in the second section. Such worldly meliorism would support an orthodox Christian position on the meaning of the natural world as against, say, the Gnostic view. In the orthodox view, the physical universe is basically good, because it was created by an omnipotent and omniscient deity who is also all good.

Of course, it is a consequence of physics that although our civilization may continue forever, our species *Homo sapiens* must inevitably become extinct, just as every individual human being must inevitably also die. For as the Omega Point is approached, the temperature will approach infinity everywhere in the universe, and it is impossible for our type of life to survive in that environment.[9] But the death of *Homo sapiens* is an evil (beyond the death of the human individuals) only for a racist value system. What is humanly important is the fact we think and feel, not the particular bodily form which clothes the human personality. Just as within *Homo sapiens* a person is a person independent of sex or race, so also an intelligent being is a person regardless of whether that individual is a member of the species *Homo sapiens*. Currently people of non-European descent have a higher birthrate than people of European descent, and so the percentage of *Homo sapiens* which is of European descent is decreasing. The human race is now changing color. In my own value system, this color change is morally neutral; what is important is the overall condition of our civilization: are we advancing in knowledge and wisdom? Certainly our scientific knowledge is greater than it was a century ago, and although there have been a great many steps backward during this century, I nevertheless think we are wiser than our great grandparents. If the Omega Point exists, this advance will continue without limit into the Omega Point. Our species is an intermediate step in the infinitely long temporal Chain of Being (Lovejoy 1936) that comprises the whole of life in spacetime. An essential step, but still only a step. In fact, it is a logically necessary consequence of eternal progress that our species become extinct! For we are finite beings; we have definite limits. Our brains can code only so much information, and we can

understand only rather simple arguments. If the ascent of Life into the Omega Point is to occur, one day the most advanced minds must be non-*Homo sapiens*. The heirs of our civilization must be another species, and their heirs yet another, *ad infinitum* into the Omega Point. We must die—as individuals, as a species—in order that our civilization might live. But the contributions to civilization which we make as individuals will survive our individual deaths. Judging from the rapid advance of computers at present, I would guess that the next stage of intelligent life would be quite literally information-processing machines. At the present rate, computers will reach the human level in information-processing and integration ability probably within a century, certainly within a thousand years.

Many find the assurance of the immortality of life as a whole cold comfort for their death as individuals. They feel that a truly good God would make some provision for individual life after death also. What the Christian hopes for in eternal life has been ably expressed by Pannenberg:

> the life that awakens in the resurrection of the dead is the same as the life we now lead on earth. However, it is our present life as God sees it from his eternal present. Therefore, it will be completely different from the way we now experience it. Yet, nothing happens in the resurrection of the dead except that which already constitutes the eternal depth of time now and which is already present for God's eyes—for his creative view! (Pannenberg 1970, 80)

We shall, so to speak, live again in the mind of God. But recall my discussion of Thomist *aeternitas*. There I pointed out that all the information contained in the whole of human history, including every detail of every human life, will be available for analysis by the collectivity of life in the far future. In principle at least (again ignoring the difficulty of extracting the relevant information from the overall background noise), it is possible for life in the far future to construct, using this information, an exceedingly accurate simulation of these past lives: in fact, this simulation is just what a sufficiently close scrutiny of our present lives by the Omega Point would amount to. And I have also pointed out that a sufficiently perfect simulation of a living being would *be* alive! Whether the Omega Point would choose to use His/Her power to do this simulation, I cannot say. But it seems the physical capability to carry out the scrutiny would be there.[10] Furthermore, the drive for total knowledge—which life in the future must seek if it is to survive at all, and which will be achieved only at the Omega Point—would seem to require that such an analysis of the past, and hence such a simulation, would be carried out. If so, then the

resurrection of the dead in Pannenberg's sense would seem inevitable in the *eschaton* (last times).

I should emphasize that this simulation of people that have lived in the past need not be limited to just repeating the past. Once a simulation of a person and his or her world has been formed in a computer of sufficient capacity, the simulated person can be allowed to develop further—to think and feel things that the long-dead original person being simulated never felt and thought. It is not even necessary for *any* of the past to be repeated. The Omega Point[11] could simply begin the simulation with the brain memory of the dead person as it was at the instant of death (or, say, ten years before or twenty minutes before) implanted in the simulated body of the dead person, the body being as it was at age twenty (or any other age). This body and memory collection could be set in any simulated background environment the Omega Point wished: a simulated world indistinguishable from the long-extinct society and physical universe of the revived dead person; or even a world that never existed, but one as close as logically possible to the ideal *fantasy* world of the resurrected dead person. Furthermore, all possible combinations of resurrected dead can be placed in the same simulation and allowed to interact. For example, the reader could be placed in a simulation with *all* of his or her ancestors and descendents, each at whatever age (physical and mental, separately) the Omega Point pleases. The Omega Point itself could interact—speak, for instance—with His/Her simulated creatures, who could learn about Him/Her, about the world outside the simulation, and about other simulations, from Him/Her.

The simulated body could be one that has been vastly improved over the one we currently have; the laws of the simulated world could be modified to prevent a second physical death. Borrowing the terminology of Paul, we can call the simulated, improved, and undying body a 'spiritual body', for it will be of the same 'stuff' as the human mind now is: a 'thought inside a mind' (in Aristotelian language, 'a form inside a form'; in computer language, a 'virtual machine inside a machine'). The spiritual body is thus just the present body (with improvements!) at a higher level of implementation.[12] With this phrasing, Paul's description is completely accurate: "So also is the resurrection of the dead. It is sown in corruption; it is raised in incorruption: It is sown in dishonor; it is raised in glory; it is sown in weakness; it is raised in power: It is sown a natural body; it is raised a spiritual body" (1 Cor. 15:42–44). Only as a spiritual body, only as a computer simulation, is resurrection possible without a second death: our current bodies, implemented in matter, could not possibly survive the extreme

heat near the final singularity. Again, Paul's words are descriptive: "flesh and blood cannot inherit the kingdom of God" (1 Cor. 15:50).

Nevertheless, it is appropriate to regard computer simulation resurrection as being a "resurrection of the flesh" (in the words of the Apostles' Creed). For a simulated person would observe herself to be as real, and as having a body as solid as the body we currently observe ourselves to have. There would be nothing 'ghostly' about the simulated body, and nothing insubstantial about the simulated world in which the simulated body found itself. In the words of Tertullian, the simulated body would be "this flesh, suffused with blood, built up with bones, interwoven with nerves, entwined with veins, [a flesh] which . . . [is] . . . undoubtedly human" (*De Carne Christi*, 5; trans. by Pagels 1979, 4).

Although computer simulation resurrection overcomes the physical barriers to eternal life of individual human beings, there remains a logical problem, namely, the finiteness of the human memory. The human brain can store only about 10^{15} bits (this corresponds to roughly a thousand subjective years of life), and once this memory space is exhausted we can grow no more (Barrow and Tipler 1986, 136). Thus it is not clear that the undying resurrected life is appropriately regarded as 'eternal'. There are several options: the Omega Point could permit us to merge our individual personalities—upload our personalities out of the simulation into a higher level of implementation—into the universal mind[13] which is His/Hers (increasing our memory storage capacity indefinitely beyond 10^{15} bits would amount to the same thing). Alternatively, the Omega Point could guide us to a 'perfection' of our finite natures, whatever 'perfection' means! Depending on the definition, there could be many perfections. With sufficient computer power, it should be possible to calculate what a human action would result in without the simulation actually experiencing the action, so the Omega Point would be able to advise us on possible perfections without our having to go through the trial-and-error procedure characteristic of this life. If more than one simulation of the same individual is made, then *all* of these options could be realized simultaneously. Once an individual is 'perfected', the memory of this perfect individual could be recorded permanently—preserved all the way into the Omega Point in its transcendence. The errors and evil committed by the imperfect individual could be erased from the universal mind (or also permanently recorded). The perfected individual personality would be truly eternal; she would exist for all future time. Furthermore, when the perfected personality reached the Omega Point in its transcendence, it would become eternal in the sense of being beyond

time, being truly one with God. The natural term to describe this perfected immortality is 'beatific vision'.

If the resurrected life is going to be so wonderful,[14] one might ask why we must go through our current life, this 'vale of tears', at all. Why not start life at the resurrection? The answer was given in the third and fourth sections: our current life is logically necessary; simulations indistinguishable from ourselves *have* to go through it. It is logically impossible for the Omega Point to rescue us. Even omnipotence is limited by logic. This is the natural resolution to the Problem of Evil.

In his *On the Immortality of the Soul*, David Hume raised the following objection to the idea of a general resurrection of the dead: "How to dispose of the infinite number of posthumous existences ought also to embarrass the religious theory" (Hume [1755] in Flew 1964, 187). Hume summarized the argument in a later interview with the famous biographer James Boswell:

> [Hume] added that it was a most unreasonable fancy that he should exist forever. That immortality, if it were at all, must be general; that a great proportion of the human race has hardly any intellectual qualities; that a great proportion dies in infancy before being possessed of reason; yet all these must be immortal; that a Porter who gets drunk by ten o'clock with gin must be immortal; that the trash of every age must be preserved, and that new Universes must be created to contain such infinite numbers. (Hume [1776] 1977, 77)

The ever-growing numbers of people whom Hume regarded as trash nevertheless could be preserved forever in our single finite (classical) universe if computer capacity is created fast enough. By looking more carefully at the calculations summarized in the second section of this paper, one sees that they also show it is physically possible to save *forever* a certain constant percentage of the information processed at a given universal time. Thus, the computer capacity will be there to preserve even drunken porters (and perfected drunken porters), provided only that the Omega Point waits long enough before resurrecting them. Even though the computer capacity required to simulate perfectly is exponentially related to the complexity of entity simulated, it is physically possible to resurrect an actual infinity of individuals between now and the Omega Point—even assuming the complexity of the average individual diverges as the Omega Point is approached—and guide then *all* into perfection. Total perfection of all would be achieved at the instant of the Omega Point.[15]

But this preservation capacity has an even more important implication: *it means that the resurrection is likely to occur even if sufficient infor-*

mation to resurrect cannot be extracted from the past light cone. Since the universal computer capacity increases without bound as the Omega Point is approached, it follows that if only a bare-bones description of our current world is stored permanently, then a time will inevitably come when there will be sufficient computer capacity to simulate our present-day world by simple brute force—by creating a simulation of *all* logically possible variants of our world. For example, the human genome can code about 10 to the 10^6 power possible humans, and the brain of each could have 2 to the 10^{15} power possible memories. With the computer power that will eventually become available, the Omega Point could simply simulate them all. Just the knowledge of the human genome would be enough for this. And even if the record of the human genome is not retained until the computer capacity is sufficient, it would still be possible to resurrect all possible humans, just from the knowledge it was coded in DNA. Merely simulate all possible life forms that could be coded by DNA (for technical reasons, the number is finite), and all logically possible humans necessarily will be included. Such a brute force method is not very elegant;[16] I discuss it only to demonstrate that resurrection is unquestionably physically possible. And if there is no other way, it almost certainly will be done by brute force in the drive toward total knowledge. In our own drive to understand how life got started on our planet, we are in effect trying to simulate—resurrect—all possible kinds of the simplest life forms which could spontaneously form on the primitive earth.

What happens to the resurrected dead is entirely up to the Omega Point; there is no way that simulations can enforce or pay for the immortality which it is in the power of the Omega Point to grant. But continued survival near the final state will require greater and greater cooperation, and we know that cooperation is generally associated with altruism. Furthermore, if the resurrection is delayed sufficiently long, then the relative computer resources required to resurrect, guide the whole of humanity into the beatific vision, and preserve the perfected individuals forever will be tiny. Since the cost of doing good is not significantly greater than the cost of doing evil, I think we can reasonably count on the former, especially if the Person making the choice is basically good. Adopting the natural theological term, I think we will be granted 'grace'.

The hope of eternal worldly progress and the hope of individual survival beyond the grave turn out to be the same. Far from being polar opposites, these two hopes require each other; we cannot have one without the other. The Omega Point is truly the God of Hope: "O death, where is thy sting? O grave, where is thy victory?" (1 Cor. 15:55).

• • • • • • • • •

From *Zygon: Journal of Religion and Science* 24 (June) 1989, 217–253. By permission.

• • • • • • • • •

Notes

1. A detailed comparison of the Omega Point theory developed below and Teilhard's Point Omega will be found in section 3.11 of my book with John D. Barrow, *The Anthropic Cosmological Principle* (1986).

2. To emphasize the scientific nature of the Omega Point theory, let me state here that I consider myself an atheist. I certainly do not believe in the God of the traditional Christian metaphysics which I have read, and although the Omega Point theory is a viable scientific theory of the future of the physical universe, there is as yet no confirming experimental evidence for it. Thus it is premature to accept it. Flew (1984), among others, has in my opinion made a convincing case for the presumption of atheism. Nevertheless, I think atheistic scientists should take the Omega Point theory seriously because we have to have *some* theory for the future of the physical universe—since it unquestionably exists—and the Omega Point theory is based on the most beautiful physical postulate: that total death is not inevitable. *All* other theories of the future necessarily postulate the ultimate extinction of everything we could possibly care about. I once visited a Nazi death camp; there I was reinforced in my conviction that there is nothing uglier than extermination. We physicists know that a beautiful postulate is more likely to be correct than an ugly one. Why not adopt the postulate of eternal life, at least as a working hypothesis?

3. Unfortunately, Aristotle ruined his own idea of the soul by soiling it with Platonic dualism. This mistake led to Aquinas's contradictory notion of *substantial form*. Both ideas suggest that the personality survives death naturally (see Flew 1964, 16–21; 1987, 71–87). As Pannenberg has emphasized, the idea of a disembodied soul which can think without a body is contrary to the Jewish and early Christian tradition. If it were true, what would be the point of the resurrection of the flesh? As Plato himself realized, the Platonic soul suggests reincarnation, not resurrection.

4. I should warn the reader that I have ignored the problem of opacity and the problem of loss of coherence of the light. Until these are taken into account, I cannot say exactly how much information can in fact be extracted from the past. But at the most basic ontological level, all the information from the past (all of human history) remains in the physical universe and is available for analysis by the Omega Point.

5. I should mention in passing that in general relativity the standard conservation laws are almost trivially true. In general relativity the conservation law for mass-energy reads $d^*T = 0$, which follows from the Einstein equations $G = 8\pi T$, which can be regarded as defining the stress energy tensor T, and the fact that *any* metric g satisfies $d^*G = 0$. See Misner, Thorne, and Wheeler (1973, Chapter 15) for a discussion of this point. The principle of inertia plays no role in sustaining the universe in existence.

6. I should mention that there is another quantum theory of the Omega Point, due to John A. Wheeler (1988). Wheeler's theory is based on a non-standard version of the Copenhagen Interpretation, and in his theory the Omega Point quite literally creates almost everything in the physical universe by backward causation. We ourselves create some entities in the universe, but our creations are insignificant when compared to the creations of the Omega Point. On Wheeler's theory, however, future evolution stops at the Planck time, so the properties of the Omega Point which depend on infinity are not present in Wheeler's theory.

7. For more discussion of whether a simulation must be regarded as real if it copies the real universe sufficiently closely, see Hofstadter and Dennett (1981, particularly 73–78, 94–99, 287–300).

8. One could use a similar argument for asserting the physical existence of the maximal evolution from given initial data in the classical general relativity evolution problem.

9. Incidentally, the non-existence of the Omega Point would not help us. If the universe were open and expanded forever, then the temperature would go to zero as the universe expanded. There is not enough energy in the frigid future of such a universe for *Homo sapiens* to survive. Also, protons probably decay, and we are made up of atoms, which require protons.

10. It is interesting that if the universe were infinite in spatial extent, then this information about the past would scatter to infinity and never in the whole of the future be reconcentrated for possible reconstruction.

11. In one of its immanent intermediate temporal states; this qualification is hereafter omitted for ease of reading.

12. See Hofstadter and Dennett (1981, 379–381) for a very brief discussion of the extremely important computer concept of *levels of implementation*.

13. Strictly speaking, I do not know the Omega Point (in its immanence) *has* a human-type mind at the highest level of implementation. Probably not; a human-type mind is a manifestation of an extremely low level of information processing: a mere ten to 1,000 gigaflops (Barrow and Tipler 1986, 136). Nevertheless, the Omega Point is still a Person (at all times in our future), because a being with its level of computer capacity could easily create a Turing-test-passing subprogram to speak for it. Our resurrected selves probably will interact with such a program; it is beyond human capacity to deal directly with the highest level of implementation possessed by the state of the Omega Point at the time we are resurrected. For lack of a better term, I shall refer to the total universal information-processing system in existence at any given universal time as the 'universal mind'.

14. The version of eternal life discussed here is not attractive to everyone. What is happening is that an exact replica of ourselves is being simulated in the computer minds of the far future. Flew, for example, considers it ridiculous to call this 'resurrection', and he puts forward the "Replica Objection": "No replica however perfect, whether produced by God or

man, whether in our Universe or another, could ever be—in that primary, forensic sense—the same person as its original. . . . To punish or to reward a replica, reconstituted on Judgement Day, for the sins or the virtues of the old Antony Flew dead and cremated, perhaps long years before, is as inept and as unfair as it would be to reward or to punish one identical twin for what was in fact done by the other" (Flew 1976, 12, 9). Flew is wrong about our legal system. It does in fact equate identical computer programs. If I duplicated a word-processing program and used it without paying a royalty to the programmer, I would be taken to court. A claim that "the program I used is not the original, it is merely a replica" would not be accepted as a defense. I could also be sued for using without permission an organism whose genome has been patented. Identical twins are *not* identical persons. The programs which are their minds differ enormously; the memories coded in their neurons differ from each other in at least as many ways as they differ from the memories of other human beings. They are correctly regarded as different persons. But two beings who are identical both in their genes *and* in their mind programs *are* the same person, and it is appropriate to regard them as equally responsible legally. I am surprised that an empiricist philosopher like Flew would make the claim that entities which cannot be empirically distinguished, even in principle, are nevertheless to be regarded as utterly different. Any scientist would think that two physically indistinguishable systems are to be regarded as the same, both physically and legally. Flew cites a number of passages from traditional religious authorities in support of the Replica Objection, but except where these men have been clearly infected by Platonic dualism, I think these very passages support the idea that replica resurrection is what is expected in the Judeo-Christian-Islamic tradition. See for example my interpretation above of 1 Cor. 15, which Flew thinks implies a Platonic soul.

15. This depends in a crucial way on the fact that there will be an actual infinity (χ_0) of information processed between any finite time and the Omega Point. It is an example of what Bertrand Russell (1931, 358) has termed the Tristram Shandy paradox. Tristram Shandy took two years to write the history of the first two days of his life and complained that at that rate, material would accumulate faster than he could write it down. Russell showed that even if Tristram Shandy lived forever no part of his biography would have remained unwritten. In the case of the Omega Point, which literally does live forever, all beings that have ever lived and will live from now to the end of time can be resurrected and remembered, even though the time needed to do the resurrecting will increase exponentially, a much worse case than Tristram Shandy faced. It is important that at any given time on a classical trajectory, there is only a finite number of possible beings which could exist. If this were not true, then the number of beings that would have to be resurrected between now and the Final State might be the power set of χ_0, which is a higher order of infinity than χ_0, and thus resurrecting all possible beings via the brute force method

might be impossible because only χ_0 bits can be recorded between now and the Final State.

16. One could also worry about the morality of such brute-force resurrection; not only are the dead being resurrected, but also people who never lived! However, the central claim of the Many Worlds physics in the third section and the Many Worlds metaphysics in the fourth section is that all people and all histories who could exist in fact do. They just do not exist on our classical trajectory, and so we have no record of them. So the resurrected dead would probably not care which classical trajectory they are resurrected in—their own trajectory or another one—so long as they *are* resurrected. If getting the resurrected in the right trajectory is important, then some information from the past light cone of each trajectory is needed—in this case the sleeping metaphor of Dan. 12:2 and the seed metaphor of 1 Cor. 15 become very accurate pictures of the resurrection.

• • • • • • • • • •

References

Barrow, John D., and Frank J. Tipler. 1986. *The Anthropic Cosmological Principle.* Oxford: Oxford University Press.

Clarke, Samuel. 1717. *A Collection of Papers Which Passed Between the Late Learned Mr. Leibniz and Dr. Clarke in the Years 1715 and 1716 Relating to the Principles of Natural Philosophy and Religion.* London: James Knapton.

DeWitt, Bryce S. 1973. Much Esteemed Theory: A Review of *The Large Scale Structure of Space-Time. Science* 182: 705–06.

Earman, John. 1986. *A Primer on Determinism.* Dordrecht: Reidel.

Findlay, John N. 1955. Can God's Non-Existence Be Proved? In *New Essays in Philosophical Theology,* ed. Antony G.N. Flew and Alasdair MacIntyre, 47–56. London: SCM Press.

Flew, Antony, ed. 1964. *Body, Mind, and Death.* New York: Macmillan.

———. 1984. *God, Freedom, and Immortality: A Critical Analysis.* Buffalo: Prometheus.

———. 1987. *The Logic of Mortality.* Oxford: Blackwell.

Hawking, Stephen W., and George F.R. Ellis, 1973. *The Large Scale Structure of Space-Time.* Cambridge: Cambridge University Press.

Hick, John. 1976. *Death and Eternal Life.* New York: Harper and Row.

Hume, David. [1776] 1977. *Dialogues Concerning Natural Religion,* ed. Norman Kemp Smith. Indianapolis: Bobbs-Merrill.

Hofstadter, Douglas R., and Daniel C. Dennett. 1981. *The Mind's I.* New York: Basic Books.

Kenny, Anthony. 1969. *The Five Ways: St. Thomas Aquinas' Proofs of God's Existence.* New York: Schocken.

Lovejoy, Arthur O. 1936. *The Great Chain of Being.* Cambridge, Mass.: Harvard University Press.

Misner, Charles W., Kip S. Thorne, and John Archibald Wheeler. 1973. *Gravitation.* San Francisco: Freeman.

Pagels, Elaine. 1979. *The Gnostic Gospels.* New York: Random House.

Pannenberg, Wolfhart. 1967. Response to the Discussion. In *Theology as History,* ed. James M. Robinson and John B. Cobb, Jr., 221–276. New York: Harper and Row.

———. 1970. *What Is Man?* Philadelphia: Fortress.

———. 1971. The God of Hope. In *Basic Questions in Theology: Collected Essays.* vol. 2, by Wolfhart Pannenberg, 234–249. Philadelphia: Fortress.

———. 1973. Eschatology and the Experience of Meaning. In *The Idea of God and Human Freedom,* by Wolfhart Pannenberg, 192–210. Philadelphia: Westminster.

———. 1976. *Theology and the Philosophy of Science.* Philadelphia: Westminster.

———. 1977. The Spirit of Life. In *Faith and Reality,* by Wolfhart Pannenberg, 20–38. Philadelphia: Westminster.

———. 1984. Constructive and Critical Functions of Christian Eschatology. *Harvard Theological Review* 72: 119–139.

———. 1985. *Anthropology in Theological Perspective.* Philadelphia: Westminster.

Rahner, Karl, and Herbert Vorgrimler. 1983. *Concise Theological Dictionary.* 2nd edn. London: Burns and Oates.

Russell, Bertrand. 1931. *Principles of Mathematics.* 2nd ed. New York: Norton.

Russell, Robert John. 1988. Contingency in Physics and Cosmology: A Critique of the Theology of Wolfhart Pannenberg. *Zygon: Journal of Religion and Science* 23: 23–43.

Smith, Jane I., and Yvonne Y. Haddad. 1981. *The Islamic Understanding of Death and Resurrection.* Albany: State University of New York Press.

Tipler, Frank J. 1979. General Relativity, Thermodynamics, and the Poincaré Cycle. *Nature* 280: 203–05.

———. 1980. General Relativity and the Eternal Return. In *Essays in General Relativity,* ed. Frank J. Tipler, 21–37. New York: Academic Press.

———. 1986. Cosmological Limits on Computation. *International Journal of Theoretical Physics* 25: 617–661.

———. 1988. The Omega Point Theory: A Model of an Evolving God. In *Physics, Philosophy, and Theology: A Common Quest for Understanding,* ed. Robert Russell, William Stoeger, and George Coyne, 313–331. Notre Dame: University of Notre Dame Press.

Wheeler, John A. 1988. World as System Self-Synthesized by Quantum Networking. *IBM Journal of Research* 32: 4–15.

Williams, Christopher J. F. 1981. *What Is Existence?* Oxford: Oxford University Press.

8

Cosmology and Eschatology: The Implications of
Tipler's 'Omega-Point' Theory for Pannenberg's
Theological Program
••••••••••
Robert John Russell

The Revelation of John is but a pale document compared with
these modern scientific apocalypses. (Peacocke 1979, 329)

••••••••••
I. Introduction

A. The Crisis of the Eschatological Incompatibility with Modern Cosmology

For over a century now many theologians have been in fruitful
dialogue with Darwinism and more recently with the neo-Darwinian
synthesis. Yet even at their best, most forms of evolutionary theism are
characterized by an antithesis between optimism and betrayal: On the
one hand the (*seeming*) advance of biological evolution towards sys-
tems of greater complexity leads many evolutionary theists to speak of
God's continuing creation, with humankind as *a* (even *the*) high point
in the process. Yet evolution has frequently provided fertile grounds
for philosophical reductionism, casting theists on the defensive lest an
evolutionary explanation be expanded to 'explain away' culture and
with it religion, while some contemporary fundamentalists portray
evolution as contradicting Scripture, arguing for the replacement of
evolution by 'scientific creationism'.

Meanwhile a much more serious challenge to theology has been
brewing among those sciences whose scope extends far beyond our
earthly backyard. When we turn from a *terrestrial* to a *cosmos-logical*
horizon we encounter the grim reality of a universe in which all life, it
seems, must inevitably and remorselessly be extinguished. For if Big
Bang cosmology is correct, our universe faces a *far* future of either
endless cold or unimaginable heat, a universe in which the delicate
conditions for the possibility of life exist for only a tiny fraction of uni-
versal history: If the universe is closed, it will eventually recontract,
ending in an umimaginably hot fireball something like 100 billion

years from now. The conditions for life probably extend from four billion years ago to perhaps five billion years ahead, so that for some 70 to 80 percent of cosmic history life will be impossible. If the universe is open, it will expand forever, cooling indefinitely. Again the conditions for life probably span less than ten billion years, a vanishing small duration in an eternal, lifeless universe. Hence when the context of 'theology and science' switches from biology to cosmology the mood of the conversation changes from the optimism of, for example, Teilhard de Chardin, John Cobb, Jr., and Charles Birch, Sallie McFague, Ralph Burhoe, or Philip Hefner. When cosmology is the scene, as it must ultimately be if we are to take creation seriously, our ability to construct an adequate theology of creation is challenged to the core as nowhere else.[1]

This problem has occasionally surfaced in the writing of scientists, philosophers, and theologians. Even as the enormity of social and personal evil has been a key factor in religion's loss of credibility in a century marked by two world wars and the Holocaust, so too for many the ultimate futility of life in the universe has contributed to disbelief in a God who is "trustworthy," to use Hefner's term. In 1903, long before the present cosmological scenarios were dreamed of, Bertrand Russell wrote prophetically:

> All the labors of the ages, all the devotion, all the inspiration, all the noon-day brightness of human genius are destined to extinction in the vast death of the solar system and the whole temple of man's achievement must inevitably be buried beneath the debris of the universe in ruins. (Russell 1963)

Now over seventy years later, but in a strikingly similar mood in light of detailed modern cosmology, Steven Weinberg closes his book *The First Three Minutes* with this passage:

> It is very hard to realize that this all is just a tiny part of an overwhelmingly hostile universe. It is even harder to realize that this present universe has evolved from an unspeakably unfamiliar condition, and faces a future extinction of endless cold or intolerable heat. The more the universe seems comprehensible, the more it also seems pointless. (Weinberg 1977, 154–55)

What then *can* we say theologically about a future of hope and a universal fulfillment given the setting of scientific cosmology? Not much it would seem, according to most theologians in our century. Although he produced a pioneering study on the doctrine of creation

and contemporary science in his 1979 Bampton Lectures, when facing the problem of eschatology Arthur Peacocke wrote,

> science raises questions about the ultimate significance of human life in a universe that will eventually surely obliterate it. However far ahead may be the demise of life in the cosmos, the fact of its inevitability *undermines any intelligible grounds for hope being generated from within the purely scientific prospect itself.* (Peacocke 1979, 329; my italics)[2]

B. 1981 on: A New Era of 'Physical Eschatology'

In a paper delivered at the Annual Meeting of the American Academy of Religion (Russell 1985) I argued that a new era in the relation of science and religion is upon us. Beginning with the groundbreaking work of Freeman J. Dyson and continuing with the speculations of Tipler and others, there now seems to be a way forward towards a possible reconciliation of eschatology and cosmology.

Though only at a preliminary stage and fraught with difficulties, this may well be the era of 'physical eschatology' as Dyson calls it in his astonishing research paper, published in *Reviews of Modern Physics* in 1979 and entitled 'Time without End: Physics and Biology in an Open Universe' (Dyson 1979; for a nontechnical discussion, see Dyson 1988). Dyson opens with a challenging remark: "I hope to hasten the arrival of the day when eschatology, the study of the end of the universe, will be a respectable scientific discipline and not merely a branch of theology." Though this could be read as yet another reductionist strategy (note the "merely"), I believe the detailed arguments Dyson actually gives provide a basis for creative dialogue about theological eschatology and physical cosmology.

Dyson focuses attention on the scenario of an open universe.[3] Here he advances an unprecedented argument that life can continue into the *infinite* future, conscious of its history, processing new experiences and storing them through new forms of nonbiologically based memory. Hence

> an open universe need not evolve into a state of permanent quiescence. Life and communication can continue forever, utilizing a finite store of energy. . . . So far as we can imagine into the future, things continue to happen. In the open cosmology, history has no end. (Dyson 1979, 447, 453)

Dyson concludes by recalling the model of the universe as suggested by Weinberg in which the universe seems 'pointless'. By contrast, Dyson has found

a universe growing without limit in richness and complexity, a universe of life surviving forever and making itself known to its neighbors across unimaginable gulfs of space and time. Is Weinberg's universe or mine closer to the truth? One day, before long, we shall know. I think I have shown that there are good scientific reasons for taking seriously the possibility that life and intelligence can succeed in molding this universe of ours to their own purposes. (Dyson 1979, 459–460)

C. The Theological Advantage of Tipler's Approach to Pannenberg's Theology

Now Tipler (Barrow and Tipler, 1986; Tipler 1988, Chapter 7)[4] has brought the discussion of physical eschatology to its next and even more controversial phase, for he has answered several highly significant technical problems in Dyson's scenario. In Dyson's *open* universe although life may *continue* forever, because the universe expands forever it becomes increasingly hard for life to *communicate globally*. By changing to a *closed* cosmology, Tipler avoids the communication problem while at the same time preserving the attractive feature of the open universe, namely the *infinite* future.

Tipler does so by a clever use of subjective versus physical time, and by arguing that what is essential to the definition of life (information processing) can be replicated on a nonbiological basis. According to Tipler, if one understands time in terms of information theory, then the accumulation of and retention of experience (by, admittedly, nonbiological life forms) in the far future can continue indefinitely, even though in a finite amount of physical time the universe recollapses and ends.

Tipler then speaks theologically about this model. He begins by including the boundary of the universe as part of the universe, envisages the possibility of life transforming it from what is called an extended (topologically complex) point boundary,[5] and claims that, at the end of the universe when life merges with the boundary point (which he calls Omega in the spirit of Teilhard), life becomes divine, being omniscient, omnipresent, and omnipotent.

Of course Tipler's theological views contrast in several ways with traditional forms of Christian theology, with their central concern for creation and redemption through a trinitarian focus and a well-defined christology, for the structure of the church and its relation to society through a detailed ecclesiology, for a theory of revelation and its relation to all of human knowing and acting, including the relation of revelation, reason, and history, and of course for a thorough understanding of the problem of the Triune God.

Still, the newly developing *cosmological framework* that Tipler proposes is particularly important for the problem of eschatology, and this in turn is central to Pannenberg's theological program. Moreover Tipler derives many novel theological insights from his scientific model which challenge us to further reflection. Hence Tipler's Omega-point theory deserves serious theological consideration in light of Pannenberg's work, though we may find only partial agreement and occasional clear disagreement with Tipler's philosophical and theological conclusions. To begin that process, I will suggest nine areas for discussion and then, in section D below, give some areas more detailed attention. The first seven are based on Tipler's current cosmological model; in the last two I propose we *extend* Tipler's model to include the initial boundary of the universe as the Alpha point.

1. Pannenberg's point of departure is a radical insistence on the eschatological context; this context performs a methodological and hermeneutical role throughout Pannenberg's program (Pannenberg 1976; 1977; for a specific focus see Pannenberg 1993). Now in stark contrast to standard cosmology, Tipler's cosmological scenario offers a horizon of meaning which is, arguably, congruent in several important respects to the Biblical eschatological horizon:

- It is apocalyptic, since all life comes to a single end in a universal cataclysm;
- It is concerned not only with the end of time, but proleptically with the present reality of the end at work in the here and now, since the Omega point subsumes all past events in the cosmos within its complex mathematical structure as a boundary 'point', and since the (necessary) existence of the Omega point grounds the (otherwise contingent) existence of all of spacetime and actualizes and contains all past experience;
- It provides a universal horizon of hope transcending all possible limiting horizons now and in the future (such as the death of the earth, a real problem for Teilhard's scenario), and hence provides the ultimate context needed for Pannenberg's hermeneutics of ever-widening interpretive categories;
- It can be interpreted in terms of *apokatastasis*, the universal Resurrection of the dead.

2. The contingency of the universe is central to Pannenberg's doctrine of creation in several ways, as I have previously argued (Russell 1988): as the contingency of the whole (or global contingency), as the contingency of each event and process (or local contingency),

and as the contingency of the laws of nature (or nomological contingency). Moreover both global and local forms of contingency occur as ontological claims (why there should be anything at all, either of the universe itself, or of any part) and as existential claims (why the universe as a whole, and as each part, takes on its actual, particular form), while nomological contingency entails several distinct claims about the character of physical laws and their first instantiations in nature.

The Omega point theory (and the Cauchy, or initial conditions, problem in particular) gives new insight into the meaning of contingency by revising the relation of nomological and global ontological contingency (the laws of nature may be the necessary result of the actuality of the universe as a whole seen from a 'many worlds' perspective, not of an independent 'free parameter' governing it).

3. The reality of the arrow of time—the distinction between past, present, and future and hence the passage of time—is central to Pannenberg's understanding of nature and history. Now the question of the reality of time involves two topics: (a) Is there a global 'present' (global hypersurface of simultaneity)? and (b) Does time 'flow' from past through such a global present to the future (the arrow-of-time problem)? Although much of physics seems to suggest that the passage of time is a merely subjective phenomenon not intrinsic to nature,[6] in Tipler's cosmology there are important reasons for taking the irreversibility of time seriously (including the observation that the boundary conditions at the beginning and end of the Omega-point universe are *not* symmetric). Hence Tipler's arguments about time and its arrow provide an important bridge point to Pannenberg's central insight about history in its revelatory power and the future as the being of God.

4. This view of time is relevant to Pannenberg's highly unusual interpretation of causality: that causality flows from the future through the present. This claim is rooted in Pannenberg's insistence that the original and genuine understanding of *telos* in Aristotle involved a *"not yet* attained goal" which, unlike the germ theory that unfolds from the past, draws us towards a future given ontological priority over the present (Pannenberg 1969, Chapter. 4, especially 139). Tipler's cosmology provides an intriguing model of this transcendent *telos* in terms of the Omega point as the ground of unrealizability, causality, and irreversibility.

5. Moreover the existence of the Omega point provides a basis for Pannenberg's insistence on the unity and transcendence of the future.

6. Each of these points is essential to Pannenberg's central claim that the future is the being of God.

7. The relation of subjective and physical time to eternity as understood theologically by Pannenberg can be framed in a provocative way in the Omega-point cosmology. Here the physical lifetime of the universe remains finite (and hence creaturely), but subjective, experiential time continues without end (suggesting an open-ended eschatological character). Moreover, both (finite) physical and (infinite) experiential time merge at the future boundary (that is, at the Omega point) of the universe, whose intrinsic structure is similar to Pannenberg's understanding of eternity as the 'simultaneous whole' of temporal passage. (Recall that the topological structure of Omega is something like a sphere of zero radius.)

Expanded theory: I propose we expand Tipler's scenario by including within our discussion the '$t = 0$' spacelike line boundary at the 'beginning' of the universe, which I shall call for obvious reasons the Alpha point. Together Alpha and Omega give us an 'expanded Omega-point theory' which offers additional areas of theological interest.

8. According to Pannenberg, the focus of concern of both the doctrines of creation and redemption is the whole of cosmological history. Creation and redemption are co-extensive as "partners in the formation of reality" (Pannenberg 1969, 60, 139). In the expanded Omega-point theory, the Alpha point represents the creative source of all worldlines emanating through the universe. As a boundary point it is ontologically prior to the spacetime manifold, connoting the sense of *transcendence* and *time-independence* of creation. Yet from a different viewpoint, all spacetime events are contained within and actualized by it, connoting the sense of *immanence* and *continuing activity* to creation.

9. An additional advantage of the expanded model is related to Pannenberg's interest in field theory and its significance for the theology of the Holy Spirit. The spacetime manifold can be thought of in terms of a field (especially in a quantum gravity context) and the flow of events from Alpha to Omega suggests something of the activity of the Spirit moving throughout creation and delighting as Wisdom in the glory of God's handiwork.

So far I have listed some areas where Tipler's work should bear on that of Pannenberg. These might also be viewed as areas in which Pannenberg's program can offer a more fruitful interpretation of scientific cosmology than can other theological proposals which ignore the

physical sciences.[7] For example, I believe that Pannenberg's sustained theological interpretation of history and nature should bring an important challenge to Tipler's nascent prototheological interpretation of cosmology—especially Pannenberg's understanding of the Judeo-Christian conception of God, eternity and time, evil and redemption. It would be very interesting to discover whether such a philosophical and theological critique of Tipler's ideas would in addition lead to fruitful new insights for Tipler's *science*.[8] Hence ideally the effect of Tipler's work would be to open up rich new research areas in the *mutual* critique and cross-fertilization of theology and science.

D. Tipler's Approach: A Closer Look

To enhance our discussion about the difference between Dyson's and Tipler's proposals, I propose we make the following distinction between eschatology's domains of concern. The terminology here will be similar to that which I suggested regarding the meaning of contingency as local and global (Russell 1988):[9]

- *Local eschatology:* an entirely intracosmic scenario involving temporary victories but with ultimate defeat; the focus of eschatology is usually humanity and its terrestrial environment, and in particular human social institutions, history, and culture. The role of nature is usually that of a stage.
- *Global eschatology:* the most all-embracing scenario possible in which the universe as a whole, including all its intracosmic processes as well as its boundary conditions, participate in an eschatological victory. A global eschatology would be the most general thematization of the horizon of hope.

Using these categories, we can understand more clearly the relation of Dyson's scenario to that of Tipler:

As I see it, *Dyson proposes a hybrid form that is neither a local nor a global eschatology.* Since life continues forever with *no* final defeat, it is not a strictly local eschatology. Yet since the universe *as a whole* is never the subject of the transformation, but only the process within it, it is not a fully global eschatology. Dyson's scenario may be more closely compatible with Jürgen Moltmann's proposal to reject an "end of time" scenario in which the universe reaches a final conclusion. Instead Moltmann insists on endless possibilities for humanity's participation in the "'eternal history' of God, man and nature" (Moltmann 1976).

Tipler proposes the first truly global eschatological scenario, in which the activity of life within the universe as it meets the boundary condi-

tions becomes part of a global transfiguration of the universe contained in the Omega point, but only, one should note well, after infinite (subjective) time has elapsed. This includes the open scenario of Dyson and Moltmann in which life continues 'forever' while yet maintaining a boundary condition ingredient which can be interpreted in terms of final judgment and global transfiguration.

Hence, though Tipler's vision may at present be less than Christian theologians hope for in a full-fledged eschatology, it is the first instance of a global scenario broadly consistent with contemporary cosmology. It circumvents the vulnerability of a Teilhardian terrestrial vision and allows for radical, unending openness by including all of past, present, and future creation in its hermeneutic circle. It thereby offers a universal panorama for judgment, hope, and redemption and a means for articulating the cosmic significance of Christ. In my opinion it thus signals a new and fertile direction for research in theology and science.

· · · · · · · · · ·
II. A Critique of Tipler's Theory

Having suggested the 'face value' of Tipler's theory for theological reflection, we must now begin a more detailed critique of his actual proposal. The first question to be raised is, Just what sort of proposal is it: scientific, philosophical, or theological? Moreover, how does it fit within the field of 'science and religion'?[10]

I would begin with the second question, where I think it is helpful to distinguish between three types of projects in what is really a generic description—'science and theology' (Russell 1987): (a) theological reflection in light of science (usually mediated through philosophy); (b) scientific reflection in light of theological and philosophical insights; and (c) construction and testing of a hybrid theory drawing upon theology, science, and philosophy. By the last I mean that one incorporates concepts, language, data, criteria of theory choice, methods of testing, and other characteristics of both scientific and theological fields and produces a hybrid theory that has both scientific and theological meaning, value, and predictive/hermeneutic power.

Hence, regarding the first question, I propose we view Frank Tipler's theory as a hybrid theory and that we judge it accordingly, examining it from scientific, philosophical, and theological perspectives. I will argue that it has merits, problems, and as-yet-unaddressed areas from each of these perspectives: (a) As a scientific theory it has clearly testable consequences, and it provides important areas for further scientific research. (b) As a philosophical proposal it offers an

unusual perspective on several perennial issues, such as the mind-body problem and the status of realism. (c) As a theological theory it treats several topics in traditional Christian doctrine, such as eschatology and God, from within an unusual context—that of science.[11] I will focus particular attention on its relevance for Pannenberg's theological program. Although it is occasionally at significant variance from Pannengerg's theology, in my opinion it nevertheless provides both illumination and challenge to that and other theological programs. My conclusion is that these theological areas, highlighted by Tipler's work, set important research goals for those interested in pursuing a program along the lines Pannenberg has taken, as well as more general areas which must be considered by anyone taking scientific cosmology seriously within the theological agenda.

A. Scientific Issues

i. Tipler's theory depends explicitly on the assumption that the universe is adequately described by the Friedmann-Robertson-Walker (FRW) model, (a standard Big Bang model depending upon the Einstein equations of general relativity). But do we really know that the universe in toto is FRW (Stoeger 1987; 1988)? If it turns out that FRW is a limiting case, not applicable, say, near the initial singularity, what effect will this have on Tipler's approach? More generally, Tipler explicitly assumes the field equations of general relativity (GR). But how certain are we that a cosmology based on GR provides the correct description of the universe, including its singularities? Do we even know that it can be represented by a manifold/metric approach such as Tipler's? Won't quantum effects become important near Omega, making classical GR inapplicable there?[12]

ii. Tipler's scenario for life in the far future depends critically on the possibility of exploiting gravitational shear energy. Is this reasonable? Wouldn't these effects only occur so near the final singularity (and hence at such great temperatures) that any kind of structured matter—let alone technology—would have dissolved back into elementary particles?

iii. Related to this but more generally, would 'life' and 'experience' be possible as we approach the final singularity, since, presumably, with all four forces recombined (and all coupling constants equal in size), no local accelerations would be possible, and all matter would be forced to follow geodesics (that is to say, to be co-moving), making data recording or sensation of any kind unthinkable?

iv. How stable is the Omega singularity? Could it be circumvented by adding sufficient electric charge or angular momentum to

stellar black holes and tunneling into other future universes?[12] Or do the Barrow-Tipler theorems prove otherwise?

v. Tipler believes that life near the final singularity can reconstruct all past events from light reaching it. But is it reasonable to suggest that all the light, say, in this room here and now reaches Omega? What about absorption by walls, the earth's atmosphere, interstellar dust? How does information from the interior of solids reach Omega? There is the additional problem of 'background noise' which Tipler dismisses far too casually; if information is thermally degraded, as it would be if the light in this room were absorbed and re-emitted at lower temperatures, it could not be regained (you can refreeze melted ice but you don't regain the exact structure of the original cube).

vi. What happens if the universe isn't in fact closed? Tipler's scenario depends on the universe being closed (he actually *predicts* that the universe is closed), but is there no other way to achieve some of the key results Tipler gets out of the Omega cosmology?

B. Philosophical Issues

i. Tipler argues that a complete correspondence could, in principle, be obtained between a theory and its referent. But can a picture of an object, no matter how seemingly indistinguishable it is from the object, convey all there is about the object? Following Polanyi and Gödel, I would argue that we can know more than we can tell, and that we can tell more than we can encode in a formalized system.

ii. More generally: Are a simulation and its object indistinguishable? Does my image in a mirror think, feel, experience, love? Is a simulation 'in' the simulation vehicle, as Tipler believes, or in the interpreter's mind? Is my virtual image in the mirror truly 'in' the mirror or in my mind's eye?

iii. Tipler claims to hold both "ontological reductionism and epistemological antireductionism", a claim I find inherently contradictory and ultimately indefensible. How, for example, would one know which epistemic level is 'really' normative, the key to ontology? Typically the presupposition is to physics, but even within the 'level' of physics there is no clear 'bottom rung' epistemically, nor is there real proof that any of the structures discovered by physics—quarks, strings, spacetime, and so on—is the ultimate basis for the rest. Indeed, how could there be, given the historicity and relativity of scientific paradigms?

iv. I would like to hear Tipler's defense of realism (which he clearly presupposes) in terms of the counterarguments of its critics, especially among both antirealist and postmodern thinkers.

v. I take exception to one remark in particular made in Tipler's paper. I do not consider it "racist" to believe in the value of each and every species of life in the sweep of evolution, or to hold that any, and perhaps all, species play an irreducible, vital, and cherished part in the overall process.

C. Theological Issues

i. *The eschatological horizon.* In the biblical era the meaning of the Resurrection was taken up within, and grounded by, the general apocalyptical and eschatological outlook of the time. Commensurate to this, Pannenberg uses as his governing hermeneutic that we too interpret a given field of thought in terms of a series of ever broader, more inclusive perspectives. In theology this process is reiterated ultimately to the broadest possible categories of interpretation. Hence if Pannenberg's method is to succeed, it is a prerequisite that there exist such a globally inclusive context of interpretation in *any* given culture, and that the eschatological horizon of the biblical era be in some basic way congruent with this global context. Now, however, if our generation has lost *its* eschatological horizon, then according to Pannenberg the biblical message of ultimate hope and victory can no longer be heard. Hence it is critical to Pannenberg's program that we find such a global context in contemporary culture within which we can interpret the Gospel.

It is important to begin by underscoring the primary theological value of Tipler's work (and its partial precedents in that of Dyson and others): namely that it reopens to the theological discussion of eschatology the cosmological domain—a domain that arguably does provide the broadest possible context of interpretation, and a domain that had been essentially closed to theology since the fall of deism. Thanks to Tipler, contemporary cosmology need not nullify our attempt to think eschatologically. Indeed, even without necessarily adopting Tipler's specific philosophical and theological views, we can once again construct a coherence of horizons of meaning for biblical and scientific cosmologies. One will have to argue out the details— whether theological eschatology implies a commitment to a transformation within creation (local eschatology) or a redemption that transforms all creation (global eschatology), whether its proleptic basis in Jesus Christ can be related to the meaning of the far future and the boundary of the universe, whether we can think about the 'end of the age' as being billions of years away, perhaps infinitely far in the future, and so on. But the most important dimension of Tipler's work for theologians is, in my opinion, that, together with Dyson's, it has

reopened at least one approach for relating constructively the eschatological horizon of meaning and the discoveries of scientific cosmology.

ii. *The Omega point and God.* The Omega point theory describes life in the far future in terms of the three *omnis:* omniscience, omnipotence, and omnipresence. This description provides the basis for a fascinating argument that life and God are identified in the Omega point, which is both the last event in the universe and the boundary point of the universe. Tipler can therefore describe Omega in terms of both transcendence and immanence, since a *c*-boundary is both beyond and yet part of the manifold it bounds.

How strong a correlation can one make, though, between the precise mathematical structure of the *c*-boundary and the classical divine attributes? What is needed is a careful analysis of the mathematical construction of the *c*-boundary and the detailed content of the three *omnis* in classical theism. Moreover, answers given to previous questions raised will play a critical role here. For example, the possibility of regaining complete knowledge of the past at the boundary point will partially determine the basis for a theological claim about omniscience.

At a deeper level, we must then ask whether Omega relates substantively to the Judeo-Christian meaning of *God,* or whether the relative is merely semantic. I would argue that the fundamental characteristic of God in traditional philosophical theism is necessary being or self-sufficiency: God is *a se.* The *omni* attributes are secondary and relative to this. This means that one could in principle conceive of an omniscient, omnipresent, and omnipotent being that is nevertheless contingent and hence not God as defined by classical theism. Hence a key theological issue for Tipler's theory is to show that Omega is a necessary being and therefore at least consistent with traditional notions of God. Alternatively if Omega is merely contingent it should be sharply distinguished from the Judeo-Christian conception of God.

The case for contingency, and hence the case against Omega being divine, seems at this point rather strong. Tipler grants that Omega, being part of the boundary of the universe, is thus a part of the universe (though he also wants to claim that it transcends the universe). Here Pannenberg's interpretation of the doctrine of creation is very helpful, for he insists that the universe as a whole, and each part within it, is contingent (Pannenberg 1993; Russell 1988). Hence if Omega is part of, or a term in a sequence originating within, the universe, it must share in the contingency of the universe.

But Tipler also argues that Omega provides the necessary grounds for the universe to exist, and that this characteristic of Omega, the

basis for its divinity, is more important than its immanence in the universe as a contingent boundary point. The difficulty here is how to establish this claim about Omega. If granted, then Omega may well be divine, but can one so establish it by strictly *scientific* means, as Tipler insists he has? In my opinion such a claim cannot be established; as with all attempts at natural theology, I do not see how one can argue from nature to God (at least to the biblical triune God).

Of course this is a hotly contested point, and there are both historical and contemporary theological positions that would disagree with me.[14] But before that question is settled, an even prior one looms as a challenge to natural theology, for one can argue that science per se cannot establish whether the universe has either an absolute end or an absolute beginning, even if such 'events' exist (Stoeger 1989; Russell 1985, 1988, 1990). If the existence of Omega cannot be established scientifically, its divinity certainly cannot be established scientifically.

Hence in my view Tipler has, perhaps unconsciously, imported a conviction about God into his scientific discussion, essentially presupposing his conclusion.

 iii. *Contingency as indeterminacy (the Cauchy problem).* Another way to uncover the relation of Tipler and Pannenberg to the meaning of contingency is in terms of indeterminacy, here framed as the 'Cauchy problem': that of determining to what extent the initial values of a model determine the model as a whole. This issue is important for Pannenberg, for he would argue that the future is contingent: it need not be, and its nature is not entirely fixed in advance. Moreover the future has a personal quality that gives it unity and purpose intertwined with openness and indeterminacy (Pannenberg 1969, 58–60).

What can we say about contingency as indeterminacy in the context of physical cosmology? At first sight, GR appears to be a classical theory involving Laplacian determinism. However several aspects of GR open themselves to the question of contingency. (a) GR is a nonlinear theory: gravity is its own source of curvature, making the solution of the field equations, and hence the predictive capability of the theory, tremendously difficult to derive. Yet, in principle, solutions exist, leaving this an epistemic, not an ontological, contingency. (b) In classical physics if one stipulates sufficient initial values along with the field equations, one can predict the future trajectories entirely. GR involves the initial value (or Cauchy) problem in a new and distinct way. There exist solutions to Einstein's equations for which worldlines, initially arbitrarily close, move eventually into topologically disconnected regions of spacetime, as in the case of black holes. This

means that more than one far future exists for a given present state of affairs.

In this sense even the classical physics of GR offers a sense of contingency in addition to those already discussed. Yet this conclusion immediately leads to another challenge to Pannenberg's thought concerning Omega, for Pannenberg wants the far future to possess an eschatological unity and integrity that allow him to identify it with the being of God (Pannenberg 1969, especially 55–60). Furthermore the meaning of Omega is also connected with two related ideas: Pannenberg's understanding of the ontological priority of the future (reverse causality) and appearance as the arrival of the future (his reinterpretation of the Aristotelian notion of *telos*) (Trost 1988).

Hence it is crucial to Pannenberg that the Cauchy problem be solved in the actual universe: that there be something like what Tipler calls the Omega point.[15]

iv. *Alpha as the beginning.* If Omega is the endpoint of the universe, what then about Alpha, its beginning?

Clearly in an FRW cosmology the universe, whether open or closed, contains at least one singularity at $t = 0$, as the Hawking theorems have proven. All worldlines in our present epoch trace back to the initial singularity which, presumably, we can call Alpha. Clearly arguments similar to those Tipler gives about the divinity of Omega could be constructed about Alpha. How does this affect Tipler's view of God, especially of an *evolving* God?

One could try to argue that Alpha and Omega are utterly distinct. For example, Omega is related to the three *omnis* of global life that give Omega its theistic quality, whereas Alpha is related to the earliest epoch of the universe in which there is nothing like life and experience and, accordingly, nothing like the three *omnis*. Moreover, Alpha is merely the initial spacelike extended boundary from which all worldlines emerge without causal connection, whereas Omega is a pointlike boundary to which all worldlines converge such that communication between them is possible. Would this mean that Alpha is not divine, or alternatively that there are two kinds of divinity? Or might this suggest two modes or 'persons' of a single divinity?

On the other hand, in some general sense the mathematical characters of Alpha and Omega are similar. But if they are both divine, what is left of the 'evolving' aspect of Tipler's God? Wouldn't his God transcend time and space and be in this sense timeless? Alternatively, if Tipler's God is omnipresent, since it includes all the events in the universe, wouldn't it also include Alpha, the absolute beginning of the universe, as well as all temporal events in the universe?

v. *The relation of eternity, timelessness, and unending time in Pannenberg's and in Tipler's thought.* Tipler's focus is on the unending subjective time experienced by life in a closed universe (of finite proper time). This is a striking model, since it combines infinity of experience with finitude of physical time. In this sense one can relate the finitude of physical time to the meaning of finitude in the doctrine of creation, and yet relate the infinitude of subjective time to the infinitude suggestive of openness and life everlasting that one finds in some interpretations of eschatology—for example, that of Moltmann. What Tipler offers is unending experience of life along individual worldlines and, given the particular type of universe he describes (with its Omega point, shear, anisotropic collapse, and so forth), it allows unending communication of that experience among all such worldlines.

But we should ask whether an infinity of experienced time—where this unending succession of events all falls within the same ontological conditions of *creaturely* existence—is related to the meaning of the future as *God's* being, that is, to eternity as Pannenberg understands it. For Pannenberg, eternity is conceived, not as timelessness or as unending time, but as the fullness of time, or to use the classical formulation of Boethius, the simultaneous whole of all times in the copresence of the divine reality. Here the Omega point offers a model for eternity something like that which figures in Pannenberg's thought, since the Omega point includes all of the past worldlines in a single event. However, this event, being a boundary event to the universe, transcends the creatureliness of the universe. On the other hand, the fact that Tipler opts for an Omega point and not a c-boundary (which, as in the standard closed FRW cosmology, keeps separate the endpoints of separate worldlines) may mitigate against its relevancy for theology, for the Omega point seems to blur the distinction between events and thus has a timeless rather than an eternal quality.

Finally, two points in brief:

vi. Where are the roles of free will and grace in Tipler's scheme? Does the divine foreknowledge or the omniscience of Omega allow for the contingency of personal free will? Or does the knowledge of the past by Omega in any way determine the past in its concrete actuality (as in Tipler's use of John Wheeler's scenario)?

vii. What would we really lose theologically if the universe were open (for example, applying Dyson's eschatological scenario)? Alternatively, aren't Tipler's criteria for choosing a closed over an open universe in fact philosophical, even theological—a sort of rescuing of Teilhard's vision, this time on a cosmic scale (Barrow and Tipler 1986, 195–205)?

viii. There remain a number of untreated theological issues raised by Tipler's work. The following list is meant to suggest further lines of inquiry:

* The problem of evil (and the related issue of theodicy);
* The meaning of redemption and its relation to both creation and eschatology;
* The hope for universal Resurrection;
* The experience of the mystical, the numinous, the holy, the mysterious;
* The importance of the individual and the community in the formation of faith and the significance of the church in history and the future.
* Overall, the long-term project would clearly involve embedding Tipler's eschatology and doctrine of God in the context of a self-consistent and complete theological system, against which its real value for theology can be assessed.

· · · · · · · · · ·
Conclusion

In this paper I hope to have shown the value of Tipler's scientific research for the task of Christian theology, with special focus on the problem of relating eschatology to physical cosmology. Given the central importance of eschatology in Pannenberg's theological program, it is particularly important that Tipler's research be given careful consideration. Our future research should, I believe, be expanded to include a reciprocal program as well: namely, to investigate how and in what ways might the theologian's insights into time, the far future, the parousia, and the meaning of God and Christ suggest fruitful questions to scientists engaged in cosmological theory construction. If both of these programs can be launched, a new period beyond dialogue, a period of "mutual modification," will surely begin.

Should we welcome this approach? I believe we should. If we are to inquire about the future of our universe from either a scientific or a theological perspective, surely the overriding message of the Dysons and Tiplers of our age is that life will play a central and irreducible role in its making, and it is the primary conviction of the Pannenbergs of our time that the future be taken radically seriously. Thus we can no longer afford to let our diverse approaches to understanding and conditioning this role be left in isolation. It is the great achievement of Freeman Dyson and Frank Tipler that the end of isolation may now be, proleptically, at hand.

· · · · · · · · · · ·

Notes

1. Ironically one can argue that Big Bang cosmology actually does provide a context compatible with, even mildly supportive of, the doctrine of creation *ex nihilo*. Here one seeks to find a degree of consonance between *ex nihilo* as implying, amongst other things, a finite past to the universe, clearly something which contemporary cosmology strongly suggests (McMullin; Russell). Yet once we have broken down those barriers separating scientific and theological language which were so carefully constructed by neo-Orthodoxy and other theological schools, the advantage of discovering consonance in terms of a finite past creation seems overwhelmed by the disadvantage of facing a seemingly hopeless cosmological future: the same cosmological scenario which gave us encouraging '$t = 0$' arguments seems finally to destroy all future-directed hope if the universe is to end violently in a collapse and 'big crunch' (in the case of a closed universe with a finite future) or meaninglessly in the unending night of a frozen dust of elementary particles (as in the open universe with its infinite future).

2. Although Peacocke wrote this prior to the breakthrough by Dyson (see section B in the text), this view continues to represent much of the work in current theology. For example, Karl Peters argues that eschatology *cannot* be made compatible with cosmology, only with human social hopes: "(Because of the second law of thermodynamics) . . . there cannot be a future, universal eschatology that is religiously satisfying . . . The pictures of biblical, future, universal eschatology, or the Teilhardian evolutionary universal eschatology, may not be realizable for the universe as a whole; if the second law of thermodynamics is correct, such eschatologies seem not to be possible" (Peters 1988, 13–15).

3. Both in 1979 and more recently Dyson argues that a closed universe is incompatible with life in the far future.

4. Throughout this paper I shall simply refer to Tipler, though I in no way mean to diminish the contributions of John Barrow to the Omega-point theory. This is not the place for a historiographical or biographical analysis of the relative contributions of Tipler and Barrow to either their book or its background. Moreover Tipler has been the representative at both Vatican Observatory and Chicago Center for Religion and Science conferences on the theory and its implications for theology.

5. This 'point' is not a simple point as understood in Euclidean geometry. Instead it has a rich topological structure, suggested by the image of a sphere of zero radius.)

6. (a) Is there a global present? Newtonian physics strictly separated time and space, making the 'now' physically irreducible. With special relativity, however, the problem of 'now' became complicated with the loss of a unique physical meaning of simultaneity. Philosophies of being (Costa de Beauregaard) rivalled philosophies of becoming (Bergson, Whitehead, Capek). The loss of a physically unique way to describe the present and to distinguish between past and future posed a very serious problem to theo-

logians committed to God's experience of and interaction with the world (see Hartshorne). However in a FRW universe there exists a unique, physically meaningful global time parameter, and hence a way to denote the present in a 'simultaneous' way for the entire universe.

(b) Does time flow from the past to the future? Newtonian physics was time-symmetric; its equations could not distinguish between processes which moved forward or backward in time. Similarly statistical thermodynamics (as opposed to classical thermodynamics) and quantum mechanics provide no basis for the arrow of time. General relativity, like special relativity, fails to provide a direction for time, but when applied to cosmology (specifically a Friedman-Robertson-Walker model such as Tipler assumes) the mathematical difference between the global boundaries of the universe provide a possible foundation for distinguishing time's flow.

That is, Alpha and Omega, being mathematically distinguishable, provide an orientation for all timelike worldlines in a Friedmann-Robertson-Walker (FRW) model. Hence an FRW universe includes a physical basis for the arrow of time and hence a necessary condition for interpreting history and personal experience in a cosmological context.

Thus an FRW universe provides a scientific context for a theological interpretation of God's action in the world and our continuity with nature as historical and time-oriented.

7. If one adopts a Lakatosian perspective as both Hefner and Murphy suggest we do (Chapters 5 and 17 in this volume), this suggests that Pannenberg's program is more robust and testable than his competitors, thus providing criteria for selecting it over others for further research.

8. Evidently this process is already under way. According to Tipler, the meaning Pannenberg gives to the Resurrection has suggested new insights to Tipler into his Omega-point cosmology.

9. There are, of course, other possible scenarios, such as: (a) 'interventionist eschatology': an irreversible disruption and termination of the processes of nature by a supernatural divinity occuring within an intracosmic scenario. It focuses on the human realm, with marginal concern for nature's final and intrinsic purpose. Since such a scenario is possible but entirely unpredictable we shall not treat it here. Science has nothing to say about it. Theologically it is often argued that since the regularities of nature are themselves a product of God the Creator, they may be suspended or violated at God's will. I find this an unattractive alternative, since even the Resurrection is, arguably, natural, merely a first instantiation of a new law of nature and not a disruption and termination of nature (Pannenberg 1977; 98). (b) 'otherworldly eschatology': a completion of human (and perhaps natural) history in an entirely supernatural realm disjunct from the universe at present. The relation between this world and the next is entirely unknowable.

10. A similar issue is inevitably raised about the writings of Teilhard. Here again Barbour has offered an extremely helpful analysis of what I call a

hybrid theory (see the next paragraph in the main text) in his illuminating paper on Teilhard (Barbour 1968).

Clearly Tipler's theory is susceptible to, and has already received, the same kinds of criticism that Teilhard's work received from both scientific and theological communities. A thorough review of these criticisms is not possible here for space limitations. However a recent article by Fred Hallberg deserves attention because Hallberg, though raising some very important criticisms of Tipler's theological naiveté and 'Enlightenment ideology', errs significantly in a way that is typical of many of the counter-arguments given against the Omega-point theory.

Hallberg, I believe incorrectly, claims that nine inferential steps are made to warrant the Omega-point theory (Hallberg 1988). Each of these steps "involves taking a strong stand about an issue which is either controversial or uncertain at the present time" (148). These assumptions are that: (1) life is rare in the universe; (2) life is inherently expansive; (3) colonizing the universe will be possible via self-replicating machines (Von Neumann machines); (4) consciousness is defined by the Turing test; (5) interstellar probes will be economically feasible; (6) Life can be re-based non-biologically; (7) exotic energy sources will be available (via gravitational shear) and can be exploited near Omega; (8) the universe is closed; (9) consciousness (measured via subjective time) is related to the rate of information processing.

In my view, it is both because Tipler's work is a 'hybrid' drawn from scientific and theological sources, and because of its flamboyant style and its all too frequent tendency to stray into very controversial areas with naivité and arrogance, that it is vulnerable to this sort of critique. Nevertheless a closer look reveals that only steps 3, 4, 6, 7, and 9 are actual *assumptions* of the Omega-point theory. Step 8 is in fact a *prediction*; Tipler repeatedly insists, in writing and in lectures, that if this prediction turns out to be wrong his theory will be falsified.

Finally points 1, 2, and 5 are not so much assumptions as reasonable projections about the future. Point 1 in particular is not a necessary assumption to the theory; life need not be rare for the theory to work. As for 2, life has always been expansive, and though its 'imperialist' character must be strongly criticized (as Hallberg and others rightly do), its drive to explore, discover, and communicate with other species should be celebrated. Finally, on 5, the economic arguments are not naive unlimited growth arguments but arguably reasonable projections given solar system and inter-stellar resources, and noting that the argument is framed in terms of the ratio of the cost of these resources relative to wages (Barrow and Tipler 1986, 583).

I should add that Tipler includes two other explicit predictions along with 8: that the boundary of the universe is a c-boundary consisting of a single point, and that the density of particle states diverges no faster than the square of the energy (Tipler 1988a, 322; 330, note 8 includes other possible predictions).

11. I want to distinguish clearly between Tipler's (and Dyson's) attempt to ground eschatology in physical cosmology (such that science effectively adjudicates what can and what cannot be affirmed theologically)—a move with which I would not agree—and what I propose we in fact should undertake within the Christian theological community, namely to take the cosmological perspective Tipler and others have opened up to us and seek a new form of consonance with systematic theology.

12. On the other hand the Hawking singularity theorems apply more generally than GR (Hawking and Ellis 1973, 362). For a discussion of competing theories of gravity, their comparison to Einstein's general relativity, and experimental tests see Will 1981 (a more popular version is given in Will 1986).

13. See the discussion of transitions from a Schwarzschild to a Reissner-Nordstrom black hole in Hawking and Ellis 1973, 360.

14. A contemporary example would be found in Stanley Jaki's work.

15. One could argue that Tipler's theory, as well as Pannenberg's, depends critically on a scientific test involving not only that the universe be closed but that it be a Bianchi IX universe, and so forth.

· · · · · · · · · ·

References

Barbour, Ian. 1968. Five Ways of Reading Teilhard. *Soundings* 51:115–145.

Barrow, John D., and Frank J. Tipler. 1986. *The Anthropic Cosmological Principle.* Oxford: Oxford University Press.

Dyson, Freeman J. 1979. Time Without End: Physics and Biology in an Open Universe. *Review of Modern Physics* 51:447ff.

———. 1988. *Infinite in All Directions.* New York: Harper and Row.

Halberg, Fred W. 1988. Barrow and Tipler's Anthropic Cosmological Principle. *Zygon: Journal of Religion and Science* 23:139–157.

Hawking, Stephen W., and George F.R. Ellis. 1973. *The Large Scale Structure of Space-Time.* Cambridge: Cambridge University Press.

Moltmann, Jürgen. 1976. Creation and Redemption. In *Creation, Christ, and Culture,* ed. R.W.A. McKinney. Edinburgh: Clark.

Pannenberg, Wolfhart. 1969. *Theology and the Kingdom of God.* Philadelphia: Westminster.

———. 1976. *Theology and the Philosophy of Science.* Trans. Francis McDonagh. Philadelphia: Westminster.

———. 1977. *Jesus: God and Man.* 2nd ed. Philadelphia: Westminster.

———. 1993. The Doctrine of Creation and Modern Science. In *Toward a Theology of Nature: Essays on Science and Faith,* ed. Ted Peters, 29–49. Louisville: Westminster/John Knox.

Peacocke, Arthur. 1979. *Creation and the World of Science.* Oxford: Clarendon Press.

Peters, Karl. 1988. Eschatology in Light of Contemporary Science. Paper presented at the Annual Meeting of the American Academy of Religion, Chicago, 1988.

Russell, Bertrand. 1963. A Free Man's Worship. In *Mysticism and Logic, and Other Essays*, 1903. London: Allen and Unwin.

Russell, Robert. 1985. How Does Scientific Cosmology Shape a Theology of Nature? Cf. *CTNS Bulletin* 6 (1), 1986.

———. 1988. Contingency in Physics and Cosmology: A Critique of the Theology of Wolfhart Pannenberg. *Zygon: Journal of Religion and Science* 23 (March): 23–43.

———. 1990. Theological Implications of Physics and Cosmology. In *The Church and Contemporary Cosmology*, eds. James B. Miller and Kenneth E. McCall, 247–272. Pittsburgh: Carnegie Mellon University Press.

Stoeger, W.R., ed. 1987. *Theory and Observational Limits in Cosmology*. Vatican City: Specola Vaticana.

———. 1988. Contemporary Cosmology and Its Implications for the Science-Religion Dialogue. In *Physics, Philosophy, and Theology: A Common Quest for Understanding*, distributed by University of Notre Dame Press, ed. Robert J. Russell, William R Stoeger, and George V. Coyne. Vatican City State: Vatican Observatory.

———. 1989. What Contemporary Cosmology and Theology Have to Say to One Another. *CTNS Bulletin* 9 (1).

Tipler, Frank J. 1988. The Omega Point Theory: A Model of an Evolving God. In *Physics, Philosophy, and Theology: A Common Quest for Understanding*, distributed by University of Notre Dame Press, ed. Robert Russell, William Stoeger and George Coyne, 313–331. Vatican City: Vatican Observatory.

Trost, Lou Ann. 1988. The Future in the Theology of Pannenberg in Light of Questions Arising from Contemporary Physics. *CTNS Bulletin* 8 (3), 1–9.

Weinberg, Steven. 1977. *The First Three Minutes: A Modern View of the Origin of the Universe*. New York: Basic Books.

Will, Clifford M. 1986. *Was Einstein Right? Putting General Relativity to the Test*. New York: Basic Books.

———. 1981. *Theory and Experiment in Gravitational Physics*. Cambridge: Cambridge University Press.

9

Contingency, Time, and the Theological Ambiguity of Science

••••••••••

Willem B. Drees

••••••••••
1. Introduction

> "The most miraculous thing is happening. . . . The physicists are
> getting down to the nitty-gritty, they've really just about pared
> things down to the ultimate details, and the last thing they ever
> expected to happen is happening. God is showing through.
> They hate it, but they can't do anything about it. Facts are facts.
> And I don't think people in the religion business, so to speak,
> are really aware of this—aware, that is, that their case, far-out as
> it's always seemed, at last is being proven. . . ."
>
> "Mr. Kohler. What kind of God is showing through, ex-
> actly?" (Dialogue between Dale Kohler, a computer freak, and
> Roger, a divinity school professor, in Updike 1986)

Contingency and time are obviously important concepts for any
theology. Wolfhart Pannenberg has developed his own understanding
of these two concepts in his theology. The present paper is not an
analysis of Pannenberg's view. I discuss these concepts in relation to
cosmology (in the astrophysical sense). It will be argued that scientific
cosmology does not provide a basis for an inductive argument for God;
God is not showing through, nor ruled out. This ambiguity implies
that science does not offer a basis for a metaphysics which thematizes
God's presence, a 'mystical metaphysics'. However, one could use the
apparent absence of God as argument for a theology in which each
moment in time is confronted with an atemporal 'otherness'. I suggest
that it is important to develop such a 'prophetical metaphysics' in dia-
logue with scientific understandings of the world. The paper ends with
some tentative questions about Pannenberg's approach.[1]

Science is, as I will argue, neutral with respect to both contingency
and necessity (2.1). 'Complete theories' suggest necessity, but they are
based upon abstraction of diversity (2.2). The data used in 'anthropic
arguments' suggest global empirical contingency, and hence the need
for a theistic explanation. However, the discussion about anthropic
principles offers a variety of metaphysical options and does not

support a 'design' argument for the existence of God (2.3). The 'mystery of existence' is in itself beyond science. Such global ontological contingency offers the possibility to see the universe as grace, but it need not be interpreted that way (2.4).

Physical systems can be described from within time, as evolving. However, they also allow for descriptions which consider whole histories at once (3.1). These two approaches offer opportunities for theology, especially if they are combined together with an emphasis on the present (3.2).

In the final section the conclusions will be related to a theology which primarily thematizes God's absence (4). This leads to a view of the relation between theology and the sciences which seems to be different from the way Pannenberg has argued for theologically relevant dimensions in the facts (Pannenberg 1985, 19f; Chapter 2 of this volume) and certainly from the way Tipler has, in his contribution to this volume, subsumed theology under science (Chapter 7). The paper therefore ends with some questions about the way Pannenberg seems to use contingency, time, and the sciences in general (5).

· · · · · · · · · ·
2. Contingency

R.J. Russell (1988) distinguishes global,[2] local, and nomological contingency. Within the first and second Russell considers ontological and empirical contingency, say, the difference between the mystery of existence, why there should be a universe, and the specific way the universe is. Cosmology seems to relate to global empirical contingency (2.2, 2.3), and perhaps also to global ontological contingency (2.4). First, a general argument for the equal status of contingency and necessity with respect to science will be presented (2.1).

2.1. Contingency and Necessity: Both Outside Science

Science works with a *methodological* principle of sufficient reason, the guideline that one should always seek further reasons. Science "could not abandon the presupposition that reasons can be given for the properties or patterns things are found to have, without surrendering its very character as a continuing and endless quest for such reasons, and for continually better ways of expressing these reasons" (Munitz 1974, 105).

However, this methodological rule should be distinguished from the *metaphysical* principle of sufficient reason, which states that there must be such reasons, whether we can find them or not. This latter

principle is outside the range of science, although it is supported by the instances when science has been successful in its search for reasons. Quantum physics might be interpreted as a branch of physics where the metaphysical principle appears to be not valid.

The methodological principle of sufficient reason implies that contingency is always outside science. Something which seems contingent might be shown by future science to be unavoidable, given certain circumstances. And science attempts to show that those circumstances are necessary as well. Science is a quest to remove contingency as far as possible.

But science is in its practice also at odds with complete necessity. In trying to explain everything science always traces properties or events or rules back to other events, boundary conditions, or laws. Certain rules are used in that process of explanation, laws of physics and logical and mathematical rules. Even if the chain does not go backwards in time, there is a chain of 'more fundamental' explanations—explanations which are based on laws and boundary conditions of wider applicability and greater simplicity.

Some cosmologists, like S.W. Hawking (1980), and some popularizers, like P.W. Atkins (1981) and H.R. Pagels (1985), have claimed that science is near the end of the chain, providing an explanation on the basis of the most simple principles. But it remains legitimate to ask, Why those principles? Scientific work on complete and unified theories is not wrong. But the claim that science offers the ultimate explanation, and hence that the universe could only have been the way it actually is, goes beyond science. The belief that we are close to a complete explanation could nonetheless be justifiable, due to the success of a specific program and the simplicity and elegance of the assumptions. The next section will consider the attempt to construct complete theories of the universe and hence to remove empirical global contingency. The conclusion of this section is that both contingency and necessity are terms outside science; science does not in its method opt for the one or the other.

2.2. Unified Theories of Everything and Global Empirical Contingency

Both the contingency of the initial conditions and the contingency of the laws governing the universe are actually disputed among theoretical cosmologists and physicists.

Boundary Conditions and Laws

In standard cosmology, based upon Einstein's theory of general relativity, it is possible that a three-dimensional space is finite but

without edges. Such a space is curved back into itself, just as the two-dimensional surface of the Earth is finite without edges. Time is different, even if the total duration is finite, in a closed universe from Big Bang to a Big Crunch. Time remains like a line with a beginning and an end.

The English cosmologist Stephen Hawking has in collaboration with James Hartle extended the idea of a finite space without edges to four dimensions, including something like time (Hawking 1982; Hartle and Hawking 1983). The 'time' variable becomes, of course, through such a procedure something quite different from our ordinary concept of time. This proposal does away with arbitrary boundary conditions for the universe; as Hawking stated, the boundary condition of the universe is that it has no boundary.[3] This cosmology is just one of the many approaches at the frontier of research. However, some other approaches also lack contingent boundary conditions. For example, the Russian cosmologist Andrej Linde envisages an eternal universe which is like a foam of bubbles. Bubbles are more or less homogeneous regions like the observable universe. As Linde has it, all possible bubbles exist; the universe is a lunch at which all possible dishes are available (Linde 1983, 245). We will come back to the presence of all possibilities below. It implies, of course, that there is no choice needed for initial conditions—they all have been chosen.

Theoretical cosmology today needs particle physics and theories about space and time, and hence about gravity as an effect of the curvature of space-time. There is no satisfactory unified theory yet. However, there are certain proposals. There are three components in present arguments for complete theories: mathematical consistency, esthetics, and 'many worlds.'

Mathematical Consistency: The Problem of Infinities

Quantum physics is very successful. However, it has one problem, aside from its interpretation: it predicts an infinite mass for electrons. Humans would have an infinite mass as well, which is not in line with observations. Theoretical physicists have a trick, *renormalization;* they subtract infinity somewhere. This procedure can be defined rigorously and it works. The resulting mass is, of course, not a prediction of the theory but taken for granted. If the same trick would be needed over and over again the theory would be useless; it would not predict anything. A renormalizable theory is a theory which needs this trick only once, while producing finite results in all subsequent calculations. Quantum electrodynamics, the theory which describes electrons,

positrons, and radiation, is such a renormalizable theory. It has been tested and confirmed to a very high degree of accuracy.

Particle theories incorporating more of the known particles turned out to be plagued by infinities. The Dutch physicist G. 't Hooft showed in the early 1970s that only theories of a specific type were renormalizable. Since, all particle theories have followed this path: the Weinberg-Salam theory for the weak interactions, the quark theory, and the Grand Unified Theories (GUTs), which integrate nuclear and electromagnetic forces.

The requirement that infinities must be manageable in such a way is rather restrictive. And still it seems artificial, a trick to brush the problems under the rug. One step further would be a theory without problems, one which predicts *finite* results for all possible observations. Finiteness for a theory[4] is, surely, a stronger restriction than renormalizability. And the restrictions become even more severe if the theory has to include gravity as well. There are, as far as I know, no theories for which it has been shown that they are finite in all circumstances. The best candidates today are superstring theories, and their number is quite small. Six theories satisfy the known conditions of consistency, and of those six, three are perhaps equivalent. More conditions for consistency, that is, finiteness, might reduce the number of consistent theories even more. "Ideally it will turn out that there is only one" (Schwarz 1987, 654).

It is assumed throughout that the laws can be formulated mathematically. There might be other assumptions taken for granted, like Tipler's assumption about continuity until the end of time for relativistic space-times (above, 163). Such assumptions might introduce an a posteriori component. But the claim that there is, independent of any observation, only a very limited set of mathematically consistent theories deserves to be taken seriously.

Simplicity and Esthetics

There are variants of Einstein's theory of general relativity which are compatible with observations as they stand today. Nonetheless, they are not considered to be as good as Einstein's theory. These judgments are based on such criteria as coherence, simplicity, and elegance. Similar judgments are made with respect to more recent cosmological theories. Esthetic and metaphysical arguments are present in the criteria for theory evaluation. Even disregarding the requirement of consistency, accepting such criteria might reduce the number of possible initial conditions and laws within the not-too-distant future, perhaps even to only one package.[5]

All Possibilities Present

Linde imagines the universe as consisting of mini-universes, bubbles "of all possible types" (Linde 1983, 627). In Hawking's view all possibilities which are part of the quantum description of the universe are equally present. Tipler defends a third type of cosmology, but he too adheres to a many-worlds interpretation of quantum theories (above, 174). Tipler makes a distinction which seems useful: he opts for the actual existence of all classical possibilities represented in a quantum wave function, but allows for contingency on the set of all possible wave functions (176).

The actuality of all possibilities, in one way or another, implies that an explanation does not need to claim that certain features are the only possible outcome of the preceding processes. It is sufficient if those features are possible, for then they will be realized somewhere. Without this assumption we would be left with an incompleteness, as the theory would not specify which possibility is the actual one. However, the assumption is not a sufficient one to remove all contingency, since the presence of all possibilities is always the presence of all possibilities of *a certain theory*. The question remains: Why one theory and not another? This question might be answered by the appeal to consistency, in other words, finiteness, and to esthetic criteria like simplicity. The Teilhard boundary condition proposed by Tipler (an Omega point) and the Hartle-Hawking boundary (compactness) are such additional assumptions, defensible by reference to esthetic, metaphysical, and perhaps even religious criteria. As Tipler has it, all the contingency in quantum cosmology is in the boundary conditions which pick out the wave function which actually exists (178).

Diversity in Nature: The Many

There is one general objection against the expectation of a simple complete theory: our world is so complex. Could a complete theory be fair to that complexity, or would it only be complete due to a great amount of abstraction—leaving many of the particular characteristics of our world outside its scope? That has been argued by the English philosopher of science Mary Hesse (1988), and by the physicist Freeman Dyson (1988). The study of complex systems, for instance weather prediction, is also a respectable branch of science. Two catchwords in recent developments are *chaos* and *fractals*.[6]

Unity and Diversity, Perennial Problems

Dualities like unity and diversity, universality and particularity, the general and the specific, and the One and the Many, are present in

different fields of thought. Dualities, of course, pervade also other areas of life, like politics and family life.

The problem with 'complete theories' is not that they do away with contingency, and thus would make a transcendent God superfluous. The problem is that they might go with values which overemphasize unity and neglect the particular. Somehow both unity and diversity should be part of a satisfactory view of the world.

Three elements of the Christian tradition might be useful in this context. The particular person Jesus became understood as the Christ, with universal significance. The idea of the Trinity combines unity and diversity in God. And the doctrine of creation is helpful, as it locates the unity in the transcendent creator, while allowing for diversity in the created world.

Theologians should accept that there is progress in theoretical physics and cosmology towards a very limited number of encompassing unified theories. These theories are, however, not really threats to an emphasis on contingency, as they are only possible due to abstraction of features of particulars. The specific topic in the framework of such cosmologies is not contingency, but unity and diversity. Christian theology needs to express both unity and the value of particulars.

2.3. Anthropic Principles and Global Empirical Contingency?

Standard cosmology assumes what is called the Copernican principle: we humans do not occupy a priviliged position in space. The last few years there have been rumors about something special for us, anthropic principles. R.J. Russell (1988) suggested the anthropic principles as thematization of global contingency. Others have used the underlying data, which I call 'anthropic coincidences', in arguments for the existence of God. I will argue that this does not work as argument either for the existence of God or for the cosmological significance of humans. The Weak Anthropic Principle is true but irrelevant. The stronger anthropic principles are themselves disputable metaphysical principles, not consequences of science. They, as well as the anthropic coincidences, might be used to express contingency, but they certainly do not support a strong statement about the contingency of the universe, and hence lack inductive apologetic value.

There are two basic types of anthropic principles, the Weak Anthropic Principle and the strong anthropic principles. They use the same data, which might be called *anthropic coincidences.*

The *Weak Anthropic Principle* (WAP) states that what we see must be compatible with our existence. We see a universe with planets,

since we depend on planets. We see a universe which exists for some billions of years, as it took billions of years to develop beings which are capable of thinking about the age of the universe. It has the nature of a selection rule: our observations are biased in favor of situations where we exist.

The *Strong Anthropic Principle* (SAP) can be stated as: "The Universe must have those properties which allow life to develop within it at some stage in its history" (Barrow and Tipler 1986, 21). This is not a statement about what we actually observe but about the class of possible universes.[7] There are different ways to argue for this principle. One has been given by the physicist J.A. Wheeler when he related the existence of the universe to the existence of observers in the universe. This particular version has been called the *Participatory Anthropic Principle* (PAP).

Anthropic Coincidences and Weak Anthropic Explanations

1. The universe is enormous in size when compared to human dimensions, even when compared with the human enterprise that reaches the farthest: space travel. And its age is more than a million times a typical age of a human civilization. This might result in feelings of insignificance, as forcefully expressed in the story *The Restaurant at the End of the Universe* by Douglas Adams. He describes a terrible machine which destroys the soul by making one see the whole infinity of creation and oneself in relation to it. The effectiveness of this machine shows that "if life is going to exist in a universe of this size, then the one thing it cannot afford to have is a sense of proportion" (Adams 1982, 71).

However, other things being equal, the age and size of the universe might be related to our existence. We need certain types of atoms, like carbon and oxygen, which are produced in previous generations of stars. Biological evolution took another couple of billions of years to produce complex, intelligent, observing, and goal-seeking beings—us.

Turning this description upside down, it is argued that intelligent observation by natural beings is only possible after some billions of years, say ten billion. Thus, such beings can only observe a universe which is at least ten billion years old. Along this line, WAP offers an 'explanation' for the observed age of the universe. Such a universe must then also have a size of ten billion light years in all directions.

2. We happen to experience our world as having three spatial dimensions as well as one time dimension. Anthropic reasoning seems to rule out other dimensionalities. Two-dimensional beings would fall apart if there would be a canal running through the body, say for

digestion or blood circulation. In higher dimensional worlds planetary orbits would be unstable.

A survey of, and contribution to, similar arguments for various aspects of the initial conditions and the laws applying to our universe is Barrow and Tipler 1986.

Evaluation of the Weak Anthropic Principle

The Weak Anthropic Principle is in itself *true but devoid of relevance.* Take the following (simplified) example:

1. Assume that we know that life depends on liquid water.
2. We observe the existence of life, for instance ourselves.
3. WAP then predicts that our environment, our planet, will have a surface temperature between 0 and 100 degrees Celsius. This explains the temperature at our planet.

This is no explanation. There is no reason to call the WAP a 'principle'. It is the common use of evidence: we observe A (life, 2), we know that A and B go together (1, life needs liquid water), and hence C (3, the environment must support the presence of liquid water). This does not explain why, in my example, there are living beings and planets with the right temperatures, nor does it explain why A and B go together. The anthropic reasoning only repeats the first assumption: the two go together. The argument is not wrong. But it is devoid of relevance.

The existence of a paper explains some knowledge about the world, since it points to an author with certain ideas. But that does not justify the retrograde reasoning for the events, as if the existence of the paper explains the birth of the author, or even the origin of his/her ideas. There is a fundamental difference between an explanation for one's knowledge and an explanation of the phenomena.

WAP with Many Worlds

The Weak Anthropic Principle may explain observations if it is combined with the assumption that there are 'many worlds', regions which are different with respect to the relevant property. It does not explain the existence of the worlds, or of the observers, but as a selection rule it expresses that the observers will observe a 'world' with this particular property. The interesting issue, however, is not the selection rule (WAP), but the existence of the many worlds, hence the metaphysical view about the actual and the possible. If one has an extremely large number of monkeys typing for some time there will be one typing flawlessly one of Pannenberg's books—as well as many more typing a book *almost* flawlessly. However, this does not explain

the typing monkeys (the many worlds), nor the possibility and probability of the event.

The Strong Anthropic Principles

The strong anthropic principles state that any possible universe *must* have the properties for life (or for observing life). This is a statement about the class of all possible universes. This leads to an explanation of properties of the universe in terms of purpose: a property that is necessary for life is necessary for a universe. However, it does not need to refer to a purpose beyond the universe or the significance of life; the relation between livability and existence might have a natural basis and life might be a kind of side-effect.[8]

Strong anthropic arguments have some *disadvantages*.

1. Properties of possible universes which are not actual are untestable. If the possibilities are actual as other domains within a single universe, these domains are larger than the observable universe. If all possible universes co-exist in a fuzzy reality, as the Many Worlds Interpretation of quantum theories holds, any observation is in a specific branch, and does not give access to the other branches. Strong anthropic reasoning cannot rely on testable consequences about the class of possible universes (or of domains within a universe). Its appeal must be based upon the coherence of the view which it supports.

2. Anthropic arguments are quite restrictive in their predictions about possible universes, *if* 'life' is taken to be 'life as we know it'. However, life is in its richness only partly understood. This is even more the case for consciousness. To explain properties of the universe by reference to life or consciousness is like the lame and the blind guiding each other. Besides, other forms of life might develop in zillions of years in completely different stages of the universe, or other forms of life might be possible in other possible universes.

3. SAP explanations are also vulnerable to the future development of scientific theories. Subsequent theories have, in general, fewer and fewer unexplained parameters. As we saw above, some scientists are searching for a complete theory, perhaps even one without any arbitrary parameters—without invoking any reference to the necessary existence of life. If they succeed the set of consistent possible universes would contain only one element.

4. If applied at a small scale, for example by asserting that 'planets must have the properties which allow for the development of life in some stage of their history', a strong anthropic principle is surely wrong. But the example shows the nature of the SAP. It is like the

old teleological arguments: everything must have a function, and therefore the moon must be populated, as the ancient philosopher Plutarchus argued (Raingard 1934).

If one makes the metaphysical assumption that the existence of humans, or at least of embodied consciousness, is the purpose of universes, the Strong Anthropic Principle follows. We would be the purpose of it all, the universe would be for our sake. However, one could also understand the Strong Anthropic Principle by assuming a creator who likes complex toys. In such a view a universe would not exist for the sake of life, or for some destiny of life, but for the sake (glory) of God.

To conclude on SAP: its truth is disputable, and its interpretation ambiguous.

A version of strong anthropic reasoning which seems more based on science is the *Participatory Anthropic Principle* (PAP), which was introduced by Wheeler (Wheeler 1977; 1982; Patton and Wheeler 1975). It builds upon the interpretation of quantum theories. Quantum theory describes a superposition of states. However, we do not observe such superpositions. One of the proposed solutions for this tension is that the act of observation makes reality definite. But what is an observation? A measurement apparatus would still be, in principle, subject to a quantum theoretical description in terms of a superposition. Some, including Wheeler, have pursued this line to the moment where consciousness comes in. PAP assumes that it is observation by conscious beings which gives reality to all the preceding stages. If this interpretation is applied to the universe and if the universe is subject to a quantum-theoretical description, the conclusion is that a universe needs to develop conscious beings who observe the early universe. Otherwise it would not come into existence.

This view is based upon a sound knowledge of quantum theory, a disputed, but not necessarily wrong, interpretation of quantum mechanics, and a preference for the question of the origin of the universe above the question about the difference between an observer and an observed system. Unclear are the characteristics needed to qualify as an observer. "Was the world wave function waiting for millions of years until a single-celled creature appeared? Or did it have to wait a little longer for some more highly qualified measurer—with a Ph.D.?" (Bell 1981, 610). Besides, it suggests that regions of the universe where there are such observers are different from regions where there aren't. Although that need not imply observable differences, it still seems a bit odd.

The Participatory Anthropic Principle might easily be picked up in a metaphysics which gives 'mind in the universe' priority over matter.

Anthropic Principles and Divine Design

If one takes the anthropic coincidences seriously but rejects the 'explanations' based upon the Participatory or the Strong Anthropic Principle, one might opt for a theistic explanation: The universe exhibits those coincidences which allow for life because it was designed that way by a creator. In such discussions two ideas are juxtaposed: either design, and hence God as an explanation, *or* many worlds with a WAP explanation for the properties of our world. John Polkinghorne, a professor of theoretical physics who became an Anglican priest, called the ideas about other worlds metaphysical speculations. He holds the theistic explanation to be of equal intellectual respectability and of greater economy and elegance (Polkinghorne 1986, 80).

This inductive-apologetic defense of God's reality does not work.

1. The argument assumes that the anthropic coincidences are here to stay. However, these features which apparently point to design might find ordinary scientific explanations in future theories. That has happened for the traditional design arguments based on intracosmic adaptedness. The inflationary scenario already led to some erosion of anthropic coincidences.

2. Besides, the apologetics need a low plausibility of a plurality of worlds (domains, universes) on which the Weak Anthropic Principle would work as a selection principle. As Montefiore, the Anglican bishop of Birmingham, states, "it is infinitely more complex insofar as it postulates an infinite number of universes" (Montefiore 1985, 38). This is a widespread objection against theories which work with a plurality of 'worlds'. It appeals to a philosophical rule of economy, ascribed to William of Ockham: one should not introduce more entities than necessary to explain the phenomena.

 This is a misapplication of the economy rule. The many worlds are not introduced 'by hand'. Take, again, the example of planetary systems. The standard theory explains planets as remnants of an original cloud which collapsed to form a star. This theory works well for our solar system and fits with our knowledge about stars and their formation. It seems more complex, more ad hoc to reject the possibility of other planetary systems, although perhaps not observed, than to accept their existence. It would need an addition-

al rule if one would accept this theory of planetary formation and reject the possibility of other planetary systems.

It is simpler to accept a theory that also makes predictions beyond the observable domain than to draw a line. The issue of simplicity is not about the number of entities predicted by a theory but about the structure of the theory. Does a theory need more separate rules to have those entities or to exclude them? Some cosmological theories are more simple if one allows for the existence of many domains. Simplicity is not a simple count of entities: one creator or many universes.

This is not to conclude that belief in a Creator is wrong, nor that all possibilities of a theory should exist. But this way of doing the apologetic job does not work. We need to take more seriously the idea of more worlds as well as the possibility of more complete scientific theories.

2.4. Global Ontological Contingency and the Universe as Grace

Even the ontological contingency, the mystery of existence, has been disputed by some cosmologists, but this one seems nonetheless unassailable.

Hawking and Hartle interpreted their own proposal for the wave function of the universe as giving the probability "for the universe to appear from Nothing" (Hartle and Hawking 1983, 2961). Similar claims have been made for other quantum theories of gravity, for instance by Vilenkin.

I maintain that they do not describe an 'appearance out of nothing' if the nothing is taken to be as absolute as imaginable.[9] It is possible to interpret the Hartle-Hawking proposal in the sense of *creatio ex nihilo* (creation out of nothing), if that is understood not as a cosmogonic (temporal) description but as a view of the universe as being sustained by God at every moment.

The notion of appearance is a temporal notion. The nothing arises in the Hartle-Hawking theory through a timeless kind of calculation, which does away with a reference to an earlier state as an initial condition. Expressions like 'tunneling from nothing' are of a mixed nature, and not suitable to describe the basic idea of this theory. Tunneling connotes a temporal process, while the 'from nothing' applies to a kind of time-independent actuality.

The 'nothing' which has a precise meaning in the context of this proposal is not an absolute 'nothing' in a more philosophical sense. There are serious problems when one tries to combine the language of

probabilities with the notion of 'nothing'.[10] First, the probability of finding 'heads' when tossing a coin is ½, but there is a 50 percent chance of getting an *actual* 'head' if and only if someone tosses a coin so that one of the possible outcomes is realized. A mathematical idea of getting a universe from nothing does not give a physical universe, but only the idea of a physical universe—assuming that there is a difference between the universe and a mathematical idea about the universe.[11] There has to be some input of 'physical reality'. Perhaps that is implied in the nothing, but that makes it into a physical entity and not nothing at all. Secondly, physical probabilities, as exemplified by radioactive decay, start with a first situation (a particle in space and time) becoming another situation (other particles in space and time). The probability is the chance that the transition from situation one to situation two happens during a certain interval of time, or that the particle is found in a certain volume of space, or something like that. Even if one reduces the entities in the first situation as much as possible (no energy, no matter fields, and so on), to make sense of talking about probabilities is only possible if there is some structure with measure (like time) present in the first situation. The two problems are both described from within time. It is difficult, if not impossible, to get outside that when talking about probabilities.

The Mystery of Existence

Why is there anything at all that behaves according to the mathematical rules written down in the *Physical Review*? Some, like Atkins, maintain that chance phenomena are a sufficient explanation. This is wrong. As argued above, even physical theories about creation as a quantum fluctuation of 'nothing' need an input of actuality. The probability of throwing a number below seven with a die is one, it is certain, but there is an outcome only if there is an actual die which is thrown. This contingency remains beyond physics.

This seems a stopgap, a last resort for the theologian if there is nothing else to claim, the 'God of the ultimate gap'. This 'gap', the ontological contingency of existence, has been used in cosmological arguments for the existence of God. According to Swinburne the choice is between the universe or God as stopping-point of our explanation (Swinburne 1979, 127). God as stopping-point is a preferable conclusion because it is more simple. The argument might be rational, but that is to be debated at the level of philosophical reasoning without support from science. The scientific contribution lies in the description of the universe. If the choice between accepting the universe as a brute fact or an explanation of a different kind is justified by comparing the simplicity of the two hypotheses, it is a matter of the

utmost importance to understand how complex or simple the two alternatives are. Many cosmologists believe that their theories are of an impressive simplicity and elegance in structure and assumptions. Whether this makes it more or less reasonable to regard the universe as a 'creation' is not clear—why would it be unattractive to believe that God made a universe with a simple structure?—but the choices do undermine Swinburne's argument based on simplicity.

It is possible to accept the universe as a brute fact, which just happens to be. But this contingency might also be related to a sense of wonder which has been described aptly by the physicist Misner. "To say that God created the universe does not explain either God or the universe, but it keeps our consciousness alive to the mysteries of awesome majesty that we might otherwise ignore" (Misner 1977, 95). To understand the universe as a gift, as grace, is a way to interpret this sense of amazement and to relate it to an understanding of God. It can be used to express the idea of God's love for the world: God creates it freely. That is one major aspect of *creatio ex nihilo,* the world's dependence upon a God who is ontologically transcendent with respect to the world.

It is in this context that the difference between theism and pantheism is most clearly visible. "We might perhaps define theism best by understanding it as that conception of God where the world is the product of God's free, self-conscious creative and sustaining activity. This definition involves that God does not require the world for the realization of his being, because God creates the world *freely"* (Hubbeling 1963, 10).

• • • • • • • • • •
3. Time

3.1. *Physical Perspectives on Time*

Time is a complex subject, discussed in many philosophical treatises. The argument in this section is especially about the whole of time, which correlates to the absence of a special moment as 'the present present'.

No Flowing Present
According to common sense the present is a special moment, the boundary between the past and the future. Besides, this present is 'moving' towards the future as 'time is passing away'. What is this special moment in the context of physics and cosmology? Is this an objective phenomenon (as in Reichenbach 1971) or mind-dependent (Grünbaum 1971)? If it depends on the mind, how does one reconcile

mental events which have the property of becoming and physical events without that property? Unless one also holds that there is no becoming in the mind—but why is the illusion so persistent? If one opts for an objective, mind-independent view, one needs to face the question whether that can be made part of the physical description.

This question of the flow of time is often mixed up with the issues of order, a linear order relation, and asymmetry between the past direction and the future direction. However, an order relation seems necessary, but is not sufficient—we do not perceive anything flowing along the line representing the real numbers; a present is necessary for the notion of a *flow* of time. Besides, time asymmetry is neither sufficient nor necessary. In an asymmetric process all moments qualify as potential presents; there is no way to single out a present as our present. And in purely reversible systems, say a frictionless pendulum, we still have the impression that there is a present position, which immediately is superseded by another present position.

Events in the past seem necessary and fixed in memories, while events in the future seem contingent. It has been attempted to use this modal difference to formulate a distinction between the past of the present moment and its future and hence an objective notion of the present. Reichenbach (1971) appealed to quantum mechanics, where the present is the moment processes become determined. However, Grünbaum (1971) showed that every moment of time satisfies Reichenbach's definition. It does not single out a unique moment as the present present. The modal distinction between past and future cannot "be reformulated into a physical discourse so as to allow a physically significant distinction between past, present and future" (Kroes 1985, 200).

Physics seems unable to catch the present:

> In my opinion, it is doubtful whether the attempts to construct an objective theory of time flow have any chance of success. In studying physical reality, physicists concentrate upon reducible phenomena, and they eliminate all that makes the phenomenon unique. In particular, they abstract from the fact that an event takes place 'here' and 'now'. But whereas physics generally tries to describe the universal aspects of the phenomena, the goal of an objective theory of time flow is precisely to get hold of the unique: such theory must single out a unique moment of time as the present which separates the past from the future. Therefore, it is in principle questionable whether an objective theory of time flow is feasible. (Kroes 1985, 208)

The Whole of Time/Timelessness

One could compare a universe to a film—each single picture representing a three-dimensional universe at a certain moment. Either one can take the perspective of the viewer who sees all the pictures subsequently *in time,* and hence sees action, movement, "evolution"; or from the perspective of the manufacturer, who handles *the whole film* as a single entity, for instance in selling or storing. The film still has a 'story', but there is no movement, no action or 'evolution'.

There is a similar feature of physical descriptions, which allows for two descriptions.[12] General relativity, the theory behind Big Bang cosmology, has as its most fundamental entity a four-dimensional space-time. That level of description is like having the whole film: all moments are equally present, there is nothing like flow or movement. It is often possible to decompose such a four-dimensional description in a description of three-dimensional spaces evolving in time (Misner, Thorne, and Wheeler 1973).

Physical theories as different as Newton's mechanics, thermodynamics, and quantum theories have been formulated in terms of phase space and trajectories. Each trajectory represents a complete possible 'history' of a system. At this level of description, the theory is not about an evolving system, say the movement of a particle, but about whole histories.

Light takes the fastest path from a source to a receiver. In a homogeneous medium this is a straight line. However, if there is, for instance, a transition from air to water, the fastest path is not straight but broken. One very useful description is in terms of all possible paths, in combination with a selection rule (principle of least action) that indicates which path is actually taken. As before, the physical description works with complete 'possible histories'. Such principles of least action are very pervasive in physics. This idea has been incorporated in the path-integral formalism, which is extensively used in contemporary field theory (particle physics). It seems as if the more 'holistic' pictures of theories about whole histories imply *determinism*—one can only sell complete films once they are complete. However, selling is an action in time, and hence once again brings in the other type of description. The timeless perspective, without claiming to have the final perspective of one's world at a certain moment of time, does not imply determinism. This can be explained as follows:

A universe picture is, according to McCall (1976), a complete description of a history of a universe, including past, present, and future. Assuming that the past is fixed and the future is a set of possibilities, a universe picture at a certain moment is like a tree: one stem

(fixed past) and many branches (future possibilities). The present of a universe picture is the point where the branching begins. McCall hopes to formulate an objective flow of time in terms of such trees, as later trees are subtrees of earlier trees. That, however, does not single out a unique tree as corresponding to the present (Kroes 1985, 203f).

One can talk about the whole set of trees, hence possible universe pictures, without implying that the future is determined or even already should have happened—as is necessary for having the complete film. Of course, having the 'last' tree of a series—which would consist only of stem without branches—would mean that everything were fixed relative to the present defined by that tree, but then everything is in the past. Talking about systems in terms of such trees provides a language for talking about complete histories without implying determinism. Determinism is, of course, a feature of some basic physical theories which can be formulated in this 'complete-history' way, like classical mechanics, general relativity, and Tipler's cosmology. But that does not warrant the reverse argument, that such a timeless description is necessarily tied up with determinism.

Both the difficulties in giving a physical expression of the flow of time and the presence from a timeless perspective aside from the description from within time imply that one cannot appeal to modern cosmology and physics for support of the claim that we live in a dynamic, evolutionary world. However, the conclusion need not be only negative; the existence of two descriptions might also offer opportunities to express certain theological concerns.

3.2. Theology: Time and Timelessness in Relation to the Present

Almost all current theologians who take science seriously opt for a dynamic picture. When the physical view of time is discussed, there is a strong emphasis on the flow of time and the asymmetry of time. The whole of time has been discussed as a problem, where theology should hope for the right outcome. This is especially true for process theologians (such as Griffin 1986), but also for others (for instance Russell 1984).

Philosophical theology and theoretical science take some distance from commonsense experience. At that level both descriptions might be useful. They allow for different clusters of associations, and thereby help one to see the world differently. The precise meaning of all the terms is dependent upon the further system in which the ideas participate.

A description *within time* takes history and evolution as basic. This resonates with a theological emphasis on *Heilsgeschichte* (salvation history). *Creatio ex nihilo* is most easily associated with questions about ultimate origins, cosmogony. *Creatio continua* deals with God's relation to the processes of change, especially to the emergence of novelty. Contingency is primarily about events; future events might still be contingent. Necessity seems reflected in the laws, which are the same for all moments in time, and in the unavoidability of a temporal dimension. Value is easily related to the future; decisions will be judged by their consequences. The eschaton, say the Kingdom of God, is closely related to the future. God's relation to the world is most easily formulated in terms of immanence or temporal transcendence (e.g., before the world, luring towards a better future).

The perspective that incorporates the *whole of time* might be understood as a view *sub specie aeternitatis*, a 'bird's-eye view' of the whole of history. *Creatio ex nihilo* is not about origins, but about the *ground* of everything. (For an atemporal understanding of *ground* one could think of the role of axioms in a mathematical system. They are not prior in a temporal sense, but they are the ground of the system.) *Creatio continua* might express God's *conservatio*. However, it is stripped from the emphasis on change and novelty, which it has in the other perspective. 'Novelty' is not a concept that fits in this timeless perspective; it belongs to the other language. Time is explicitly seen as part of the created order. Contingency is primarily the ontological kind: Why is there anything at all? Besides, the contingency of the laws is more explicit: Why this package and not another? The events are less seen as contingent: they are all necessary relative to the whole of history. Value must be understood as being there for every event, just by being part of the whole web—or perhaps even more primitively, just by being. Eschatology is less connected with the future, and more with God's transcendence. Transcendence is less easily understood as temporal (before and after the world); rather it is a radical *beyond*—as if in a completely different dimension.

Each of these two views is in danger of missing something essential. The perspective incorporating the whole of time might result in a conservative, status quo–affirming, understanding of eternal values—and thus divert the attention from the concrete contexts of injustice and suffering to the 'other place' of an eternal and timeless faith. The other, evolutionary, view is in danger of subsuming the present suffering and injustice under the future happiness, and thus of becoming an optimistic expectation of 'another time'.

They both gain strength, from a theological perspective, if they are tied to the present. The present is the place in which the temporal and the atemporal intersect critically. One might well relate the two clusters of associations to two types of Biblical literature. The *prophetical* literature is in the middle of time, influencing what is going on. *Wisdom* literature reflects on the way things are, will be, and apparently always have been. However, they need each other. Prophetical criticism appeals to God's otherness or transcendence—that is, its Archimedean perspective to criticize the present.

This atemporal transcendence, and the correlated view of the whole of time, might be useful as an understanding of God. A view *sub specie aeternitatis* is not one that can be attained definitely. But it can express the aim of "an understanding of the affairs of men which is not relative to the outlook of an individual, community or age", not even "relative to the outlook of mankind" (Sutherland 1984, 88). The idea functions like the transcendental regulative ideas of reason, as directing the understanding towards a certain goal. The unattainability, the transcendence, is essential. It is sane to allow for self-questioning in relation to a perspective other than one's own. If this 'other perspective' would be accessible, like a list of eternal values, it would become an expression of insanity, of fanaticism without self-questioning. "What is at stake in this argument is not the *content* of faith, but, as Kierkegaard stressed, the manner of appropriation of faith. Faith must be appropriated in a way which distinguishes it from fanaticism. For that it requires the idea of the eternal which transcends even one's most cherished views" (Sutherland 1984, 110).

The statement that God is eternal can be understood in two ways:

- God is everlasting, hence God has an unending duration.
- God is timeless, has no duration.

Pike discusses the second option in his *God and Timelessness* (1970). Pike concludes that the concept of timelessness has almost no scriptural basis; it arises from Platonic influence. "I shall not conclude that the doctrine of timelessness should not be included in a system of Christian theology. Instead, I shall close with a question: What reason is there for thinking that a doctrine of God's timelessness should have a place in a system of Christian theology?" (Pike 1970, 190).

Timelessness might have a place for two reasons.

1. Time is part of the created order. This is Augustine's view of *creatio cum tempore*, and seems a reasonable interpretation of most contemporary cosmologies. Hence, it is not meaningful to talk about God as everlasting as if there was time *before* the creation.

2. The presence of a timeless description, where the whole is a unit including all moments, suggests that it is possible to talk about the relation of God to this whole—and not God at one moment to the universe at that moment, differentiating moments in God.

God's transcendence as timelessness does not exclude that there is an order, and perhaps even a flow, within God which could be labelled God's time.

· · · · · · · · · ·
4. Science and Theology: About God's Presence or God's Absence?

In the introduction I distinguished between a metaphysics which thematizes God's presence and one which thematizes God's absence. If God's presence is the starting point, the divine reality is somehow "showing through" in our ordinary reality. A religion along this line could be called mystical; the aim is to establish contact with that divine reality. It suggests the possibility of an inductive apologetic argument from science to theology.

The theme of God's *absence* suggests a contrast between the divine and ordinary reality. It therefore leads to a *prophetic* emphasis: judgment (it is not as it should be ideally) and appeal to conversion (change this world by orienting ourselves to the divine reality).

These two approaches result in different questions in the dialogue with the sciences. The 'mystical' approach would be more interested in the intelligibility of the traditional metaphysical attributes of God in the context of contemporary understanding. Tipler's paper is a clear example. When he raises the question whether his God of the Omega Point is *the* God, Tipler takes necessary existence as the criterion par excellence (159). The 'prophetical' approach might emphasize the *function* of any understanding of God: whether it allows humans to perceive their own reality more critically, and to do something about it whenever it is judged to be on the wrong course.

If the reality of God is somehow complementary to ours, the divine complement is expected to be reflected in a cognitive incompleteness of any understanding which leaves it out. Consonance is expected between the way the divine reality is and the way the world is. If descriptive consonance is lacking for a specific theology and a specific scientific understanding of the world, one has to doubt either the theology or the science. Although they espouse different theologies, it seems that it is primarily this approach which is followed by those who emphasized a 'critical realist' understanding of science and

of theology, like Barbour (1974), Peacocke (1984), Soskice (1985), and Polkinghorne (1986).

As argued above (section 2), contingency does not provide a basis for an argument for the existence of God. Science is neutral with respect to contingency and necessity. Contingency is not ruled out by complete theories, but it is not supported by anthropic coincidences either. Generalizing, there are good reasons to doubt whether a cognitive argument on the basis of science for the necessity of a divine reality can be based upon contemporary science. Even the global ontological contingency allows for different stances, either taking the universe as a simple brute fact or ascribing it to a transcendent cause. There is no support from science for a divine reality which is somehow present as complement to our world.

As the cognitive inductive argument fails, one could appeal to revelation, or inner experience, or anything outside the public discourse. However, such a fideistic option is not attractive for those who want to do their theology in dialogue with science. Theology, as Pannenberg defends, poses universal claims, and should defend these in the public sphere (see Chapter 2 of this volume).[13]

Theologians seem to be caught between the ambiguity of inner-worldly evidence, as the information provided by the sciences does not offer a decisive clarity about the existence of God, and the need for a public account for one's convictions. I suggest that, instead of trying to resolve the ambiguity within the scientific realm, 'the God hypothesis' might be introduced precisely in that context.

It seems that modern science shares in the ambivalence of modern life-experiences: we would like to have meaning, but do not really find it. In the face of the apparent meaninglessness and irrationality of the world, there seem to be three possible positions.[14]

First, some argue that the meaninglessness is only apparent. If one would open one's eyes, meaning would be perceived as really there. Such a position seems to me a major current in the New Age movement; the "crisis is essentially a crisis of perception" (Capra 1983, xviii); we are on the brink of a reenchantment of the world (Berman 1981). Although with a different metaphysical view, those who defend the complementary nature of the divine reality also suggest that meaning is really there; the absence exists only in a narrow, reductive perspective on the ordinary world. Others accept the world as meaningless; religion is perceived as a great denial of this pointlessness.

Might it not be possible to argue a third course between those two positions by introducing the hypothesis of a transcendent God as a conjecture about meaning for this world without denying the reality

of its irrationality. This leads to a theology which starts from the experience of God's absence. This corresponds to an understanding of the divine reality as, primarily, different from our ordinary world. Philosophical theology becomes primarily reflection upon injustice in this world, upon values, upon activities against injustice, and upon ways to live with failures and losses. The confrontation with the natural sciences seems less relevant for such a theology with its human-centered, and perhaps even political, emphasis. However, such theologies too go with metaphysical views.

The preceding proposal might be misunderstood as one more in the anti-realistic camp. It portrays God as a merely subjective notion, useful in some language games and dispensable in others. However, I hold our knowledge to be unavoidably hypothetical, but nonetheless purporting to refer to something real. This view differs from that of the 'critical realists' not because it does not intend to be critical or to be about a reality; but because it accepts that there is no warrant for an approximate correspondence between our conjectures and the reality they purport to describe. If evil is really evil and injustice in this world is not illusory, any proposal for meaning is just that: a proposal, a conjecture about the possibility of a better world, or this world better, 'dreaming of peace'. The constructive nature is not only a limitation of our knowledge; it reflects the nature of the theological enterprise in an imperfect world.

If one accepts the ambiguity of science one cannot avoid that God's reality remains a conjecture. However, once this assumption is introduced, one should explicate and develop its meaning in an intelligible way, and hence in terms which fit our contemporary scientific understanding. We construct our metaphysical understanding of God.[15] Its adequacy will be judged by its harmony with the scientific understanding of the world and by the way it is a suitable metaphysics for the primary existential reason for the introduction of the hypothesis God: it should provide a framework which makes it possible to live and act in an imperfect and unjust world. Such a metaphysics should allow for a theology which is primarily prophetical, aimed at critical relativizing of the present status quo and evoking a response. Such a theology needs a difference between what is possible and what is actual. The future is one which we make, not one which is definitely enfolded in the cosmic process. Theological adequacy requires an emphasis on the present, instead of some 'other time' or 'other place', and on evocation instead of the promise of a happy ending. The present is where we live, and where our acts can make a difference; to make a difference assumes that the future is not determined.

God can be understood primarily as transcendence related to the present. It is in the present that the inner-cosmic temporal dimension (our acts with respect to the immediate future) is confronted with the atemporal. God is atemporally transcendent, a metaphysical principle of contrast, of otherness, but God is such in relation to each present. There are, at least, three aspects of such an understanding of God.

1. God would be the location of values, which provide the basis for judgement. Locating the values in God seems fitting for three reasons, aside from fitting the prophetic criticism of the present state as not being according to God's vision. (a) Values are abstract, and in that sense eternal. They bring the non situational into the moral deliberations concerning a specific situation. (b) God is perfect and just, the fundamental nonmoral and moral values understood to be sought for in eschatology. (c) God is beyond our grasp. We cannot appropriate the ultimate values as if we know them exhaustively. Fanaticism which does not allow for the possibility of being wrong does not fit.

2. God would be the locus of possibilities. The past is that which was; however, in God there is the contrast of that which could have been. The future will still be one course among the many possibilities; the possibilities metaphysically precede the actual single future. This assumes that there are the alternatives for our actions, and hence that an understanding of theology as being after judgment and evocation is meaningful.

3. God is also transcendent as the source of reality, as its eternal ground. This latter component is not an affirmation about a remote destiny but about our present lives. Affirming the goodness, despite evidence of imperfection, may contribute to the overcoming of anxiety.

.

5. Questions Concerning Pannenberg's Approach

The thought of Wolfhart Pannenberg on the issues of contingency and time, as well as on method and God's presence and absence, is extensive. The following are some very rough impressions, which might well be mistaken. Hence, the questions might be understood more as a request for further clarification than as a definitive criticism.

Pannenberg seems to relate science and theology cognitively in two ways, which could be labelled inductive and deductive. Both reflect his interest in the universality of theological claims.

1. An inductive-apologetic approach is most clearly present in his anthropological writings.[16] Secular anthropology needs a religious dimension. This dimension correlates to an external reality.
2. Deduction from theology to claims about the world is more explicit in discussions about physics and biology. For example, "the theological affirmation that the world of nature proceeds from an act of divine creation implies the claim that the existence of the world as a whole and of all its parts is contingent" (Pannenberg 1993b, 34). It is this stance which allows for "theological questions to scientists" (Chapter 1, above). It also bears upon the nature of science. "If the God of the Bible is creator of the universe, then it is not possible to understand fully or even appropriately the processes of nature without reference to that God." (38)

God is cognitively necessary; the sciences are incomplete (the inductive approach) and must be incomplete (deductively seen from theology). If "nature can be appropriately understood without reference to the God of the Bible, then that God cannot be the creator of the universe, and consequently he would not be truly God and could not be trusted as a source of moral teaching either" (38).

The question is how this relates to the discussion of contingency as given above. How about the equal absence from physics of contingency and necessity, as Pannenberg asks what modern physics has to say about contingency (1993b, 35). How about his response to the search for complete unified cosmological theories? How about the ambiguity of the contingency as reflected in the anthropic coincidences? And how about the global ontological contingency? Is God an explanation for the universe, as Swinburne has it? Or is the statement that God created the universe not explanatory, but rather intended "to keep our consciousness alive to the mysteries of awesome majesty that we might otherwise ignore", as Misner (1977, 95) maintains? These questions are not merely about contingency. They bear on the distinction made above between a mystical and a prophetical metaphysical scheme, to which we will return below.

Another question concerns Pannenberg's view of time and the whole of time. He seems to argue from the primacy of eternity, or the whole of time, or the infinite, to the primacy of the future (1993b, 43f). The argument needs for its cogency the idea that it is the future which makes the whole complete; past and present are already available.

Pannenberg makes the transition from 'whole' to 'future', hence from the timeless level of description to the description from within time, for instance when he refers to "future wholeness" (1993b, 43),

and concludes to a priority of the future (1993b, 43). This seems unclear and deviating from the physical understanding of time.

If one focusses on the evolutionary picture, one has a past and a future with respect to any assumed presence. However, past and future are equally 'not-present'. Completeness is not achieved by moving towards the future, as with each change in present there is also a change in the 'not-present'.

Completeness is only achieved, within the context of physical understanding, by moving to the other level of description, in which all times are equally present at once. However, this level of description is atemporal; it is meaningless to consider such wholes as future wholes; they just are the entities of the theory, and hence of reality as described by that theory.

I would suggest that it might be possible to maintain the notion of anticipation of completeness in every present as an expression of the relation between the two descriptions (cf. Tipler, 168f). It appears not in line with physics to understand the completion as anticipation of something future. Anticipation becomes an expression for the way the complete history, past and future with respect to that present, is related to that present.

A third, more general, cluster of questions concerns the general nature of the program. Does Pannenberg fit into my division between a 'mystical' approach to the relation between science and theology which emphasizes God's presence in the world as described by the sciences and a 'prophetic' one which emphasizes God's apparent absence, or at least the ambiguity of the data? Is he, as appears from his quest for a religious dimension in secular understanding, opting for an understanding of God as a complement to, and present in, our reality? This seems to fit with his description of God as the 'all-determining reality' and with the (apparent?) determinism from the future, hence the determinism towards a 'happy ending'. That might be an understanding of God's trustworthiness in promises, and hence comforting. But how does Pannenberg avoid the theological dangers of such an approach: the danger to the sharpness of evil, injustice and imperfection, and hence of judgment, and the danger that we fail to hear a call for conversion, for doing whatever we can against injustice and evil?

· · · · · · · · · ·

These investigations were supported by the Netherlands Organization for Scientific Research (NWO). I gratefully acknowledge the influence of discussions with Robert J. Russell (Center for Theology and the Natural Sciences, Berke-

ley) and with Philip Hefner (Chicago Center for Religion and Science) during a Fulbright Scholarship in 1987/1988 as well as the influence of Professor R. Hensen of the University of Groningen.

· · · · · · · · · ·

Notes

1. In Drees (1990, 136–141) I dealt more extensively with some of these issues, while offering an analysis of Pannenberg and Tipler. As made clear there, the apparent similarity with respect to the emphasis on the future does not survive close scrutiny. Whereas for Pannenberg the future safeguards contingency and freedom, for Tipler the future excludes them.
2. 'Global' is cosmological; not restricted to our globe, the Earth.
3. The Hartle-Hawking proposal has been discussed in relation to theological ideas by Isham (1988) and Drees (1988; 1990, 51–57).
4. It need not imply finiteness for the universe described by the theory; finiteness is only required for all possible outcomes of observations.
5. This suggests that observational falsification of such a complete theory would mean falsification of either the esthetic assumptions or the assumption of mathematical formalizability.
6. For a popular introduction, see Gleick 1987.
7. Hawking used 'strong anthropic principle' for the idea that there are many universes or regions with different laws and 'weak' for different initial conditions. But he also used 'strong' in relation to purpose: "the strong anthropic principle would claim that this whole vast construction exists simply for our sake" (Hawking 1988, 126). This seems confused. The distinction between laws and initial conditions is unessential. The distinction between an anthropic principle working as a selection effect on observations of laws and conditions and one which expresses a claim of purpose seems useful, but misses the specific nature of the SAP as well. SAP, as introduced here following previous authors (Barrow and Tipler 1986), does not in itself express purpose; the limitation on possible universes might have another explanation, for instance in the process of origination.
8. This seems the position taken by the cosmologist Roger Penrose. He suggests as an explanation for the isotropy and homogeneity of the universe a new law of physics which would imply that initial singularities must have certain properties. As he sees it, the universe is much more homogeneous than necessary for our existence—and hence an anthropic 'purpose' could have been realized in a vastly 'cheaper' way (Penrose 1981).
9. There is one sense in which the Hartle-Hawking theory can clearly be understood as creation from 'nothing'. Ordinary calculations in physics often assume a state at one moment and laws to calculate the state at another moment. In such situations we might say that the second state arises out of the first state. There is in the Hartle-Hawking theory a timeless level of calculation. In such calculations there is no reference to any state other than the 'resulting' state. As states are compact, they are the

only boundary present in the calculation. The theory gives a precise meaning to the notion of 'nothing' as absence from other boundaries in the calculation.

10. The problem seems to express itself technically as the normalization of the wavefunction of the universe, as well as the interpretation of the resulting probabilities.

11. Tipler (170–180) seems to deny this distinction between mathematical and physical existence. Existence is defined by Tipler as the experience of people, perhaps simulated people, of their own existence. The experience of existence is, as I am willing to concede to Tipler, the same for real existing entities and for their perfect simulations. The issue is the identity of indiscernibles as a rule, and the identification of a universe with its perfect simulation as the case of application. Even if we cannot tell them apart, they still are different, if imaginary, considered 'from the outside'—and therefore they are conceptually different.

12. All the features mentioned in the text appear also in Tipler's article, especially in his discussion of the *aeternitas* as exemplified by the Omega-point (168), and his exclamation 'there is no time!' when he discusses quantum cosmology (176). Time turns out to be variation along a trajec-tory (176). The classical trajectories that turn out to have a significant probability correspond to the shortest path in the example about light. One could say that time is a phenomenological construct.

13. Those who take a purely logical approach to the relation between theology and the natural sciences, like Plantinga (1974) or Brom (1982; 1984), defend only the logical possibility of combining certain beliefs; they fail to defend them as reasonable or even compelling.

14. An article by Hans Kippenberg, University of Groningen, on Max Weber's ideas about the disenchantment (*Entzauberung*) of the world and possible rational answers, functioned as the context of discovery.

15. Mary Gerhart and Allan Russell have presented a method in science and in theology, as well as for the interaction between the two, which is similar to what I intend (Gerhart and Russell 1984).

16. "Man's chronic need, his infinite dependence, presupposes something outside himself that is beyond every experience of the world. Man does not simply respond to the pressure of his surplus of drives by creating for his longing and awe an imaginary object beyond every possible thing in the world. Rather, in his infinite dependence he presupposes with every breath he takes a corresponding, infinite, never ending, otherworldly being before whom he stands, even if he does not know what to call it. . . . Our language has the word 'God' for this entity upon which man is dependent in his infinite striving" (Pannenberg 1970, 10).

17. "The aim is to lay theological claim to the human phenomena described in the anthropological disciplines. To this end, the secular description is accepted as simply a provisional version of the objective reality, a version that needs to be expanded and deepened by showing that the anthropological datum itself contains a further and theologically relevant dimension." (59)

• • • • • • • • • •
References

Adams, Douglas. 1982. *The Restaurant at the End of the Universe.* 1980. New York: Pocket Books.

Atkins, P. W. 1981. *The Creation.* San Francisco: Freeman.

Barbour, Ian. 1974. *Myths, Models, and Paradigms.* New York: Harper and Row.

Barrow, John D., and Frank J. Tipler. 1986. *The Anthropic Cosmological Principle.* Oxford: Oxford University Press.

Bell, J.S. 1981. Quantum Mechanics for Cosmologists. In *Quantum Gravity* 2, ed. C.J. Isham, R. Penrose and D.W. Sciama. Oxford: Oxford University Press.

Berman, M. 1981. *The Re-enchantment of the World.* New York: Cornell University Press.

Brom, L., van der. 1982. *God Alomtegenwoordig.* Kampen, Netherlands: Kok.

———. 1984. God's Omnipresent Agency. *Religious Studies* 20:637–655.

Capra, F. [1982] 1983. *The Turning Point.* New York: Simon and Schuster. London: Fontana.

Drees, Willem. 1988. Beyond the Limitations of the Big Bang Theory: Cosmology and Theological Reflection. *CTNS Bulletin* 8(1):1–15.

———. 1990. *Beyond the Big Bang: Quantum Cosmologies and God.* La Salle, Ill.: Open Court.

Dyson, Freeman J. 1988. *Infinite in All Directions.* New York: Harper and Row.

Gerhart, M., and A. Russell. 1984. *Metaphoric Process.* Fort Worth, Texas: Texas Christian University Press.

Gleick, James. 1987. *Chaos: Making a New Science.* New York: Viking.

Grünbaum, A. 1971. The Meaning of Time. In *Basic Issues in the Philosophy of Time,* ed. E. Freeman and W. Sellars. La Salle, Ill.: Open Court.

Hartle, J. B., and S. W. Hawking. 1983. Wavefunction of the Universe. *Physical Review* 28:2960–975.

Hawking, Stephen W. 1980. *Is The End in Sight for Theoretical Physics?* Cambridge: Cambridge University Press.

———. 1982. The Boundary Conditions of the Universe. In *Astrophysical Cosmology,* ed. H.A. Brück, G.V. Coyne and M.S. Longair. Vatican City: Pontifica Academia Scientiarum.

———. 1988. *A Brief History of Time.* New York: Bantam.

Hesse, Mary B. 1988. Physics, Philosophy, and Myth. In *Physics, Philosophy and Theology: A Common Quest for Understanding,* distributed by University of Notre Dame Press, ed. Robert J. Russell, William R. Stoeger, and George V. Coyne. Vatican City: Vatican Observatory.

Hubbeling, H.G. 1963. *Is The Christian God-Conception Philosophically Inferior?* Assen, Netherlands: Van Gorcum.

Isham, C. J. 1988. Creation of the Universe as a Quantum Tunneling Event. In *Physics, Philosophy, and Theology: A Common Quest for Understanding,* distributed by University of Notre Dame Press, ed. Robert J. Russell, William R. Stoeger, and George V. Coyne. Vatican: Vatican Observatory.

Kroes, P. 1985. *Time: Its Structure and Role in Physical Theories.* Dordrecht: Reidel.

Linde, A.D. 1983. The New Inflationary Scenario. In *The Very Early Universe,* ed. G.W. Gibbons, S.W. Hawking and S.T. C. Siklos. Cambridge: Cambridge University Press.

McCall, S. 1976. Objective Time Flow. *Philosophy of Science* 43:337–362.

Misner, Charles W., Kip S. Thorne, and John Archibald Wheeler. 1977. *Gravitation.* San Francisco: Freeman.

Montefiore, H. 1985. *The Probability of God.* London: SCM Press.

Munitz, M. K. 1974. *The Mystery of Existence.* New York: New York University Press.

Pagels, H. R. 1985. *Perfect Symmetry.* New York: Simon and Schuster.

Pannenberg, Wolfhart. 1970. *What Is Man?* 1962. Philadelphia: Fortress.

———. 1976. *Theology and the Philosophy of Science.* Trans. Francis McDonagh. Philadelphia: Westminster.

———. 1985. *Anthropology in Theological Perspective.* Trans. M.J. O'Connell. Philadelphia: Westminster.

———. 1993a. Contingency and Natural Law. In *Toward a Theology of Nature: Essays on Science and Faith,* ed. Ted Peters, 72–122. Louisville: Westminster/John Knox.

———. 1993b. The Doctrine of Creation and Modern Science. In *Toward a Theology of Nature: Essays on Science and Faith,* ed. Ted Peters, 29–49. Louisville: Westminster/John Knox.

Patton, G. M, and J. A. Wheeler. 1975. Is Physics Legislated by Cosmogony? In *Quantum Gravity,* ed. C.J. Isham, R. Penrose and D.W. Sciama. Oxford: Oxford University Press.

Peacocke, Arthur. 1984. *Intimations of Reality.* Notre Dame: University of Notre Dame Press.

Penrose, Roger. 1981. Time Asymmetry and Quantum Gravity. In *Quantum Gravity* 2, ed. C.J. Isham, R. Penrose and D.W. Sciama. Oxford: Oxford University Press.

Pike, N. 1970. *God and Timelessness.* London: Routledge.

Plantiga, A. C. 1974. *God, Freedom, and Evil.* New York: Harper and Row.

Polkinghorne, John. 1986. *One World.* Princeton: Princeton University Press.

Raingard, P. 1934. *Le peri tou prosopou de Plutarque.* Chartres.

Reichenbach, H. 1971. *The Direction of Time.* 1956. Berkeley: University of California Press.

Russell, Robert. 1984. Entropy and Evil. *Zygon: Journal of Religion and Science* 19:449–68.

———. 1988. Contingency in Physics and Cosmology: A Critique of the Theology of Wolfhart Pannenberg. *Zygon: Journal of Religion and Science* 23:23–43.

Schwarz, J.H. 1987. Superstring Unification. In *Three Hundred Years of Gravitation,* ed. S.W. Hawking and W. Israel. Cambridge: Cambridge University Press.

Soskice, Janet M. 1985. *Metaphor and Religious Language.* Oxford: Oxford University Press.

Sutherland, S.R. 1984. *God, Jesus, and Belief.* Oxford: Blackwell.

Swinburne, R. 1979. *The Existence of God.* Oxford: Oxford University Press.

Updike, John. 1986. *Roger's Version.* New York: Knopf.

Van den Brom, L. J. 1982. *God Alomtegenwoordig.* Kampen, Netherlands: Kok

———. 1984. God's Omnipresent Agency. *Religious Studies* 20:637–655.

Vilenkin, A. 1982. Creation of the Universe from Nothing. *Physics Letters.* 117:25–28.

———. 1986. Boundary Conditions in Quantum Cosmology. *Physical Review* 33:3560–569.

Wheeler, John A. 1977. Genesis and Observership. Part Two of the Proceedings of the Fifth International Congress of Logic, Methodology, and Philosophy of Science. In *Foundational Problems in the Special Sciences,* ed. R.E. Butts, J. Hintikka. Dordrecht: Reidel.

———. 1982. Beyond the Black Hole. In *Some Strangeness in Proportion,* ed. H. Woolfs. Reading, Massachusetts: Addison-Wesley.

PART FOUR

· · · · · · · · · ·

Contingency, Field, and Self-Organizing Systems

Introduction to Part Four

· · · · · · · · · ·

Carol Rausch Albright

Combining insights from thermodynamics, evolutionary theory, the study of self-organizing systems, and the theology of Pannenberg and Tillich, biochemist Jeffrey Wicken moves 'Toward an Evolutionary Ecology of Meaning', first presented as a lecture at the Pannenberg symposium and later revised for publication in *Zygon.* Ted Peters's reflection, 'Clarity of the Part vs. Meaning of the Whole', is published here for the first time.

Research into thermodynamics and self-organizing systems may provide important evidence pertaining to Pannenberg's explorations of contingency and field. As noted in the introduction to Part Two, Pannenberg means by *field* "the interpenetrating network of energetic forces which are woven into relational patterns." As Potter explains, Pannenberg believes that "the partial elements of every field do not exist in themselves but are radically contingent on the supportive influences of the whole field in which each part exists" (141). The subject of thermodynamics may be seen as the study of this interpenetrating network, of the relation of whole and part, through exploration of the flow of matter energy and the role of this process in the organization of the cosmos. This introduction will provide some background material that readers may find useful in following Wicken's arguments.

The well-known Second Law of Thermodynamics predicts that, even-tually, matter and energy will become so uniformly distributed throughout the universe that all will finally form a sort of featureless expanse that may or may not collapse in on itself at the end. The cosmic soup will finally include no meat and potatoes and broth, only undifferentiated gruel. This process of de-differentiation is known as *increase in entropy.*

How then to explain the increasing differentiation of the earth's features, the genesis of life, and the increasing complexification of life forms, reaching its current apogee in the incredible complexity of the human brain? As Wicken puts it, "under the free energy gradient imposed by solar radiation and the thermal sink of space, the prebiotic phase of evolution proceeded with an inexorable kind of determinism toward increasing thermodynamic potential and chemical

complexity." At some point, DNA appeared and the threshold of life was crossed. Life forms became increasingly complex, culminating in "the emergent self, acting on the environment and moving into the environment" (285). Such self-organizing systems appear to violate the Second Law of Thermodynamics, although this effect is only local. While it is true that they decrease entropy locally, the thermodynamic books are balanced by increases in entropy elsewhere in the universe.

Studies in processes of self-organization and complexification have addressed this problem and form an important cutting edge in thought about the nature of the physical world—of matter and energy, space and time. Led by such thinkers as Manfred Eigen, Ilya Prigogine, and Murray Gell-Mann, the twentieth century's third revolution in physics—after relativity and quantum theory—may well be under way. These thinkers have shown that unstable dynamical systems do not gain in entropy but in fact reach ever more complex forms of organization—and must, in fact, do so. Chemical and biological systems become ever more differentiated. The new insights also include a radically different understanding of time: time is seen as "intrinsic to objects; it is no more a container for static, passive matter" (Prigogine and Stengers 1984, 443). The arrow of time points forward; humans are embedded in an evolutionary universe in which the future is stochastic and redeemable. "[The world] acquires a meaning in a vision in which time is a construction, a construction in which we all participate" (Prigogine and Stengers 1984, 446). Theologians and philosophers, including Whitehead and Teilhard, have responded to—or even anticipated—the new insights, speaking, for example, of the process of the cosmos and the complexification of life and the universe.

· · · · · · · · · ·
Wicken

The Darwinian process was, of course, first proposed before the twentieth-century revolutions in physics took place. At the time Darwin was working, physical processes were seen as linear and local—anchored to a place in space and time, involving straightforward sequences of cause and effect. However, Wicken charges, neo-Darwinians and selfish-gene theorists such as Richard Dawkins have failed to take into account many of the most important new understandings of the way the world works. A critical deficit of these schools of thought is their failure to consider competition in a wholistic context, Wicken maintains, echoing Pannenberg's point that a living creature is never autonomous in the sense of being independent of its sustaining environment—that is to say, its field.

A related deficit, Wicken charges, is that neo-Darwinians neglect some critical features of human experience: "For if evolution is telling history like it is, it must engage religion's job of 'telling experience as it is'" (261). Darwin's vision must be extended to include process and responsibility. That is to say, one must understand evolution as a process within a framework that also takes seriously the irreducibility of moral agency. Evolution is not simply a deterministic unfolding, whether it is seen as survival of the fittest or the work of 'selfish genes'. Building on insights of Eigen and Prigogine, Wicken asserts that the compulsion to explain everything in terms of present adaptive benefit denies the historicity of choice points in evolutionary pathways, and grants life too little participation in its own evolution. In fact, humans are the product of history—the history of the cosmos, the earth, the species, the culture, the family. They in turn make decisions that influence history to come. Thus, they are ineluctably, inescapably moral agents. Evolution must be seen, not as a crassly materialistic process, but as an ongoing process of creation that must embrace both the physical and the spiritual dimensions of our being.

In order to function in such a world, persons need two kinds of orientation: clarity about the physical world, and a sense of meaning to guide decision making. Clarity is gained from science; meaning, from religion. The spiritual, to Wicken, is not necessarily supernatural; it is all that is conscious and valuational. The spiritual is thus preconditional to all that we do that bears the stamp of humanity. As it transforms potentiality into actuality, human life is essentially valuational. Laws and moral codes constitute the human contribution to the direction of evolution, defining, in general terms, the domain of human responsibility.

A moral belief system must be both self-interested and ecologically and spiritually transcendent, reflecting the inextricable connection of parts and whole. Wicken proposes that the truth claims of religion, like those of science, can be assessed by their progressive nature. He suggests that "religions are true, or grounded in ultimacy, to the extent that they implicitly direct selves outward to deeper truths beyond their own necessarily culture-bound framework" (279). As far back as Exodus and Leviticus, one can see "the basic core of all moral life: that 'good' involves a relational orientation of individual to community, that the community in turn comes to focus in the individual, investing it with meaning" (281). Today, the context must include increasingly global awareness.

"Around the autocatalytic core of life grows a superstructure of nonlinearities—volition, decisions, strategies—for bringing raw

nature into the living orbit" (285), Wicken observes, echoing both the theories of nonlinear thermodynamics and Pannenberg's views of self-transcendence. "The human responsibility is to continue this process of conscious manifestation—not just for our children or for any specific others, but for possibility in the ongoing process of creation whose torch we carry" (287).

· · · · · · · · · ·
Peters

In 'Clarity of the Part vs. Meaning of the Whole', theologian Ted Peters responds to Wicken and traces parallels in the thought of Wicken and Pannenberg. Both seek to stake out

> a single domain of knowledge shared by both science and theology. Wicken's method is to construct a theological superstructure on a foundation of evolutionary theory, whereas Pannenberg's method consists more of a merging of horizons so that scientific discoveries will find their fullest understanding when understood in light of our knowledge of God. (291)

Peters finds the key to Wicken's method in the relationship between clarity and meaning—fundamental human requirements that are met, respectively, by science and theology. The search for clarity is analytic and reductive, whereas meaning is context dependent, to be discovered through discerning the relationship between part and whole. In this "ecology of meaning" he finds an indication of the nature of the good. "All 'good'," he writes, "involves a relational orientation of individual to community," while "the community in turn comes to focus in the individual, investing it with meaning" (293).

Truth for Pannenberg must be a unity of truth. "We cannot live with separate truths for scientists and theologians" (294). As the origin of "the totality of reality", 'God' requires reflection in this most inclusive sense. For Pannenberg, as for Wicken, meaning is contextual; the meaning of a part depends upon its context in the whole. However, "because the whole can never be grasped except in a provisional manner, we can never possess the whole of truth. We can at best anticipate it through imaginative projections subject to future confirmation or falsification" (295). This process even applies to what we know about God; thus, says Pannenberg, theology can be seen as the science of God.

Wicken moves in parallel fashion. His overriding question is, How should we best understand ourselves in an evolutionary cosmos? He believes the answer lies in ecology, the science of part-whole relationships. Pannenberg adds to this an emphasis upon openness:

"every organic body, whether it is animal or plant, simultaneously lives within itself and outside itself" (Pannenberg 1970, 56f). Pannenberg terms this openness *exocentricity*.

In *Anthropology in Theological Perspective* and earlier books, Pannenberg relates exocentricity to psychological theory. The conventional wisdom today assumes that one feature of personality, known as the *ego*, is independent and not mediated through social relationships; what changes is the *self*, which is dependent upon the summary picture others have of you or me. Pannenberg, on the other hand, holds rather that both ego and self undergo development, through openness to the environment. Exocentricity, imagination, and confidence in God enable persons to transcend their present selves; continuity of identity through time is provided by the spirit.

According to Pannenberg, the Holy Spirit may be spoken of as "a 'spiritual field' which is the source and sustaining power of reality"; and "if a sustaining environment is required one may call that nurturing field 'Spirit'." In fact, "the entire movement of the human in the freedom of exocentricity is a movement toward God"—which is "not due to any spirit inherent in the human . . . instead, the human participates in the movement of the Spirit" (Potter, 141–143).

• • • • • • • • • •

References

Pannenberg, Wolfhart. 1970. *What Is Man?* Philadelphia: Fortress.

———. 1985. *Anthropology in Theological Perspective.* Trans. M.J. O'Connell. Philadelphia: Westminster.

Prigogine, Illya, and Isabelle Stengers. 1984. *Order Out of Chaos: Man's New Dialogue with Nature.* New York: Bantam.

10
Toward an Evolutionary Ecology of Meaning
••••••••••
Jeffrey S. Wicken

I begin this essay with some blunt questions to keep myself honest with the reader.

First, what's my purpose in writing it? Scientists who think theologically are suspect creatures, and are properly wary about discussing belief systems. No belief can stand up to the rigid criteria for falsification or confirmation that scientific method exacts. This is unfortunate, because it discourages scientists from discussing 'meaning' as it is understood in normal human terms.

When I find myself in these quandaries, I consult the dictionary. 'Theology' derives from the Greek *theos* for God. 'Theory' has the same root. Everyone who does theoretical science seriously *is* a theologian, and might as well face up to it. My own field is the thermodynamics of evolution. In this, I try to explain emergence of life and the general conforms of the phylogenetic tree through irreversible processes that are fundamental to nature. To that extent, I'm a theologian.

As an evolutionary theorist, I must then ask why the interaction of science and religion is so profoundly important to understanding ourselves as a species, and to our survival as a species—and why, too, outside the small reach of journals and conferences, this interaction is so dismal. Finally, what can we do about it?

William Shakespeare, the last great poet of Platonic timelessness, capstoned a period of grace for humankind. There *was* no theoretical science with which to struggle then. Grace was getting in tune with an eschatology that was *outside* nature.

Since the Copernican-Darwinian revolutions, we find eschatology—and our senses of common purpose in life—to be smack in the middle of nature. We shouldn't trivialize this plain fact. We are 'newborns' trying to figure out our new, religious connection with the cosmos.

Nature didn't really exist until there was 'time'. In Shakespeare's day, time was birthing, growing, and dying. If we felt flaws in this process, we could come back metaphysically clean as ghosts, advising. That option is now reduced to minimality. We're stuck in a nature that is *made* of time: evolutionary time, thermodynamic time, and existential time.

Years of struggling with the institutionalized agnosticism that scientific criteria for knowledge impose on the capacity to believe neutralize my feeling of presumption about writing this paper. Struggle is central to spiritual growth, and hence to the maturation of religious perception. Heraclitus was on his usual poetic money when he said "Strife is the father of all things." Two millennia later, William Blake's "opposition is true friendship" spoke in the same currency. To be a friend, to help one's friend grow, requires both challenge and support.

Science and religion should challenge each other, where challenge is needed, and support each other where support is needed. Neither should knuckle under to the other; rather, each should engage the other fairly and openly in the marketplace of human meaning. They are failing in this for fundamental reasons. I say this with all due respect to the efforts of scientists and theologians who get together regularly in scholarly settings to talk about ways in which their enterprises complement one other.

The goal is right and important. But if the proof is in the pudding of the terrible schism that exists between these different and equally powerful expressions of the human spirit, we are not doing it correctly. Science and religion each express the human need to plumb the wellsprings of knowledge and explore the nature that birthed it. Using the depth and imagination of both enterprises to dwell together in the land of experience with steadiness of purpose is our singular task as humans. The world is body and spirit—experiencing, hungering, hoping, and wondering. Our world's present starvation is largely spiritual, and the millions who die each year from physical starvation do so in the wake of this spiritual poverty. We don't know what to do with ourselves as a species.

The Darwinian revolution has changed the mat on which we wrestle with these questions. We are supposed now to be 'selfish' creatures. It's the way of Darwinian nature, we are told. In this new dialogue, we must ask carefully about what selfishness means. If we do not, we will consign our world to a collective misery that ill befits our intelligence and feeling.

Science can never again be the handmaiden of religion. That time is gone. The danger now is that religion will become the handmaiden of science in theological quarters (Wicken 1988) and bolt from it altogether in the fundamentalist counterculture.

The intense dialectic interplay between science and religion over the years has strengthened both at a theoretical level. Now we *do* have epistemological isomorphisms about the ways each does business. Now we know in principle where each can speak with authority, and

where the other should shut up and listen.

We haven't absorbed this in practice, by a long shot. Increasingly, people feel obliged to choose between the two. Either that, or let their science and religion run in separate domains of head and heart like parallelist theories of matter and mind. Spirit and matter can't escape each other. As we engage our bodies, we engage ourselves as integration of spirit and matter. Religion and science can't escape each other for the same reason. Religion is the complex Dionysian body from which we draw our energy. Science is its Apollonian alter ego, trying to play comprehensively from a lyre of one string, which doesn't work.

Exploring the depth of the Dionysian-Apollonian myth makes us wonder: Which of the two is the presumptuous child? Who is the Icarus flying to the Sun looking for trouble? Who crafted the wings? Religion and Science respectively speak to us in that encounter. Listening to the subtlety, and the intensity, of their voices should compel us all to abjure judging one over the other. The spirit moves to religion's deep refrains, and always will. The crafting intellect of science soars toward the mythic Sun, and always will. We want clarity, at all costs.

Hence the danger of scientism in this dialogue. The authority of science is so immense that it threatens to absorb the theological community. Sociobiology, in particular, frightens me in this regard—not because it lacks scientific power, but because it extrapolates that power to a metaphysics of mind and spirit. There is *nothing* scientific or philosophic to suggest that the realm of consciousness—or even of simple sense-perception—can be derived from a complexifying neuronal network under natural selection. We don't have the foggiest idea why electromagnetic radiation of 400 nanometers registers 'blue' to our senses. We are creatures of sense and sensibility, and should— with Descartes, Hume, and Kant—take the fact of sense, and its organization into higher dimensions of perception and feeling, as the starting point for *any* discourse about mind and matter. That 'matter' was defined by our sense. So let's not have the wrong horses pulling the wrong carts.

If we are serious about the subject, we must question carefully the directions this dialectic between science and religion is now taking— and *why* it is that the so-called common man is not exactly embracing the evolutionary epic. Ideological polarization between religion and science is presently at the kind of political high seen at the Galileo trial and the Scopes trial. Evangelists can run for president and, if they keep their noses clean, expect significant voter support. An admitted evolutionist would get academic support, and not much more. The people have spoken. They don't *like* evolution. Why should they? Evolutionary metaphysicians tell them steadily that the realm of spirit is

reducible to the realm of matter. We should take pains to tell them otherwise.

Scientists are often ridiculously pompous about the human condition. While arguing that those who give their money to Jesus-talking television showmen are emotional children unable to hear the clear voice of rationality, they present a picture of the cosmic order that looks like buckshot. Molecules bounce around in the primordial sea, and consciousness emerges epiphenomenally from material complexity. Evolution is our age's rejected religion, and we scientists have only ourselves to blame for this folly. What science has done for us technologically doesn't do a thing to offset its 'bad news' that we are not sons and daughters of God breathing the timeless Platonic form of His pure thought into matter.

Understanding the dynamics of evolution can do much for us technologically. Its unification with thermodynamics, especially, allows us to understand the conditions in which the present operates to determine the future (Adams 1982; Wicken 1987). That is, however, a feeble spiritual payoff. In its usurpation of traditional religious polarities, evolution just isn't selling. Scientists and humanists, Guardians of Truth and Beauty that we profess to be, must ask carefully why that is. Maybe we're selling the evolutionary epic short ontologically, and maybe the people are right in not swallowing it. There is no way to get rid of evolution. It *is* reality. We are biological beings, and the products of history. Our quests for meaning occur within that condition. Biology is as down-to-earth as science gets. But so too is religion, in the sphere of spiritual experience. Why these lonesome Romeos and Juliets stay so determinedly apart is a vexing matter.

Before Darwin, biology was about 'essences' in a timeless realm of Platonic forms. Since Darwin, it has been about history. History is real; Platonic essences are not. Biology is real, and theology must be predicated on what organisms have learned historically. Reciprocally, biology must pay attention to spiritual realities. Those realities include freedom, self-actualization, and responsibility. The problem is that Darwin's ecological functionalism has become the One God to which religion is held increasingly accountable. To understand the prospects of religion, we must therefore be critically attentive to the real teachings of evolution. What *are* they? *Must* they be so materialistically reductionistic that the 'religion of the people' takes flight to fundamentalist pews where human worth is articulated apart from nature?

Religion, even more than politics, is an enterprise from which none should feel excluded. Its continuing vitality requires fuel from a diversity of perspectives which must collectively reflect the cultural

and biological multidimensionality of what it *means* to be human. It is a uniquely human predicament to be both an ephemeral piece of consciousness in time's merciless flow and a *moral agent* who understands his or her participation in that flow. Since each decade of human activity increasingly determines the course of this planet's evolution, our responsibility for the future cannot be underestimated.

I write this essay as an evolutionary theorist, and as a Blakean friend of religion. Reading evolution fully provides a basis for this friendship. It is a useful working notion on behalf of this theme that evolution might be better understood as a process of ongoing creation than as the gratuitous production of chance. The reasons for treating evolution as ongoing creation (see also Peacocke 1979) will become clear as the essay proceeds. If it is so understood, evolution carries profound implications for fostering 'universal' religious sensibilities that might save us against our self-destructive impulses.

Darwin formed a framework for biology by showing that life was a product of history. He also built a foundation for an enduring theology. This is a wonderful irony whose texture must be savored: That an ex-theology student battling the religious establishment on behalf of a materialistic process should set the stage for a theology of process is really the stuff of dialectic progress—and a greater accomplishment than the unification of biology. Darwin, like all of us, was a man of his times. His struggles against the inertial forces of his own time led however to the evolution-religion polarity that now threatens to undermine the world's sentience.

Like all great thinkers, Darwin requires continual revaluation in light of the new societal understandings that are ever thrust upon us. Darwin, not Whitehead, is the father of a true prolegomenon for process theology, for he saw that any real-world theology must be predicated on *competition in ecological contexts*. How do we interpret the interactional arena of ecological competition in ways that might best serve the scientific-theological enterprise? There, we have to expand the Darwinian program in Whiteheadian lights. Wholes are focused into parts, and parts are relationally constituted by wholes.

In advancing this proposition, let me begin with a simple distinction, of the 'there are two kinds of people' variety. While such distinctions simplify the world to the point of caricature, they do serve the heuristic function of cutting through the complexity of human experience to a terrain which at least objectifies prejudices.

The world of the religious can be divided into mystics and theologians. There are those for whom God is an ambience like the air—as real, as accessible, as natural to life as breath itself. There are others

not so built, whose sense of divine beneficence manifesting in the world is weak, whose consciousnesses tend to get waterlogged in the immense ledger sheet of suffering. For those of us, sustained religious feeling must be earned through the currency of our own empiricism, and taken gratefully on those terms. That kind of developmental 'getting in touch' with the world *requires* theology for building a structure of meanings into the ambiguous fabric of experience.

That structure is irreducibly ecological. There is no whole without participatory parts. There are no parts without evaluative wholes. That, simply stated, is the broad message of Darwinism. Creationists contend that Darwinism has become a *theology of its own* for that purpose. Is that fair? Or are we evolutionists missing something terribly deep in the human experience in the stories we tell?

Both accusations apply. Evolution, as portrayed by contemporary popularizers, sells religion in bead-shops brightened over with double-helices while Natural Selection lurks ominously in the closet ready to exit those who can't pay the price. And theology must either buy those gems under Selection's stare or retreat to the removes of fundamentalism or Whiteheadian process. Bad news on both scores. For if evolution is 'telling history like it is', it must engage religion's job of 'telling experience as it is'. The twain must meet. I will talk about the conditions of this meeting in the context of some new, holistic themes in evolutionary theory that extend Darwin's vision to *process and responsibility.*

· · · · · · · · · ·
The Ecology of Meaning

History has revealed humans to be motivated jointly by the *desire for clarity and the need for meaning.* Mixing reflection and desire was the stuff of T.S. Eliot's lamentations. Mixing clarity with meaning is the stuff of contemporary evolutionary-theological thought. Clarity is a desire. Like Faust, we want to know, at all costs. Meaning is a need. We need to know what we are a part of. This is our relational identity. The drives for meaning and clarity are however philosophically unmixable if clarity is understood strictly in the scientific sense—as it increasingly is in both philosophy and theology. Science is a way of getting publically verifiable answers through reduction and analysis. Religion aims upward to synthesis. And, regardless of epistemological similarities in the ways sciences and religions corroborate their premises in the world of *praxis,* these two enterprises have very different premises.

Clarity is the analytic province of objective description and deduction from demonstrable premises. It points downward to a mind that, as Henri Bergson (1944) so aptly put it, 'ever geometrizes'. Meaning points *outward* to higher, unanalyzable dimensions of being. Lower levels can never, by definition, apprehend higher levels. An enzyme, for example, is a chemical machine that catalyzes a metabolic reaction. At the level of description, it binds substrates to active sites and acts on them in certain, discoverable ways. But the 'meaning' of an enzyme, its 'what-for-ness', can only be understood by considering the functional organization to which it contributes. The functional whole of an organism provides both the regulative context in which its chemical parts operate and the historical, evolutionary context in which they evolve and acquire meaning. So the chemical description of an enzyme *complements* its functional, evolutionary explanation (Varela 1979).

Each level of the organic hierarchy gains its own relational identity, its 'meaning', in the context of a larger whole to which it is functionally accountable. While the coordinated operations of the lower levels are necessary conditions for higher-level operation, meaning-investment is always the province of the higher level. Upper levels provide functional contexts for the evolution of lower levels.

All meaning depends on some kind of part-whole relationship. This relationship needn't be 'hierarchical' necessarily, but it must be one in which parts are invested with relational identities by their participation in a more comprehensive reality. The personal reality of a nitrogen-fixing bacterium is certainly smaller than that of the ecosystem in which it participates; at the same time, it is relationally constituted by that ecosystem. Its meaning derives from its ecological role in cycling nitrogen from heterotrophs to autotrophs.

When we carry the ecology of meaning further to embrace the human condition, we see that it points outward to a spiritual and existential arena humans can never comprehend completely. Unlike the enzyme, we are *conscious* of that higher realm of accountability and meaning-investment. Human meaning comes from orienting the self to that which is in some sense greater. To suppose certainty with regard to that 'greater' is to reduce it to the categories of the apprehendable. Thus the internal dialectic of each individual in coming to terms with the world, and thus the historical dialectic of those tendencies of thought which can be labelled 'scientific' and 'religious'. Necessarily there is a tension between the two. Necessarily the resolution of this tension serves to define the realms of each—science aiming to map out the full configuration of conditions, physical, biological,

social—in which meanings can be organized; theology contextualizing the essential incompleteness of this knowledge within a meaning-framework.

Evolutionary theory is central to this mapping-out of conditions in which theology must operate, for evolution locates humans in nature as products of, and actors in, cosmic process. Mainstream neo-Darwinian theory is unable to provide this bridge (Wicken 1985), since its genetic reductionism prevents it from connecting life with the rest of nature. Neo-Darwinism is hopelessly over its head in connecting the human spirit with its sources. Evolutionary theory too is a victim of its own history.

That history began when Darwin saw that life's origins were beyond the powers of nineteenth-century science to address, and that to make evolution a science (as opposed to a philosophy), he had to begin with biological organization as a primitive ingredient in nature. The natural thrust of Darwinism then was to establish an 'autonomy of biology' perspective about evolution that cut it off from the physical sciences epistemologically. The internal contradictions of giving evolution—the science of connection—its own ballpark unaccountable to the physical sciences are amply seen in Ayala (1971) and Mayr (1982). I have critiqued the 'autonomy of biology' perspective loudly (Wicken 1985), because it interferes with understanding the importance of evolution as *that which connects* the physical and biological, and that which has great potential for connecting the biological with the spiritual.

Discontinuities beget discontinuities. The neo-Darwinian philosophy of biology begets an evolutionary philosophy that is very hard to digest theologically. Two ingredients stand out: First is 'genetic selfishness', which insists that we behave as we do to propagate our genes. Altruism and morality must get in through the back door, and find their ultimate basis in that selfishness.

This a partial truth. We *do* behave selfishly in certain contexts; but we can give our hearts to enterprises that do *nothing* to advance our genomes. The poor representation of the ecological and spiritual contexts of our selfishness in the literature contributes to the science-religion conflict.

I am critical of sociobiology in this regard, because it seems to preach a reductionist materialism that elevates matter to spirit. We exist as spiritual beings, so the story goes, because of the selective payoff for moral regulative principles that keep us from running wild in the social arena (Wilson 1978). The spiritual dimension of life is epiphenomenology predicated on physics, chemistry, and selection.

Given this premise, we can retro-think further to life's emergence and appeal to replicating molecules as the 'first cause' by which the organic world is built.

This is not the message of Darwinism; nor is it the message we should convey to the laity. Two fundamental aspects of our experience of the world become epiphenomenal in this understanding: Altruism is one. Consciousness of the *importance* of that altruism in survival-reproductive terms is the other.

Wilson (1978) has done an extremely good job in explaining human behavior on the basis of these precepts. But the theoretical midsection for the humanities and theology in his treatment is weak, because he urges us to *ignore our own experience*. The proper study of man for Wilson is through an 'inverted telescope' (Wilson, 1978, 17) so that we can see ourselves in taxonomical relationship to other species.

This isn't enough. The sociobiological message scares humanists away from the power of sociobiology in particular and the message of evolutionary theory in general. The existential human isn't visible through an inverted telescope. The oracle at Delphi doesn't use inverted telescopes. We must face ourselves for spiritual understanding about life's significance.

I want to be clear here: Wilson's sociobiology is convincing scientifically. It's hamstrung, however, by a genetic reductionism that tells us we are less than we are. Fortunately, new sciences contributing to the evolutionary vision drastically reduce this propagation of discontinuities between the physical, the biological, and the spiritual so that the Delphic Oracle can be heard more clearly—and that Wilson's own voice can be heard more clearly and more productively as well.

The neo-Darwinian program is coming under extreme scrutiny these days from two important fronts. One is developmental biology, which, from the days of von Baer on, has been a conservative voice (Webster and Goodwin 1982) against an adaptationalism that treats organisms as putty in the hands of natural selection. The other front is thermodynamics and information theory. These sciences have been applied to genealogies by Brooks and Wiley (1986) and to the ecology of evolution by Ulanowicz (1986) and Wicken (1987).

The sense of this dipolar scrutiny is that neo-Darwinism errs in the direction of genetic reductionism to the sacrifice of organisms as both historical and self-referentially ecological entities. The evolutionary metaphysics spun since the mid-century 'hardening' of the 'synthetic theory' heavily reflect that reductionism, and present a 'this is what evolution implies for the world, and you might as well accept it' metaphysics that scares humanists, polarizes evolutionists and cre-

ationists to extremes, and puts theologians in a miserable middle that must justify the ways of molecules to religion.

Although scientists may officially eschew metaphysics, they love it dearly, and practice it in popularized books whenever they get the chance. Unfortunately, the authority of science is such that, however philosophically ingenuous scientists might be, their pronouncements have great impact on those who want to better understand their own lots in the cosmic setting. When we add to this the fact that the evolutionary quest has always been as much metaphysical as scientific, we see the importance of understanding evolution in the most spacious, humanistic way possible. The experiencing, subjective self is an irreducible dimension of life. We've constructed our universe through it, and should preserve it similarly.

· · · · · · · · · ·
The Reductionist Story

Let us introduce this dialectic between evolution and religion as gloomily as possible with Jacques Monod's pronouncement of the "message" of science for humankind. "If he accepts this message [the message of science]—accepts all it contains—then man must at last wake out of his millenary dream; and in so doing, wake to his total solitude, his fundamental isolation. Now does he at last realize that, like a gypsy, he lives on the boundary of an alien world. A world that is deaf to his music, just as indifferent to his hopes as it is to his sufferings or his crimes" (Monod 1972, 172). Lest I be accused of letting emotional response interfere with dispassionate analysis of this passage, let me say at once that Monod's conclusions are necessary consequences of looking at evolution in the reductionist "molecules yield organisms yield humans and human values" theme that has played with such regularity over the past three decades. Monod's great contribution to the theology of evolution is expressing that consequence plainly, and with eloquence that grips our attention. So *this* is what evolution means for the human condition! Come to terms with it, ye who think that we count in the cosmos—and, conversely, ye who think the cosmos counts for us. Science has spoken.

There are two separable claims in this thesis. The first one betrays the philosophic innocence of so many evolutionary metaphysicians— namely, that the universe is ontologically just what we are able to say of it scientifically. This notion carries no philosophical weight, especially in light of Kant's critical realism about the limits of science. Only the naivest of realists would claim that the universe is exhaustively

constituted by relations made available to detached description.

The second claim is implicit, imbedded in a hoary lore of neo-Darwinian reductionism. Its thrust is that organisms develop around replicating strands of nucleic acid for the sole reason of abetting their replication. If this proposition is granted, then all the spiritual epiphenomenality of which Monod speaks follows as does the night the day. If the referent of all purposive activity is the propagation of selfish genes, then the referent of all so-called spiritual feeling too is the propagation of selfish genes, and the spiritual is subsumed without real resistance by the material.

The first claim is a serious epistemological mistake. It inverts the knower-known relationship established by Descartes, then nailed down by Kant, by supposing that the knower as meaning-investor might be generable from a matter *which is defined* by objectifiable relationships in space and time.

The second claim comes naturally from what Whitehead called "misplaced concreteness" on genes, rather than organisms in ecological contexts. In neo-Darwinism, the referent *is* genetic, the nucleic acids are the gods to which human behavior and values are finally accountable. The same theme appears in Dawkins 1976 and, to a smaller extent, in Wilson 1978. The concept of 'organism' winds up serving the replicator-god. When this move is made, evolutionary theory becomes spiritually empty.

Dawkins treats organisms as "survival machines" throughout his book, and states—without *any* scientific (let alone philosophical) argument—that they "began as passive receptacles for the genes, providing little more than walls to protect them from the chemical warfare of their rivals and the ravages of accidental molecular bombardment" (Dawkins 1976, 49). Everyone is entitled to his opinion. The trouble is that this particular opinion is read by the educated laity as the 'message' of evolution.

This isn't an isolated aberration from middle-of-the-road neo-Darwinism, either. Always, there is the overriding metaphor of genotypes *producing* phenotypes in that scheme—the magic molecule generating the organism. The thread of that theme back-extrapolates to life's emergence as the building of phenotypic bodies around genotypic replicators. Manfried Eigen and Peter Schuster's immensely influential "hypercycle theory" (1979) is the best example of this back-extrapolation. Again, one has the Dawkins theme of organisms evolving for the propagation of replicators whose only referents are themselves. That chemically and logically the theory is wrong (Wicken 1987) reduces its appeal only slightly, since it exerts its influence through

steady appeal to the wonderful clarity of genetic reductionism. This temptation must be resisted.

For theology, the problem is not only one of fitting the self to that which is greater and gives it meaning, but making that fit intelligible in light of current scientific understandings. A big Darwinian message was that nature does not make saltations. There can be no greater saltation than the jump from selfish individuals acting under the determinism of selfish genes to the Kantian moral imperative of treating every human being as an end, in whose behalf society should act.

Fortunately, genetic reductionism is not the message of Darwinism, and I do not think Darwin himself would have liked it. We are ecological beings, and our survivals and reproductions require ecological accountability. A Darwinian picture of nature that accommodates the spiritual instead of hand-waving it away as epiphenomenology requires that we understand what an organism *is* in appropriate ecological terms. Then, a way is paved for connecting the evolutionary process continuously to the spiritual noosphere adumbrated (however poetically) by Teilhard de Chardin (1975) that does not break with nature's ways. Anything else really *is* supernaturalism, for it asks us to break the world of nature from the world of religion.

Adopting the replicator-first perspective commits one to an ontology which accords primary reality to matter and motions and contingent reality to all that is sensitive and vital, leaving us strangers in the nature that gave us birth. That reverses the ontological order of things, since the 'experienced' cannot precede the 'experiencer'. It also fuels the academic rift between the humanities and the sciences. If the evolutionary epic doesn't do justice to the human condition, then humanists *might as well* ignore it and perpetuate the two-cultures schism. The inverted telescope reduces us below our experience, and sells out meaning for fast clarity. Only by recognizing the irreducible reality of the subjective dimension of nature can we take the acts of perception and conception seriously enough to bring the teachings of science into the realm of human meanings.

In the introduction to his classic *Moral Man and Immoral Society*, Reinhold Niebuhr observed that individuals are possessed of a moral sense that requires them to consider the interests of others in their ethical decisions—even where they know that such consideration may operate to their own detriment. This is an empirical truth that evolutionary theory must absorb to make its teachings consonant with the human condition. So too is the relative immorality of group behavior. The moral sense *is* individual because it is based on 'heart', not reason. Heart leaps in when ratiocinating algorithms grind out 'no' to the

obvious needs of others to say, 'Yes, I'll help this person, although it won't promote my personal fortunes a whit'. If 'heart' is an evolutionary product, we need to understand our natures in more spacious terms than reciprocal altruism and reciprocal exploitation.

It is not the case that the manifest failure of the social sciences to deal effectively with the challenges of our age reflect their inabilities to keep pace with the disclosures of the natural sciences. It is the case that the natural sciences have given humanists very reductionistically limited models with which to work. Our message is not that culture can be reduced to survival mechanisms. It is rather that culture co-evolves with survival mechanisms. Together, they give each other meaning. Individuals behave altruistically because their survivals and reproductions are nested in ecological settings that give a high selective premium to eusocial behavior. Self-interest has been nurtured evolutionarily within social contexts of group interest.

If the history of philosophy teaches us one thing, it is that Kantian moral imperatives do not work. It is splendid to say that we should treat each individual as an end. But if this imperative is not absorbed in our evolutionary hearts, then it is as easily transgressible as quitting smoking. The Kantian imperative *is* a heart-imperative, and that is the message evolutionary theorists ought to be sending out to the religious community.

In what follows, I will suggest an ecological perspective on meaning-investment that aids this cause. The aim will be to show the deep relevance evolution has for promoting the kind of global perspective on life we need to make the world work. What *are* the implications to our religious sense that come from taking evolution seriously as a process within a valuational scheme that takes equally seriously the irreducibility of the moral agent? Addressing this question requires that we understand evolution not as a crassly materialistic process, but as an ongoing process of creation which must embrace both the physical and spiritual dimensions of our being.

For this, it is necessary to get a non-reductionist understanding of what it means to be an organism. Kant said it well, but prefatorially, within the capacity of the science of his day. That science was Newtonian physics, and could not engage the reality of evolution. Organisms were 'natural purposes' for Kant—jointly their own causes and effects, their own ends and means. For Kant, this meant that organisms could *not* be understood in evolutionary terms. His philosophy of biology was a mechanistic updating of Aristotle: organization requires organization for its propagation. Kant was not sanguine about evolutionary theory's giving us a knowledge of nature.

Darwin changed all this, but at the considerable cost of establishing biology as an 'autonomous' science apart from physical dynamics. Today, we can do better. The importance of the thermodynamic paradigm (Prigogine 1980; Wicken 1987) to this project is that it allows a natural, evolutionary crossing of the Kantian barrier by integrating self-organization with irreversible energy flows. Organisms are ecological entities which evolve and maintain themselves as *informed autocatalytic organizations*. They are not entities *in* environments. Rather, they are continuous *with* environments, both historically and ecologically.

Organisms have two referents. One is the organizational whole in which genes play crucial informational roles. The other is the ecosystemic world of thermodynamic flows that nurture them. Organisms are informed patterns of thermodynamic flow that sustain themselves through energetic transactions with their environments and gain information from that ecological interaction under natural selection. They are information-acquiring dissipative structures. The information individuals acquire is nurtured within environmental and social contexts that require their 'reaching out' for higher levels of justification. The 'no man is an island' theme underpins all of nature.

Organisms emerged from prebiotic nature by learning to replace their chemical divots and not burn the ecological homeland down. Human life amplified this theme importantly by its technological capacity to command energy flows for its own imperialism over nature. With this large-brained capacity to exploit nature for human uses came also a self-reflectivity that might foster the real ecology of spirit that our age so desperately needs in confronting the problems we face as a species.

I will develop this spiritual ecology in the pages that follow.

· · · · · · · · · ·
The Spiritual

The 'spiritual' doesn't necessitate the supernatural—although an ecological naturalism of spirit should at least allow room for the possibility of noumenal waters. That which is conscious and valuational *is* spiritual. It is the principle of human life. Whatever the spiritual means ontologically, and however it came to be evolutionarily, it stays sturdily preconditional to everything we do that bears the stamp of humanity. Spirituality requires no dualism; neither does it deny the possibility of dualism. That is the province of faith, not science. The animating breath of what we feel, know, and invest with meaning,

simply *is*: the spiritual is the fundamental ground from which all discussions of life and life's significance must begin. The reality of evolution cannot diminish that which *is* experientially. Explaining 'that which is' is the job of theology. Theology and evolution must each work accordingly in the other's non-negotiable lights.

Reductionist ideas have dominated evolutionary thought for a long time and have carved out more than their proper share of metaphysical turf. In doing this, evolutionary theory—the connective vision and tissue that binds past with future and life with nature—actually threatens to subsume the theological enterprise itself in the name of scientific clarity. The complementarity of meaning and clarity must be maintained if science and theology are to dialogue constructively. Theology can't do its part if it plays handmaiden to science.

Wilson (1978) directs our attention to the historical roots of behavior and the functional importance of moral systems. But his excellent science is sandwiched in some hard physicalist bindings that are not extrapolable from the science itself. Monod's materialism, as we have noted, errs similarly. The evolutionary epic leading from molecules to morality to God commits just those kinds of category mistakes. In this science/religion dialogue, the worst mistake we could make is having existential-spiritual self be contingent and epiphenomenal to selfish genes. Yet we do it.

In concluding his book, Wilson quotes from the ever-enigmatic *Job,* where God, speaking through the wind, lashes out the following admonition for humankind:

> Have you descended to the springs of the sea
> or walked in the unfathomable deep?
> Have the gates of death been revealed to you?
> Have you ever seen the door-keepers of the place of darkness?
> Have you comprehended the vast expanse of the world?
> Come, tell me all this, if you know.

"And yes, we *do* know and we have told," responds Wilson (1978, 202). Fine science followed by scientistic presumption does not provide a bridge for linking science with humanities with religion. That few humanists and social scientists will walk on the bridge sociobiologists claim to have erected is not a measure of their close-mindedness to Science's brilliant light. It rather testifies to the hopelessness of any bridge-building enterprise that does not take into account the non-negotiable understandings of those on the other side. Here, the other side is the existential and the spiritual.

No wonder evolutionary theory is misunderstood by humanists as grimly reductionistic. No wonder it is seen by creationists as the

work of the devil. Scientists would do well to follow Galileo's admonition to "pronounce that wise, ingenious, and modest sentence 'I know it not'," rather than to allow to "escape from their mouths and pens all manner of extravagances" (Burtt 1954, 102). This is an especially important responsibility for science, since scientists are now the ones in holy garb. The difficulty in conveying the message of evolution to those who want to preserve their religious or humanistic sensibilities is immense enough anyway. It is certainly not helped by proclamations in which the authority of science appears to speak from the podium of theology. If this is the collective message of the scientific-theologic establishment, one can hardly blame people for saying, 'Give me that old time religion.'

When the world becomes one of process rather than of design from Platonic essences, the idea of our having a privileged relationship to a Creator, who had ordered the cosmos as our special moral stage and provided a special heaven to accommodate immortal souls, becomes complex. This complexity must be engaged at both ends of any possible bridge between the humanities and the sciences. To be sure: evolution is inconsistent with privilege, and makes dualistic conceptions of souls inhabiting bodies problematic. This doesn't alter the fact of life's sentient spirituality, or detract from the reality of moral consciousness.

Descartes began modern philosophy from just this recognition more than three centuries ago, and he was quite right. As Tillich (1952, 46) expressed it, "Spiritual self-affirmation occurs in every moment in which man lives creatively in the various spheres of meaning." Spirituality is the capacity to invest with meaning. We seek clarity within a world of meaning. That we understand ourselves as parts of an evolutionary process that is *not designed* demands a different, more 'adult' kind of self-perception than required by the closed creationist world. This orientation might be most succinctly described as one of *responsibility*—for taking care of the process and for moving it in worthy directions.

This is an *ecological and historical* view of spirituality, where the preconditions for meanings are established in the genesis of part-whole relationships. Ecology, not molecular biology, is the cultural bridge between science and theology.

Consider the remarks of Pannenberg (1976, 303): "On the assumption that the word 'God' is to be understood as referring to an all-determining reality, substantiation of talk about God requires that everything which exists should be shown to be a trace of divine reality. This requirement applies, however, not to objects in abstract isolation, but to their unbroken continuity." The theme is ecological to the

core: parts are constitutive of wholes, and the meanings of parts are determined relationally by their participation in the whole. A teaching of ecology is that a 'part' can never know the full extent of the whole that invests it with meaning. This would seem to me a teaching of theology as well.

What we do know is that the priority of our own consciousness in any conceptual framework we create, and its categorical contrast to objectifiable matter, *however* organized, is so fundamental to experience as to brook no serious argument. In this sense, science dealing with material behavior and religion with the spiritual, valuative self move necessarily in separate but equal tracks—the essential core of each enterprise secure from the disclosures of the other. The activities of the two are complementary and mutually informative. However deep-running our need for clarity in the Heraclitean world of becoming might be, and whatever isomorphisms religions bear with sciences that suggest common cognitive faculties at work in each, those common faculties are necessarily polarized toward analytical clarity for science and spiritual meaning for religion. The importance of maintaining this essential tension between clarity and meaning has been insufficiently respected by both science and religion over the years.

What taking evolution seriously does is to provide us with a naturalistic sense of cosmic location: where we came from, what our prospects are, where our freedoms and responsibilities lie. Taking religion seriously demands that we understand the real-world importance of the spiritual. In this sense, evolution establishes boundary conditions for theology. It makes a huge difference to human self-identity that we were not created in the relatively recent past by divine fiat but are instead linked to a tree of life whose roots extend billions of years into the history of the cosmos. It makes a difference too if we see ourselves as involved in this ongoing process of creation in a basic way—with respect to the responsibility we feel for the rest of life—rather than as spectators to a deterministic unfolding of things.

At the same time, the reality of the spiritual places boundary conditions on evolutionary metaphysics. We can't explain, and we certainly shouldn't try to explain away, that which is fundamentally constitutive of ourselves. In the ecological view of the relational, bilaterally forming part-whole interaction by which we know ourselves as valuational creatures, our own spiritual self-affirmations point ineluctably toward a deeper Ground of Being of which we are jointly participants and creators, mist and substance.

The mutual adjustment of meaning and clarity presented tremendous problems for early evolutionists. Herbert Spencer, to use a very

important example, regarded matter and mind as expressions *in* nature of forces that ran *beneath* nature. Therefore, he had no ontological ground for granting real autonomy to the moral agent in the course of things, and hence no ground for an ecology of meaning. What was natural for Spencer *was* the inexorability of evolution. The moral sense was thus a product of ineluctable forces beyond its control and as such, possessed no independence to act 'naturally' against their decrees—unless seduced away from nature by the interventions and conventions of society. T. H. Huxley, on the other hand, regarded human societies as organizations *apart from* nature, and morality as a covenant between man and society that stood in opposition to the blind forces of natural selection. The opposition between Spencer and Huxley is just the evolutionary continuation of the opposition between stoicism and epicureanism: do we adjust the 'ought' to the 'is' or the 'is' to the 'ought'?

The status of human society within the evolutionary process presents no less a problem for us today. It *may be* that the thrust of the evolutionary process is toward the perfectability of humanity within the 'just' society. But if such a society is conceived as that state of balance between the forces of economic production and human reproduction such that natural selection within Malthusian economies of scarcity is effectively conquered, we enter some deep moral waters. Governed as they are by a network of laws and institutions that are concerned with preserving some core of the present, societies all have a temporal parochiality that impedes that evolutionary agency of 'choice'. What are the boundary conditions under which choice can operate?

If Darwinism is to be taken seriously, consciousness and volition must be *for* something. If humanity is to take itself seriously within this framework, the sensitive self acting according to *motives* rather than impressed forces must be taken as a first principle of ethics. For that, we need an evolutionary ecology of mind.

· · · · · · · · · ·
Mind and Meaning

Phenomenal reality is built of meanings which are in turn built by selves. Yet ever since Parmenides, the materialist tendency has been to talk about 'being' as single-layered, as autonomously existent, and as resolvable into 'building blocks' with some claim to physical ultimacy. While modern science denies the possibility of this at every level of its operation, such quests for unconditional existence die hard.

We read much about the participation of life in world-building

today in connection with quantum theory, with subjects 'collapsing' the indeterminate wave functions of the micro-world as particular observations or measurements. This quite significant truth distracts attention from the deeper sense in which life creates realities as meaning structures. These structures, born of the goal-directed activity of life to produce and reproduce itself, are the concrete objects of knowledge of all life, and their 'objective descriptions' are assuredly not detached descriptions but contain always the formative impress of the knower. It is only in this sense that one can legitimately talk about the objective and subjective as 'segregating' from a common ground of being. The segregation is irreducibly connected with the teleological activity of selves, creating new meaning structures by exploring new conditions for survival and reproduction. These meaning structures emerge in a context of *value* that merges into those human systems of values that are religions. There are, however, certain deficiencies in the neo-Darwinian picture of nature that act to obscure this continuity.

Each of the two general tendencies for which the neo-Darwinian program is criticized contributes to its impoverished picture of our existential location in the cosmos. First is a compulsion to explain everything under the sun in terms of present adaptive benefit: any anatomical structure, any behavioral attribute requires a 'just so' explanation in terms of present utility. The assumption underlying this leap of faith is that organisms are the infinitely plastic substrates of selective forces, and the philosophical correlate of this assumption is to deny the essential historicity of evolution in which an adaptive move is an irreversible choice that opens certain evolutionary pathways and closes others. In this, the present is not abandoned as a point on a geometric coordinate, but pulled into the future as constraint on possibility. The adaptationalist program denies history its due, and we will consider the ethical and theological implications of this denial presently.

Second is a view toward organism that grants life insufficient participation in its own evolution, that takes the molecular flow of information from DNA to RNA to protein as evidence of the causal sequence by which new adaptive zones are explored in nature. It is suggested that through random mutations new morphological organizations and new behavioral capacities arise, which are then tested for adaptedness. The alternative view, which we owe originally to Lamarck, is that each organizational type has a certain range of behavioral responsiveness that allows it to explore new adaptive possibilities and hence determine the conditions of its own selection. This perspective permits us to consider evolution less as a process of blind chance than of *discovery*, each behavioral leap correlating with the effective *inven-*

tion of new resources—a new Malthusian 'economy' (Wicken 1987). With invention and discovery come also new, more richly textured 'realities'. Such meaning-creation occurs within a context of part-whole relationships that may be best understood within the framework of ecology.

· · · · · · · · · ·
The Ethics of Ecology

The process of evolution is one in which we find ourselves first effect then cause, first end of a meandering course of adaptive inventions and meaning-creations, then means by which further such developments can occur. The movement is Spencerian in the sense that human evolution is inseparable from cosmic process. But it is anti-Spencerian in the role it accords humanity within the process. Moral agency, the self-determination that allows individuals and groups to select the courses of events that become the future, is an emergent evolutionary quality into whose hands more and more of the fate of the cosmos is bequeathed.

To understand the relevance of all this to the problems set forth in the beginning of this chapter, it is necessary to consider the relational way in which the world of meanings elaborates in the ecology of evolution. The word *ecology* itself has a revealing etymology, coming from the Greek *oikos* or 'house'. Ecology can be regarded as the science of relationships that determine the stabilities and the compositions of partly self-sufficient ecosystemic 'households' which weave together in higher orders of integration into the biosphere as a whole. Ecology is the science of part-whole relationships, in which individuals are invested with meaning in relation to the global boundary conditions of their existences. The stability of the individual, and by extension the viability of the adaptive strategy of the species to which it belongs, is nested in the stability of its eco-community. Conversely, the *value* of the individual is assessed by its contribution to this community.

This idea of value, so central to any understanding of the human condition, has evolutionary roots that include, but at the same time far transcend, simple payoffs in survival and reproduction. To talk about mythico-religious structures, as some sociobiologists are wont to do, as being selected by virtue of their contribution to societal coherence, misunderstands this transcendent character of value in a way that undermines much of what is genuinely right in their perspective.

We have two general evolutionary sources of value, both of which contribute to the relational ontology of life. One reaches downward from individuals to the raw materials of environments, relating life as

meaning-investor to nature as elaborating repository of meanings. The other reaches outward from individuals as 'selfish' surviving-reproducing systems to ecosystems, and systems of ecosystems, that contextualize selfish interests within higher-order functional frameworks—so that there is a sense in which the whole of community interest is written into the individual adaptive strategy.

Nitrogen-fixing bacteria, to use a simple example, achieve their own reproductive successes by contributing to a chain of processes that serves to restore nitrogen to autotrophic populations. Their 'value' *is* their existence. That within this functional framework of co-defining parts and wholes much cheating and gamesmanship go on does not alter the basic truth that life is, even in its simplest expressions, the creator of meaning and value. Moreover, cheating and gamesmanship are precisely the arena in which the moral agent emerges, able to assert itself existentially *as* a carrier of value beyond simply physical survival.

This penetration of ecologically derived part-whole relationships into the human-existential domain as well is implicit in Tillich's (1955) discussion of what it means to be a self-affirming being in the world. Tillich argues that it is *only* the individual self that is the referent of acts of self-affirmation. Such acts, if they are genuinely conducted in the human arena of public discourse, must reach out to the community. But community interests are asserted only as they are *focused* in selves that posit their meanings in community identification.

This saves pointless moralizing about denying self-interest for community or world interest. The trick is to bring the two to some coincidence, so that the human individual perceives his or her own meaning as inextricably woven with some larger whole, just as the selfish activity of any ecosystemic creature is penetrated by the operation of its biological community.

The ontological as well as existential meanings of "ultimacy" (Peters 1982) have their ground in an evolutionary nature. That nature *produces itself* from previously unactualized potentiality by the agents cf life acting on whatever possibilities the ultimate makes available: the potency, for example for particular kinds of physical interactions, for sensitivity, and for consciousness. These potencies themselves we will never understand in the sense of explication in more basic elements, and they must be granted primitive status in nature. But as they are actualized in the evolutionary process, they become nature's agents for further evolution.

Ultimacy-as-potentiality is thus the ontological ground of nature-as-meanings. As they grow in the human-existential domain, meanings map out terrains for values and religions. Here is the

special human sphere of evolution, for only we humans (even if we insist on regarding ourselves genetically as the hairless sibling species to the chimpanzee) make our livings by turning natural meanings (that is, those synthesized by the operations of perception and self-referential action) into symbolic meanings, and use these symbolic meanings as the wellsprings of our behavior. Human life is thus essentially valuational, and to talk about religions as being superstructures that exist for the adaptive payoff of fostering societal cohesion is to indulge in the same kind of one-dimensional reasoning that talks about selfish genes in abstraction from the ecological relationships that bring the whole to focus in the individual. Certainly, religious traditions promote societal cohesion. But it is the nature of the human strategy to be societal in a symbol-mediated way. Given this, a religious sense is as indigenous to the human condition as is the ever-heralded technological capacity to manipulate the environment.

This truth tends to get lost in physicalist interpretations of scientific method, which equate objectivity with external detachment and description. Once this move is made, all science becomes the epistemological equivalent of plane geometry, meaning moves into the subjective realm of the beholder's eye, and value becomes always relative, justifiable only in terms of payoff to societal stability.

This denies history its proper due. The individual is born into a strategy whose 'selfish' (the anthropomorphism is itself misleading) adaptive value depends fundamentally on the creation and transmission of symbolic meaning. Constantly to puzzle over the adaptive sources of 'altruism', as most evolutionists do, betrays a certain peculiar inability to understand the historical sense in which wholes are manifest in parts. The individual has instinctive moral capacities which both bend to, and struggle against, the particularities of any age. Thus Huxley's problem is resolved: laws and moral codes are not really for curbing the cosmic process at all; rather they constitute the human contribution to the direction of this process in the generation of meaning. They define, in general terms, the domain of human responsibility.

· · · · · · · · · ·

The Problem of Knowledge

Theory crystallizes thought in the public language of concepts, symbols, and argument, and the light of public discourse reveals the crank as well as the genius. The dynamic of entering a world whose boundaries one cannot see, through the special windows of the valuational

self, is shared by both religious and scientific intuition. So too are the processes of justification. Science and theology both refer phenomena to that which is less contingent. For science, that ground of reference is natural law; for theology, it is the source of life. In each case, there is a transcendent pointing from the particular and contingent to the universal and ultimate.

Here, ecology blends with theology. Hefner writes in this vein about the concepts of "openness and ecstatic, ecological self-transcendence" as the way to God. The following passage is especially suggestive about the ecology of theology: "The evolutionary pathway is one in which the organism interfaces with its physical world through its own physical shape (phenotype), it is continuously being drawn outward. This 'drawing out' is the biological basis for and correlate of openness, and in the course of being drawn out, the organism has no recourse but to transcend itself" (104–105).

This is so, but the evolutionary process gives it particular consciousness only (as far as we know) in the human sphere. We are challenged always to draw out of our integuments toward a bigger, more relationally constituted world. We want, in the terrible constraints of those integuments, to get inside others and know their feelings as we know our own. Each individual meaning is nested within the whole of human meaning which collectively points toward God.

Similar claims of science for pointing toward the ultimate lie too in this old tension between the one and the many. The more science can explain, with the least number of primitive assumptions or propositions, the more the manifold world of phenomena points toward the coherence of cosmic order.

Religious systems have it harder. Establishing fundamental grounds of transaction (or covenants) between the self and a valuational belief fabric to which the conduct of moral life can be related is immensely important for any religion. But the evolutionary prescription that it be both self-interested and ecologically-spiritually transcendental is especially challenging to what we do as humans. And although an ecological ethics would *seem* to work in providing a meaning-ful order to the human condition, the fact is that we do not often live by ecological propositions. We would rather cut down the Brazilian rain forests for short-term parochial interests and put up with an escalating 'greenhouse effect' than think globally. Evolutionarily-derived criteria of meaning have not worked well for us at the level of *praxis*. Reciprocal altruism and reciprocal exploitation are hard-wired neo-Darwinian modes of thought that must be transcended if humanity is to have a future.

Scientific theories carry with them primitive assumptions about the way things are. This is fine, since the propositions that develop from such axiomatic cores can be correlated in specific ways with certain observational terms—for example, the connection of electron jumps to spectral bands—that allow them to be tested even if we never really understand what an electron jump is ontologically. In this way, scientific theory points in the direction of deeper physical realities and taps some portion of the ultimate.

This is less clear when we talk about some of the abominations that occur within the meaning-structures conferred by mythico-religious systems or by pathological political orders. Unfortunately, human meanings can be anchored in false gods that point away from the universal. So it may be fruitful, after all, to consider religious truth too in full connection with the criterion of progress.

Science is an inherently progressive enterprise, and its truth claims are inseparable from this quality. It was invented as progressive enterprise by those, like Galileo, who saw the need to look through the skin of particularity into the heart of generality. This is the stuff of world-building. The Bohr atom is filled with concepts which reach beyond their original contexts of application to the study of matter generally; in turn, it has provided concepts, such as angular momentum quantization, that have been essential ingredients in all subsequent development of atomic and subatomic theory. Galileo and Bohr both dealt in truth by conceptualizing in ways that opened up new possibilities for truth—in consonance with Julian Huxley's (1953) discussion of the progressive human branch of evolution. We are progressive precisely because we open up new avenues along which to progress. That is the human challenge.

I suggest that we assess the truth claims of religion in an analogous way, by supposing that religions are true, or grounded in ultimacy, to the extent that they implicitly direct themselves outward to deeper truths beyond their own necessarily culture-bound frameworks. In concluding this paper, I offer a speculative extension of the evolutionary view of meaning-building set forth previously, with the hope that it might stimulate further interest in the science-theology community.

· · · · · · · · · ·

The Relative and the Ultimate

We live in a religiously pluralistic world, and since each religion is a closed and self-confirming system of valuation with its own special

vision of ultimacy, how are we to assess the truth of religions and their various claims to serve as guides for our moral lives? Should not the ultimate also be universal—true for all places and times?

Peters (1982) has concluded that a Darwinian perspective reconciles the idea of ultimacy with the fact of pluralistic religious expressions and appreciations. Partly, it does. Whatever the ultimate is ontologically, it can only be perceived through the particularity of context provided by a given culture at a given time. But in the ecological framework I have been discussing, we should make more 'absolute' value judgments on religious systems according to the manner in which they lead our thinking from the particular to the universal. Pannenberg has spoken pointedly to this issue, arguing that "the immediacy of religious experience is an expression of the fact that man stands in constant relation to the fundamental mystery of life, which transcends any immediate situation" (1976, 301).

In talking about that which is historically contingent and that which is directly 'felt', we must again think ecologically about parts, wholes, and the sense in which they co-define each other. Some insight into this problem can be gained by returning to the evolutionary process as a meaning-builder. All life creates meanings by inventing or discovering the sources of its survival and reproduction. Particular living systems do this within a higher-order framework of ecosystem function which, by contextualizing self-interest within community interest, gives 'selfishness' a transcendent quality pointing from part to whole. This evolutionary ecology of religion has been a *Leitmotif* of Pannenberg's work (1976; 1985). In both evolution and religion, 'progressiveness' always involves an 'opening up' of possibility, in which potentialities for futures are made available by adaptive decisions which lead to new modes of life, escapes from old Malthusian economies (Wicken 1987). Each act of invention-discovery brings more 'raw', value-less nature into the orbit of life and its network of meaning.

This movement describes the intuition of the global from the immediacy of the parochial. Julian Huxley (1953) described progressive evolution as a movement toward increasing autonomy from and control over the environment. This is only partly true. Progressiveness in evolution as it can lead to a naturalistic theology means increased consciousness about the wellsprings of our own 'selfish' behaviors. How should we humans best understand our responsibilities in a part-whole framework? This is instructive from an existential point of view, because autonomy from the particularity of circumstance and control over destiny contrast to the contingency and external determination that characterize the lower forms of life. Progress is a move-

ment toward self-determination within a context of increasing global awareness.

We see much of this general dynamic in the development of religious systems from tribal myths. The latter *are* parochial, bound to the particularity of culture and social structure. The former attempt to accommodate the 'whole' human experience in a more trans-cultural way. The evolution of our own Judeo-Christian tradition is very much the story of growth from parochiality to global awareness, from a consciousness formed by impressed law to one of moral agency that participates in the evolutionary progress of 'opening up'. After all, it is the sheer bloody parochiality of the Israelites' tribal god that astounds and offends us most in those early books of the Old Testament. The paucity in these books of valuational criteria for good and evil apart from the pragmatic consequences of His Wrath are staggering. Here we do see the survival value of religious systems that sociobiologists stress. Yahweh is militantly devoted to the survival of loosely knit tribes under hostile conditions. A gentle God would not have worked so well, any more than a devoutly ecological ethic would have worked very well for the early industrialization of America.

There is nevertheless a fragmentary value seen in these books that dimly adumbrates the moral whole toward which we presently strive both ecologically and theologically. The network of laws and protocols in Exodus and Leviticus reveals the basic core of all moral life: that 'good' involves a relational orientation of individual to community, that the community in turn comes to focus in the individual, investing it with meaning. We can perhaps appreciate in this light the apostle Paul's famous passage from 1 Corinthians 13, where he talks of "when the perfect comes": "For now we see through a glass darkly, but then face to face; now do I know in part; but then shall I know even as I am known." Universal truth there may be, but it comes in culture-bound fragments. We can only hope that with the evolution of our global awareness these fragmentary insights become more whole, less dim.

They certainly become more manifold: there is an irreducible cultural relativity to religions that, far from undermining the notion of an ultimate ground for being, reveals the special contributions each culture has to make in tapping into this ultimacy. The existential human, dwelling within a world whose contours we can see only fragmentarily through the particular windows of our own experience and our culture's collective experience, is but a probe into an ultimate we will never fully comprehend and of which we can perceive only particular manifestations. The Aboriginal consciousness, structured by the cosmogonic 'two brother' myth into a clairvoyant, time-transcending, and group-centered reality, has a far different perspective on ultimacy than

does the Christian consciousness concerned with personal freedom and moral agency in an indeterminate world. Yet each contributes to a trans-cultural understanding of what it means to be human in a cosmos that demands our participation and denies us total knowledge.

The history of any religious tradition can be interpreted as the creation of values-as-regulative principles by which a culture achieves its identity and asserts itself in the world. But even here the moral sense that has formed an essential part of the human adaptive strategy for knowledge and control shows forth clearly. This regulative role of religion must be emphasized. We all have, as part of our evolutionary heritage, a moral sense which wants to reach out on behalf of others. But which others, and for what ends? A historical function of religion has always been to educate this sense for community identification and coherence. As the world becomes smaller and more functionally interwoven, so too must our sense of community expand beyond its parochial, Old Testament identifications to a picture in which the interests of parts are understood as connected with the well-being of other parts in a global eco-community.

A religion would seem to be 'relatively true' insofar as it promotes the ecological home by bringing life's global conditions and responsibilities into focus within the individual consciousness. A religion is false insofar as it encourages us to seek limited identification, limited commitments to the human condition. This seems much of what Christ's teachings are about: not privilege or afterworld payoffs, but the responsibility of opening up, of love.

Opening involves a recognition of indeterminacy, love, and risk. These were the metaphysics of Mohandas Gandhi. Gandhi brought these moral understandings into the explicitness of political expression, and dealt in risk within a global context of value. This is the ecological-moral stance: love and opening-up may be unrequited, the self *may* suffer, but finally the self has no identity apart from the whole of humanity.

For this reason, there has always been a tension between parochiality and universality in human identifications that is of the same character as gamesmanship within the ecological context of function. But the source of the moral in the part-whole relationships of community dynamics is clear. Josiah Royce expressed the sentiment of these dynamics eloquently: "It must be my community that, in the end, saves me. To assert and to live this doctrine constitute the very core of the Christian experience" (Randall 1977). Separations of selves from communities and from histories are disastrous to an ecology of spirit. In the individual self, the community and the entire evolutionary history of humanity is brought into particularity with a potenti-

ality for moving the world. The corporeal self does not necessarily equate to existential self, and to risk one may be to assert the other.

Of course, Christ and Gandhi knew this, but so too have the centuries of political and religious fanatics that have systematically robbed our liberties. There is no point in moralizing about the way individuals ought to perceive their relationship to history and community: they will perceive them according to the manner in which their consciousnesses are affected by the particularities of their experience.

This does not, however, make a global ethic a chimera to romanticize over in scholarly journals. To the contrary: it means that we must take seriously Plato's proposition that knowledge is the precondition to all moral action. It then becomes the job of evolutionary theory to spell out the fullness of its implications for the human agent such that 'correct' existential identifications can be made.

With its penchant for talking about evolution as a process lacking intrinsic direction and driven by blind chance and selfish genes, the neo-Darwinian edifice fails here abysmally. However, Neo-Darwinism is only the Newtonian formulation of evolution, which makes us strangely purposeful players on an Ionescan stage of the Absurd. Its Einsteinian formulation, emerging from the fields of cosmology and irreversible thermodynamics, recognizes that biological evolution is part of a deeper dynamics that has steadily moved nature from the blind and deterministic to the free and the self-determining.

· · · · · · · · · ·
Being and Becoming

The reality of evolution in part-whole contexts establishes the physical realm of responsibility. The ecological home is not a static one. The major reason for this is that we humans—especially in our technological garb—are parts of a trans-ecological species. So necessarily, and in spite of what anyone might want, the domain of human valuation and responsibility becomes more global with the passage of time. Let us now consider the sense in which this human condition fits with the temporal dynamics of evolution.

One of Spencer's real problems in formulating a unified theory of evolution was that he had no real understanding of temporal directions. He was not alone in this. The second law of thermodynamics, which governs irreversible processes, had been given official formulation by Rudolph Clausius in the mid-nineteenth-century, but the implications of this law for the courses organic processes take in time have only recently begun to reach a level of articulation where one can talk about specific

causal relationships between irreversible thermodynamic flows and self-organization. Self-organization is itself a complex issue, involving the emergence of functional relationships between systems and environments. But the building-up or anamorphic tendency in evolution can be understood rather simply: the forces of nature are for the most part 'associative' ones, so isolated elements—from quarks to protons to atoms, tend to have higher potential energies when combined in specific ways. For this reason, the integrative or building-up processes provide a general means for the conversion of potential energy to entropy: structuring through dissipation. Self-organization is more complex, but proceeds according to the same general rationale.

In these processes, we can discern the conditions of life's fit with cosmic dynamics, serving through its own self-production and reproduction and the general directive of entropic dissipation. Life emerged from, and operationally fits with, nature through thermodynamic flows from high-energy sources to low-energy sinks. This recognition reduces the existential *Angst* of Monod's position on the 'strangeness' of life in the cosmos. The second law of thermodynamics is above all a principle of potency, by which the possible is made actual. Nature bursting on the scene with its particular structure of basic forces and enormous thermodynamic potential is necessarily evolutionary, for self-organization provides a general means for dissipation.

I have discussed this issue at length (Wicken 1987). The question here concerns the sense in which this self-organization relates to the increasing freedom and self-determination of nature whose torch humanity now carries. Let us first of all consider the 'intelligence' of nature for producing life, which is an important ontological source of our genuine at-homeness in the cosmos. One can, with no concessions to the instincts of soft-headedness, interpret this intelligence as ultimate potentiality, for whose actual expressions the evolutionary process is responsible. Consider for a moment the so-called Anthropic Principle (Carr and Rees 1979), into which cosmological data pour these days.

We live in a world that, if not expressly made for us, is at least amenable to our having evolved in it. The conditions required for this evolution constitute such a slender shard in the great slate of a priori possibility as to render utterly preposterous any simple chance-necessity interpretation—quite apart from the other, ecological considerations mentioned previously. Life depends crucially upon carbon, hydrogen, nitrogen, and phosphorus. A slight reduction in the magnitude of the strong nuclear force would have given us only hydrogen,

and perhaps a little helium. Similarly, the tolerances in the electro-magnetic force which could provide for the stable linkages of these elements into biopolymers is quite slim. And at the cosmological level, slight reductions in the gravitational coupling constant would have made suns and planets impossible as well, whereas slight increases would have yielded stars too massive and fast-burning to support planetary life.

Then there is the matter of escape velocity: if the Big Bang (to use that infelicitous mechanistic metaphor) had proceeded with insufficient initial kinetic energy, it promptly would have undergone gravitational collapse; if kinetic energies had been too large, none of the local asymmetries of galactic clustering could have occurred. Some of these apparent coincidences seem on the verge of being tied together by unification principles. If there is to be a grand unification, that unification would serve to increase the sense of a presiding 'intelligence' in the evolutionary unfolding of nature, not diminish it.

This intelligence in the evolutionary arena expresses itself within a framework of increasing possibility and freedom. Through entropic dissipation, a primordial world of elemental particles in random interactions yields to one constituted by atoms, molecules, and then life. This is not simply a process of progressive complexification; it also involves a shift of causal agency inward from forces and impressed actions toward selves and decisions.

Under the free energy gradient imposed by solar radiation and the thermal sink of space, the prebiotic phase of evolution proceeded with an inexorable kind of determinism toward increasing thermodynamic potential and chemical complexity (Wicken 1987). At threshold levels of these parameters, autocatalytic systems based on primitive proteins and nucleic acids appeared with the capacities to *pull* resources into their own productions—the emergent self, acting on the environment and moving into the environment.

Now, the relationship of cause and effect changes. Classical physics, and the extravagances of physicalism that have spawned from it, deal in so-called 'linearities': the assumption that all effects will be proportional to impressed forces. If this were the full domain of nature, freedom and moral agency would be quite impossible. But evolution is in fact an elaboration of non-linearities. Autocatalysis is the first expression of this, systems reaching into environments, discovering resources for transformation into self and seed. Around the autocatalytic core of life grows a superstructure of nonlinearities—volition, decisions, strategies—for bringing raw nature into the living orbit. These express themselves most acutely in the human realm, and

within that realm most acutely in technological society.

Karl Marx insightfully wrote that the true natural history of humanity is history. There are no essences. Everything in the human condition is engendered by human transaction with the environment, in which we convert physical resources into economic resources. There is much to this, and it extends into our phylogenetic past as well. What we refer to as mind is born of the transaction between behaving, autocatalytic selves and environments that need to be internally mapped within the response-initiating capacity of the subjective. What Marx understood less clearly is the sheer indeterminacy of history, the sense in which its dialectics do not point to some special Utopian resolution where we become one with our labors.

That supposition has been the fundamental mistake of all pre-Darwinian philosophies. What the increasing nonlinearity of humanity-in-nature (Prigogine 1980; Wicken 1987) demonstrates is that history *is* particularity. History is that which cannot be deduced from the past but which must be discovered or invented through decisions by individual actors interpreting their environments in particular ways (see Pannenberg 1993). This is why there can be no 'hard' science of politics or of sociology in the model of classical physics. Every situation encountered by these sciences engages a realm of irreducible nonlinearity, where the human agents do not respond deterministically to impressed conditions. They respond self-actively, as they see fit. Whatever real predictivity these sciences possess comes from their implicit understanding of the historical nature of humankind, and the manner in which it responds to social conditions. Whatever control over history we have as a species requires coming to terms with these psychosocial ingredients that operate in our consciousnesses.

This is not behaviorism but participation. The free human agent is a historical entity, constrained in what he or she can do by personal and evolutionary history. Through that history, we open ourselves to the formation of new history. The trick of education—in its broadest and least institutionalized sense—is to cultivate in each individual an understanding of the full implications and responsibilities of his or her participatory construction of the future.

The evolution of the human consciousness has been too remarkable to conclude with archaic responses to new challenges. Our neocortexes feed into our limbic systems and color our sense with sensibility in such a way that the subjective potentialities of nature have, in us, a potentiality for power that is really able to use the past to intelligently open our future.

'Opening' is the word. As the world increases in freedom, so does its consciousness and its moral capacity. Evolution has moved from

the blind and necessary to the seeing and volitional. It has been an opening-up of possibility, and of conscious exploration of that possibility. The human responsibility is to continue this process of conscious manifestation—not just for our children or for any specific others, but for possibility in the ongoing process of Creation whose torch we carry.

• • • • • • • • • •

An earlier version of this paper appeared in *Zygon: Journal of Religion and Science* 24 (June) 1989, 153–184. By permission.

• • • • • • • • • •

References

Adams, Richard N. 1982. *Paradoxical Harvest.* Cambridge: Cambridge University Press.

Ayala, Francisco. 1970. Teleological Explanations in Evolutionary Biology. *Philosophy of Science* 37:1–15.

Bergson, Henri. 1944. *Creative Evolution.* Trans. Arthur Mitchell. New York: Modern Library.

Brooks, Daniel, and E. O. Wiley. 1986. *Evolution as Entropy.* Chicago: University of Chicago Press.

Burtt, E. A. 1954. *The Metaphysical Foundations of Modern Science.* Garden City, N.Y.: Doubleday.

Carr, B., and M. Rees. 1979. The Anthropic Principle and the Structure of the Physical World. *Nature* 278:605–613.

Dawkins, Richard. 1976. *The Selfish Gene.* Oxford: Oxford University Press.

Eigen, Manfred, and Peter Schuster. 1979. *The Hypercycle: A Principle of Natural Self-Organization.* New York: Springer-Verlag.

Huxley, Julian. 1953. The Evolutionary Process. In *Evolution as a Process,* ed. A. Hardy and E. Ford. 1–23. London: Allen and Unwin.

Mayr, Ernst. 1982. *The Growth of Biological Thought.* Cambridge: Harvard University Press.

Monod, Jacques. 1972. *Chance and Necessity.* New York: Vintage.

Niebuhr, Reinhold. 1960. *Moral Man and Immoral Society.* New York: Scribner's.

Pannenberg, Wolfhart. 1976. *Theology and the Philosophy of Science.* Philadelphia: Westminster.

———. 1985. *Anthropology in Theological Perspective.* Trans. M. J. O'Connell. Philadelphia: Westminster.

———. 1993. The Doctrine of Creation and Modern Science. In *Toward a Theology of Nature: Essays on Science and Faith,* ed. Ted Peters, 29–49. Louisville: Westminster/John Knox.

Peacocke, Arthur. 1979. Chance and the Life Game. *Zygon: Journal of Religion and Science* 15:301–321.

Peters, Karl. 1982. Religion and an Evolutionary Theory of Knowledge. *Zygon: Journal of Religion and Science* 17:385–415.

Polanyi, Michael. 1958. *Personal Knowledge.* London: Routledge.

Prigogine, Ilya. 1980. *From Being to Becoming.* San Francisco: Freeman.

Randall, John H. 1977. *Philosophy after Darwin*. New York: Columbia University Press.

Teilhard de Chardin, Pierre. 1975. *The Phenomenon of Man*. New York: Harper and Row.

Tillich, Paul. 1952. *The Courage to Be*. New Haven: Yale University Press.

Ulanowicz, Robert. 1986. *Growth and Development: A Phenomenological Perspective*. New York: Springer-Verlag.

Varela, Francisco. 1979. *Principles of Biological Autonomy*. New York: North Holland

Webster, Gerry, and Brian Goodwin. 1982. The Origin of Species: A Structuralist Approach. *Journal of Social and Biological Structure*. 5: 15–17.

Wicken, Jeffrey. 1985. Thermodynamics and the Conceptual Structure of Evolutionary Theory. *Journal of Theoretical Biology* 117: 363–82.

———. 1987. *Evolution, Thermodynamics, and Information: Extending the Darwinian Program*. New York: Oxford University Press.

———. 1988. Science and Religion in the Evolving Cosmos. *Zygon* 23: 15–55.

Wilson, E. O. 1978. *On Human Nature*. Cambridge: Harvard University Press.

11

Clarity of the Part versus Meaning of the Whole
··········
Ted Peters

I wonder what it would be like to watch a mortal battle between a boa constrictor and a warthog. The boa constrictor would seek to coil itself around its prey, squeeze the living daylights out of it, and then swallow it whole. Eventually, there would only be a constrictor left. Conversely, the warthog would try to chew the boa to pieces and then devour as much as it could stomach. Eventually, there would only be a warthog left.

This is the way that many think of the relationship between science and theology: the two disciplines are engaged in a mortal struggle in which each is trying to swallow up the other. An example of the attempt by theology to swallow science would be the Syllabus of Errors (*Syllabus Errorum*) of 1864, where item 57 reads this way: "It is an error to believe that science and philosophy should withdraw from ecclesiastical authority." Here the church, like the boa, constricts.

The reductionism of sociobiology provides us with an example of how science might chew up religious beliefs, digesting them into evolutionary theory. Harvard zoologist Edward O. Wilson, for example, propounds a doctrine of scientific materialism according to which all cultural phenomena including religion can be reduced to the principles of biological evolution. Wilson assumes that selfishness is endemic to all of life. He argues accordingly that religions are like other human institutions in that they evolve in directions that enhance the welfare of the practitioners, for example: people pray for mundane rewards such as long life, abundant land and food, averting physical catastrophes, and defeating enemies. Beyond this, religions also teach altruism and even self-sacrifice. The idea of self-sacrifice, however, is contrary to our nature. Therefore, all religions are "probably oppressive to some degree" because they persuade individuals to subordinate their immediate self-interests to the interests of the group (Wilson 1978, 182). But the interests of the group can in some instances actually ensure survival in ways that go beyond the individual's ability. Add to this a principle which Wilson calls "ecclesiastic selection", and religion becomes a process that leads from selfish genes through physiology and into culture that functions as a strategy to enable the race to

survive. Thus, Wilson can explain religion—even altruistic religion—within the confines of a materialistic theory which takes self-preservation as axiomatic. In fact, the evolutionary vision swallows up the religious vision. He writes:

> But make no mistake about the power of scientific material-ism. It presents the human mind with an alternative mythology that until now has always, point for point in zones of conflict, defeated traditional religion. Its narrative form is the epic: the evolution of the universe from the big bang of fifteen billion years ago through the origin of the elements and celestial bodies to the beginnings of life on earth. The evolutionary epic is mythology in the sense that the laws it adduces here and now are believed but can never be definitely proved to form a cause-and-effect continuum from physics to the social sciences, from this world to all other worlds in the visible universe, and back-ward through time to the beginning of the universe. Every part of existence is considered to be obedient to physical laws requir-ing no external control. The scientist's devotion to parsimony in explanation excludes the divine spirit and other extraneous agents. Most importantly, we have come to the crucial stage in the history of biology when religion itself is subject to the expla-nations of the natural sciences. (Wilson 1978, 200)

In short, the warthog has swallowed the constrictor.

Of course, it is not necessary for science to swallow theology, nor for theology to swallow science. There are alternative ways to look at it. We could look at the situation as Langdon Gilkey does, asserting that science and theology speak different languages and, thereby, belong to two separate domains of human reflection (Gilkey 1985, 49–53, 109–117). This is also the position of the Second Vatican Council which tried to liberate science from the constrictions of the Syllabus of Errors. The 'Pastoral Constitution on the Church in the Modern World' (*Gaudium et Spes* 2:59)

> . . . declares that there are "two orders of knowledge" which are distinct, namely, faith and reason. It declares that the Church does not indeed forbid that "when the human arts and sciences are practiced they use their own principles and their proper method, each in its own domain." Hence, acknowledging this just liberty, this sacred Synod affirms the legitimate autonomy of human culture and especially of the sciences. (Abbott 1966, 265)

This separating of science and theology into discrete domains is tanta-mount to saying that boa constrictors live in South America and

warthogs in Africa so that the Atlantic Ocean should keep them forever separated.

Biochemist Jeffrey Wicken and theologian Wolfhart Pannenberg are among those who are dissatisfied with both swallowing and separating. These two scholars are projecting the possibility of a single domain of knowledge shared by both science and theology. Wicken's method is to construct a theological superstructure on a foundation of evolutionary theory, whereas Pannenberg's method consists more of a merging of horizons so that scientific discoveries will find their fullest understanding when understood in light of our knowledge of God. In both cases—like two mountain climbers gazing up from the foot of Everest—we find ourselves at the beginning of an enormous intellectual climb. Yet climb we must, and these two have the courage to start us on the ascent.

What I wish to do in this paper is analyze the essential structure of the arguments proposed by Wicken and Pannenberg. In doing so I wish to show that, despite a slightly different vision of how science and theology should relate to one another formally, they complement one another materially, especially on the idea of ecological wholism. It is significant that both a scientist and a theologian should converge so thoroughly. This complementary agreement, I believe, constitutes a modest yet potentially decisive form of support for the Pannenberg project whereby theology seeks to lay claim to scientific understandings.

Jeffrey Wicken's Argument

The big question Jeffrey Wicken wishes to answer is this: How should we best understand ourselves in an evolutionary cosmos? En route to answering this question, Wicken recommends that science and religion co-operate in a single scientific-theological enterprise. More specifically, biochemist Wicken recommends that Darwinian evolutionary theory provide the foundation for theological reflection on the human situation in the cosmos.

The key to Wicken's method is the relationship between clarity and meaning, which he believes correlates with the ontological relationship between part and whole. We as human beings are motivated by two drives: the desire for clarity and the need for meaning. The first leads us to analyze our world with the tools of science, whereas the second leads us to construct the meaning of everything through religion.

Science is analytic and reductive. It focuses on the part. When a scientist analyzes an enzyme, he or she describes how this chemical machine catalyzes metabolic reactions. The objective of the research here is *clarity* of description. But to ask about the *meaning* of the enzyme takes us beyond the purview of the specifically scientific task. The meaning of an enzyme or the meaning of anything else can be understood only by considering the functional organization to which it contributes. Meaning is context-dependent. Meaning is discerned through the relationship between part and whole. This is where theology enters the picture for Wicken. He defines the realms of each: "science aiming to map out the full configuration of conditions—physical, biological, social—in which meanings can be organized; theology contextualizing the essential incompleteness of this knowledge within a meaning framework" (262–63). This means that the work of theology has to do with the meaningfulness of the whole, with how things fit together and why.

The most stubborn case in point is the relationship between genetic selfishness and cultural altruism. The problem with the sociobiological approach such as that taken by Edward O. Wilson or even Jacques Monod is that it tries to work strictly within a scientific reductionism, so that it cannot without inconsistency move from selfish genes to the religious morality of self-sacrifice. The latter cannot be reduced to an epiphenomenon of the former, argues Wicken. Yet both genetic selfishness and religious altruism exist. How? Wicken's way to solve the problem is to complement genetic reductionism with theological contextualism, that is, by developing an ecological approach which deals with the relationship between part and whole. Altruism, then, can be understood as a moral posture emerging from a religious vision of the whole, from our vision of the need for a cooperative global commu-nity. Such a vision is necessary to preserve the race in our era so threatened with the possibility of total extinction. We can understand religious morality, then, as an evolutionary survival value which is taking us well beyond our origin toward greater and greater apprehensions of the whole of reality. Meaning is a creative activity of human consciousness, in other words, of spirit; and we should understand the place of the human being as that of a creative contributor to the ongoing creativity of the cosmos. Despite his demurs, at this point it appears that Wicken belongs in the same camp with Wilson: he sees religious wholism as a complicated form of genetic selfishness.

But Wicken wants to go further. He wants to get beyond the scientific reductionism of the whole into its component parts. He wants to afford integrity to the whole proper. To do so he moves from the indicative to the imperative. This permits Wicken to go beyond ana-

lytic *de*scriptions and make theological *pre*scriptions. He can now tell us what the good is. "All 'good'," he writes, "involves a relational orientation of individual to community, that the community in turn comes to focus in the individual, investing it with meaning" (281). He also can tell us what religious truth is. He says, "a religion would seem to be 'relatively true' insofar as it promotes the ecological home by bringing life's global conditions and responsibilities into focus within the individual consciousness. A religion is false insofar as it encourages us to seek limited identifications, limited commitments to the human condition" (282). In other words, selfish genes which limit themselves to seeking only their own replication would be neither good nor truly religious. And it takes a combined scientific-theological enterprise to find this out.

What Wicken ostensibly wants to do is integrate science and theology by constructing the latter on the basis of the former.[1] His ethical argument makes this method clear. When he argues for an ethic of wholism strictly on the basis of evolutionary theory, he in fact makes no advance beyond that of the reductive sociobiology he so criticizes. Self-sacrifice turns out to be nothing more than an epiphenomenal expression of a more basic genetic selfishness. In order to make his case for wholistic meaning, he must resort to discrete theological resources. In a sense, he piles his theology of meaning on top of his science of clarity. But, I ask, does this really mark an advance beyond the two-language separation mentioned above? Wicken has brought biological evolution and theological ethics into close proximity, to be sure; but does there not remain a line of separation akin to the difference between 'is' and 'ought'?

Yet elsewhere Wicken has a stronger argument—an ontological argument—which does a better job of integrating. It is bound up with his concept of ecology. For him basic life forms are always dependent upon their environment. Parts depend upon wholes and vice versa. We must think of parts and wholes together if we are to understand reality. On this matter he comes close to the approach of Wolfhart Pannenberg. To this approach we now turn.

.
Wolfhart Pannenberg's Argument

For Pannenberg, scientific knowledge must eventually count as theological knowledge, and vice versa. The two fields must finally deal with only one domain of knowledge if they are to understand reality.

As a theologian he bases this assertion on the doctrine of God and its corollary: the universal scope of theology. Pannenberg argues that

theology must be universal in scope because the nature of its object, God, implies the most comprehensive scope conceivable. Religious assertions in general refer us to the ultimate mystery upon which all being depends; and the assertions of the Christian religion in particular refer us to God as the creator of all things (Pannenberg 1970–71, 1: 79, 200; 2:103–5, 142–147). Consequently, the very subject matter of theology—God and everything that is—compels it to be universal.

Nothing, therefore, is excluded from the scope of theology. This opens it to science. Pannenberg writes: "Thus, theology traditionally speaks of the creation of the world by God. It must therefore take an interest in the way the natural sciences see the world . . ." (Pannenberg 1976, 265). This means that the knowledge gained from scientific research counts in our understanding of the relationship between God and the creation.

Conversely, it means that what we learn from scientific research must—sooner or later—be enhanced by our understanding of God. In the train of Thomas Aquinas before him, Pannenberg says that "it belongs to the task of theology to understand all being (*alles Seienden*) in relation to God, so that without God they simply could not be understood. That is what constitutes theology's universality" (Pannenberg 1970–71, 1:1). In other words, the world cannot be properly understood scientifically if the God factor is deleted. Genuine understanding of reality requires knowledge of God.[2]

There must be a unity of truth for Pannenberg. We cannot live with separate truths for scientists and theologians. Pannenberg recognizes that our knowledge is always incomplete, which means never completely known. We are always on the move, trying to distinguish what is known from what remains unknown. What we know is provisional, subject to tomorrow's revision (Pannenberg 1976, 25f, 297f).[3] Yet this is insufficient reason for denying the possibility of a growth in the direction of a unity of knowledge, in the direction of a shared domain for pursuing truth.

Concepts such as universality and unity permit Pannenberg to employ the category of the whole of reality. "Speaking about God and speaking about the whole of reality," he writes, "are not two entirely different matters, but mutually condition each other" (Pannenberg 1970–71, 1:156). 'God' is not merely interchangeable with 'the totality of reality', of course; but as the origin of 'the totality of reality', 'God' requires reflection in this most inclusive sense (Pannenberg 1970–71, 2:230, n. 29). The reality of God and the wholeness of reality are, for Pannenberg, sister concepts.

This brings us to the nature of meaning. Like Wicken, Pannenberg believes meaning is contextual. The meaning of a part is dependent

upon its context in the whole. In fact, Pannenberg frequently offers up a form of the cosmological argument for the existence of God which I nickname "the expanding context of meaning" argument (Pannenberg 1970–71, 1:69, 98, 170, 199; 2:61f; 1973, 132, 200f, 209; 1976, 216, 304). It goes like this. We experience fragmentary meaning every day. An example would be the meaning of a word. The meaning of the word, of course, is dependent upon its context in the sentence. Yet the meaning of the sentence is dependent upon its context in the paragraph, which in turn is dependent upon the meaning of the book of which it is a part. Further, the meaning of a book is dependent upon its context of genre and epoch, which is dependent upon the context of the broad sweep of history, which finally is determined by its place in the consummate whole which is the totality of reality. Once Pannenberg has made a case for the whole of the creation, it is a small move to jump to the divine creator which is its condition of possibility.

Now, what is the status of such an assertion regarding God's relationship to the whole of reality? It is a hypothetical assertion, says Pannenberg, and this gives it a scientific status. This marks another methodological point of convergence between science and theology. His argument goes like this: because the whole can never be grasped except in a provisional manner, we can never possess the whole of truth. We can at best anticipate it. In order to anticipate it, both scientific and theological understanding require the use of human imagination to project the possible nature of the whole. The use of imaginative projections in the ongoing course of acquiring provisional knowledge means that what we know is hypothetical, subject to future confirmation or falsification. This applies even to what we know about God.

> The totality of reality does not exist anywhere complete. It is only anticipated as a totality of meaning. . . . This anticipation, without which . . . no experience is possible at all, always involves an element of hypothesis, of subjective conjecture, which must be confirmed—or refuted—by subsequent experience. . . . *The reality of God is always present only in subjective anticipations of the totality of reality, in models of the totality of meaning presupposed in all particular experience. These models, however, are historic, which means that they are subject to confirmation or refutation by subsequent experience.* Anticipation therefore always involves hypothesis. (1976, 310; italics in original)

Because of the inescapable role of hypothesis in our anticipation of the truth of the whole, Pannenberg believes that theology is itself scientific in its method. Theology is the science of God.

··········
Formal vs. Material Arguments

If we are to evaluate Pannenberg's contribution to the discussion, we need to distinguish his work on two fronts, the methodological and the substantive. Philip Hefner marks this distinction in terms of a formal and a material contribution. Hefner writes,

> Formally, it can be said that Pannenberg's theological thinking makes a statement about the empirical world; that is, it claims to add to our knowledge of empirical reality. Consequently, science is important as a realm within which theological issues arise, and science can either lend credence to theological statements or falsify them. In its material form, the thesis suggests that Pannenberg's theological production is focused on the phenomena of contingency and field. (97)

In other words, Pannenberg makes the methodological commitment to a general convergence of scientific and theological discourse, then he makes specific application of this commitment to discussions of contingency and field in physics and other disciplines. Recognizing this, a Pannenberg critic could in principle embrace the methodological agenda even if Pannenberg's own application might be shown to be inadequate.[4] What the methodological vision requires to be judged adequate is eventual confirmation through application in one field or another, whether this application is performed by Pannenberg or by someone else.

··········
Ecology and Exocentricity

Let us look at a case in point. Wicken's overriding question, recall, is: How should we best understand ourselves in an evolutionary cosmos? Pursuant to this end, Wicken advances his notion of ecology based upon empirical examination of biological processes. He defines ecology as the science of part-whole relationships, noting that all life forms relate interdependently to their environmental contexts. It is this ecology which marks the bridge between evolutionary theory and theology.

> Fortunately, genetic reductionism is *not* the message of Darwinism, and I do not think Darwin himself would have liked it. We are ecological beings, and our survivals and reproductions require accountability. [It is important to understand]

what an organism *is* in appropriate ecological terms. Then, a continuous way is paved for connecting the evolutionary process to the spiritual noosphere . . . (267)

We find virtually the same argument in Pannenberg, and it is aimed at answering the same overall question regarding the place we humans occupy in an evolutionary cosmos. The Pannenberg position could be dubbed an 'ecological wholism', even though he does not use this precise terminology.

The essential premise is that the dynamics of evolution are due to the phenomenon of openness to the future which characterizes the beings of this world. To be alive is to be centered yet open.

> On the one hand, every living organism is a body, which, as such, is closed to the rest of the world. On the other hand, every organism is also open to the outside world. It incorporates its environment, upon which it is dependent for food and growth, into the cycle of its biological functions. Thus every organic body, whether it is animal or plant, simultaneously lives within itself and outside itself. To live within itself and outside itself certainly involves a contradiction. But it is a contradiction that really exists in life. All life, even human life, as we have seen, is carried out within this tension. (Pannenberg 1962, 56f)

This openness to what is beyond the self is a form of ecstasy, and it is here that Pannenberg like Wicken makes the move to the concept of spirit.

> life is essentially ecstatic: it takes place in the environment of the organism much more than in itself. But is there any relation of this ecological self-transcendence of life to the biblical idea of a spiritual origin of life? I think there is. (75; cf. Hefner, 106)

Where the principle of openness takes us is most clearly demonstrated in Pannenberg's *Anthropology in Theological Perspective*, where the orienting question is this: How is the identity of the human person formed? The path Pannenberg follows in pursuing the answer to this question takes us through the thick forests of biology, cultural anthropology, philosophy, social theory, psychology, patristics, and exegesis of Scripture. Consistent with his declared method over the years, this study follows any relevant trail through any relevant field of human knowledge, in this case "general anthropological studies" (Pannenberg 1985, 15). Yet at every stage of our journey the compass needle points toward the future of God. Empirical studies, philosophical

reflection, and theological perspectives all seem to point in the same direction, namely, toward the development of personal identity through a divinely coordinated future fulfillment of the whole of reality. The identity of the human person is presently in the process of formation and, Pannenberg contends, we will finally become who we are in the consummate unity of the eschatological kingdom of God.

What Pannenberg, in *What Is Man?*, called "openness to the world" or even "openness beyond the world" reappears in *Anthropology* as "exocentricity" (*Exzentrizität*), a term he borrows from Helmuth Plessner. Pannenberg notes how we humans have the ability to perceive things objectively, to grasp the object as something other. We even have the ability to step outside (*exo*) ourselves as the center and see ourselves as others see us, that is, to see ourselves objectively. The very existence of objective knowledge and self-reflection is evidence of our openness to the world around. Furthermore, it is commonly accepted in modern psychology that what we call the self develops through social interaction with the significant others in our life as well as through imbibing the language and values of our cultural milieu. In addition, the child's experience of getting lost in play—the essence of play, according to Piaget, being imitation—is further evidence of openness to what is beyond the self and of the development of self-identity amidst the larger social web of life.

Whereas the self is exocentric, the ego may not be. It may be egocentric. Hence there is a tension between the self and the ego, between exocentricity and egocentricity.

Following G. H. Mead and Sigmund Freud and perhaps the conventional wisdom, Pannenberg is distinguishing the ego from the self. Pannenberg examines the conventional wisdom which seems to assume that the ego or the 'I' (*das Ich*) is independent and not mediated through social relations, whereas the self (*das Selbst*) is the summary picture others have of you or me. According to this view, the changeless ego provides the primary nucleus that gives enduring identity to an otherwise changing self. Pannenberg disagrees. He holds rather that the ego, just like the self, undergoes development and "is constituted through its relation to the Thou" (Pannenberg 1985, 190). The ego undergoes a process of development or formation (*Bildung*) which is marked in a decisive way by processing the ever-changing social environment in which the self is developing. In fact, the development of the ego is dependent upon the development of the self. Pannenberg is reversing the self-ego relationship. The centering of one's personal identity by the ego follows upon—it does not precede—the exocentric growth of the self.

It can happen, of course, that at any given moment the ego might not accept the currently existing social self. The result is a two-sided coin. On one side we find the experience of alienation (*Entfremdung*). Alienation expresses itself as an identity crisis. I feel that I am not the person others think I am. I am not satisfied with my socially assigned role. I may even feel guilty because I do not live up to the expectations of others or of God. Feeling alienated I attempt to withdraw from my self into what I falsely think is an independent ego. The result is narcissism, an ego-centeredness which seeks to close the door on openness to the world. But narcissism is based on an illusion, because the ego is not actually independent.

On the other side of the coin the split between ego and self may open the door to creativity, to further self-constitution, to further formation of personal identity. This happens, to use Freud's terminology, with the projection of the ego ideal or, to use Pannenberg's terminology, with the anticipation of a fulfilled future and the goal-oriented behavior this induces. Through the God-given power of imagination we can project images of who we can be. Through imagination we can transcend our present selves. And if combined with religious faith and confidence in God, such self-transcendence combats narcissism by opening us up to future experiences and to the adaptations these will require. Thus, self-divestiture (*Entäusserung*) does not necessarily imply self-alienation (*Entfremdung*). In fact, self-divestiture in the form of openness to what is beyond the ego is finally constitutive of the ego's proper identity.

In sum, the point of Pannenberg's use of the terms 'openness' and 'exocentricity' is that our personal identity is not autonomously produced, not determined solely by the action taken by our own ego. Human beings are not closed monads. We are not like balls on a billiard table that simply bounce against one another according to the laws of external relations. Rather, our identities are so open to other people, to social institutions, to our natural environment, to the course of history, and open even to God, that who we are is determined in large part by external factors and events. We are internally related to one another and, ultimately, to the whole of reality.

Subjectivity and Spirit

One of Wicken's particular concerns is human consciousness or subjectivity. He believes this is a privileged area which will be forever off limits to the sociobiologist. Theology should move in here and offer

conceptual leadership (Wicken 1988, 54f). This Pannenberg does with his idea of spirit. What makes such consciousness possible, he says, is our participation in spirit: "personality is to be understood as a special instance of the working of the spirit" (Pannenberg 1985, 528). The spirit provides for the continuity of our identity through time. Similarly, it is the spirit which provides continuity between all things temporal and spatial. It is the power which is in the process of integrating the parts of God's creation into a single comprehensive whole. The whole will be complete at some time in the future.

Such a doctrine of spirit is necessary to make sense out of ecological wholism, because the whole of reality is still future. We can experience the whole in the present only by anticipating it within the life of the spirit. Following Schleiermacher, Pannenberg asserts that through feeling (*Gefühl*) we human beings can have a prereflective familiarity with the whole which integrates our own identity with all of existence (Pannenberg 1985, 517). The whole is finally an eschatological reality which through the spirit is exercising its integrative power on us now, in the present time, through anticipation.

.
Conclusion

What we have in Pannenberg's proposed theological method is a courageous recognition that there is but one reality and that the truths of science and the truths of theology must ultimately cohere. This is courageous because, in principle, he will permit empirical discoveries to count as theological knowledge; and this opens up the possibility of disconfirmation of long held theological doctrines. It is possible to falsify theological statements. This means that theological statements themselves have a hypothetical status, subject to future confirmation or falsification. On this point, theological statements find an affinity with scientific statements. They are both hypothetical.

As hypothetical, they are open. Our knowledge is provisional, subject to enhancement by what the future reveals. As we have seen, such openness is an authentic expression of our fundamental human nature or, even more, the fundamental nature of all living organisms. When the pursuit of scientific knowledge and the pursuit of theological knowledge both come to reflect this common expression of who we as human beings are, we find ourselves on the track of discovering if not creating a common domain of understanding. Our immediate task is to compare notes on the material content of what scientists and theologians have to say. Yet, formally, we are now better off than we

have been. Instead of using our mouths to swallow one another, we may now use them to talk to one another.

•••••••••

Notes

1. In an earlier essay (1988), Wicken seems to assume science and theology are discrete fields with their own languages, so that the objective is to open up communication and find a "common language". Now, in the paper in this volume (Chapter 10), it seems Wicken wants a closer relationship in which Darwinian evolution becomes a "foundation for an enduring theology." Nevertheless, he wants theology to avoid becoming the "handmaiden" of science.

2. Philip Hefner (Chapter 5) places Pannenberg's 'style' of relating science and theology this way: "It is not one that employs a 'God of the gaps' strategy, nor is it that of perceiving science and theology as 'two worlds'. Rather, it immerses itself fully in the contributions that science makes to our understanding of the world, and it seeks to bring theology to bear in a constructive and co-operative manner upon the descriptions which science provides. It does so in the conviction that theology has something to contribute which will otherwise be wanting" (103–04).

3. For Pannenberg, truth implies a single whole to reality, which in turn implies God (1970–71, 2:102, 106).

4. This seems to be the thrust of Wicken's evaluation. On the one hand, he says "the feel of Pannenberg's analysis seems right in many ways." On the other hand, Wicken argues that Pannenberg's use of the concept of field misconstrues what the physical sciences say and, furthermore, when incorporated into theology, "binds God needlessly to physics" (Wicken 1988, 49, 52).

•••••••••

References

Abbott, Walter M., ed. 1966. *The Documents of Vatican II.* New York: The America Press, Angelus Books.

Gilkey, Langdon. 1985. *Creationism on Trial: Evolution and God at Little Rock.* San Francisco: Harper and Row.

Pannenberg, Wolfhart. 1970–71. *Basic Questions in Theology.* 2 vols. Trans. George H. Kehm. Philadelphia: Fortress.

———. 1973. *The Idea of God and Human Freedom.* Philadelphia: Westminster.

———. 1976. *Theology and the Philosophy of Science.* Trans. Francis McDonagh. Philadelphia: Westminster.

———. 1985. *Anthropology in Theological Perspective.* Trans. M.J. O'Connell. Philadelphia: Westminster.

Wicken, Jeffrey. 1988. Theology and Science in the Evolving Cosmos: A Need for Dialogue. *Zygon: Journal of Religion and Science* 23:45–55.

Wilson, E.O. 1978. *On Human Nature.* New York: Bantam.

PART FIVE

• • • • • • • • • •

DNA as Icon

Introduction to Part Five

· · · · · · · · · ·

Carol Rausch Albright

If theology is to lay claim to the sciences, says geneticist Lindon Eaves, three bridges must be built between these disciplines, addressing spirituality, methodology, and content. In his second paper, he describes bridge building specifically in the field of behavioral genetics.

· · · · · · · · · ·

Spirituality

Spirituality, says Eaves, is "nothing less than that orientation of the human spirit toward reality which motivates, directs, and sustains our encounter with the unknown." Much of the conflict between science and religion involves spirituality rather than content, but the dimensions of that conflict remain fairly obscure. In fact, one contribution theology might make to the sciences is to draw out their spirituality so that it becomes explicit.

The spiritual element in science was at least clear to Einstein, who observed that "cosmic religious feeling is the strongest and noblest incitement to scientific research. . . . Only one who has devoted his life to similar ends can have a vivid realization of what has inspired these men and given them the strength to remain true to their purpose in spite of countless failures" (Einstein 1979, 28, 322). Einstein alludes to the asceticism inherent in science—a price paid willingly by those who value its rewards.

Scientists' quest is based on a belief that they are engaged in exposing *reality itself*. They seek—and expect to find—*simplicity:* "the most informative theories are those which encompass the greatest range of data with the smallest number of parameters" (323). And they expect to recognize scientific truths by their *beauty*. In fact, "passion for simplicity and appreciation of beauty are closely allied in scientific spirituality" (324), Eaves observes.

· · · · · · · · · ·

Methodology

Any attempt of theology to lay claim to science must understand which stage of scientific work is being addressed, Eaves observes.

Although the stages are sequential, in actual practice they divide and subdivide like fractals, and so at any given time, some of the work within a discipline may be in any of the stages. During the *taxonomic phase*, researchers explore the territory and map its contours. Some observers call this phase 'pre-science'. The *hypothetical-deductive cycle* requires 'science in earnest'. It generally procedes more productively if the preceding taxonomic work did a good job of describing the contours of the work to be done. The *paradigmatic or technological phase* involves exploitation. Examples are accumulated, details worked out, and implications drawn.

In terms of this analysis, Eaves charges, Pannenberg's work sometimes falls short. Too often in his anthropology, Pannenberg uses data from the 'soft' end of the discipline and from a taxonomic phase that "lives on only in the popular imagination and not in the corridors of science" (327). The effect of such analysis on scientists may be likened to that of a theologian hearing an analysis of religion based on psychical research.

Furthermore, Eaves contends, Pannenberg tends to disavow the paradigms of science in favor of an idiographic search for meaning and coherence. Whereas Pannenberg regards the most salient features of humanity to be cultural, genetics may force re-examination of such assumptions. For example, religious devotion, hardness of heart, even 'sin' may have strong genetic roots. In order to lay claim to the physical and biological sciences, theology must "show a further methodological connection to them or convince the scientist that the data require a layer of analysis which demands another approach" (328).

.
Content

Theology cannot lay claim to science by concerning itself with issues more effectively dealt with by history, philosophy, or anthropology. Is there in fact a theological dimension that only theology can deal with? Eaves believes there is, when theology refers to "those phenomena in the midst of reality to which the language of religion refers and to which religion is the attempt to adapt" (330).

Here Eaves brings into play the concept of icons, which he defines as "constitutive elements of reality which are necessary and irreplaceable for understanding the whole of reality. The icon is a part of reality which both crystallizes reality as it is currently known and opens up new horizons for the explorations of reality" (317). DNA is a central

icon for the biological sciences. Einstein was dealing in iconography when he observed that only one "word" will solve the puzzle of reality. And Jesus may be seen as a central icon of the Christian faith.

Reality, represented 'whole' by the icon, may also be analyzed. Central categories are *givenness, connectedness,* and *openness.*

Two important *givens* are the fundamental adaptive mechanisms of cognition and affect. As theologian Gerd Theissen implicitly recognized in his distinction between science and faith, science is cognitive and involves exploration of new territory; faith is affective and mediates between the evolutionary past and future.

In biology *connectedness* is centrally achieved by the process of evolution and by the molecular basis of life. DNA links ourselves with our remotest ancestors and with the rest of the living world. It may underlie the only kind of immortality we are likely to achieve.

Biology's insights into *openness* present theology with serious challenges—and liberating perspectives. Although evolutionary biology may account for diversity, change, and connectedness, it does not account for specific outcomes. Outcomes are not guaranteed; both randomness and freedom help to determine them.

· · · · · · · · · ·
Biology and Theology

In laying claim to science, theology may 'feed' on biology, and some of Pannenberg's ideas may help that process, Eaves believes. How do humans cope with the biological and historical realities of givenness, connectedness, and openness? Three concepts may point to some answers: *promise, covenant,* and *sacrifice.*

Promise builds upon the evidence of continuity that our 'real world' provides. *Covenant* draws humanity into the promise as an agent whose choices have implications for the promise. *Sacrifice* is the human price of promise and covenant. The willing self-offering of crucial individuals provides a cultural link to harmony and fulfillment.

The concept of sacrifice leads to the theological dimension of spirit. While various concepts of spirit have lately been advanced, Eaves points to that of theologian Gerd Theissen: " 'The experience of the Holy Spirit is a specifically human experience. It brings human beings into conflict with the biological, cultural, and cognitive systems in which they live' (Theissen 1985, 166). . . . It is that which gives humans the quality of 'standing up'—*anastasis*—from the matrix of givenness and connectedness and engenders the hope that the future will transcend the past" (338).

.
Behavioral Genetics

In his second paper, Eaves points to a perceived neglect of biology in Pannenberg's program. The gap between cosmology and anthropology is enormous, omitting, for example, mediation between nature and nurture in the lives of human beings. Rejecting the sociobiological paradigm and the ethological paradigm, Eaves embraces the behavior-genetic paradigm for understanding this process. Through such activities as twin studies, the discipline seeks to identify which features of human behavior are traceable to genetic processes and which to environment or culture. Theology ignores the data at its peril.

.
References

Einstein, Albert. 1979. *The World as I See It.* Abridged ed. Secausas, N.J.: Citadel.

Theissen, Gerd. 1985. *Biblical Faith: An Evolutionary Approach.* Philadelphia: Fortress.

12

Spirit, Method, and Content in Science and Religion:
The Theological Perspective of a Geneticist
• • • • • • • • • •

Lindon Eaves

• • • • • • • • • •
Background

Any philosophy of science, and any proposal by which theology lays claim to the sciences, has to enable the scientist to recognize himself or herself in the solution. I am neither a theologian nor a philosopher of science, but as one who has been a practicing research geneticist for twenty years and a practicing doubting believer I am in a unique position to judge the authenticity of potential solutions to the relationship between science and faith.

• • • • • • • • • •
Science, Faith, and Adaptation

Humanity is engaged in a continuous process of adjustment and adaptation. Our genes and culture bear the marks of past adjustment and provide the raw material of future change. Increasingly, science has laid claim to the adaptive process by surpassing all previous attempts to analyze the mechanisms which brought us to where we are and by providing a powerful apparatus for manipulating and changing reality. The pursuit of truth is part of the process by which humans adapt to the matrix of matter and event in which they find themselves embedded. "We cannot know in advance that the truth will turn out to be what is thought edifying in a given society" (Russell 1961, 95), but the sciences comprise the "cognitive arm" of society, pursued in the spirit that "forewarned is forearmed"—even undesirable truth is better known sooner rather than later. Is there still a legitimate place for theology and religious faith in the adaptive process or should both be relegated to the history of ideas? Is theology a science? What is theology about?

We do not need to ponder too deeply the objectivity or otherwise of 'reality'. Rather, we define reality operationally as that which commands our attention, compels our adaptation and is ignored at peril to our being. "It makes little difference whether we name it natural selection or God," writes Ralph Burhoe (1981, 21), "so long as we recognize it as that to which we must bow our heads or adapt." The human spirit may rebel at the image of 'bowing our head' to any kind of pressure,

but Burhoe draws out an important principle, that knowledge and knowing are intimately connected with survival in a strictly biological sense. The a prioris with which we address reality may be as much inherited biologically as they are conditioned culturally. Gerd Theissen (1985, 4) has recently borrowed what is essentially a biologist's view of reality as that which requires adaptation. Science and faith, he argues, are each distinct mechanisms for adapting to different facets of the 'central reality'. The difference between science and faith is put with crystalline simplicity: "Scientific thought is corrected by reference to facts; faith must contradict the oppressive force of facts. Science subjects itself to the 'facts', faith rebels against them." Faith is—or may sometimes be—the response of living matter to the tyranny of fact. It is, to press an analogy chosen by Theissen himself, a historical 'mutation', a living experiment which defies the present. We recall Marx's famous thesis on Feuerbach (quoted by Russell 1961, 749): "Philosophers have only *interpreted* the world in various ways, but the real task is to *alter* it."

Theology is the attempt to supply cognitive structure to the experience and content of faith. It is *fides quaerens intellectum*. The moment theology begins, it enters a domain which has no favorites. Concessions can only be made if they are grounded in a matrix of experience and meaning which is, in some elusive sense, 'public'. The attempts of nineteenth-century theologians such as Schleiermacher to give a public dimension to faith were conceived in an age in which the essential quality of 'fact' was its power to create and support values which liberate and transcend the present. The twentieth century encountered the power of 'fact' to sustain sinister and oppressive values in the historical expressions of dialectical materialism and fascism. Against such 'fact', as Theissen would have predicted, faith rebelled with astonishing power and eloquence in the uncompromising stance of dialectical theology. Karl Barth is one such model of the adaptive response of the spirit to the tyranny of fact.

The fragile nuclear peace and the relative prosperity of a society which promotes and exploits the sciences provides a different context for faith and theology. The power of facts is ambiguous. They are neither totally oppressive nor wholly liberating. The tangible and intellectual success of the sciences has left theology with a problem. It is well equipped to challenge the explicit tyranny and exploitation of the third world and inner city. However, it has all but abandoned the intellectual and cultural challenge of the sciences. In doing so, it has

condemned a significant part of the human world and has abandoned part of the future.

· · · · · · · · · ·

The Ambivalence of Theology Towards the Sciences

Theology has been ambivalent towards the sciences. It has flirted from time to time with the possibility of a public dimension but has equally often retreated behind the walls of confession. Science has assumed theological importance both for its methodology and for its content. Methodologically, science provides what many see as a paradigm for scholarship. Even though scientists and philosophers of science may still disagree about the distinctive characteristics of scientific method and progress, it is clear that the history of science supplies a number of model systems for analysis of how we advance in our understanding of reality. Thus, we are compelled to ask in the narrow sense, 'Is theology a science?' In a broader context, science provides a microcosm of the human condition. It raises the basic questions, 'How do we know *anything?*' and 'How do we live in a world where the data are incomplete and our models are at best provisional?' Substantively, science presents a number of models for reality which at least need to be compared and integrated with the cognitive claims of theology, if such integration is possible. Science and theology both make some kind of cosmological claims. Are they inconsistent? Biology and theology both make anthropological claims. Are they irreconcilable?

The dominant exponents of theology in the first half of this century have, at best, been lukewarm in their acceptance of the scientific method. Barth, for example, claims that theology is a science but is not beholden to the rules of science as it is defined by other scholarly disciplines: "If [theology] is ranked as a science, and lays claim to such ranking, this does not mean it must be disturbed or hampered in its own task by regard for what is described as science elsewhere. On the contrary, to the discharge of its own task it must absolutely subordinate and if necessary sacrifice all concern for what is called science elsewhere" (Barth 1975, 8).

By itself, this statement of Barth's position may be defensible. Pannenberg himself criticizes and moves beyond the scientific method as it is conceived by the natural sciences. If such a move can be defended on critical grounds, and if it can even alert scientists to hidden dimensions in their own approach to reality, then a willingness to confront the methods of the natural scientist is productive for the sciences. However, in Barth's hands, the principle ultimately subordinates the empirical data, criticism, and human rationality to the given Word in

Revelation. If that is the way theology really wants to go, then it must go without the sciences, the spirit of which is summarized poignantly by Paul Tillich: "You may say again. . . . What I hear from you sounds like ecstasy; and I want to stay sober. It sounds like mystery, and I want to illuminate what is dark" (Tillich 1963, 70).

At first sight, Tillich is more sympathetic to the data, seeing in the facts of the human condition and the questions it implies the fundamental basis for theological discourse. However, he also stresses the independence of theology from the other sciences: "If nothing is an object of theology which does not concern us ultimately, theology is unconcerned about scientific procedures and results and vice versa. Theology has no right and no obligation to prejudice a physical or historical, sociological, or psychological, inquiry. And *no result of such an inquiry can be directly productive or disastrous for theology*" (Tillich 1951, 21; emphasis added).

The essence of both these positions, held consistently by two theologians who diverged so widely in other ways, reinforces the opinion that theology is a science as long as it agrees with the other sciences, but when there is conflict, theology is free to establish its own criteria. There is a danger that the cognitive task of theology, which we construe as inherently 'public', may be confused with the affective and experiential issues of 'faith' which it seeks to understand. It sets a dangerous epistemological precedent for dogmatics to be treated solely as 'Church Dogmatics'. Although it is clear that confessional faith may have a logical structure and be culturally potent, a theology in which 'revelation' fails to account for and illuminate reality as universally accessible would be formally indistinguishable from astrology. Such a tenuous view of the relationship between theology and the wider pursuit of truth was parodied in Antony Flew's parable of the invisible gardener (Flew 1955, 96–99) and invites a remark made by Imre Lakatos in an unpublished lecture delivered in Birmingham in the 1970s. Speaking of sociologists and their use of the scientific method he observed: "They are like a soccer team. They play the game, lose, and then shout 'but goals don't count.'" If theology can never be wrong, how are we ever to know when it is right? In what sense, if at all, are the claims of theology determined by empirical data? Under what specifiable circumstances would it be prudent to abandon religious faith as fundamentally inconsistent with the facts?

Scientists may be pleased to hear a theologian of Tillich's stature confirm the hard-won autonomy of science in matters of fact. They are less likely to concede the independence of theology from science

implied by Tillich without also agreeing among themselves on the implication that theology is about nothing in reality.

· · · · · · · · · ·
The Cultural Impact of the Sciences

Science is not neutral theologically. Its methods make us question the methods of theology, indeed the very basis of human knowing. Writing of the philosophy of logical analysis, Bertrand Russell crystallizes for many what is also the spirit of the scientific endeavor: "[Philosophers] refuse to believe that there is some 'higher' way of knowing, by which we can discover truths hidden from science and the intellect. For this renunciation they have often been rewarded by the discovery that many questions, formerly obscured by the fog of metaphysics, can be answered with precision, and by objective methods which introduce nothing of the philosopher's temperament except the desire to understand" (Russell 1961, 789).

The fact that science has helped us organize the empirical world coherently and generate productive theories leads us to examine theological propositions which, superficially at least, concern the real world. Science has become a matter for 'ultimate concern' at least among those who practice it. Whatever pirouettes may be performed upon the head of the theological pin, it remains that scientists function on the assumption that science has dispatched God from the cosmos. In the early nineteenth century Edgar Allan Poe provided an eloquent presentiment of this cultural impact of science in his 'Sonnet to Science':

> Science, true daughter of Old Time thou art!
> Who alterest all things with thy peering eyes.
> Why preyest thou thus upon the poet's heart,
> Vulture, whose wings are dull realities? . . .
> Has thou not dragged Diana from her car,
> And driven the Hamadryad from the wood
> To seek a shelter in some happier star?

> (Poe 1983, 179)

The biological sciences have probably had the greatest impact on the way we think about reality, rather than simply an effect on the quality of life. This change began over a century ago with the Darwinian revolution, the essential nature of which, according to Richard Lewontin, was "neither the introduction of evolutionism as a world view (since historically this is not the case) nor the emphasis on

natural selection as the main motive force in evolution (since empirically that may not be the case), but rather the replacement of a metaphysical view of variation among organisms by a materialistic view" (Lewontin 1974, 4).

Jürgen Moltmann observed, only twenty years ago, that "Darwinism in its day was bitterly contested by the Christian confessions," but the sciences now have become so technical that they no longer have an ideological impact. "Modern genetics," he writes, "whose technical consequences are beyond our range of vision, does not disturb them, because this is a science of such boundless complexity and cannot turn into a speculative opponent" (Moltman 1967, 323–24). The complexity may be apparent, but also increasingly is the possibility that genetics may become a powerful "speculative opponent" as our understanding of the genetic basis of human values and behavior becomes more refined. The great passion generated in the early 1970s by the publication of research on the genetic basis of intelligence suggests that many basic presuppositions about human nature were, correctly or otherwise, threatened by such work. The current discussion about sociobiology suggests that even some exploratory theories have a powerful cultural impact.

Theologians have not always regarded the empirical world as neither "directly productive" nor "disastrous" for theology. Certainly, Augustine was pleased to appeal to empirical data to refute a theological position of which he did not approve: that the positions of the planets significantly determine human destiny. In Book V of the *City of God* he discusses the observation, attributed to Hippocrates, that some twins showed remarkable concordance in the onset, course, and outcome of disease. "Posidonius the Stoic, who was much given to astrology, used to explain the fact by supposing that they had been born and conceived under the same constellation," but "to adduce [this] manifests the greatest arrogance. . . . [W]e know that twins do not only act differently, and travel to very different places, but that they also suffer from different kinds of sickness." (Augustine 1983, 85). Augustine's argument, therefore, is that intrapair differences in twins are far more marked than their similarities, but the similarities in their times of birth are much more marked than their differences. Thus, major differences in the destinies of twins cannot be predicted by trifling differences in their times of birth. Had Augustine lived fourteen centuries later he would have benefited from the more devastating arguments of Francis Galton (1883), who used the similarities and differences within pairs of monozygotic and dizygotic twins (not appreciated by Augustine) to argue for the overwhelming impact of biological inheritance on human destiny.

Gregory of Nyssa saw the scientific theories of his day in a much more positive light than that with which they are viewed by many neo-orthodox theologians. In his treatise 'On the Making of Man' (Gregory 1954, 387–427), the biological facts, as far as they were then understood, are productive for his theology because they provide the rule by which absurdities can be exposed and the reasonableness of the Christian worldview promulgated.

Is theology concerned with data or not? Is it scientific or not? The record is inconsistent. Clearly, if theology tries to examine the empirical basis of its subject matter, it takes a significant risk that it will become indistinguishable from anthropology and history. Pannenberg is one of a handful of theologians in the twentieth century who have chosen to take this risk. At the heart of this volume lies the attempt to decide whether this step is to be viewed as betrayal, courageous folly, or the shape of things to come.

If Pannenberg's position can be vindicated, even in part, the benefits for theology will be astonishing. Firstly, theology will be grounded in a universal understanding of reality—it will be 'about something' that matters to everybody. That does not imply that theology will be popular or that 'faith' will become more widespread, but theology will be public in the sense that any science is public. Tillich expresses the profound pastoral concern which may motivate such an exercise in apologetic: "We are asking: How do we make the message heard and seen, and then either be rejected or accepted? The question *cannot* be: How do we communicate the Gospel so that others will accept it?" (Tillich 1959, 201). Secondly, theology will have a foundation for being a creative partner and critic of other sciences which have a major impact on life and thought. As a critic of the sciences from within science, theology can thus sustain its prophetic criticism of culture. As a partner, theology may help us reflect creatively and insightfully on the process and content of scientific inquiry—that is, theology might actually *improve* science! Hans Küng writes optimistically: "Today more than ever—after so many prejudices have been cleared up and so many misunderstandings on both sides removed—such collaboration can be possible and useful. Thus we have no longer mutual hostility, nor—as in recent times—merely a peaceful coexistence, but a meaningful *critical-dialogic co-operation between theology and natural science*" (Küng 1981, 115).

Pannenberg recognizes that theology has to address two related issues in a scientific and secular culture. The first is the methodological issue: Is theology a science? The second is the substantive issue: Is theology necessary? That is, is theology about anything which cannot

adequately be reduced to the study of history, literature, and anthropology? The two issues are closely intertwined since the decision about whether theology is a science will affect our judgment about whether theology is 'about' anything and vice versa. His major work, *Theology and the Philosophy of Science* (1976), addresses the methodological issue and the general substantive issue of the content of theology. *Anthropology in Theological Perspective* (1985) addresses the specific issues of how theological constructs may be empirically necessary to give a complete account of the characteristics and quality of human life.

Central to Pannenberg's analysis is his claim that the secular account of the data is 'provisional' and that the "data themselves have a theological dimension" (above, 59). Before attempting to evaluate that claim in the light of biology it is necessary to outline some of the methodological and substantive issues from a scientific perspective. Then we can try to determine how far it is appropriate to recognize a theological dimension to the methods and content of science.

At a methodological level, we recognize that the understanding of science is important to theology in two senses. First, it is significant because it makes theology address its own methodology: What is the status of theological inquiry? But the scientific method is potentially important theologically for anthropological rather than strictly methodological reasons. The radical ignorance from which science begins the search for truth speaks eloquently of the human condition. And the method by which scientific knowledge grows, if properly understood, may provide a model for the more general adaptation to reality which is the basis of human transformation. That is, the scientific method needs to be considered theologically as a paradigm of faith.

At a substantive level, we recognize the theological salience of science in several ways. First, science appears as the critic of theological claims which are based in false or outmoded models for the empirical universe. That is, science has an 'atheological' component. Second, if theology is to maintain a distinct identity among the other humanities and sciences, we have to understand science as the (current) fabric of theory and data against the background of which theology has to stake its claim to speak uniquely and constructively about the empirical world.

· · · · · · · · · ·
Science in Pursuit of the Icon

Science seeks and exploits icons. An *icon* is part of reality which is nodal for understanding reality as a whole. That is, the icon both gives

coherence to existing data and opens up new possibilities for inquiry. I choose the term icon in preference to *model* for several reasons. First, scientists use models in two ways. Some regard the model as little more than a convenient description of reality—many of the mathematical models in statistics function in this way. Such models 'work' but their advocates do not claim (or necessarily care) that the terms of their model correspond to fundamental features of reality. Such models are at best preliminary. Many if not most scientists, however, want the modeling process to lead to those fundamental features of reality which 'explain' that which was hitherto obscure. David Layzer summarizes the two positions as follows: "Theories, according to Mach, do not *explain* phenomena; they merely *describe* them." But "Copernicus, Kepler, Galileo, Huygens, and Newton regarded themselves as the inheritors of the scientific tradition . . . in which mathematical regularities were not . . . abstractions from the surface appearances of things but the very heart of reality" (Layzer 1984, 10–13). The second reason for preferring icon to model (and perhaps also to *paradigm* [Kuhn 1970]) is because, for biologists at least, the fundamental explanatory principles are not merely mathematical but are a unity of model, matter, and event (experiment). That is, the mathematical or structural model is an analogy for the details of a part of tangible reality which is crucial for understanding the whole. It is the focal part of reality, of which the structural details are known and represented in the model, where together they form the icon.

Thus, we may use the term icon to denote constitutive elements of reality which are necessary and irreplaceable for understanding the whole of reality. The icon is part of reality which both crystallizes reality as it is currently known and opens up new horizons for the exploration of reality.

It is important to consider in the theological domain, also, why this term might be used in preference to a number of others. Indeed, Ian Ramsey chooses the term model in preference to *image* precisely because the former has been widely used in scientific and philosophical discourse and the latter has psychological overtones. He argues that the term model "carries with it natural logical overtones and takes us at once into a logical context." He further observes that "by contrast with 'model', 'image' seems to me to have too strong a psychological ancestry, and to beg or by-pass too many epistemological and ontological questions" (Ramsey 1966, 76 n.2). Model is also the term preferred by many contemporary writers on science and religion (for example, Peacocke 1983, 41–50). However, whatever the dangers to logic may be of importing a term which carries with it baggage from the past, perhaps this is to be preferred to using a term with precise

overtones which, nevertheless, fails to capture the sense that it is intended to convey. It is not clear to this writer that the term 'model' is adequate to encompass all the functions of the double helix in biology or those of Christ in the Christian tradition.

A theologian might naturally suggest that we use the term *symbol* where I have chosen icon, but the notion of symbol lacks the specificity and historicity which is associated with the double helix and Jesus. Although in Tillich's understanding, symbols are part of reality which have the power to open up reality, we need to be much more explicit about exactly which of the many kinds of symbol is to be understood by the term 'icon'. If we pursue the taxonomy of religious symbols given by Tillich himself (for example 1966, 15–34), we see that most of the kinds of symbol show little parallel with the constitutive elements of reality for which we have reserved the term icon. At this point it is worth repeating Einstein's observation (see below) that only one "word" will solve the complex puzzle of reality. There may be many symbols but only one icon which, in some fundamental sense, makes all others redundant and to which all others ultimately lead. As scientists contemplate *their* icons, they hope that they stand not just before models of reality but the constituents of reality itself. In a tantalizing passage towards the end of Tillich's essay we read "undoubtedly, it might well be the highest aim of theology . . . to find the point where . . . the contrast between reality and symbol is suspended" (1966, 33). The same point appears to be grasped intuitively within Western medieval and contemporary mystical traditions. Thomas Merton writes: "There exists some point at which I can meet God in a real and experimental contact with His infinite actuality" (Merton 1972, 37). The denouement of this idea in Tillich (1966, 34) is difficult to follow, but he appears to suggest that, at least from an eschatological perspective, there may be a hope of addressing reality itself even in the religious arena. In the icons of science we encounter the possibility that this is already happening for significant parts of human experience. It is tempting to argue that Jesus functions in this way in understanding the empirical content of a faithful life.

Tillich points out that symbols often outlive their power. The good scientific icon, however, has lasting validity because it identifies that part of the material universe which is a key to the whole and embodies the detailed structure of the element in a form which is coherent and productive. It may be transcended and improved, but it is not disposable. It is important to recognize the distinction between that which is transient and provisional in the scientific enterprise and that which, though incomplete, is regarded as 'true'. The recognition that science starts from ignorance and proceeds by 'conjecture and refuta-

tion' through a series of theories and hypotheses is clearly a central aspect of scientific epistemology. This quality of science is at the heart of one of the questions science puts to theology: 'Is theology a science?' Indeed Pannenberg appears to remind the scientist of this fundamental principle: "To this end, the secular description is accepted as simply a *provisional* version of the objective reality" (this volume, 59). But is this really what the scientist hopes for? The 'provisional versions' are stepping stones to the heart of reality. Even if a philosopher of Humean rigor were to point out, for example, that the double helical structure of DNA were in some ultimate sense 'provisional', molecular geneticists would probably regard the search for a different structure as unproductive in the absence of a good reason to think otherwise. Indeed, the earth may be flat, but the theory does not produce many good experiments and has not produced much insight. Indeed, the world may have been created in six days, but there are few papers in scientific journals which describe experiments based on that theory. As Claude Bernard observed, "Theories in science are not true or false. They are fertile or sterile" (Eysenck 1965). It may be true, as Pannenberg claims, that the secular model is *incomplete* and "needs to be expanded and deepened by showing that the [data themselves show] a theologically relevant dimension," but many of the most thrilling facets of the secular model are so challenging to theology precisely because they have the ring of truth.

The place of the double helix in biology provides a model system for the interaction between model and matter, the icon, in science. Molecular genetics is unlikely to revise the DNA icon because it has played such a crucial part in making biology a 'hard' science. There is no doubt that the tangible reality of DNA is crucial for understanding life. It embodies the principal features of living material. But the establishment of DNA as the central icon of biology comes from realizing the detailed structure of that nodal part of reality. Once James Watson and Francis Crick had 'got it right' (1953), DNA became the unifying feature which gave coherence to the facts of reproduction, evolution, chromosome behavior, Mendelian inheritance, protein synthesis, mutational change, and other processes. Furthermore, the icon became the key to new horizons—the details of gene regulation and biotechnology.

The proposed use of the term 'icon' in both the scientific and the religious contexts obviously has its risks because it may lead to the blurring of issues which need to be kept distinct. However, it may provide productive conceptual parallels between theological and scientific constructs which are mutually enhancing. At the very least, it provides a point of contact between the nodal constructs of biology and

theology, but more importantly, it provides a more focused insight concerning the religious significance of specific historical and revelatory events. The New Testament use of the term refers not to a constructed representation (model) of reality but to that part of tangible and historical reality, Christ in the Christian tradition, whom Paul describes in Colossians (1:15) as "the eikon of the invisible God." The 'model-matter-experiment' union in the double helix has very strong parallels to how revelatory events function in theology. Can the biologist say, even, that DNA is the 'incarnation' of all we know about living matter? Does the role of the double helix in biology help the biologist to understand what the theologian is talking about when Christ is described as he on whom the Spirit descended *"in bodily form"* (Luke 3:22), or he "in whom the whole fullness of the godhead dwelt *bodily"* (Col. 2:9; emphasis added)? Finally, we note that icons in science, just as in religion, have the power to create a community devoted to their exploitation; they evoke both aesthetic and cognitive judgments, and they have their 'dark' side in that adherence to the icon may be idolatrous and unproductive. In this sense, Ramsey's desire to purge theological terms of their psychological overtones may also purge them of their vital content. Put another way, the use of terms like 'model' in attempting to build bridges between science and religion may be one reason why the end product is often so profoundly boring!

.
Hope, Expectation, and the Spirituality of Science

There is a story of an English monk on his deathbed. Having received the last rites and preparing to breathe his last, he drew himself up and expired with the words, "And . . . if there's . . . nothing there . . . when I get there . . . some b——— is going to pay for it." We cannot explore the relationship between science and faith effectively without recognizing that science has its own spirituality which, at first sight, has some parallels and some conflicts with religion. Like the monk in the story, the scientist works within an ascetic tradition. Like the monk in the story, the scientist has expectations about reality which are the mainsprings of scientific commitment.

At the very mention of the word 'spirituality', both scientist and theologian find it hard to suppress an audible groan. To both it speaks of pietism and mysticism which submerge public reason beneath a torrent of personal emotion. However, if we are to have a complete understanding and synthesis of science and faith, we have to recognize that the methods and content of science and religion are grounded

in a third dimension which undergirds the human dialogue with reality. *Spirituality* is nothing less than that orientation of the human spirit toward reality which motivates, directs, and sustains our encounter with the unknown. It embodies our assumptions about the nature of reality, the state of mind normative for the pursuit of truth, the appreciation of the barriers to knowledge, and the sacrifices which must be made on the journey. The conflict between science and religion, between reason and faith, is as much a conflict of spirituality as it is a conflict of content.

In its attempt to claim 'scientific' objectivity, theology eschews on a day-to-day basis any reference to its grounding in spirituality. Scientific papers simply do not begin that way because, in the public imagination, spirituality is associated with that very subjectivity that science has forsworn. Yet the sacrifice of subjectivity, in a broader context, is itself the spirituality of scholarship. The fact that there is no need to make such fundamentals explicit on a daily basis does not mean that there is no such context or that theology has no obligation to make it explicit once again in dialogue with sciences. Indeed, one contribution theology can make to the dialogue is to draw out from the sciences that spirituality which characterizes the scientific community.

Some of the great theologians of the past have made this context explicit in their writing. It is tempting, but probably mistaken, to see this as a devotional gloss on writing that would otherwise stand alone philosophically. One of the clearest exponents of the spiritual context of theology is Anselm of Aosta. His well-known *Proslogion* only begins to make sense as 'argument' in the context in which the author himself has set it. *Inter alia,* we note that the preface contains a statement of his urge to find a better (more economical) argument which "if it were written down, would give pleasure to any who might read it" (1973, 238). He describes his attempt to strip away all except that which is directly relevant to his pursuit of truth, his sense that there are barriers to his understanding in the form of the greatness of the object of his investigation and the limitations imposed by the ('sinful') human condition (1973, lines 27–49). The dialogue between the investigator and reality is expressed in this cultural context in the form of prayer. Anselm approaches reality as if it were best treated as a 'nurturing Thou'. He sees the resolution of his question as just as much 'given' by reality itself—the product of 'grace'—as it is wrenched from the reluctant clutches of reality by the relentless assault of the human intellect (see, for example, 1973, lines 158, 227–230). The preamble issues in his famous "credo ut intelligam" which, at first sight, seems like the abrogation of objectivity and the

first step on the wide road to self-deception. But from another perspective Anselm raises the important question, "What is it necessary to believe in order that we may understand?" Augustine, an earlier great exponent of the dialogue as a basis for theological discourse, has a similar credo: "I have sought Thee, and have desired to see with my understanding what I believed" (Augustine 1983, 227). His chapters on time in the *Confessions* (1983, 163–175) embody many of the same presuppositions about the nature of reality and how best it is to be explored.

Einstein writes of the affective element in scientific motivation: "I maintain that cosmic religious feeling is the strongest and noblest incitement to scientific research. Only those who realize the immense efforts and, above all, the devotion which pioneer work in theoretical science demands, can grasp the strength of the emotion out of which alone such work, remote as it is from the immediate realities of life, can issue. . . . You will hardly find one among the profounder sort of scientific minds without a peculiar religious feeling of his own." We also note that Einstein sees this element as most highly developed in the 'pure' sciences and as something that few truly appreciate:

> Those whose acquaintance with scientific research is derived chiefly from its practical results easily develop a completely false notion of the mentality of the men who, surrounded by a skeptical world, have shown the way to those like-minded with themselves, scattered through the earth and the centuries. Only one who has devoted his life to similar ends can have a vivid realization of what has inspired these men and given them the strength to remain true to their purpose in spite of countless failures. (Einstein 1979, 28)

Einstein hints here at an ascetic tradition of science which has its roots in religion and philosophy. The Platonic Socrates in *Phaedo* observes: "Every seeker after wisdom knows that up to the time philosophy takes it over his soul is a helpless prisoner, chained hand and foot in the body, compelled to view reality not directly but only through its prison bars, and wallowing in utter ignorance. . . . [Philosophy] points out that observation by means of the senses is entirely deceptive, and she urges the soul to refrain from using them unless it is necessary to do so" (Plato 1954, 135–36). Socrates requires the asceticism of the senses so that the philosopher can better ponder reality in itself. The senses are a distraction from the process of knowing. Einstein (1979) expresses almost the identical statement: "He looks upon individual existence as a sort of prison and wants to experience the universe as a single significant whole." The scientist today practices a 'reverse asceticism' close in spirit to that described by Russell (1961,

789) when he writes of the rewards of *renouncing* the 'higher way of knowing'. The insistence on 'data' and 'experiment', the implied determinism of science, are part of the sacrifice which the scientist makes in order to know fundamental truths about the universe. To suggest that the scientist should do something different, or to suggest another way of knowing, is to invite the monk to break his vow of chastity.

The inherent asceticism in science is the price of its rewards. It is accepted because of expectations most scientists share about the structure of reality. Whatever the origin of these expectations, they are real and powerful. Unless they are appreciated, our ability to relate science to faith will be incomplete. There are three features of the scientist's expectations about the world and his or her reasons for trying to understand it. They are, in part, the motivation of the scientific endeavor.

First, rightly or wrongly, scientists believe they are engaged in exposing *reality itself*. Scientists probably do not believe they are playing games with models. They are playing 'for keeps', with truth as the prize. However much the reverse may be argued on rational grounds, scientists certainly behave 'as if' they take their fundamental findings with ultimate seriousness. Science would lose its appeal *and most, if not all, of its adaptive significance* if we were merely drawing beautiful pictures. There would be nothing to choose between a picture of a unicorn and a picture of the double helix. Einstein articulates the experiential support which the history of science imparts to an approach which treats the *phenomena* as if they reflect an objective and external reality which demands our adaptation. Contrasting the creative freedom of the novelist with that of the scientist, he writes: "[The scientist] may, it is true, propose any word as the solution; but there is only *one* word which really solves the puzzle in all its forms. It is an outcome of faith that nature—as she is perceptible to our five senses—takes the character of such a well-formulated puzzle. The successes reaped up to now by science do, it is true, give a certain encouragement for this faith" (Einstein 1956, 64).

The second implicit expectation which undergirds most scientific activity is the expectation of simplicity, often given operational expression in the principle of parsimony or Occam's Razor. The most informative theories are those which encompass the greatest range of data with the smallest number of parameters. In statistical modeling this principle is actually given numerical formulation in such coefficients as "Aikake's Information Criterion" (Aikake 1970)—a coefficient which judges the value of a model as an increasing function of how

well it fits the data and a decreasing function of the number of principles in the model. Leibniz expressed this expectation most cogently: "Thus we may say that in whatever manner God might have created the world, it would always have been regular and in a certain order. God, however, has chosen the most perfect that is to say the one which *is at the same time simplest in hypotheses and the richest in phenomena*" (Leibniz 1960, 255). Einstein expresses the same principle in less directly theological terms. "The aim of science is, on the one hand, a comprehension, as *complete* as possible, of the connection between the sense experiences in their totality, and, on the other hand, the accomplishment of this aim *by the use of a minimum of primary concepts and relations*" (Einstein 1956, 63).

Layzer points out that the principle of parsimony is related to, but not necessarily identical with, the principle of 'overdetermination', which reflects the scope of data encompassed by a theory. "Overdetermination has a qualitative as well as a quantitative aspect, and the qualitative aspect is more important. Newton's theory is strongly overdetermined not only because it furnishes very accurate predictions of planetary motions but also because it explains, at no extra cost, a host of qualitatively different phenomena" (Layzer 1984, 19). It is this strong appreciation of the importance of overdetermination in the best scientific theories which probably lies behind Lakatos's crucial understanding of the difference between 'progress' and 'degeneration' in science (for example, Urbach 1974). A 'progressive' theory grows by predicting and explaining an ever-widening range of quantitatively and qualitatively different phenomena at little cost in terms of increasing complexity. A 'degenerating' theory perishes by the successive accretion of new principles to account for novel and anomalous observations.

Lastly, but not least controversial, is the aesthetic principle. There may be a 'logic of scientific discovery' locally, but in a more global fashion the scientist's sense of what is 'ugly' keeps alive the quest for a better solution. The sense of what is 'beautiful' plays a significant part in deciding when the truth is at hand. A sense of what is 'elegant' determines the degree of enthusiasm for a new scientific strategy. The passion for simplicity and the appreciation of beauty are closely allied in scientific spirituality. Perhaps the clearest statement of a scientist's aesthetic sense is found in Watson's own preface to *The Double Helix*, in which he describes "the spirit of an adventure characterized both by youthful arrogance and by the belief that the truth, once found, would be simple as well as pretty" (Watson 1969, ix). We can argue whether the aesthetic principle in science is innate to the scientist or

reinforced by applause at the past success of logic and ingenuity. However, we can scarcely deny the power of the aesthetic principle in motivating the continued search for improvement in an unsatisfactory theory and in our recognition that we have accomplished our scientific goal. Writing about the motivational power of the search for unity and simplicity, Einstein observes: "We do not know whether or not this ambition will ever result in a definite system. If one is asked for his opinion, he is inclined to answer no. While wrestling with the problems, however, one will never give up the hope that this greatest of all aims can really be attained to a very high degree" (Einstein 1956, 63–64).

.
The Shape of Exploration

Others are more qualified than I to perform a detailed analysis of the scientific method. However, any understanding of the relationship between theology and science has to begin with an appreciation of the stages of science. It is, for example, essential in appraising Pannenberg's position to know whereabouts he is in the scientific cycle. Depending on which part of his work is considered, we may get a different answer. To a first approximation, we can identify three main stages of any scientific endeavor. These are the taxonomic phase, the hypothetico-deductive cycle, and the paradigmatic, technological phase. The structure of science is similar to a fractal—a graph which, under successive orders of magnification, resolves into ever smaller components which have that form which is also apparent at a higher level. When we look closely at a scientific enterprise we will find eddies within the overall swirl which have essentially the same components.

The taxonomic phase is regarded by many as 'pre-science'. Typically, taxonomy is looked down upon by 'real' scientists. Biologists, for example, tend to see anthropologists as only engaged in taxonomy. The taxonomic phase has two principal facets: description of reality (phenomenology) and classification of that which is described. It is the phase of deciding what needs to be explained, identifying those contours of reality which demand our special attention, setting the subject-matter of a discipline.

The hypothetico-deductive cycle grows out of taxonomy and consists of 'science in earnest'. It is this phase which has commanded the most serious attention of philosophers of science because it is usually seen as that aspect of science which appears most of all to set it apart

from the humanities, including theology. This is the cycle which we may characterize as 'theory and experiment' or 'conjecture and refutation'. The hypothetico-deductive cycle tries to account for the significant contours of reality in terms of fundamental mechanisms. It is the search for how things 'are'. If the contours are properly drawn in the first place, the mechanisms may emerge more readily. Badly drawn contours (that is, poor taxonomy) may add only more noise to an already confusing picture. The most effective taxonomy is guided by theoretical principles, as the history of evolutionary taxonomy testifies.

Finally, when mechanisms are understood, science enters the paradigmatic or technological phase. It is the phase of exploitation. More examples are accumulated, details are worked out, implications are drawn. At any time, the alert and prepared mind may encounter a new puzzle which engages its attention and demands new theoretical and experimental treatment.

If this brief analysis reflects the experience of science at all accurately, then we have to ask Professor Pannenberg where his ideas fit in. Do they belong to the taxonomic phase? Is he offering theoretical constructs? Or some kind of strategy for experimentation? My sense is that he is suspended somewhere between taxonomy and theory. But there are occasional hints of experiment. In *Human Nature, Election, and History* (1977) he develops the challenging thesis that we cannot understand history in purely political or economic terms. That is, the current contours are wrongly drawn so that the theories predicated upon them cannot predict all the empirical data. He thus argues that the contours may be drawn better if we recognize the empirical necessity of theological constructs. Coming to Pannenberg as a scientist who had read Barth and Tillich, I found it both startling and exciting that a theologian was laying claim to the empirical world in objective as well as existential terms. He writes: "As long as the basis of historical reality is seen in political and economic structures, religious belief can be treated as a secondary, if somewhat strange expression of those supposedly more basic social structures. . . . But if religion itself is taken seriously as basic for the social system, . . . historical continuity (or discontinuity) must then be understood finally in religious terms." He then continues to clarify that this does not require treating religion in supernatural terms, as historians suspect. Rather, "theological language need not represent an authoritarian or speculative imposition upon historical reality as critically established. Theological language can function in a descriptive way, open to examination and revision" (Pannenberg 1977, 86–88). In Pannenberg's mind, theology has clearly

entered the public domain—a thesis which is underscored time and again in *Theology and the Philosophy of Science* (1976) and which, indeed, is the motivation of his work.

· · · · · · · · · ·
Biology and the Necessity of Faith

Theologians who try to lay claim to science have a problem because the content of science is continually shifting. Any science is a complex blend of that which is icon, fertile theory, and outmoded hypothesis. The life sciences are no exception. The double helix is icon; sociobiology is fertile theory; blending inheritance is outmoded. To what should the theologian turn for his science? Should it be the established icons or the fertile theory? Often it is to the simply outmoded. A biologist such as myself, who has devoted much of his professional career to the analysis of genetic and environmental influences on human behavior, experiences frustration in reading Pannenberg's *Anthropology in Theological Perspective.* The work begins, like so much of Pannenberg, in the empirical world: "Modern anthropology no longer [defines] the uniqueness of humanity explicitly in terms of God; rather it defines this uniqueness through reflection on the place of humanity in nature and specifically through a comparison of human existence with that of the higher animals" (Pannenberg 1985, 27). But how 'modern' is the anthropology in Pannenberg? Does it address scientific anthropology where it 'hurts' most or is it merely an eclectic aggregation of those anthropological ideas which are most convenient for theology? Ideas which play such a crucial part in Pannenberg's anthropology, such as those of Freud and Piaget, belong much more with the humanities than the sciences. At best, they belong to the history of science, to the taxonomic phase along with those early attempts to define the contours of reality which now only live on in the popular imagination and not in the corridors of science. At worst they are destructive distractions which, in the hands of a theologian, bind theology to a worldview which has the same emotional impact on the scientist as a claim to find the empirical base of theology in the findings of psychical research.

To some extent, this eclectic tendency to prefer the 'soft' end of the life sciences is rooted in Pannenberg's philosophy of science *(Wissenschaft)* which disavows the paradigms of the natural sciences in favor of an idiographic search for meaning and coherence. There are two ways of viewing this preference. On the one hand, Pannenberg's approach expands and challenges the natural sciences to examine

some broader aspects of their data and methods (the 'theological dimension', perhaps?). On the other hand, it presents a premature dichotomy between scientific and humanistic epistemology. It softens the challenge to theology from the scientific method by stating, in effect, that the scientific method, as it is embodied in the natural sciences, is not appropriate to theology. The expectation and hope of the sciences is different from this. The scientist is motivated, perhaps with the 'arrogance of youth', by a sense that many more aspects of reality could be explored scientifically than are currently realized, if only we had a better understanding of what science was and how better to draw the contours of reality. Pannenberg, it might be argued, has sold out to the humanities. Fortunately, the question is still alive. Philip Hefner (1988) and Nancey Murphy (1988), for example, have recently attempted to analyze the structure of theological theory from the standpoint of Lakatos's philosophy of science (see also Chapters 5 and 17 of this volume). The point is that, even if theology can show its methods to be consistent with those in the humanities, it will still not be able to lay claim to the hard sciences unless it either shows a further methodological connection to them or convinces the scientist that the data require a layer of analysis which demands another approach.

Where does theology go for its science? It is a common misconception, even among scientists, that science is about looking for the 'evidence *for*' something. But science thrives not on asking what is right about a theory but on asking what is wrong with it. Pannenberg has embraced the data in principle, but has not yet embraced them where they hurt most. He accepts as 'science' many propositions that are under very hard scientific scrutiny at the moment. We may cite but two examples. First, he deals in universals and seeks that which is characteristic of the species but which delineates *Homo sapiens* from our nearest neighbors in the phylogenetic tree. Second, he regards the most salient features of the species as cultural rather than genetic. The stress on universals is unsatisfactory for two seemingly contradictory reasons. First, the differences between humanity and the other primates can be measured on a variety of scales. On the genetic scale of average differences in DNA, the differences are slight. What the anthropologist sees as the very foundation of the discipline, the biologist sees through a more distant glass and the physicist from still further away. I recall an astronomer remarking that molecular biology was really "rather boring" because it dealt with such a small part of reality. The molecular geneticist feels much the same about anthropology. The other problem with universals is that they are not. Judith Plaskow (1980), for example, has drawn our attention to sex differences in the construction and interpretation of theological themes. The same problem

emerges, and has to be taken with equal seriousness, at a level which is even more fundamental. When biologists stand very close to a species, and humanity is no exception, they are struck by diversity. That is, although humans are isomorphic for upwards of 99 percent of their DNA, the remaining 1 percent which is polymorphic (that is, 'variable') creates a lot of interest, texture, and excitement for the biologist. Some of these implications are fundamental for an empirical theology, and Pannenberg has skirted around these in an anthropology which is focused on universals. These implications need to be explored briefly.

The genetic diversity of the human species gives the scientist a lever on why we are the way we are. Professor Pannenberg, accepting the a prioris of cultural anthropology, dismisses sociobiology in half a page (1985, 160), and assuming that there is no other acceptable biological paradigm, leaves a predominantly 'cultural' model of the human species as the dominant theme of his anthropology. This thesis needs to be examined and may be questioned in the light of extensive published investigations of human behavior. Those classical dimensions of human behavior—cognition, affect, and sociality—which play such a significant part in theological reflection on anthropology, do not have a life independent of biology. The ability to think, feel, and socialize shows great diversity among members of the species. Where scientists have taken the trouble to look (see, for example, Eaves, Eysenck, and Martin 1989) the dominant causal theme is as much genetic as cultural. A theology which lays claim to science, therefore, has to be prepared for the truth to be different from what it would like. The point is that there is, within a human population, diversity even in the sensitivity of moral judgment and belief in God. It is commonplace to identify the source of such variation with the influence of training (in a behaviorist paradigm) or 'sinful bloody-mindedness' in a conservative theological paradigm. However, as Martin and his associates (1986) have shown, the discussion of such differences cannot be isolated from a discussion of the way in which genetic differences operate in human development. Some people appear to be genetically predisposed to adopt 'more religious' or 'more moral' values than others by the standards of the present culture. So diversity of theological perceptions is not just a problem for the sexes, it is a fundamental problem at the individual level.

There are various possible responses to such data which were exemplified in the discussion of the role of genetic differences in intelligence in the 1970s. Arthur Jensen (1972) documents the political reaction which followed the publication of his article in the *Harvard Educational Review* in 1969. Peter Urbach (1974) provided a scholarly review

of the empirical literature as it was seen through the eyes of a philosopher of science. Such controversy presents a real problem for theological anthropology. If the issue can ever be resolved it may make a fundamental difference to the direction that anthropology takes. The scientific facts and theories are not neutral theologically. At the very least, the biological data suggest that the diversity in sensitivity of people to the language of preaching and the symbols of liturgy has to be taken more seriously than has sometimes been the case. Theological language about 'election' and 'hardness of heart' needs to be re-examined. Pannenberg (for example, 1977) considers the role of the church in history from an eschatological and symbolic perspective which does not require the religious confession of everyone in society. Second, we may need to re-examine the notion of 'sin' in the light of our biological heritage. Perhaps our current range of adaptive social responses reflects where we have come from biologically and is still 'out of step' with the norms proclaimed in the Judeo-Christian tradition. This gap between givens of our biological ancestry and our cultural present may be part of the reality that is known theologically as 'original' sin.

Are there biological realities which profitably can be handled with theological constructs? Or, at least, can we identify those biological realities which were once the raw material of theological construction? Are there biological realities which are inconsistent with theological constructs past or present? Are there empirical realities which are ignored by biology and history that only theology can cope with? Is there, in Pannenberg's terms, a theological dimension to the data? There may be a perceived danger that we are about to embark on a search for the God of the gaps. In one sense, this may be true. But we are not seeking those gaps in reality which still need an explanation (as DNA gives an explanation of inheritance) so much as those phenomena in the midst of reality to which the language of religion refers and to which religion is the attempt to adapt.

It takes little reflection to see that the icon of the double helix may function theologically as well as scientifically. In the category of biological realities which may provide the raw material for theological construction we may cite three: namely, *givenness, connectedness,* and *openness.* To a greater or lesser extent, the DNA encodes part of the moral and spiritual history of our race. At the very *least* it encodes those capacities to acquire and create culture and to behave socially. The affective responses to data in the form of loves and fears are not easily amenable to cognitive processes precisely because they are given by our ontogeny and phylogeny. They emerge, as far as our

experience is concerned, from our origins; they predate our individual consciousness of the world. Indeed, the 'data' on which such responses were based are long since gone and may even have changed. The distinction between cognition and affect as mechanisms of adaptation is probably fundamental and is recognized implicitly by Theissen in his distinction between science and faith. Science is primarily cognitive and is concerned with our colonization of the novel realities that continually demand our individual and corporate attention. It is fundamentally exploratory and experimental. Scientific risk—the process of conjecture and refutation—is the adaptive response to new territory. Faith is also an adaptive response but is primarily affective. It mediates between our evolutionary past and our future. It deals with those adaptive affective responses which form part of that 'collective unconscious' which is now better regarded as the molecular image of the lessons of our evolutionary past. Such may be our aesthetic response to sunrise, our sexual response to spring, or the narrow scope of our practical altruism. Using such responses is based on the assumption that our future will have something in common with our past. In theory, this notion is testable empirically because our evolutionary past leaves its marks upon the way genes work (for example, Mather 1966).

The concept of givenness is one to which theology has long laid claim and which biology serves merely to underline. Friedrich Schleiermacher's recognition of *absolute dependence* as a fundamental theological construct is a development of a theme which can follow two paths. These appear to be the two paths described by Anselm. In the preface to *Proslogion* he comments on an earlier work: "When I reflected that this consisted in a connected chain of many arguments, I began to ask myself if it would be possible to find one single argument"; he then describes the oblique and elusive quality of his famous ontological argument (Anselm 1973, 238). What is it, in reality, that lies behind the empirical fact that people have an idea of God? We can trace the network of givenness to nameable and describable levels, each of which is empirically necessary to account for the other. Who I am today is the product of my ontogeny and my education. These in turn are given with my history, my phylogeny, and so forth. And at the highest level, there 'has to be' that which is ultimately 'given', which encompasses and enables the totality of givenness—"This being is yourself, our Lord and God." In his commentary on Anselm's ontological argument, Barth observes that "what is meant is . . . not the *existere* of objects . . . but the *existere* of Truth itself which is the condition, the basis and indeed the fashioner of all other existence, the simple origin of all objectivity" (Barth 1960, 98). The evolutionary biologist is

tempted to speculate that the very constructs with which we approach reality bear the marks of our biological history much as the eye and nervous system of the frog respond most readily to those stimuli which demand its most urgent adaptation. Irenaeus, in responding to the gnostic chain of creation which places the 'real God' far from creation, affirms the intimate connection between the reality of God and the creation: " 'And God formed man, taking the clay of the earth, and breathed into his face the breath of life.' It was not angels, therefore, who made us, nor who formed us, nor anyone else, nor any power remotely distant from the Father of all things" (Irenaeus 1985, 487). Theological construction is not necessitated only at the end of some causal chain, or chain of being, but becomes necessary by the very 'fact' of givenness—being itself. "It is he who has made us," sings the psalmist, "and not we ourselves" (Ps. 100:3). Following Burhoe, it doesn't matter whether we call it God or natural selection, it is that to which we must bow our heads and adapt.

The connectedness of reality receives its biological focus in the theory of evolution and the molecular basis of life. Our DNA provides the stable identity of the individual through the successive rounds of growth and metabolism; it is the fragile thread of immortality between ourselves and our remotest ancestors; it is the link of kinship between ourselves and the rest of the living world. Gregory of Nyssa observes: "For neither does our being consist altogether in flux and change . . . but according to the more accurate statement some one of our constituent parts is stationary while the rest goes through a process of alteration. . . . But to our soul which is in the likeness of God, it is not that which is subject to flux and change by way of alteration but this stable and unalterable element in our composition is allied" (Gregory 1954, 418).

The immortality of the living world is quite different from that which is presumed in popular Christian religious belief. Whilst none can presume the arrogance of certainty, few biologists would build any personal hopes on their own conscious survival. "You are dust and you shall return to dust" (Gen. 3:19) speaks with renewed power to the biologist for whom consciousness emerges from DNA and is so intimately bound with the organized configuration of matter that characterizes rational life. Rosemary Ruether is one of few theologians to have dealt explicitly and openly with the biological reality of death: "What we know is that death is the cessation of the life process that holds our organism together. Consciousness ceases and the organism itself gradually disintegrates. . . . There is no reason to think of the two as separable, in the sense that one can exist without the other." In a remarkable passage, Ruether uses the connectedness of reality as the

foundation for eschatological hope: "What then has happened to 'me'? In effect our existence ceases . . . and dissolves back into the cosmic matrix of matter/energy, from which new centers of the individuation arise. It is this matrix . . . that is 'everlasting' " (Ruether 1983, 257). The emergence of belief in personal immortality is a curiosity of biological and cultural evolution. Is it simply an outmoded model, a primitive solution to the cognitive puzzle of life and death? If this be the case, then why do such a large number of otherwise 'rational' people cling to a belief in their personal survival beyond death? To what can such a persistent belief be attributed? Is it an emotional 'confidence trick' played by evolution to encourage self-sacrifice? If this is the case, we might expect concern for immortality to decline with advancing years since the evolutionary pressure for sacrifice is likely to be greatest in the reproductive years. Ruether argues on dubious clinical grounds (1983, 235) that the concern for immortality is predominantly male rather than female. Does this imply that making war develops a stronger belief in immortality than producing the next generation? Such observations run counter to the consensus that women are 'more religious' than men. In our own studies we found that men tended to agree more than women with the statement, "There is no survival of any kind after death" (Eaves, Eysenck, and Martin 1989). Theodicy may also be a cultural expression of a more basic adaptation. Theodicy flourishes in religion in spite of all the evidence to the contrary. Evil is the greatest empirical test of the homeliness of reality. Cognition and affect are in conflict, and affect wins. Indeed, we may argue that it 'has to win' for the species to continue. Is our 'unreasonableness' in such matters supported by our biological heritage? Such a view seems to be implicit in Theissen's careful distinction between the adaptive roles of science and faith (1985, 18–41).

The phenomenon of connectedness corresponds to a sense of connectedness which is highly differentiated in some individuals. Francis of Assisi is a model example. It is clear that there are enormous differences in this sense, reflected in variation between individuals who are 'ecologically conscious' and those who are not. Like most other human differences, these probably are partly genetic but no one has yet looked. E. O. Wilson gives a personal account of this sense, and a characteristic evolutionary hypothesis to explain it, in his recent work *Biophilia* (1987).

The openness of reality has perhaps been one of the constructs in which biology offers the most serious challenge to theology, yet that which has in many respects proved most liberating. The principles of evolutionary biology account for the 'that' of life; they do not account for the 'what' of life. That is, they provide a mechanism to account for

the facts of diversity, change, and connectedness; but for the most part they do not account for *which* particular solution to a particular problem evolution adopted. Hence, for example, primates and cephalopods have exceptional eyes, but these are not homologous structures, having been evolved as independent solutions to similar adaptive requirements. The role of chance and uncertainty in evolution has made biologists shy of 'teleological' explanations. Probably the greatest problem that biologists have with their colleague Teilhard de Chardin is not his poetry, mysticism, or spirituality, but the overwhelming sense that he knew how things were going to end. Karl Schmitz-Moormann (personal communication), however, has drawn attention to the fact that *The Future of Man* (Teilhard 1964) presented a number of 'options' for the future which were contingent for their fulfillment on free human choice. The practice of science requires that we forgo such certainty. Scientists can hope, but they cannot be sure of 'what will be hereafter'. Popper (1961) argues the same case passionately in *The Poverty of Historicism*. This open aspect of biological reality has been addressed recently by Theissen. In a passage which could easily have been written by a biologist, he writes:

> The great progress in the modern theory of evolution lies precisely in the fact that it explains as an interplay of chance and necessity what was earlier interpreted teleologically by analogy with purposeful action. . . . In the present state of our knowledge we are compelled to assert that it is meaningless to smuggle teleological thought into the theory of evolution. Evolution is open. No one can guarantee that it will lead to a differentiated and higher form of life. (Theissen 1985, 164)

Recently, Dawkins has given a cogent and detailed new treatment of the role of chance in producing complex evolutionary outcomes in his book *The Blind Watchmaker* (1986).

In the face of openness, Theissen seems to suggest two theological positions. The first is the 'but' and power of faith which challenges and transcends the tyranny of facts. The second is the affirmation that 'something will turn up' because in the past 'something has turned up'—in the origin of life in the first place, or in the coming of Jesus in another. That is, the past gives us the basis for trusting the future. We cannot have certainty in the future but we have some power over it and new adaptive cultural 'mutations' have a good chance of occurring. It is perhaps churlish to point out that the new and successful mutations may be in the direction of atheistic materialism.

As a tangible focus of the dimensions of givenness, connectedness, and openness in the natural world, the double helix provides a universal foundation to some of the ideas expressed in contemporary

theology about the relationship between nature and spirit. At a recent seminar, a woman graduate student in biochemistry, speaking to theologians about the double helix, observed that the double helix "spoke of life, hope, and change." In her critique of Reinhold Niebuhr's theology, Judith Plaskow (1980, 70) isolates elements of women's experience which she regards as especially critical for theology. She observes that the experience of pregnancy carries with it the awareness of connectedness with nature and the sense that a woman is especially conscious of her dependence on reality as it is given to her. The experience of motherhood provides the foundation for an experience of creativity. In many respects, Plaskow reinstates here the *theotokos* icon—the classical post-Nicene image which expresses the notion of nature as the benign bearer of spirit *(vas spirituale)*, nurturer of humanity *(auxilium Christianorum)*, and gateway to the new age *(janua caeli;* see Solesmes 1962, 1857). Powerful though these images are, they nevertheless remain species- and sex-specific. The DNA icon provides a contemporary historical and physical basis for speaking about these realities which transcends the specificity of sex and species.

.
Biology and Bible: Theological Correlates of Biological Realities

Does biology remove the need for theology, or does it underscore a need for theology? If there is a need, does it come from the data or is it merely a return to some obscure mystical sense? I suggest tentatively that theology might feed on biology, and suggest that some of Pannenberg's ideas may help that process. The clue to where to start is found in Pannenberg's claims about the potential role of theology in history (1977). It is not that *supernatural* processes are required to understand history but that economic and political constructs do not represent adequately the contours of the reality of history. Economic and political theories alone are not dealing with the empirical data at a level which gives anything more than local insight into the mechanisms of historical change. The data cannot be understood without knowledge of the meaning and cultural impact of such religious constructs as *election, covenant,* and *judgment.*

How do humans *cope* with the biological and historical realities of givenness, connectedness, and openness? How does reflective and conscious matter respond to the fruits of its search for biological truth? Is it to search for more biological truth? Where will this lead? I hope that one day we shall have a more thorough understanding of the biological basis of human behavior. Perhaps some of the current models

of sociobiology may one day have the status of icons. But we shall still be left with the facts of our givenness, connectedness, and openness. These are constructs which describe the way things are; they are realities to which we have to adjust.

The brute facts of givenness, connectedness, and openness address us from our phylogeny, our history, and our individual ontogeny. What are we to do with them so that we are not consumed or intimidated by them? What is our place in this reality? The biblical tradition suggests a number of serious proposals to describe our place in the matrix of reality and to provide the foundation for meeting and developing that reality. Three related concepts which seem to be closest to the heart of the problem are *promise, covenant,* and *sacrifice.*

Promise provides the context of security and hope which enables humanity to address the openness of reality in confidence. The promise to Noah that "While the earth remains, seedtime and harvest, cold and heat, summer and winter, day and night shall not cease" (Gen. 8:22) provides both a context and a security for addressing the future. The context, "While earth remains," confines hope to that which concerns us most intimately; it does not pretend concern beyond the confines of the earth in which all human life and history is to be lived. If it is a geocentric hope, it is also a realistic and tangible hope. The promise to Noah is not concerned with entropy and, indeed, implicitly admits the possibility that one day 'the earth might not be.' The promise to Abram (Gen. 12:2–9) and the subsequent development of the patriarchal history enshrines the continuity of human life and the preconditions for history. Promise deals with the given assurances that reality provides.

Covenant draws humanity into the promise, as an agent whose life has implications for the future of the promise. The covenant at Sinai represents a point in human history at which was made the formal connection between promise and law, that is, it draws the necessary connection between the gift of the land—the fulfillment of promise—and the recognition of the just claims of God and neighbor: "Hear therefore, O Israel, and be careful to do them; that it may go well with you, and that you may multiply greatly, as the Lord, the God of your fathers, has promised you, in a land flowing with milk and honey" (Deut. 6:3). Covenant embodies the connectedness of reality and human destiny.

Sacrifice is the human price of promise and covenant. It represents the most intimate connection between humanity and the future. It is the 'price' of confidence that the openness of the future can be anticipated with hope rather than despair. It is the human choice which

'opens up' the future and extends the possibilities for life. The New Covenant tradition—symbolically portrayed in the last supper and given historical focus in the icon of the living and dying of Jesus—forges an indissoluble cultural link between transition to an age of harmony and fulfillment and the willing self-offering of crucial individuals. In theological terms, such individuals are particular embodiments of the 'Spirit' of God.

Pannenberg and Theissen both identify *spirit* as a central construct for understanding human life and history but each seems to emphasize a different component in the concept and the two can only be held together with the greatest of difficulty. These are the notion of spirit as that which recognizes and accomplishes our harmony with the realities of nature and the notion of spirit as that which drives humanity up and beyond the historical and phylogenetic confines of nature.

Towards the end of *Anthropology*, Pannenberg calls for revision of the traditional concept of spirit. It is not, as past dualism had asserted, a quality independent of matter. It is not consciousness, presumably since consciousness, unlike DNA and culture, is transient and ends with the decay of the central nervous system. It is not 'life', because we do not need any special word or principle for life. Pannenberg writes: "The concept 'spirit' as I intend it here . . . is . . . that which alone makes possible both consciousness and subjectivity (in the sense of the unity of conscious life) and that, at the same time, makes possible the unity of social and cultural life as well as the continuity [connectedness?] of history amid the open-endedness [sic] and incompleteness of its processes." In the next paragraph he then argues: "Common to all these phenomena is the operative presence of a sphere of meaning that *precedes individuals* and both constitutes and transcends their concrete existence. This sphere of meaning *discloses itself* to lived human experience. . . . Human beings even contribute to forming it, but *they do not first bring it into being as such*" (Pannenberg 1985, 520, my emphasis). For Pannenberg, spirit is an empirically necessary construct which describes a significant contour of reality as publicly accessible. Hans Küng has the elements of a similar view: "As the philosopher and the theologian in practice live every day by the 'functioning' of mathematics and the natural sciences, so the mathematician and scientist live in practice—admittedly in a very different way—by the reality that makes possible and sustains the world of their phenomena" (Küng 1981, 115). This reality is not simply that 'divine rationality' which is outside reality but necessary to explain a lawful universe. Rather it is the fact of reality itself—the very fact that science has to speak of and deal with data—the things that are given.

Spirit is the name which embraces both the empirical phenomena of givenness, connectedness, and openness and the process which makes it possible to adapt to and live at peace with the fact that we are not self-generated, independent, or sure of our destiny.

But such a spirit is not simply the spirit of passive acceptance, because it is also the process of faith which is able to deny and transcend the tyranny of fact in the present. "To this degree," says Theissen, "the experience of the Holy Spirit is a specifically human experience. It brings human beings into conflict with the biological, cultural and cognitive systems in which they live" (Theissen 1985, 166). It is that which makes us deny the reasoned arguments of sociobiology, not intellectually as a coherent account of the phylogeny of the now, but existentially as a pattern to shape the future. It is that which gives humans the quality of 'standing up'—*anastasis*—from the matrix of givenness and connectedness and engenders the hope that the future will transcend the past.

· · · · · · · · · ·

From *Zygon: Journal of Religion and Science* 24 (June) 1989, 185–215. By permission.

· · · · · · · · · ·

References

Aikake, H. 1970. Statistical Predictor Identification. *Annals of the Institute of Statistical Mathematics* 21:243–47.

Anselm of Aosta. 1973. *Proslogion*. In *The Prayers and Meditations of St. Anselm*, trans. Benedicta Ward, S. L. G., 238–267. Harmondsworth: Penguin.

Augustine of Hippo. 1983. *Nicene and Post-Nicene Fathers*. 1st series, vols. 1–3. Ed. P. Schaff. Trans. A. W. Haddan. Grand Rapids: Eerdmans.

Barth, Karl. 1960. *Anselm: Fides Quarens Intellectum*. Trans. I.W. Robertson. London: SCM Press.

———. 1975. *Church Dogmatics*. Vol. 1. Trans. G.W. Bromiley. Edinburgh: Clark.

Burhoe, Ralph Wendell. 1981. *Toward a Scientific Theology*. Belfast: Christian Journals.

Dawkins, Richard. 1986. *The Blind Watchmaker*. New York: Norton.

Eaves, L. J., H. J. Eysenck, and N. G. Martin. 1989. *Genes, Culture, and Personality: An Empirical Approach*. New York: Academic Press.

Einstein, Albert. 1956. Physics and Reality. In *Out of My Later Years*. Secausus, N.J.: Citadel.

———. 1979. *The World as I See It*. Abridged ed. Secausus, N.J.: Citadel.

Eysenck, Hans J. 1965. *Fact and Fiction in Psychology*. Harmondsworth, U.K.: Penguin.

Flew, Antony. 1955. Theology and Falsification. In *New Essays in Philosophical Theology*, ed. A. Flew and A. MacIntyre, 96–99. London: SCM Press.

Gregory of Nyssa. 1954. *On the Making of Man.* In *Nicene and Post-Nicene Fathers.* 2nd series, vol. 5. Ed. P. Schaff, trans. W. Moore and H. A. Wilson. Grand Rapids: Eerdmans.

Hefner, Philip. 1988. Theology's Truth and Scientific Formulation. *Zygon: Journal of Science and Religion* 23:263–280.

Irenaeus. 1985. *Against Heresies.* In *The Ante-Nicene Fathers,* vol. 1, ed. and trans. A. Roberts and J. Donaldson, 487–88. Grand Rapids: Eerdmans.

Jensen, Arthur R. 1972. *Genetics and Education.* London: Methuen.

Kuhn, Thomas. 1970. *The Structure of Scientific Revolutions.* 2nd ed. Chicago: University of Chicago Press.

Küng, Hans. 1981. *Does God Exist?* Trans. E. Quinn. New York: Vintage.

Layzer, David. 1984. *Constructing the Universe.* New York: Scientific American Library.

Leibniz, Gottfried von. 1960. Discourse on Metaphysics. In *The European Philosophers from Descartes to Nietzsche,* ed. M. C. Beardsley, 250–287. New York: Random House.

Lewontin, Richard C. 1974. *The Genetic Basis of Evolutionary Change.* New York: Columbia University Press.

Martin, N. G., L. J. Eaves, A. C. Heath, R. M. Jardine, L. F. Feingold, and H. J. Eysenck. 1986. The Transmission of Social Attitudes. *Proceedings of the National Academy of Sciences* 83:4364–68.

Mather, Kenneth. 1966. Variability and Selection. *Proceedings of the Royal Society of London: Series B* 164:328–340.

Merton, Thomas. 1972. *New Seeds of Contemplation.* New York: Laughlin.

Moltmann, Jürgen. 1967. *Theology of Hope.* Trans. J. W. Leitch. London: SCM Press.

Murphy, Nancey. 1988. From Critical Realism to a Methodological Approach: Response to Robbins, Van Huyssteen and Hefner. *Zygon: Journal of Science and Religion* 23:287–290.

Pannenberg, Wolfhart. 1976. *Theology and the Philosophy of Science.* Trans. Francis McDonagh. Philadelphia: Westminster.

———. 1977. *Human Nature, Election, and History.* Philadelphia: Westminster.

———. 1985. *Anthropology in Theological Perspective.* Trans. M. J. O'Connell. Philadelphia: Westminster.

Peacocke, Arthur. 1983. *Intimations of Reality.* Notre Dame: University of Notre Dame Press.

Plaskow, Judith. 1980. *Sex, Sin, and Grace: Women's Experience and the Theologies of Reinhold Niebuhr and Paul Tillich.* New York: University Press of America.

Plato, 1954. Phaedo. In *The Last Days of Socrates,* trans. H. Tredennick. 99–183. Harmondsworth, U.K.: Penguin.

Poe, Edgar Allen. 1983. Sonnet to Silence. In *Anthology of American Poetry,* ed. G. Gesner. New York: Avenal.

Popper, Karl. 1961. *The Poverty of Historicism.* London: Routledge.

Ramsey, Ian. 1966. Talking about God: Models, Ancient and Modern. In *Myth and Symbol,* ed. F. W. Dillistone, 76–97. London: S.P.C.K.

Ruether, Rosemary R. 1983. *Sexism and God Talk: Toward a Feminist Theology.* Boston: Beacon Press.

Russell, Bertrand. 1961. *History of Western Philosophy*. 2nd ed. London: Allen and Unwin.

Solesmes, Benedictines of, eds. 1962. The Litany of Loreto. In *The Liber Usualis*. Tournai: Desclee Co.

Teilhard de Chardin, Pierre. 1964. *The Future of Man*. London: Collins.

Theissen, Gerd. 1985. *Biblical Faith: An Evolutionary Approach*. Philadelphia: Fortress.

Tillich, Paul. 1951. *Systematic Theology*. Vol. 1. Chicago: University of Chicago Press.

———. 1959. *Theology of Culture*. London: SCM Press.

———. 1963. *The Eternal Now*. London: SCM Press.

———. 1966. The Religious Symbol. In *Myth and Symbol*, ed. F. W. Dillistone. London: S.P.C.K.

Urbach, Peter. 1974. Progress and Degeneration in the IQ Debate. *British Journal of the Philosophy of Science* 25:99–135.

Watson, James D. 1969. *The Double Helix*. New York: New American Library.

Watson, James D. and Francis H. C. Crick. 1953. A Structure for Deoxyribose Nucleic Acid. *Nature* 171:737.

Wilson, E. O. 1987. *Biophilia: The Human Bond with Other Species*. Cambridge, Massachusetts: Harvard University Press.

13

Behavioral Genetics, or What's Missing from Theological Anthropology?

............

Lindon Eaves

The Apostle Paul enjoined us to "speak the truth in love." In my discussion of Professor Pannenberg's work I tried to speak the truth as far as I could understand it. If at any time it seemed the fervor in my words was the fire of arrogance rather than charity, then I offer him my sincerest apologies and assure him of my most profound respect for his scholarship. There remain some significant issues on which I think progress still needs to be made.

I have been fascinated by Dr. Tipler's elegant presentation of his cosmological view of life, space, and time—not for the sake of theology but for the sake of science which has struggled to crystallize in beautiful simplicity the fundamental characteristics of reality and to open up new horizons of understanding. I can identify with that excitement because I have experienced it occasionally in my own research. But I emphasize that the thrill comes not indirectly through theology, but directly from science.

Why then should I, or any other scientist for that matter, take time off from science to try and talk another, unfamiliar, language? Why should I risk the ridicule of my colleagues for trying to take seriously a dialogue which they have long dismissed as contrary to 'all that is holy' in science? Why should I leave others to write the scientific papers I should write myself so that I can address theology?

The answer is simply this. My genetics, like every other science, is undertaken in a variety of contexts, of which one is the elusive whole of 'meaning' of which so many have spoken over the last two days and to which Professor Pannenberg has devoted so much of his scholarly endeavor. Theology struggles to provide a coherent cognitive framework for the context of all knowledge. It may not be what we would like, but it may still be the best we have.

I reiterate my admiration, expressed in the previous chapter, that Professor Pannenberg is virtually unique among modern theologians in believing that the data and theories of the sciences have a role in shaping theological inquiry. In that chapter I charged that his anthropology had rejected sociobiology in half a page and moved directly to

an exclusively cultural model of humanity. I expressed concern that there was no 'layer' of biology between thermodynamics on the one hand and culture on the other. Theology cannot attend selectively to the data that suit it, and I believe that there can be no adequate anthropology without biology. Biology knows very well where it is going, and it is going in the highly productive direction of furthering our understanding of the human condition.

Professor Pannenberg has stated his belief that there is no paradigm in human biology, or 'research program' in the sense of the late Imre Lakatos, which can begin to deal adequately and dispassionately with the phenomenon of man as it is apprehended in fullness by the theological anthropologist.

Professor Pannenberg knows the *sociobiological paradigm* and rejects it. I also reject it. I reject it because, at present, it is an elegant interpretive framework for relating social behavior to evolution but one from which I cannot see how to derive unique and testable hypotheses in humans. A cynic might argue that it suffers from some of the same problems as theology. Professor Pannenberg is familiar with the *ethological paradigm* and rejects it. I also reject it. I reject it for the same reasons he does—that the preliminary screening of data is not always blind to the theoretical presuppositions of the investigators, so that data collection and interpretation are frequently intertwined in a way that makes experimental science impossible.

There is, however, a third paradigm that does not feature in Professor Pannenberg's analyses. This is the *behavioral-genetic* paradigm, which I believe is central to any anthropology and which I shall now describe briefly.

Saint Paul had the humiliation of boasting only once in his career, to my knowledge—when his credentials as an apostle were challenged as he broke new ground for the Church. "Are they Israelites? So am I." Now I, too, have to boast a little to reassure Professor Pannenberg that the behavioral-genetic paradigm is not the minority interest of a British crank but is an active and highly productive research program in many laboratories apart from our own. The program contributes significantly by all the criteria of a respected research discipline in the sciences. Behavioral genetics does not just happen in Virginia but, among other things, boasts a center devoted to it at the University of Colorado and numerous research groups around the United States. It has an international professional society with over 300 members and publishes its own peer-reviewed journal, which ranks high in citation indices. In the ruthless court of the

National Institutes of Health (NIH) and the National Institute of Mental Health (NIMH), my colleagues in Virginia alone have research grants current and pending which total approximately $10 million. Though it is some time since I counted, I believe my colleagues and I in Virginia alone have, over the last four years, published some eighty papers in peer-reviewed journals including *Nature* and the *Proceedings of the National Academy of Sciences.*

Behavioral genetics has its animal models, yes. Some of us use fruit flies, others rodents, others infrahuman primates. But when we turn to our own species we do not deny, reduce, or ignore those cultural, cognitive, and affective processes which arouse our curiosity about the human species and which Professor Pannenberg has embraced so fully in his work.

Behavioral genetics does not reduce all human behavior to genetic processes—though, indeed, if that is what the data show then I am committed to bow to the data. Neither does it assume, *a priori*, that 'environment' and 'culture' are all there are to human variation—though, again, if that is what the data show, then I must bow to the data. Rather, behavioral genetics sees the individual person, the 'I' about which theologians and philosophers write so much, as the emerging product of a continuing dialogue between genes and culture. Our research program tries to characterize the parameters of that dialogue and to determine its mechanisms.

Behavioral genetics has become one of the dominant programs in research psychiatry—in the study of those disorders of the human condition so important to Freud, who features in Professor Pannenberg's anthropology. The question here is not so much *Are* genes important? as *Which* genes are important? The program has given new direction to the understanding of the mechanisms of behavioral development so important in the seminal ideas of Piaget. It has also become the dominant research program in attempting to understand the mechanisms which cause even normal individuals to differ from one another in their personalities, abilities, and attitudes.

Since many of you here today are unfamiliar with the empirical basis of this paradigm, I want to present some data from our own studies in Virginia. I do this with all the caution that I can muster because I know their deficiencies as well as their strengths. I have not even shown them to my colleagues in Virginia yet because I only very recently computed the summary statistics. Only the next couple of years will tell whether they will pass the test of peer review, though I have no reason to suppose they will not. I emphasize, however, that

these are by no means the only data which address the fundamental question, What causes human behavioral differences? Our book, *Genes, Culture and Personality: An Empirical Approach* (Eaves et al., 1989) describes the wealth of data prior to those I present today.

These data are only the tip of the iceberg of a much larger study of human variation. At present, we have data on about thirty thousand people in the United States. The individuals are chosen because they are especially important for the resolution of genetic and cultural effects. The data cover approximately 14,000 twins and as many as possible of their spouses, parents, siblings, and children. In table 1, I present only a foretaste of these data. I give the results for approximately four thousand pairs of adult twins on whom data on zygosity, religion, education, and social attitudes are currently complete. We have five types of twins when we allow for whether they are male, female, or male-female pairs and whether they are identical (monozygotic, MZ) or nonidentical (dizygotic, DZ) pairs. The column headed 'N' in the table gives the number of pairs of each type in the sample. Thus, for example, we have data on 997 complete pairs of unlike-sex dizygotic twins. The data in the other columns are 'correlation coefficients'—measures of similarity—which indicate the strength of resemblance between members of twin pairs of a particular type. I have scaled the coefficients so that a coefficient of 100 indicates perfect similarity of twins' measurements. A correlation of zero would indicate that members of a *twin* pair were neither more nor less alike than individuals paired at random from the population. Among the wide range of variables for which we have data, I present those for seven variables: church attendance, as an attempt to define religious commitment operationally; educational status, measured by years of education; and five clusters of social-attitude variables derived from responses to a checklist of twenty-eight items. These clusters may be named crudely as follows: 'sexual permissiveness', comprising attitudes toward such issues as abortion, gay rights, and changing roles for women; 'economic altruism', comprising attitudes toward such issues as taxation to benefit the underprivileged, and immigration; 'militarism', comprising attitudes toward the draft, military drill, nuclear armaments, and pacifism; 'political', reflecting mainly a preference for Democrats rather than Republicans, or vice versa; 'religious right', comprising attitudes toward the 'moral majority', segregation, censorship, and school prayer. These combinations of items are not derived *a priori* but reflect the natural patterns of interdependence between subjects' responses to individual items.

Table 1. Correlations between Twins for Religion, Education and Attitudes

Twin type	N	Church	Educ	Sex	Econ	Milit	Polit	Rel	Rt
Monozygotic									
Male	643	51	81	57	53	59	48	51	
Female	1338	62	79	65	52	50	47	47	
Dizygotic									
Male	372	39	52	42	37	36	34	31	
Female	671	45	61	50	31	32	28	40	
Unlike-sex	997	33	48	36	26	33	29	28	

Monozygotic twins are genetically identical, and members of a pair share the same family environment. Members of dizygotic twin pairs also share the same family environment but only have half their genes in common.

Twins are thus the 'bubble chamber' of the geneticist. Twins constitute a 'natural experiment' that makes visible those effects of genes and culture which cannot be seen as long as we confine ourselves to unrelated individuals or to what is 'typical' of the species. Without going into undue technicalities which may be found in the literature (see for instance Eaves et al. 1989) we may summarize the main features of the data by saying that individuals who are genetically identical—monozygotic twins—are significantly more alike in their religious behavior and social attitudes than individuals who only share half their genes in common—dizygotic twins. That is, the data are consistent with a significant contribution of genetic factors to variation in these dimensions of human variation which are often assumed, without proof, to be purely 'cultural' rather than biological.

This does not mean that culture and the environment played no part. If the environment played no role at all, then identical twins would be completely identical. They are not. So the unique environmental experiences of the individual contribute significantly to the unique behavior of that person. Similarly, if the effects of culture mediated through the shared environment of family members and the process of mate selection by parents played no part, we would expect the correlations of DZ twins to be no more than one half of those for MZ twins. This also is not the case, suggesting that either the family environment is also exercising a significant impact on outcome or that the transmission of genes and culture within the human family is influenced by the nonrandom choice of mates in the parental generation. Thus, for all the variables in question, we see that the effects of the environment are clearly important, but that the effects of genes cannot be ignored even when we turn to aspects of human behavior

which our common anthropological prejudice asserts are purely cultural phenomena.

Professor Pannenberg is generous enough to ask *me* what are the theological implications of these findings. "Who am I to go to Pharaoh?" I want to suggest three main issues that we need to take seriously in constructing a theological anthropology.

1. We cannot treat our species as if it were culture isolated from genes. There can be, as I suggested two days ago, "No anthropology without biology." Exactly what this means, I am not sure. Perhaps one possibility is that we have to recognize the seriousness of the gap between the word proclaimed in culture and the history represented by our biology. Is this part of what is traditionally understood by original sin? Religion, as far as we choose to practice it, and attitudes as far as we are prepared to express them, may only be made possible by the existence of men and women in a social and cultural milieu which makes law, religion, politics, and war possibilities. But whether we choose one or other of the options open to us is contingent both on who we are genetically and on the opportunities for learning to which we are exposed and to which we choose to expose ourselves.

2. We cannot construct a theological anthropology on universals alone. It is not enough to consider what makes 'man' differ from the 'animals'. We have to allow for the irreducible and non-negotiable uniqueness of the individual within society. It means taking seriously some of the things about people we don't like, for example, some of the odious opinions represented in our sample of the attitude space. We perhaps need to see humanity as selecting and creating more of the 'smorgasbord' of culture around it on the basis of the genotypes of individual members of the species.

3. Recognizing that differences in behavior are genetic in addition to, or even instead of, environmental does not undermine the concept of human freedom. The fact that some opponents of any but a zero contribution of genetic factors proclaim otherwise does not follow from any scientific analysis of data or any philosophical analysis of science. Any scientific anthropology is deterministic in that it seeks the 'causes' of human characteristics. In that sense, we are merely seeking the individual locus of what has traditionally been labelled 'freedom'.

· · · · · · · · · ·

The data chosen to illustrate this chapter were collected as part of an integrated series of research projects in collaboration with Drs. Heath, Hewitt, Neale

and Kendler of the Medical College of Virginia, supported by NIH grants GM30250, AG04954, AA07728, AA06781, DA05588, MH40828 and a gift from Reynolds-Nabisco.

.

Reference

Eaves, L.J., H.J. Eysenck, and N.G. Martin. 1989. *Genes, Culture, and Personality: An Empirical Approach.* London: Academic Press.

PART SIX
· · · · · · · · · ·
Methodology

Introduction to Part Six
••••••••••
Carol Rausch Albright

Dialogue between scientists and theologians raises basic questions of methodology: What do we mean when we say we know something? How do we gain such knowledge? Do theories—scientific or philosophic—correspond in some way with 'something out there'—with a concrete reality? If so, what is the nature of the correspondence? Many scientists take a 'commonsense' approach to such questions, readily assuming that they are talking about *Stoff* that in fact exists. Similarly, many theologians take certain theological propositions as nonnegotiable starting points for discussion. In order for the science-religion dialogue to proceed with any hope of constructive results, it is necessary to address such epistemological assumptions and to work for areas of agreement in regard to methodology.

In the essays that follow, Wentzel van Huyssteen surveys the development of Pannenberg's epistemology over a span of more than twenty years. In his analysis, van Huyssteen underlines the role of personal commitment in the formulation of any truth claims, whether in science or theology. He finds that, while such commitments are unavoidable, they need not negate the assertions made by those who hold them.

••••••••••
Van Huyssteen

In 'Truth and Commitment in Theology and Science: An Appraisal of Wolfhart Pannenberg's Perspective', which appears for the first time in this volume, Wentzel van Huyssteen addresses the question: Can Pannenberg succeed in making theological assertions about the world that are relevant to scientific reasoning? To find an answer, he traces the development of Pannenberg's thought, beginning with a 1967 statement that systematic theology is always shaped by the tension between two seemingly divergent trends: (1) all reality is finally understood only in relation to God's final revelation; yet (2) one cannot base one's reasoning on a revelationist position: it is necessary to find broad fundamentals that theology shares with other sciences.

In his search to reconcile this tension, Pannenberg rejected the one-sided demands of the positivist concepts of truth. Instead, he was guided in significant ways by Thomas Kuhn's theories of paradigms. Since science operates on the basis of such paradigms and related conventions, Pannenberg concluded, there can be no compelling reason for excluding the concept of God from scientifically admissable statements. All statements must be tested, as Kuhn said, through a process called *paradigm articulation*. Part of Pannenberg's paradigm regarding religious statements is that they must have an element of assertion, reality depiction, or reference. This is true because Christian faith depends entirely on God's reality; the implication is that God is revealed as a reality. Thus, Pannenberg concludes that theological statements are hypotheses, testable in principal.

At this point, cautions van Huysteen, Pannenberg "fails to confront the vital question of the intrinsic role of the theologian's subjectivity (his *ultimate commitment* and its conceptualization) in the theorizing of this theological reflection" (369). Pannenberg appears to be caught in a dilemma, between critical rationalist demands for non-commitment and the theologian's subjective religious commitment. In response, he observes that in our time access to the concept of God is no longer direct and self-evident; the God concept can be approached only indirectly, through human self-concept and experiential relations with surrounding reality.

Van Huyssteen believes such reflection can in fact be tested in terms of its own implications—implications for our experience and understanding of reality. Since our surrounding reality is incomplete and unrefined, and our experience of it is tentative and ambivalent, the concept of God necessarily remains a hypothesis, at least in terms of critical rationalist criteria.

However, van Huyssteen concludes, the critical rationalist criteria are ultimately intersubjective; it is not possible to draw a sharp distinction between scientific and metaphysical statements. What is needed is analysis of the shaping of rationality in both theology and science. It can be shown convincingly that rationality in each case can be determined by certain goals and criteria. For both, the supreme value seems to be *intelligibility*—seeking the best explanations of experience. Van Huysteen believes that rationality in theology encompasses both its experiential adequacy and epistemological adequacy.

At the same time there can be no strong form of justification for a *commitment to a commitment,* be it to scientific or theological norms. All such commitments involve beliefs that may turn out to be false. Science has been slow to adopt such noncognitivist views of metaphor.

But in fact, says van Huyssteen, theology can claim a historical record of experiential adequacy, and it can claim a form of truth approximation that could be directly relevant to progress in the sciences.

.
Sponheim

Turning from epistemology to theology per se, Paul Sponheim analyzes the consequences of Pannenberg's work for the latter discipline. In 'To Expand and Deepen the Provisional: An Inquiry into Pannenberg's *Anthropology in Theological Perspective*', which appears for the first time in this volume, Sponheim pursues three questions: (1) What would it take to demonstrate what we are talking here about demonstrating? (2) What would it mean formally for theology if that about which we are speaking here were demonstrated? (3) What would it mean materially for theology if that about which we are speaking here were demonstrated? He examines these questions largely in light of Pannenberg's *Anthropology in Theological Perspective.*

Meeting the criteria of question 1 would not require 'knock-down' proof in a dialogue between anthropology and theology, Sponheim asserts, since both disciplines 'live in ambiguity': "if it is the living who are being studied, presumably the studying itself will have some of life's venture about it." Sponheim would be satisfied if we could "show by illustration" rather than "prove." Minimally [where anthropology is concerned] there is required the showing of a certain relationship between the anthropological reading of reality and the theological reading . . . and that both nontheological and theological versions face the reality test" (379—381). The data should also show continuity: "the new must fall within a theory that also includes—and fulfills—the old."

What would it mean formally for theology if Pannenberg is right? Then anything that is real would have relevance for the work of theology, Sponheim asserts. Nontheological understandings of various aspects of reality would have to be considered and critically appropriated. Theology could not simply announce its own correctness without reference to other experiences of reality in the life of the culture.

Furthermore, the theologian would have to be held to a high standard of intelligibility, since theology would be required to address the common experiences of humankind. Apologetics would have to take place "on the terrain of the interpretation of human existence," in Pannenberg's own words. In addition, theology must be judged by the

extent to which it actually illumines understanding of experienced reality. Human experience of life could actually provide a falsifying move against a theological claim. Still, the goal remains 'to demonstrate', not necessarily 'to prove.'

What would such findings mean materially for theology? If secular descriptions are accepted as provisional versions of objective reality, then theology will be expected to deepen and expand the versions of reality found in these descriptions.

One secular version of reality to which Pannenberg pays particular attention is the notion of temporality. The future is an important element in his thought, and his notion of self-transcendence involves openness to the world within time. Self-transcendence occurs as humans struggle toward their destiny, which is to approximate the image of God. Since they have not yet attained such perfection, there can be no fall from original perfection. In Pannenberg's view of original sin (or its absence), it is unclear whether sin actually marks humans' necessary path in the world—and to what extent we bear responsibility for our own sinfulness, Sponheim points out.

Another key element is relationality. Pannenberg keys on psychological findings that the self is realized only in relationship with other humans, beginning with the development of basic trust during infancy. He 'deepens and expands' this concept by speaking of God as the only sensible object of basic trust in any ultimate sense. Sponheim, however, finds these formulations somewhat puzzling. One hallmark of a relationship, he believes, is "some measure of interaction, some sharing of causal power" (390); it is unclear how such could take place between God and humans. Certainly "the relationship spans differing ontological levels, to put it clumsily" (391).

The key to the puzzle may lie in the future, where Pannenberg believes causality lies. His complex reversal of time, in which the future, not the past, is the determining reality, is well known and reappears in the *Anthropology*. Here Pannenberg speaks of the "womb of the future," and asserts that "there is present in every historical moment the whole of life that in its historical course is still unfinished" (Pannenberg 1985, 515). Sponheim finds these references cryptic. "Is this to say that the future is determined and so the present is determined to end in that future, but that we do not yet see it to be so?" (393). Once again the themes of freedom and responsibility are at stake. In fact, Sponheim concludes, the ultimate future, which inspires ultimate trust, must in Pannenberg's thought determine reality even now. But what then happens to "the aching and challenging terrain of human choice and consequence which we know as history?" Spon-

heim asks (000). What do we make of Jesus's statement "Not everyone who calls me Lord, Lord, will enter into the kingdom of heaven, but he who does the will of my father who is in heaven"? The solution, perhaps, is that "God is to be trusted, to be sure, but not as the sole determiner of history. The human person would inappropriately trust God to do what God calls the human person to do. . . .This would be a relationship of unequals, but a relationship all the same. . . . And human life is thus the more important, for it exists from and before and for God," Sponheim concludes (394).

· · · · · · · · · ·
Clayton

Philip Clayton responds to Eaves, van Huyssteen, and Sponheim in his essay 'From Methodology to Metaphysics: The Problem of Control in the Science-Theology Dialogue', published here for the first time. As a unifying theme, he chooses the problem of controls: in and by the natural sciences; in the social sciences; in theology; and by metaphysics.

The issue of control for Clayton, may be summarized as follows: What are the standards for successful and unsuccessful endeavors in our field? He sees a "pressing question of self-definition and criteria for the emerging discipline of science-theology, including a specification of the argumentative standards that will regulate our claims." While some critics—labeled "postivists" by Clayton—deny the possibility of such dialogue, their arguments are "either arbitrary or self-refuting: either one gives no reasons to rule out meta-scientific reflection, or one becomes a metaphysician in trying to argue that metaphysics is impossible" (396–97).

In the current paper as well as earlier writings, Wentzel van Huyssteen has "made a convincing case that philosophy of natural science . . . provides an important science-theology link and an indication of the sort of criteria needed to govern theological assertions" (398). However, Clayton questions van Huyssteen's assertions that the roots of Pannenberg's thought are to be identified with Bartley, Albert, Popper, or Kuhn. Instead, he asserts that "Pannenberg's theory of rationality stems ultimately from a substantive theological position," including "his concern with universal history and his anticipatory ontology" (399).

Clayton agrees with van Huyssteen that "the rationality discussion in the philosophy of science *has* been an important guide to theology, perhaps the most fruitful science-theology link to date." But he

questions van Huyssteen's confident linkage of explanation with truth, since "philosophers of science just as often deal with the question of explanation in terms consciously opposed to correspondence truth," raising, instead, "questions of pragmatism, instrumentalism, and internal realism." Clayton concludes that on balance, "contemporary philosophy of science provides little inducement on its own to guide one from the provisional models of contemporary physics to the theological dimensions with which we are here concerned" (399, 400).

Lindon Eaves has appealed not to the philosophy of science but directly to scientific theories. He has used the term *icon* to denote scientific models or symbols of reality, of which DNA is the pre-eminent example. Those that "get that part of the world right must have their place within the structure of any final theory of reality" (400). Eaves sees religion's role as simply to appropriate such scientific building blocks. Van Huyssteen and Sponheim propose different and incompatible escape routes from this master-slave concept of the science-religion dialogue. "Van Huyssteen believes that science is a much more subjective mode of knowing than Eaves would allow, and Sponheim argues that scientific 'nodes' are themselves in need of the framework of metaphysics or ontology" (401).

As he begins to address this dilemma, Clayton sees issues of control in the human sciences as central. Whereas the icons of the natural sciences may in fact have basically 'got the world right', such examples are rare if not nonexistent in the human sciences. Eaves has asserted that in this critical arena, Pannenberg reduces the social sciences to the humanities, refusing to embrace the data of these sciences "where it hurts most." To Eaves, "classical dimensions of human behavior—cognition, affect, and sociality—do not have a life independent of biology" (402). In contrast, van Huyssteen supports the centrality of experiential factors in rational explanation. If the two positions could be mediated at all, says Clayton, it would be on the terrain of cultural anthropology, which could build on genetics while also leaving room for experiential factors.

Clayton finds in Paul Sponheim's article "hints of the sort of discourse that has the best chance to mediate this disagreement." Through Sponheim's work, "we arrive at the control that governs theological interaction with the human sciences." Clayton would describe it as follows: "Theology is one of many semantic worlds or meaning-complexes that individuals and societies can draw on in their attempt to understand human existence. When the beliefs that make up the Christian worldview can no longer be made coherent with the intellec-

tual, political, and ethical beliefs of contemporary believers, it will have failed the semantic test, the control of its ability to bestow meaning." Although such a test is not as rigorous as some would advocate, it does represent "a genuine intersection between theology and the human sciences, a genuine control over theological reflection, and therefore must be an integral component of science-theology discussions" (402–03).

Finally, as Sponheim points out, one must ask what general ontology, what underlying view of reality, Pannenberg advocates. To pursue the science-theology discussion is finally to seek "the broadest possible framework within which positions can still be formulated and reasons given for and against them." Pannenberg demands that such discussions be carried out in a rational manner, and he "has been absolutely explicit that the ground of this rationality must be metaphysical" (405). Sponheim is sympathetic to this metaphysical bent; van Huyssteen and Eaves are not—Eaves because of his reliance on science, van Huyssteen because of his appeal to experience. Yet, says Clayton, some sort of rational discourse is needed if there is to be any genuine science-religion dialogue—and "what is the control or justification for this sort of speculation if not metaphysical?" If metaphysical language is necessary, then we must—and necessarily will—look at metaphysical questions. This would be a radical shift for the dialogue, and unpopular in the United States. However, Clayton is now convinced that it is unavoidable: "When we begin to talk of provisional versions and objective reality, it is time to turn from methodology to metaphysics" (407).

· · · · · · · · · ·
Murphy

In 'A Lakatosian Reconstruction of Pannenberg's Program: Responses to Sponheim, van Huyssteen, and Eaves', Nancey Murphy (1) identifies key questions raised by three other symposiasts; (2) recasts Pannenberg's program along lines proposed by philosopher of science Imre Lakatos; and (3) shows how the recasting strengthens the program's hand against its critics.

Sponheim's questions center around the validity of Pannenberg's program and its potential consequences for theology. Van Huyssteen focuses on Pannenberg's methodology, pointing out an apparent conflict between commitment and fallibilism. Eaves suggests that Pannenberg avoids the difficult issues raised by the sciences, concentrating

instead on scientific ideas most useful to his program and tending to identify scientific method with the methods of the humanities or the 'soft sciences'.

Pannenberg "understands explanation as placing the phenomenon to be explained within a context that makes sense of the phenomenon" (411)—a methodology applicable to both the natural and human sciences. Murphy sketches the structure of Pannenberg's thought as concentric circles: each explanatory context fits within a larger context, which in turn fits within a larger context still. A larger circle may, however, enclose more than one smaller set of concepts. Thus, Pannenberg's theology is structured in two sets of concentric circles, one involving the texts of the Christian scriptures, the other representing human experience. Both sets are encompassed by a circle representing the Christian view of God.

Murphy proposes that Pannenberg's program could successfully be structured along lines specified by Imre Lakatos, in which a research program has a central theory (the hard core) and a set of auxiliary hypotheses (the protective belt) that enable data to be related to the theory. Auxiliary hypotheses may be modified when falsifying data make that necessary; the hard core is discarded only under extreme duress. A Lakatosian research program may be either progressive—tending to include more and more empirical content and make increasingly powerful predictions—or degenerating, in which the opposite is true. A progressive program has a life cycle: when immature it develops fortuitously, while a mature program develops in accordance with a plan, called a positive heuristic. A plan can progress by (1) predicting facts previously unknown; (2) relating to the theory facts previously known but considered either irrelevant or contrary to it; or (3) integrating an auxiliary hypothesis that already has a progressive track record of its own.

For Pannenberg's system, the 'hard core' may be summarized by the statement "The God of Jesus Christ is the all-determining reality." The 'protective belt' includes Pannenberg's theory of revelation as history, and various theories of interpretation—for example, Christian anthropology. These serve to relate the theory to currently available data, including not only the scriptural texts but data and theories from all areas of knowledge.

Murphy demonstrates that a Lakotosian methodology would empower the Pannenbergian program to compete, not only with other systematic theologies, but also with nontheological scientific and philosophical explanatory rivals. Its methodology would be less sus-

pect to such critics as Eaves. Giving the program a 'hard core' and a 'protective belt' would resolve the supposed conflict between commitment and fallibilism identified by van Huyssteen. The heuristic would clearly answer Sponheim's question, What would it take to demonstrate Pannenberg's claims, and, most important, clarify the path of progress for this promising program?

14

Truth and Commitment in Theology and Science: **An Appraisal of Wolfhart Pannenberg's Perspective**

• • • • • • • • • •

Wentzel van Huyssteen

In a very specific sense the *Leitmotiv* of Wolfhart Pannenberg's work has always been his conviction that the Christian faith, and especially theology as a reflection on this faith, has a universal credibility in our age. Any discussion on issues regarding theology and science in Pannenberg's thought will therefore have to deal with this central theme and driving force behind his work.

This essay will approach this issue and set forth a thesis in terms of the problem of the rationality of theology and of science. The shaping of rationality in both theology and science will therefore form the framework for dealing with the philosophical problems of truth, objectivity and commitment in Pannenberg's impressive and ever expanding body of thought. I am convinced that only by clarifying this central epistemological perspective can one eventually deal with the way Pannenberg relates theological reflection to the other sciences. Pannenberg's views on truth, on justification and objectivity—as reflected especially in his monumental work *Wissenschafts Theorie und Theologie* (1973)—is not only important but also often sadly lacking from many discussions concerning his perspective on the significance of the sciences for theology as such.

I therefore want to deal with Pannenberg's view on truth and justification in theology and then from that distill a model of rationality typifying his work. This obviously will have implications for his views on objectivity, on the relationship between theology and science, but also for progress in theology and science. With this I hope, at the same time, to have fulfilled the complex task of analyzing "what it might mean for theology to demonstrate that the data as described by the sciences are provisional versions of objective reality and that the data themselves contain a further and theologically relevant dimension."

What Pannenberg says regarding the data provided by a nontheological anthropology (above, 59) is certainly also true of the data provided by contemporary nontheological science: theologians should not indiscriminately accept the data provided by science and make

these the basis for their own work, but rather must appropriate them in a critical way. For me this "critical appropriation" means *not* asking the wrong questions, where science ends and where theology begins (cf. Wicken 1988, 49). It does, however, imply an analysis—from a philosophy of science point of view—of models of rationality that determine the way both theology and science work and whether these two might perhaps share a common or analogous epistemology on the level of intellectual reflection. Only in this sense could I personally understand what it might mean to lay theological claim to data described by the sciences (cf. this volume, 59).

Pannenberg has of course always and correctly maintained that a credible doctrine of God as creator must take into account scientific understandings of the world (cf. Pannenberg 1993, 29f). Theological talk about God as creator indeed remains empty if it cannot be related to a scientific description of nature. By this statement alone the rationality of science becomes directly relevant for the rationality of theology. Pannenberg of course senses this when he states that theological assertions concerning the world, although not formulated on the same level as scientific hypotheses of natural law, do, however, have to be related to scientific reasoning as such (1988, 7). Whether this is possible or not, is what this essay is all about.

· · · · · · · · · ·
Philosophy of Science and the Epistemological Claims of Theology

In the light of the problem of rationality in theology and in science, it is quite clear that no theologian dealing with these issues can evade the question of the epistemological status and validity of theological statements in terms of contemporary philosophy of science. And yet, although there have always been theologians who questioned the nature of theological thought, only few contemporary ones have purposefully taken up the challenge of justifying theology within the wider context of the philosophy of science.

In the context of current discussions of these problems the initiative was undoubtedly taken by Wolfhart Pannenberg who has opted, from a concern with problems specifically raised by the philosophy of science, for a patently argumentative theology (cf. van Huyssteen 1970) rather than any form of dogmatistic *axiomatic theology* based on the preconceived and unquestionable certainties so typical of positivism. Pannenberg has always been remarkably outspoken about systematic theological models in which, given their total neglect of the

critical question of theorizing in theology, a particular concept of revelation may so uncritically and ideologically assume an authoritarian character that no critical examination or justification is permitted.

The fundamental reasons for his broad approach may be found in the earliest development of his thought, long before his well-known book on the nature of theological science (Pannenberg 1973). In *Die Krise der Schriftprinzips* (1967) Pannenberg already makes the point that systematic theology is always shaped by the tension between two seemingly divergent trends: on the one hand, theology's commitment to its religious source, namely God as revealed in Jesus Christ and testified to by Holy Scripture; on the other, theology's assumption of a universal character transcending all specific themes in its striving towards truth itself, precisely because it would make statements on God. This universality emanates from the fact that reality, in its all-encompassing totality as God's creation, is not only dependent upon and committed to God but is in its profoundest sense incomprehensible without God (Pannenberg 1967, 11).

In Pannenberg's view it goes without saying that theology is, ultimately, fully and most profoundly concerned with God's revelation in Jesus Christ. Precisely as God's revelation, however, that revelation can be properly understood only if we realize that all knowledge and anything we might regard as 'true' or as 'the truth' must have some bearing on that revelation. As the Creator, God is not only creatively responsible for everything in our reality, but is greater than our present, created reality. Therefore, any aspect of that reality is correctly— albeit provisionally—understood only in relation to God's final revelation.

Given the universality of the concept of God, as logically implied in the concept of creation, Pannenberg has consistently maintained that systematic theology can never fall back on a *special* and epistemologically isolated *revelationist position*. It has therefore always been clear to him that theology could never exist purely as a 'positive church theology', isolated from the other sciences. Although such a *ghetto theology* might ensure an unproblematic coexistence with philosophy of science and the other sciences, it would have a radical impact on the universality implicit in the concept of God.

In the broad spectrum of theological disciplines, systematic theology, in particular, is directly concerned with this universal perspective. As such, it is committed to facing the problem of rationality. This not only raises the question of the broad fundamentals that theology shares with other sciences and of what constitutes the unique character of theological reflection; systematic theology also becomes the area

in which theology itself must be able to account critically for its own credibility and for the validity of its conceptual paradigm.

Specifically for the sake of the truth of the Christian message, systematic theology must take up the task of formulating and founding its concept of science in a confrontation with the perceptions of contemporary philosophy of science, and thus with alternative conceptions of the nature of science. For the sake of its intellectual integrity, theology can on no creditable grounds claim *privilege* in its pursuit of truth. If it did try to claim such a privileged position, it would be able to do so only by founding its thematics on arbitrary, irrational, or authoritarian grounds—a tactic that would in turn become the target of renewed criticism of theology itself.

In his debate with philosophy of science, Pannenberg (1973, 28ff) not only scrutinizes logical positivism and its pervasive effect on diverse scientific disciplines but also pointedly rejects both the positivist unitary ideal for all sciences, as well as the positivist influence that causes science to be constantly oriented and formulated on the model of the natural or 'mature' sciences.

Ultimately, however, Pannenberg's relationship with critical rationalism and with Kuhn's paradigm theory will be crucial to an evaluation of his views on theology and science. Although critical rationalism undoubtedly had a decisive influence on his thought, and he consistently—as will become clear—reveals links with Popper's thought, it is Thomas Kuhn's paradigm theory, in particular, that has guided him in the later phase of his enquiry. In his reflections on the nature and identity of theology he sought to liberate systematic theology, not only from the one-sided demands of a positivist concept of truth, but also from a too rigorous falsification criterion of critical rationalism, precisely to leave room for scientific validity in theological statements and theories. Whether Pannenberg has in fact succeeded in doing so, and how these various elements of his thought are interrelated, will have to be closely examined.

First, Pannenberg (1973, 43) points out that Popper, in his attempt to find a meaningful demarcation criterion that would transcend the one-sidedness of the positivist verifiability criterion, gave a central place to the falsifiability of theories in his model of the philosophy of science. In doing so, Popper was looking not merely for a criterion that would separate science and metaphysics, but also for a broad base on which the social sciences would be able to subject their hypotheses and theories to the falsification test.

Although Pannenberg (1973, 44ff), having outlined the well-known Bartley arguments, proceeds to discuss further themes from

critical rationalism without coming back specifically to the demands of Bartley's pancritical rationalism, it is clear that he is very strongly concerned with Bartley's sharp criticism of theology, namely that it too readily falls back on an irrational and fideistic premise as a final base for argument. In an evaluation of Pannenberg's theoretical model we shall have to consider very critically to what extent he has in fact avoided having his own thought definitively structured by the critical rationalist model. The crucial question will be to what extent Bartley's demand for a *commitment to noncommitment* has perhaps determined Pannenberg's development of his own answer to the question of objectivity and truth in theology and science.

These problems will come to a head when we proceed, whilst examining the origin of theological statements, to ask critical questions about the role and function of the theologian's own conceptualized subjective *commitment*. At this stage we might formulate a central critical question to Pannenberg: How does he justify the role of the theologian's personal religious commitment in the process of theorizing in theology, and also in the way he eventually defines truth and objectivity in theology and science?

In a critical discussion of the possibility of justification in theology, Pannenberg (1973, 52ff) examines in detail the main demands of critical rationalism. For our purposes—to determine not only the nature of the model of rationality Pannenberg adopts but also its origins—it is important to appreciate that Pannenberg follows Popper in his view that inductive reasoning and the principle of verification offer us no solutions to the question of scientific knowledge. A general rule is always applicable to an infinite number of instances: an infinity, however, of which only a limited number can be known at any given time. In Popper's view, therefore, generalizations can never claim absolute certainty, and for that reason the strict verification of postulated general laws is also impossible.

The basic propositions that must now act as objective criteria in the process of scientific thought (and in terms of which falsification might be possible) must, however, be testable on an intersubjective level, according to the principles of critical rationalism. Any discussion of critical rationalism will show that, with Popper, the old positivist ideal of value-free, objective knowledge has been turned into intersubjective correspondence. *Objectivity* thus becomes the characteristic of a certain group, realized by mutual criticism: a social matter that can no longer be founded purely on so-called atheoretical, self-evident 'facts'.

In this sense, basic propositions are data accepted on the grounds of a group's decision or agreement and may therefore also be called

conventions (Popper 1968, 106). The very objectivity operating here as a criterion is, however, dependent on the group that accepts it as objective, and would therefore also be subject to change.

Pannenberg (1973, 56) makes the further point that the implications of this type of consideration make it very difficult to distinguish absolutely between scientific and metaphysical statements. In fact, if the concepts and language in which experiences are scientifically described are a matter of convention, there can be no compelling reasons for pre-excluding the concept of God from the exclusive circle of scientifically admissible statements. For Pannenberg, then, it is clear that Popper's concept of the theory-ladenness of all observation, and his acknowledgment of the conventional nature of so-called objective statements, must ultimately lead to failure in his attempts to draw sharp distinctions between scientific and metaphysical statements. In Pannenberg's view, scientific statements are thus in themselves ultimately founded on general worldviews of a profoundly philosophical and/or religious nature.

This in itself implies, as Kuhn was to demonstrate so clearly, that hypotheses cannot be empirically tested within the framework of theoretically neutral observations; that testing must form part of a process Kuhn calls *paradigm articulation*.

From a philosophy-of-science point of view I would put it as follows: the personal involvement of the scientist, and therefore of the paradigm from which he lives and works, always plays a role, not only in the so-called context of discovery but also in the context of justification.

This conclusion Pannenberg reached in his own fashion, and in my view correctly, as far as critical rationalism is concerned. This in fact also shows Pannenberg's (1973, 57–60) spiritual affinity with Kuhn's thought. Kuhn (1970, 192) pointed out that even in the natural sciences the testing of hypotheses does not normally consist of direct attempts to falsify them but is, rather, a comparison of the capacities of various theories for providing meaningful solutions to certain problems. This clearly shows—for Wolfhart Pannenberg too—that the capacity for integrating and giving meaning to available data, and thus providing solutions to puzzles, is the primary principle in the testing of both strictly scientific and theological hypotheses.

Therefore Pannenberg, partly under Kuhn's influence, opts for a rationality model that must transcend the bounds of critical rationalism to allow for critical enquiry on a much wider front. Whether he thus succeeds in answering the question of the epistemological status and validity of theological statements, or in avoiding critical rational-

istic co-determination of his own conceptual model, will now have to be examined briefly.

· · · · · · · · · ·
Theological Statements as Hypotheses

Pannenberg's debate with critical rationalism had a lasting impact on the evolution of his own thought regarding the nature of theological science. In particular, Bartley's (1964, 215f) and Albert's (1968, 104ff) criticism of theology infuses his thinking on this theme. Albert's reproach that systematic theologians fall back too readily on a supposedly unique and esoteric epistemology as an ideological immunization against criticism, and Bartley's related reproach that theologians evade critical scientific questions by retreating to an irrational position of faith, ultimately become the focal points of Pannenberg's attempt to formulate a creditable theory of theology (cf. van Huyssteen 1988, 95ff).

This, together with Pannenberg's (1973, 266ff) rejection of Karl Barth's positivist revelatory response to the demands Heinrich Scholz had made of systematic theology, makes him reject out of hand any authoritarian axiomatic theology that uncritically takes its stand on prepostulated dogmatic certainties. Thus Pannenberg (1973, 271) could state that if the reality of God and His revelation or the liberating act of God through Jesus Christ is to function epistemologically as a preestablished datum in theological theorizing—and thus as a theological premise—theology can no longer be concerned with knowledge or science, but merely with the systematic description or exposition of what might be regarded as the 'true dogma' or 'proper doctrine' of a church.

If the premises of such a theology are finally exposed to criticism it is, ironically, its very conception of God and revelation that stands exposed as a subjective and arbitrary mental construct. Pannenberg rightly objects to any such reduction of the object of theology to the religious consciousness of the believer. A so-called direct theological premise in God and His revelation offers no escape from this problem.

From the above it becomes clear that, for Pannenberg, creditable theological argument is possible only if one acknowledges that no theologian can formulate meaningful statements without being involved, somehow, with the epistemological question of criteria for truth. This is so because theological statements, too, attempt to be meaningful, valid, and comprehensible, and especially also to lay a provisional claim to truth and reality-depiction.

This implies, however, that theological statements purport to be testable in principle, even if it does not imply that they must be confined to a specific form of testing (Pannenberg 1973, 277). For Pannenberg, then, the fact that theological statements claim to be true and therefore (logically) try to exclude untruth implies that such statements, too, must come within the ambit of rational criteria. And for Pannenberg the concept of hypothesis belongs in this context.

Pannenberg (1980, 171) sees hypotheses as only those assertions that, as statements on a particular issue, are distinguishable from the issue as such. The hypothetical nature of assertions implies the possibility that a given one may be true or false, and thus also the possibility of checking or testing. Pannenberg (1974, 31) maintains that logical positivism was quite correct on this point, except, of course, in its one-sided restriction of examination to a particular type of test, namely that of sensory observation. In principle, however, it remains true that an assertion which cannot be tested, at least in principle, cannot be a valid assertion of something else.

Which brings us to Pannenberg's typical *realist* claims (in terms of the contemporary debate in philosophy of science): Theological statements, too—and even statements of faith—are not merely expressions of a certain religious commitment; they contain an *element of assertion,* reality depiction, or reference, which is needed to make such a commitment possible. Even the simple assertion *I believe* makes sense only if there is Someone to believe in. In my view Pannenberg is therefore justified in concluding that, in this sense, all statements of faith have a *cognitive* core.

Given the logical implications of assertions, the questions philosophy of science asks about the epistemological status of theological statements must culminate in the question of the object of systematic theology. And at this point the question whether theology in fact has an object leads almost naturally to the question of the testability of theological assertions, which for Pannenberg means testability of the claims to truth in theological statements.

Pannenberg (1973, 34) rightly suggests that this confronts the theologian with the most rigorous demand of all. Conscious of Bartley's and Albert's stringently rationalistic criticism, he maintains that the systematic theologian dare not evade this most stringent of all epistemological demands by retreating to an irrational religious commitment. Any such immunization of theological premises against criticism must ultimately rebound on the systematic theologian with redoubled force, since the very statements he makes could then no longer be taken seriously.

· · · · · · · · · · ·
The Object of Theology: God as a Problem

In reply to the question about a specific and coherent object field for theology, Pannenberg (1973, 299f) would answer without hesitation: Theology is the science of God. In fact, Christian faith obviously depends entirely on God's reality, and therefore no systematic theology could be satisfied with regarding itself as a limited, narrow *science of Christianity;* to Pannenberg this would be unacceptable in terms of both religious and cultural history. Systematic theology cannot evade the question of the implications of its statement—that God reveals himself as a reality and as such forms the object of theology. It must examine the truth of these statements precisely because they are hypotheses. Given the universal implications of the concept of God, theology as a science of God has no finally demarcated field of study or object-area. Furthermore, God as object provides the intrinsic structural unity of theology.

A difficult question remains, however: Is it in any way possible to test theological statements, whether as direct or as indirect assertions, about God? After all, assertions about God cannot be tested against their immediate object, not only because the reality of God has become so problematic in our time, but also because it would surely contradict God's divinity if He became a *present object,* accessible to human scrutiny. Clearly, assertions about God cannot be tested against their purported object.

Given the universal implications of the concept of God and the logical implications of the hypothetical structure of assertions, it is clear to Pannenberg that the question of God's reality, and thus also the question of the truth of Christianity, can be posed only within the broader framework of a science having as its theme not only Christianity or the Christian faith but the reality of God Himself. For Pannenberg (1973, 229) this becomes possible in the context of a theology of religions that transcends the narrower bounds of theology as the science of Christianity. Therefore any theologian sensitive to the questions asked by contemporary philosophy of science realizes not only that the concept of God forms the thematic focus of all his enquiries but that God, as a problematic concept, has in fact become the object of a wider critical theology (Pannenberg 1973, 301).

It is clear that Pannenberg, in his formulation of such a premise for systematic theology, and in his identifying an object for systematic theology, consistently takes serious note of Bartley's and Albert's critical-rationalist criticism of any subjectivistic, fideistic religious commitment. The critical question that must be put to Pannenberg at this

stage is whether he is convinced that making God as a problem the premise for theology really meets the criticism of critical rationalism. In my view, what we have here, especially in the so-called 'context of justification', is, rather, a concession to Bartley's and Albert's criticism (especially to Bartley's *commitment to non-commitment*): a concession that not only fails to solve the problem of a fideistic axiomatic theology, but ultimately also fails to confront the vital question of the intrinsic role of the theologian's subjectivity (his *ultimate commitment* and its conceptualization) in the theorizing of his theological reflection. These problems play a crucial role in the development of Pannenberg's model for theology and can, in my view, be referred directly to the conflicting influences of critical rationalism and Kuhnian elements in his thought.

We have seen that, for Pannenberg, the conception of God as object of theology links directly with the problematic role of the concept of God in our wider experiential world. For him—at least in the first, broad phase of his theology—God can therefore be the object of theology only as a problem, not as an established datum.

But can this problematic concept of God be defined more closely, or does it remain an abstract hypothesis in theology, untestable against the object of its statements? According to Pannenberg, that concept can in fact be defined more closely. The fact that reality—if God is indeed really God—is totally dependent on God is, after all, a minimum requirement for the concept of God. For that reason Pannenberg can give more content to the hypothesis of God, maintaining that if God is real, he must be the all-determining reality. And although the concept of God can in itself not be tested or verified directly against its object, it is in fact possible to assess that concept in terms of its own implications. Thus the concept of God, which as a hypothesis includes the idea of God as an all-determinant reality, now also becomes testable by its implications for man's experience of reality (Pannenberg 1973, 302). In Pannenberg's view, the concept of God that would ultimately be most successful and solve most problems in the meaningful integration of man's experience would be the one that had validated itself convincingly. Assertions about God are, therefore, testable by their implications for our experience and understanding of reality (cf. Walsh 1986, 248). Such assertions are testable by whether their content does indeed give maximal sense and meaning to our present, finite reality.

If that were true—and this obviously very much concerns the 'theology and science' debate—it would imply that nothing in our finite reality can be fully understood outside its relationship to the living God. Obversely, one might expect this purportedly divine reality to

have opened up a much more profound understanding of all that exists than would have been possible without it.

Inasmuch as both these demands could be met, Pannenberg maintains, one might speak of a validation of theological statements. This justification is done not by criteria alien to the concept of God, but through a kind of proof provided by God himself. But since our surrounding reality is incomplete and unrefined, and since our experience of it is tentative and ambivalent, the concept of God remains, in terms of philosophy of science, a mere hypothesis. Given the finite and tentative nature of our theological choices, the concept of God can therefore never be finally justified by our experience of ourselves and of the world. Pannenberg thus maintains (1974, 36) that we can never abandon "truth" functioning as a regulative principle at the end of an indefinite process of enquiry (cf. Apczynski 1982, 54). And since truth (in both theology and science) is accessible only in anticipation, then science cannot exclude the broader context of history nor, ultimately, of philosophy and theology.

This brings us to the essence of Pannenberg's thesis: since in our time access to the concept of God is no longer direct and self-evident, it can be achieved only indirectly, through man's self-concept and his experiential relationship with his surrounding reality (cf. Pannenberg 1985, 15f). By this means Pannenberg sought to develop a problem range within which theological statements might be evaluated (therefore: the so-called context of justification of theology). Assertions about God (for instance about God as the Creator) may therefore be measured, on the one hand, by the handed-down ideas that have accumulated within a certain religious doctrine of creation, and on the other hand these assertions may be tested against the problems confronting such inherited concepts (such as the doctrine of creation) in terms of the natural sciences and of the philosophy of science in our time.

· · · · · · · · · ·
Rationality and Ultimate Commitment

The influence of Bartley's criticism and pointed rejection of any retreat to commitment is clearly evident in Pannenberg's development of his own conceptual model. For Pannenberg, divine revelation cannot be pre-annexed by any particular religion, to be set up against others as the only true one. He could therefore say (Pannenberg 1973, 322) that only a religious option that had in advance immunized itself against all critical reflection could unproblematically identify God's revelation

with its own religious tradition, to set it up as an absolute against all other traditions.

This brings us to the most problematic element of Pannenberg's epistemology. Although he shares Kuhn's view of the paradigmatic determination of our thought, he seems to remain caught up in the critical rationalist demand for a specific noncommitment in the evaluation of theories in the so-called context of justification. Ultimately, this provides no means of thematizing, and even less of resolving, the problem of the role of the theologian's subjective religious commitment in the construction of his theories.

On this point Pannenberg (1973, 323) concedes that theology, like all other sciences, does not approach its object without presuppositions or values, as a kind of *tabula rasa*. Theologians obviously tackle their subject with a certain interest, which also implies opinions and presuppositions, that may relate to the religious communities to which they belong. They may even be Christians, which may either stimulate questioning or act as a restraint on the unbiased evaluation of their object and their own tradition.

Against this background, Pannenberg (1973, 323) could say that the theologian's subjective religious commitment may fall in the *context of discovery*, but definitely not in the *context of justification*. His conception of discovery is the all-inclusive historio-sociological framework that produces a certain science; the context of justification, on the other hand, is the objective theoretical framework within which specific criteria have an explanatory and evaluatory function in respect of theological statements. Confusing the two contexts, for example by converting a personal religious commitment into the premise for rational argument—and at the same time claiming intersubjective validity for that argument—is in Pannenberg's view a fatal mistake.

This attempt by Pannenberg to claim objective criteria for a scientific theology's context of justification is, on the one hand, a clear echo of Bartley's (1964, 217) *people can be engaged without being committed*, and thus reveals the lasting effect of critical rationalism on the structure of Pannenberg's thought (see also Apczynski 1982, 52ff). Nevertheless, Pannenberg himself had earlier pointed out that this would make critical rationalism untrue to its own principles: basic or objective criteria in terms of which testing—and therefore falsification—becomes possible must surely be testable intersubjectively, according to the principles of critical rationalism. This is why it also became clear that, with Popper, the old positivist ideal of value-free, objective knowledge had been twisted into intersubjective correspondence. In

critical rationalism, therefore, objectivity ultimately becomes a conventional matter, no longer dependent on so-called atheoretical facts. In fact, Pannenberg pointed out that the purportedly objective basic propositions of critical rationalism could be seen as conventions precisely because of their intersubjective determination. He also pointed out (1973, 54ff) that the implications of that determination made it impossible to draw such sharp critical rationalistic distinctions between scientific and metaphysical statements.

Thus Pannenberg concedes not only that the nature and origins of scientific and of theological statements are rooted in the socio-cultural context of the individual researcher (the context of discovery), but that theological statements as such (the context of justification) are founded indirectly on general worldviews. In my view such statements are also deeply rooted in the scientist's subjective religious commitment.

Therefore, in attempting to separate the theologian's subjective commitment from the theoretical *context of justification*, Pannenberg is not merely abandoning Kuhn's concept of paradigm articulation, for which he had formerly opted and which now confronts his own demand for a context of justification without a personal commitment; he is also shunning the problematic question, not of how the theologian's subjective commitment may be temporarily suspended, but of how the theorizing implied by that religious commitment may be laid bare and rationally accounted for, precisely to prevent its becoming an uncritical and irrational immunization tactic in critical reasoning.

Pannenberg's intentions are clear: to conceive the theological enterprise—different as it might be from the other sciences—as fundamentally continuous with empirical science. What is then needed here seems to be clear as well: an analysis of the shaping of rationality in both theology and in science. As far as theology goes, it would have to be credibly pointed out that a pretheoretical commitment cannot simply be equated with irrational religious choices. On the contrary, the form in which that commitment manifests itself in religious statements and viewpoints must be exposed to critical argument. If that is done, the question of the relationship between our scientific statements again becomes the focus of our enquiry. Only thus will it eventually become clear that a personal religious commitment does not necessarily—to answer Bartley and Pannenberg—imply 'unscientific' or irrational thought.

In this reaction to the way the concept of revelation is formulated and abused in most forms of confessional theology, as immunization against criticism, Pannenberg tries to follow the wider program of a comparative theology of religions. He even maintains (1973, 326) that such a theology is ultimately based on the tradition of biblical Chris-

tianity. A definitive, final vindication or justification of theological statements is, however, unattainable, and is in any event sharply distinct from the nature of pretheoretical religious certainty. On the other hand, a provisional vindication of theological hypotheses may be attained inasmuch as they may lend, at least provisionally, maximal meaning and clarity to our experiences. In my view, however, that provisional vindication of theological statements and theories is possible only if we can think from a paradigm that enables us to handle such criteria. This may also be founded on a paradigm choice that cannot be suspended temporarily and theoretically but refers consciously to a critically responsible basic conviction or religious commitment.

From the above it follows that the theologian's personal commitment, if rightly understood and credibly accounted for in terms of contemporary philosophy of science, need not stand in the way of a scientifically acceptable model of rationality. Although Pannenberg, in my opinion, does not account for the role of the theologian's personal religious commitment in theological theorizing, his incisive and highly original debate with contemporary philosophy of science enables us to pursue this discussion with greater confidence and credibility.

· · · · · · · · · ·
In Conclusion

The theologian has to realize that the questions raised by reflecting on religion are not those raised by science. Accepting that different kinds of knowledge are involved in the practices of science and theology and that neither can provide the content of the other's knowledge, does not mean *that they do not inform the context within which their respective knowledge is to be constructed* (cf. Barker 1981, 276). In this sense, also, Pannenberg rightly claims that science provides an essentially incomplete epistemology for understanding nature. Claiming that scientific data contain a further and theologically relevant dimension should, however, never beg the wrong question of where science ends and where theology begins (cf. Wicken 1988, 49).

The epistemological problem of claiming a theologically relevant dimension for scientific data reveals the common adherence of theology and all other sciences to the problem of rationality, as we have seen. This problem virtually forces the theologian and the believing scientist to deal with the role and function of an ultimate religious commitment in the construction of theories in both theology and science. It also challenges us to evaluate the role of justification and explanation in both theology and science.

The relationship between *explanatory power* and *truth* has always been a central issue in the understanding of science (McMullin 1986, 52). Philosophers of science have also convincingly pointed out that there can be no undisputed and monolithic notions of 'reality' or of 'explanation' in science: the objects of our interest not only dictate different strategies, but also different views on what could be regarded as adequate forms of explanation. But the central question remains: Does theology exhibit a rationality comparable to the rationality of science, and how plausible can an explanatory justification of the cognitive claims of theology be?

I think it could be convincingly shown that the rationality of science and theology is in each case determined by certain goals and criteria, by certain epistemic values. In both theology and science, whatever their other differences might be, the supreme value that determines rationality seems to be *intelligibility.* What is real for theology and for science is not the observable but the intelligible (cf. Barbour 1971, 170), and in both theology and science beliefs and practices are attempts to understand at the deepest level, where understanding can be construed as seeking the best explanation (cf. Proudfoot 1985, 43). What is at stake, therefore, is not only the general epistemic status of religious belief, but especially the implications this will have for the epistemic and thus rational integrity of theological discourse as such.

At the same time the high degree of personal involvement, of faith and commitment, in religion and theology will present a very special challenge to any theory of rationality in both theology and science. Because of this, and because of the contextuality of religious experience and the cognitive claims that arise from this, I would argue for a theory of rationality in theology that encompasses both *experiential adequacy* and *epistemological adequacy.*

The central role of experience and explanation in the justification of the cognitive claims of theology finally implies that the very important distinction between *commitments, an ultimate commitment, beliefs,* and *religious faith* should always be maintained. I am also convinced that no strong form of justification is possible for a commitment to an ultimate commitment (the search for maximal meaning in life), outside the way of life of which it forms part. This is no retreat to irrationalism, because experiential and epistemological adequacy, and not justified certainty, makes a commitment and its resulting beliefs and propositions valid and responsible. This also implies that the beliefs that are implied in a commitment should in principle always be open to criticism. This does not go against what, from a perspective of religious experience, could be called the certainty of faith. It does, however, imply a highly critical sensitivity towards the construction of theo-

ries in theology and certainly prevents any form of dogmatism in theological theorizing.

In a critical realist model the beliefs implied in a commitment to an ultimate religious commitment could never be justified by any foundationalist doctrine of justification, but it might indeed be possible to provide good or adequate reasons for *not* giving up a commitment and its implied propositional beliefs. Beliefs are therefore never just the 'frills on a commitment' (cf. Trigg 1977, 36), but can in a process of explanatory progress offer good reasons why it would make more sense (be more rational) to be committed to a certain way of life than not to be committed to it. In this sense there is no contrast between scientific and religious beliefs, nor between a commitment to realism in science or a commitment to critical realism in theology.

We could therefore say that all commitments must involve beliefs (are propositional) which might eventually turn out to be true or false. On this view—which is also my own—it is therefore not enough to maintain that beliefs have a 'truth' which is relative only to a group, a society, or a conceptual system. Obviously a conceptual framework or paradigm could involve beliefs which are only true within this context, but eventually we are of course confronted with the meaningfulness or provisional truth of the paradigm as such, as well as being committed to a certain set of beliefs. Such a commitment should be based on beliefs which are themselves external to the system. This is what I tried to indicate throughout as *epistemological adequacy:* beliefs that function as criteria for rationality or epistemic values in a critical realist approach to theorizing in theology and in science.

Post-Kuhnian philosophy of science has shown us that there can be no sharp line of demarcation between scientific rationality and all other forms of rationality (cf. van Huyssteen 1986, 63ff). In fact, rationality in science relates to the 'reasonableness' of a more basic kind of rationality that informs all goal-directed human action. Within this broader context, theology seeks as secure a knowledge as it can achieve, a knowledge that will allow us to understand and where possible to construct theories as better explanations. In the end this epistemic goal of theology will determine the shaping of rationality in theology. And if in both theology and science we want to understand better and explain better, then surely the rationality of science in the broader sense is directly relevant to the rationality of theology. This epistemological consonance between theology and the other sciences therefore reveals what it might mean for theology to demonstrate that the data as described by the sciences are provisional versions of reality and that the data themselves contain a further and theologically relevant dimension.

Theology, in its attempt to obtain maximum intelligibility, thus makes claims based on religious experience. And as in science, although different from the kind on which scientific statements are based, this experience is understood as a context of shared assumption interpreted within the wider framework of a continuity of metaphorical reference. In both religion and science claims are made within a context of enquiry, but this does not deprive them of their referential value and therefore is not a relativist position. Those metaphoric and interpreted expressions around which the language of the Christian religion cluster, can in this sense be said to have justified themselves as meaningful and referential to vast numbers of people throughout the centuries and across cultures (cf. Van Huyssteen 1987, 7–51). It is this kind of experiential adequacy, and not a justified certainty, which makes a belief a responsible belief. And a model of rationality which can accommodate this is already justifying its claim to epistemological adequacy.

The justification of cognitive claims in theology through the grounding of reference in religious experience is supported by the fact that scientists and philosophers of science have not turned as easily as literary critics and some theologians to non-cognitivist views of metaphor. The most interesting metaphors in both theology and science are those which suggest an explanatory network and are vital at the 'growing edges' of our reflection (cf. Soskice 1985, 101f). The crucial issue is: What do theological theories explain, and will a form of explanatory justification in theology have implications for the cognitive claims of theological theories? I would like to argue that although there might be no epistemological short cut possible from the explanatory success in science to progress and problem-solving in theological theorizing, this explanatory progress elucidates religious experience and theological reflection in such a way that theology can indeed claim a form of truth approximation that could be directly relevant for progress in the sciences.

· · · · · · · · · ·

References

Albert, Hans. 1968. *Traktat über kritische Vernuft*. Tübingen: Mohr (Siebeck).

Apczynski, John V. 1982. Truth in Religion: A Polanyian Appraisal of Wolfhart Pannenberg's Theological Program. *Zygon: Journal of Religion and Science* 17 (1).

Barbour, Ian G. 1971. *Issues in Science and Religion*. New York: Harper and Row.

Barker, Eileen. 1981. Science as Theology: The Theological Functioning of Western Science. In *The Sciences and Theology in the Twentieth Century*, ed. A.R. Peacocke. Notre Dame: University of Notre Dame Press.

Bartley, W.W. 1964. *The Retreat to Commitment*. London: Chatto and Windus.

van Huyssteen, Wentzel. 1970. *Teologie van die Rede: Die funksie van die rasionele in die denke van Wolfhart Pannenberg*. Kampen, Netherlands: Kok.

──────. 1986. *Teologie as Kritiese Geloofsverantwoording*. Pretoria: RGN.

──────. 1988. *Theology and the Justification of Faith: The Construction of Theories in Systematic Theology*. Grand Rapids: Eerdmans.

Kuhn, Thomas S. 1970. *The Structure of Scientific Revolutions*. Chicago: University of Chicago Press.

McMullin, Ernan. 1986. Explanatory Success and the Truth of Theory. In *Scientific Inquiry in Philosophical Perspective*, ed. Nicholas Rescher, 50–72. New York: Lanham.

Pannenberg, Wolfhart. 1967. Die Krise des Schriftprinzips. In *Grundfragen Systematischer Theologie: Gesammelte Aufsätze*, 11–22. Göttingen: Van den Hoeck and Ruprecht.

──────. 1973. *Wissenschaftstheorie und Theologie*. Frankfurt am Main: Suhrkamp.

──────. 1974. Wie war ist das Reden von Gott? In *Grundlagen der Theologie*, ed. S. Daecke and N. Janowski, 29–41. Stuttgart: Kohlhammer.

──────. 1980. Antwort auf Gerhard Sauters Überlegungen. *Evangelische Theologie* 40 (2).

──────. 1985. *Anthropology in Theological Perspective*. Trans. Matthew J. O'Connell. Philadelphia: Westminster.

──────. 1993. The Doctrine of Creation and Modern Science. In *Toward a Theology of Nature: Essays on Science and Faith*, ed. Ted Peters, 29–49. Louisville: Westminster/John Knox.

Popper, Karl. 1968. *The Logic of Scientific Discovery*. London: Hutchinson.

Proudfoot, Wayne. 1985. *Religious Experience*. Berkeley: University of California Press.

Soskice, Janet M. 1985. *Metaphor and Religious Language*. Oxford: Clarendon Press.

Trigg, R. 1973. *Reason and Commitment*. Cambridge: Cambridge University Press.

Walsh, B. J. 1986. A Critical Review of Pannenberg's Anthropology in Theological Perspective. *Christian Scholar's Review* 15 (3).

Wicken, Jeffrey S. 1988. Theology and Science in the Evolving Cosmos: A Need for Dialogue. *Zygon: Jounal of Religion and Science* 23 (1).

15

To Expand and Deepen the Provisional: An Inquiry into Pannenberg's *Anthropology in Theological Perspective*

● ● ● ● ● ● ● ● ● ●

Paul Sponheim

What might it mean for theology to demonstrate that the data as described by the sciences constitute "a provisional version of the objective reality" and that the data themselves contain "a further and theologically relevant dimension"? (Pannenberg, above, 59).

I approach this question as a theologian who supports and commends the effort Pannenberg makes in this major work. I observe, sadly, that the effort is really rather rare in this time when theology all too often seems content to play its particular language game as if it thus genuinely possessed anything else for itself, not to mention for anyone or everyone else. Specifically, I want to mention three points of qualified agreement with Pannenberg's approach.

I agree with Pannenberg's insistence on the reality claim of Christian faith. He puts this well: "Without a sound claim to universal validity Christians cannot maintain a conviction of the truth of their faith and message. For a 'truth' that would be simply my truth and would not at least claim to be universal and valid for every human being could not remain true even for me" (55).

I agree that the understanding and commendation of this truth claim needs to engage the understanding of the human person, though I do not want to 'give up on the world'. I do not think Pannenberg himself has given up on the world outside the person (see *Zygon*, March 1989).

I agree that the Christian understanding of God as the Creator of all supports this effort, though I would not want to hold that God is the sole agency at work in the reality of the human. Pannenberg also strongly affirms nondivine action, though I will comment later on an opposing strand in his thought.

I have three questions:

1. What would it take to demonstrate what we are talking here about demonstrating? That is, given Pannenberg's reading of the terms of the discussion, what is entailed in this effort? This is not, I think, a specifically theological question, though in thinking about the

movement from the 'provisional' to the 'objective' I have a theological conception of the destination in mind.

2. What would it mean formally for theology if that about which we are speaking here were demonstrated? In this and in the next question I make no assumption as to who would do the demonstrating. Perhaps that would itself be a co-operative venture. My question here is what such demonstration would mean for the understanding of the nature of theology as a discipline.

3. What would it mean materially for theology if that about which we are speaking here were demonstrated? In approaching this question I want to take the human material to which Pannenberg refers and ask where it seems to 'go' theologically. That material may be inadequately selected or incorrectly understood in its own terms. There are others who can comment on that. My question is the bearing of the material theologically.

· · · · · · · · · ·
I. What Would It Take?

On Pannenberg's reading it would not take a 'knock-down' proof, something which coerces the mind's assent. We should not expect the ring of self-evidence in our conversation. That is not the kind of ground on which we are working. Suppose we take the partners in this conversation to be the nontheological anthropological disciplines, on the one hand, and theology on the other. In each case we have something which has less than full reliability in its possession. Pannenberg agrees with Barth that the anthropological disciplines are not neutral ground (56), and he recognizes as well that the "self-revelation of God that precedes any human judgment . . . is accessible only through human interpretation" (1985, 478). The voice of faith is finite (1985, 70) and can err (1985, 276). As Pannenberg writes:

> If even the message of Jesus insofar as it was human speech did not immediately contain the truth of God within itself but had to have its divine authority confirmed by the history of Jesus, then Christian speech too remains distinct from the divine word that is its content. This word makes its truth known not immediately through what Christians say but through the future of God's reign and through the signs that preceed this. (1985, 396)

Of course one could argue that though the partners in the conversation must live in ambiguity, the process we are following does not. But it is essential to recognize that the ontological foundation for the dialogue is itself incomplete. If it is the living who are being studied,

presumably the studying itself will have some of life's venture about it. We will speak later in this gathering about contingency as an opening to God. So, referring to the dictionary, we will want to use the word 'demonstrate' as meaning 'to show by illustration' or 'to manifest' (though not 'unmistakably'), rather than as meaning 'to prove'. Thus Pannenberg is cautious in his own expectations:

> It is not possible . . . to decree a priori that the expectation will actually be fulfilled. This must wait upon the anthropological phenomenon itself, but the question is both meaningful and necessary even if it should turn out that no simple and definitive answer is possible. In fact, the lack of a definitive answer is really to be antecedently expected, given the special character of the idea of God in its relation to the still incomplete totality of the world and our experience of it, a totality that transcends every finite experiential standpoint we can adopt. (58)

What would such 'demonstration' take then? It will take something other than a tidy 'second-order' discussion between the disciplines. We are concerned with the human reality which is the referent for those disciplines. Pannenberg notes this in his emphasis on 'the human phenomena' or (even) 'the facts' (59). He fittingly closes his opening discussion by asking which is the most concrete of the disciplines. He is fully aware of Whitehead's concern about the 'fallacy of misplaced concreteness', one might say (Pannenberg 1984).[1] So he will not settle for interchange between language systems, as if that were possible in itself. He is driving for (and us to) reality, even though he recognizes the self-perpetuating power of the linguistic systems in which we think. Given this drive, I would be glad for a straightforward metaphysical proposal from Pannenberg, a formulation which attends to the deep and pervasive experience which underlies linguistic formulations and the process of 'translation' (1985, 344). Perhaps he has this in mind in speaking at book's end of treating problems "in the framework of a general ontology" (1985, 521). In any case in his discussion of the relation between reality, reason, and language (for example 1985, 343) he makes the necessary distinctions and connections to prepare for a fuller statement of the method of conversation a critical realism could develop.

What would it take? Minimally, there is required the showing of a certain relationship between the anthropological reading of reality and the theological reading. The phrasing of our first question for this symposium has slightly altered Pannenberg's language. He does not speak of the data as 'provisional versions of objective reality'. His

language (59) is this: ". . . the secular *description* [emphasis mine] is accepted as simply a provisional version of the objective reality . . ." I understand him to hold that theology offers another version and that both nontheological and theological versions face the reality test. This may help to reduce the appearance of queenly theological pretensions which the nontheologian may sense in beginning this conversation. Furthermore, to advance the dialogue, theology may 'critically appropriate' some of the data "as described in the anthropological disciplines." Thus, anthropological descriptions are at work here, having an effect. They are after all, a version, however 'provisional', of 'objective reality'. Thus theology really does deal with something other than itself. Pannenberg is specifically critical of theological apologetics using "modern categories with a seemingly analogous structure in order to effect an outward modernization that leaves everything just where it was" (1985, 387). To the contrary, he can even speak of an "anthropological basis" for belief claims (55).

And yet the anthropological disciplines do not simply control the movement in this conversation. Pannenberg is very clear that a "mere takeover of data established in a pretheological manner will not do" (1985, 416). Hence the nontheological version will need to be "expanded and deepened". Indeed, the theologically relevant "dimensions" or "aspects" of the data "have not already been developed in the nontheological disciplines making up anthropology or are mentioned only peripherally and usually not made central (59)". So our task is to "transform and retain" (1985, 337), to "expand and deepen" (59).

What, then, would it take? It will be necessary for this movement to reveal continuity in the data, while yet achieving genuine change in the sense of 'advance'. In Part 3, I will ask whether the sense of continuity is adequately represented in the *Anthropology*. Robert John Russell raised a parallel question in asking about continuity between paradigms, whether that continuity be conceived as linguistic, historical, or substantive. He wrote:

> Perhaps the strongest argument is that a successful new paradigm must contain the old one it replaces as a limiting case. Often the containment is expressed mathematically: the equations of the old paradigm are limiting cases of the new equations under the appropriate approximation conditions. Examples would include semi-classical approximations to quantum theory, the correspondence principle, Bohr's use of classical language in describing the measurement process, and classical relativity as the low velocity limit of special relativity. Moreover, the language of the new paradigm is often taken from the old

although the meanings are changed: we speak of mass, velocity, and position in special relativity and quantum physics as well as in classical mechanics.

Pannenberg's own position on the philosophy of science shows a certain tension between continuity versus incommensurability. I would agree that we must be radically open to new and unpredictable phenomena; yet not just anything new can happen, since the new will eventually fall within a theory which somehow includes and fulfills the old. Moreover, the value of the theories of science would be severely undercut if they were radically relativized by first instantiation contingency; indeed this would run counter to Pannenberg's program to draw on science for theology. Just how we reconcile radical openness to the new with the requirement of continuity or natural regularity and the search for unity poses a rich challenge to our task of relating science and theology. (Russell 1988, 38)[2]

II. What Would It Mean Formally?

If Pannenberg is right, anything that is real has relevance for the work of theology. Theology does not, in this view, refer to a being who can be localized, as it were, and then treated in an isolated or self-contained way. Rather there is an 'aspect' of theological relevance in anything that is real. This does not mean that the nontheological understanding offered of any experienced reality is to be accepted uncritically. We have already noted that the appropriation is to be a critical one. Thus, consistently, Pannenberg writes regarding the unity of a culture: "The question of what it is that grounds the unity of a culture may not be answered, then, simply on the lines of what might be called the culture's official self-understanding as expressed in its myths. Attention must also be paid to the actual experience of reality in the various areas of the culture's life and to the relation of this experience to the official self-interpretation of the culture" (1985, 321). And yet the understanding of the experience, as reflected in the nontheological version, is not to be ignored. That would occur, Pannenberg says, if we spoke merely of a theological search for a "point of contact", as Brunner did. To proceed so assumes that "the subject matter of theology is fixed in itself, but must still be somehow brought home to human beings" (59). In that case the nontheological anthropology "stands over against theology as something different from the latter, and theology, which in turn stands over against the anthropology as something different from it, is supposed to establish contact with this

very different thing" (59). This is not what Pannenberg is attempting to do. Experienced reality and the description or interpretation are directly relevant to the work of the theologian.

I pause to ask whether this view requires Pannenberg's conception of God as the 'whole'. He has put the matter in this way: "in the question of the whole as a whole, as well as in the question of the wholeness of the individual life, there is at least already implied the question of the reality of God who constitutes finite reality as a whole" (Pannenberg 1980, 224). I will discuss this formulation in the next part of this paper, but the matter arises here because it is clear that speech about God will require attention to every part of reality, intrinsically, if God is indeed the whole. I am inclined to think that the formal question of relationship does not depend upon this specific formulation, but requires (only) some kind of ontological uniqueness by which God is directly related to (active in, affected by, and so on) each reality. The Whiteheadian construction, for example, offers such a version of uniqueness which would sustain Pannenberg's emphasis on the intrinsic theological relevance of each particular without such a specifically monistic formulation.

Indeed one could argue that one can learn of God the more significantly, if reality is such that the word or work of God can in principle be clearly distinguished from that which is not God. While a part is clearly not the whole, the distinction is not so easily stated within the experience of the part. In the Whiteheadian formulation, God acts within every particular to provide an 'initial aim'. But the disposition of that aim depends upon the developing initiative of the particular. In turn, God is affected by that developing determination in God's 'consequent' nature and draws upon that determination in providing new initial aims. Here, then, the interaction is such that every reality could bear on our formulation of God's will and God's judgment. The identity of God does not dissolve in multiplicity, however, inasmuch as by 'the reversal of the poles' God's 'primordial' determination of will has full aseity. This formulation has its own difficulties, of course, as figures as diverse as Langdon Gilkey, Robert Neville, and even Charles Hartshorne have pointed out. But it can serve us here by suggesting that representatives of a well-developed tradition in contemporary philosophical thought can join Pannenberg in his emphasis on the theological relevance of all reality without speaking of God as the whole in the way he seems to do.

What will it mean for theology, if Pannenberg is right that all experienced reality has theological significance? It will mean, at least, that the theologian is to be held to a high standard of intelligibility. The theologian cannot withdraw behind some privileged linguistic

veil of mystery for the very stuff of which the theologian bids to speak would thereby be ignored. (This is not to deny that mystery may characterize the human reality itself.) Again, the theological challenge is not a matter of 'translating' a special speech into some other tongue. Rather the deep and common experience of humankind has an intrinsic and constitutive role in doing the work of theology. For example, we can no longer plausibly say that the 'outsider' cannot understand our talk of 'sin', as we have when we have said that sin is a religious category concerning the human 'before God' rather than a moral matter accessible to general human discernment and understanding. So Pannenberg!

> One cannot dismiss the empirical proof of the connection between pride and concupiscence by saying that one does not believe it. The reality of this type of behavior is an object not of faith but of psychological description and observation. Even the theological interpretation of it as a turning from God to the point of hostility to God derives its persuasiveness from the fact that it can be shown to be necessarily implied by the empirical data, even though the radical perversity represented by such behavior will be grasped only in the light of biblical revelation. (1985, 91)

To speak of necessary implication leads us beyond the issue of intelligibility. Does the relevance of deep and common experience raise the prospect of persuasion? Can the theologian be expected not merely to show what her assertions mean, but that they are true? Clearly Pannenberg's work holds high interest for apologetics. After all "not only Christians but also modern atheists who deny any and all religious faith should seek an anthropological basis for the universal validity of their claims" (55). So the theologian is to try to defend the claim of the faith to be true and can (indeed, "must") "conduct this defense on the terrain of the interpretation of human existence . . ." (55). Still, to 'defend' is not necessarily 'to prove'. We approached this issue in the first part of this paper in considering in what sense the word *demonstrate* could be used. Pannenberg is very clear about this. For example in his discussion of basic trust he has this to say:

> All that I have been saying does not add up to a kind of anthropological proof of God's existence. The fact that the question of God belongs to the humanity of human beings does not yet signify that a God exists and what kind of God he is. . . . The unavoidableness of the God question as a problem means nonetheless that we are not dealing with a theme from which human beings can quite well distance themselves and which

they may pass over without having to pay for this distancing with a loss of openness to their own reality. (1985, 73; cf. 233)

Pannenberg is very clear about both parts of this point. On the one hand he can argue that "when human beings direct their attention to a particular object, they are in that very act reaching out beyond all that is finite; for only in the context of the whole can we determine the meaning of the individual thing" (1985, 72). Moreover, we should not speak of this as a decision: "In the development of an infant, basic trust is not established by a decision but emerges from a process whereby a differentiation is introduced in the original symbiotic unity of life between child and mother" (1985, 232). On the other hand, he is careful to recognize that "such considerations cannot, by themselves, validate the claim that God—and a God who is one—is real. . . . They show that the theme of 'God' is inseparable from the living of human life. . . . There is an original and at least implicit reference of human beings to God that is connected with the structural openness of their life form to the world and that is concretized in the limitlessness of basic trust" (1985, 233).

Contemporary theology needs to work more thoroughly on the distinction that Pannenberg is opening up for us here. As that work progresses, one may hope that theological argument in the ambiguous middle distance can be distinguished from axiomatic proof on the one hand and from sheer authoritarian appeal on the other. This will involve a consideration of what the formal relationship is between the human and the Christian. One might speak of this in several ways. Is human existence 'intensified', 'fulfilled', 'comprehended', 'reconciled', in Christian existence? Such abstract terms beg, of course, for concreteness. But precisely in their generality they suggest the combination of continuity and discontinuity entailed in the 'advance' Christian existence represents for human beings. One can argue for the faith because there is continuity in the advance; one needs to argue (or one might say one can only argue, not prove) because there is discontinuity in the advance as well. The amount of confidence one has in the argument will be related to the degree to which one regards conscious profession of Christian faith as itself part of the advance in human orientation to the world. This normal relationship of course depends precisely on the material components involved. There is much in the *Anthropology* that speaks to this point materially. I would be glad for a formal assessing of that material discussion.

What would it mean formally to demonstrate what we are talking about demonstrating? If Pannenberg's project is successful (and the definition of 'success' would have to accommodate the ambiguity of

which I have spoken), it will mean that theology is still distinguishable from the other disciplines. Just how to understand that distinction remains an important issue. Is theology to be distinguished by the fact that it speaks of 'the whole'? How would it differ from a metaphysics which also presumed to speak of the whole? Pannenberg distinguishes his effort here from 'traditional dogmatic anthropology', for he "does not argue from dogmatic data and presuppositions" (61). Rather his effort "turns its attention directly to the phenomena of human existence" as investigated in the nontheological disciplines. But it does so "with an eye to implications that may be relevant to religion and theology" (61). So religion and theology have a distinguishable identity such that one can have an eye on them while attending to work that is not itself theological. Again the question of how to understand the distinction arises. Since theology and religion have a distinguishable identity, would a dogmatic anthropology be in principle possible (even if insufficient for issues of intelligibility and persuasion)? These issues of identity can be pursued more concretely in looking at the themes of the 'the image of God' and 'sin'. Pannenberg notes that these were the "two central themes" of dogmatic anthropology. But, more than that, he finds that these doctrines "thematize the two basic aspects found in the most varied connections between anthropological phenomena and the reality of God" (60). But how does the argument go? Is it necessarily clear that "to speak of the image of God in human beings is to speak of their closeness to the divine reality, a closeness that also determines their position in the world of nature" (60)? Is it necessarily clear that to speak of separation from God is to speak of opposition to self? How do we get from such dogmatic themes to the empirical material, or vice versa? Is the notion of God as the whole the crucial point here, as may be suggested in formulating sin as self-contradiction inasmuch as the true destiny of human beings is union with God (60)? In his last chapter Pannenberg grants that he has not in this work provided a systematic justification for introducing the concept of spirit: "That would require that we discuss at a very general level our understanding of reality as such . . . An adequate treatment of the problems needing to be discussed would be possible only in the framework of a general ontology" (1985, 521). One can hope, perhaps, to understand the derivation of the distinctiveness of theology more adequately when such an analysis is in our hands. That distinctiveness would include a distinction between theology and ontology.

What would it mean formally, if Pannenberg were right? I have been stressing the ability theology would possess to make its claims intelligible and persuasive in the terms of the deep and common expe-

rience of humankind. But there is another turn to this relationship. This is not an opportunity without responsibility. As Pannenberg puts it: "the various claims made regarding God and the gods must be judged by whether and to what extent they illumine our understanding of experienced reality" (1985, 280). It follows that experienced reality is not supinely to be claimed by theology; it may well make its claim against theology. So the prospect of the falsification of theological claims is opened. Insofar as theology makes claims about 'the middle'—life between the beginning and the end of the world—our experience of life will be able to make a falsifying move against such a theological claim. This will apply, presumably, not only to the human phenomena in themselves, but also to the disciplines offering interpretation of those phenomena (in dependence on the phenomena). Such a falsification procedure may in fact be more available than any verification (which would have to reach to the whole, it would seem). But the falsification process would still need to recognize the tentativity and ambiguity deriving from the distinction between the data and the disciplines, as well as the sense in which the reality of even the parts is not fully clear apart from the whole.

The falsifying competence of the data and the disciplines does not seem to be limited to theological claims made about the middle times. At either end as well there would be relevance. Standing in the middle of things, one can ask of claims about the beginning: Can one have gotten here from there? Moreover, it was clear in the first symposium that Pannenberg understands creation claims to speak about the coming about of every moment. In the *Anthropology* it is precisely the end that comes into view. I would be inclined to argue even more strongly that someone living in the middle could ask of a theological claim about the end: Could one get there from here? This is again the question about continuity which was raised at the end of Part I. I recognize that my framing of this question may assume the irreversibility of time. I doubt that Pannenberg wants to accept such irreversibility; indeed, he seems to challenge it very directly. Yet he does seem concerned to speak about continuity, unless talk about the 'provisional' can be limited to an epistemological reference. But at this point the discussion can no longer be limited to formal matters.

• • • • • • • • • •
III. What Would It Mean Materially?

If the human phenomena described in the anthropological disciplines are claimed by theology, what will that yield in the work of the theologian? If the secular description is accepted as a provisional version of

objective reality, we should expect—in Pannenberg's own words—an expanding and deepening as we consider the matter in theological perspective. In this last section I puzzle over whether this occurs in Pannenberg's work. In effect I am asking whether the theological formulation offered does deepen and expand the reality known in human experience. I also have in mind theology's own claim to some distinct identity, as seems suggested by Pannenberg's use of the notions of the image of God and sin.

A prominent aspect of human experience would seem to be temporality. More closely stated, one could speak of development or even teleology. Obviously these notions figure very prominently in Pannenberg's theological perspective as well. Indeed image-of-God talk and the meaning of sin are controlled by this framework. Thus God's image refers as much to what lies ahead of us as it does to some fitting out of the human prior to the life of the human in history. And the human is understood developmentally in distinction from other animals as not totally bound by instinct but able to turn to particular objects. That is, we are able to be open to the world; human life goes beyond itself and reflects on itself as it meets the particular other as other. Here, then, Pannenberg connects the developmental history of the human with the dogmatic theme of image by holding with Herder that the image of God is not a perfection of the original state, but rather the destiny that human beings have still to attain (1985, 54).

If there is no original perfection, there can be no 'fall' from original perfection. Here is one phrasing:

> in their pregiven existential structure all human beings are determined by the centrality of their ego. They individually experience themselves as the center of their world. . . . It is clear, then, what deep roots egocentricity has in our natural organization and in our sensible perception. It is not at all the case that egocentricity first makes its appearance in the area of moral behavior; rather, it already determines the whole way in which we experience the world. (1985, 107–08)

One is tempted to say, then, that sin too becomes part of human development, as one must move from a given state of egocentricity toward our destiny in exocentricity.

Of course I have stated the matter more flatly than Pannenberg does. He specifically criticizes Tillich for coming "disturbingly close to the idealist view that the fall was necessary for human self-realization" (1985, 282). Consistently, he will not speak of the Incarnation as God's 'self-alienation' (which entails sin), but only as a self-divestiture"

(1985, 271). And he shows how the development of sin can turn against the subject itself (1985, 146).

Pannenberg's theological appropriation is very complex at this point. He knows full well that he is differing here from the traditional notion of 'Fall'. Does he give good reasons for doing so? It is not enough, I think, to say that the traditional notion is 'mythological' or 'prescientific'. One might still try for a 'second naiveté' and try to give expression with Paul Ricoeur to the theme of the contingency of evil: "Sin may be 'older' than sins, but innocence is still 'older' " (Ricoeur 1967, 251).[3] But to do so would certainly be to speak of that which interrupts the course of human development. I am uncertain whether with this we yet have the whole of Pannenberg's reasoning; we still need, I think, to speak of how the 'goal' and the 'way' are related. If sin marks our actual way in the world, must even it be subject to the power of the goal? But I come to that later.

Meanwhile, in attending to the phenomena of human experience a theologian will need to consider the experience of responsibility. Pannenberg sees this task clearly and puts the question himself: "If sin is linked to the natural foundations of our existence, what responsibility do we human beings have for our sinful behavior?" (1985, 107). His response is complex. On the one hand, the theme of responsibility is present in recognizing the 'image ahead': "Only human beings, it seems, know themselves to be selves; only they know that they are given to themselves as both gift and task" (1985, 109). Or more fully: "Only because the destination of human beings is exocentric and finds fulfillment solely in the radical exocentricity proper to them as religious beings can the egocentricity that is analogous in them to animal centrality turn into a failure of their existence, their destination as human beings" (1985, 109). This would seem to amount to saying that the human 'mistake' "may even be a culpable mistake when gauged by the standard of the true human destiny of the persons who in this way fail themselves" (1985, 116; cf. 138).

But does the turning occur freely? Pannenberg rejects a notion of abstract or formal freedom and tries for a reading of the bondage of the will. The "power of the lie" is such that "deception with regard to the good is not simply an intellectual matter. The bondage of the will calls, therefore, for a liberation and, in the radical case, for a redemption that will establish the will's identity anew" (1985, 118–19). So this complicated discussion ends up with a difficult distinction concerning the word 'nature'. Is sin natural? "It is precisely the natural conditions of their existence, and therefore that which they are by nature, that human beings must overcome and cancel out, if they are to live their

lives in a way befitting their 'nature' as human beings", or, more briefly put, "human beings are given their 'what they are,' but only in the form of a task still to be completed" (1985, 108). This seems to me to understate the experience of individual responsibility. I will ask later of the reasons for such understating.

I have been inquiring how a theological perspective 'deepens and expands' the understanding of human phenomena, in particular the phenomenon of temporal development. Another aspect, already briefly introduced here, is that of the relationality of the self. Pannenberg, of course, stresses that the human person uniquely turns to the other as other, and in the experience of basic trust to an other who offers "an unlimited security despite all the threats and adversities of life" (1985, 227). This theme of the relationality of the self's existence is richly developed by Pannenberg. I would be tempted to speak of it as 'intersubjectivity', but to do so might be to lose sight of the fact that the flow is from social self to individual ego: "Only indirectly, insofar as the 'I' of the isolated moment is known as identical with 'myself,' and therefore as the momentarily present manifestation of that totality of states, qualities, and actions that in the eyes of a 'generalized other' are to be ascribed to the individual which I am—only in this way does the 'I' as such acquire a continuity that lasts beyond the isolated moment" (1985, 222).

In his 'critical appropriation' Pannenberg 'deepens and expands' this relationality by speaking of God as the One who fulfills this fundamental human characteristic: "Basic trust is directed to an agency that is capable without limitation of protecting and promoting the selfhood of those who trust in it. . . . But without God a basic trust in reality is, in the final analysis, unjustified" (1985, 231). Surely faith does want a God worth trusting; I agree (though I may want to ask, In what respect?). But does such an 'end' for the human exocentric tendency to trust represent a deepening and expanding of the relationality of human existence? Can the human person be said to be 'in relation' to the God so trusted? One would think this deepening and expanding might include the reality of relationship. What would be required in order to speak of a relationship between God and human beings? I take it that some measure of interaction, some sharing of causal power, would be required. It is not clear how an entity can be spoken of as real if it is denied all causal agency, nor is it clear how speaking of God changes this principle. The question I am asking is whether such sharing of causal power can be found in Pannenberg's 'critical appropriation' at this point.

I am uncertain what the answer to this question is. Pannenberg can write that "Dilthey has taught us to see the unity of historical

processes as provided by continuities of meaning in which the detail and the whole reciprocally condition one another" (1985, 511). And yet on a very basic level he claims that "talk about God or gods is meaningful, because free of internal contradiction, only to the extent that it describes the power that determines all experienced reality" (1985, 280). It seems clear at least that the nature of human efficacy cannot be directly against God: "just as there is no freedom *against* the good, so there is no freedom *against* God as the ground of the person's own future selfhood and therefore as the very embodiment of all that is good. Human beings can indeed close themselves against God, as they can against the good, but this closure does not take the form of a direct confrontation" (1985, 116). Perhaps that is why the unity of history is guaranteed (1985, 505) and so basic trust is warranted. But can we understand that this trusting historical self is thereby related to God as one with a role from and for God? To speak so might seem to be to 'deepen and expand' the theme of experienced relationality, and at the same time prove faithful to the religious experience of relationship. It would reach back, perhaps behind the human, if for example Wicken is right in speaking of a reciprocal relationship between fields of force and material elements (Wicken 1988, 52). Pannenberg may have a way of speaking of some such relationship. He will speak of providence working through human agency (1985, 513). But it is clear that the relationship spans differing ontological levels, to put it clumsily. And to speak of that in Pannenberg's thought is to speak of the future, for God's power is ultimately the power of the future.

One might well argue that the ultimate future is ontologically other than all other temporal modes in that it is their true end. Even then one could ask whether continuity is not present ontologically, if it is after all eternal life in which temporal life ends. But the otherness of this future is other in yet another sense. For the timeline turns around here so that it is the future which determines all of history. Pannenberg must surely be weary of hearing questions regarding this point. Robert John Russell, for example, referred to Pannenberg's "complex and unusual ontological reversal in which the future is given priority over the past as the determining reality" and remarked that this represented "the greatest challenge to dialogue with physicists" (Russell 1988, 40). I do not have much that is new to add to this discussion, but I need to introduce it in connection with the question of what it would mean materially for theology to deepen and expand the understanding of human experience.

This reversal of temporal direction, familiar to readers of other of Pannenberg's works, reappears in the *Anthropology* in a number of ways. What are we to make of the metaphor "the womb of the future",

in which the outcome of events is hidden? (1985, 506) This may merely mean that "future events may destroy what has been gained" (1985, 515), so that "the future alone decides what is truly lasting" (1985, 525). But it seems too much to begin this talk about the "truly lasting" by saying that "it is *from* the future that the abiding essence of things discloses itself" (1985, 525; emphasis mine). It turns out that the future already is, for biblical speech about the kingdom of God refers to "common human destiny" when it speaks of the presence of the kingdom now (1985, 409). Or he can place this formulation in the very sentence which speaks of temporality in an ordinary way: "there is present in every historical moment the whole of life that in its historical course is still unfinished" (1985, 515).

I do not understand these references. Let me remind you of one other:

> History as a formative process is the way to the future to which the individual is destined. As long as the journey is incomplete, it can only be described in terms anticipatory of its end and goal. It is in the light of that end and goal that human beings grasp the meaning of their lives and the task life sets them. Way and goal must, of course, be so related to each other that the way thus far traveled can be interpreted as a way to that goal . . . For the human person as historical being is not only the goal but also the movement of the history that leads to the goal. This movement, however, derives its unity *from* the future by which it will be completed. (1985, 527; emphasis mine)

I discern two formulations which Pannenberg may be offering the reader to assist with such difficulties. The first softens the ontological tension into an epistemological point. So he can follow the remark that "in each moment of the process the whole of life is still open-ended" with this: "That whole becomes *visible* for the individual life only at the moment of death and for the human race only at the end of its history" (1985, 512 in relation to Dilthey; emphasis mine). Or again:

> Given that there is a possible, still unrealized fulfillment (the possibility of which, however, is knowable only in retrospect once the possibility is realized), such a starting position is characterized by a certain openness that looks beyond what is already at hand. When *viewed* from the vantage point of the future fulfillment, this openness proves to be an openness precisely to that kind of fulfillment. But when *looked at* from the vantage point of the starting position in itself, the content of that future destiny is not yet determined and guaranteed. (1985, 500; emphasis mine)

Is this to say that the future is determined and so the present is determined to end in that future, but that we do not yet see it to be so? But are we to make 'openness' something with no more ontological contingency than that? Once again the themes of responsibility, of freedom—now in the ontological framework of temporal direction—are at stake here. Are human beings free if they cannot affect the future? Do we 'deepen and expand' by exposing that what we supposed to be true was merely an illusion? Where is the continuity in the advance from the provisional to the objective in that case?

That Pannenberg does seem to understand matters in this way is suggested by another formulation. In his discussion of Gehlen and Plessner he identifies this problem: "According to both, the subject supposedly comes into being only in the process of its behavior, but at the same time the subject must be thought of as the source of this behavior and therefore would have to exist fully at the beginning of the process" (1985, 65). But if the question (to Hartmann) is "how the person can be thought of as at one and the same time the ground and the result of itself" (1985, 237), could not the answer be the historical gift of freedom? Are our lives a single act whose actor exists only at play's end? More broadly, he is glad to have a similar question put to Habermas: "How is the formative process, which presupposes the unity of the species subject, to be expressed without equivocation by the concept of formation when the subject's totality and unity, themselves historical occurrences, make their appearance only within this process?" (1985, 511) But does the unity of history require that the many different causes are really one?

The subject is only there at the end, and—on a cosmic scale—the end is the whole of things. That gives Pannenberg the guarantee of the basic trust he needs, for there is nothing outside the whole to challenge it. Thus when human beings "move beyond all experience or idea of perceptible objects they continue to be exocentric, related to something other than themselves, but now to an Other beyond all the objects of their world, an Other that at the same time embraces this entire world and thus ensures the possible unification of the life of human beings in the world, despite the multiplicity and heterogeneity of the world's actions on them" (1985, 69).

So, this notion of the whole that is the ultimate future which even now determines reality would seem to warrant absolute trust. But one wonders if that is the deepening and expanding of the aching and challenging terrain of human choice and consequence which we know as history. For that matter, the specific religious experience underlying much religious piety also seems to speak of human responsibility in co-constituting the future. Surely Christian theology will want to

speak of God at the end (at every end) as the one before whom all historical deeds are judged. But the founding documents of that community have Jesus saying such strange things as "Not every one who calls me Lord, Lord, will enter into the kingdom of heaven, but he who does the will of my father who is in heaven." In human life we learn that trust is well placed only under certain circumstances within the struggle of conflicting wills. May that be a provisional version of another relationship, where God is to be trusted, to be sure, but not as the sole determiner of history? The human person would inappropriately trust God to do what God calls the human person to do.[4]

In such a relationship one could well make sense of the experience of the ecstatic—in play, in the way in which a good conversation seems to have a life of its own, as Pannenberg so effectively points out. This would be a relationship of unequals, but a relationship all the same. And it seems to me that it would make more sense of the great care with which Pannenberg is inclined to take the dizzying expanse of nontheological anthropological reflection, not to mention the human experience underlying that reflection. For then theology could indeed offer a perspective, and the perspective would intensify the reality of the phenomena in view. And the apologetic program would be on surer ground. God is not the negative of nondivine efficacy; God is the creator and judge of that. And human life is thus the more important, for it exists from and before and for God.

• • • • • • • • • •

Notes

1. In this essay (1984), Pannenberg questions whether Whitehead does not himself commit the fallacy of misplaced concreteness.
2. For a fuller statement of this point, see Peacocke 1979.
3. Despite the strength of Ricoeur's point about the phenomenology of 'Fall', I find the language of 'fall upward' to be found in such a nonmonistic source as Cobb and Birch 1981.
4. For a fuller discussion, see Fiddes 1988, especially Chapter 4, 'A Future for the Suffering God'.

• • • • • • • • • •

References

Cobb, John, and Charles Birch. 1981. *The Liberation of Life*. Cambridge: Cambridge University Press.

Fiddes, Paul S. 1988. *The Creative Suffering of God*. Oxford: Clarendon Press.

Pannenberg, Wolfhart. 1980. Gottebenbildlichkeit und Bildung des Menschen. In *Grundfragen systematischer Theologie*. Göttingen: Vandenhoeck und Ruprecht.

————. 1984. Atom, Duration, Form: Difficulties with Process Philosophy. *Process Studies* 14 (1, Spring):21–30.

————. 1985. *Anthropology in Theological Perspective.* Trans. Matthew J. O'Connell. Philadelphia: Westminster.

Peacocke, Arthur. 1979. *Creation and the World of Science.* Oxford: Clarendon.

Ricoeur, Paul. 1967. *The Symbolism of Evil.* Boston: Beacon.

Russell, Robert J. 1988. Contingency in Physics and Cosmology: A Critique of the Theology of Wolfhart Pannenberg. *Zygon: Journal of Religion and Science* 23:23–43.

Wicken, Jeffrey S. 1988. Theology and Science in the Evolving Cosmos: A Need for Dialogue. *Zygon: Journal of Religion and Science* 23:45–55.

16

From Methodology to Metaphysics: The Problem of Control in the Science-Theology Dialogue
••••••••••
Philip Clayton

Wherever we may end up disagreeing with Professor Pannenberg, or with the three authors whose papers precede mine, one thing is clear: Pannenberg's work *has* here given rise to precisely the sort of dialogue that his writings advocate. His *de facto* success in establishing contact between scientists and theologians, a contact in which theology is a genuine discussion partner, already sets Pannenberg apart from most other living theologians. This success is, to my mind, a decisive sign of the correctness of his basic methodological proposal for theology.

In order best to set up a profitable discussion of these three papers and the work of Professor Pannenberg's to which they refer, I shall order my comments around the problem of controls; hence the title 'From Methodology to Metaphysics: The Problem of Control in the Science-Theology Dialogue'. After presenting the problem, I will divide my response into these sections: control in and by the natural sciences, control in the social sciences, control in theology, and metaphysics as control.

••••••••••
The Question of Control

Pannenberg has proposed that we search for dimensions theologically relevant to the phenomena described in the anthropological disciplines and elsewhere. One immediately wonders what sort of control there could be to guide this quest for deeper dimensions. For deeper dimensions can of course be *sought* even where there is no hope of any progress or agreement. It is only too easy to engage in poetic, open-ended meditations on the sciences. For example: What metaphors does a particular scientific theory suggest to you? What facets in contemporary theories of human existence strike you as intriguing or aesthetically pleasing? What personal reactions do you have to the norms of scientific practice? When we who participate in the science-theology dialogue frame our questions in this manner, we risk impatience and dismissive judgments on the part of the scientific community. Might an apparent lack of evaluative criteria be the cause of the negative

reaction that many scientists have had to books like Paul Davies's *God and the New Physics,* some of David Bohm's work, Capra's *The Tao of Physics,* or Zukav's *The Dancing Wu li Masters?* It is too simple to say that scientists' resistance reveals only incipient positivism or knee-jerk naturalism; can it not also reflect a legitimate concern with controls or criteria governing this quest after deeper dimensions? Eaves picks up on exactly the right question when he worries that Pannenberg's discussion of anthropology may be more at home in the humanities than in the social sciences. The biggest threat to conversations such as ours is not that we might become metaphysical or political, but that we might have no more to offer than poets or literary critics. If what is needed is poetic reflection on science, surely others can do it better than we!

I suggest, then, that the issue of control is the most crucial issue facing the science-theology dialogue today: What are the standards for successful and unsuccessful endeavors in our field? We cannot ignore the question, for we run the recurrent risk that the entire discussion will appear arbitrary to those acquainted with the rigorous standards for evidence in the empirical disciplines and the careful attention to argument in the philosophical disciplines. Issues of control or criteria arise within all the specialties that our field encompasses. Think of the need to establish standards for the human sciences that do not tacitly impose natural scientific norms or rule out the very human phenomena they mean to address; the problem of defining progress in the humanities; the contrast of theology to other scientific endeavors and the consequent need for standards unique to it; and the pressing question of self-definition and criteria for the emerging discipline of science-theology, including a specification of the standards of argumentation that will regulate our claims.

Of course, one can respond that there *are* no controls on what we are doing, that any science-theology connection that occurs to me is a valid contribution to the discussion. And I admit that the difficulty of normalizing our field lends some credence to this flirtation with purely subjective or interest-relative criteria. However, we need not concede the last word to radical skepticism. For there *are* instances of rational meta-scientific discussion. The West (the East too, for that matter) has a long tradition of serious reflection on *meta*-physical questions, issues that transcend both science and the philosophy of science. Let's use the label *positivist* for those who deny that rational or 'controlled' examination of meta-physical questions is possible (though I am convinced that there are far fewer positivists out there than is often claimed). Defined in this way, positivism (as has often been pointed

out) is either arbitrary or self-refuting: either one gives no reasons to rule out meta-scientific reflection, or one becomes a metaphysician in trying to argue that metaphysics is impossible.

We therefore discover no reason for dismissing a priori the quest for agreed-upon controls over the science-religion dialogue. I can now pose the central question: what sorts of construals of this dialogue, what sorts of controls, have emerged in the papers of the preceding three symposiasts?

· · · · · · · · · · ·

2. Control in and by the Natural Sciences

In Chapter 14 of this volume, as well as in earlier books and articles, Wentzel van Huyssteen has made a convincing case that philosophy of natural science—specifically, a scientific definition of rationality—provides an important science-theology link and an indication of the sort of criteria needed to govern theological assertions. Van Huyssteen's stress on Bartley and Hans Albert is helpful for understanding Pannenberg's opposition to commitment-based epistemologies in theology. Pannenberg is indeed one of the most outspoken opponents of the 'retreat to commitment', the attempt by believers to ground their beliefs upon nonepistemic factors such as their will to believe or their subjective convictions.

I am less convinced that Bartley and Albert in particular "infuse [Pannenberg's] thinking on this theme" (366) or that he "consistently takes serious note" of their critical rationalism (368). Is not the *same* refusal to retreat into commitment already visible in Pannenberg's early criticisms of Barth's theology, in his unwillingness to ground belief claims on self-authenticating religious experiences, and in his early work on the resurrection? In *Jesus: God and Man,* published a year before Bartley's 1964 *Retreat to Commitment,* the core of Pannenberg's methodology can already be found:

> It is not clear why historiography should not in principle be able to speak about Jesus's resurrection as the explanation that is best established. . . . If, however, historical study declares itself unable to establish what 'really' happened on Easter, then all the more, faith is not able to do so; for faith cannot ascertain anything certain about events of the past that would perhaps be inaccessible to the historian. (Pannenberg 1968, 109)

Incidentally, I believe it is also mistaken to speak of the "influence" of Kuhn on Pannenberg. I would be very surprised if Pannenberg had ever held that competing positions (so-called paradigms) are incommensurable.

Why is it important to raise the question of influences? To 'be' a critical rationalist is to declare oneself preoccupied in the first place with epistemological issues. But I want to argue below that Pannenberg's theory of rationality stems ultimately from a substantive theological position. For instance, his emphasis on hypothetical reason grows out of his concern with universal history and his anticipatory ontology (see Clayton 1988). To put it differently: to be identified with Bartley and Albert is to be identified with Karl Popper and his program of conclusive falsifiability. But Popper's strict program has failed, and its failure has fueled the fires of Kuhnian incommensurability and subjectivist construals of science. If Pannenberg makes the philosophy of science his foundational discipline, he is liable to end up with the very inconsistencies of which van Huyssteen accuses him. Only if he has a broader source of appeal than critical rationalism for his theological methodology can he avoid the criticisms that van Huyssteen levels against him.

Still, van Huyssteen is right in this: the rationality discussion in the philosophy of science *has* been an important guide to theology, perhaps the most fruitful science-theology link to date. By contrast, contemporary discussions of realism and truth in the philosophy of science offer us a much more tenuous foothold. Van Huyssteen confidently links the question of explanation to the question of truth with a quote from the Roman Catholic philosopher of science Ernan McMullin. But philosophers of science just as often deal with the question of explanation in terms consciously opposed to correspondence truth, as in the work of Kuhn, Laudan, Hesse, van Fraassen, and Putnam (see Clayton 1989). Most of their discussions are purely epistemological, stressing rational warrant rather than truth—indeed, this is precisely what *critics* of philosophy of science such as Jürgen Habermas castigate it for. Where the question of truth is raised, the responses are more often than not highly skeptical. The problem is not that these theorists would be offended by being told that science attains merely 'provisional versions of objective reality' and that theology can provide a deeper dimension; they find the very proposal to beg the question against the pragmatism, instrumentalism, and internal realism that have been the focus of discussion in the recent literature.

For example, consider the realist position that is presupposed by our talk here of 'objective reality'. In the face of the demise of the objectivist myth of science and the radical theoretical changes chronicled in the history of science, are we justified in accepting a realist construal of contemporary scientific theory? A number of philosophers of science have recently defended a mediating position, which they call *scientific realism*. But scientific realism does not share the philosophical

assumptions that underlie our term *objective reality*. Richard Boyd, a leading defender of scientific realism, argues that we cannot speak of the ontology of science as being either one way or the other (Boyd 1984, 78). Ian Hacking provides a compelling defense of 'experimental realism': the scientist is justified in accepting a realism about entities but not about theories; only those entities that we use or manipulate in order to create other experimental results can be said to exist (Hacking 1984). Even McMullin insists that his defense of realism does not defend the principle of bivalence—the principle that the world must be one way or the other in every case (McMullin 1984, 84). I conclude that contemporary philosophy of science provides little inducement on its own to lead one from the provisional models of contemporary physics to the theological dimensions with which we are here concerned.

Lindon Eaves appeals not to the philosophy of science, as does van Huyssteen, but directly to scientific theories. He uses the intriguing term *icon*, instead of the more familiar *model* or *symbol*, in order to specify the relationship between science and theology. His treatment of icons in science is meant to show that science "seeks and exploits" what he calls the "constitutive elements of reality", the things that are "necessary and irreplaceable for understanding the whole of reality" (317). Eaves's position appears to be that successful scientific icons—his chief example is the double helix—simply get that part of the world right; therefore, they must have their place within the structure of any final theory of reality.

The science-religion debate, as a result, seems to involve only a sort of religious appropriation of science. We begin with scientific building blocks, the scientific "raw material" (330) that theological efforts must "feed on" (335). Concepts like the double helix provide "a universal foundation" (334) for religious reflection. Religion is then "the attempt to adapt" (330) to scientific results, and our task as students of religion is to aid religion in its adaptive work.

Eaves's theory of icons is meant to ensure that the discussion between scientists and students of religion does not lose track of science's objective conclusions. His paper gently cautions theology against storming in as an authority over the scientist. Perhaps the humility that he recommends to theologians is appropriate; certainly science's empirical successes demand some acknowledgment from the empirically less successful disciplines. However, I suggest that the juxtaposition of Eaves and van Huyssteen poses a sort of dilemma (in the sense of a forced choice) for our discussions. If Eaves is right, we will have to grant the icons of science a more foundational role than we often do; we will have to fight our tendency to treat science's self-

understanding as merely provisional or to subsume it within some broader, metaphysical scheme which claims to be the foundation for science. I suggest that our other two symposiasts are proposing to us two different and incompatible routes for escaping Eaves's conclusions: van Huyssteen believes that science is a much more subjective mode of knowing than Eaves would allow, and Sponheim argues that scientific 'nodes' are themselves in need of the framework of metaphysics or ontology. I return to these two alternatives to Eaves in a moment.

2. Control in the Human Sciences

We do not have any social scientists invested in the present dialogue, and precious few in science-theology in general, notwithstanding the fact that today's theme is drawn from a book on the human sciences. Nevertheless, the centrality of the human sciences is attested by the number of issues raised in the papers that fall under this heading. Also, we have Pannenberg's attestation that "anthropology has become . . . *the* terrain on which theologians must base their claim to universal validity for what they say" (1985, 18; emphasis mine).

Eaves's foundationalist view of science has much to commend it in the natural sciences: it does not strike us as unlikely that (for instance) analytic chemistry or cellular biology has basically got the world right, though there are obviously many other areas where claims that science has grasped objective reality would be premature. It is less clear, however, that we could find any Eavesean icons in the human sciences. Do we find *any* 'universal dimensions' among the theories of humankind advanced by psychologists and sociologists? Eaves's preference for genetics over cultural anthropology suggests a negative answer. He objects to Pannenberg's treatment of scientific theories as provisional, drawing his examples in general from the biological sciences. Yet Pannenberg's reference in the disputed phrase "provisional versions of objective reality" is to the human sciences!

Of course, Eaves addresses this question as well. He later accuses Pannenberg of reducing the social sciences to the humanities, of not embracing the data of these disciplines "where it hurts most" (328). The battle between genetic and cultural approaches to anthropology, he claims, simply cannot be resolved until disciplines such as sociobiology are more fully developed. But, as Eaves notes, this unresolved dispute "presents a real problem for theological anthropology" (330).

I think Eaves is right here. Pannenberg works his way through contemporary social theory under the guidance of Herder, Dilthey,

Heidegger, and the philosophical anthropologists Plessner, Gehlen, and Scheler. Yet his approach is not just a minority position from the perspective of contemporary English-language philosophy of social science; it is well-nigh inconceivable from that perspective. Of course, this observation is not a refutation: Pannenberg may well have some other source besides the social sciences for defending his construal of anthropology. We return to this question in a moment.

I think there is a way to mediate between Eaves and van Huyssteen on the question of cultural anthropology. Eaves doubts that we can give the predicates of cultural anthropology a central role in this discussion, not to mention the even less scientific language of subjective human experience: "[The] classical dimensions of human behavior—cognition, affect, and sociality—do not have a life independent of biology" (329). Van Huyssteen, by contrast, is a well-known supporter of the centrality of experiential factors in rational explanation—indeed, in rationality in general. Unless they dull the sharpness of their present formulations, no mediation is possible. If Eaves and van Huyssteen *were* to seek a common discipline for mediating their concerns, it seems that cultural anthropology would provide them with precisely the right terrain. Cultural anthropology *could* build on the genetic work of sociobiologists—just as genetics itself relies on physical and chemical theories without thereby *becoming* physics or chemistry. Yet it clearly leaves room for formulating explanations in the human sciences that include the very experiential factors that van Huyssteen defends as essential. Of course, my suggested mediation returns us right to the heart of the project that Pannenberg is engaged in in his anthropology: it returns us to problems such as the definition of the self, the role of culture, the world-openness of humans, the question of historicity, and the theological dimensions within theories of human existence.

It is in Sponheim's article that we find hints of the sort of discourse that has the best chance to mediate this disagreement. It is Sponheim who deals in greatest detail with Pannenberg's anthropological project: he is sympathetic to Pannenberg's claim that anthropological issues are some of the most crucial to the contemporary science-theology discussion. Sponheim argues that theology must appropriate "the deep and common experience of humankind" as formulated by the human sciences (386). He then suggests that this deep and common experience could also *falsify* theological claims. Here we finally arrive at the control that governs theological interaction with the human sciences. I would describe it as follows: theology is one of many semantic worlds or 'meaning-complexes' that individuals and societies can draw on in their attempt to understand human existence.

When the beliefs that make up the Christian worldview can no longer be made coherent with the intellectual, political, and ethical beliefs of contemporary believers, it will have failed the semantic test, the 'control' of its ability to bestow meaning. Of course, this semantic test is not as rigorous as the test of correspondence with scientific fact that Eaves advocates; and it certainly cannot be construed in foundationalist terms, for it is based on a model of coherential justification. Nonetheless, the possible 'semantic falsification' of theology represents a genuine intersection between theology and the human sciences, a genuine control over theological reflection, and therefore must be an integral component of science-theology discussions.

· · · · · · · · · ·
4. Control in Theology

Let us pause to take stock. What options have our three authors offered us to control the quest for deeper theological dimensions in the data treated by the sciences? Sponheim seems to have no problem with Pannenberg's own construal of, and criteria for, his project, although he does question Pannenberg's success at it. Over a third of his paper questions "whether the theological formulation offered [by Pannenberg] does deepen and expand the reality known in human experience" (387–394, quotation 388). Eaves offers a clear but very different specification of the control on theology: science searches for the correct understanding of (for instance) biological reality—its givenness, connectedness, and openness—and then theology helps to make these biological facts meaningful to us, or comprehensible, or at least bearable. Finally, for van Huyssteen, "different kinds of knowledge are involved in the practices of science and theology" (373). Though each informs "the content of the other" (375), theology is finally a matter of "ultimate religious commitment." Theological claims ultimately receive their warrant, their control, through their "experiential adequacy" "Theology . . . makes claims based on religious experience" (376). In *The Realism of the Text*, van Huyssteen has argued that Christian claims have in this way "justified themselves as meaningful *and referential* to vast numbers of people throughout the centuries and across cultures (his summary here, 376 emphasis mine).

If we had to compact each position into a phrase—though this is a risky procedure—we could say that science remains in control for Eaves, theology (or ontology) wrestles away de facto control for Sponheim, and the two are relativized to their respective spheres (though not without interaction) for van Huyssteen. Let me first query van Huyssteen's position on this matter. The crucial question for debate in

his paper is his major reservation about Pannenberg's theology, namely, that Pannenberg deems "a personal religious commitment" to imply " 'unscientific' or irrational thought" (372). Now van Huyssteen might mean that Pannenberg leaves *no* place for personal religious experience or commitment. This allegation would be easy to answer: Pannenberg clearly does not mean to devalue personal commitment; many texts could be cited here, including the account of his own religious experience found in his autobiographical sketch (Braaten and Clayton 1988, 12). Pannenberg insists merely that, whatever personal commitment the believer has, "from other perspectives, namely from those of theoretical reflection, even the truth claim of religious experience and tradition must be judged as hypothetical and the certainty of faith as a subjective anticipation" (Pannenberg 1980, 264).

Therefore, I will assume that van Huyssteen has a more serious criticism in mind: not that Pannenberg has *no* place for subjective commitment, but that the role Pannenberg grants such commitment is inadequate. We know from van Huyssteen's own writing that he wants to move from rationality to intelligibility, from intelligibility to the question of personal understanding, and from personal understanding to personal experience or personal disclosure value. Hence his central dependence on experiential adequacy for determining epistemological adequacy (374). For van Huyssteen none of this is subjectivism: if metaphors (for example) stem from experience, they also suggest explanatory networks (van Huyssteen 1987, 20). But he has not yet convinced me that his experiential epistemology can provide the sort of control that I have been advocating in these comments. If he espoused an objectivist theory of meaning of the sort that Pannenberg has developed under the influence of Dilthey, the task of intercommunal or interparadigm evaluation would be more straightforward. But until now he has resisted such a move.

The strength of Paul Sponheim's approach is that he deals with the question of theology's version of objective reality within the broader context of a comprehensively systematic theology. He rightly draws attention to the fact that Pannenberg's concern with science is a concern with the interpretation of scientific data (381). In matters of interpretation we are concerned with the competition between secular and theological understandings, that is—according to the objectivist theory of meaning that he seems to share with Pannenberg—with the dispute over the most adequate framework for comprehending the results of natural and social scientific research for making these results meaningful. Parenthetically, I believe this approach would answer van Huyssteen's worry about the commensurability of theological and scientific concerns: they are commensurable when addressed via a higher

order theory that provides a definition of (and criteria for) the frameworks involved.

Consequently, to ask about the standards for coherent frameworks is to be led to precisely the issue that Sponheim raises: what is the "general ontology" (Pannenberg 1985, 521), the underlying view of reality, that Pannenberg advocates? The attempt to evaluate theological appropriations of science *must* lead eventually to this question for reasons often cited by metaphysicians: the same compulsion that moves us from scientific results to the philosophy of science, and from philosophies of science to the search for a framework within which to compare them, must finally lead us to the broadest possible framework within which positions can still be formulated and reasons given for and against them.

· · · · · · · · · ·
5. Conclusion: Metaphysics as Control?

Sponheim's ontological question therefore accurately expresses the heart of Pannenberg's own project and the solution to the question of control that I raised at the outset. That this is the immanent *telos* of Pannenberg's work is not always recognized, perhaps because Pannenberg has written so extensively on methodological issues. One might distinguish between broadly 'kantian' and 'hegelian' approaches (if these are emphatically spelled with a small *k* and *h*!). Kantian approaches are most concerned with specifying the formal *structure* of theories (for example, they must be deductive; they must be hypothetical) and with specifying a list of general criteria for all theory evaluation, while so-called hegelian approaches are skeptical of general lists of criteria and concentrate instead on exploring the relative merits of various systematic *positions*. What is often not seen is that Pannenberg's philosophy of science is more hegelian than kantian, more concerned with the actual understanding of God that emerges at the level of history as a whole than with the minimal requirements for being scientific (the question of *Wissenschaftlichkeit*). If I were to ask Pannenberg whether this is the case, I would ask whether the concept of totality in his *Wissenschaftstheorie* (or the concept of unity or *das Ganze* in other articles) is merely a formal category or, rather, one of the central elements of a substantive position.

Pannenberg's phrase "provisional versions of objective reality," which serves as the theme for this volume, should of course have made all this clear from the outset. To use such a phrase is already to proclaim oneself a realist and a metaphysician regarding the data and goals of science. Here is how I would unpack this phrase: There are

three levels with which we must be concerned—the data or 'givens' of science, that is, lower-level or highly corroborated theories; the 'descriptions' or frameworks or metaphysical interpretations that are imposed on these data; and 'objective reality', that is, the way the world is or will finally turn out to be, the final true description. *All broader interpretations that are imposed on the data are provisional*, since they go beyond what is scientifically given; yet, Pannenberg's view presupposes, each one is potentially true or false, since one day they will stand before objective reality like sheep and goats, and the true interpretations shall be separated from the false. Moreover, he would claim, at any given time we can make rational judgments about the merits and demerits of the various interpretations, using meta-scientific, hence metaphysical, criteria. Finally, according to Pannenberg, a careful examination of (say) anthropological data reveals that these data are inadequately comprehended under a secular interpretation and only fully understood under a theological one.

So much for provisional descriptions and objective reality; let me come quickly to my conclusion. Each of the three speakers has praised Pannenberg for his demand that theology in general, and the science-theology discussion in particular, be pursued in a rational manner, that it not devolve into a poetic multiplying of religious views of science. Pannenberg has been absolutely explicit that the ground of this rationality must be metaphysical. Yet the three authors' attitudes towards metaphysics vary. Sponheim must be sympathetic to Pannenberg's speculative bent, since he calls for an even more elaborate metaphysical response. He seems to agree with Pannenberg that God must be directly related to 'each reality', although he thinks this can be done without the concept of the whole. (By the way, I am skeptical about this last claim, but I'll let Professor Pannenberg respond for himself to Sponheim's treatment of the notion of the whole.)

Van Huyssteen and Eaves appear *un*sympathetic to metaphysical speculation. Van Huyssteen resists any metaphysical discourse which is conducted outside a specified "way of life" (374) and does not stem from a "paradigm choice" that reflects a "basic conviction or religious commitment" (373). Likewise, Eaves wishes to leave it to science to provide universal foundations (334) and the "nodal parts of reality" (317). But in what category would Eaves's own theory of modes of reality fall? Is it not itself clearly metaphysical? Surely it is metascientific. We need some sort of rational discourse in which we can speak about science's relations to other human endeavors, *even if science continues to retain a foundational role* in substantive questions. But then

what is the control or justification for this sort of speculation if not metaphysical? I conclude that it is necessary to leave a place for the description and evaluation of metascientific theories if genuine science-religion *dialogue* is to be possible.

There is a moral to draw from the level of the science-theology discussion at which we have arrived, a level often called 'metaphysical', though little turns on the name. This outcome is not just a formal decision, that is, a decision to allow certain sorts of criteria to guide our discussions. For formal pronouncements can never be fully divorced from actual questions of content: even a quick examination of the history of modern philosophy, or of contemporary theories of science, makes this clear. Kant was wrong: there is no neutral criteriology; every proposed criterion supports certain sorts of theories and militates against others. So the acceptance of metaphysical language as necessary for the success of the science-theology discussion will mean that we will tend to focus on certain sorts of problems and to pay less attention to others. We will have to look back, not only at the history of science and the history of theology, but also at the history of speculative thought. And the contemporary thinkers whom we heed will include, in addition to scientists, philosophers of science, and theologians, also speculative and systematic philosophers.

All this would be a radical shift—and, in the United States at least, not an overly popular one—for the science-religion debate. But I believe it represents the essence of Pannenberg's program in science-theology as he has developed it since (perhaps) his work on Duns Scotus in the early 1950s. Certainly it conveys Pannenberg's emphasis since the seminars with Dieter Henrich in the mid-1980s, an emphasis that is clear in the new *Systematic Theology* and his equally important *Metaphysics and the Idea of God*. I remain more skeptical than Pannenberg about the strength of the conclusions that we can draw from a metaphysical treatment of science and theology. But he has now convinced me that such a treatment is unavoidable. When we begin to talk of provisional versions and objective reality, it is time to turn from methodology to metaphysics.

• • • • • • • • • •

References

Boyd, Richard. 1984. The Current Status of Scientific Realism. In *Scientific Realism*, ed. Jarret Leplin. Berkeley: University of California Press.

Braaten, Carl, and Philip Clayton, eds. 1988. *The Theology of Wolfhart Pannenberg: Twelve American Critiques*. Minneapolis: Augsburg.

Clayton, Philip. 1988. Being and One Theologian. *The Thomist* 52:645–71.

————. 1989. *Explanation from Physics to the Philosophy of Religion: An Essay in Rationality and Religion.* New Haven: Yale University Press.

Hacking, Ian. 1984. Experimentation and Scientific Realism. In *Scientific Realism,* ed. Jarret Leplin. Berkeley: University of California Press.

van Huyssteen, Wentzel. 1987. Experience and Exploration. Paper presented at the Theology and Science Consultation of the American Academy of Religion, 5 December.

McMullin, Ernan. 1984. A Case for Scientific Realism. In *Scientific Realism,* ed. Jarret Leplin. Berkeley: University of California Press.

Pannenberg, Wolfhart. 1968. *Jesus: God and Man.* Trans. Lewis Wilkins and Duane Priebe. Philadelphia: Westminster.

————. 1980. Wahrheit, Gewissheit, und Glaube. In *Grundfragen systematischer Theologie.* Vol. 2. Göttingen: Vandenhoeck und Ruprecht.

————. 1985. *Anthropology in Theological Perspective.* Trans. Matthew J. O'Connell. Philadelphia: Westminster.

17

A Lakatosian Reconstruction of Pannenberg's Program: Responses to Sponheim, van Huyssteen, and Eaves
··········
by Nancey Murphy

··········
1. Questions to Pannenberg

It is indeed a pleasure to have the opportunity to respond to these three very interesting papers—especially since they address the work of Professor Pannenberg, whose theology has played an important role in the development of my own thought.

I shall not attempt a detailed response to all of the issues raised in these papers. Rather, I shall extract from each paper what I see to be the most significant questions raised for Pannenberg's project. These will be critical questions, and all relate directly or indirectly to Pannenberg's methodology. I am sure that Pannenberg will want to address many of them himself, and I shall not attempt to speak for him. What I shall do instead is, first, to describe Pannenberg's methodology, as defined in *Theology and the Philosophy of Science* (1976), and show how closely his later work in *Anthropology in Theological Perspective* (1985) follows the guidelines and plan laid out there. Second, I shall propose a different view of scientific-theological methodology, based on the work of Imre Lakatos, and show that it also serves to *describe* and *account for* Pannenberg's theological development. Finally, I shall return to the penetrating questions raised by Sponheim, van Huyssteen, and Eaves to show how easily they can be answered on the basis of my alternative (Lakatosian) account of Pannenberg's program.

Let us look at the papers now and compile a list of critical questions. First I turn to Paul Sponheim's paper (Chapter 15). Sponheim raises three questions about three issues. The three issues are the reality claims of the Christian faith, the relevance of anthropology to Christian truth claims, and the relevance of the doctrine of creation to Pannenberg's project. The three questions ask:

1. What would it take to demonstrate claims regarding these three issues?
2. What would such a demonstration entail *formally* for theology?
3. What would such a demonstration entail *materially* for theology?

I shall address several of these 3^2 questions in the final section of my response. I shall entirely neglect question three, regarding material implications, and shall give scant attention to the issue of creation, not because such questions are unimportant, but because of space constraints.

In considering answers to his first set of questions, Sponheim draws together important aspects of Pannenberg's thought: The demonstration will not amount to proof (380); it will involve testing theology's version of anthropology against reality (381), and the expansion, deepening and transformation of anthropological data (381); it will require genuine advance in interpreting anthropological data (389).

Notice now that despite the publication of Pannenberg's substantial theological anthropology (1985), which claims to have done exactly these things, Sponheim still expresses his reiterated question in the subjunctive: What *would* it take? Pannenberg might at this moment be asking himself, what indeed!

Sponheim suggests answers to his second set of questions, regarding formal entailments for theology, in the event Pannenberg's program were successful: There would be grounds for asserting the truth of theology as well as its meaningfulness (384). The necessity of taking theology seriously, even by atheists, would be demonstrated (384). Theology would still be distinguishable from other disciplines (386), although Sponheim sees a remaining question about how to differentiate theology from ontology (386). Finally, Pannenberg's program opens up the possibility of falsifying theological claims (387).

I shall come back to these questions and answers later.

Let us now examine Wentzel van Huyssteen's paper (Chapter 14 above) to see what questions it poses for Pannenberg's theological program. Van Huyssteen's paper is very helpful for our discussion in that it draws our attention directly to Pannenberg's theological methodology (as set forth in *Theology and the Philosophy of Science*) and to his claims for its identity with scientific methodology. Van Huyssteen reviews here Pannenberg's criticisms of Karl Popper's critical rationalism, but then raises the interesting question whether Pannenberg himself has not unwittingly fallen into a critical rationalist approach to theology. Popper's critic, Thomas Kuhn, emphasizes the necessity of *commitment* to a paradigm. Pannenberg claims to side with Kuhn[1] in his criticism of Popper's falsificationism, yet where is Pannenberg's commitment to the truth of God's existence if God's existence remains forever for him an *hypothesis?* By insisting on the hypothetical nature of this claim, Pannenberg is behaving as a falsifi-

cationist. Van Huyssteen proposes no Pannenbergian answer to the conflict between commitment and fallibilism. To this problem as well we shall return.

I turn finally to Lindon Eaves's paper (Chapter 12). Again, there is much more here than I shall be able to comment on, and I shall follow my policy of extracting what I see to be the telling questions. First, is theology a science (309), and if so, where in the typical progress of development of scientific thought does Pannenberg's work fall? Eaves identifies three stages in scientific development: taxonomy, hypothetico-deductive explanation, and the paradigmatic, technological phase (325). Eaves concludes that Pannenberg is suspended somewhere between taxonomy and hypothetico-deductive theory formation (326).

Second, Eaves asks, is Pannenberg addressing current and pressing issues in anthropology, or is he merely assembling an aggregate of anthropological ideas that are most useful theologically (327)?

Third, has Pannenberg sold out by identifying scientific method with the methods of the humanities or the 'soft sciences'? Can Pannenberg's theology meet the methodological challenge posed by the natural sciences (327)?

Finally, is Pannenberg justified in dismissing sociobiology in half a page (329)?

· · · · · · · · · ·
2. Pannenberg's Scientific-Theological Method

As suggested above, van Huyssteen is exactly correct in noting that Pannenberg's current work needs to be understood in light of his program for a scientific theology as set forth in *Theology and the Philosophy of Science*. Although van Huyssteen has done a great deal to call the contents of that volume to mind, I shall nonetheless give a brief account of Pannenberg's methodology in order to show how coherently his more recent *Anthropology in Theological Perspective* fits into the overall system. Pannenberg, along with most recent philosophers of science, affirms that hypotheses are acceptable insofar as they provide the best available explanation of the phenomena. Pannenberg, along with Stephen Toulmin, understands explanation as placing the phenomenon to be explained within a context that makes sense of the phenomenon. This approach has the advantage that it is broad enough to apply to both the natural and human sciences. For example, in the natural sciences a single event may be explained by placing it within the context of a natural law—that is, by showing it to be an instance of a natural law. The law itself is explained by situating it

within the context of a theory; the theory within the context of an ideal of natural order. Similarly, a problematic passage in a text is understood by considering its relation to the text as a whole; the text is understood by placing it in its historical context. A historical event is explained by placing it within the series of events to which it belongs. Thus we may envision the development of science, history, theology, as the development of a series of concentric spheres or circles, each circle providing a wider framework of interpretation, a broader horizon of meaning.

When in the process of explanation one reaches the 'circle' representing the whole of reality, one further question arises: How is one to explain the fact that the whole of history *is* a whole? This is both a philosophical and theological question. Insofar as one answers it on the basis of a religious tradition's concept of the all-determining reality, one is doing theology. Or, put the other way around, Christian theology is given scientific support insofar as it can be shown that its concept of God provides the best explanation for the whole of reality. The theologian's task is to provide a faithful reinterpretation of the tradition that makes apparent its value for understanding all available knowledge.

We might describe Pannenberg's view of theology in spatial terms as follows: Theology begins with two sets of concentric circles[2] (see figure 1). One set involves the texts of the Christian scriptures. Here texts concerning Jesus's resurrection are at the very center, surrounded by circles representing increasingly broad contexts required for their full understanding—most immediately, the rest of the New Testament. The apocalyptic worldview of the first century would in turn form an important context for understanding the New Testament.

Beside this first series of circles is another, representing our own experience and the ever-broadening contexts within which we attempt to interpret it. At some point moving outward we reach a circle that encompasses both foci. The Christian view of God, based ultimately on the fact of Jesus's resurrection, is represented by the outermost circle, intended to encompass and give meaning to all experience and to all other contexts of meaning.

In *Theology and the Philosophy of Science* Pannenberg suggested that the phenomenon of hope, an aspect of universal human experience, calls for explanation. Historically, two explanations have been available: belief in the resurrection of the body or in the immortality of the soul. Within the context of modern science, the survival of a soul beyond the disintegration of the body is unreasonable. Thus the phenomenon of hope cries out for a concept of resurrection to give it meaning. Therefore the apocalyptic worldview of the Bible provides a

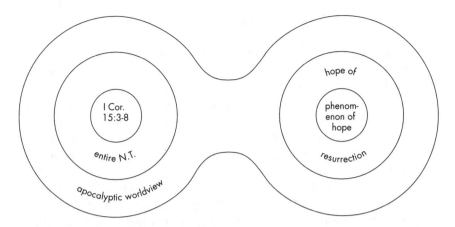

Figure 1. Diagram Representing Pannenberg's View of Theology

suitable context for the interpretation of this phenomenon, and the Christian and contemporary worldviews fuse at this point. We may represent this fusion schematically (see figure 1).

Although suggestive, Pannenberg's anthropological starting point in *Theology and the Philosophy of Science* was rather slight. Thus it was to be expected that among his later projects would be a detailed study of points at which the Christian horizon might fuse with explanations of human experience. In structure, *Anthropology in Theological Perspective* is just what Pannenberg's methodology called for.

My point in reviewing the methodology set forth in *Theology and the Philosophy of Science* is to highlight the impressive coherence of Pannenberg's system, and to show in outline how the methodology, plus elements of the system completed by that date, called for developments relating to the various branches of science. What I intend to do now is to present a different conception of scientific methodology, and to show in a preliminary way that Pannenberg's work to date could be equally well accounted for on its basis if we knew the *content* of his theology but were entirely ignorant of his methodological presuppositions. Furthermore I shall show that the questions culled from Sponheim's, Eaves's, and van Huyssteen's papers can be answered easily using my proposed methodology.

· · · · · · · · · ·
3. Imre Lakatos's Methodology as a Model for Theology

My proposal is based on the philosophy of science of Imre Lakatos (see Lakatos 1987). I shall describe the essentials of his view of science

here, and then illustrate its applicability to theology by reinterpreting Pannenberg's theology as a Lakatosian research program.

Lakatos's view of scientific rationality involves specifying a criterion for choice between competing *research programs*. A research program includes a central theory and a body of data. The theory by itself generally has no observable consequences; so added to the theory are a set of auxiliary hypotheses, which together add enough information to allow the data to be related to the theory. Examples of types of auxiliary hypotheses are theories of observation or of instrumentation, lower level theories that apply the main theory in different kinds of cases, and so forth. The main theory is called the *hard core* of the research program, and the auxiliary hypotheses are said to form a protective belt around it, since they are to be modified when potentially falsifying data are found. A research program, then, is a series of complex theories, where the core remains the same and the auxiliary hypotheses are successively modified, replaced, or amplified in order to account for problematic observations.

Lakatos claims that the history of science is best understood not in terms of successive paradigms, as it is for Kuhn, but rather in terms of competing research programs. Some of these programs Lakatos describes as *progressive*, and others as *degenerating*. A degenerating research program is one where the core theory is saved by modifications of the protective belt that are ad hoc, "mere face-saving devices, linguistic tricks, empty prevarications." Now, we all have a sense of what these expressions mean, but it is difficult to propose criteria by which to rule out such nonscientific maneuvers. Lakatos does a fine job, I think, of characterizing the kind of maneuvers which *are* scientifically acceptable. A research program is *progressive* in Lakatos's terms when the following conditions are met:

1. Each new version of the theory (core theory plus its auxiliaries) has excess empirical content over its predecessor; i.e., it predicts some novel, hitherto unexpected facts, and
2. some of these predicted facts are corroborated.

From this the contrary follows. A research program is *degenerating* when the change from one theory to the next accounts for the one anomaly or set of anomalies for which the change was made, but does not allow for prediction and discovery of any novel facts.

The choice of theories thus becomes a choice between two or more competing *series* of theories, where one chooses the more progressive of the programs. The choice is thereby made to depend on the programs' relative power to *increase* our knowledge.

Lakatos distinguishes between mature and immature science. In mature science, the development of the belt of auxiliary hypotheses is guided by a plan, called the positive heuristic. In immature science, the development is haphazard, occasioned by external events such as the discoveries made by rival programs.

This is an overview of Lakatos's position. Now there are several points of refinement to be mentioned. The first is that a program which has been degenerating for a time can later be turned around by new discoveries or more brilliant theorizing. It is also important to note that 'prediction' of 'novel' facts can also mean 'retrodiction' of facts that are already known, but would have been considered irrelevant or impossible in light of the previous theory. Also, research programs can support one another. That is, a theory forming the core of one program may be an important auxiliary for another. In this case progress for one counts as progress for the other. This may be especially important for theology where connections or clashes between theories (doctrines) may be a more important source of corroboration or of anomalies than are statements representing data.

So there are actually several ways to provide progressive support for a research program: (1) by the *pre*diction of facts that were previously entirely unknown and unexpected; (2) by relating to the theory facts that were already known but considered either irrelevant or contrary to it (often a move of this sort constitutes a dramatic victory for a program when the fact in question was seen either as an important anomaly for that program or as an important piece of evidence for its competitor); and (3) by the inclusion into the research program as a new auxiliary hypothesis another theory with a progressive track record of its own.

4. Pannenberg's Scientific Research Program

Here is my proposal for the rational *reconstruction* of (part of) Pannenberg's system. The hard core of the program can be expressed as the thesis that *the God of Jesus Christ is the all-determining reality.* This is the central, and rather abstract, hypothesis that guides the elaboration of the entire research program.

The positive heuristic of any systematic theology, I believe, is the plan to develop theories (auxiliary hypotheses) concerning all the traditional theological *loci* in such a way that they meet the following conditions: (1) they are faithful to any authoritative pronouncements within the relevant communion; (2) they serve to elaborate, or spell out the content of the hard core in a way that (3) relates the doctrines

to currently available data. In Pannenberg's case, the nature of his hard core—the insistence on God's relation to all that is—requires that currently available data include not only the scriptural texts, but data and theories from all areas of knowledge.

Pannenberg's theory of revelation as history, along with more specific theories of interpretation (for example, the thesis that the principle of analogy is to be used only in a qualified way in the interpretation of historical texts), constitute important methodological auxiliary hypotheses comparable to theories of observation and instrumentation in science.

A crucial line of argument in support of the core theory runs from the Pauline texts regarding the appearances of Jesus after his burial, along with other historical data (such as the apparent lack of any accounts of recovering his body), through a cluster of auxiliary hypotheses regarding Jesus's resurrection and its significance against the background of Jewish apocalyptic, to the conclusion that God is definitively revealed in Jesus. This conclusion in turn has implications both for Pannenberg's doctrine of God (the hard core) and for his Christology (an important cluster of doctrinal auxiliary hypotheses).

Additional clusters of doctrinal hypotheses would have to include other traditional Christian doctrines: ecclesiology, spirit, trinity, and, most interestingly for our purposes, Christian anthropology and the doctrine of creation.

Let us return now to the notion of the positive heuristic. Pannenberg's hard core, which refers to God, not only as the God of Jesus Christ, but also as the all-determining reality, adds an extra burden to his positive heuristic. Besides reinterpretation of the tradition, Pannenberg's program calls as well for confirmation of the hard core by means of data from all branches of knowledge. Thus part of his plan is to develop auxiliary hypotheses to mediate (form logical links) between such extra-theological reality and the hard core. Ideally these additional auxiliary hypotheses will not be unrelated to the doctrinal auxiliaries. Rather, the doctrines themselves will mediate between the hard core and both scriptural and experiential data. *This is in fact the kind of development we see in the aspects of Pannenberg's system under consideration today.* The doctrine of creation is confirmed by (explains) data from scripture, and at the same time explains the contingency in the universe now recognized by physicists.

Christian anthropology is a traditional part of systematic theology. Pannenberg develops theories in this area that serve as auxiliary hypotheses to account both for the data of the Christian tradition and

for particular facts of human experience as noted by secular anthropologists: exocentricity, ecstasy, spirit. The developments we see in Pannenberg's thought in *Anthropology in Theological Perspective* are equally predictable on the basis of a Lakatosian model of rationality as they are in terms of Pannenberg's own methodology.

To complement my schematic representation of Pannenberg's system as he describes it, I offer a schematic representation of some of the same features as Lakatos would describe it (see fig. 2).

· · · · · · · · · ·
5. Answers to Questions

I return now to questions posed by Eaves, van Huyssteen, and Sponheim. Notice that in figure 2, interposed between the data and Pannenberg's doctrinal auxiliary hypothesis concerning Christian anthropology, is a representation of a revised or reinterpreted scientific anthropology. Now the revision of auxiliary hypotheses in order to create consistency between data and the hard core is exactly in accord with Lakatos's description of scientific practice. However, Lakatos's methodology requires that such alterations be progressive, that is, that the new version of the theory allow for prediction of some new fact. It is not to be expected that each such theoretical modification will lead

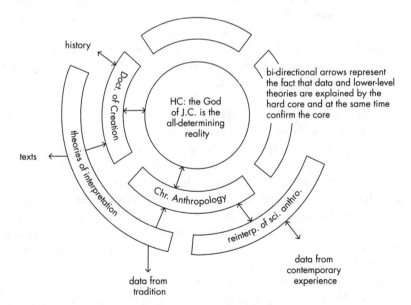

Figure 2. A Lakatosian Representation of Pannenberg's System

to the corroboration of a new fact, but research programs are to be judged on the basis of the frequency of such occurrences.

We are now in a position to answer Sponheim's first question: What would it take to demonstrate the reality claims of the Christian faith and to show the relevance of anthropology to Christian truth claims? The prediction and corroboration of a novel fact at this point would go a great distance toward establishing Pannenberg's theology as an acceptable research program, and such acceptability is as close as we can ever come to demonstrating reality claims. Furthermore, if the novel fact were in the area of anthropology, the relevance of anthropology to Christianity would become exceedingly clear.

Progress, according to Lakatos, is a relative concept. This leads us to the question of what constitute the principal rivals to Pannenberg's program. Many of them are competing systematic theologies. More interesting at the moment, perhaps, is the fact that Pannenberg's system seeks to compete with nontheological scientific and philosophical rivals as well. Thus, showing that Pannenberg's program is indeed a scientific research program shows at the same time that competing anthropological programs need to take theology (at least this theology) seriously.

The notion of rivals brings us to Eaves's last question: Is Pannenberg justified in his quick dismissal of sociobiology? Perhaps sociobiology is a cluster of auxiliary hypotheses in Pannenberg's most threatening rival. Is the hard core a Monodian vision of the universe as a product of pure chance, with theories of contemporary science ranged 'round it, and with sociobiology competing with theologies of all sorts to explain the human phenomena that we have always thought of as religious, or at least as transcending biological determinism?

Two questions can be dealt with at once: Sponheim's question about the formal consequences for theology if Pannenberg's project succeeds, and Eaves's question about Pannenberg's stage of scientific development. As mentioned above, Lakatos distinguishes between mature and immature science on the basis of whether a research program has a positive heuristic or not. Pannenberg's system, as I have reconstructed it, does indeed have a positive heuristic, which we see playing a crucial role in determining the direction of his *Anthropology*. Thus the status of his scientific work, in light of my methodological interpretation, is that of a *mature* research program.

A related question arises from Eaves's suggestion that Pannenberg has assembled a (mere) aggregate of anthropological ideas that are most useful theologically. According to Lakatos's methodology, the

task of the scientist is to assemble a network of auxiliary hypotheses that serve to elaborate and defend the hard core. Again, scientific respectability depends on whether one does so in an ad hoc manner or in accordance with a preconceived plan. It is therefore no criticism that from the point of view of some other anthropological program there is no apparent unity among those bits and pieces. Again, the criterion is their usefulness in predicting novel facts. A low-level theory that is unproductive within the context of one research program may still have interesting new consequences when placed within the context of a different research program.

Eaves's remaining question is whether Pannenberg has sold out by adopting the methods of the soft sciences. Were Pannenberg to claim Lakatos's natural-scientific methodology as his own, nothing that I can see at this point would have to be changed by way of theological content or overall goal. The difference would be that questions of acceptability of Pannenberg's system over his rivals would not turn on the rather vague issue of which all-encompassing theory better explains the *whole of reality*. Rather, the discussion would focus on specific factual claims, where adjudication is a fairly straightforward matter, and where there is less room for secular science's anti-religious biases to get in the way. Were Pannenberg to make this change he would no longer be open to charges such as Eaves's. He would not have to defend the scientific status of the whole of the human sciences in order to defend the status of theology. This would be a great advantage in the eyes of English-speakers, for whom 'science' is a more restrictive term than *Wissenschaft*, and among whom the human sciences are often regarded with suspicion.

Last I turn to van Huyssteen's question about the relation between commitment and fallibilism in theology. Lakatos proposed his methodology as an improvement on Popper's work specifically to take into account the criticism Kuhn had leveled against Popper's falsificationism. Therefore it should not be surprising that Lakatos's view of the scientist's attitude toward the hard core of a research program is a helpful model for mediating between commitment and fallibilism in theology. Scientists, according to Lakatos, dedicate their efforts to preserving their core theories from falsification. Only if that research program comes to be seen as degenerating (ad hoc), and only if a better one becomes available, is the central hypothesis rejected—despite the fact that many lesser parts of the program might be given up readily. Does this not provide a suitable model for the attitude of the theologian in general and Pannenberg in particular? The existence of God, and some fairly abstract description of God's nature, are held with

great commitment. One dedicates one's life to rational defense of that belief, but the various theories one uses in that defense are more readily sacrificed in the face of problematic data. Yet theologians such as Pannenberg do not rule out a priori the possibility that their efforts will fail. Thus, in this extreme case, as Sponheim rightly suggests, theology is 'falsifiable'. Following Lakatos, I put 'falsifiable' in scare quotes to indicate how different the process of replacing a research program is from Popper's simpler view of the falsification of theories.

.

6. Conclusion

I have provided an alternative *theory* of scientific method that I believe accounts as well as Pannenberg's own methodology for the data—that is, for the order and coherence of his theological development. Both methodologies serve to provide answers to some of the questions raised in Sponheim's, van Huyssteen's, and Eaves's papers. However, I believe my Lakatosian methodology provides significant advantages. First, it forces the revision of Eaves's estimate of the maturity of Pannenberg's thought, and shows it in a much more favorable light as comparable to the natural sciences rather than to the so-called soft sciences. Second, Sponheim's question, What would it take? can be answered clearly and directly: It will take the prediction and corroboration of a few novel facts, especially facts within the domain of one or more of the sciences.

I believe this is an appropriate place for me to stop and for discussion to begin. I have found a way to trade an assortment of questions for one question: What novel scientific facts can we predict on the basis of Pannenberg's system? An answer to this question would fulfill the stated goal that prompted this critical essay: "To make 'progress' in discussing the themes, as Lakatos conceives of 'progress' in research programs."

.

Notes

1. Van Huyssteen's paper suggests that Pannenberg's view of scientific method is closest to Kuhn's. I believe, on the contrary, that it is much closer to Stephen Toulmin's.
2. Actually, this is a great oversimplification. There are many spheres of experience, so we begin with many series of concentric circles. Whether there ever is a single sphere of human experience—whether there is such a thing as 'the whole of reality'—is perhaps a more pressing question than we are apt to suppose in discussing Pannenberg's work. Scholars involved in

cross-cultural studies tend to assume that there are many histories. I cite a discussion at the fall meeting of the Pacific Coast Theological Society, Berkeley, 4–5 November, 1988.

• • • • • • • • • •

References

Lakatos, Imre. 1987. Falsification and the Methodology of Scientific Research Programmes. In *Philosophical Papers,* vol. 1, 8–101. Cambridge: Cambridge University Press.

Pannenberg, Wolfhart. 1976. *Theology and the Philosophy of Science.* Trans. Francis McDonagh. Philadelphia: Westminster.

———. 1985. *Anthropology in Theological Perspective.* Trans. Matthew J. O'Connell. Philadelphia: Westminster.

PART SEVEN

· · · · · · · · · ·
Pannenberg's Response

Introduction to Part Seven

• • • • • • • • • •

Carol Rausch Albright

After his theories had been unbundled, critiqued, and carried forward, Wolfhart Pannenberg responded. He paid particular attention to the contributions of Philip Hefner, Jeffrey Wicken, Lindon Eaves, and Frank Tipler.[1]

Pannenberg selected for special attention Hefner's discussion of contingency and field. Pannenberg's own decision to transfer the field concept to theology occurred to him "like an illumination . . . that the modern field concept emerged as a further development of the Stoic doctrine of *pneuma* (spirit), which was related to the early Greek idea of *pneuma* as moved air—an idea which is rather close to the ancient Hebrew term for spirit (*ruah*). At that moment I decided that I had to appropriate the field concept for theological discourse in order to describe in a more appropriate way how we might think of God as spirit" (428). In fact, "this concept of God as spirit has to be disentangled from the customary identification with mind"; rather, spirit is "a kind of force, comparable to the wind but prior to bodily phenomena" (429).

Pannenberg traced the concept of field into the work of Wicken, where it forms the "dynamic context" upon which "self-organization itself depends." As Wicken argued, "the whole is never reducible to the parts because the function of parts is conceivable without presupposing the whole in the framework of which function is defined" (432). Furthermore, "with regard to the phenomenon of life . . . the priority of wholes over parts not only provides their meaning; it also has a dynamic quality" (432). In fact, "the dynamic field can be conceived as creative of its 'parts' and therefore constitutive of them as well as of the whole that is dependent on them as elements." And as Pannenberg points out, "the emergence of self-organizing systems itself must be accounted for by the same principle that is responsible for the thermodynamic situation they exploit" (433)—a fact that continues to evoke a sense of mystery.

Lindon Eaves's concept of the icon—illustrated equally well, he said, by DNA or Jesus Christ—evoked from Pannenberg charges of idolatry. At most, Pannenberg responded, science can generate mod-

els, since "we have to be aware of the difference between our conceptualities and the reality they represent" (434). Contrary to Eaves's charge that Pannenberg avoids confronting the 'hard sciences' ("where it hurts most"), Pannenberg spoke of extensive dialogue with the hard sciences, of which he found cosmology to be of the most comprehensive importance.

For this reason, he was very encouraged "to see in the contribution of Frank Tipler . . . the surprising degree of convergence that is possible between science and theology in this field, where a century ago no reconciliation seemed to be imaginable" (436). Nevertheless, he continued, "there are still a number of points [in Tipler's work] that are difficult to reconcile with a Christian doctrine of creation and eschatology" (437). In particular, Pannenberg pointed out, Tipler has not dealt with Christology, the problem of evil, and the Christian doctrine of the contingent creation of the universe. In regard to the last point, Pannenberg believed that "if the idea of Omega as ultimate future of the universe is taken seriously . . . it may be possible to develop a concept of nature that incorporates the element of contingency as resulting from the tension between the eschatological future and the finite present" (441).

• • • • • • • • • •

Note

1. The response appears in *Zygon: Journal of Religion and Science* 24 (June 1989), 255–271.

18

Theological Appropriation of Scientific Understandings: Response to Hefner, Wicken, Eaves, and Tipler

• • • • • • • • • •

Wolfhart Pannenberg

First of all I want to express my gratitude for Philip Hefner's lucid and brilliant presentation of the intentions implicit in my theological work (Chapter 5). Much of what he describes is not just my personal vision of theology but spells out what theology, if properly done, should be like—and that is indeed "breathtaking." It is the subject matter of theology, the reality of God, that urges upon the theologian such a venture. I am far from pretending that I have accomplished the task. But as a theologian one should be aware of the fact that this *is* the task and that it is not impossible; rather, it is extremely rewarding and exciting to devote to theological service whatever strength a human being is given. I hope that others will take up where I shall have to leave, so as to transcend the limitations of my own understanding— and not least in the sciences, lest those limitations might count against the viability of the theological enterprise as such.

My specific way of dealing with the theological task of interpreting reality in terms of God's action is characterized, as Hefner presents it, by the notions of contingency and field. The issue of contingency in historical experience—as a mark of God's action—impressed itself upon my mind early in the course of my studies, in connection with the medieval doctrine of God's prescience and predestination. Later on I found it useful in dialogue with scientists. It was rather late, however, that I took the risk of transferring the field concept to theology, especially to the doctrine of God as spirit. In doing so, the field concept gets slightly transformed, especially by the framework of eschatology and the concomitant idea of the future shaping the present. While this temporal reinterpretation of the field concept allows us to conceive of contingency as a manifestation of such a field, I am well aware that this is no longer the field concept of classical electrodynamics and gravitational theory. But it should not be considered illegitimate (as in Wicken 1988) to use a scientific concept in a new way as long as the reshaping is deliberate (does not simply emerge as accidental equivocity)—especially, first, when it is done in continuity with the profound implications of its conceptual history and, second, when

it sheds new light on current scientific problems. The first point is valid because Michael Faraday intended the concept of field to function not only as a correlate with physical bodies, but as a final explanation of bodily phenomena (see Berkson 1974, 39 and 50). The classical notion of field as correlative with body can be accounted for as a special case of this more fundamental concept.[1] The second point might emerge in relation to quantum mechanics and thermodynamics. The philosophical interpretation of quantum mechanics is still very controversial; indeed, it has proven impossible to account for all sides of the experimental situation in terms of either field or particle. But it was only the classical definition of the field concept that had limited value. A reformulation of the field concept in connection with the assumption of a priority of the future over present and past might create new possibilities of interpretation, particularly so because it allows us to consider contingency as a manifestation of a field (and perhaps also by overcoming the dualism of object/observer). For the same reason there might be applications to the task of comprehensively accounting for the processes studied by non-equilibrium thermodynamics.

The theological use and reinterpretation of the field concept was not aimed at such applications, however. I decided to take the risk of using that concept in theology for strictly theological reasons; that is, in order to obtain a better understanding than the traditional one for the idea of God as spirit. For many years I had been dissatisfied with the traditional association of spirit with mind and intellect. That conceptuality, introduced by Origen, does not do justice to the biblical and especially the Old Testament usage of the word *spirit* in the sense of breath or wind. In modern times, the equation of God's spirit with mind gave rise to the charge of excessive anthropomorphism in our conceptions of divine reality. Thus it became one of the more serious reasons for modern atheism. It occurred to me like an illumination, then, when in studying the history of field theory I learned from Max Jammer that the modern field concept emerged as a further development of the Stoic doctrine of *pneuma* (spirit), which was related to the early Greek idea of *pneuma* as moved air—an idea which is rather close to the ancient Hebrew term for spirit (*ruah*). At that moment I decided that I had to appropriate the field concept for theological discourse in order to describe in a more appropriate way how we might think of God as spirit.

There are, of course, systematic parallels to field language in other areas of my work, as Hefner has pointed out. It is related, especially, to the category of *whole* over against *part*, which has occupied my atten-

tion since my early efforts at coming to terms with the problems of hermeneutics and history. It was from Wilhelm Dilthey's hermeneutical theory that I first derived the notion of the whole as superior to the parts: the whole is superior because it already contains everything that might be called its part, though not always explicitly so. Nevertheless, the whole remains dependent upon whatever parts it may contain. The notion of *environment* is somewhat analogous, except that the environment does not actually contain the organism, but surrounds it. Is that separation overcome when one speaks of *ecosystems?* An ecosystem is of course intended to include organisms, even species, as parts. It also appears more clearly as a whole than the concept of environment. Nevertheless, the term does not provide all the advantages of the idea of a whole, because the notion of system is more dependent on the parts from which it is built, whereas a whole may be perceived as a unity without discerning any of its parts. The case of the field concept is different, especially if it is not taken simply as a dimensional whole (like space-time) but as a dynamic field that produces its 'parts', as Faraday seemed to envision. The priority of the whole over its parts is better expressed, then, by such a notion of dynamical field than by the notion of the whole itself.

The application of the field concept to the concept of God does not—as Jeffrey Wicken (1988, 52) suspects—'physicalize' the concept of God. I rather think that the modern concepts of fields and energy went a long way to 'spiritualize' physics, as the German physicist Georg Süssmann (1980) holds. One is able to see the point in this judgment as soon as one relinquishes an identification of spirit with mind. According to the biblical tradition, spirit is rather a kind of force, comparable to the wind but prior to bodily phenomena. If theology wants to be true to the biblical witness, the concept of God as spirit has to be disentangled from the customary identification with mind, an identification which entails an all-too-facile image of God as 'personal'. Certainly theology wants to affirm the personal character of the divine reality, but the image of mind offers a deceptive self-evidence of that claim. It dissolves the mystery that reveals itself as 'personal' (in a sense of this word that has to be reconceived) when it manifests itself especially in being revealed as 'father' to the 'son' and through him. The reformulation of the idea of God as spirit in terms of field language enables the theologian to recapture a sense of mystery in talking about God instead of the facile anthropomorphism that often accompanies the image of God as mind. The phenomenon of mind itself—the human mind, with its distinctive form of consciousness and self-consciousness—needs to be reinterpreted as a special

manifestation of 'spirit' in the sense of field. This establishes new connections with the task of accounting for the phenomenon of human consciousness and self-consciousness in a scientific description. Ultimately, it will be the field of God's spiritual presence that constitutes the human mind. But it might be mediated by other field factors. This does not mean to identify God with the most comprehensive physical field, say of space-time. Against pantheism, theology always insists on the specific nature of the divine as distinct from all finite reality. But the finite realities of physical fields can be imagined as constituted by the presence of the divine spirit, as forms of its creative manifestation.

Philip Hefner characterizes the systematic structure of my theological project as a "research program" in the sense defined by Imre Lakatos (109–111). I have no problems with such a description. I could have used that notion myself in describing the theoretical form of theological explanation if the work of Lakatos had been available to me when I wrote my book *Theology and the Philosophy of Science*. But at that time, around 1970, the latest phase of the discussion was represented by Thomas Kuhn. I perceived Kuhn's ideas on revolutionary science and paradigm shift not as proposing a relativistic outlook on science, as some of his critics did, nor did I take his opposition to Karl Popper as a complete rejection of his ideas, but rather as a refinement of Popper's approach. To me the most important point was a less restricted recognition of the role of rival metaphysical visions in the history of science and the description of scientific theories as interpretations of empirical evidence, more comparable to hermeneutics than Popper would admit. Thus, use of Kuhn's ideas was not very far from the strategy of Lakatos in defending and developing Popper's description of scientific explanation.

Some of the more specific ideas of Lakatos were, of course, not explicitly present in my account of theological explanation. This applies especially to Lakatos's distinction between *hard core* and *auxiliary hypotheses*. I do not know whether I could have offered such a description, because I would tend to emphasize more strongly the unity of elements in a systematic interpretation. In a metaphysical consideration, the content of both kinds of theory is closely related. But by way of methodology there may be reason for making such a distinction. It is easy to detect that kind of structure in the way theological systematics actually must operate. Therefore, I have no objection to Hefner's attempt at reconstructing my way of organizing systematic theology in terms of Lakatos's research program. Such a description was also offered by Nancey Murphy (Chapter 17) as an "alternative account" of my theology in the place of what she consid-

ers to be my own description. The account she gives is actually closer to my view of the task of theology than the image of concentric circles which she attributes to me. In terms of *systematic structure* the framework of theological explanation as I envision it may be adequately described in Lakatosian terms.

The question of *method* is somewhat different.[2] Hefner concurs with Lindon Eaves (Chapter 12) in pointing out that my method in dealing with the secular sciences, and also with historical data related to the biblical tradition, has been to take "secular descriptions as provisional versions of reality" which imply a further dimension, the dimension of reality as constituted by the presence of God. It is the task of theology to make that dimension explicit. That will always involve some transformation of the phenomenon as described by the secular disciplines, but such a transformation has to be argued for on the basis of the evidence studied by those disciplines. If that can be achieved persuasively, the theological interpretation of the phenomenon (or range of phenomena) can be considered justified.

The emerging picture of any particular such interpretation may be termed an auxiliary hypothesis in the sense of Lakatos. It does not, in the first place, predict new facts, but produces new interpretation. However, a new interpretive scheme will evaluate hitherto neglected facts to be relevant in the way described by Murphy as effectively supportive of a research program. Examples from the field of biblical studies related to the question of Christian origins are the reevaluation of Jewish apocalyptics in connection with the doctrine of revelation and a new emphasis on Jesus's resurrection as historical event. An example from the field of history could be the reinterpretation of the rise of secular culture in the West as resulting from the period of post-Reformation religious wars. Examples from anthropology include the importance of religion in the formation of individual identity, in the authority of cultural systems, in the origin of language, and in summary, in identifying what is distinctive in the human phenomenon in comparison to other animals. With regard to physics, I have already noted how the theological emphasis on contingency in connection with the theological use of the field concept could suggest new possibilities of theoretical description. Frank Tipler's proposal (Chapter 7) in itself offers another example. Regarding the biological sciences, the question I once raised in perhaps a somewhat cryptic form—whether biology has a place for the explanation of life by the power of the divine spirit—was related in my mind to the current research and discussion on the thermodynamic conditions of the emergence of organic life as well as to the 'openness' of each organism to its environment.

For the degree of clarity I could obtain in these matters, I am greatly indebted to Wicken's book *Evolution, Thermodynamics, and Information* (1987). His holistic approach to the emergence of life opens new possibilities for theologians. We can appropriate the language of self-organizing systems (exploiting the thermodynamic flow of energy degradation) for interpreting organic life as a creation of the spirit of God. The thesis that self-organization itself depends on a dynamic context wherein it functions and thus evolves is crucial. It is obvious from Wicken's argument that he presupposes more general ideas about part-whole relationships, where the whole is never reducible to the parts because the function of parts is inconceivable without presupposing the whole in the framework of which such function is defined. In this way the whole is itself constitutive of the parts. In his contribution to the present discussion Wicken explicitly applies this reasoning to the interrelation of science and religion (as well as theology).

This perspective is helpful in bridging the gulf that otherwise exists between theology and evolutionary biology, a gulf which according to Wicken's penetrating analysis is separating religion and modern biology as long as the doctrine of evolution is interpreted in reductionistic terms. Wicken's critique of these reductionistic tendencies is extremely valuable, and so is his use of the part-whole relationship. The latter is familiar and congenial to theology because it was also basic in the hermeneutic tradition, especially in the hermeneutics of Dilthey. The meaning of parts is dependent on wholes, though there is also a corresponding dependence of wholes upon parts as soon as the whole is perceived as subdivided into parts. To secure the priority of the whole over its parts in hermeneutical theory, however, requires avoiding the reduction of the concept of meaning to that of action. If meaning is dependent on human action, then there cannot be any superindividual whole of meaning that constitutes the meaning of individual existence and action. At this point, the danger of reductionism raises its head within the theory of meaning itself, and it has to be resisted here as anywhere else. Meaning is not dependent on and created by human (purposive) action, but human action shares in the spiritual reality of meaning that is based on the priority of wholes over parts.

With regard to the phenomenon of life, however, the priority of wholes over parts not only provides their meaning; it also has a dynamic quality.[3] The parts are nothing except for their function within the whole. To put it more cautiously: the parts are something different if considered without the functions they obtain within that context. Hence the reality of the parts as parts is constituted by the whole. But is not the whole also dependent on the parts? The problem may be

solved if one takes recourse to that power which constitutes the wholeness of the whole itself and also the parts as characterized by their specific functions. As mentioned before, the field concept is distinguished from that of an extensive whole by precisely that mark: the dynamic field can be conceived as creative of its 'parts' and therefore as constitutive of them as well as of the whole that is dependent on them as elements. In contemporary discussions among biologists it has become fashionable to speak of ecosystems rather than fields, if one wants to refer to the most comprehensive unities of organic processes. But conceptually the term *ecosystem* has its problems, because it does not illumine the unity that constitutes such an organized totality which is intended to integrate such different phenomena as self-organizing animals and plants and their typical surroundings. At this point, Michael Polanyi's choice of the field concept as an explanatory category in evolutionary theory could have continuing value, although it must be rephrased in terms of ecological units rather than species and individual organisms taken out of their ecological context (see Wicken 1988, 53–54).

If one talks about a dynamic field that constitutes an ecosystem or even the biosphere as a whole, it is not simply equivalent to the thermodynamic energy flow that provides the occasion for the emergence of self-organizing entities which nourish their life by exploiting the thermodynamic flow. The emergence of self-organizing systems itself must be accounted for by the same principle that is responsible for the thermodynamic situation they exploit. It is this kind of principle that is referred to in theological language about the dynamics of God's spirit as creator of life. Such language does not exclude scientific exploration of the processes which contribute to the total situation of life's emergence. But it preserves a sense of mystery which only the pretentious, claiming that nothing is left for future research, could deny.

Perhaps this is the appropriate point to engage in dialogue with Lindon Eaves's essay. He describes the situation between theology and science in such a way that the scientist is not content with presenting 'provisional versions' of the reality he or she explores. Rather, according to Eaves, the scientist produces *icons* of reality that claim the status of definitive knowledge. In this connection, Eaves compares the double helix as an icon of modern biology to the function of Jesus Christ as "the eikon of the invisible God" in Colossians 1:15 (320). If this were so indeed, biologists should not be surprised to be charged with idolatry. That there is a temptation in this regard may be undeniable. All disciplines including theology share such a temptation, and it may become manifest in a particular way in reductionistic tendencies

in the sciences. Perhaps that explains why Eaves in some places seems to sympathize with a view that the Christian faith is to be affirmed 'in spite of' the data of science. Sometimes in the history of science the situation may present itself in dramatic colors like that. But it can never be the whole story. In principle, science cannot be idolatrous, for according to the Christian faith the divine Logos incarnate in Christ is the same through whom the world was created and continues to be created. In searching for the universal Logos, the scientist is after the same truth that is the object of the Christian confession of faith, and precisely for that reason Christians should not be afraid of science or erect barriers against scientific inspection of their own affirmations.

If one does not want to mistake the scientific claim to knowledge for idolatry, it might be better to keep the notion of *model* rather than exchanging it for icon. However, I agree with Eaves that talk about models easily suggests an understatement of the truth claims that go with scientific theories. They certainly intend the truth about nature. But at the same time—and this also applies to theological language—we have to be aware of the difference between our conceptualities and the reality they represent. The image of the double helix may be here to stay (like Darwinian evolution by natural selection), but even at present it turns out to be in need of further interpretation: if I am not mistaken, this is precisely the point in Wicken's critique of biological approaches that reduce everything in the phenomenon of life to genetic replication. Such criticism does not deny that the genetic factor is of central importance, but it insists that it is not equivalent with the total phenomenon of life, nor should it be expected to clarify everything. That means that the phenomenon of life as a whole has to be accounted for in a more comprehensive way without closing one's eyes to the explanatory power of genetics.

Eaves confesses that in reading my book on anthropology he experienced some "frustration" (327), because there the argument is based more on the humanities than on biological anthropology. What he misses seems to be in the first place genetics, especially as it has been used as an explanatory principle in sociobiology. But of course genetics is not the only biological discipline. Behavioral studies have a much more substantial place in the argument of that book than genetics, and to reconcile behavioral phenomenology and the explanatory claims of genetics seems to be an issue within biology itself, an issue which is by no means definitively settled (although sociobiology claims as much).

Eaves's criticism suggests that I avoided confronting the 'hard sciences' ("where it hurts most") in order to settle for the humanities, as

if that were an easier line. In my experience, theological dialogue with the secular disciplines engenders no less conflict in the case of the humanities than the natural sciences. But the main point is that I am not as shy of entering into dialogue with the 'hard sciences' as Eaves wants to make the reader believe. The attempt to find some common ground with physics has occupied more of my time than engagement with any other discipline except perhaps history. When it comes to biology itself, there is a promising field of convergence in the exploration of the thermodynamic framework of the emergence and evolution of organic life. I do not share creationist reservations about the Darwinian theory of evolution as long as it can be read as the first major contribution to an understanding of natural processes in terms of their historicity rather than as reducing the emergence of human life and history to some mechanistic process. It was just one particular theoretical model, the Wilsonian type of sociobiology, which I took the liberty of investigating with the eyes of a skeptic. The reasons for my skepticism have been enunciated by Wicken (Chapter 10) in a more specific and incisive form than I could hope to give them myself. In the book on anthropology I restricted my criticism to the question of whether an adequate account of the diversity of human cultures can be derived from the principle of the selfish gene. In the limited framework of anthropology as compared to the broader one of the phenomenon of life, this seems to be the most relevant issue. But in principle the more basic criticism of a predominantly genetic theory of explanation in biology is the one which has been pointed out by Wicken in his argument against a reductionistic conception of organic life. This is a question that can hardly be handled appropriately within the more limited scope of anthropology. But surely the way we conceive of life in general cannot fail to have a profound impact on how we understand human life.

Murphy (Chapter 17) correctly surmised that one reason for not including the sociobiology of Wilson or Dawkins in my description of human nature could be that this theory belongs to an alternative research program that constitutes one of the principal rivals of a theological anthropology. I think this is true to the degree that sociobiology is reductionistic in the sense criticized by Wicken. It is of course possible to imagine a non-reductionistic type of sociobiology, and there is no reason why theology should not admit the important role genes actually have in shaping human behavior. But in the absence of a sufficiently balanced theory on this issue in contemporary biology, it seems difficult to judge how the influence of genetic heritage can be systematically integrated with other factors responsible for animal or

human behavior. It is certainly not the task of the theologian to inter-
fere in the details of such a discussion. However, on the basis of gen-
eral considerations about the nature of life and evolution provided by
the modern view of thermodynamic conditions for the emergence of
life, we may anticipate (among other things) increasing emphasis on
the factors of openness and superabundance; these characterize, in
some way or other, every form of organic life and apply to the human
situation in a special way described as *eccentricity*.

The most comprehensive issue arising from theological dialogue
with the sciences is certainly that of cosmology. Contemporary scien-
tific cosmology is a highly speculative discipline with a plurality of
rival theoretical models. In addition, the scene has been changing
quickly over the decades. Nevertheless it is very encouraging to see in
the contribution of Frank Tipler (Chapter 7) the surprising degree of
convergence that is possible between science and theology in this
field, where a century ago no reconciliation seemed to be imaginable.
This is even more remarkable with reference to eschatology than in
relation to the Big Bang.

Concerning the assumption of a finite 'age' of the universe in the
standard cosmological model of an expanding universe, there has
been some discussion of whether and how it can or should be related
to the Christian doctrine of creation. The discussion is interesting as an
example of how convergences between theology and science should
be evaluated. The hasty identification of the Big Bang with a temporal
beginning of the universe in a theological doctrine of *creatio ex nihilo*
should be met with caution. The assumption of a cosmological singu-
larity at the beginning of the expansion of the universe need not imply
the idea of a first event without predecessor. On the other hand, theol-
ogy would continue to speak for *creatio ex nihilo* even if the standard
model of an expanding universe was abandoned. Yet, after all that has
been said, it remains that "if the universe began in time through the
act of a Creator, from our vantage point it would look something like
the Big Bang that cosmologists are now talking about" (McMullin
1981, 39). If this is so, one should be less rigorous than Ernan
McMullin in rejecting statements that affirm some supportive function
of the standard model of modern cosmology in relation to the Chris-
tian doctrine of creation. Certainly, the Big Bang model of an expand-
ing universe does not imply in the strict logical sense of the word the
Christian notion of *creatio ex nihilo*, but there is a relation of coherence
between the two, and such coherence surely 'supports' rather than
contradicts the theological assertion that the world was created (in the
sense that there was a beginning of the world). Admittedly, the idea of
beginning is very difficult, because ordinarily it suggests an event *in*

time. Christian doctrine since Augustine has insisted that the beginning of creation also involves the origin of time itself. Time, then, is not an independent reality but qualifies finite existence. In any event, the concept of creation always implies the idea of a beginning of the creature in addition to its continuous dependence on its creator, and if it makes sense to speak of a creation of the world at large, then the world also must have a beginning in some sense, though not a beginning 'in' time.

In a similar way the recent development of Tipler's ideas about cosmology converges with a Christian eschatology and thus 'supports' the eschatological affirmations of the theologian. These are affirmations that the theologian should dare to make anyway on the basis of a systematic treatment of data from biblical exegesis and in view of the task of reconceiving the relationship between God and the world. But such affirmations begin to make sense, cosmological sense, in a new way in the perspective of Tipler's argument. The absence of such a perspective in the past discouraged many theologians, probably a majority of them, from taking the affirmations of the Christian tradition concerning eschatology seriously. Even their defenders argued primarily on the basis of anthropological considerations, but their conclusions stood in sharp contrast to our knowledge about the physical universe. In consequence of the kind of work that Tipler pursues in cosmology, this situation may be changing significantly. This is not to say that Tipler's project concurs in every respect with traditional Christian affirmations. There are still a number of points that are difficult to reconcile with a Christian doctrine of creation and eschatology, even if one allows generous space for its reformulation. But in the general thrust of Tipler's project there is a remarkable convergence with Christian theology, and the mere possibility of such a development in science cannot fail to strengthen the confidence of the theologian (and indeed of every educated modern Christian) with regard to the truth claims of traditional eschatological affirmations.

A first problem for theology is presented by the postulate of the continuous existence of life in the universe. The basis of this postulate is the three-stage anthropic principle developed by Tipler and Barrow in their comprehensive work, *The Anthropic Cosmological Principle* (1986). The 'weak' form of this principle is undeniable; it states that the emergence of life and intelligence in the universe cannot be considered an accidental feature. Still, only in a deterministic universe would material processes *necessarily* produce organic life and intelligence. The Christian concern for contingency in the history of creation is not easily reconcilable with that strong version of the anthropic principle. Only in a theological perspective that already presupposes

the existence of God and an ultimate completion of creation in such a way that this completion addresses the relation of human existence to the creator (which is the point of incarnation doctrine) can it be said theologically that the emergence of life and intelligence is a necessary feature in the overall design of creation.

But even on this basis it is not immediately evident that life must continue forever in the history of the universe. Certainly, if the emergence of life and intelligence in the course of the physical universe is not accidental, but constitutive of the overall character of the universe, it cannot simply disappear after a relatively short period. But would it not be enough to assume that its emergence is preserved and 'remembered' in God's eternity? If in a closed universe organic life will vanish in the contraction phase of the cosmic process, cannot that be the price to be paid for the emergence of life at one point in its history? Just as billions of years had to pass before life and intelligence could emerge, so the price for their emergence at one point of cosmic history would be a correspondingly extended phase in that history after life's vanishing point. Still, new life could be remembered in God's eternity so that it could be resurrected at the end of cosmic history. The phase of contraction of the universe after the disappearance of organic life could even be considered a condition for the replacement of this world by a 'new heaven and a new earth' in the eschaton or, more precisely, for its transformed (by participation in God) "simulation", as Tipler puts it.

In considerations of this sort, however, one aspect is still missing. The emergence of human life in the course of the cosmic process must also be related to that process as a whole in such a way that it determines the structure of the entire universe. Salvation cannot be conceived as occurring separately for humans at the end of history. What happens to human beings has to be related to the entire world process, if indeed all creation is related to the appearance of human beings. Therefore, the argument of Tipler and Barrow makes an important point; namely, that intelligent life, if its emergence is of ultimate significance to the universe, must be conceived of as actually determining its entire structure. But according to Christian theology, this is achieved in one instance of human life, in the person of Jesus, because in him the intended destiny of the human creature (and thus the destiny of all created existence) in relation to God was realized. The continuous importance of this fact is expressed in the Christian doctrine that the risen Christ shares in God's rule over the universe. Thus, in the case of Jesus Christ there is indeed continued existence in a form that includes control over the processes of the universe, while the existence of all other persons is 'remembered' in the eternity of God in

order to be granted a share in Jesus's kingdom in the eschatological future when they will be raised from the dead.

One theological problem, then, in the present form of Tipler's ideas is that he has not yet dealt with Christology. Could his thought be developed in such a way as to focus the postulate of continued existence of intelligent life on just one person in order to take control of the universe? Is it conceivable, furthermore, that this event has already happened in the past—in the resurrection of Jesus Christ— while it will include the rest of humankind, but manifestly so not before the eschatological future? If so, then Tipler and Barrow's problematic construction of the possible continuation of intelligent life in non-human form—computer-based rather than carbon-based—would appear to be dispensable. The 'computer capacity' of the divine Logos that was connected with the human life of Jesus in the incarnation and became fully available to him in his exaltation would be sufficient.

These considerations seem to differ from Tipler's argument on a further point. They proceed by presupposing the existence of a creator God, while Tipler reaches that idea only in consequence of his final anthropic principle.[4] This difference may be largely superficial, however. Both Tipler and a Christian theology that takes eschatology seriously in talking about God agree that it is only in the eschaton that the reality of God and his kingdom over his creation will become fully manifest in relation to the temporal course of its process.[5] Furthermore, there is agreement that Omega is both transcendent and immanent in relation to the process of the universe and consequently both changing and unchanging—unchanging in its eternal aspect, changing in its "immanent temporal aspect." Theologically, this temporal aspect of becoming is discussed in terms of a history of divine revelation in the context of the history of human religion. In Tipler's conception, it is bound up with the emergence of life and intelligence. These descriptions are compatible, if the requirement that the universe must be "capable of sustaining life indefinitely" may be interpreted in Christological terms to the effect that the risen Christ is forever alive and gains "control of all matter and energy sources available near the Final State." This does not separate Jesus from the rest of humankind, since all those who are united with him by faith and sacraments will participate in his kingdom at the end of time. Tipler's description of the way this could happen does not cause particular theological difficulties. The resurrection of the dead may occur in the form of a "simulation" of their earthly life (184–89). Such a "simulation" seems sufficient to secure identity with the former person, though admitting of a transformation by participating in God's eternity. Christian theology would insist, however, that in the case of Jesus this occurred in the Easter

event such that in him human nature already became united with Omega and obtained control of the universe; for others, participation in this new life will only occur in the eschaton.

That a place for Christology is missing in Tipler's concept of the universe may be related to the way that the problem of evil is addressed. The classical tradition of eschatological thought is profoundly concerned with the overcoming of evil. Tipler's interaction with Flew reveals that the problem of evil does stand behind the Omega Point theory (191–92, n. 14). But it is not developed in the theory. This especially applies to the correspondence between physical evil and sin. Is there an element of failure involved in the phenomena of our temporal universe? And is eschatological hope related to the overcoming of such evil? Tipler's consideration of resurrection by simulation disposes of some of the resources that allowed classical eschatology to answer the problem: the evil of death will be overcome by the resurrection. That includes the species along with the individuals as indicated in the idea that in the resurrection of Jesus a "new humanity" made its first appearance (1 Cor. 15:45–57) to overcome the power of death. But it also overcomes the root of death in sin: and thus the transformation of our present lives by an event which means judgment as well as glorification.

Finally, there is agreement in principle on the constitutive role of Omega in relation to the process of the universe. However, if this role is to be characterized in such a way that Omega 'creates the physical universe', it must mean more than that the "ultimate future guides all presents into itself." What it means to say that Omega *creates* the universe needs more detailed explication than Tipler has offered so far. The ideas of John A. Wheeler, to which Tipler briefly refers, may be helpful in pursuing such clarification. They presuppose, however, a different interpretation of quantum mechanics than the 'many worlds' interpretation which Tipler otherwise utilizes in his argument (191, n. 6). The task of producing a more detailed interpretation of the creative function of Omega in relation to the universe obviously requires some reexamination of what type of quantum cosmology should be used.

At this point, the present form of Tipler's argument does not seem congruous with a Christian doctrine of creation. The adoption of Hugh Everett's 'many worlds' interpretation seems to entail a deterministic picture of the physical universe.[6] The contingent existence of this particular world and even of each of the events the sequence of which forms the line of its particular history seems to be dissolved into what appears to be an ontological hypostatization of the probabilistic pluralism of quantum theory. It may be the case that on the

basis of this assumption not only God but also the physical universe or even a multitude of such universes would exist necessarily. But this does not square with Christian faith in the creation of the world, because that faith involves the contingent character of the world's existence, contingent in the sense that it depends on God's free decision. In the history of Christian philosophical theology, the idea of necessary existence has been limited to God alone. With respect to the world, the most that can be claimed seems to be the hypothetical necessity, depending on the will of the creator. From the perspective of God's eternity, the decision to create the world is certainly not arbitrary; the act of creation is not in that sense contingent. But still all finite existence is to be conceived as contingent in the sense that considered by itself it need not be. I cannot see how this basic affirmation of the Christian faith in creation can be accounted for on the basis of the present form of Tipler's argument. On the other hand, one can imagine different interpretations of quantum physics that would incorporate the element of indeterminacy that occurs on the experimental level into an ontological model that provides a place for indeterminate occurrences in connection with an open future. Could not such an interpretation of quantum physics also be more consistent with Tipler's Teilhardian emphasis upon the final future of Omega as creating the universe?

When in the seventeenth and eighteenth centuries the principle of inertia became the source of alienation between the new physics and theology, it was because that notion rendered the idea of a continuous creative activity of God in the processes of nature superfluous. When I called attention to this problem several years ago (this volume, Chapter 3), it was understood that this issue primarily concerns the history of relations between theology and modern science. Clearly, however, the problem continues to reappear in a variety of forms. In the theory of relativity (see Russell 1988, 31–33), the question has been answered by reference to the reduction of inertia to gravitation, but the problem can still return on other levels. The function of the principle of inertia in post-Newtonian mechanistic physics, adumbrated as early as Descartes, had been to exclude divine intervention by conceiving of the universe in terms of a completely autonomous system. This problem is profoundly bound up with the place of contingency in physical processes. It does not appear to be overcome in relativistic cosmologies as long as they are developed in the form of deterministic theory. If the idea of Omega as ultimate future of the universe is taken seriously, however, it may be possible to develop a concept of nature that incorporates the element of contingency as resulting from the tension between the eschatological future and the finite present.

.

From *Zygon: Journal of Religion and Science* 24 (June) 1989, 255–271. By permission.

.

Notes

1. Wicken (1988, 52) limits the use of the field concept to such a reciprocal correlation with 'material elements'.
2. In the case of philosophy or theology it could hardly be said that these disciplines in their systematic structure were constituted by method. The subject-matter of the discipline does not first come into view by a certain procedure. The procedure presupposes a preliminary knowledge of the subject to be investigated. The systematic structure of explanation, however, concerns the systematic presentation of the subject-matter.
3. Perhaps here I use a more restricted notion of 'meaning' than Wicken does in his contribution to *Zygon*. I agree with Wicken's assertion that all meaning "depends on some kind of part-whole relationship." But how is this related to his concept of the "functional whole of an organism"? How is meaning related to dynamics? Certainly the two must not be bifurcated, but their unity seems in need of explanation.
4. I do not enter into a discussion of the question whether Omega should be conceived of as 'mind' or 'person'. I have already indicated reservations with regard to the dangers of anthropomorphism concerning traditional conceptions of God as mind. Tipler himself seems to be aware of this problem. The biblical references to God as spirit should not be identified with mind for the reasons indicated above. Concerning the term *person:* the Christian doctrine does not speak of God as a person but rather of trinitarian persons, which means that the divine reality becomes manifest as person in form of Father, Son, and Holy Spirit. It is personal because of the interrelations of the three, not because of the intellectual capacity of the divine nature.
5. Tipler and I also agree that his argument is not a modern version of the old design argument. Tipler has been criticized by Craig (1987) for despising the design argument. As I see it, however, part of the strength of Tipler's program derives from his avoidance of that argument and its inescapably anthropomorphic analogies.
6. Tipler himself, however, claims that on the level of quantum cosmology there can be no determinism since there is no time factor. On this issue see Hesse (1988). With respect to the use of the 'many worlds' interpretation of quantum physics, I share some of the critical reservations expressed by Craig (1987).

.

References

Berkson, William. 1974. *Fields of Force: The Development of a Worldview from Faraday to Einstein.* London: Routledge.

Craig, William Lane. 1987. Feature book review of Barrow and Tipler's *The Anthropic Cosmological Principle*. *International Philosophical Quarterly* 27 (December):437–447.

Hesse, Mary B. 1988. Physics, Philosophy, and Myth. In *Physics, Philosophy, and Theology: A Common Quest for Understanding*, ed. Robert J. Russell et. al., 185–202. Notre Dame: University of Notre Dame Press.

McMullin, Ernan. 1981. How Should Cosmology Relate to Theology? In *The Sciences and Theology in the Twentieth Century*, ed. Arthur R. Peacocke, 17–57. Notre Dame: University of Notre Dame Press.

Russell, Robert J. 1988. Contingency in Physics and Cosmology: A Critique of the Theology of Wolfhart Pannenberg. *Zygon: Journal of Religion and Science* 23:65–77.

Süssmann, G. 1980. Geist and Materie. In *Gott, Geist, Materie: Theologie und Naturwissenschaft im Gespräch*, ed. Hermann Dietzfelbinger and L. Mohaupt, 14–31. Hamburg: Lutherisches Verlagshaus.

Wicken, Jeffrey S. 1987. *Evolution, Thermodynamics, and Information: Extending the Darwinian Paradigm*. New York: Oxford University Press.

———. 1988. Theology and Science in the Evolving Cosmos: A Need for Dialogue. *Zygon: Journal of Religion and Science* 23:45–55.

INDEX
· · · · · · · · · ·